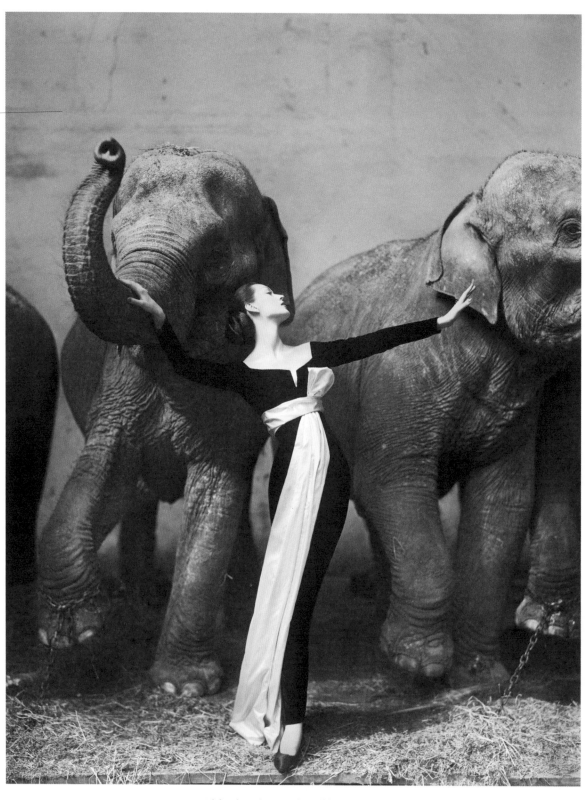

Richard Avedon, *Dovima with elephants,*
evening dress by Dior, Cirque d'Hiver, Paris, August 1955
Photograph by Richard Avedon
© The Richard Avedon Foundation

The Thames & Hudson Dictionary of Photography

Edited by *Nathalie Herschdorfer*

 Thames & Hudson

NATHALIE HERSCHDORFER is a curator, writer and art historian specializing in the history of photography. She is currently Director of the Museum of Fine Arts, Le Locle, Switzerland. In her capacity as curator, she is the director of the Alt. +1000 photography festival in Switzerland and has produced internationally touring exhibitions for the Foundation for the Exhibition of Photography, including *Coming into Fashion: A Century of Photography at Condé Nast*. Previously, she was a curator at the Musée de l'Elysée in Lausanne, where she worked for twelve years on major exhibitions including *Face: The Death of the Portrait*, and retrospectives of Edward Steichen, Leonard Freed, Ray K. Metzker and Valérie Belin.

Herschdorfer's previous books published by Thames & Hudson include *Coming into Fashion* (2012) and *Afterwards: Contemporary Photography Confronting the Past* (2011). She was the editor of *Le Corbusier and the Power of Photography* (2012) and the co-author, with William A. Ewing, of *reGeneration* (2005) and *reGeneration2* (2010).

Contents

In the second decade of a century marked by the massive expansion of the internet and digital technology, it may seem almost perverse to publish a dictionary on paper. We need only type a word into a search engine, and within a fraction of a second a welter of information appears, from the briefest of summaries to full articles. So why bother to consult a printed work that offers just one paragraph for every entry? What can such a work provide that Wikipedia cannot?

The internet is a tool that can help the learner, the amateur and the highly educated researcher in equal measure. However, in contrast to the boundless information it appears to provide – which is expanding by the day – a paper dictionary has a strictly limited content. Once it has been written, it is fixed. That is why this dictionary makes no attempt to compete with the multiple resources available on the internet. What distinguishes it is the fact that the material assembled here is the result of a painstaking selection process. The internet cannot offer any sort of hierarchy, classification or sense of priority: everything is available within easy reach and in unlimited quantities. And therein lies the main problem: one can never embrace all that knowledge. In this present context, therefore, it makes perfect sense to publish a book that reduces a seething mass of information to a structured and orderly work of reference.

This dictionary has been compiled by a group of specialists to provide the reader with the most basic facts. It has not been an easy task. How can one condense the huge field of photography – its cultural, technical, artistic and biographical history, extending to all four corners of the globe – into a set number of pages? Here the digital world has the priceless advantage of having no restrictions and being able to evolve as the subject evolves, and with no added expense. The printed book, no matter how carefully it has been put together, remains static, so that if a new invention, a new photographer or a new technique should revolutionize the world of photography tomorrow, it would not be mentioned here. However, in the digital era we often need to stop the flow of information and understand the connections that lead from past to present (and future). The brief entries here will broaden the reader's knowledge; the digital world is there if he or she wants to deepen it.

Photography was officially born in 1839, and its story is far from finished. There are certainly more images produced now than at any time before. Within this dictionary you will find all the names, genres, movements and institutions that have made the medium what it is today. It embraces a vast variety of domains: art, advertising, journalism, fashion, politics, science and everyday life. Throughout its history photography has continued to develop

through new chemical processes and technological advances, and its products can now be found in family albums, archives, museums, books, magazines and newspapers, and on walls and millions of computer screens.

In order to cover not only the medium's history, but also its global impact, consultants from all five continents were asked to draw up a list of the most important personalities, trends and technologies. Thanks to their expertise, the resulting overview is international and comprehensive. It contains more than 1,200 entries, a third of which offer an introduction to the principal movements, techniques and subjects that permeate the medium's narrative, while two-thirds are devoted to the photographers themselves. Here the process of selection was far from simple, especially when it came to assessing the importance of non-Western photographers, bearing in mind the profusion of North American, French and British practitioners who have become household names since photography's earliest days. Nevertheless, space has been given to outstanding representatives from Latin America, Africa, Asia and Oceania, and we hope they may encourage the reader to find out more from other sources. Discovering new talents was never our aim, but we have included many living artists who have already made their mark and are still pursuing their careers. History marches on.

This project was first conceived in 1998, at a time when dictionaries and encyclopaedias were the most common reference works, and the digital era had not yet begun in earnest. For some years it had to be shelved, and it was not until 2010 that the project was revived. A team of 80 researchers and some 150 consultants were engaged – all of them photography specialists in their own right – to assemble the 1,200 entries and to ensure that all the information was as accurate as possible. I would like to offer my heartfelt thanks to each and every one of them, because without them this huge undertaking would never have materialized. My hope is that the dictionary will not only provide pleasure and information, but will also encourage every reader to broaden his or her knowledge of this endlessly fascinating and versatile medium.

Nathalie Herschdorfer

Index of entries

The initials following each entry refer to the author of that text, on whom you can find details on pages 22–25.

11

D'Amico, Alicia · SdJ
Davanne, Alphonse · HO
Davidson, Bruce · APh
Davies, John · CB
Davison, George · HO
Day, Corinne · CB
De Biasi, Mario · AB
Deakin, John · CR
Deal, Joe · AW
DeCarava, Roy · FZ
Delahaye, Luc · RB
Delamotte, Philip Henry · HO
Delano, Jack · JK
Delius, Charles · NN
Demachy, Robert · NH
Demand, Thomas · VT
Denderen, Ad van · WvS
Depardon, Raymond · JK
Derges, Susan · HR
Diamond, Hugh Welch · CR
DiCorcia, Philip-Lorca · MO
Dieulefils, Pierre · MN
Dieuzade, Jean · MG
Dijkstra, Rineke · HP
Disdéri, André-
 Adolphe-Eugène · NH
Disfarmer, Mike · MO
Dłubak, Zbigniew · AU
Dohnány, Miloš · MB
Doisneau, Robert · LD
Domon, Ken · CO
Dondero, Mario · LBa
Donovan, Terence · CC
Douglas, Stan · AW
Drahos, Tom · EKH
Draper, John William · EKH
Drégely, Imre · GM
Drtikol, František · AR
Du Camp, Maxime · CL
Ducos du Hauron,
 Louis Arthur · NH
Dührkoop, Rudolph · NH
Duncan, David Douglas · MS
Dupain, Max · ERu
Durandelle, Louis-Émile · NH
Duroy, Stéphane · MN
Eastlake, Elizabeth · HO
Edgerton, Harold Eugene · CC
Edinger, Claudio · SdJ

Eggleston, William · CC
Eisenstaedt, Alfred · RV
Elsken, Ed van der · MP
Emerson, Peter Henry · NH
Engström, J. H. · WG
Eperjesi, Ágnes · GM
Erfurth, Hugo · AB
Errazuriz, Paz · AR
Erwitt, Elliott · RV
Escher, Károly · GM
Espino Barros y Rebouche,
 Eugenio · SdJ
Eugene, Frank · EM
Evans, Frederick H. · AW
Evans, Walker · CC
Faas, Horst · EM
Facio, Sara · SdJ
Faigenbaum, Patrick · MG
Farkas, Antal Jama · GM
Fastenaekens, Gilbert · AB
Faucon, Bernard · CC
Faurer, Louis · EM
Fehr, Gertrude · HP
Fei, Sha · HR
Feininger, Andreas · RV
Fekete, Alexandra Kinga · GM
Feldmann, Hans-Peter · CG
Felizardo, Luiz Carlos · SdJ
Fenoyl, Pierre de · RB
Fenton, Roger · NH
Ferrez, Marc · SdJ
Fieret, Gerard Petrus · ML
Fink, Larry · MO
Finsler, Hans · HP
Fischer, Arno · JM
Fischli & Weiss · MO
Fleischer, Alain · PEY
Fleischmann, Trude · EKH
Florence, Hércules · SdJ
Florschütz, Thomas · MJ
Fontana, Franco · AB
Fosso, Samuel · ND
Fraga, Voltaire · SdJ
Franck, Martine · JK
Frank, Robert · MO
Franklin, Stuart · CB
Freed, Leonard · CB
Freund, Gisèle · JK
Friedlander, Lee · MP

Frima, Toto · LC
Frith, Francis · CL
Fujiwara, Shinya · TI
Fukase, Masahisa · WG
Fulton, Hamish · NM
Funke, Jaromír · AR
Furuya, Seiichi · TI
Fuss, Adam · CB
Galella, Ron · AF
Garanger, Marc · JK
García, Romulado · SdJ
García Rodero, Cristina · HC
Garcia-Alix, Alberto · ERu
Gardner, Alexander · NH
Garduño, Yanez Flor · SdJ
Garnell, Jean-Louis · JK
Gasparian, Gaspar · SdJ
Gasparini, Paolo · SdJ
Gaumy, Jean · JK
Geddes, Anne · AM
Genthe, Arnold · CC
Gernsheim, Helmut · LBo
Ghirri, Luigi · RB
Ghisoland, Norbert · AB
Giacomelli, Mario · CC
Gibson, Ralph · MG
Gidal, Tim · MK
Gilden, Bruce · LBa
Gimpel, Léon · VL
Gioli, Paolo · ML
Glanville, Toby · APh
Gloeden, Baron
 Wilhelm von · VL
Godwin, Fay · CR
Goldberg, Jim · MO
Goldblatt, David · APo
Goldin, Nan · MO
Golestan, Kaveh · AB
Gomes, Alair · SdJ
Gomis, Joaquim · HC
Gonnord, Pierre · EKH
Goodwin, Henry B. · AT
Gosani, Bob · AR
Gossage, John R. · AW
Gowin, Emmet · HBe
Graham, Paul · CB
Greene, John Beasley · HO
Greenfield, Lauren · HBe
Griffin, Brian · CB

Groebli, René · MK
Gros, Jean-Baptiste Louis · HO
Grossman, Sid · LBa
Gruber, Leo Fritz · AB
Gruyaert, Harry · AR
Guerra, Jorge · EKH
Guidi, Guido · WG
Güler, Ara · VL
Gulyás, Miklós · GM
Gundlach, F. C. · JM
Gursky, Andreas · CG
Gutmann, John · HBe
Haas, Ernst · RV
Hagemeyer, Johan · HBe
Hajek-Halke, Heinz · HP
Halawani, Rula · ML
Halsman, Philippe · RV
Hamaya, Hiroshi · CO
Hamilton, David · MG
Hannon, Édouard · AB
Hanzlová, Jitka · AR
Hardy, Bert · LBa
Hartwig, Edward · AU
Hawarden, Lady
 Clementina · CO
Hatekeyama, Naoya · HR
Hausmann, Raoul · HP
Hayashi, Tadahiko · HR
Heinecken, Robert · AW
Heinrich, Annemarie · SdJ
Henderson, Nigel · LBa
Henle, Fritz · RV
Henri, Florence · HP
Henson, Bill · WG
Hers, François · JK
Hervé, Lucien · MN
Hido, Todd · MBC
Hill and Adamson · NH
Hilliard, John · CB
Hine, Lewis Wickes · NH
Hiro · MP
Hoepker, Thomas · JM
Höfer, Candida · CG
Hofer, Evelyn · MJ
Hoffmann, Heinrich · VL
Hofmeister, Theodor
 and Oskar · AB
Holdt, Jacob · MP
Holland Day, Fred · ND

Hollyer, Frederick · HO
Homma, Takashi · WG
Hoppé, E. O. · GH
Hopper, Dennis · CC
Horsfield, Craigie · LBa
Horst, Horst P. · MP
Horvat, Frank · MP
Hosoe, Eikoh · CO
Howlett, Robert · APh
Hoyningen-Huene,
 George · RV
Hubmann, Franz · JM
Hugo, Pieter · EM
Huguier, Françoise · EKH
Hujar, Peter · JM
Humbert de Molard,
 Louis Adolphe · NH
Hurley, Frank · HE
Hütte, Axel · CG
Ignatovich, Boris
 Vsevolodovich · MK
Ishimoto, Yasuhiro · WG
Ishiuchi, Miyako · TI
Itier, Alphonse
 Eugène Jules · HO
Iturbide, Graciela · SdJ
Izis · LD
Jackson, William Henry · WG
Jacobi, Lotte · VL
Jäger, Gottfried · VT
Jiang, Jian · HR
Jiménez, Agustín · SdJ
Jodice, Mimmo · MBC
Johnston, Frances
 Benjamin · AC-K
Jones, Sarah · MBC
Jones Griffiths, Philip · ERu
Jonsson, Sune · AT
Josephson, Kenneth · WG
Jouve, Valérie · HP
Kállay, Karol · MB
Kálmán, Kata · GM
Karsh, Yousuf · DSM
Käsebier, Gertrude · NH
Kawada, Kikuji · WG
Kawauchi, Rinko · JS
Keetman, Peter · MJ
Keiley, Joseph Turner · HO
Keïta, Seydou · WG

Kerekes, Gábor · GM
Kertész, André · CC
Kessels, Willy · AB
Keuken, Johan van der · WvS
Khaldei, Yevgeny · MK
Al-Kharrat, Ayman · EM
Killip, Chris · CB
Kimura, Ihei · CO
Kitajima, Keizo · TI
Kivijärvi, Kåre · CH
Klauke, Jürgen · HP
Klein, Steven · MP
Klein, William · MP
Klemm, Barbara · JM
Knight, Nick · CC
Knorr, Karen · RB
Knudsen, Knud · CH
Kolehmainen, Ola · JM
Kollar, François · CM
Kollár, Martin · MB
Konopka, Bogdan · AU
Koo, Bohn-Chang · JJY
Kopek, Gábor · GM
Korda, Alberto · SdJ
Korniss, Péter · GM
Koudelka, Joseph · RB
Kouyaté, Adama · NN
Kratsman, Miki · ML
Krims, Les · WG
Krull, Germaine · MJ
Krzywoblocki, Aleksander · AU
Kudoyarov, Boris · NN
Kühn, Heinrich · HP
LaChapelle, David · MO
Lake Price, William
 Frederick · HO
Lange, Dorothea · JK
Larrain, Sergio · AR
Lartigue, Jacques Henri · HP
Laughlin, Clarence John · CR
Le Gray, Gustave · NH
Le Secq, Henri · NH
Lebeck, Robert · JM
Lee, Russell · JK
Leibovitz, Annie · LD
Leiter, Saul · JM
Lekegian, Gabriel · HBa
Lekuona, Nicolás de · HC
Lemos, Fernando · EKH

O'Sullivan, Timothy · NH
Ouka Leele · HC
Outerbridge, Paul · GH
Page, Tim · CR
Paillet, Fernando · EB
Palma, Luis González · A-MW
Pam, Max · GH
Pardington, Fiona · AM
Parke, Trent · AW
Parkinson, Norman · JM
Parks, Gordon · HBe
Parr, Martin · MO
Parry, Roger · LD
Patellani, Federico · AB
Pécsi, József · GM
Pellegrin, Paolo · CM
Penn, Irving · CC
Peress, Gilles · JK
Pérez Bravo, Marta María · EB
Pérez Siquier, Carlos · HC
Peryer, Peter · AM
Peterhans, Walter · LD
Petersen, Anders · MG
Petit, Pierre · HO
Petrusov, Georgy
 Grigorievich · NN
Petschow, Robert · NM
Pierre et Gilles · ND
Pinkhassov, Gueorgui · NM
Plachy, Sylvia · EKH
Plicka, Karol · NN
Plossu, Bernard · JK
Poitevin, Alphonse Louis · HO
Polidori, Robert · HBe
Ponting, Herbert George · LBa
Post Wolcott, Marion · JK
Prince, Richard · JM
Pruszkowski, Krzysztof · AU
Puskailer, Bohumil · MB
Puyo, Constant · NM
Rangel, Ricardo · NN
Ranney, Edward · HBe
Rauschenberg, Robert · AW
Rawlings, John · CC
Ray-Jones, Tony · CB
Rejlander, Oscar Gustav · NH
René-Jacques · CM
Renger-Patzsch, Albert · RB
Rey, Guido · ERu

Rheims, Bettina · LD
Riboud, Marc · JK
Richards, Eugene · MO
Richardson, Terry · MO
Richter, Gerhard · CG
Riefenstahl, Leni · VT
Riis, Jacob A. · NH
Rio Branco, Miguel · SdJ
Ritts, Herb · CC
Rivas Ribeiro, Humberto
 Luis · EB
Riwkin-Brick, Anna · AT
Robakowski, Józef · AU
Robertson, James · NH
Robinson, Henry Peach · NH
Roche, Denis · HP
Rodchenko, Alexander · MK
Rodger, George · APh
RongRong · HR
Ronis, Willy · LD
Rosenblum, Walter · LBa
Rosenthal, Hildegard · SdJ
Rosenthal, Joe · LBa
Ross, Henryk · LBo
Rössler, Jaroslav · AR
Rostain, Pascal · AF
Rothstein, Arthur · JK
Al Roumi, Mohamed · FZ
Rousse, Georges · JM
Rovner, Michal · MK
Ruff, Thomas · CG
Ruka, Inta · CR
Rydet, Zofia · AU
Saanio, Matti · A-KR
Salas Freire, Osvaldo · EB
Salgado, Sebastião · LD
Salomon, Erich · LD
Salzmann, Auguste · NH
Sandberg, Tom · CH
Sander, August · MJ
Sasse, Jörg · CG
Sassen, Viviane · WvS
Saudek, Jan · AR
Schad, Christian · VT
Schadeberg, Jürgen · AR
Schall, Roger · CM
Schatzberg, Jerry · MP
Schmidt, Michael · SG
Schuh, Gotthard · MK

Scianna, Ferdinando · AB
Seawright, Paul · CB
Sébah, Pascal and
 Jean-Pascal · CL
Secchiaroli, Tazio · AF
Seeley, George Henry · AC-K
Sekula, Allan · CB
Sella, Vittorio · NH
Sellerio, Enzo · AB
Senn, Paul · MK
Serrano, Andres · MO
Sewcz, Maria · NN
Seymour, David 'Chim' · EM
Shadbolt, George · APh
Shafran, Nigel · APh
Shahbazi, Shirana · CG-D
Shahn, Ben · JK
Shaikhet, Arkady
 Samoylovich · MK
Sheeler, Charles · JK
Sherman, Cindy · MO
Shibata, Toshio · HR
Shinoyama, Kishin · ERu
Shore, Stephen · CC
Shterenberg, Abram
 Petrovich · MK
Shulman, Julius · SG
Sidibé, Malick · APo
Sieff, Jeanloup · HP
Siegel, Arthur · LBa
Silva, António Sena da · EKH
Silva Meinel, Javier · SdJ
Silvy, Camille · CB
Simpson, Lorna · ND
Siskind, Aaron · EM
Smith, Graham · CB
Smith, W. Eugene · RV
Snowdon, Earl of · CC
Sommer, Frederick · AW
Sommer, Giorgio · CL
Soth, Alec · MO
Sougez, Emmanuel · MBC
Southworth & Hawes · NH
Stankowski, Anton · AB
Steele-Perkins, Chris · CB
Steichen, Edward · RV
Steiner, Ralph · HBe
Steinert, Otto · HP
Stern, Bert · CC

Panel of international experts

To reach a democratic and global view of photography that is balanced in terms of chronology, culture, theme and genre, Nathalie Herschdorfer consulted 150 professional experts and institutions throughout the dictionary's planning stages. Each consultant was chosen for his or her expertise within the full scope of photographic history, practice, technology, conservation, curatorship, criticism and collection.

Vince Aletti
Stuart Alexander
Séverine Allimann
Dag Alveng
Bérénice Angremy
Art Gallery of New
 South Wales,
 Sydney
Alexandra Athanassiadou
Irene Attinger
Quentin Bajac
Gordon Baldwin
Els Barents
Martin Barnes
Gabriel Bauret
Vladimir Birgus
Anne Biroleau-Lemagny
Jean-Christophe Blaser
Bibliothèque Nationale
 de France, Paris
Claudia Bohn-Spector
Michaela Bosáková
Christophe Brandt
Susanna Brown
François Brunet
Gail Buckland
Xavier Canonne
Anne Cartier-Bresson
Centro de La Imagen,
 Mexico City
Clément Chéroux
François Cheval
Chung-Ang University,
 Seoul
CMAC
A. D. Coleman
Cathie Coleman
Marguy Conzémius

Corcoran Gallery of Art,
 Washington, D. C.
Charlotte Cotton
Emmanuel d'Autreppe
Nassim Daghighian
Claudio de Polo
Michael Diers
Nathalie Dietschy
Régis Durand
Okwui Enwezor
William A. Ewing
Angela M. Ferreira
Marc Feustel
Finnish Museum of
 Photography, Helsinki
Joan Fontcuberta
Fotografie Forum
 Frankfurt
Fototeca de Veracruz
Michel Frizot
Fundació Foto
 Colectania
Gwenola Furic
Martin Gasser
Thierry Gervais
Frits Gierstberg
Marta Gili
Jean-Louis Godefroid
Vicki Goldberg
Andy Grundberg
André Gunthert
Sophie Hackett
Hasselblad Foundation
Patricia Hayes
Manfred Heiting
Helsinki City Art Museum
Sylvie Henguely
Pascal Hoël

Hanne Holm-Johnsen
Andréa Holzherr
Graham Howe
Hungarian House of
 Photography in Mai
 Mano House, Budapest
Instituto de Artes Gráficas
 de Oaxaca
Vangelis Ioakimidis
Mimmo Jodice
Christian Joschke
Joanne Junga Yang
Jean Kempf
Susan Kismaric
Kiyosato Museum of
 Photographic Arts
Mika Kobayashi
Fani Konstantinou
Marloes Krijnen
Zuzana Lapitkova
Latvian Museum
 of Photography, Riga
Lech Lechowicz
Jiyoon Lee
Anne-Françoise Lesuisse
Ludwig Museum of
 Contemporary Art,
 Budapest
Olivier Lugon
Lumiere Brothers Center
 for Photography, Moscow
Nathan Lyons
Lesley Martin
Alessandra Mauro
David Mellor
Pedro Meyer
Michael Stevenson Gallery,
 Cape Town
Moderna Museet, Stockholm
Herbert Molderings
Gilles Mora
Musée Carnavalet, Paris
Musée Suisse de l'Appareil
 Photographique, Vevey
Museo di Storia della
 Fotografia Fratelli
 Alinari, Florence
Museum Folkwang,
 Essen

Museum für Photographie
 Braunschweig
Musset for Fotokunst,
 Odense
Carole Naggar
National Gallery
 of Australia, Canberra
National Gallery of
 Victoria, Melbourne
Simon Njami
Colette Olof
Erin O'Toole
Colette Olof
Engin Ozendes
Pascale Pahud
Martin Parr
Nissan N. Perez
Timothy Persons
Peter Pfrunder
Chris Phillips
Ulrich Pohlmann
Michel Poivert
Marta Ponsa
Phillip Prodger
Jorge Ribalta
Fred Ritchin
Pamela Glasson
 Roberts
Brett Rogers
Jeff Rosenheim
Oliva Maria Rubio
Giuliana Scimé
Mark Sealy
Thomas Seelig
Laura Serani
Wim van Sinderen
Carol Squiers
Urs Stahel
Charlie Stainback
State Historical
 Museum, Moscow
Stedelijk Museum,
 Amsterdam
Radu Stern
Michael Graham
 Stewart
Olga Sviblova
Mariko Takeuchi
Ann Thomas

Anne Wilkes Tucker
Roberta Valtorta
Ruud Visschedijk
Michèle Walerich
Brian Wallis
Marta Weiss
Steve Yates

Contributor biographies

MATHILDE ARRIVÉ (MA) is Associate Professor at Paul-Valéry University, Montpellier.

ELISA BAITELLI (EB) is currently working on a PhD in the history of photography at the University of Paris 1.

HEIDE BARRENECHEA (HBa) is an art historian specializing in photography. She is currently the recipient of a scholarship from the German Research Foundation (DFG) at the Berlin University of the Arts.

LAETITIA BARRÈRE (LBa) holds a PhD in the history of contemporary art from the University of Paris 1.

HÉLÈNE BEADE (HBe) holds a master's in English-language visual arts and culture.

RAPHAËLE BERTHO (RB) has a PhD in art history and is a lecturer at the University of Bordeaux.

MURIEL BERTHOU CRESTEY (MBC) is a postdoctoral researcher at the Institute of Modern Texts and Manuscripts (ITEM) in Paris.

LINDSAY BOLANOS (LBo) is a photographer and collections manager. She lives and works in Canada.

MICHAELA BOSÁKOVÁ (MB) is a curator and project manager at the Central European House of Photography in Bratislava.

CLARA BOUVERESSE (CB) is currently working on a PhD on the history of Magnum Photos at the University of Paris 1.

ADRIENNE BOVET (AB) is a photographer who works in Switzerland and Germany.

NATASHA BULLOCK (NB) is Curator of Contemporary Art and formerly Assistant Curator of Photography at the Art Gallery of New South Wales, Sydney.

ALICE CARVER-KUBIK (AC-K) holds a master's in photographic preservation and collections management from Ryerson University, Toronto, and George Eastman House, Rochester, NY.

NATHALIE CASEMAJOR LOUSTAU (NCL) is a postdoctoral fellow in the Department of Art History and Communications Studies at McGill University, Montreal. She holds a PhD in communication from the University of Québec and Lille University.

HÉLOÏSE CONÉSA (HC) is curator at the Museum of Modern and Contemporary Art, Strasbourg. She is currently working on a PhD in contemporary Spanish photography at the University of Paris 1, and is Head of the Contemporary Photography Collection at the National Library in Paris.

LAURE CUÉREL (LC) holds a master's in art history from the University of Lausanne. She lives and teaches in Switzerland.

CORINNE CURRAT (CC) is an associate curator at the Fondation de l'Hermitage, Lausanne.

NATHALIE DIETSCHY (ND) is an art historian specializing in contemporary art. She holds a PhD in the history of art from the University of Lausanne.

LYDIA DORNER (LD) is an assistant curator at the Musée de l'Elysée, Lausanne.

HELEN ENNIS (HE) is Associate Professor at the Australian National University School of Art, specializing in the history of Australian photography.

AURORE FOSSARD-DE ALMEIDA (AF) teaches photography at the University of Lyon and is currently working on a PhD in film studies.

MARIE GAUTIER (MG) holds a PhD in the history of contemporary art from the University of Paris 1. She currently teaches at the École Nationale Supérieure de la Photographie, Arles.

STEFANIE GERKE (SG) is chair of Art and New Media at Humboldt University, Berlin.

WILLIAM GREEN (WG) is currently working on a master's in photographic preservation and collections management at Ryerson University, Toronto.

CHRISTINE GÜCKEL-DAXER (CG-D) is working on a PhD on constructed images and the staging of the everyday in contemporary photography at the Freie Universität, Berlin.

CLAUS GUNTI (CG) teaches at the University of Art and Design Lausanne and at the University of Lausanne. His researches focus on digital technologies, documentary practices and photography theory.

CHRISTINE HANSEN (CH) is a Norwegian photographer and adjunct professor in photography and theory at the Bergen Academy of Art and Design.

EMILY KAY HENSON (EKH) is an independent arts writer currently based in Chicago. She has held fellowships at the Museum of Contemporary Photography, Chicago, and the Graham Foundation.

NATHALIE HERSCHDORFER (NH) see page 4.

GRAHAM HOWE (GH) is a curator, writer and artist, and the CEO of Curatorial Assistance. He lives in Los Angeles and Sydney.

TAKAHIRO ITO (TI) is an assistant curator at the Tokyo Metropolitan Museum of Photography.

MIN-YOUNG JEON (MJ) studied German language and literature and art history at the Ruhr-Universität Bochum. She earned her doctorate at the Berline University of the Arts,

with a thesis on media mechanisms and their perception. She is an associate lecturer at 'Das Fotografische Dispositiv', a graduate college of the Hochschule für Bildende Künste, Braunschweig.

SAMUEL DE JESUS (SdJ) is a lecturer and researcher at the School of Communication and Arts at the University of São Paulo.

JOANNE JUNGA YANG (JJY) is the director and curator of the Y&G Art Global Contemporary Project. She lives and works in Seoul.

JEAN KEMPF (JK) is professor of American civilization at the University of Lyon.

MASHA KREIMERZAK (MK) holds a master's in art history from Geneva University.

CONSTANCE LAMBIEL (CL) is a historian of photography and teaches at the École Cantonale d'Art in Valais, Switzerland.

MARC LENOT (ML) is working on a thesis on contemporary experimental photography at the University of Paris 1.

VÉRA LÉON (VL) studied at the École Normale Supérieure in Lyon. A historian by profession, she has researched German press photography of the 1920s and is currently working on a PhD thesis on gender and photography training in France from the post-war period to the 1970s.

ATHOL MCCREDIE (AM) is Curator of Photography at the Museum of New Zealand Te Papa Tongarewa, Wellington.

EMILY MCKIBBON (EM) is a specialist in photography preservation and collections management. She was previously the Howard and Carole Tanenbaum Curatorial Fellow at George Eastman House, Rochester, NY.

JONATHAN MAHO (JM) is working on a PhD in anglophone studies at the University of Paris 7.

PAULINE MARTIN (PM) is a special projects coordinator at the Musée de l'Elysée, Lausanne.

GÁBOR MÁTÉ (GM) is a lecturer in photography at the Moholy-Nagy University of Art and Design, Budapest.

NOLWENN MÉGARD (NM) is an assistant lecturer in contemporary art history at the University of Geneva.

LAURELINE MEIZEL (LM) is working on a PhD in the use of photography in 19th-century French publishing at the University of Paris 1.

CHRISTELLE MICHEL (CM) is studying for a master's in art history at the University of Lausanne.

MARINE NÉDÉLEC (MN) is working on a PhD in art history with a focus on post-war Surrealism.

NATHALIE NEUMANN (NN) is a Berlin-based independent curator specializing in documentary photography.

CLÉMENTINE ODIER (CO) is finishing a master's in museum studies at the University of Neuchâtel.

HÉLÈNE ORAIN (HO) is completing a PhD in photography at the University of Paris 1.

KEN ORCHARD (KO) is an artist and photography historian. He lives in Adelaide.

MAUDE OSWALD (MO) is a teaching assistant at the University of Lausanne and is writing her PhD thesis on the history of photography.

ALLAN PHOENIX (APh) holds a master's in photographic preservation and collections management from Ryerson University, Toronto, and George Eastman House, Rochester, NY. He works as a photography preservation specialist at the Chicago Albumen Works.

HÉLOÏSE POCRY (HP) works at the Swiss Dance Collection and is writing a PhD thesis on the teaching of photography.

ARIANE POLLET (APo) is an art historian who has contributed to books including *The Bitter Years* (Thames & Hudson, 2012).

MAUD POLLIEN (MP) holds a master's in cinema theory and

practice from the University of Lausanne.

ERIKA RABERG (ERa) is studying for a master's in photography and visual critical studies at the School of the Art Institute of Chicago.

ANNA-KAISA RASTENBERGER (A-KR) is Chief Curator at the Finnish Museum of Photography, Helsinki.

CAROLINE ROCHE (CR) is currently working on a PhD on the photographer Minor White at the University of Paris 1.

ANAËLLE ROD (AR) is an archivist at the Fondation Henri Cartier-Bresson in Paris.

HOLLY ROUSSELL PERRET-GENTIL (HR) is Assistant Curator of Photography at the Musée de l'Elysée, Lausanne.

ELISA RUSCA (ERu) is an art historian, freelance curator and critic.

MANON SAUDAN (MS) holds a master's in art history and museum studies from the Universities of Lausanne and Neuchâtel.

JOHANNA SCHÄR (JS) teaches at the University of Lausanne, where she is completing a PhD in photography.

DANIELLE SHRESTHA MCALLISTER (DSM) is a photo archives specialist based in

Ontario. She holds a master's in photographic preservation and collections management from Ryerson University, Toronto.

CÉCILE SIMONET (CS) is an art historian who works at the Museum of Modern and Contemporary Art in Geneva.

WIM VAN SINDEREN (WvS) is a founding member and senior curator of the Hague Museum of Photography. He is also the conservator of the photography collection of the Gemeentemuseum, The Hague.

EDWARD STOKES (ES) is an Australian photographer and writer, and the founder of the Photographic Heritage Foundation, Hong Kong.

ANNA TELLGREN (AT) is the curator of photography at Moderna Museet in Stockholm.

VERONIKA TOCHA (VT) is an assistant lecturer at the Berlin University of the Arts. She is currently completing her PhD thesis on the work of Thomas Demand.

AGATA UBYSZ (AU) is a Polish art historian and journalist. She studied at the University of Warsaw and worked at the Musée de l'Elysée in Switzerland from 2010 to 2012. She is the author of many articles published in specialized journals in Poland and is the co-founder of the Lookout Foundation for the Development of Photography.

RACHEL VERBIN (RV) holds a master's in photographic preservation and collections management from Ryerson University, Toronto. She is currently the Images Archivist at The Canadian Press.

EMILY WAGNER PHOENIX (EWP) holds a master's in photographic preservation and collections management from Ryerson University, Toronto, and George Eastman House, Rochester, NY. She works at the Chicago Albumen Works as a photography conservation technician.

ANNE-MARIE WALSH (A-MW) is an independent curator and photography conservation specialist based in Washington, D.C.

ALANA WEST (AW) is working on a PhD in art history at Queen's University, Belfast.

PERIN EMEL YAVUZ (PEY) is completing a thesis on narrative art at the École des Hautes Études en Sciences Sociales in Paris.

FATMA ZRANN (FZ) is a teacher of English and the author of a thesis on identity issues in the work of African-American photographers.

A

Abbas [Abbas Attar] (b. 1944) Iranian photojournalist. Abbas's work is dedicated to documenting the social and political issues of societies living in conflict. Apprenticed to a newspaper in Algeria in 1962, he studied mass communication in the United Kingdom between 1964 and 1968. Since 1970 he has covered armed conflicts all over the world. From 1977 he chronicled the Iranian Revolution, publishing the book *La révolution confisquée* in 1980. He was a member of the Sipa agency from 1971 to 1973, and of → Gamma from 1974 until 1980. In 1981 he joined → Magnum Photos.

Abbe, James Edward (1883–1973) Portrait and fashion photographer, and pioneer of American photojournalism. Abbe opened his first studio in New York in 1917. Known for his portraits of stars taken on the film sets of Hollywood and New York, he moved to Paris in around 1924. His images appeared in → *Vogue*, → *Harper's Bazaar*, *Vanity Fair*, → *Vu* and the *New York Herald Tribune*. From 1926 until 1936 he covered major political events, including the civil wars in Mexico and Spain. On his return to

the United States Abbe stopped working as a photographer.

Abbott, Berenice [Bernice Abbott] (1898–1991) American documentary, portrait and scientific photographer. She studied journalism at Ohio State University before moving to New York in 1918, initially with the intention of becoming a writer, then a sculptor. Abbott took part in the Greenwich Village art scene of Marcel Duchamp and → Man Ray, moving to Europe in 1921 to study sculpture in Paris and Berlin. As Man Ray's darkroom assistant in Paris (1923–26), she learnt portrait photography and became involved with the → Surrealists. Abbott opened her own studio in Paris in 1926, photographing writers, including Jean Cocteau and James Joyce, publishing in → *Vogue* and → *Vu* magazines, and showing in exhibitions such as *Abbott: Portraits Photographiques* (1926), the *Salon de l'escalier* (1928; both in Paris) and → *Film und Foto* (Stuttgart, 1929). Abbott and her circle fought against → Pictorialism, instead supporting a modernist aesthetic and drawing inspiration from historical pioneers → Eugène Atget and

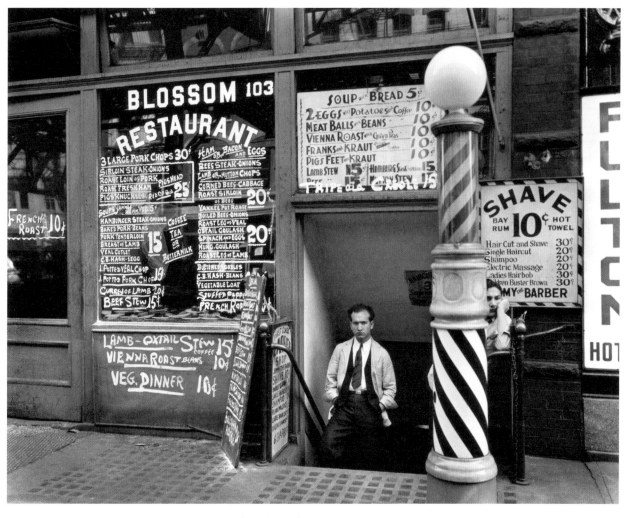

Berenice Abbott, *Blossom Restaurant,*
103 Bowery, Manhattan, 1935

→ Nadar. Abbott acquired Atget's estate in 1928 and endorsed his work alongside her own; she co-managed it with the dealer → Julien Levy from 1930 until it was sold to the → Museum of Modern Art, New York, in 1968. After moving back to New York in 1929, Abbott exhibited at the Julien Levy Gallery and published in → *Fortune* and → *Life*. She received a large grant from the Works Progress Administration Federal Art Project in 1935 for *Changing New York*, producing 305 photographs between 1935 and 1939. Abbott was the photography editor of *Science Illustrated* (1944–45) and the founder of House of Photography, a company that sought to invent new photographic equipment. The Massachusetts Institute of Technology hired

her as a scientific photographer in 1958 for pedagogical purposes in the context of the Cold War.

Aberhart, Laurence (b. 1949) New Zealand photographer. He is renowned for his black-and-white images that evoke the past. His subject matter – invariably taken with an 8 × 10 inch view camera and presented as → contact prints – has typically consisted of Masonic lodges, old Maori churches, cemeteries, war memorials and historic structures. A major retrospective of his work was published as *Aberhart* in 2007.

Ackerman, Michael (b. 1967) Israeli-born American photographer. A member of the Vu photo agency,

— A •

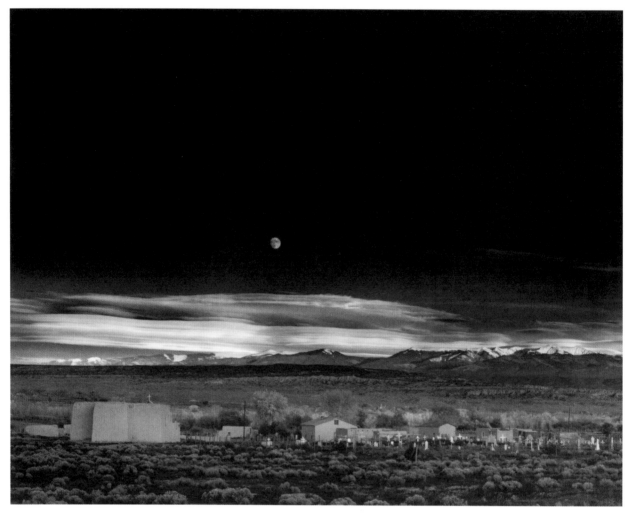

Ansel Adams, *Moonrise,
Hernandez, New Mexico*, 1941

Ackerman is known internationally for his work on Benares entitled *End Time City*, for which he was awarded the Prix Nadar in 1999. Drawn from his travels, his blurred images – in black and white and, more recently, in colour – are characterized by marked contrasts and the use of multiple frames. They convey the sense of a world torn apart, populated by ghostly characters.

Adams, Ansel (1902–1984) American photographer and environmentalist. His grand landscape photographs of the American West, such as *Clearing Winter Storm* (1940) and *Moon and Half Dome* (1960), have become iconic. Adams's images are now so entwined with the idea of

wilderness in the United Sates as to be almost inseparable. A long-time member of the Sierra Club, as a young man he spent a great deal of time hiking in the wilderness of California taking photographs, but in 1927 he decided to pursue photography as a vocation and a career, publishing his first portfolio, *Parmelian Prints of the High Sierras*, that year. His association with → Edward Weston and others converted him from a → Pictorialist style into a more modernist approach that used crisp focus and a wide depth of field to portray his subjects. This philosophy culminated in the founding of → Group *f*.64 with Weston, → Imogen Cunningham and → Willard Van Dyke. Along with Fred Archer, Adams developed a scientific methodology for

the production of black-and-white prints, called the 'zone system'. A fastidious and prolific printmaker, he frequently compared photography to music, with the negative as the score and the print the performance. He continued to make prints of his most popular images, including *Rose and Driftwood* (1932), *Moonrise, Hernandez, New Mexico* (1941) and *Aspens, Northern New Mexico* (1958), throughout his life. His image of *The Tetons and the Snake River* (1942) was included on the Voyager spacecraft's Golden Record as one of the 116 images representing humankind.

Adams, Eddie (1933–2004) American photographer. Eddie Adams was a Pulitzer Prize-winning photojournalist who documented thirteen wars over the course of his career. Adams began covering conflicts as an enlisted combat photographer during the Korean War (1950–53). He took part in three tours of Vietnam with the Associated Press; while there, he took his iconic photograph of General Nguyen Ngoc Loan executing a Viet Cong prisoner in Saigon, 1968.

Adams, Robert (b. 1937) American photographer noted for his photographs of the American West. Self-taught in photography, Adams holds a bachelor's degree from the University of Redlands, California, and a PhD in English from

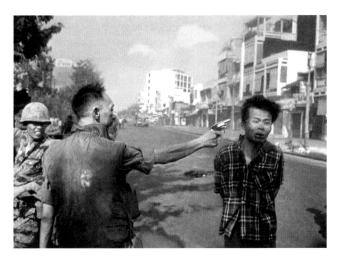

Eddie Adams, *South Vietnam National Police Chief Nguyen Ngoc Loan Executes a Suspected Viet Cong Member*, 1968

• A —

Robert Adams, *Colorado Springs, Colorado*, 1968

the University of Southern California. His first serious work, *New West* (1968–70), documents emerging suburban development and tract housing on the outskirts of Colorado. Adams initially came to notoriety through his inclusion in the 1975 exhibition → *New Topographics: Photographs of a Man-Altered Landscape*. His career spans over four decades and focuses on the American West as its subject, particularly California, Oregon and his home state, Colorado. Working in black and white, Adams creates photographs for exhibition and has published extensively, with over twenty titles to his name, including critical essays on photography.

Additive processes Colour processes based on the principles introduced by James Clerk Maxwell in 1861, according to which all colours are achieved by combining or adding the three primary colours of light: red, green and blue. White light is obtained when all three colours are mixed equally (see diagram overleaf). When white light passes through an additive coloured filter, only the colour of the filter is transmitted; the rest of the colour spectrum is absorbed. In colour photography systems, such as the → autochrome

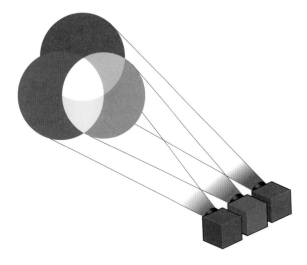

Additive processes: Additive colour mixing of the primary colours in light (red, green and blue). When added together in equal measures, the three colours create white light.

and other screen-plate processes, a colour image is created by photographing and viewing an image through a screen of lines or dots in primary colours. In assembly processes such as → dye transfer and → carbro, separation negatives are made through additive colour filters and then printed using subtractive coloured pigments and dyes. *See also* → subtractive processes.

Advertising The use of photography in the field of advertising goes back to the end of the 19th century, but it did not become common practice until the late 1920s, when developments in technology enabled photographs and typographic elements to be combined on the same page. Between the wars, the democratization of photography encouraged businesses to publish brochures, for which they often engaged the services of young photographers. The fact that many of them belonged to the avant-garde is evident in the commercial work that they produced. Until the late 1930s photographic advertising tended to be confined to luxury brands, and most companies still used illustrations. From the 1950s onwards, however, with the emergence of the consumer society and the arrival of new colour processes, photography took over in the press and in advertising posters. Some studios and agencies engaged photographers

to produce simple, routine work, but others preferred to hire figures with artistic flair, with a view to giving themselves a more distinct image and delivering a message that went beyond the purely commercial. Advertising photography became considerably more professional in the 1970s, with the advent of communications agencies and the emergence of some remarkable artists, including Jean-Paul Goude, → Sarah Moon, → Guy Bourdin, Jean-Baptiste Mondino and → Oliviero Toscani, each of whom had a highly individual, and sometimes controversial, style. Since the 1990s, under the influence of luxury brands and fashion magazines, international trends have varied from realism to 'porno chic' (much discussed during the 2000s).

Aerial photography Photography involving a range of viewpoints in relation to the ground, a variety of observation points (monuments, hot-air balloons, kites, planes or spacecraft) and, frequently, specialized equipment. The technique has been employed in many fields, including archaeology, geography, cartography and town-planning. In 1858 → Nadar made his first attempts at taking images from above during a balloon ride over Paris, but the oldest extant aerial photograph is a view of Boston, Massachusetts, taken by James Wallace Black in 1860. With the advent of aviation at the beginning of the 20th century, the technical aspects of aerial photography evolved rapidly, and it became a tool for military reconnaissance, especially after the outbreak of World War I. From the first decade of the 20th century bird's-eye views became popular, for example in publications that required a documentary, serial and topographic approach to land surveying. Aerial photography played a central role in avant-garde movements, especially the → New Vision, and allowed for the exploration of fresh viewpoints and sensations of space. By flattening and defamiliarizing everyday objects, it helped open the way to abstraction and became an influential presence in modern photography. From the 1960s and the advent of space photography, images could encompass the earth itself. Today advances in digital technology have revitalized the practice of aerial photography.

Antoine d'Agata, *Nuevo Laredo, Mexico*, 1991

AES+F Russian collective of four artists.
The group was formed in 1987 under the name
AES by Tatiana Arzamasova (b. 1955), Lev
Evzovich (b. 1958) and Evgeny Svyatsky (b. 1957).
It became known as AES+F with the arrival of
Vladimir Fridkes (b. 1956) in 1995. Arzamasova
and Evzovich have a background in architecture,
Svyatsky in the graphic arts and Fridkes in
fashion photography, and their output is highly
varied. They work mainly with photography
and video installation, often manipulating their
images digitally, but they also tackle the realms
of sculpture, drawing, painting and ceramics.
The group's oeuvre has been exhibited
internationally in many museums, galleries
and festivals. The group represented Russia
at the Venice Biennale in 2007.

Agata, Antoine d' (b. 1961) French photographer.
He studied at the International Center
of Photography in New York and has been
a member of → Magnum Photos since 2008.
Often blurred by motion, his portraits have
an autobiographical dimension but circumvent
the notion of voyeurism, presenting nocturnal
images of sex, drugs, prostitution and
aimlessness.

Agency An organization that manages and
distributes photographs. These institutions
first appeared at the beginning of the 20th
century and reflected the development of
the illustrated press and photojournalism.
The role and status that the agencies accorded
to the photographer evolved over time. During
the 1920s photographers were considered
as cameramen and did not own their images.
In order to defend their rights as authors,
therefore, some photographers established
their own organizations following World War II.
The most famous example is the → Magnum
cooperative, founded in 1947. The best-known

agencies of the 1960s were → Gamma, Sipa and Sygma, all based in Paris. Then, at the turn of the 21st century, the so-called wire agencies (Agence France Presse, Reuters and Associated Press) began to dominate the market. They employ photographers around the world and are in a position to withstand competition from the new media. Alongside these large businesses are smaller collectives that operate in a participative manner.

Aigner, Lucien (1901–1999) Hungarian-born American photojournalist. In 1925 Aigner moved to Paris and became famous for his unusual portraits of political figures including Benito Mussolini, Adolf Hitler and Winston Churchill. His → reportages were published in → *Vu*, → *Life* and other magazines. In 1939 he emigrated to the United States. The rediscovery in 1970 of a suitcase containing 100,000 negatives from his European period led to numerous solo exhibitions.

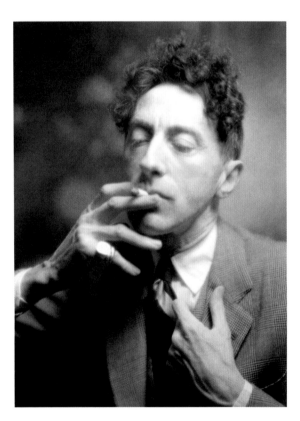

Laure Albin-Guillot,
Jean Cocteau, 1935

Albin-Guillot, Laure [Laure Maffredi] (1879–1962) French photographer. Born in Paris, he studied art before learning photography. Albin-Guillot's career included experimentation in both → Pictorialism and photographic modernism. He was an early contributor to the cutting-edge → *Vu* magazine. His work, such as *Micrographie décorative* (1931), recalls the → Surrealism of his → New Vision contemporaries while maintaining an artisanal feel more closely associated with Pictorialism.

Album A book for displaying photographs that usually prioritizes visual appeal over textual and other information. The publication in 1844 of *The Pencil of Nature* by → William Henry Fox Talbot – the first book to be illustrated with → calotypes, of which there were twenty-four – had its images pasted in and provided a basis for the photograph album. Other early forms of the album included notebooks in which scientists kept photographic records of their work, and artists' albums that allowed images of artworks and monuments to be seen by a wider public. The voyages and expeditions of the 1840s, followed by the rise of commercial tourist photography between 1860 and 1890, paved the way for amateur and instant photography, and turned the album into a popular tool for storing images.

Albumen print The most commonly used method of producing a photographic print in the 19th century. The albumen print was invented in 1850 by the printer → Louis Désiré Blanquart-Evrard, who wanted to improve on → salted paper prints. The process involves coating a sheet of thin paper with a layer of albumen (egg white) and table salt (sodium chloride). The paper is then made light-sensitive by dipping it into a silver nitrate solution. The print is made in natural light by placing the → negative (usually a glass plate with collodion → emulsion) onto the prepared paper. The image is formed on the layer of albumen, which binds the silver salts together and prevents them from sinking into the paper fibres, as occurred with salted paper prints: this gives the print greater brightness, definition and contrast. Gold chloride → toning is used on most

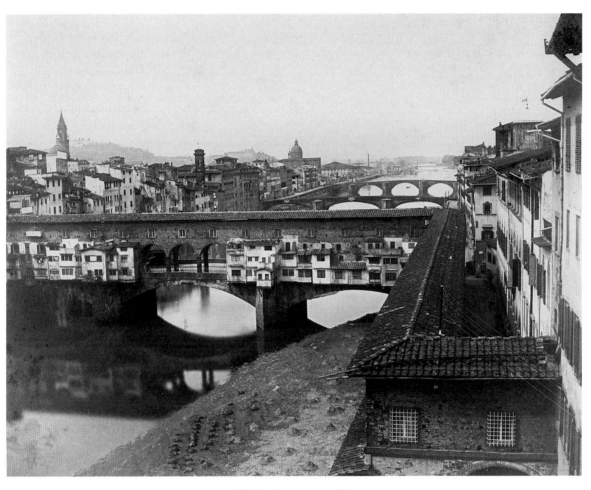

Fratelli Alinari, *Panorama of Florence
with the Ponte Vecchio in the Foreground*, c. 1855

albumen prints: this stabilizes the image and gives it a sepia tint, which can range from purple to brown-black. The process was widely used for → *carte-de-visite* portraits, landscapes, and art and architecture photography.

Alinari Family of Italian photographers and founders of one of the 19th century's most famous studios. In 1852 Leopoldo Alinari (1832–1865) set up a photographic studio specializing in portraits and photographs of historic monuments and works of art. In 1854, along with his brothers Giuseppe (1836–1890) and Romualdo (1830–1890), Leopoldo founded Fratelli Alinari, the oldest photographic firm in the world. Located in Florence, which in 1865 became the capital of a recently unified Italy, the Alinari firm expanded rapidly. The Alinari soon became the most important suppliers of images to Italian libraries, museums and academies, and the Alinari collection was universally recognized as the new documentary archive of Italian art. The studio was also a meeting place for the Florentine bourgeoisie, who flocked there to have their portraits taken. In 1890, following the death of the two surviving brothers, the family business was taken over by Leopoldo's son, Vittorio Alinari (1859–1932). He transformed the firm into a truly international business. In 1893 the company set up its own publishing wing, and Vittorio developed many projects to document Italy's cultural heritage. Alongside artistic views, the Alinari firm also produced documentary-style images. Today the → agency possesses over 4 million photographs that embrace the entire history of the medium.

A

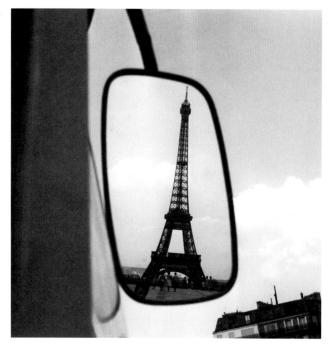

Paul Almásy, *The Eiffel Tower Reflected in the Wing Mirror of a Car*, 1960

The documents in the Alinari archives cover both Italian and world history.

Almásy, Paul (1906–2003) Hungarian-born French photojournalist. Following studies in political science to prepare him for a diplomatic career, Almásy turned to journalism and took up photography with the aim of illustrating his articles. Initially a press correspondent in Paris (1930), he subsequently travelled widely, carrying out many assignments, particularly for WHO and UNESCO.

Almeida, Helena (b. 1934) Portuguese artist. She studied fine art in Lisbon and became inspired by the Neo-Concrete movement in Brazil. Her performative photographs use sculpture, painting and drawing to challenge the limits of two-dimensional space by exploring contradictions between the flattening properties of paint and the illusionary depth of photographs, the distance between the art object and the spectator, and the relationship between body and space. Almeida represented Portugal at the Bienal de São Paulo (1979), the Venice Biennale (1982 and 2005) and the Sydney Biennale (2004).

Alpert, Max Vladimirovich (1899–1980) Russian photographer. Born in Simferopol, Alpert moved to Odessa in 1914 and became apprentice to a local photographer. He began his professional career during the 1917 civil war, photographing the troops of the Red Army, for which he subsequently volunteered in 1919. Arriving in Moscow in 1924, he became a photojournalist for *Rabochaya Gazeta*. Four years later he joined the editorial office of *Pravda*. In 1929 the construction of the town of Magnitogorsk in the Urals began, and Alpert visited on several occasions to photograph its development. With *Giant and Builder*, he produced a series chronicling the life of Victor Kalmikov, an illiterate mason who became a celebrated steelworker. Alpert's photographs also commemorate the construction of the Turkestan–Siberia Railway, a huge project linking Central Asia and Siberia. In 1931 he began working for the publication *USSR in Construction*, and with → Arkady Shaikhet and Solomon Tules created *24 Hours in the Life of the Filippov Family*, a series of propaganda photographs documenting the simple life of a Russian worker in the Red Proletariat factory and his family, contrasting it with workers' lifestyles in capitalist countries. During World War II Alpert worked as a correspondent for TASS. From 1946 he was a reporter for the Novosti news agency, and from 1961 was employed by the APN agency.

Álvarez Bravo, Lola [née Dolores Martinez de Anda] (1907–1993) Mexican photographer. In 1925 she married the photographer Manuel Álvarez Bravo, but the couple separated in 1934. At the beginning of her husband's photographic career she helped him in the darkroom. Her own artistic practice began in 1925 and lasted until 1989, when her sight failed. Her most famous series of photographs portray her friend the artist and painter Frida Kahlo.

Álvarez Bravo, Manuel (1902–2002) Mexican photographer. Álvarez Bravo is recognized as the pioneer of modern Mexican photography. On the death of his father, he accepted a government post to help his family financially.

He subsequently took art classes in Mexico City and then turned to photography, being largely self-taught. In 1930, in the wake of → Tina Modotti's forced exile, he replaced her on the magazine *Mexican Folkways* and took portraits of the painters Diego Rivera and José Clemente Orozco. Exploring various techniques and artistic styles, Álvarez Bravo experimented with → Pictorialism, Cubism and abstraction. In 1933 he met → Paul Strand, → Henri Cartier-Bresson and → Walker Evans, with whom he exhibited at the Julien Levy Gallery in New York (1935). In 1938 André Breton discovered his celebrated photograph *Good Reputation Sleeping*, which he exhibited in Paris. Known for his nudes, Álvarez Bravo also developed his vision of Mexican culture and identity during the renaissance the country experienced following the revolution.

Displaying a preference for street scenes (*The Daydream*, 1931), natural lighting and the effects of shadow and light (*The Crouched Ones*, 1932–34), Álvarez Bravo experimented with myth and gave his images a universal resonance by drawing on literary and musical references. After a period in the film industry (1943–59) he returned to photography, and his international reputation grew. He was the recipient of numerous awards. Since the 1970s his work has been widely exhibited in the United States and in Europe.

Alveng, Dag (b. 1953) Norwegian photographer. He studied photography at Trent Polytechnic in Nottingham (1976–77). Together with → Tom Sandberg and Per Berntsen, he belongs to the 'English generation' of Norwegian photographers who trained in the United

● A —

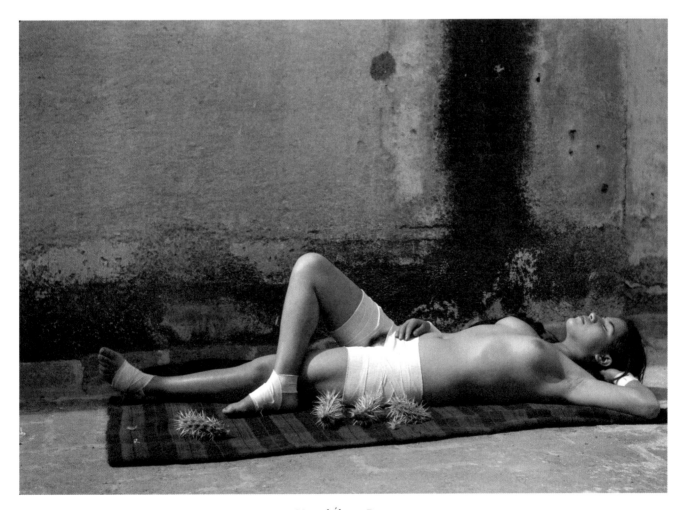

Manuel Álvarez Bravo,
Good Reputation Sleeping, 1938–39

Kingdom. Alveng's show *Vegger* ('Walls', 1979) at the Fotogalleriet, Oslo, was an early example of conceptual photography in Norway. The artist photographed the walls of the gallery and mounted the photographs so that they covered up their subjects perfectly. The exhibition occasioned several hostile reviews in Norwegian newspapers. His book *Asylum* (1987) is of black-and-white photographs of a mental institution where Alveng worked as a night-watch. The series constitutes a quiet but powerful glimpse into the rooms and objects belonging to a psychiatric institution. Alongside the social anthropologist Hanne Müller and the author Kjartan Fløgstad, in *Verftet i Solheimsviken* ('The Wharf in Solheimsviken', 1991) Alveng documented the working life and changing fortunes of the largest shipyards in Bergen. In 1994 he curated the exhibition *Verden er* ('The World Is') in connection with the Winter Olympic Games in Lillehammer. His book *Summerlight* (2001) chronicles the Norwegian summer through lyrical black-and-white photographs of outdoor family scenes and the seashore in southern Norway; the accompanying text is by the American photographer → Robert Adams, with whom Alveng shares some similarities. Alveng is represented in the Metropolitan Museum of Art and the → Museum of Modern Art, New York; the Stedelijk Museum, Amsterdam; the Bibliothèque Nationale de France, Paris; Museum Folkwang, Essen; the Hasselblad Center, Göteborg; the Spengel Museum, Hannover; and in numerous private collections.

Amateur photographer Any person who practises photography for pleasure rather than commercial gain. Amateurs of the 19th century were typically serious photographers dedicated to the advancement and improvement of the medium. By mid-century → photographic societies and camera clubs began to appear around the world, many producing journals. The role of amateurs within these societies and publications was significant, in that they invented and promoted improvements to the medium. Early photographic processes were technically complicated and rather expensive.

Many 19th-century amateurs, therefore, were men of financial means, although there were some significant women practitioners. → George Eastman's invention of roll film and the Kodak Brownie in 1890 revolutionized photography and changed the meaning of the amateur's role. Launched with the slogan 'You press the button, we do the rest', the Brownie camera was purchased pre-loaded with a 100-exposure roll of film and required no technical knowledge. After use it was sent back to → Kodak intact for processing and reloaded before being returned to its owner. The simplicity of the Brownie democratized photography, helping to swell the ranks of amateur photographers. Kodak's advertisements targeted women in particular, who were seen as the largest potential market. In response to this new class of photographers, the → Pictorialist movement emerged, whose members pushed for the advancement and acceptance of photography as fine art. Although they hoped to distinguish themselves from amateurs, many members of Pictorialist societies were upper-class, non-professional individuals working to improve the medium, as their counterparts had done in the mid-19th century.

Amateur Photographer, The British periodical. Founded in 1884, *The Amateur Photographer* appeared at a time when → amateur photographers were increasing in number owing to the advent of portable cameras, accessible processes and affordable prices. The aim of this weekly magazine was to teach photography to this new class of amateurs from a technical point of view, but also an aesthetic one. In 1908 the magazine merged with the British magazine → *Photographic News*.

Ambrotype *see* **Collodion positive**

Andriesse, Emmy (1914–1953) Dutch photographer. She is best known for her harrowing, illicit documentary photographs of the 'Hunger Winter' of 1944–45. Her image of a small, emaciated boy clutching an empty saucepan has become an icon of the suffering inflicted by the Nazi occupation of the Netherlands. After the war, Andriesse became a successful

portrait, → commercial, → fashion and → travel photographer. As such, she was one of the first all-round professional photographers in the Netherlands. In 1956, following her early death, a retrospective of her work was published under the title *Beeldroman*. An archive of her negatives is now in the care of Leiden University Library.

Andujar, Claudia (b. 1931) Swiss-born Brazilian photographer. From 1958 Andujar produced → reportages on Brazil and its people for → *Life*, *Look*, → *Fortune* and → *Aperture*, then worked with the magazine *Realidade*. In 1971 her magnificent portraits of the indigenous Yanomami people were included in the collection *Amazônia*, produced alongside George Leary Love's works.

Annan, James Craig (1854–1946) Scottish photographer. James Craig Annan learnt photography from his father, → Thomas Annan. After studying chemistry and philosophy he returned to the family studio. Annan specialized in → photogravure, a technique he learnt in 1883 from the inventor of the process, Karl Klic. In the early 1890s he produced photogravures from the → calotype negatives of → Hill and Adamson. At the same time he decided to create his own photographic compositions. An adherent of the → Pictorialist movement, Annan was elected a member of the → Brotherhood of the Linked Ring in 1894, and his work was published by → Alfred Stieglitz in → *Camera Work* in 1904. Annan participated regularly in Pictorialist exhibitions in Europe and the United States until 1916, after which he pursued photography within the confines of his family studio.

Annan, Thomas (1829–1887) British photographer. Apprenticed as a lithographic writer and engraver (1845) at the *Fife Herald* newspaper, he later took up a position at Joseph Swan's lithographic establishment. Annan set up his business in 1855 and, after gaining the patent rights to the → photogravure process, established his own photographic studio in 1857. In 1866 Annan was commissioned by the Glasgow City Improvement Trust to document the narrow passageways and slums of the old part of Glasgow before its conversion to a modern metropolis, resulting in

the landmark series of photographs *Old Closes and Streets of Glasgow* (1868–77).

Anschütz, Ottomar (1846–1907) German photographer. Taught by Ferdinand Beyrich, Anschütz initially devoted himself to the art of the portrait before becoming more interested in spontaneous photography. A pioneer of cinema, he was the inventor of the one-thousandth of a second → shutter and the electrotachyscope: a manually powered spinning disc of twenty-four glass slides that gave the illusion of movement.

Anthropometry The measurement of a human individual, in an attempt to correlate physical features with racial or psychological traits. It has also been used for the purposes of identification and to describe physical variations. It was employed in positivist contexts in the 18th century and later underpinned the pseudo-sciences of phrenology, physiognomy and craniometry. Anthropometry is perceived as controversial owing to its application in colonial-era racial profiling and the Nazis' eugenics programme. Photography has been used to

Thomas Annan, *Close No. 75, High Street*, 1868

A

Nobuyoshi Araki,
from *Tokyo Novelle*, 1995

document anthropometric measurements since the invention of the medium. The 'Bertillonnage' system, developed by the French police officer → Alphonse Bertillon in 1883 to distinguish and identify individual criminals, combined specific head and body measurements with photographs of criminal suspects in standardized poses. The method spread from France throughout Europe and the United States but was replaced by fingerprinting in the early 20th century.

Aperture *see* **Iris diaphragm**

Aperture Quarterly magazine specializing in the field of photography, founded in 1952 in New York by figures including → Ansel Adams, → Dorothea Lange, → Barbara Morgan, → Minor White, and the art historian → Beaumont Newhall and his wife, Nancy. In 1965 *Aperture* expanded its remit to include book publishing. In 2005 it opened a gallery in Chelsea, New York.

Appelt, Dieter (b. 1935) German film, video and performance artist known mostly for his photographic work. He studied music in Leipzig and Berlin, and → experimental photography and art at the Berlin University of the Arts under → Heinz Hajek-Halke. Appelt sang in the chorus of the Deutsche Oper Berlin between 1961 and 1979, and has been a professor at the Berlin University of the Arts since 1982. Influenced by the Fluxus movement, his work deals with such topics as death, suffering, the passing of time and decay.

Arago, François [Dominique François Jean Arago] (1786–1853) French astronomer, mathematician, scholar and politician. He transformed the discovery of photography into an event of worldwide significance and devoted his life to the service of scientific, economic and social progress. Arago supported the new medium by persuading the government to acquire the rights to the → daguerreotype and was instrumental in passing legislation granting an annual pension and life annuity to → Louis Daguerre and to Isidore Niépce, son of the inventor → Nicéphore Niépce. On 7 January 1839 Arago wrote a letter to the Académie des Sciences in which he outlined

recent photographic research and indicated possible applications for the new medium. Arago also doubled his efforts to assure artists that their skills would not be threatened by these new mechanical images. From the time of this very first letter, Daguerre is cited as the process's inventor, and Niépce is mentioned as a friend and collaborator. Learning of the parallel discoveries made by → William Henry Fox Talbot, however, Arago assumed a patriotic standpoint and used Niépce's invention to cast doubt on Talbot's claim to have discovered a similar, but better, process before Daguerre. → Hippolyte Bayard also wrote to Arago, describing how he had developed a photographic process on paper. Fearing controversy, Arago denied Bayard public recognition. In June 1839 the French government acquired the details of the daguerreotype process and appointed Arago to illustrate it before a combined meeting of the Académie des Sciences and the Académie des Beaux-Arts. On 19 August 1839 he officially announced the discovery of the daguerreotype and presented Daguerre as the inventor, along with Niépce, of photography.

Araki, Nobuyoshi (b. 1940) Japanese photographer. Araki lives and works in Tokyo, where he was born. Graduating from the department of engineering at Chiba University in 1963, he was awarded the Taivo Prize the same year. Initially a cameraman, he became a freelance photographer in 1965. In 1971 he published *A Sentimental Journey*, an intimate photographic diary of his honeymoon. Adopting an autobiographical approach and displaying a fascination with sex and death, he contemplates Japanese culture and its profound changes. A prolific artist deeply affected by the death of his wife in 1990, he produces works that are intentionally provocative, featuring bondage, prostitution and flowers as metaphor for the female genitalia. He has published over 350 books. In 2004 Travis Klose dedicated a documentary, *Arakimentari*, to him.

Arbeiter Illustrierte Zeitung [AIZ] German illustrated magazine founded by Willi Münzenberg in 1924. It was affiliated to the German Communist party (KPD) and the

Neuer Deutscher Verlag editorial trust. With its elaborate layout, comparable to the middle-class press, *AIZ* was the first widely distributed weekly journal of the far left (half a million copies were printed in 1927) and it paved the way for → *Vu* and *Regards* in France, among others. Organized along the lines of a cooperative, *AIZ* sought to liberate itself from the big press agencies and launched an appeal for contributions from workers who were also amateur photographers documenting the daily life of the working class. A sister publication, *Die Arbeiter-Fotograf*, provided technical and aesthetic advice for the amateur. *AIZ* also attracted well-known contributors such as → John Heartfield, who produced numerous → photomontages, George Grosz and Käthe Kollwitz. The publication closed in 1933 following the Nazis' rise to power, but it reappeared in Prague and Paris under the name *Volksillustrierte*.

John Heartfield, *The Meaning of Geneva: Where Capital Lives, Peace Cannot Live!*, photomontage for the cover of *Arbeiter Illustrierte Zeitung*, 1932

Arbus, Diane [née Diane Nemerov] (1923–1971) American photographer. Arbus was introduced to the world of photography by her husband, Allan, and together they set up a fashion photography studio producing images for the magazines of the time. She worked as art director of the studio from 1946 to 1956, following which she began to photograph on her own. She studied with → Lisette Model, Marvin Israel and → Richard Avedon, three figures with whom she had much in common in terms of sensibility. Her photographic work included commissions, → reportage for magazines, and a series of highly personal portraits (all taken in 6 × 6 format) of misfits and outsiders of various kinds, ranging from transvestites to people with Down's syndrome, as well as ordinary passers-by viewed from unusual angles.

Archer, Frederick Scott (1813–1857) British sculptor and portrait photographer. Excited by new techniques and negative processes, in 1849 Archer discovered the → collodion process. To use this technique, a photographer had to apply the collodion himself, because the plate remained sensitive only while it was still wet. The process allowed for a graduation of tones, and reduced the time the subject was required to pose from several minutes to just a few seconds. The unpatented wet-plate process was introduced in 1851. Its precision, sharpness and marked contours assured its success, to the detriment of the paper negative, → calotype and → albumen-coated glass plate processes. Archer also developed the → collodion positive (also known as the ambrotype) in 1852: once the → latent image on the glass plate had been developed, it was placed on a black background. The positive image could be read perfectly and used like a → daguerreotype or miniature.

Architectural photography The photographic depiction of buildings, architectural details and models for documentary, political, economic and artistic purposes. Architecture is one of the oldest subjects of photography; being immobile, it was well suited to the long exposure times required in the medium's early years. Two of the earliest-known photographs are primarily

Frederick Scott Archer,
Untitled portrait, 1845

architectural: → Nicéphore Niépce's *View from the Window at Le Gras* (1826) and → Louis Daguerre's *Boulevard du Temple* (1838). The first professional photographer of architecture was → Édouard-Denis Baldus, who collaborated on the → Mission Héliographique: a documentary initiative, launched in 1851, that attempted to photograph all French buildings worthy of preservation. By 1850, new techniques such as the → collodion process and the → albumen print had facilitated the recording of detail and the reproduction of photographic images, making architectural photography a medium of visual communication. The circulation of photographs of foreign buildings increased, which in turn influenced European architecture by fuelling historicism. In the 19th century, the conventions for documentary architectural photography included shots from mid-height, symmetry and strong contrasts. Humans were included mostly as indicators of scale. By 1900 photography was the central marketing tool

for architects, since architectural magazines reached a far wider audience than the buildings themselves. → Pictorialism introduced an artistic element into architectural photography, as did the conceptual approach evident in → Eugène Atget's shots of Paris streets. From the 1920s, modern architecture called for a new photographic style. What emerged was strongly influenced by → Lucia Moholy's photographs of the → Bauhaus buildings in Dessau and the → New Vision movement: an emphasis on dynamics and volumes rather than symmetry, and the absence of human figures. Also rooted in this period are collaborations between architects and their favoured photographers. During and after World War II, documentation of destruction became increasingly important, as did changing cityscapes and views of the spreading International style. → Bernd and Hilla Becher influenced a whole generation of architectural photographers with their typologies of industrial architecture, making architectural photography shift further towards the fine arts.

Archive In photography, a collection of material of historical interest preserved for future reference. Since the mid-19th century, photography's ability to record the present has been exploited for archival purposes. Various projects were established with the aim of creating a visual inventory of a society or a cultural heritage, the French → Mission Héliographique being a prime example. Many institutions also began to conserve images for their documentary value. It was not until photography became established as an art form, leading to the foundation of specialized institutions, that it ceased to be treated solely as a witness to history and was collected for its artistic value. Institutions have endeavoured to improve methods of photographic → conservation following the example of numerous international programmes.

Arke, Pia (1958–2007) Danish artist. Born in Greenland and closely attached to the land of her birth, Arke pursued her studies at the Academy of Fine Arts in Copenhagen. She used her documentary work to speak out on the

Eugène Atget,
Versailles, The Fountain of Diana, 1901

subject of Denmark's colonization of Greenland. Juxtaposing text and images taken on site, the artist created a parallel between the Arctic's past and present.

Arnatt, Keith (1930–2008) British photographer. He began his career in the 1960s as a conceptual artist, producing works such as *Self-Burial (Television Interference Project)* (1969). In the early 1970s he began to favour photographic → series over purely performance or conceptual pieces, and was noted for making the mundane and banal seem strange and humorous. He gradually shifted into the realm of conceptual photography, using the language of → documentary photography in the vein of → Walker Evans and → August Sander. His

series *The Visitors* (1974–76) and *Walking the Dog* (1976–79) are at once ironic and gentle. Moving from black and white to colour in the 1980s, Arnatt produced the series *Miss Gracie's Lane* (1986–87), *Pictures from a Rubbish Tip* (1988–89) and the poignant *Notes from Jo* (1990–94).

Arnold, Eve (1912–2012) American photographer. She studied photography in 1947 under → Alexey Brodovitch. Ten years later she became the first female member of → Magnum Photos. Known principally for her portraits of Marilyn Monroe, she also produced → reportage work all over the world, focusing on themes such as religious minorities, veiled women and apartheid.

Arnoux, Hippolyte (active *c.* 1860–*c.* 1890) French photographer. He worked in Port Said, Egypt, where he sold prints to travellers from the darkroom on his boat, which bore the sign 'Photographie du Canal'. Arnoux specialized in images of ancient Egyptian monuments and street trades, and in → ethnographic portraits. He also travelled to Cairo, Aden, Jerusalem, Sudan, Somalia and Ethiopia, and documented the excavation of the Suez Canal. He worked occasionally with the → Zangaki brothers and, later, with Antonio Beato. Arnoux's photographs were exhibited at the 1889 Exposition Universelle in Paris.

Art photography Creative photography produced with the intention that it should be viewed as art. The 19th century witnessed a long, continuous debate between those who approached photography as a commercial venture and those who saw photography as a unique art form. Art photography emerged through the work of individuals who embraced the photographic medium while looking to other art forms for inspiration. Such early art photographers included the Scottish duo → David Octavius Hill and Robert Adamson, → Oscar Gustav Rejlander, → Gustave Le Gray and → Julia Margaret Cameron. The → Pictorialist movement, which began around 1885, claimed that photography would be accepted as an art form only if it emulated other arts, such as painting and printmaking. Many Pictorialists aimed to use photography to create works of artistic expression. This was done through manipulated negatives and prints, and the use of ink-based photography and blurred imagery. In the 1970s photography was increasingly viewed as art, though not completely accepted as such until the 1980s. Since then, however, photography has occupied a permanent place alongside other art disciplines, and many contemporary artists use photography as their medium of choice. This turnaround was due to several factors, including the emergence of a burgeoning photography market – increased sales at auction, and the opening of commercial galleries devoted solely to photographs – and the creation of curatorial departments in many American and European art museums, where photography was collected and shown alongside traditional art. The modern viewer is hard pressed to make such distinctions: so many photographers now work both commercially and artistically, and both types of art are bought and sold at the same time as being displayed in galleries as art.

Arts et Métiers Graphiques French magazine, first published in 1927. In 1930 the publication of a special issue devoted to photography aroused great interest. Containing 130 images presented in sequence in an avant-garde layout, this 'Photographie' supplement promoted the ideas of the → New Objectivity (Neue Sachlichkeit) in France. Mainly on the basis of aesthetic considerations, *Arts et Métiers Graphiques* presented photography as an art in its own right, including creative, commercial, industrial and scientific images within its pages, but excluding war photography and political → photomontages. By featuring → photograms, new viewpoints, urban landscapes and references to industry and machinery, the magazine highlighted the photographic trends of the inter-war period.

Atget, Eugène [Jean-Eugène-Auguste Atget] (1857–1927) French photographer. Becoming interested in photography in around 1888, Atget moved to Paris in 1890 and opened a studio specializing in source images for artists, architects and set designers. Initially a sailor and travelling actor, Atget described himself as a photographer who was a keeper of records, identifying himself with the French tradition of historicizing landscapes and monuments. He worked with a large-format bellows camera, developing his own dry collodion plates. In 1898 he embarked on a project with the quasi-encyclopaedic aim of capturing the old city of Paris under threat from new urbanization. Occupying a unique position at the crossroads between the 19th century and the modern era, Atget shied away from modernity in order to better prepare for its arrival. He showed people's day-to-day environment without embellishment, with a total lack of reference to the traditional conventions of framing and composition.

Atget was animated by an uncommon interest in subjects that were not usually considered 'artistic': architectural details, streets, cul-de-sacs, street furniture. His landscapes were rediscovered in 1924 by → Man Ray and, later, by Man Ray's assistant → Berenice Abbott; although they had never been exhibited or published, for the followers of the New Photography they were the embodiment of photographic austerity. Atget was viewed unanimously as the instigator of a decisive break. Rescued from anonymity by Abbott, who acquired the majority of his archives at his death, Atget has since been acknowledged as one of the precursors of modernism in photography.

Atkins, Anna (1799–1871) British botanist and photographer. A friend of → Sir John Herschel and → William Henry Fox Talbot, Atkins published *British Algae*, the first book to be illustrated with photographs, over a period of ten years (1843–53). In the 1850s the photographer devoted herself

Anna Atkins, *Dictyota dichotoma,*
in the Young State; and in Fruit, 1843

to the → cyanotype, a process that Herschel had invented. Her images of botanical specimens stand out from those of her contemporaries for their delicacy of line.

Atwood, Jane Evelyn (b. 1947) American photographer. Atwood took up photography in 1976 and became the first winner of the W. Eugene Smith Award in 1980. In her intimate → reportage projects, taken over long periods, Atwood tackles sensitive social issues including prostitution, blind children, landmines, women in prison, and poverty and violence in Haiti. The Maison Européenne de la Photographie in Paris staged a retrospective of her work in 2011. Since 1971 Atwood has lived in France.

Auerbach, Ellen (1906–2004) German-born American photographer. She trained first as a sculptor but then studied under the → Bauhaus photographer → Walter Peterhans. She founded a pioneering female-run photography studio in Berlin in the late 1920s, where she created memorable portraiture and advertising photographs in the spirit of the → New Vision movement. The studio, consisting of Auerbach and her close friend → Grete Stern, came to a sudden end with Adolf Hitler's rise to power. Throughout her flight from Berlin to Tel Aviv and then to London, she managed to work as a photographer. In 1937 Auerbach emigrated to the United States, where she worked as a freelance photographer and, later in life, as an educator for children suffering from schizophrenia.

Autochrome An early colour photography process that used glass-plate transparencies. Invented in 1904 by the → Lumière brothers, it was marketed to the public in 1907. Thanks to the innovative nature of the process and the commercial strategy adopted by its inventors, it became widely popular with photographers. A relatively expensive but easy process, the autochrome was made up of a mosaic of microscopic grains of potato starch that were dyed orange-red, green and blue-purple, covered with a coating of light-sensitive silver halide. The colour image could be viewed when the

Aziz + Cucher, *Chris
(Dystopia Series)*, 1994

leading to a collaboration that lasted until 1965.
Avedon's photographs were characterized by
their vitality, freshness and sense of movement.
He photographed his models outdoors, often
in the street and sometimes in incongruous
settings, such as the Cirque d'Hiver in Paris, but
in the early 1950s he began to work exclusively
in the studio. He abandoned urban settings and
natural light, but movement remained central
to his aesthetic approach. Those who sat for his
portraits included celebrities, ordinary members
of the public and those on the margins of society.
Using an optical camera, he photographed his
subjects against a white background, head-on
and full frame. *Observations* (1959) and *Nothing
Personal* (1964) were his first two books. *In
the American West* (1985), which took the form
of an exhibition and a book, was the result of
a project produced in collaboration with the
Amon Carton Museum in Fort Worth, Texas.
Over a period of five years, Avedon photographed
over seven hundred working-class subjects –
miners, farmers, housewives, workers in the oil
fields – from seventeen different western states.

Azaglo, Cornelius Augustt (1924–2001)
Ivorian photographer. In 1958 he opened his
photographic studio, called 'Studio du Nord',
in Korhogo. He is known for his passport-like
images and his portraits in black and white.
In 1994 he participated in the first Rencontres
de la Photographie in Bamako, Mali. His
archives contain approximately 100,000 negatives,
all rigorously classified by the photographer.

Aziz + Cucher Artistic duo consisting of the
American-born Anthony Aziz (b. 1961) and
the Peruvian Sammy Cucher (b. 1958). They
tackle issues relating to the human body, using
digital technology to create disturbing portraits
showing the disappearance of sexual organs and
facial features, creating mutant bodies that are
metaphors for the failings of society. In other
works, they use the textures of flesh and skin
to produce surreal architectural labyrinths.

plate was backlit or projected. Despite its
reliability, the autochrome had the disadvantage
of producing only single images that could not
be duplicated, and whose colours were difficult
to transfer onto paper. The technique remained
in use until the 1930s.

Avedon, Richard (1923–2004) American
photographer celebrated for his fashion
photography and portraits. The son of the owner
of a women's fashion store, the young Avedon
was captivated by → Martin Munkácsi's fashion
photography and enrolled at the YMHA Camera
Club when he was 12 years old. From 1941 to 1942
he studied philosophy at Columbia University,
New York. Between 1942 and 1944 he served
in the photography department of the United
States Merchant Marine. From 1944 until 1950
he attended a photography course taught by
→ Alexey Brodovitch, who hired him as a fashion
photographer at → *Harper's Bazaar* in 1945. At the
same time Avedon also worked for → *Life*, *Look*
and *Graphic*. He was editor and photographer for
Theatre Arts magazine from 1952 to 1955. In 1965
he was poached from *Harper's Bazaar* by → *Vogue*,

B

Backhaus, Jessica (b. 1970) German photographer. The daughter of artists, Backhaus left her native town of Cuxhaven, in northern Germany, for Paris in 1986, where she studied photography and visual communication. She then moved to New York for fourteen years before returning to Berlin in 2009. Her colour images capture details of the everyday, whereas her portraits are closer in style to those of the → New Objectivity movement.

Backlighting Situation in which the light source is directly in front of the camera and the subject is between the two; the subject therefore appears in shadow. It is a common mistake in amateur photography, but can also be used as a deliberate effect by professionals.

Bae, Bien-U (b. 1950) South Korean photographer. Bae has done much to promote the natural beauty of South Korea through his graceful, meditative photographic landscapes, which possess an almost calligraphic quality. He graduated from Hongik University with an applied arts degree and from its graduate school with a craft design degree. At the invitation of

Bielefeld University of Applied Arts in Germany, he studied photo and film design there for one year. In 2006 he was the subject of a solo exhibition at the Museo del Prado, Madrid – the first devoted to an Asian photographer. In 2009 he was commissioned by the Spanish government to photograph the Alhambra and Generalife gardens in Granada, a World Heritage Site since 1984.

Bailey, David (b. 1938) British photographer. Bailey is celebrated for his fashion photography and his portrayal of Swinging London. From a modest background, he acquired his first camera while doing military service. Returning to London in 1958, he worked as a studio assistant before signing with → *Vogue* in 1960. Alongside → Terence Donovan and Brian Duffy, he was one of the so-called 'Terrible Three' and excelled in capturing the energy of the 1960s, taking his inspiration from the attitudes and concerns of the new generation while acquiring celebrity status himself. Michelangelo Antonioni's film *Blow-Up* (1966) was inspired by his career. His books *David*

B —

John Baldessari, *Throwing Three Balls
in the Air (Best of 36 Attempts)*, 1973

Bailey's Box of Pin-Ups (1965) and *Goodbye Baby
& Amen* (1969) featured eloquent and innovative
portraits of the influential cultural figures of
the time.

Baldessari, John (b. 1931) American conceptual
artist. He was educated at San Diego State
College, earning a bachelor's degree in 1953
and a master's in 1957, as well as at the Otis
Art Institute and Chouinard Art Institute,
both in Los Angeles. Although he trained as
a painter, in the mid-1960s Baldessari began
using appropriated photographic images.
His early work in this vein combined image
and text in juxtaposition. With such projects
as *Wrong* (1966–68) and *Throwing Four Balls
in the Air to Get a Square* (1974), he began
taking his own photographs, although he has
never considered himself a photographer. He
utilizes → photomontage, text, painting, digital

manipulation, colour and scale to comment on
the nature of art and communication. Based
in Los Angeles, he has spent the majority of his
artistic career as an art educator, influencing
many artists through his teaching.

Baldus, Édouard-Denis (1813–1889) Prussian-
born French painter and photographer. Baldus
emerged in the 1850s as one of the era's most
eminent architectural photographers. He left
Prussia to settle in Paris in 1838, with the aim
of studying painting. He took up photography
in 1848, and in 1851 was employed by the
Commission des Monuments Historiques to
take part in the → Mission Héliographique.
His assignment to photograph famous buildings
before their restoration led him to Fontainebleau,
Burgundy and the south of France. This journey
resulted in more than 300 negatives on paper,
over which the photographer applied a gelatin

Édouard-Denis Baldus,
Viaduct at La Voulte, c. 1861–62

→ emulsion to obtain better definition. Baldus's images were also characterized by their scale, created by joining several negatives together. Once back in Paris, he wished to compile a volume of architectural views of French towns, for which he obtained the financial support of the Interior Ministry. Called *Les Villes de France photographiées*, it was limited to the capital city, the Midi and a few other celebrated locations. In 1854 he travelled to the Auvergne and produced images of its harsh landscapes. In 1855 he received a commission from Baron James de Rothschild to compile an album of fifty plates showing views taken along the route of the Northern Railway (*Chemin de fer du Nord: Ligne de Paris à Boulogne*). The following year he produced a photographic report on the damage caused by the flooding of the Rhône. Between 1855 and 1858 Baldus recorded the construction of the new Louvre, which he reproduced in its entirety. In 1859 he produced a new album on the railways to mark the extension of the line between Marseille and Toulon – a body of work that shows him moving towards a new genre, the representation of the architecture of engineering. In 1875 Baldus presented a synthesis of his work in the volume *Les Monuments principaux de la France*. His participation in the various international exhibitions of the 1850s established him as one of the greatest photographers of that decade.

Ballen, Roger (b. 1950) American-born South African photographer. Ballen was introduced to photography by his mother, Adrienne Ballen, who worked for → Magnum Photos and founded one of the first photography galleries in New York. His square images mainly represent South Africa's marginalized groups and reflect a move from a documentary style towards a more personal aesthetic, which rests somewhere between → Surrealism and Art Brut. This development is visible in his six books: *Boyhood* (1979), *Dorps* (1986), *Platteland* (1994), *Outland* (2001), *Shadow Chamber* (2005) and *Boarding House* (2009).

Balogh, Rudolf (1879–1944) Hungarian photographer and newspaper editor. Having taken part in the first Hungarian art photography exhibition in 1907, Balogh opened a studio in Budapest in 1912 and worked as a photojournalist during World War I. In his early career he worked in a painterly style, but by the end of the 1920s he had formed his own language based on → documentary photography. He had a huge influence on the Hungarian National Press Agency (MTI), and on *Vasárnapi Újsag* and *Az Est*, the most significant Hungarian newspapers of the time. He was one of the creators and the most prominent representative of the so-called 'Hungarian style'. Balogh focused mostly on everyday life on the Great Hungarian Plain, portraiture and village scenes, but he also took

Dmitri Nikolaevich Baltermants,
Soviet Troops Leap over a Foxhole, 1941

Lewis Baltz, *Southwest Wall, Vollrath,*
2424 McGaw, Irvine, 1974

emblematic photographs of Budapest. In the
1930s he participated in several exhibitions
in Hungary and abroad. In later years he was
director of the Hungarian Film Office Laboratory.
The most prestigious Hungarian award for
photography, founded in 1992, bears his name.

Baltermants, Dmitri Nikolaevich (1912–1990)
Russian photographer. Born in Warsaw,
Baltermants studied mathematics at Moscow
University from 1928 until 1933 with the aim
of becoming a teacher. Self-taught, he began
a career as a photojournalist in 1939. The
same year he carried out his first → reportage,
a commission from the daily newspaper *Izvestia*
that sent him to western Ukraine to cover the
invasion of Poland by the Soviet Union. During
World War II Baltermants photographed the
Red Army in combat, including the Battle of
Stalingrad. Upon his return in 1945, he worked
as a photographer for the illustrated magazine

Ogonyok, becoming head of the photography
department and associate editor in 1965. His
work was exhibited internationally for the first
time in London in 1964 and New York in 1965.

Baltz, Lewis (b. 1945) American-born
photographer, theorist, writer and teacher,
associated with the New Topography movement.
Baltz studied at the San Francisco Art Institute,
where he received his bachelor's degree (1969),
and the Claremont Graduate School, Claremont,
where he obtained a master's degree (1971).
The seminal 1975 exhibition → *New Topographics:
Photographs of a Man-Altered Landscape* included
his series *The New Industrial Parks near Irvine,
California*. His work has consistently dealt with
architecture and relationships of power. In the
late 1980s Baltz moved to Europe and continues
to live and work there, exploring colour and
digital photography while teaching photographic
theory and practice.

— B •

Bán, Andrej (b. 1964) Slovak photographer. Born in Bratislava, Bán was the principal reporter and photographer of the weekly Slovak magazine *Týždeň*. He is the curator, founder and chairman of People in Peril, a humanitarian organization. His photography focuses mainly on regions of the world in crisis (Kosovo, Pakistan, Afghanistan and Iran, for example). In 1987 he joined the weekly journals *Mladé rozlety*, *Plus 7 dní* and *Mladý svět* as a photojournalist. In 2000 he became the co-founder of the Slovak Documentary Photography association, and is also the author of several award-winning documentary films. His photographs aim to capture something eternal in the ephemeral.

Baňka, Pavel (b. 1941) Czech photographer and magazine editor. After training as an electrician in Prague, Baňka chose to devote himself to photography in the late 1970s. He is principally known for his fantastical → *mises-en-scène*, in which Baňka combines female nudes with geometric elements. In 2002 he was co-founder of the magazine *Fotograf*.

Barbey, Bruno (b. 1941) Moroccan-born French photographer. After studying at the École des Arts et Métiers in Vevey, Switzerland, Barbey joined → Magnum Photos in 1964, becoming a full member in 1968. His photographs are the product of many voyages all over the world. He has covered great political events and several

Olivo Barbieri,
from the *Dolomites Project*, 2010

George N. Barnard,
Sherman and his Generals, 1864–65

civil wars, and his work has been published in many books and magazines, including *Time* and → *Life*.

Barbieri, Gian Paolo (b. 1938) Italian photographer. Born into a family of fabric wholesalers, Barbieri was acquainted with the fashion world from an early age. In 1965 → *Vogue Italia* commissioned him to produce the cover of its first issue. In 1982 Barbieri published his first book, *Artificial*: with an introduction by Giorgio Armani, it confirmed his status in the realm of haute couture photography. Since the 1990s he has changed genre and now focuses on documenting islands, travelling from the Seychelles to Madagascar.

Barbieri, Olivo (b. 1954) Italian photographer. Barbieri studied philosophy at Bologna University before turning to photography. In 1978 he began to exhibit his images of urban environments. His *Site Specific* series (2003 onwards), which includes photographs and videos of the world's biggest cities, brought him fame. Making use of tilt-shifting techniques to alter the → depth of field, these aerial views give the sensation that the urban landscape has been miniaturized.

Barnard, George N. (1819–1902) American photographer. Barnard is celebrated for his images of the American Civil War (1861–65). Initially a studio photographer, from December 1863 he supplied the US army with photographs for military and topographical purposes. In 1866, after the war had ended, he published an album of sixty-one → albumen prints showing General Sherman's campaign and many devastated landscapes.

Barney, Tina (b. 1945) American photographer. Through her work, Barney investigates affluent social classes in the United States and Europe. Inspired by Édouard Vuillard and Pierre Bonnard, she pioneered the use of large-format chromogenic prints whose scale and stiff, formal compositions evoke traditional → portraiture. Recent work has included *The Europeans* (2005) and *Small Towns* (2012).

Barrada, Yto (b. 1971) French-Moroccan photographer. After studying history at the Sorbonne, Barrada trained at the International Center of Photography in New York and at the École des Beaux-Arts in Paris. In 1998 she carried out her first project on the military roadblocks in the West Bank. Drawing on her dual cultural heritage, her photographs and videos address

Yto Barrada, *Girl in Red*, 1999

the issues of immigration, borders and boundaries. From 1999 until 2003, in the *Strait Project*, she focused on the Strait of Gibraltar as a physical and symbolic place of passage between two different and unequal situations. Her work has now gained international recognition. In 2006 she co-founded the Cinémathèque de Tanger, of which she is art director.

Barros, Geraldo de (1923–1998) Brazilian photographer, painter and designer. An exponent of abstract and concrete art, de Barros trained as a painter and became interested in photography in 1946. He experimented with various techniques, including → rayographs, → photograms, multiple exposures, cropping and drawing on the negative. His photographic work was confined primarily to two distinct and separate periods, marked by the *Fotoformas* series (1949–51) and the *Sobras* series (1996–98).

Barthes, Roland (1915–1980) French theorist, critic and philosopher. Barthes's work on photography can be divided into two periods: that covering his interest in structuralism, which culminated in *The Photographic Message* (1961), and *Camera Lucida*, his final work, written in 1979. *The Photographic Message* was an exercise in formal but illuminating methodology, in which he applied the principles of linguistics to the visual object. Somewhat paradoxically, it was the latter work – which was only indirectly about photography, adopting the medium as a symbol and metaphor for disappearance – that would become a point of reference for the photographic world. Although described as a work of phenomenology, *Camera Lucida* can instead be viewed as an elegy on the pain of loss, and even a mystic text on the possibility of reincarnation. Barthes highlighted the state of pure perception a viewer experiences before an image, leading him to formulate two notions that were widely adopted: the 'what-has-been' of the photograph (an acknowledgment of loss, but also of the superiority of the spectator, who knows that death awaits the subject that is depicted), and the distinction between *studium* and → *punctum*, which sanctions the spectator's subjectivity.

Baryta paper Fibre-based photographic support consisting of a paper base coated with a layer of baryta (barium sulphate) and a light-sensitive → emulsion of gelatin, bromide and/or chloride, and silver nitrate. Fibre-based papers were developed in the mid- to late 1870s, with baryta coatings becoming standard for gelatin silver photographs from 1880.

Basilico, Gabriele (1944–2013) Italian photographer. An architect by training, Basilico initially worked as an architectural photographer. In 1983 he held his first exhibition, *Milano: Ritratti di fabbriche* ('Milan: Portraits of Factories'). In 1984 and 1985, he took part in the French → DATAR photographic project, going on to participate in many similar projects throughout Europe. His work, in black and white, is concerned primarily with the urban environment and industrial landscape.

Battaglia, Letizia (b. 1935) Italian photographer. After training as a journalist, in 1970 Battaglia moved to Milan, where she began to take photographs to illustrate her articles. In 1974 she returned to her native Palermo and founded the agency Informazione Fotografica. She documented the violent *anni di piombo* ('years of lead') in Italy and the struggle against the Mafia (1970–90), but her photographic output diminished between 1985 and 1997, when she became involved in politics. In 1993 one of her photographs, taken in 1979, was used by the justice system to denounce Giulio Andreotti, seven times prime minister, who had denied links with the Mafia.

Baudrillard, Jean (1929–2007) French sociologist and philosopher. Baudrillard's entire oeuvre displays his interest in the subject of the simulacrum and its relationship with reality. It was, therefore, perhaps only natural that he should turn his attention to photography, about which he wrote several books and which he also practised from the 1980s on. He believed that photography was 'pure simulation', completely removed from reality. As automatic recordings of the world around us, photographic images were *only* images, he argued; photography was

Gabriele Basilico,
Le Touquet, 1985

a 'magic art', since it fell within the realm not of judgment, but of enthralment. This paradoxical and intentionally polemic concept met with some success in the field of art criticism but remained marginal in any consideration of photography, since it constituted an aesthetic rather than a critical or hermeneutic act.

Bauhaus German school of arts and crafts, originally founded in Weimar in 1919 by the architect Walter Gropius and in operation until 1933. The institute was originally established to offer a new approach to the teaching of skills relating to construction (*Bau* in German), achieved by means of studio classes run by artisans and visual artists. Photography was considered seriously as a medium in its own right only from 1929, having previously been linked with the teaching of industrial design at → László Moholy-Nagy's initiative. Within this context Moholy-Nagy had passed down an interest in exploring the opportunities offered by new techniques and lighter, more compact cameras. The apprentices' experiments, which took the form of → collages and → photograms, were characterized by creative framing, new uses of perspective and dramatic compositions. Among the most notable Bauhaus photographers were → Lucia Moholy, → Walter Peterhans and Erich Consemüller,

Lothar Baumgarten,
VW do Brazil, 1974

director of the department of photography from 1929 to 1933.

Baumgarten, Lothar (b. 1944) German conceptual artist who exerted a pioneering influence on the emerging → Düsseldorf photography school in the late 1960s and early 1970s. Baumgarten studied at the Kunstakademie Düsseldorf between 1969 and 1971, partly under Joseph Beuys. He was the German representative at the 1984 Venice Biennale. He uses photography to document his anthropological investigations, which revolve around the antithesis between nature and culture, the self and the other.

Bayard, Hippolyte (1801–1887) French pioneer of photography. A civil servant in the Ministry of Finance, with no particular scientific education but an interest in the chemical action of light, Bayard developed a photographic process on paper independently of the experiments conducted by → Nicéphore Niépce, → Louis Daguerre and → William Henry Fox Talbot. His first direct → positives on paper consisted of images obtained in the darkroom. He made his results known publicly and organized the first ever exhibition of photographs, in July 1839, displaying thirty direct positives on paper showing → still-lifes, sculpture and architectural views. Fearing a dispute, → François Arago refused to recognize Bayard's achievement and on 19 August 1839 proclaimed Daguerre as the inventor of photography, together with Niépce. It was not until the following year that Bayard



presented his process to the Académie des Sciences. Suffering from a sense of injustice, on 18 October 1840 Bayard executed his *Self-Portrait as a Drowned Man*, adding a sarcastic note on the back. A work of condemnation, it was also the first staged photograph. Bayard abandoned his process in 1842 in favour of Talbot's → calotype, which was faster and, thanks to the use of a → negative, could also be reproduced. In 1851 he was chosen by the Commission des Monuments Historiques to take part in the → Mission Héliographique. Bayard used the → albumen on glass negative process to photograph a series of historical buildings about to undergo restoration; some prints of this survey have survived. From 1855 Bayard specialized in the reproduction of works of art and → *carte-de-visite* portraits, using the wet → collodion process. Three books by Bayard were published by the → Blanquart-Evrard publishing house: *L'Art religieux* (1853), *Le Musée photographique* (1853) and *L'Art contemporain* (1854). A pioneer of photography on a par with Niépce, Daguerre and Talbot, Bayard bequeathed a highly personal oeuvre, rich in architectural views, garden scenes and self-portraits.

Bayer, Herbert (1900–1985) Austrian-born American graphic designer, typographer, painter, photographer, sculptor and architect. Between 1921 and 1923 Bayer studied at the → Bauhaus in Weimar, most notably in Kandinsky's mural painting studio, and from 1925 taught typography and graphic design at the Bauhaus in Dessau. In 1928 he left for Berlin, where he worked as art director for → *Vogue*. The following year he participated in the noted → *Film und Foto* exhibition in Stuttgart. His photographic work of the 1920s and 1930s reflected the principles of the → New Vision and → Surrealism. *Fotoplastiken* (1936), his last major series of photographs, combined organic and geometric forms. In 1938 Bayer emigrated to the United States, where he spent periods in New York, Colorado and California, and exhibited at Black Mountain College, North Carolina (1939), among other venues. He took part in land-development projects and became artistic adviser to several large corporations.

Bayer-Hecht, Irene (1898–1991) American photographer. She was born in Chicago and raised in Hungary. Influenced by the experimental 1923 → Bauhaus exhibition in Weimar, she studied art in Paris and photography in Leipzig. She married → Herbert Bayer and became instrumental in advancing his photographic career. Her photographs of artists living at the Bauhaus were included in the → *Film und Foto* exhibition in Stuttgart (1929). Bayer-Hecht returned to the United States in 1938 to work as a translator.

Beard, Peter (b. 1938) American writer and photographer. Influenced by visits to Africa and the writings of Karen Blixen, after completing his studies in history of art at Yale University, Beard settled in Kenya in 1961. In Kenya he worked on his *Diaries*, which are travel notebooks enhanced with photographs, paintings, → collages and drawings. In addition he documented the disappearance of some species of African wildlife, which he denounced through the publication of numerous works, the best-known being *The End of the Game* (1965).

Hippolyte Bayard, *Self-Portrait as a Drowned Man*, 1840

Beato, Felice (1832–1909) Italian-born British photographer. Beato was one of the first photographers to travel through the Middle and Far East. He was born in Venice and later became a British citizen. The brother of the photographer Antonio Beato, Felice began his career when he joined forces with his brother-in-law → James Robertson, photographer and superintendent of the imperial mint in Constantinople, whom he met in Malta in 1850. Beato became his assistant and then his associate before establishing himself as an independent photographer. Beato and Robertson worked together in Constantinople and, in 1855, produced a photographic report on Sebastopol during the Crimean War. They subsequently worked in Malta, Palestine, Egypt and Greece. Having been appointed official photographers of the British army, Robertson and Beato travelled to India to photograph the carnage that followed the 1857 Indian Rebellion in Lucknow, in which separatists revolted against British rule. Beato travelled alone to China and, during the Second Opium War, reported on the Anglo-French expedition of 1860, taking images of corpses lying on the battlefield. In 1862 he settled in Japan, opening a studio in Yokohama and photographing the country's inhabitants, monuments and historical events. Beato returned to China in 1870, and in 1884–85

- B •

Felice Beato, *Samurai of the Chosyu Clan during the Boshin War period*, 1860s

he followed the Mahdi Revolt against the British in Khartoum. At the end of the 1880s he opened studios in Rangoon and Mandalay and specialized in the export of Burmese applied arts.

Beaton, Cecil (1904–1980) British photographer and stage designer. Beaton was known for his portraits of celebrities and his fashion photography. Born into a wealthy family, he was able to take advantage of his education to satisfy his love for the theatre and to photograph members of the bohemian aristocracy he admired. From 1927 the success of his prints, imbued with nostalgia for the Edwardian era, led to a promotion at → *Vogue*, and he became one of its most prestigious collaborators. During World War II his style assumed a greater sobriety as he documented the war effort and aimed to strengthen the image of British leaders. The 1950s were synonymous with a return to splendour – particularly in his royal portraits, which rekindled the glory of a recent past.

Becher, Bernd (1931–2007) **and Hilla** (b. 1934) German photographic partnership. Major figures in contemporary photography, they met in 1959 and married in 1961. Together they began to document obsolescent and rapidly disappearing examples of industrial architecture, such as water towers, cooling towers, silos and lime kilns, initially in Germany and then elsewhere in Europe and in the United States. The Bechers' extremely rigorous approach (black-and-white prints, frontal views, uniform lighting, large-format view cameras) and the images' lack of temporal and geographical context, emphasized by the framing and presentation, gave rise to a characteristic formal homogeneity. Generally associated with a documentary trend that arose in Germany in the wake of the → New Objectivity (Neue Sachlichkeit) movement, their works were initially published in specialized magazines such as *Werk und Zeit* and *Deutsche Bauzeitung*. Working in → series, minimizing authorial interventions in the creative process and rejecting entirely any hints of narrative, Bernd and Hilla Becher established an inventory

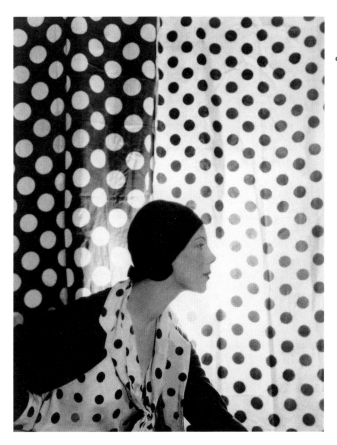

Cecil Beaton, *Tilly Losch*,
from *Vogue*, 10 May 1930

of typological forms that they exhibited or published in series, in order to render them consistent, subordinating photography's archival purpose to a conceptual approach. From the late 1960s their typological images gradually attracted attention in artistic circles, especially among conceptual artists. The exhibition *Anonyme Skulpturen*, held at the Kunsthalle in Düsseldorf (1969), and the accompanying catalogue led to the Bechers' institutional recognition as artists; and their participation in the influential → *New Topographics: Photographs of a Man-Altered Landscape* exhibition at George Eastman House, Rochester, New York (1975), firmly established their reputation as important landscape photographers. Professor at the Kunstakademie Düsseldorf from 1977, where he held one of the first chairs in 'artistic' photography alongside his wife, Hilla, Bernd Becher was instrumental in teaching major figures in contemporary German photography. His pupils, who include

— B •

Bernd and Hilla Becher,
Water Towers, 1963–88

→ Thomas Ruff, → Andreas Gursky, → Candida Höfer and → Thomas Struth, are known collectively as the → Düsseldorf School.

Bedford, Francis (1816–1894) British commercial photographer. He began his career as a lithographer and chromolithographer specializing in architectural subjects before turning to photography in the early 1850s, recording English architecture and views. He ran a successful business selling photographs commercially. In 1865 Bedford accompanied the Prince of Wales on a tour of the Middle East. He is known especially for his contributions to photographically illustrated books.

Bélégou, Jean-Claude (b. 1952) French photographer. Bélégou studied philosophy, history of art and archaeology at the Sorbonne, Paris. Heavily influenced by the → Bauhaus, he completed his master's dissertation on photography in 1976, having begun his career in 1970. His images typically depict women or are compositions devoid of human figures. He has explored the city of Le Havre periodically, and between 1985 and 1988 was commissioned by the region of Haute-Normandie to photograph thirty artists living or working in the area. He created Photographies & Co. in 1982, an association that organized exhibitions and seminars about the subject of photography. In 1986 he co-founded the group Noir Limite alongside Yves Trémorin and Florence Chevallier.

Belin, Valérie (b. 1964) French photographer. Since 1993 she has produced small → series, creating minimalist variations on a single theme. Her preference for taking frontal views against black or white backgrounds means that her subjects are removed from their immediate context, resulting in a uniform aesthetic, while at the same time displaying the inexpressive and interchangeable attitudes dictated by a society predicated on appearances. With her striking images of bodybuilders, models, mannequins, dogs and food packaging, Belin blurs the boundaries between natural and artificial, dead and alive, seduction and repulsion, and real and virtual, in a disturbing manner.

Valérie Belin, *Moroccan Brides (Untitled)*, 2000

Bellmer, Hans (1902–1975) German-born French artist. Bellmer initially studied engineering at the Berlin Institute of Technology (1923), but left after only a year. Following the advice of George Grosz, he started an apprenticeship as a typographer with the publishing house Malik Verlag. He then set up his own advertising agency, which he was forced to close in 1933 for political reasons. In 1932 he took numerous photographs of a mannequin he had made, which he published in a work entitled *The Doll* (1934). This doll would feed his imagination for years to come and attract the enthusiasm of the → Surrealists, to the extent that Bellmer became something of an emblematic figure for them. In 1937, a year before moving to Paris, he created a new doll. This version, better articulated, was made to assume lascivious poses, which he captured in black-and-white and then coloured. In 1949 Bellmer published fifteen images, accompanied by poems by Paul Éluard, under the title *Les Jeux de la*

poupée ('The Doll's Games'). Other photographs illustrated works by Georges Bataille, who shared his interest in eroticism. Bellmer employed various techniques – photography, sculpture and drawing – but his work displayed a consistent focus on themes of the body and sexuality. In 1954 a lithograph by Bellmer appeared on the cover of the sadomasochistic novel *The Story of O* by Pauline Réage (an alias of Anne Desclos). His prints were shown at the *Fantastic Art, Dada, Surrealism* exhibition at the → Museum of Modern Art, New York (1936) and at Documenta II (1959) and III (1964) in Kassel.

Belloc, Auguste (1800–1867) French photographer. A painter and miniaturist, Belloc became interested in photography during the 1840s following a suggestion by → Louis Adolphe Humbert de Molard. He became a member of the → Société Héliographique in 1851 and the → Société Française de Photographie in 1854. Alongside nudes and portraits in academic poses, he also produced a number of erotic → stereoscopic images that were seized by the authorities in 1860.

Hans Bellmer,
La Poupée, 1935

Bellocq, E. J. [Ernest James Bellocq] (1873–1949) American commercial photographer. E. J. Bellocq worked mainly in New Orleans. He is remembered largely for his uncommissioned portraits of prostitutes and opium addicts in the city's Storyville and Chinatown neighbourhoods. These posthumously discovered images were published by → Lee Friedlander in the 1970s and popularized through exhibitions.

Benchallal, Nadia (b. 1963) Algerian-born French photographer. Benchallal's work is an investigation into origins. She developed a project entitled *Sisters* (begun 1992) that portrayed the daily life of Muslim women in Algeria and across the world. This work is a personal reflection on the way in which Muslim women have progressed without, however, becoming detached from their environment.

Benjamin, Walter (1892–1940) German philosopher, literary critic and translator. Benjamin studied German language and literature, art history and philosophy in Freiburg and Berlin. In 1915 he met the Jewish historian Gershom Scholem and the two became close friends. In 1920 he completed his doctoral dissertation *The Concept of Criticism in German Romanticism* at the University of Berne. On returning to Berlin, Benjamin worked as a freelance writer and translated the poems of Baudelaire. In 1921 he acquired a drawing by Paul Klee entitled *Angelus Novus*, which he later used in his essay *Theses on the Philosophy of History* (1940) to symbolize the central concept of his historical approach: the angel of history, with outspread wings, propelled into the future by the storm of progress while looking back on the ruins of the past. In 1923–24 he wrote a professorial thesis, entitled *The Origin of German Tragic Drama*, at the University of Frankfurt, but it was rejected. In the years that followed, Benjamin travelled to Paris, Moscow and Ibiza. He worked on a translation of Marcel Proust's *À la recherche du temps perdu*, wrote about his own childhood in *Berlin Childhood Around 1900*, and also collaborated with Bertolt Brecht on several projects. In 1933 Benjamin left Nazi Germany for Paris, where he met Hannah

E. J. Bellocq,
Storyville Portrait, c. 1912

Arendt. In this period he worked on his extensive 'Arcades Project', which he never completed, and wrote one of his best-known essays, *The Work of Art in the Age of Mechanical Reproduction.* He committed suicide in Portbou, Spain, in 1940.

Benkő, Imre (b. 1943) Hungarian photographer. Benkő studied → photojournalism at the Hungarian Press school (MÚOSZ). He went on to work for the Hungarian National Press Agency for eighteen years, then joined the staff of *Képes 7* and *Európa* magazines, producing → reportage in over thirty countries. Between 1988 and 2000 he taught at the Hungarian Academy of Crafts and Design. Benkő is interested in presenting people and their environments using a specific documentary style, exhibiting great empathy with his subjects and a close attention to the rapidly changing world that surrounds him. Focusing always on the human, he uses only ambient natural light and mainly black-and-white film, creating uncropped, finely composed prints full of subtle tones. He generally works on the same themes for decades. Important photographic albums include *Acélváros* ('Steel City', 1996), *Szürke fények* ('Grey Lights', 2000), *Blues Budapest* (2003), *Arcok* ('Faces', 2003), *Utak* ('Paths', 2004) and *Ikrek* ('Twins', 2009). He won the World Press Photo gold and silver medals in 1975, and the gold in 1978. He also received the Pulitzer Memorial Award in 1991 and the W. Eugene Smith scholarship in 1992, and in

2004 was formally recognized by the Hungarian Republic as an Artist of Merit.

Benoliel, Joshua (1873–1932) Portuguese photographer. An early photojournalist, Benoliel first published his photographs in the sports magazine *O Tiro Civil* in 1898 and contributed many images to *Illustração Portugueza* (1903–18). He was the first Portuguese correspondent for the Spanish newspaper *ABC* (1904–32) and the French magazine *L'Illustration*, and collaborated on many national and international journals. Benoliel was the official photographer for Carlos I of Portugal and covered key events of Portuguese history and culture, including the assassination of the king in 1908 and the 1910 republican revolution. He also reported on Portuguese participation in World War I and events related to the *coups d'état* of Sidónio Pais (1918) and Gomes da Costa (1926). Over the course of a thirty-year career Benoliel produced over 60,000 negatives.

Berengo Gardin, Gianni (b. 1930) Italian photographer. Born in Santa Margherita Ligure in a hotel run by his parents, Berengo Gardin initially seemed destined to succeed them in running the establishment. As a child, he was attracted by Mussolini and fascism, but his mother persuaded him to see reason and transformed him into a humanist. He took up photography in 1954; that same year his first work was published in *Il Mondo*, the magazine to which he would contribute until 1965. In 1963 he received the World Press Photo Award. Berengo Gardin travelled throughout Italy, compiling a sociological portrait of the country year after year. His militancy led him to refuse payment for any of his politically engaged → reportage, which touched on such themes as the treatment of patients in psychiatric hospitals and the fate of the gypsy community.

Bergemann, Sibylle (1941–2010) German photographer. Born in Berlin, Bergemann became known for her photographs in the 1960s, and especially for her contributions to the East German woman's fashion magazine *Sibylle*. Her work ranged from → fashion photography

to → reportage, and from 35mm to → Polaroid. She was a regular contributor to the magazines *Stern*, *Spiegel* and *Geo*. In 1990 she and her husband, the photographer → Arno Fischer, founded the Ostkreuz photography agency.

Berger, John (b. 1926) British novelist, essayist, playwright, painter and critic. After serving in the British army, in 1946 Berger began to study at the Chelsea School of Art and at Central School of Art in London. In 1952 he became art critic for the *New Statesman*. The author of numerous publications on art coloured by a profoundly Marxist vision, he achieved international acclaim with the publication of *Ways of Seeing* (1972), which was accompanied by a documentary series for the BBC. It examined the relationship between advertising rhetoric and visual culture in capitalist society. That same year he was awarded the Booker Prize for his novel *G.* His political engagement and his belief in free and democratic exchange led to numerous collaborations, including with the photographer Jean Mohr and the film directors Mike Dibb and Alain Tanner. Berger currently lives in France.

Berges, Laurenz (b. 1966) German photographer. Berges studied at the University of Essen and was taught by → Bernd Becher at the Kunstakademie Düsseldorf. His work revolves around concepts of emptiness, absence and silence, and shows abandoned spaces (principally interiors). His compositions highlight the passing of time and the faint traces left by former inhabitants on these inhospitable sites.

Berggren, Guillaume (1835–1920) Swedish photographer. He established himself as a studio photographer in Constantinople in the 1870s. He is famous mainly for his panoramic townscapes, but also for his images of bazaars, back alleys and the famous sites of the Bosphorus. In addition he made a series of portraits of Turkish professions.

Bergström, Johan Wilhelm (1812–1881) Swedish photographer. Following in the footsteps of his father, an inventor and engineer, Bergström trained as a glassmaker and established an innovative business that produced glass using

Laurenz Berges, *Krefeld (#2571)*, 2007

metallic moulds. As demand fell, he turned his attention to the new photographic techniques, primarily the → daguerreotype and the stereotype, becoming the first in Sweden to capture prominent figures at court and in the arts, as well as the country's landscapes. Following a study tour around Europe, he resumed his metalworking activities and participated in the international exhibitions in London (1851) and Stockholm (1866).

Berko, Ferenc (1916–2000) Hungarian-born American photographer and filmmaker. Of Jewish heritage and raised in Germany, Berko successfully evaded the Nazis by moving first to London, where he studied photography with → E. O. Hoppé, and later to Bombay, where he opened a portrait studio and filmed for the British army. He remained in Aspen, Colorado, after photographing the 1949 Goethe

Bicentennial, becoming the official photographer for the Aspen Institute. An early advocate of colour photography, Berko travelled frequently throughout the United States producing commercial work and portraiture.

Berssenbrugge, Henri (1873–1959) Dutch photographer. His oeuvre is a supreme example of the often difficult transition from → Pictorialism to New Photography. Many of Berssenbrugge's early photographs of everyday urban life in Rotterdam (*c*. 1906–16) are unmatched in their romanticism. Yet he owes his fame to his portraits, mainly of academics, politicians, artists, musicians and theatre producers. Clients could visit his modernist portrait studio in The Hague (designed in 1921 by the De Stijl artists Jan Wils and Vilmos Huszár) and sit for either a soft, painterly portrait in the form of a gum or → bromoil print, or a more

experimental work in half-tone engraving –
a technique that produced a more abstract
image. In the 1930s Berssenbrugge embraced
the ideas of the New Photography movement
and produced experimental nudes, still-lifes
and → photograms. By that time, however, his
innovatory ambitions had been overtaken
by those of younger photographers such as
→ Piet Zwart and Paul Schuitema, who aimed to
transform Dutch photography once and for all.

Bertillon, Alphonse (1853–1914) French
anthropologist. In 1882 Bertillon became head
of the police identification service in Paris. He
applied the theory of → anthropometry to the
identification of individuals, with the aim of
catching criminals and preventing them from
re-offending. Opposed to the idea of
fingerprinting as the sole means of determining
an individual's identity, Bertillon, who became
head of the photography department at the
Paris prefecture of police in 1888, invented
a camera capable of taking images head on and
in profile. Forensic photography, which utilized
records compiled by the Communards in 1871
and which Bertillon subsequently developed
into a system, was designed not to create
a stereotype but to secure the identity of each
criminal. Each photographic record would
consist of a double portrait (face on and in
profile) as well as precise details of the subject's
nose, eyes and ears. In addition to aiding
simple identification, Bertillon's system evolved
towards the assumption that certain individuals
bore criminal characteristics. Bertillon was the
author of *La photographie judiciaire* (1890) and
Identification anthropométrique (1893).

Alphonse Bertillon,
Synoptic Table of Nose Shapes, c. 1893

Bertsch, Auguste Nicolas (1813–1870) French
scientist and founding member of the → Société
Française de Photographie. A self-taught
photographer, Bertsch ran a portrait studio while
also devoting his time to improving developing
techniques. He introduced a rotary shutter in
1852 and published *Notes sur l'emploi du collodion
rapide*. He showed his first photomicrographs at
the Paris Exposition Universelle in 1855, carried
out research into instantaneous photography
and photographed a lunar eclipse. In addition
to studying enlargement techniques, he invented
an automatic camera and a mechanical spring
shutter. Bertsch viewed photography as a
tool for scientific exploration that allowed for
the faithful reproduction of reality without the
need for a draughtsman's 'inaccurate' hand.
In 1858 he was awarded the Légion d'Honneur
for his work.

Besnyö, Eva (1910–2003) Hungarian-born Dutch
photographer. After studying in Budapest, Besnyö
travelled to Berlin and to the Netherlands, where
she settled and began to carve out a reputation.
Politically engaged, she combined aesthetic
experimentation with social documentary. In 1955
her work was included in → *The Family of Man*
exhibition at the → Museum of Modern Art, New

York, and she was awarded the Erich Salomon Prize in 1999.

Beyer, Karol (1818–1877) Polish photographer. A metallurgical engineer, Beyer learnt his trade in his uncle's foundry. In 1845, having mastered various photographic processes in Paris, he opened his first → daguerreotype studio in Warsaw. Known principally for his portraits in profile, he also photographed cities and immortalized the urban landscapes of Gdańsk, Warsaw, Kraków, Częstochowa and Plock. Beyer became a member of the → Société Française de Photographie in 1855 and published numerous volumes including photographs of antiques, portraits of actors and views of Warsaw. A co-founder of the journal *Tygodnik Ilustrowany*, he was the first in Poland to provide the press with photographs. His patriotism and his passion for documentary work led him into political → reportage. In February 1861, following riots against the Russian occupation, Beyer produced post-mortem photographs of five victims in his studio. Composed as tableaux and printed in several thousand copies, these images became a propaganda tool and a symbol of Poland's struggle for freedom. Religious festivals – which Beyer also documented – often turned into political demonstrations. His politicized images led to him being incarcerated. On his release in 1862, he resumed work in his studio. At the age of 54, he abandoned photography entirely and devoted himself to archaeology and numismatics.

Bialobrzeski, Peter (b. 1961) German photographer. Born in Wolfsburg, he studied politics and sociology before becoming a photographer for his local newspaper. After travelling in Asia, he undertook formal photography classes at the London College of Printing and at the Folkwangschule in Essen. After fifteen years as a photojournalist, he has devoted the second half of his career to personal projects, which often explore the hand of man in the landscape. A winner of the World Press Photographers' Award and other prizes, Bialobrzeski is professor of photography at the University of the Arts in Bremen.

Auguste Nicolas Bertsch,
The Antennae of a Hoverfly, c. 1853–57

Biasiucci, Antonio (b. 1961) Italian photographer. Biasiucci's early interests steered him towards anthropological photography and the documentation of rural life, to which he has dedicated several projects. He moved to Naples in 1980, intending to study political science, but took up photography once again to record city suburbs and outlying districts. Commissioned by the Vesuvius Observatory, he has produced a major study on active Italian volcanoes (1984), alongside other, more personal projects.

Billingham, Richard (b. 1970) British photographer. After studying art at Sunderland University, Billingham originally took up photography to provide source material for his paintings but soon devoted himself to it exclusively. From 1990 he documented the lives of his brother and his parents in their council house, producing a series of vividly coloured images, often in extreme close-up. In 1996 this frank testimony of the precariousness

Richard Billingham,
Untitled, 1996

and intimacy of a disadvantaged family was assembled into a book, *Ray's a Laugh*, and shown the following year in the celebrated *Sensation* exhibition, which brought together up-and-coming young British artists under the aegis of the collector Charles Saatchi. Working with video, he has continued to focus on his family. Billingham has also photographed the places where he grew up, near Birmingham, and the area where Constable used to paint.

Bing, Ilse (1899–1998) German photographer. Bing became interested in the history of art and photography after studying mathematics and physics. She worked regularly for the press, in particular *Le Monde Illustré*, → *Vogue* and → *Harper's Bazaar*. Her private photographic oeuvre places her among the principal female figures of the → New Vision, as exemplified by her celebrated *Self-Portrait in Mirrors* (1931). She participated in several exhibitions, most notably *Photography 1839–1937* at the → Museum of Modern Art, New York (1937). After spending

several years in Paris she emigrated to the United States in 1941. Her work was re-evaluated in the late 1970s thanks to several major retrospectives.

Bischof, Werner (1916–1954) Swiss photographer. A pupil of → Hans Finsler at the Zurich School of Applied Arts, Bischof was familiar with the ethos of the → Bauhaus, and produced studies on light and the composition of natural objects. He opened a photography and advertising design studio in Zurich (1936), conceived the installations for the Swiss National Exhibition of 1939 and embarked on a collaboration with the Swiss magazine → *Du* (1942). In 1945 he decided to travel across Europe to document the ravages of war in collaboration with Emil Schulthess. This experience would reveal his need to testify through photography. In 1949 he was the first photographer to join the founder members of → Magnum Photos. In 1951–52 he travelled in India, South Korea, Japan and South-East Asia; in 1953 in Europe and the United States;

66

and in 1954 in South America. His images of famine in India, published in → *Life* (1951), had a considerable impact on his reputation. Bischof is still considered an artist. His choices of viewpoint and composition are expressive of an aesthetic and formal intent, counterbalanced by a powerful sensitivity and ethical involvement. Although known for his black-and-white → reportage work, he also produced a series of colour prints on the United States. He died in an accident in Peru on 16 May 1954, nine days before the death of → Robert Capa, one of Magnum's founding members. His archives are conserved by Magnum and by his children in Zurich.

Bisilliat, Sheila Maureen (b. 1931) British-born Brazilian photographer. She travelled to Brazil in 1952 and settled there definitively in 1957. From 1962 she worked as a → photojournalist, contributing to the magazine *Quatro rodas* (1972) and also to *Réalités*. She founded the O Bode folk art gallery in 1972. Her entire oeuvre entered the photographic collection of the Instituto Moreira Salles, Rio de Janeiro, in 2003.

Bisson, Louis-Auguste (1814–1876) **and Auguste-Rosalie** (1826–1900) French pioneers of photography, famous for documenting their

Werner Bischof, *Peru, On the Road to Cuzco, near Pisac, in the Valle Sagrado of the Urubamba River*, 1954

ascent of Mont Blanc in 1861 and 1862 – an extraordinary achievement considering the weight of their equipment and the precarious nature of the collodion plates. This feat aside, the focus of the brothers' work was the photographing of architectural monuments. In 1840 Louis-Auguste Bisson, who had studied architecture and chemistry, opened a photographic portrait studio with his father. In 1849–51 he took → daguerreotype portraits of the 900 members of the Assemblée Nationale. He subsequently went into partnership with his brother, Auguste-Rosalie, producing portraits but also reproductions of works of art and architectural photographs. In 1852 they photographed the Alhambra in Granada, Spain, but did not achieve the success they anticipated. The brothers then concentrated on the architecture of Paris, photographing in particular the cathedral of Notre-Dame. The owners of a photographic printing press, they published over 200 plates in a title called *Reproductions photographiques des plus beaux types d'architecture et de sculpture* between 1854 and 1863. These images combined a keen

Ilse Bing,
Self-Portrait in Mirrors, 1931

Louis-Auguste and Auguste-Rosalie Bisson,
Mont Blanc, 1858

aesthetic sensibility with mastery of technique
(the → collodion process), and were produced in
a large format (40 × 50 cm). Celebrated on their
return from the Mont Blanc expedition, the
Bisson brothers accompanied Napoleon III
across the Alps. Thereafter they were appointed
the emperor's official photographers, and their
studio became a meeting place for Parisian
artistic and intellectual life. Under increasing
pressure from competition, they became
bankrupt in 1863.

Black-and-white print A monochromatic image
of neutral, or near neutral, tonality. Before the
widespread availability of colour processes in the
1950s, the majority of photographs were black
and white. In the latter part of the 20th century
→ colour photography gradually replaced the
predominance of monochrome images in

→ commercial and consumer photography.
Although, owing to technological advances,
the use of black-and-white → film and paper
is no longer a necessity, it continues for a
number of reasons: the proven image stability
of silver-based processes, ease of reproduction
and artistic preferences.

Black Star A New York-based photographic
agency established in 1935 by the German
émigrés Kurt Safranski, Ernest Mayer and
Kurt Kornfeld. It supplied press photographs
to → *Life*, *Look* and the *New York Times*, among
others. Black Star's roster of photojournalists
included → W. Eugene Smith, → Robert Capa,
Ralph Crane, Fritz Goro, → Andreas Feininger,
→ Fritz Henle and Werner Wolff. It exists
today as a corporate and stock photography
agency, and its historic print collection

(covering *c.* 1914 to the 1990s) is held at the Ryerson Gallery and Research Centre, Toronto.

Blanquart-Evrard, Louis Désiré (1802–1872) French photographer and publisher. A wealthy merchant with a passion for chemistry, Blanquart-Evrard played an important role in France in the dissemination of the → calotype and the industrial production of photographs printed on → albumen paper, the most popular process in the second half of the 19th century. In 1847 and 1851, while still a textile merchant in Lille, Blanquart-Evrard presented the Académie des Sciences with refinements to → William Henry Fox Talbot's calotype technique. Printing processes were simplified, the absorption of silver solution by the paper support was improved and fixing became more stable. Aimed at overcoming the cost and lengthiness of printing by reducing production time, Blanquart-Evrard's methods allowed an industrial printing process to be employed. He opened his Imprimerie Photographique printing works in 1851 at Loos-lès-Lille, setting himself the goal of producing 200 albumen prints a day from a single negative. His first publication, *Album photographique de l'artiste et de l'amateur*, appeared the same year, and he subsequently published three archaeological albums: *Egypte, Nubie, Palestine et Syrie* by → Maxime Du Camp; *Le Nil* by → John Beasley Greene; and *Jérusalem* by → Auguste Salzmann. Twenty-four titles intended for artists, art collectors and antiquarians appeared over the next few years, amounting to over 550 photographs by such figures as → Charles Marville, → Hippolyte Bayard, Jean Walther and → Henri Le Secq. In 1855 the printing house was forced to close as it was no longer profitable, gravure printing having emerged as a serious rival.

Blommers & Schumm Dutch husband-and-wife team of photographers. Anuschka Blommers and Niels Schumm (both b. 1969) studied at the Gerrit Rietveld Academie in Amsterdam. Since 1996 their images have been published in magazines including *Purple*, *Selfservice*, *Visionaire* and *Baron*. They distort photographic conventions, use friends as models and create optical illusions. Blommers & Schumm participated in the Festival de Hyères in 1998, where they won the Best Young Fashion Photography Award. An anthology of their work, *Anita and 124 Other Portraits*, was published in 2006.

Blossfeldt, Karl (1865–1932) German photographer. Apprenticed to an art foundry, Blossfeldt was encouraged by his teachers to pursue his studies at the School of Decorative Arts in Berlin, where he was to teach from 1898. At the request of his professor, Moritz Meurer, Blossfeldt compiled several portfolios of plant images, which he used on his modelling courses. Working at the height of the Jugendstil movement, he adopted photography as a means of documenting and cataloguing plant forms. These close-up photographs were not, therefore, works of art in their own right. It was not until the late 1920s that his images began to arouse the interest of the art world. His first book, *Urformen der Kunst*, was published to great acclaim in 1928.

Karl Blossfeldt, *Adiantum pedatum, American Maidenhair Fern, Young Rolled-Up Fronds Enlarged 8 Times*, 1898–1928

Blueprint *see* **Cyanotype**

Blühová, Irena (1904–1991) Slovak photographer and publicist. Having attended school in Trenčín, she worked for some years as a bank clerk and developed an interest in politics. She began taking photographs in the mid-1920s. Her main focus was social documentary photography in rural regions of Slovakia. She produced her first photographs of social issues in 1925, which were intended to serve as documentation for the Communists in parliament. In 1931 and 1932 she studied photography, typography and propaganda at the → Bauhaus in Dessau; returning to Slovakia after the school's closure by the Nazis, she ran a bookshop and attended the School of Applied Arts in Bratislava. In 1933 she formed a society of leftist intellectuals called Sociofoto. Her images of the working class, tourist sites and the countryside were published in magazines such as the → *Arbeiter Illustrierte Zeitung*, and → John Heartfield used her work for his photomontages. Blühová has become a significant representative of socially orientated → reportage and documentary photography in a Central European context. Her work is significant on account of its specific expression of Slovak and Central European culture in the 1920s and 1930s.

Blume, Anna and Bernhard (both b. 1937) German artists mostly working with staged photography. Both studied fine art at the Kunstakademie Düsseldorf from 1960 to 1965; Bernhard also studied philosophy at the University of Cologne. Their large-sized black-and-white sequences show an unhinged version of everyday life in which objects possess a magical independence. Posing as a typical *petit bourgeois* couple, the Blumes themselves are the protagonists of these abstracted and ironic scenes.

Blumenfeld, Erwin (1897–1969) German-born American artist and photographer. He is considered one of the greatest fashion photographers of the 1940s and 1950s. Born to a Jewish family in Berlin, Blumenfeld showed an interest in photography from childhood. He practised painting, → collage and writing in a Dadaist style, frequenting the movement's circles in Berlin and informally representing them during his exile in the Netherlands (1918–36). He experimented with photography in the laboratory and developed several themes that had a lasting effect on his oeuvre – in particular an obsessive search for the feminine ideal and an aesthetic of dissimulation, achieved by careful handling of light and shadow, veils and opaque surfaces. In 1936 the success of his portraits, taken in his boutique, encouraged him to try his luck in Paris, where he published his work in fashion magazines before being hired by → *Vogue* in 1938 at the suggestion of → Cecil Beaton. Blumenfeld oscillated between studio work, in which he explored the techniques of → solarization, multiple exposure, distortion and reflection, and

Anna and Bernhard Blume,
Kitchen Frenzy, 1986

photographing outdoors, the vertiginous image of the model Lisa Fonssagrives on the Eiffel Tower being the best-known example. In 1941 he became an American citizen and moved to New York, where he worked initially for → *Harper's Bazaar* and then for *Vogue* from 1944. This fruitful collaboration lasted for more than fifteen years and established him as the magazine's leading photographer. He was often asked to supply cover images owing to his photographs' impact and unconventional use of colour.

Blur A lack of clarity or sharpness in a photographic image. In the early days of photography, blur was generally considered a mistake, and came to be seen as the antithesis of the detail and precision that early viewers of photography found most striking. At the turn of the century the → Pictorialists used blurring and softening in their artistic practice, but did not succeed in making it part of the photographic aesthetic. It was only in the wake of → New Objectivity and → straight photography, which valued clarity and lack of distortion above all, that blurring was once again employed deliberately by photographers; contemporary examples include → Hiroshi Sugimoto and → Thomas Ruff.

Bohm, Dorothy (b. 1924) German-born British photographer. During the 1950s Bohm photographed in Europe and overseas, favouring still-lifes, landscape and, above all, street scenes and portraits. Displaying an affinity with French → humanist photography, she worked in black and white until 1980, when, thanks to → André Kertész, she turned definitively to colour. In 1971 she participated in the creation of London's first photography gallery, the Photographers' Gallery.

Boiffard, Jacques-André (1902–1961) French photographer and doctor. Boiffard studied medicine in Paris and was introduced to the → Surrealists by his friend Pierre Naville. From 1924 he wrote automatic essays and dream poetry for the magazine *La Révolution Surréaliste*, in which he also published some photographs. He learnt photography from → Man Ray, acting as his assistant between 1924 and 1929. His images, particularly the 'Big Toe' series (1929),

Erwin Blumenfeld,
Vogue, March 1945

influenced Surrealist photography. He provided the illustrations for André Breton's novel *Nadja* (1928), but thereafter broke away from the writer, collaborating instead with Georges Bataille on the magazine *Documents* (1929–30) and his pamphlet *Un cadavre* (1930). Boiffard later abandoned his artistic work, taking up medicine once more and turning his attention to radiology.

Boissonnas, Fred [Frédéric Boissonnas] (1858–1946) Swiss photographer. The Boissonnas dynasty played a pioneering role in the history of Swiss photography. Fred Boissonnas can be considered one of the first great Swiss photographers, for the technical quality of his prints, the variety of genres he explored (principally → portraiture and → travel photography) and his expansion of the family business. In 1887 Boissonnas, the eldest son of the family, took over the photographic studio in Quai de la Poste in Geneva founded by his father in 1864, expanding it and opening branches in

• **B** —

— B •

Félix Bonfils, *The Citadel and the Mosque of Muhammad Ali, Cairo*, 1860s–1880s

Paris, Reims, Marseille and St Petersburg. Highly gifted, he received several gold medals in Berne, Vienna and Chicago, and in 1896 triumphed at the Exposition Nationale in Geneva, where he was awarded the gold medal. He also won the Grand Prix at the Exposition Universelle in Paris in 1900. His panoramic view of Mont Blanc, taken in the early 1890s, earned him a reputation beyond Europe. Enamoured of Greece, he visited it many times and travelled throughout the region, publishing several works, including *En Grèce par monts et vaux* (1910). In 1919 he founded his own publishing house, Boissonnas S.A. During the 1920s he settled in Paris. His son Edmond-Édouard took over the Geneva studio in 1920, and then his other son Henri-Paul ran the business from 1924 until 1927. Bankrupt,

Fred Boissonnas was forced to sell the studio to his son Paul in 1927. The atelier moved to new premises in 1938 and operated there until 1990.

Boltanski, Christian (b. 1944) French artist. Boltanski made his debut in the world of contemporary art in 1968 with *La Vie impossible de Christian Boltanski*, which combined puppets and film. The principal characteristics of his work were already present: the search for identity, ambivalence between truth and make-believe, and the use of different media. His photographs tackle issues concerning memory, documentation and disappearance, as, for example, in *L'Album de la famille D.* (1971), *Les photographies des Membres du Club Mickey* (1972) or *Les Leçons de ténèbres* (1985).

Bonfils, Félix (1831–1885) French photographer. A bookbinder by profession, Bonfils learnt photography from → Claude Félix Abel Niépce de Saint-Victor. He worked in France and the Middle East, opening a studio in Beirut in 1867 under the name Maison Bonfils, which became F. Bonfils & Cie in 1878. He mainly photographed Lebanon, Egypt, Palestine, Syria, Greece and Constantinople, winning many prizes, most notably from the → Société Française de Photographie in 1871. He usually sold his images individually, but he also produced collections in the form of albums. In 1872 he published *Architecture antique*, and between 1877 and 1878 a series of five albums entitled *Souvenirs d'Orient*. The latter, when shown at the Exposition Universelle in Paris (1878) and Brussels (1883), earned him considerable fame.

Boston School Also known as the 'Five of Boston', this group consisted of five notable American photographers in the mid-1980s: David Armstrong, → Philip-Lorca diCorcia, → Nan Goldin, Mark Morrisroe and Jack Pierson. They all studied together at the School of the Museum of Fine Arts in Boston and shared an intimate approach to photography, as well as a love of instant photography.

Bouali, Hamideddine (b. 1961) Tunisian photographer, teacher and art critic. Since his early career in the 1980s, Bouali has sought artistic and institutional recognition for Tunisian photography. Since the 1990s he has become one of the country's most active and prominent photographers, founding the Tunis Photo Club in 2010. Bouali is known for his images of Tunis and the Tunisian Revolution of 2011.

Boubat, Édouard (1923–1999) French photographer. Boubat studied graphic arts and typography at the École Estienne in Paris (1938–42). He worked as a photographic printer (1946–50) before turning to photography himself. He became a key figure in the → humanist movement, exhibiting at the Galerie Hune in Paris alongside → Izis, → Brassaï, → Robert Doisneau and Paul Facchetti in 1951. The publication of his first → reportage in

Réalités magazine marked the beginning of a collaboration that continued until the late 1960s and took him all over the world. Nevertheless, it is his images of everyday Parisian life that remain most representative of his work, such as the famous *Little Girl Wearing Dead Leaves* (c. 1946).

Boulat, Pierre (1924–1998) French photographer and reporter. After studying at the École Nationale de Photographie et de Cinéma in Paris, Boulat began working as a press photographer for several French magazines including *Paris-Presse*, *Elle* and *Samedi Soir*. He opened a fashion studio in 1948. A reporter for → *Life* between 1957 and 1973, Boulat then worked as a freelance photographer for → *National Geographic*, *Smithsonian Magazine* and other American publications. In 1982 he embarked on a long-term collaboration with *Paris Match*.

Boulton, Alfredo (1908–1995) Venezuelan photographer. Boulton began his career in 1928. He produced numerous prints of the

Édouard Boubat,
Little Girl Wearing Dead Leaves, c. 1946

• **B** —

Caracas Valley, which was undergoing urban development and expanding outside its former colonial boundaries. Boulton's interest in the visual arts made him one of the most prominent Venezuelan artists of the time, along with Armando Reverón, Francisco Narváez and Manuel Cabré. Alongside his photographic work, he published a history of Venezuelan painting in 1964. Like other artists and intellectuals of his generation in Latin America, Boulton sought to create an iconographic repertoire that would reflect the ethnic, geographic and cultural characteristics of the region; for him, photography represented the best way to address this challenge.

Bourdieu, Pierre (1930–2002) French sociologist. With his essay on the social uses of photography, published as *Un Art moyen* (1965), Bourdieu launched a series of writings on cultural practices that led to the publication of one of his most celebrated works, *Distinction: A Social Critique of the Judgement of Taste* (1979). Inspired by Émile Durkheim, Bourdieu discussed photography as a social phenomenon and attempted to free himself from the technical or economic terms that were generally used to describe photography. The middle classes were central to this analysis, as were their photo clubs, which Bourdieu and his colleagues identified as a means for them to distinguish themselves. Bourdieu also took photographs himself at the beginning of his career, shooting in Algeria between 1958 and 1961. These works, which were exhibited in 2002, confirmed his concept of photography as an 'expression of the distance of the observer who records and does not forget that he is recording' (*Algerian Sketches*, 2003).

Guy Bourdin,
Unpublished, for Charles Jourdan, 1978

Bourdin, Guy (1928–1991) French fashion photographer. Bourdin took advantage of his training in photography while performing his military service (1948–49), subsequently exploring the medium for a period of five years while exhibiting his paintings and drawings with the support of → Man Ray. In 1955 he began a long and fruitful collaboration with → *Vogue*, as well as enjoying complete artistic freedom in his advertising campaigns for the shoemaker Charles Jourdan from 1967 until 1981. Black humour, disturbing atmospheres and a sense of detachment with regard to subject matter all resulted in highly theatrical and powerful images – an effect reinforced by his dazzling use of colour in the 1970s. Paradoxically, the narrative element of his provocative works, which combine voyeurism and fetishism, mostly took precedence over the product itself.

Bourke-White, Margaret [Margaret White] (1904–1971) American press photographer. In the 1920s she studied at Columbia University and the → Clarence H. White School of Photography, New York, and at Michigan State and Cornell universities. She began work as an industrial photographer in 1927 and in 1929 was hired to photograph for → *Fortune* magazine (founded the following year). Bourke-White took the first non-Russian photographs of the Soviet Union's Five-Year Plan in 1930 (published as *Eyes on Russia*, 1931). In the United States she documented the Depression, co-publishing *You Have Seen Their Faces* (1937) with Erskine Caldwell. From 1936 to 1957 she was a staff photographer for → *Life* magazine; her photograph *Fort Peck Dam, Montana* was featured on *Life*'s first cover (23 November 1936). Bourke-White photographed World War II for the magazine during the 1940s, becoming the first woman accredited by the US Army Air Force and allowed to fly with combat troops. *Life* assignments sent her to Korea and South Africa in the 1950s.

Bourne, Samuel (1834–1912) British photographer. In 1851 Bourne was instructed in the → daguerreotype process by Richard Beard and began to photograph landscapes. In 1862 he resigned from his job as a clerk and left England

Margaret Bourke-White,
Fort Peck Dam, Montana, 1936

to travel in India for five years, making several ascents in the Himalayas. In 1863 he opened a studio in Shimla with the publisher Charles Shepherd, who marketed his images. Bourne sold his images of archaeological sites, monuments and landscapes, made using the → collodion process, to British tourists. In 1870 he returned to England and published his images in various photography magazines. In 1903 he became president of the Nottingham Camera Club.

Boutros, Nabil (b. 1954) Egyptian photographer. He began photographing in Cairo and its suburbs before moving to Paris to study art and design. A resident of France, Boutros regularly returns to Egypt, where he documents various aspects of Egyptian society. His work records folk performances, Egyptian café culture and nightlife, and the Coptic community.

Brady, Mathew B. (1822–1896) American photographer. A portraitist from New York, Brady was the first photographer to cover the American

B

Mathew B. Brady,
Abraham Lincoln, c. 1863

Civil War (1861–65). After studying painting, he learnt the → daguerreotype process with Samuel F. B. Morse and → John William Draper in New York. In 1844 he opened a studio on Broadway, specializing in portraiture. In 1850 he published *The Gallery of Illustrious Americans*, a collection of lithographs made from his daguerreotypes. He became famous in 1860 for a portrait he took of Abraham Lincoln on the eve of his Cooper Union address. This photograph, reproduced in several thousand copies, played a role in Lincoln's subsequent election as president. Brady is best known for the pictures he took during the American Civil War. Financing the project himself in the hope of selling his images to the government, Brady hired twenty-six assistants, including → Alexander Gardner and → Timothy O'Sullivan, to cover the war. With thirty-five operational centres and several photographic vans at his disposal, he accompanied the armies of the Union, covering almost all the great events of the war

and producing approximately seven thousand plates. The majority showed sites before and after battle, but were nevertheless viewed by Brady's contemporaries as the first photographic evidence of the reality of war. However, his photographs failed to obtain the success he had anticipated, and Brady emerged from this venture heavily in debt.

Braekman, Dirk (b. 1958) Belgian photographer. Between 1977 and 1981 Braekman studied painting and photography at the Academy of Art in Ghent, his initial idea being to master the photographic medium for use in painting. In 1982, after completing his studies, he founded Gallery XYZ and the eponymous magazine together with Carl De Keyzer. Despite harbouring other ambitions, they found themselves forced to earn their living by producing → reportages and portraits. The studio closed in 1989. Braekman left for New York, which he found fertile terrain for his work as an artist. His tendency to manipulate his → negatives and his regular use of the → camera obscura are characteristics of his photography, in which the subject, as a real, physical object, is granted little significance.

Bragaglia, Anton Giulio (1890–1960) **and Arturo** (1893–1962) Italian brothers and artists. The former was a set designer, producer and film director; the latter was a photographer and actor who subscribed to his brother's theory of *fotodinamismo*. Beginning in 1911, both attempted to define the photographic equivalent of Futurist painting by experimenting with the → chronophotography developed by → Étienne-Jules Marey. They were looking not to take snapshots of movements frozen in time but to capture the continuity of an action and portray that which remained unseen.

Brake, Brian (1927–1988) New Zealand photographer. Brake joined the New Zealand National Film Unit in 1948. In 1954 he moved to London and met → Ernst Haas and → Henri Cartier-Bresson of → Magnum Photos, achieving nominee status with the agency and full membership in 1957. Significant works include

a → *Life* photo essay, *Monsoon* (1961), and candid portraits of Pablo Picasso at a bullfight.

Brancusi, Constantin (1876–1957) Romanian-born sculptor, artist and photographer. He sought to pin down the essence of his subject matter by simplifying forms and attempting to achieve a purity that bordered on abstraction. He took many photographs, playing with light and space to reveal the outlines of form and to help him envisage a work as a whole. Photography became an integral part of his art.

Brandt, Bill (1904–1983) German-born British photographer. After starting his career with → Man Ray in Paris in 1929, Brandt became a professional freelance photographer, settling in London in 1931. As an admirer of → Brassaï and his *Paris by Night*, as well as of → Eugène Atget,

Brandt photographed London by night. During the 1930s England was suffering from severe economic depression, and Brandt endeavoured to reveal social divisions that were more marked than ever before: the wealth of a middle-class man wearing a top hat, for instance, shown alongside the poverty of a labourer or coal miner. In these photographs black dominates the sky as much as it does the street. In 1936 he published his first book, *The English at Home*. In 1945, having photographed London during the Blitz, Brandt took a step back, abandoning documentary photography in order to devote himself to portraiture (sitters included Dylan Thomas, Francis Bacon, and Edith and Osbert Sitwell), landscape and the nude, which he completely reinvented in his images. Brandt shot his nude models from unusual angles while remaining extremely close up. In 1969 the

• B —

Anton Giulio and Arturo Bragaglia,
The Typist, 1911

— B •

→ Museum of Modern Art in New York dedicated an exhibition to his work. In 2004 a retrospective at the Victoria and Albert Museum in London celebrated the centenary of his birth. Brandt's photography influenced an entire generation, including such figures as → Martin Parr and → Don McCullin, showing them that photography could also belong in the museum.

Brassaï [Gyula Halász] (1899–1984) Hungarian-born French photographer. Brassaï studied fine art in Budapest and Berlin. As a designer, writer, sculptor, filmmaker and photographer, he was the complete artist. From 1924 he earned his living in Paris as a journalist and frequented artistic circles there, mixing with figures such as Jacques Prévert, Arthur Miller, Raymond Queneau and Pablo Picasso. He met → Eugène Atget and → André Kertész, through whom he discovered photography. He took his first photographs in 1929. Fascinated by the nightlife of Paris, he published his celebrated *Paris by Night* in 1932, using his technical

and artistic abilities to capture the mysterious and poetic atmosphere of the sleeping city. His nocturnal photographs also focused on the social life that unfolded after dark in the cafés, markets and darkened courtyards; the resulting book, *The Secret Paris of the 30s* (1976), is a veritable study of customs and behaviour. For twenty years he was fascinated by the graffiti covering Paris's walls and devoted an entire book to it in 1960. His images attracted the attention of the → Surrealists and many were published in the magazine *Minotaure* during the 1930s, although Brassaï never adhered to the Surrealist movement. A contributor to → *Harper's Bazaar* from 1937 until the 1960s, he met many artists and writers, producing several → reportages. His book *The Artists of My Life* (1982) was a collection of portraits of the celebrities he had encountered and a valuable testimony of 20th-century art. Awarded the Grand Prix National for photography in 1978, he has been the subject of several major exhibitions since the 1980s.

Braun, Adolphe (1812–1877) French photographer. Working as a designer in a textile factory in Alsace, Braun began to take photographs in 1851, producing close-ups of flowers that he used as the basis for fabric designs. In 1854, following his designs' commercial success, Braun presented an album called *Fleurs photographiées* to the British Academy and then published an English edition of his works entitled *Flowers from Nature*. In 1859 he published three books that contain 100 plates of Alsatian views. He subsequently became one of the principal publishers of landscapes in Germany, Switzerland and France, producing over 400 prints of various types, from → stereoscopic to → panoramic, and opened a portrait studio. Beginning in 1866, he published many volumes on subjects ranging from farm animals and game to Swiss costumes, Egypt and the disasters of the Franco-Prussian War, and began to reproduce works of art in the great museums of Europe. Braun's technical experiments led him to choose Swan's permanent → carbon process rather than → albumen prints for his reproductions. Producing more than 500 prints a day, Braun

Bill Brandt, *Nude,*
Campden Hill, London, 1949

was appointed official photographer to the court of Napoleon III.

Brébisson, Louis Alphonse de (1798–1872) French photographer. Brébisson became interested in photography in 1839, trying out different photographic processes and publishing technical treatises on the → daguerreotype and the paper and → collodion processes. He produced architectural views and close-up images of botanical specimens. Through his energy and enthusiasm Brébisson influenced the photographers of his native Normandy and became a member of the → Société Française de Photographie in 1854.

Brehme, Hugo (1882–1954) German-born Mexican photographer. Brehme's work is known principally through his printed postcards and for his influence on other photographers, including → Manuel Álvarez Bravo. In 1912 he settled in Mexico City, where he opened his first studio. He opened another in 1919, in which Álvarez Bravo would learn his profession.

Breitner, George Hendrik (1857–1923) Dutch artist. Breitner was a successful Impressionist painter who based his works on photographs he took of his favourite subjects: dynamic urban street scenes and portraits of beautiful, semi-naked women. He never thought much of his photographs, viewing them merely as preparatory studies, not works of art in their own right. For this reason his approach was disorderly. Breitner's photographs were rediscovered in the late 1960s and are now valued as autonomous examples of early snapshot-style → street and → nude photography.

Bremer, Caj [Carl-Johan Bremer] (b. 1929) Finnish photojournalist. Bremer is one of the leading figures in post-war Finnish → photojournalism. At the beginning of his career he was attracted to the tradition of → humanistic photography, which was particularly popular in France after the war. Bremer has worked for all the biggest newspapers in Finland, and also for *Svenska Dagbladet* in Stockholm. He served as an art professor from 1978 to 1983. Bremer

Brassaï, *Mme Bijou at the Bar de la Lune, Montmartre*, c. 1932

holds the honorary title of Art Academician, which is given to highly distinguished artists.

Breslauer, Marianne (1909–2001) German photographer. In 1929 Breslauer went to Paris to complete her training with → Man Ray and frequented the city's artistic circles. Influenced by the → New Vision, she took street photography using innovative perspectives and also produced portraiture, seeing many of her images published in the press. In 1936 she moved to the Netherlands and became a gallery owner.

Breukel, Koos (b. 1962) Dutch portrait photographer. Breukel produces sober, aesthetic, sympathetic portraits that reveal the vulnerability of his subjects. These are chosen at random: they are often family members and friends, but sometimes also clearly traumatized individuals, such as the AIDS patient Michael Matthews (*Hyde*, 1996) or survivors of the 1992

Faro airport plane crash (*Survivors of An Aircrash*, 1997). On account of his sensitive approach, in 2013 Breukel was selected to take the first official state portrait of the new king and queen of the Netherlands.

Brewster, Sir David (1781–1868) Scottish scientist. Brewster published treatises on optics and invented a lenticular stereoscope and the kaleidoscope. He had taken an interest in photography before 1839 through his correspondence with → William Henry Fox Talbot. Brewster is known for having taught the → calotype process to Robert Adamson and for introducing him to David Octavius Hill.

Brigman, Anne Wardrope [née Anne Wardrope Nott] (1869–1950) American photographer. Late in 1902, Brigman discovered the → Pictorialist works of the → Photo-Secession and the magazine → *Camera Work*, and corresponded with → Alfred Stieglitz. In 1903 she joined the Photo-Secession group, and in 1906 Stieglitz nominated her as one of the founder members. Best known for her nudes and her Pictorialist landscapes, which are influenced by Symbolism and → Japonisme, she exhibited regularly between 1903 and 1924, and from 1909 onwards was a regular contributor to *Camera Work*. She devoted much of her time to poetry and in 1949 published *Song of a Pagan*, a collection of her poems and photographs.

British Journal of Photography British periodical. Founded in 1854 as the *Liverpool Photographic Journal*, the *British Journal of Photography* assumed its current name in 1860. The editorial offices moved from Liverpool to London in 1864. Published weekly, the magazine relied on articles by well-known national and international figures, replacing *The Photographic Journal*, the official organ of the → Royal Photographic Society, as the country's most informative publication.

Brodovitch, Alexey (1898–1971) Russian-born art director, graphic designer and photographer. In 1920 he moved to Paris. Influenced by avant-garde movements including Cubism, → Surrealism and Constructivism, Brodovitch used them as

inspiration for some of his illustration and advertising commissions. He emigrated to the United States in 1930, where he exerted a lasting influence as art director of → *Harper's Bazaar* (1934–58) and through his teaching at the Design Laboratory, which he founded in 1933. He inspired an entire generation, including → Richard Avedon, → Irving Penn and → Hiro, through his constant desire to renew the creative process ('Astonish me!') and his acceptance of technical mishaps as a source of innovation. His celebrated book *Ballet* (1945) put these principles into action, making use of motion blur and adopting a radical page design.

Brohm, Joachim (b. 1955) German photographer. After studying photography and cinema in Germany and the United States, in the 1970s Brohm developed a style in line with the American pioneers of → colour photography. His photographs, which are mainly focused on contemporary urban landscapes, are characterized by their rigid compositions and distance from the subject. He lives, works and teaches in Leipzig.

Bromoil print A photographic process first described by C. Welborne Piper and E. J. Wall in 1907. First a → print is made on silver bromide paper, then it is bleached in a solution of potassium bichromate, which dries out the → gelatin in the most exposed areas. Pigment is then brushed manually onto the print in the form of a greasy ink, which can alter the → toning of the image in various ways. The darker areas of hardened gelatin retain more ink, while the lighter areas of softer gelatin contain more water, repelling the ink. The inked image can be transferred to paper using a press. The transfer technique invented by → Robert Demachy in 1911 allowed multiple images to be printed from the same matrix.

Brotherus, Elina (b. 1972) Finnish artist. Brotherus made her mark on the photographic scene at the end of the 1990s, creating works based on identity and personal history. In *Suites françaises 2* (1999) she recorded her efforts to learn the French

language. Since 2000 her interest has focused on issues of a more formal nature, such as the relationship between painting and photography, or between the artist and the model.

Bruehl, Anton (1900–1982) Australian-born American photographer. After training as an engineer, Bruehl arrived in New York in 1919 and enrolled at the → Clarence H. White School in 1923. From 1926 he enjoyed commercial success, opening his own studio in 1927, where he would work until 1966. Renowned for the modernist vision he brought to advertising and magazines (→ *Vogue*, *Vanity Fair*), Bruehl also developed a highly personal oeuvre in a documentary style.

Bruguière, Francis Joseph (1879–1945) American photographer. Bruguière befriended → Alfred Stieglitz and → Frank Eugene in 1905 in New York. He joined the → Photo-Secession and began his career as a photographer. Professionally, he operated a portrait studio in San Francisco, worked for *Vanity Fair*, → *Vogue* and → *Harper's Bazaar* in New York, and was the official photographer of the Theatre Guild. His artistic work was primarily modernist in style, utilizing multiple exposures, → solarization and cut-paper abstractions. In 1928 he moved to London and produced an abstract film, *Light Rhythm*. From 1937 Bruguière changed direction, working primarily with painting and sculpture.

Buchloh, Benjamin Heinz Dieter (b. 1941) German historian and art critic. After studying humanities at the Freie Universität in Berlin, where he graduated with a master's degree in 1969, Buchloh gained a doctorate in the history of art at City University, New York, in 1994. Having taught at Columbia University, he began to teach at Harvard in 2005. His book *Neo-Avantgarde and Culture Industry* (2003) is a collection of his most influential essays published since 1970. Specializing in European and American art of the second half of the 20th century, he seeks to reconcile historicist and formalist theory, with the aim of revitalizing debate on the history of modern art. He is co-editor of *October* magazine. His monographs

on artists who worked in a combination of photography and painting (such figures as → Andy Warhol, → Gerhard Richter and Marcel Broodthaers) are widely respected.

Bucklow, Christopher (b. 1957) British photographer, painter and sculptor. Bucklow is a former curator of photography at the Victoria and Albert Museum, London (1978–95). His work often has a mystical and experimental dimension. In the emblematic series *Guests*, for example, photographic paper was exposed to sunlight passing through 25,000 holes pierced in a sheet of aluminium, which together traced the outline of his subject.

Bułhak, Jan (1876–1950) Polish photographer. Following an apprenticeship in the studios of → Hugo Erfurth in Dresden, Bułhak settled in Vilnius, where he opened his own studio in 1912. He assembled an archive of the city, taking thousands of photographs of its monuments, streets, churches and cemeteries. Having started with images that were clear and detailed, Bułhak became attracted to → Pictorialism, of which he became an advocate and theoretician. He produced a great number of photographs of towns and romantic landscapes lit by a soft light. After World War II he settled in Warsaw and documented the ruins of the capital. He was a co-founder of various associations, including the Vilnius Photo Club (1928), the Polish Photo Club (1930) and the Union of Polish Artist Photographers (1947). Between 1919 and 1939 Bułhak taught photography in the faculty of fine art at Vilnius University.

Bullock, Wynn (1902–1972) American photographer. He was born in Chicago and spent his early professional life as a singer in Europe, where he first discovered photography. Upon returning to the United States, he studied at the Art Center School in Los Angeles, experimenting heavily with alternative processes and techniques. However, Bullock's work changed dramatically in 1948 after he met → Edward Weston and was profoundly influenced by his → straight photography aesthetic. Following this encounter, much

of Bullock's work depicted nature in a precise, technically adept style. Bullock's fame grew after he featured prominently in → Edward Steichen's landmark 1955 exhibition → *The Family of Man* and endured for the remainder of his career, as he continued to explore new subject matter and techniques, including colour photography in the early 1960s.

Bunnell, Peter C. (b. 1937) American curator and educator. Born in Poughkeepsie, Bunnell began his career at the → Museum of Modern Art, New York, in the mid-1960s. However, in 1972 he left the museum to begin a thirty-year tenure at Princeton University, where he taught the history of photography and served as a curator at the university's Art Museum.

Burgin, Victor (b. 1941) British artist. Burgin had a considerable influence on the contemporary art scene. Having studied at the Royal College of Art in London and at Yale University, he began his career in the early 1960s as an exponent of → conceptual art. Photography and video became his preferred media. A great theoretician as well as a practitioner, he created a body of work in which prominence was given to the multiplicity of potential interpretations, the process of looking, variations in contextualization, and hybrid combinations of text and image. His art is complex and benefits from reflection on a variety of cultural, social, historical and ideological levels. Burgin regards photography as an interdisciplinary concept (*Thinking Philosophy*, 1982). He is much in demand as a professor in schools and universities in Europe and North America, where he teaches not only the history of art, but also the history of consciousness and the philosophy of the media.

Balthasar Burkhard,
The Reindeer, 1996

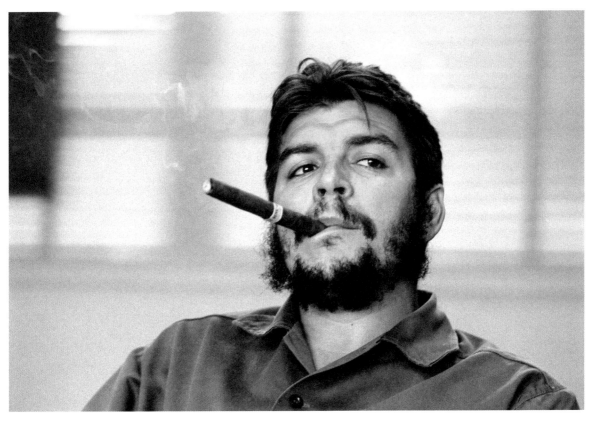

René Burri,
Che Guevara, 1963

Burkhard, Balthasar (1944–2010) Swiss photographer. He was apprenticed to the photographer Kurt Klum from 1962 to 1964 before becoming an archive photographer at the Kunsthalle in Berne. Between 1974 and 1980 Burkhard taught at the University of Illinois in Chicago. He became known at the beginning of the 1980s for his monumental images of fragmented bodies, and he also created life-size portraits of animals.

Burri, René (1933–2014) Swiss photographer. He studied at the Zurich University of the Arts, where he was taught by → Hans Finsler. Initially drawn to the cinema, he soon turned to photography. A member of → Magnum Photos since 1959, he captured the major conflicts, events and personalities of the latter half of the 20th century, but also scenes from everyday life. From Argentinian gauchos to the Suez Crisis and the fall of the Berlin Wall, from Che Guevara to Pablo Picasso, he presented a personal and

aesthetic view of the world, often allowing a narrative to be constructed over a period of time rather than concentrating on the heart of the action. The result is a powerful, bold, contrasted and evocative body of work.

Burrows, Larry (1926–1971) British photojournalist. In 1942 he started his career at → *Life*'s London office as a factotum and assistant technician. In 1945 he began working independently, producing stories on various themes. War → reportage became his speciality, particularly in Vietnam from 1962 until his death. From the heart of the conflict, Burrows captured events with the eye of a reporter and an artist, reviving the use of colour and taking risks. His photographs – realistic and violent but nevertheless full of humanity – showed the senselessness of war and had a profound effect on public opinion. In 1971 the helicopter carrying Burrows over Laos was shot down in mid-flight.

Edward Burtynsky, *Nickel Tailings No. 34,
Sudbury, Ontario*, 1996

Burton, Alfred Henry (1834–1914) **and Walter John** (1836–1880) New Zealand photographers. Active from 1867 to 1898, the Burton brothers' studio had the largest topographic coverage of any New Zealand photographic operation of the 19th century. Its success was primarily due to Alfred Burton, whose subjects included Maori villagers in the inaccessible King Country; thermal regions before and after the 1886 Tarawera eruption; and the spectacular scenery of remote Fiordland and its islands. The company was sold to the Muir & Moodie studio in 1898. The new owners continued to publish Burton views while adding a great many more of their own.

Burtynsky, Edward (b. 1955) Canadian-born photographer of industrial landscapes. Burtynsky received a bachelor's degree in photography from Ryerson University, Toronto, in 1982. He holds the title of Officer of the Order of Canada (2006) and four honorary doctorates, and is a winner of the TED Prize. His large-format colour photographs of mining, quarrying, manufacturing, shipping, oil production and recycling combine an aesthetic approach with images of ravaged landscapes, visually exploring the industrial footprint. Examples of his work are held in the collections of more than fifty museums internationally. His solo exhibitions *Oil* (2009–14), *China* (2005–8) and *Manufactured Landscapes* (2003–5) were accompanied by monographs.

Bustamante, Jean-Marc (b. 1952) French photographer. Having originally studied economics, Bustamante exhibited his photographs for the first time in 1980. These formed the first part of a series called *Tableaux* (1978–82), which showed a Barcelona suburb; it stood out for the contrast between the meticulously produced images and the banality of the subjects they represented. Bustamante referred to these colour photographs as 'slow snapshots'. As his oeuvre evolved, it gradually included other media, such as sculpture, design and architecture.

Butor, Michel (b. 1926) French poet, writer and photographer. A humanities graduate, Butor started to write about photography in 1987, collaborating with figures including Maxime Godard, Joël Lieck and → **Bernard Plossu**. In 2002 he published *Michel Butor, un viseur dans ma tête*. Alongside his literary works, he runs an amateur photography practice in partnership with his wife, Marie-Jo Butor. He uses a Semflex on his travels.

84

C-print A chromogenic colour printing process. Introduced in the 1930s, chromogenic colour is now the most successful commercial colour photographic process. Chromogenic colour materials consist of three layers of silver gelatin → emulsion with suspended dye couplers (colour-forming chemical compounds sensitive to red, green and blue light) on a paper or film support. Through a series of chemical reactions that take place during development, the silver image is formed, and the couplers react, or couple, with the developer to release complimentary → subtractive colour dye in proportion to the amount of silver in the image. The silver is bleached out, leaving an image composed of three superimposed dye layers.

Cahun, Claude [Lucy Schwob] (1894–1954) French writer and photographer. Cahun studied literature and philosophy at the Sorbonne and frequented avant-garde artistic circles in Paris during the inter-war years. She adopted her pseudonym at the age of 23. Close to the → Surrealists, she made her name as a woman of letters, actor and photographer. Her work is

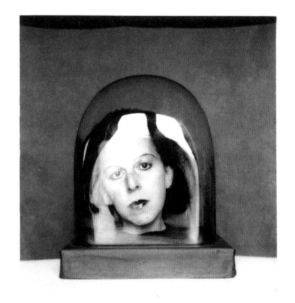

Claude Cahun,
Self-Portrait, 1927

— C •

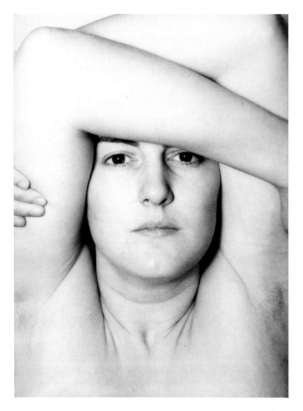

Harry Callahan,
Eleanor, Chicago, 1947

based on the search for identity, which led her to question gender and to subvert male and female roles. She produced several ambiguous self-portraits, which are characterized by her androgyny and the concept of the double. In 1929–30 she published a series of → photomontages and essays entitled *Aveux non avenus*, produced in collaboration with her companion Marcel Moore (Suzanne Malherbe).

Callahan, Harry (1912–1999) American photographer and teacher. An engineer at Chrysler Motors, Callahan began teaching himself photography in 1938, joining the Chrysler Camera Club and then the Detroit Photographic Guild in 1941. Inspired by a talk given by → Ansel Adams, he decided to devote himself to photography, his favourite subjects being his wife, Eleanor, and urban and country landscapes. In 1946 he embarked on an influential teaching career at the Chicago Institute of Design, and in 1961 co-founded the department of photography at Rhode Island School of Design. Callahan

received several prestigious prizes, including a Graham Foundation Award (1958) and a Guggenheim Fellowship (1972). He published many books, including *The Multiple Image* (1961) and *Harry Callahan: Color 1945–1980* (1980).

Calle, Sophie (b. 1953) French artist and photographer. She uses video and photography to create works characterized by their autobiographic content. Her work presents a methodical unmasking of reality – her own and others' – while leaving a limited part of this process to chance. Calle's photographs serve as evidence of her experiences: setting herself strict rules, she follows strangers in the street or invites them to sleep in her bed; she works as a chambermaid in order to photograph objects belonging to hotel guests; or she tries to find consolation after a broken relationship. The concepts of absence and disappearance permeate her works, in which images are shown alongside written reports detailing the intimacy she has shared with the spectator.

Calotype A → negative process invented by → William Henry Fox Talbot in 1840. The name derives from the Greek *kalos*, meaning 'beautiful', and *typos*, or 'print'; it is also known as the talbotype. It was the first photographic method to use a paper negative and thus became the basis of modern photography. The paper was treated with silver nitrate and potassium iodide (to create light-sensitive silver iodide), then brushed with gallo-nitrate of silver. After the dampened paper had been exposed to light using a camera, the image was developed by a further application of gallo-nitrate of silver. It was then fixed with a solution of sodium thiosulphate ('hypo'), a process discovered by → Sir John Herschel. The paper negative thus created could be used to make → positive → contact prints on salted paper. Compared to the → daguerreotype, this process was faster and more flexible, and did not require fragile glass supports. It also allowed multiple positive prints to be made from the same negative. It was nevertheless less sensitive than the daguerreotype, and the images were slightly grainy owing to the texture of the paper. In 1847 → Louis Désiré Blanquart-Evrard

• C —

Sophie Calle,
Les Dormeurs (*The Sleepers*), 1979

— C •

introduced several improvements to Talbot's process. The calotype was in use for two decades before being superseded by glass-plate negatives.

Camera A mechanical apparatus used to take a photograph. The most basic design consists of a camera body with an → aperture on one side to let in light, and on the opposite side a sensitive surface to capture that light. In most cases a camera also includes: a → lens or assembly of lenses, which are positioned over the aperture to focus the image; a → shutter, which opens to let in light when the picture is taken; a shutter release button, which the photographer presses to operate the shutter; an → iris diaphragm, which controls the aperture, or amount of light that enters the camera; and a viewfinder, through which the photographer can compose the scene. Other elements can be added as required: → flashes, interchangeable camera backs, focusing rings, etc. Many types of camera are available, with the most significant distinction currently being between analogue and digital cameras. The former records an image on a support – metal or glass plate, paper or → film – coated with an → emulsion containing grains of silver. In digital cameras, this support is replaced by an electronic sensor. Since the invention of the medium, cameras have gradually become smaller and simpler to use, with small formats eventually leading to the development of the compact (or point-and-shoot) camera. Small, lightweight and aimed primarily at the general public, these cameras were easy to use and lacked some functions: the aperture was fixed, and the image was composed through an independent viewfinder. Professionals and skilled amateurs tend to use single-lens → reflex cameras (→ SLRs), which contain a mirror that allows the same image captured by the lens to be seen through the viewfinder, thus eliminating the parallax errors caused by compact cameras. Variant designs are available for specific purposes: for example, cameras may be → panoramic, → stereoscopic or waterproof.

Camera Swiss monthly magazine. Founded in Lucerne in 1922, *Camera* appeared initially in German, and then in French and English at the instigation of Romeo Martinez, its chief editor between 1956 and 1964. He was also responsible for launching some major photographers on their careers (→ Henri Cartier-Bresson, → Bill Brandt and → Robert Frank), making *Camera* a pioneering and innovative publication. Thanks to the quality of its production and its content, it was distributed internationally from 1950. But in the wake of the financial difficulties encountered by Allan Porter, its chief editor from 1965, *Camera* went out of print in 1981. In 2013 the magazine was relaunched as a bilingual quarterly in English and French.

Camera obscura The camera obscura (Latin for 'dark room') is a simple device that provided the basis for the photographic camera. It is based around the optical effect produced by a pinhole image, which has been known for centuries: when light from a distant object passes through a tiny opening, it is projected onto a flat surface

Camera Work, Issue No. 1, 1903

placed behind the opening (a wall or the back
of a box, for example) in the form of an image.
The image produced is inverted, in colour, and
shows photographic detail; it is not simply
a shadow. The camera obscura has been known
since antiquity: in the 4th century BC Aristotle
described using a pinhole device to view an
eclipse. In 1515 Leonardo da Vinci compared the
camera obscura to the workings of the eye. In
1550 Gerolamo Cardano improved the image by
using a glass → lens inside the pinhole. To correct
the inversion of the image, a mirror was added,
tilted at 45 degrees. A scientific instrument and
a curiosity, the camera obscura later became an
accessory employed by artists while travelling,
and was widely used in the 17th and 18th
centuries. In 1824 → Nicéphore Niépce succeeded
in capturing the reflected image inside a camera
obscura by using light-sensitive silver salts, the
chemicals necessary for photography.

Camera Work A quarterly photographic journal
founded in January 1903 by → Alfred Stieglitz,
who was both its publisher and editor. Initially
it was the official organ of the → Photo-Secession,
and served to spread the movement's ideas
and to promote → art photography. It evolved to
become the American magazine of reference with
regard to the European avant-garde. No expense
was spared in its layout (it was designed by
→ Edward Steichen), materials (Japanese paper)
or printing processes (→ calotype, halftone and
→ photogravure). Each issue featured articles
written by eminent critics such as Charles Caffin
and Sadakichi Hartmann. Essays contributed
by the painters Max Weber and Marius de
Zayas were also historic landmarks. Fifty issues
were produced before the magazine ceased
publication in June 1917.

Cameron, Julia Margaret (1815–1879) British
photographer. The work of Cameron, the
greatest female photographer of the 19th century,
was split between portraiture and imaginary
scenes influenced by poetry, religion and Pre-
Raphaelite painting. Born in Calcutta and
educated in France and England, and the wife
of a diplomat who owned plantations in Ceylon
(now Sri Lanka), Cameron began to teach herself

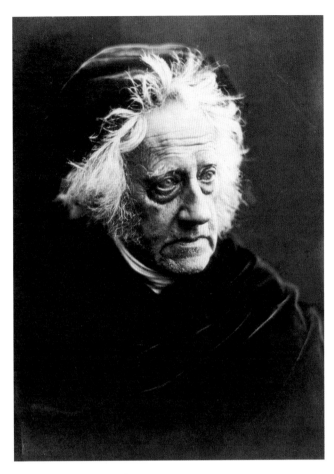

Julia Margaret Cameron,
Sir John Herschel with Cap, 1867

photography at the age of 48. In 1860, settling on
the Isle of Wight while her husband was living
in Ceylon, she was given a camera by one of her
daughters to help assuage her loneliness. In 1863
she met → Oscar Gustav Rejlander, who taught
her the basics of photography. The following
year she devoted all her time to her newfound
passion, and persuaded her servants and
members of her family to sit for her. Cultivating
her taste for allegory, she introduced Madonnas,
Venuses and angels into her photographic world.
Seeing her works, critics reproached her for her
technical 'imperfections', close-ups and use of
soft focus. In 1866 she began a series of portraits
devoid of scenery, focusing on the sitter's
face and featuring marked contrasts between
light and shadow, and between elements in
sharp focus and blurred outlines; her portraits
of Thomas Carlyle and → Sir John Herschel are

striking examples. At the beginning of the 1870s she photographed scenes taken from Arthurian legend and Alfred Lord Tennyson's *Idylls of the King*. In 1875 she left England for Ceylon, where she photographed the local people. Ten years after Cameron's death, her son published a work entitled *Annals of My Glass House*. The English → Pictorialists admired her work for its blurred quality and for her artistic references.

Caneva, Giacomo (1813–1865) Italian photographer. After training as a painter in Padua Caneva moved to Rome, where he turned to photography, immediately becoming part of the circle at the Caffè Greco. He became a master of the → calotype technique, producing views of Rome, genre scenes and allegories in substantial quantities. In 1855 he published a treatise on photography, and in 1859 took part in an expedition to China, returning with copious images.

Capa, Cornell [Kornell Friedmann] (1918–2008) Hungarian-born American photographer. After a period in Paris, Capa emigrated to New York in 1937, where he was hired by → *Life* as a photography technician (1937–41) and as a photographer (1946–54). Following the death of his brother, Robert, in 1954, he joined → Magnum Photos and succeeded → David 'Chim' Seymour as its president (1956–60). His many → reportages include the Six-Day War and the electoral campaigns of the Kennedy brothers and Adlai Stevenson. Capa was also the author of several books, including *Israel/The Reality* (1959) and *Farewell to Eden* (1964). With the aim of promoting → photojournalism and establishing an archive, he founded the International Fund for Concerned Photography in 1966, staging its first exhibition a year later and publishing an eponymous book in two volumes (1969 and 1972). In 1974 Capa established and directed the International Center of Photography in New York,

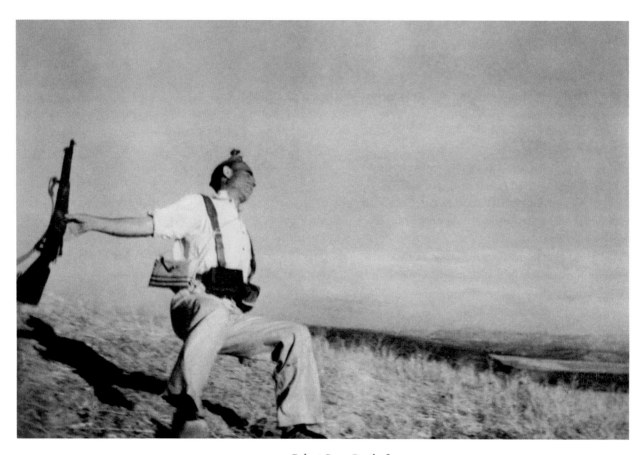

Robert Capa, *Death of a Loyalist Militiaman*, 1936

Cornell Capa, *Senator John F. Kennedy Reaches his Hands into a Crowd while Campaigning for the Presidency, California, 1960*

which was intended to be a museum, a school and a centre for photographic research.

Capa, Robert [Endre Ernő Friedmann] (1913–1954) Hungarian-born American press photographer. Born in Budapest, he studied journalism in Berlin in 1931. His first assignment from the Dephot photo agency was to photograph Leon Trotsky in Denmark, 1932. He fled Nazi Germany for Paris in 1933, changing his name to André Friedmann, where he freelanced for the Agence Hug Block, the A.B.C. Agency, the Anglo-Continental Press Photo Service and the Agence Central. He met → Gerda Taro in 1934–35, who invented the name 'Robert Capa' for him in 1936 and began selling his photographs through the Alliance Photo agency in Europe and → Black Star in America. Capa photographed and filmed the Spanish Civil War with Taro from 1936 to 1937, first on assignment for → *Vu* magazine and then for *Ce Soir*, also publishing in *Regards* and → *Life*, among others. In Spain he captured the renowned image of the death of a loyalist militiaman, published in *Vu* (1936) and *Life* (1937). Following Taro's death in July 1937, Capa went to New York, leaving Alliance and Black Star for Pix, and signing a contract with *Life*. He photographed the end of the Spanish Civil War and was named the 'Greatest War-Photographer in the World' by *Picture Post* in 1938. On assignment for *Life*, Capa was one of four professional photographers to capture the

Allies landing on the beaches of Normandy on D-Day in 1944. A co-founder of → Magnum Photos in 1947, he was killed in Indochina on assignment for *Life* on 25 May 1954. He is esteemed for his in-action 35mm shots of war, and for the saying: 'If your photographs aren't good enough, you're not close enough.' He published *Death in the Making* (1938) and has been the subject of numerous posthumous studies, books and exhibitions. His archive is held at the International Center of Photography, New York.

Caponigro, Paul (b. 1932) American photographer. A native of Boston, he began photographing at the age of 13. In the late 1950s, following a stint of military service, Caponigro studied the medium under the photographer → Minor White in Rochester, New York. During this period, White introduced him to philosophy, which inspired him to begin creating the mystical, spiritually driven work for which he is now known. Overall, his photographs are characterized by their rigorous formality and technical excellence. Throughout the 1960s, Caponigro made multiple trips to Europe. There, he made many well-known images, particularly of subjects throughout the United Kingdom commonly associated with Celtic mythology. He also photographed a vast range of landscapes, from Japan to New England.

Paul Caponigro, *Two Pears, Cushing, Maine,* 1959

— C •

Gilles Caron, *Daniel Cohn-Bendit Confronting*
a Riot Policeman at the Sorbonne, Paris, 6 May 1968

Carbon process A technique for producing permanent pigment prints. In 1855 → Alphonse Louis Poitevin, concerned with the fragility of → gelatin silver prints, invented a new, stable process based on dichromate gelatin, to which he added pigments. All other → pigment processes evolved from this discovery. Paper coated with layers of gelatin and pigment (originally ivory black, produced by charring animal bones) was sensitized with a solution of potassium bichromate. The potassium bichromate hardens, darkens and becomes insoluble when it is exposed under a → negative. This image layer is then transferred onto a second piece of paper, and a bath of warm water is used to strip away the parts of the gelatin layer that are unexposed and thus still soluble. It was not until the 1860s and the improvements introduced by Joseph Wilson Swan and the Abbé Laborde that the process became reliable enough to be exploited commercially. Variants of the carbon process were marketed by Artigue in 1894 and by Pierre Fresson in 1900, and were widely used by the → Pictorialists. Carbon prints were rich and glossy, with high contrast, available in a wide range of colours, and could be further manipulated in a number of ways. The prints were notable for their deep, dense blacks, which possessed a velvety quality, but their most prized feature was their great longevity. Owing to the complexity of the technique, industrial carbon processing ended in the 1970s.

Carbro A photographic printing process popular between 1930 and 1950 for creating colour images for advertising and fashion. Introduced commercially in 1919 by Autotype of London, this complex → subtractive and assembly process requires the use of three carbon tissues (supports coated in pigmented → gelatin). These tissues are exposed via contact with a bromide print; when layered in registration on a sheet of paper, they create the final full-colour print.

Carjat, Etienne (1828–1906) French photographer. Celebrated for his caricatures and illustrations, Carjat learnt photography from → Pierre Petit in 1858. He opened a studio ten years later, becoming known for his portraits of famous writers, actors and politicians. He broke with the conventions of portraiture, using simplified compositions and uniform backgrounds. He also worked alone, without an assistant, which enabled him to establish more intimate relationships with his sitters. Carjat exhibited at the Exposition Universelle in 1861 and 1878.

Caron, Gilles (1939–1970) French photographer. Caron's prolific and dazzling career influenced the history of photojournalism. Covering most of the significant events of his time, his → reportage work was published most notably in *Paris Match* and *France-Soir*. After training as a journalist, gaining a diploma as a civilian parachutist and performing his military service in Algeria, Caron worked in the studio of Patrice Molinard, a fashion photographer. He joined the Agence Parisienne d'Informations Sociales (APIS) in 1965, where he met → Raymond Depardon, with whom he founded the → Gamma agency in 1967. His assignments took him to Israel, Vietnam, Biafra, Northern Ireland, Czechoslovakia and Chad, though he also continued to photograph French cultural, social and political events, particularly those of May 1968. He went missing in Cambodia in April 1970 in an area controlled by the Khmer Rouge. His archives are administered by the Fondation Gilles Caron, based in Geneva.

Carroll, Lewis [Charles Lutwidge Dodgson] (1832–1898) British mathematician, novelist and photographer. Carroll is known primarily for his children's books, especially *Alice's Adventures in Wonderland* (1865). He acquired a camera in 1856 and, like many other pioneers of photography, became an advocate of the medium's artistic status. Self-taught, he initially preferred images of gardens, monuments and landscapes, before focusing on portraits of family, friends and well-known figures. In 1856 he met Alice Liddell, the daughter of a don of Christ Church College, Oxford, who became his muse. From then onwards, he principally photographed young girls, sometimes nude. Although he described these images as innocent, they caused a scandal and led him to give up his photographic work in 1880. The majority of the nudes were destroyed

C

— C •

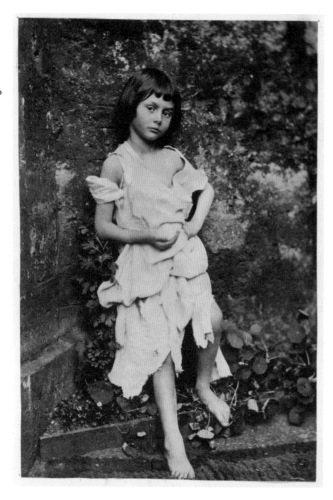

Lewis Carroll, *Alice Liddell as
'The Beggar Maid'*, 1858

by Carroll while he was still alive and by his
executors at his request. Controversial during
his lifetime, he remains so today.

Carte-de-visite Photographic format invented
between 1852 and 1854 by → André-Adolphe-
Eugène Disdéri. It led to a boom in → commercial
photography by allowing multiple portraits to
be taken at the same time by a single camera
fitted with six or eight → lenses. The resulting
small-format portraits (approximately 8.5 × 6 cm,
or 3⅜ × 2⅜ in.) were then mounted onto visiting
cards.

Cartier-Bresson, Henri (1908–2004) French
photojournalist. Born in Chanteloup, Seine-et-
Marne, he was educated at the Lycée Condorcet
in Paris. Cartier-Bresson went on to study
painting with André Lhote (1927–28) and had
an early interest in → Surrealism. He spent a year
photographing the Ivory Coast in 1931, and took
trips to Italy, Spain, Mexico and the United
States. His first exhibition, *Photographs by Henri
Cartier-Bresson: Anti-Graphic Photography*, was
held at the Julien Levy Gallery, New York, in 1933.
Cartier-Bresson returned to Paris in 1937; he
published in *Regards* and *Verve*, and worked
as a staff photographer at *Ce Soir* until he was
called to serve with the French army in 1939.
Between 1940 and 1943 he was held captive by
the Germans. He photographed the liberation
of Paris in 1945 and directed the film *Le Retour*.
The exhibition *Photographs by Henri Cartier-
Bresson* was held at the → Museum of Modern
Art, New York, in 1947. By the end of the 1940s
he was publishing in → *Harper's Bazaar*, → *Life*,
Paris Match, the *New York Times*, the *Saturday
Evening Post* and *Illustrated*. In 1947 Cartier-
Bresson was a co-founder of → Magnum Photos,
where he remained until 1966. He published
Images à la sauvette (translated into English
as 'The Decisive Moment') in 1952, and *Les
Européens* ('The Europeans') in 1955. *Henri
Cartier-Bresson: Photographies, 1930–1955* was
held at the Musée des Arts Décoratifs, Paris,
in 1955. He photographed in China, Mexico,
Cuba, Japan and India in the late 1950s and
1960s, and in the USSR and France in the early
1970s. Above all, he is known for his dynamic,
→ humanist, Surrealist-inspired → reportage
photographs and for his steadfast use of the
→ Leica. He created the Fondation Henri Cartier-
Bresson in Paris in 2003, which holds his archive.

Casasola, Agustín Victor (1874–1938) Mexican
photographer. Casasola was one of the first Latin
American documentary photographers. He
began his career in 1898, when he was hired as
a photo reporter by the newspaper *El Demócrata*.
He founded the Mexican Association of
Periodicals in 1903, and the Mexican Association
of Press Photographers in 1911. Casasola was
interested in the country's geography and local
customs and in the Mexican Revolution – themes
reflected in the negatives that constitute the
Casasola Collection.

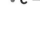

Henri Cartier-Bresson, *Behind the*
Gare St-Lazare, 1932

Casebere, James (b. 1953) American artist. Having graduated from the Minneapolis College of Art and Design, Casebere attended the Whitney Independent Study Program in New York and studied with → John Baldessari and Doug Huebler in Los Angeles. Together with such figures as → David Levinthal and → Laurie Simmons, Casebere belongs to a first generation of American post-war artists working with constructed photography. Since the middle of the 1970s he has forged and photographed complex table-top scenarios that refer to a variety of historical, cultural and social topics, ranging from contemporary incarceration and conditions of imprisonment to the Atlantic slave trade and 16th-century Ottoman architecture.

Castello-Lopes, Gérard (1925–2011) Portuguese photographer. A self-taught photographer who studied economics in Lisbon, Castello-Lopes joined the diplomatic corps of the Portuguese delegation to the Council of Europe and later settled in Paris. Influenced by → Henri Cartier-Bresson, his photographic work gained recognition after an exhibition held at the Ether Gallery in Lisbon in 1982. An avid contributor to Portuguese cinema, he inherited his father's company, Movies Castello-Lopes. He was assistant director for the film *The Birds of Severed Wings* (1962), and co-author and assistant producer for *Nationality: Portuguese* (1972). He co-founded the Centre for Portuguese Cinema in the late 1960s.

Català Pic, Pere (1889–1971) Spanish photographer. Influenced by the photographers of the avant-garde such as → Man Ray, for whom he organized his first exhibition in Barcelona in 1935, Català Pic revitalized → commercial photography under the acronym PIC (Catalan Illustrated Advertising). For the magazine *D'aci i d'alla*, he created → photomontages and → Surrealist-inspired *trompe-l'œil* images. During the Spanish Civil War Català Pic was a Republican supporter and created the celebrated poster *Aplastemos el fascismo!* ('Let's Stamp on Fascism!'), showing a foot crushing a swastika.

Català Roca, Francesc (1922–1998) Spanish photographer. The son of Pere Català Pic, Català Roca looked to restore realistic and documentary expression to the photographic medium. He took portraits of Salvador Dalí and Joan Miró and was close to the Grup R of Catalan architects, whose work he photographed. His low-angle shots of Barcelona's monuments, including the Sagrada Família, and his series on shadows indicate his desire to reconcile experimentation with a documentary approach.

Cazneaux, Harold (1878–1953) Australian → Pictorialist photographer. In 1909 Cazneaux mounted one of the first exhibitions of photography in Australia, to critical acclaim. In 1916 he co-founded the Sydney Camera Circle with the intention of advancing an Australian 'sunshine' school of photography. He was elected a member of the London Salon in 1921, and in 1937 he was the first Australian to be awarded an honorary fellowship by the → Royal Photographic Society of Great Britain. Beyond his photographic oeuvre, Cazneaux was also a prolific writer. As a correspondent for *Photograms of the Year* for more than twenty years, he was the international voice of Australian photography. His prints were exhibited in salons all around the world, and he is credited with raising the profile of photography in Australia.

Censorship The reasons behind cases of censorship in photography are many and are as much historical as political, social or economic. It results from a desire to control work that is perceived as a threat to a society's moral, political or religious values. Photography is especially susceptible to censorship on account of its apparent objectivity and the ease with which images can be reproduced and spread. Government censorship during times of conflict shows how the restriction of images can be used to control and to shape propaganda. Representations of nudity coupled with a perceived sexual slant (→ Sally Mann, Jock Sturges), homosexuality (→ Robert Mapplethorpe) or religious subjects (→ Bettina Rheims, → Andres Serrano) are the most likely to attract attempts at censorship.

Centelles, Agustí (1909–1985) Spanish photographer. Documenting the Spanish Civil War for the Republican cause, Centelles produced iconic images – soldiers sheltering behind a barricade of dead horses, for instance – that would bring him recognition as one of the greatest Spanish photojournalists. He was interned in the Bram camp in southern France but continued to practise his profession with the limited material at his disposal. While attempting to return to Spain under cover, Centelles hid thousands of negatives in a house in Carcassonne in order to protect those who might have been recognized by the Fascist police. His cache was rediscovered forty years later.

Chadwick, Helen (1953–1996) British artist and photographer. She trained at the University of Brighton and at the Chelsea School of Art. In 1982–84 Chadwick constructed simple box-like shapes, such as a boat or a pram, to which she stuck photographs of her own naked body (*Ego Geometria Sum*). In the late 1980s she superimposed enlarged images of her own cells onto photographs of nearby landscapes (*Viral Landscapes*) and photographed → still-lifes made from pieces of meat, leather and fabric (*Meat Abstracts*). Her visceral and provocative art often played on the contrast between repulsion and formal attraction. Through photographs, photocopies and microscopic images, she used organic materials such as meat, chocolate and flowers to explore the nature of desire, the body, science and the portrayal of women.

Chambi, Martín [Martín Chambi de Coaza] (1891–1973) Peruvian photographer. Chambi is perhaps the most significant indigenous Latin American photographer. His photographs, which have great historical importance and documentary value, were taken on journeys through the towns and countryside of the Peruvian Andes. Having learnt the rudiments of photography, he served an apprenticeship in the studio of Max T. Vargas, remaining there for nine years before setting up his first studio in the town of Sicuani in 1917, where he produced postcards. In 1923 he moved to Cuzco, where he opened a second studio and photographed the town's dignitaries. During the course of his career Chambi also crossed the Andes, photographing landscapes, Inca ruins and the local people. A complete retrospective of his work was shown in 1979 at the → Museum of Modern Art, New York.

Chappell, Walter (1925–2000) American photographer. Initially drawn to music, poetry and painting, Chappell studied photography in 1957 with → Minor White before collaborating with and writing for the magazine → *Aperture*. Influenced by Eastern philosophies and the esoteric teachings of George Gurdjieff, he explored his own inner being and developed a body of work with a strongly spiritual nature. He belonged within the tradition of → straight photography, taking high-contrast nudes and landscapes that bordered on abstraction. Between 1968 and 1974 Chappell experimented with Kirlian photography, a cameraless process that uses electrodes to reveal auras around the objects being photographed. He adopted this technique for a series of botanical images,

• C —

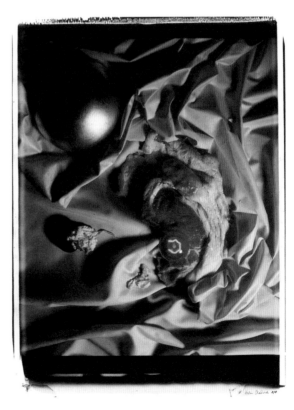

Helen Chadwick,
Meat Abstract No. 8: Gold Ball/Steak, 1989

— C •

Jean-Philippe Charbonnier,
The Swimming Pool at Arles, 1975

entitled *Metaflora*, in which the visible halo
around each subject reflects its vital energy, thus
bringing together science and mysticism.

Charbonnier, Jean-Philippe (1921–2004) French
photographer. After working for many illustrated
magazines in the years following World War II,
from 1950 until 1974 Charbonnier was one of
the principal photographers for the monthly
magazine *Réalités*, for which he covered 'scenes
from French life' and travelled the world. In the
1960s he worked in commercial and industrial
photography, then focused on → reportages
on his immediate environment near Paris.
A combination of current affairs and lyrical
popularism, his images, which were influenced by
a humanist aesthetic, were viewed as testimony
of social changes in the post-war period.

Charnay, Désiré [Claude-Joseph Le Désiré] (1828–
1915) French photographer and archaeologist.
He was an important French expeditionary and
ethnographic photographer, one of the first to
document Mesoamerican archaeological sites
using photography. Charnay studied at the Lycée
Charlemagne in Paris and went on to teach in
New Orleans. Inspired by John Lloyd Stephen's
Incidents of Travel volumes, which explored the
ruined cities of Central America, he returned to
France in 1857 to learn the wet-plate → collodion
process and to secure a commission from
the Ministry of Public Instruction to record

the Yucatán's archaeology. He took the first
successful photographs of significant sites in
the Yucatán, Chiapas and Oaxaca between 1858
and 1860, including Mitla, Palenque, Izamal,
Chichén Itzá and Uxmal. From 1880 to 1882 and
in 1886 Charnay returned to Mexico to excavate
and photograph Tula and Teotihuacán, among
others. His books include *Album Fotográfico
Mexicano* (1860), *Cités et ruines américaines* (1862),
Le Mexique: Souvenirs et impressions de voyage
(1863) and *Les Anciennes Villes du nouveau monde*
(1885). Other expeditions took in Madagascar
(1863), Chile and Argentina (1875), Java (1878) and
Australia (1878–79). Returning to Paris in 1886,
Charnay abandoned photography to lecture and
write on Mexican antiquities and his travels.

Chemigram An image created by painting
chemicals onto a light-sensitive surface. The
photographic print thus obtained is the result
of photochemical reaction alone, with no camera
being used. The technique was developed by the
Belgian artist Pierre Cordier from 1956 onwards.

Chessex, Luc (b. 1936) Swiss photographer.
Chessex studied at Vevey School of Photography
and began his career in Cuba, remaining there
from 1961 until 1975, when he established himself
as an independent photographer in Lausanne.
After earning recognition for his work in
Cuba, he photographed Africa on behalf of the
International Committee of the Red Cross. His
→ reportage now focuses mainly on Switzerland.

Chevalier, Charles (1804–1859) French
manufacturer of optical instruments. It was
Chevalier who initiated the meeting between
→ Nicéphore Niépce and → Louis Daguerre. Since
he supplied both men with components, he
knew that they were working in the same field
and brought them into contact in 1826. This
encounter led to the invention of photography,
and in particular to the development of the
→ daguerreotype, which was presented to the
Académie des Sciences in 1839. That same year,
Chevalier in his turn presented a daguerreotype
print. He later sold cameras in his shop
and produced daguerreotypes to order. On his
death, his son and his grandson continued his

• C —

Luc Chessex, *'Venceremos': Portraits of Fidel,
Camilo and Che*, 1961–68

research with the aim of improving photographic techniques.

Chevrier, Jean-François (b. 1954) French art critic and teacher. Based at the École Nationale Supérieure des Beaux-Arts in Paris since 1988, Chevrier is a discreet but significant figure in the fields of photography and contemporary art. He has curated many international exhibitions and also produced a rich body of writing. Little known to the general public until a seven-volume collection of his essays was published in 2010, it combines history with phenomenology and examines photography's place within the field of contemporary art and the wider media. His oeuvre, which is influenced by modern literature, is highly articulate despite its apparently fragmentary nature and constitutes a significant landmark in the contemporary theory of photography.

Choquer, Luc (b. 1952) French photographer. Choquer worked as a photojournalist for the Vu and Métis agencies, which he was instrumental in establishing. His documentary work focuses on individuals and their everyday lives, which he portrays in colour using flash. He was awarded the Villa Médicis Hors les Murs Prize in 1992 and the Niépce Prize in 1993.

Chronophotography A term coined by → Étienne-Jules Marey around 1881 to describe a method of capturing the various positions of a body in motion as a sequence of images on the same glass plate. To achieve this end Marey invented a gun-like camera with a turning plate that could take twelve pictures a second. Humans walking, running and jumping; horses trotting and galloping; birds flying; balls bouncing: his chronophotographs recorded successive phases of motion and allowed movements to be reconstructed and analysed. Marey was influenced by the American photographer → Eadweard Muybridge, and went on to influence other photographers such as → Thomas Eakins in the United States, who took chronophotographs of male nudes in motion. In France, → Albert Londe also worked in this field and invented his own cameras.

Cibachrome A proprietary process, now known as Ilfochrome, that reproduces slides (positive transparencies) onto a polyester base. Known for its clarity of image, high degree of colour → saturation and stability, it is typically used for → commercial and fine art photography and not by the general consumer.

Cinema and photography Owing to their similar technical processes, photography and cinema are closely related. The cinematograph, patented by the → Lumière brothers in 1895, enabled the recording and presentation of a sequence of still images, the speed in which they were projected lending a sense of continuous movement. Their invention built on experiments conducted by → Eadweard Muybridge in the 1870s and by → Étienne-Jules Marey's discovery of → chronophotography in the 1890s, though both were devised to freeze the body in mid-movement rather than animate it. Since that point the two disciplines have continuously influenced each other. Whether in the form of → photomontages, juxtapositions, serial images, transfers from film to paper, film stills or photo stories, the language of the cinema is reflected in the work of many photographers, from members of the avant-garde at the beginning of the 20th century right up to the present day. In addition, many photographers have achieved recognition as filmmakers, → Robert Frank, → William Klein, → Agnès Varda and → Raymond Depardon among them. Conversely, certain processes employed in cinema, such as the freeze frame, make reference to photography. At the opposite extreme, in 1963 → Chris Marker made *La Jetée*, a 29-minute film consisting entirely of still images. Beyond this type of formal integration, some directors have ascribed a primary role to photography within their film plots. Some examples are *M* (1931) by Fritz Lang, Roberto Rossellini's *The Machine that Kills Bad People* (1952), Jean-Luc Godard's *Les carabiniers* (1963), *Don't Look Now* (1973) by Nicolas Roeg, and *Memento* by Christopher Nolan (2000).

Claass, Arnaud (b. 1949) French photographer. After studying music, Claass turned to photography and writing in 1968, beginning

Arnaud Claass, *Untitled (Nice)*, 2003

• C –

a career in → reportage in the United States. Since the mid-1970s he has worked in → series, using photography to explore the construction of meaning in what can be seen, and the relationship between the photographer, his creations and reality. He was one of the organizers of the Cahiers de la Photographie publishing series and has held a professorship at the → École Nationale Supérieure in Arles since 1983. He has also been invited to teach at the International Center of Photography, New York, and the Vevey School of Photography, Switzerland.

Clarence H. White School of Photography The first American school dedicated to the teaching of photography as an art. It was established in New York by → Clarence Hudson White, a founding member of the → Photo-Secession and a prominent art photographer, in 1914, after he had run a summer photography school for

several years. The curriculum integrated the craft of photographs, fine art practices and design, as applied to both → art photography and → commercial photography. The school remained open until 1942 and produced many of the 20th century's leading photographers, including → Margaret Bourke White, → Dorothea Lange, → Ralph Steiner and → Paul Outerbridge.

Clark, Larry (b. 1943) American photographer and film director. Born and raised in Tulsa, Oklahoma, he acted as an assistant to his mother, who took portraits of babies. He studied → commercial photography for two years, at the same time immortalizing the group of friends with whom he began to take amphetamines from 1959. The result was the celebrated book *Tulsa*, published in 1971, which recorded the destitution of these young people from an immersive point of view. This work was followed by the more autobiographical *Teenage Lust* (1983), then *Perfect*

Childhood (1992) and a series of influential films, including *Kids* (1995). His photography and film work frequently provoked controversy for their uncompromising treatment of themes such as adolescence and the construction of an identity through social interaction, often involving sex, drugs and violence.

Claudet, Antoine François Jean (1797–1867) French photographer. In 1839 Claudet learnt of the → daguerreotype technique through the optician Noël Paymal Lerebours in Paris. He studied the process and acquired a licence to bring it to England, where he had been living for ten years, and to use it there. In 1841 Claudet opened a portrait studio that rapidly became successful owing to the improvements he made to the process (reduced exposure times, painted backgrounds and hand-colouring of the prints).

Clement, Krass (b. 1946) Danish photographer. Born in Copenhagen, Clement did not fully commit himself to still photography until he had completed his studies in film at the National Film School of Denmark. However, the narrative structures he learnt at the school carried over into the carefully sequenced and designed books of brooding, melancholic photographs he is famous for today.

Clercq, Louis de (1837–1901) French photographer. A politician, de Clercq was passionate about archaeology. In 1859 he travelled to Syria with Emmanuel-Guillaume Rey in order to illustrate a survey on fortified castles. He decided to continue travelling and published the resulting photographs in five volumes. His images reveal a perfect mastery of technique, particularly in the realization of → panoramic views. De Clercq exhibited his *Voyage en Orient* at the → Société Française de Photographie in 1861 and at the Exposition Universelle in 1862. He subsequently returned to politics.

Clergue, Lucien (1934–2014) French photographer. Clergue taught himself photography while

Larry Clark, *Untitled*, 1972

he was still young, and was encouraged in his endeavour by Pablo Picasso, with whom he struck up a friendship. In 1968, together with the writer Michel Tournier, he founded the Rencontres Internationales de la Photographie in Arles, inviting the world's greatest photographers to exhibit there. It was thanks to his energetic struggle that the French Ministry for Culture recognized photography as an art form and created the → École Nationale Supérieure de la Photographie in Arles. Already a Chevalier of the Légion d'Honneur, he was elected a member of the Académie des Beaux-Arts de l'Institut de France in 2006, for which a new section dedicated to photography was created.

Cliché-verre A → print made on light-sensitive paper by a glass plate coated with an opaque collodion layer onto which a design has been etched with the aid of a burin. This hybrid image, whose history has long remained obscure owing to its intermediate status, is not an accurate record like a photograph but can be reproduced in the same way. → William Henry Fox Talbot employed a technique midway between printmaking and photography in some of his early experiments around 1834, but the cliché-verre was perfected *c.* 1850 by the artists of the Arras school of painters, which included Constant Dutilleux, Charles Desavary and Jean-Baptiste-Camille Corot. The latter is one of the technique's most famous practitioners, creating sixty-six plates over twenty years. Corot was not the only painter to use it: Eugène Delacroix tried it only once, but → Eugène Cuvelier, another member of the Arras school, introduced the cliché-verre to the artists of the Barbizon group, among them Charles-François Daubigny, Jean-François Millet and Théodore Rousseau. In 1917 → Man Ray adopted the technique and passed it on to other artists in Paris, including Max Ernst, Pablo Picasso and → Brassaï.

Clifford, Charles (?1819–1863) British photographer. Clifford settled in Spain in 1850. Under the patronage of Queen Isabella II he photographed landscapes and architecture. He also worked as a court photographer, employing the → collodion process and producing

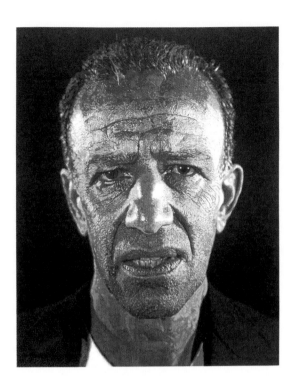

Chuck Close, *Alex*, 1993

→ albumen prints. Clifford was admired by Queen Victoria, whom he photographed at Windsor, and praised by critics following exhibitions in London and Paris. His sudden death in 1863 interrupted his plans for a more comprehensive edition of *Voyage en Espagne*, first published in 1852.

Close, Chuck [Charles Thomas Close] (b. 1940) American artist. Close graduated from Yale University in 1964, subsequently becoming one of the major exponents of → Photorealism. Although he has experimented with many techniques, since 1968 his starting point for each new work has been a portrait taken with a 20 × 24 → Polaroid camera, which he then fragments into a varying number of squares. After he suffered a spinal artery collapse in 1988, which left him partially paralysed, the form of the grid became a fundamental element in his work, in which each fragment resembles an abstract miniature. In addition to his work as a painter, he makes monumental compositions using 20 × 24 and 40 × 80 Polaroids and is interested in photographic processes including the → daguerreotype, → photogravure and holography.

• C —

- C •

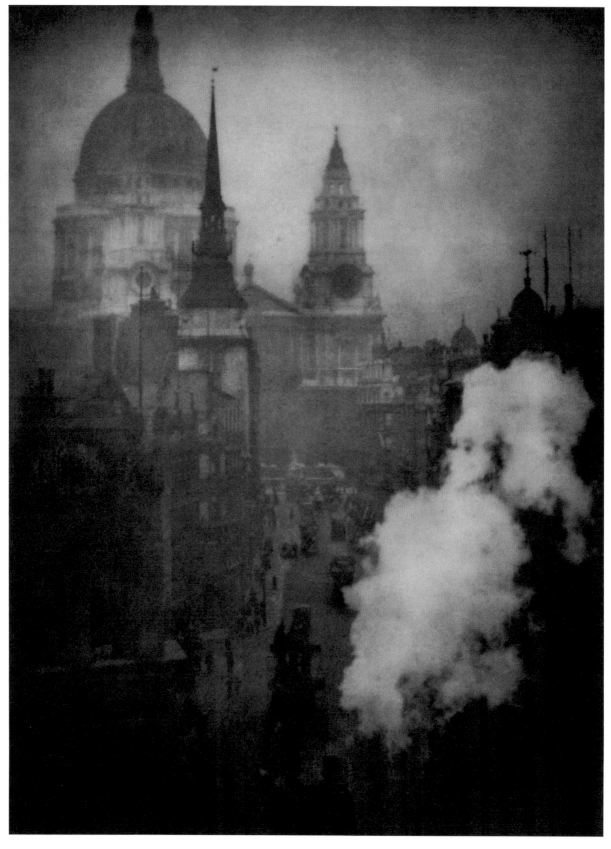

Alvin Langdon Coburn,
St Paul's Cathedral, London, 1908

Close-up A view of a subject taken at close quarters. When reproduced on a larger-than-life scale, it is referred to as a → macrophotograph or photomacrograph.

CMYK *see* **Subtractive processes**

Coburn, Alvin Langdon (1882–1966) American photographer. Born in Boston, he began experimenting with photography in 1890 after receiving a camera. He studied photography with his distant cousin → Fred Holland Day, and both travelled to England to further their education and meet key English photographers. While in London, Coburn exhibited his photographs at the → Royal Photographic Society and with the → Brotherhood of the Linked Ring, receiving praise for his → Pictorialist approach. In 1902 he returned to New York and helped form the → Photo-Secession. A year later he was elected to the Linked Ring. He returned to London and, after learning the → photogravure process, began to publish his work. A prolific producer of illustrated books, Coburn explored varied subjects, including the cities of London and New York, and illustrious men. In 1917 he exhibited his abstract *Vortographs* series, a break from his earlier work.

Cohen, Lynne (b. 1944) American-born Canadian photographer. Cohen is known for her photographs of private, public and industrial interiors devoid of people. She began photographing in the early 1970s after studying fine art at the Slade School of Fine Art in London. Working exclusively with a large-format camera, she documents the mundane details found within these architectonic spaces with a sense of anthropological detachment.

Coleman, Allan Douglass (b. 1943) American critic. Born in New York, Coleman received a bachelor's degree in English literature from Hunter College in 1964, and a master's degree in English literature and creative writing from San Francisco State College in 1967. That same year, having noticed a lack of critical dialogue surrounding photography, he began writing about the medium for periodicals including

Village Voice and the *New York Observer*. In 1970 Coleman became the *New York Times*'s first photography critic, contributing regularly for over four years. During his career, he has written eight books and over two thousand articles. In addition to his work in print, Coleman was quick to embrace the internet, authoring a notable blog and founding several websites.

Collage A technique that combines assorted materials, such as photographs, newsprint and paint, onto a single support in order to create a unique work. The term comes from the French word *coller*, which means 'to glue' or 'to stick'. Throughout the history of photography, collage has been used to create hybrid works. In the 19th century upper-middle-class Victorian women created albums of whimsical photo-collages. Until recently, these works were neglected in the discourse of the history of photography. A photo-collage is created when photographic images are cut up and combined with other media, including elements drawn with a pencil or painted in watercolour or ink. The resulting fantastical compositions were often based on family narratives or genre scenes. In the 20th century collage was used by a variety of artists for different reasons. Picasso and Braque employed the technique in around 1912, in relation to their Cubist work. Dada and → Surrealist artists used collage as a subversive practice that acted as a commentary on the dominant social mores and political conditions of the time. Using mechanically produced images in their work, including photographs, → Raoul Hausmann and → Hannah Höch, among others, created complex, multi-dimensional collages that borrowed from popular culture. The Surrealists, too, drew on the possibilities offered by juxtaposed images and materials in the creation of their work. Often associated with avant-garde movements, collage is still an active approach to contemporary image-making.

Collard, Auguste Hippolyte (1812–1887) French photographer. Collard took up photography in 1850, initially producing portraits and reproducing works of art. He then specialized in industrial photography, becoming the official

• C —

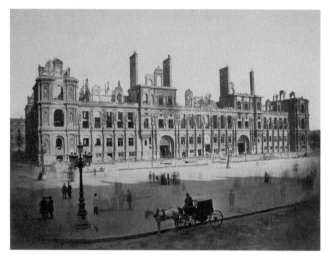

Auguste Hippolyte Collard, *The Hôtel de Ville after the Commune*, 1871

photographer of the Bridges and Highways service in Paris. His field of interest expanded further during the Second Empire (1852–70) and included commissions for engineers. Although his oeuvre is not widely known, it is admired for its modernity and its detailed views of bridges under construction, public works and the barricades of the Paris Commune.

Collodion (wet-plate collodion) process A method of producing glass-plate → negatives discovered by → Frederick Scott Archer in 1849. It replaced the paper negative process developed by → William Henry Fox Talbot. The technique used collodion (combined with potassium iodide and potassium bromide) as a binder for silver iodide on glass. The collodion plate had to be prepared by the photographer on the spot, because it remained light-sensitive only as long as it was wet. The process produced images with a good range of tones and reduced posing times from a few minutes to a few seconds. A → positive print was obtained by → contact-printing with sensitized silver-chloride paper. Owing to their precision, sharpness and clear outlines, these wet-plate images superseded paper negatives, → calotypes and the → albumen glass-plate negatives invented by → Claude Félix Abel Niépce de Saint-Victor. The technique later led to the development of the → collodion positive (ambrotype) process, also by Archer, and the

→ ferrotype. Despite its disadvantages (the need for heavy and cumbersome equipment, and a portable darkroom in which to develop the negative immediately), wet collodion remained the most commonly used photographic process of the second half of the 19th century, until it was superseded by the → dry-plate process in the 1870s and, later, by the → gelatin silver process.

Collodion positive (ambrotype; amphitype) A photograph on glass, made using the → collodion process. It belongs to the second generation of photographic processes. Developed in 1852 by → Frederick Scott Archer in England and based on the collodion process, it was particularly popular in the United States (where it was commonly known as the ambrotype) and was intended to offer an alternative to the more expensive → daguerreotype. A thin layer of wet collodion was spread onto a glass plate. The underexposed image was then developed and chemically fixed, and appeared in shades of grey. The → negative obtained in this way was not contact-printed but placed against a black surface, allowing it to be viewed as a → positive image. In commercial photography the ambrotype was replaced by the → ferrotype and the → albumen print. Like the daguerreotype, it was generally kept in a folding case or frame.

Collotype A popular form of photomechanical reproduction before the introduction of offset lithography. Invented by → Alphonse Louis Poitevin in 1855, the printing process uses dichromated colloids to create a glass printing plate that is then fitted into a printing press. Initially popular for printing postcards, the process is now used chiefly for specialized high-end publishing.

Colom, Joan (b. 1921) Catalan photographer. An accountant by training, Colom took up photography at the age of 36, joining the AFC (Catalan Photography Group) and then co-founding the El Mussol group. His photographs of the Raval neighbourhood of Barcelona, published in *Izas, Rabizas y Colipoterras* (with an essay by Camilo José Cela, winner of the Nobel Prize for Literature), made him one of the major

exponents of Spanish → street photography. Half-joking that he 'worked the streets' in order to photograph the city's most notorious neighbourhoods, Colom broke with the neo-Pictorialist tradition dear to the Franco regime in his choice of subject matter and his constant search for truth.

Colour At the invention of photography and well into the 20th century, one of the main criticisms of photography was that the images were monochromatic. Thus began the quest for a viable colour photographic process. Initially, colour pigments were applied by hand to photographic prints. There followed several relatively unsuccessful early colour processes, such as the hillotype. However, the first reliable colour processes to make an appearance were based on the theories and experiments of → Louis Ducos du Hauron. Ducos du Hauron proposed that full colour could be achieved by using a → filter composed of fine lines in primary colours, then blocking off the colours with their complementary colours. He also invented a process called the 'Heliochrome', in which three separation → negatives were made by photographing a scene through additive coloured filters. Each was printed onto a corresponding subtractive coloured gelatin bichromate sheet, then the three layers were carefully superimposed in register, producing a full-colour image. Drawing on these principles, every colour technique now incorporates dichromate and/or → gelatin silver printing processes. Two types exist: additive and subtractive. → Additive processes, such as the → autochrome and other screen-plate processes, were the first successful colour processes. Each used a coloured screen composed of fine lines or dots in primary colours. Early additive colour processes were used by artists, amateurs and journalists. → Subtractive colour processes are more common today. Included in this category are → carbro, → Cibachrome (silver dye-bleach), → dye transfer (dye imbibition), dye diffusion (→ Polaroid instant) and the → C-print (chromogenic colour). Carbro and dye transfer were first used to make advertising proofs between the 1930s and the 1950s. In the

1960s colour photography began to be accepted by the art world, journalists and the general public.

Colvin, Calum (b. 1961) Scottish photographer. A graduate of the Royal College of Art in London, Colvin works from famous paintings and works of art, which he humorously distorts and manipulates by adding new and surprising elements, sometimes transparent. By deconstructing classical points of reference, he invites us to question the process of interpretation. Since the beginning of the 2000s he has used digital software in his work.

Combination printing A process that creates a composite printed image. This is achieved through either the multiple exposure of the same photosensitive surface or the combination of multiple → negatives during development. The latter method allows for greater precision in terms of composition. The final image is

• C —

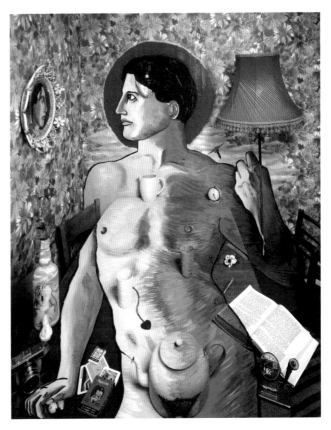

Calum Colvin, *Narcissus*, 1987

composed of multiple overlaid elements. Originating from a technical accident, combination printing was embraced by avant-garde photographers in the 1920s and 1930s and turned into a means of artistic expression. The process is still used by photographers to create visual effects or unexpected juxtapositions.

Commercial photography A type of photography in which the creation, production and distribution of images is for profit and intended for mass consumption. It can be extremely varied, covering → advertising and → fashion photography, → landscape, → still-life, food photography, nature documentary and press photography in all its forms, from paparazzi images of celebrities to war → photojournalism and → portraits of politicians. For a long time artists regarded commercial photography negatively, viewing it as the antithesis of art photography. The reproducibility and instantaneity of photographs render them perfectly suited to mass production; although scorned by → Pictorialist theory, these qualities were sometimes utilized in the work of → Alfred Stieglitz and → Paul Strand. In the second half of the 20th century, the subjects and formal characteristics of commercial photography became starting points in the search for a new aesthetic. Since the 1990s photography taken in a commercial context has received artistic recognition, particularly fashion and documentary photography.

Composite portrait A photographic image consisting of superimposed portraits of different individuals. Composite photographic portraits were born out of a late 19th-century desire to create statistically average images, or 'types'. The physiologist, anthropologist and eugenicist → Francis Galton developed this technique in an attempt to prove his own theories and establish anthropometric systems of classification. He believed that the mechanical process of photography could provide an infallible means of recording the physiognomic traits of particular classes of people. First, portraits of individuals of the same social type (criminals, members of the same family, patients suffering from the same illness, etc.) were categorized and assembled. All the portraits were produced using the same exposure times. If facial features appeared dark and defined in the composite image, Galton presumed that all the subjects shared the same traits; if they appeared pale and blurred, he concluded that the subjects did not fit the common type. However they are obtained, composite portraits are fascinating because of their unreal aspect. The merging of multiple portraits of real people effectively produces a portrait of a person who does not exist. The concept recalls the idea of aesthetically ideal forms within the artistic canon, as well as the notion that a representation can extend beyond the body's physical surface. The artifice and fantastical appearance of composite portraits remain an appealing source of study today, even though the effects can be easily achieved through digital editing software.

Comte, Michel (b. 1954) Swiss photographer. Self-taught, Comte has conducted advertising campaigns for Chloé, Armani and Dolce & Gabbana, and his work has appeared in → *Vogue*, *Vanity Fair*, *Interview* and *Stern*. The spontaneity of his portraits – of Helena Christensen, Mariel Hemingway and Sophia Loren, among others – is the result of the dialogue he maintains with his sitters during each shoot. He has also shot nudes that are integrated into the monumental Swiss landscape (2003). A defender of human rights, Comte additionally works in → reportage.

Conceptual art A broad and imprecisely defined artistic movement that appeared in Europe, North America and Latin America in the mid-1960s and lasted through the 1970s and beyond. Conceptual art, which came to public notice with the publication of the article 'Paragraphs on Conceptual Art' by Sol LeWitt (*Artforum*, 1967), emphasized the concept behind a work of art and the intentions of the artist over the execution and perception of the finished object. It appeared in a context that was critical of Western political, economical and artistic systems; it demystified the role

of the artist and challenged the power of art institutions, the relevance of exhibition spaces and the definition of art itself. Conceptual artworks take many forms and exist in many different media, including installation, performance and publications. Photography played a formative role in conceptual art and has occupied a central role in contemporary artistic practice.

Concerned photography A term advanced by the American photographer → Cornell Capa to describe a style of photography that displays a concern for social and political wellbeing. It follows in the tradition of social documentary photography established by → Lewis Hine. In order to promote its practice, Capa founded the International Fund for Concerned Photography in 1966, which became the International Center of Photography (ICP) in 1974. In 1968 he published the catalogue *The Concerned Photographer*, which brought together works by → Robert Capa, → Werner Bischof, → David 'Chim' Seymour, → André Kertész, → Leonard Freed and Dan Weiner. In 1974 a second publication united the works of → Marc Riboud, → Roman Vishniac, → Bruce Davidson, → Gordon Parks, → Ernst Haas, → Hiroshi Hamaya, → Don McCullin and → W. Eugene Smith. The International Award for Concerned Photography was established in 2006.

Concrete photography International movement related to concrete art, which unites experiments with the medium of photography and its processes within a principle of self-referentiality. This discipline allows for a certain creative autonomy free from the concerns of representation. The British photographer → Alvin Langdon Coburn is considered one of the pioneers of the movement owing to his book *The Future of Pictorial Photography* (1916) and his abstract Vortographs (1917). The theories underpinning concrete photography were set out by → Gottfried Jäger in 'Konkrete Fotografie und konstruktive Konzepte (1882–1990)' (*Fotoästhetik*, 1991) and in a bilingual English–German publication called *Concrete Photography – Konkrete Fotografie* (2005), which featured

Pierre Cordier, → Jan Dibbets, → Raoul Hausmann, → John Hilliard, René Mächler, → Man Ray, → László Moholy-Nagy, → Ugo Mulas, → Andreas Müller-Pohle and Marc Volk, among others.

• **C** —

Conservation Measures taken to prevent the deterioration of photographic objects by ensuring that they are stored at an appropriate, stable temperature and relative humidity, are housed using suitable (acid-free) materials and experience limited exposure to ultraviolet light. In the absence of preventative conservation (or preservation), photographs are susceptible to various kinds of physical and chemical deterioration. Standards for photographic preservation are dependent on the photographic process and condition of the object in question. Information on the care of photographic collections can be found in various print and online resources.

Contact print A print made by directly applying a → negative to light-sensitive paper and exposing it to light. The print is therefore the same size as the negative.

Contact sheet A form of print that allows all the images on a roll of film to be viewed on the same sheet. It is made by cutting a developed roll of film into strips and → contact-printing them on a piece of photographic paper. Traditionally it gave photographers their first opportunity to view the pictures they had taken. Aside from its use as a tool for editing and developing photographs or as an index card for the archiving of negatives or prints, the contact sheet may also be exhibited as a photographic object in itself: see, for example, the series *Contacts* (1983) by → William Klein.

Coplans, John (1920–2003) British photographer. Initially a painter, Coplans had a brilliant career in the United States as an exhibition curator and chief editor of *Artforum* magazine, which he helped to establish in 1962. He is known for his black-and-white representations of his ageing body: fragmentary photographic images that helped reinvigorate the genres of the → nude and the → self-portrait.

Coppola, Horacio (1906–2012) Argentinian photographer. Coppola became interested in photography at an early age and in 1930 travelled to Europe, where he came into contact with the avant-garde. In 1935 he arrived in Germany and joined the → Bauhaus, where he met → Grete Stern, his future wife. He is best known for his collaboration with Victoria Ocampo on the magazine *Sur*, which featured views of Buenos Aires, and for his architectural photography.

Copyright A law that grants the creator of a work specific rights over its use, usually for a fixed period of time. The concept of intellectual property includes exclusive rights (the right to reproduce, sell, distribute or display a work) and moral rights (the right to be identified as the author of a work, the right of integrity and the right to privacy). Every country defines its own copyright law and author's rights. The Berne Convention (1886) – an international agreement that sets guidelines for copyright protection – specifies a minimum copyright length of fifty years after the creator's death. When the copyright period expires, works fall into the public domain. In the digital age new forms of protection have been established: Free Art, GNU and Creative Commons licenses cover issues relevant to collective works and digital distribution.

Corbijn, Anton (b. 1955) Dutch photographer, art director and filmmaker. Corbijn's body of work includes many different forms of creative expression, united by a photographic aesthetic. In the late 1970s he began to take photographs of bands and musicians such as U2, Depeche Mode and Morrissey. He went on to shoot covers for magazines including *Rolling Stone* and *Esquire*, and album covers for a wide range of artists. He also directed music videos, including *Heart-Shaped Box* by the band Nirvana, for which he won an MTV award in 1994. A hallmark of his photographic work is the great sense of intimacy that he creates with his subjects. His images' sparse settings also create an atmosphere that seems to extend beyond the picture space into the three-dimensional world. Corbijn's sense of atmosphere and the captured moment is also apparent in his feature films, which include *Control* (2008), *The American* (2010) and *A Most Wanted Man* (2014).

Corrales Forno, Raúl (1925–2006) Cuban photographer. Corrales Forno worked as a photographer for the newspaper of the Popular Socialist Party from 1950, specializing in portraits and the daily life of poor peasants and labourers. The majority of his work was destroyed during a raid by military police in the late 1950s. Corrales Forno rejoined the Cuban Communist Party after the revolution in 1959. In 1961 he became a member of the photography section of the Union of Writers and Artists in Cuba (UNEAC). He is still remembered today for the photographs he took during the Bay of Pigs invasion in 1961. An official photographer to Fidel Castro, Corrales Forno worked for almost thirty years in the Office of Historical Affairs. In 1985 his work was shown at the Museum of Fine Arts in Havana, and in 1993 at the Visa pour l'Image festival and the Fifth International Festival of Photojournalism in Perpignan.

Coulommier, Julien (1922–2014) Belgian photographer. A self-taught artist, Coulommier exhibited regularly since the 1950s. He took his first steps in photography in the post-war period, during which individuals sought an unprecedented level of freedom. Like others, Coulommier looked for a radical renewal of photography, in style as well as content, and promoted a more innovative and personal art. He interpreted objects found in nature in unexpected ways, lingering over previously insignificant details and fragments, and giving concrete form to his inner dreamworld.

Courrèges, Christian (b. 1950) French photographer. Courrèges worked in advertising before turning to portraiture in 1990. His work presents individuals whose membership of a particular group is obvious from their appearance: his series feature bullfighters (1995); Haitians (*Haïti / Brésil*, 1998); cardinals in the Curia of the Catholic church (*Les prélats*, 2002); the Swenkas of South Africa (2012);

prisoners and prison officers in the Baumettes prison, Marseille (*Portraits de prison*, 1998); and judges in France, Britain and Spain (*Les magistrats*, 2004).

Couturier, Stéphane (b. 1957) French architectural photographer. Couturier made his debut on the art scene in 1994 with the exhibition *Archéologies urbaines* – a starting point for his studies of the city and its contemporary guises. He adopts angles that are both neutral and spectacular. The hyperrealistic rendering of these large-format colour images, combined with tricks of perspective, results in works that are somewhere between documentary vision and art, between representation and abstraction.

Cravo Neto, Mario (1947–2009) Brazilian photographer. Cravo Neto studied at the Art Student League in New York from 1968 to 1970. In collaboration with Jack Krueger, he published his first series in colour, entitled *On the Subway*, in the magazine *Camera 35*. He participated in the 11th São Paulo Biennial in 1971. Between 1971 and 1974 he made short films focusing on the relationships between people and objects, creating works that could be described as → photosculptures.

• C —

Stéphane Couturier,
Rue Auber, Paris 9, 1996

— C •

Gregory Crewdson,
Untitled (Ophelia), 2001

Crewdson, Gregory (b. 1962) American
photographer. Crewdson studied photography,
graduating in 1988 from Yale University,
where he now teaches. He is interested in
the banality of the everyday, the other side of
the American dream and the incursion of the
uncanny into apparently normal scenarios.
His work reflects the trend in contemporary
photography for staged scenarios (→ Jeff Wall
and → Cindy Sherman also employ this approach)
whose technical resources recall the methods
used by Hollywood studios; his *Twilight* series
(1998–2002) is a good example.

Cromer, Gabriel (1873–1948) French photographer
and collector. Cromer was a specialist in the
→ carbon printing process at his portrait studio
in Clamart, south-west of Paris. As a member
of the → Société Française de Photographie,
he began managing its library in 1927. He also
catalogued the photographic collections of
the Musée National des Arts et Métiers, Paris.
Cromer's personal collection was one of the
most important and comprehensive bodies of
historical photography ever assembled, and
included photographic equipment, manuals,
books and ephemera related to photography.
Furthermore, he had amassed some 500

→ daguerreotypes, mostly French; nearly 6,000 images by → Charles Marville, → Gustave Le Gray, → Édouard-Denis Baldus, Edmond Fierlants, → Henri Le Secq, → Adolphe Braun and → Bisson Frères; and albums by Eugène Durieu, → Désiré Charnay and Charles-Victor Hugo. The collection was shown in the 1925 Retrospective Exhibition on the Centenary of Photography in Paris and eventually bought by the Eastman → Kodak Company in 1939.

Cualladó, Gabriel (1925–2003) Spanish photographer. A member of the → Royal Photographic Society of Madrid and then of the AFAL group in Almería, in 1958 Cualladó co-founded the La Palangana group, which would become the School of Madrid. His images, which focus on Madrid's flea markets, Les Halles in Paris or his circle of friends, are akin to the works of Italian neo-realism and French humanism.

Cudlín, Karel (b. 1960) Czech photographer. Cudlín graduated from the Film and Television School at the Prague Academy of the Performing Arts (FAMU) in 1987, beginning his career as a photojournalist for various Prague-based magazines. Now freelance, he captures scenes charged with political or social symbolism in black and white, as can be seen in his works on East Germany, the former Soviet Union or Ukrainian refugees and workers.

Cumming, Donigan (b. 1947) Canadian visual artist working with photography, video, sound and multimedia. He holds a BSc from Florida State University (1978) and master's degree from Concordia University, Montreal (1985). Cumming is known for his images of the elderly, the disenfranchised and the homeless. Dealing with issues of corporeality, truth and representation, his work has been exhibited internationally and is held in various national and international collections.

Cumming, Robert H. (b. 1943) American artist. Cumming is a graduate of the University of Illinois (1967), where he became friendly with → William Wegman. He devoted himself to sculpture, mail art and graphic design, and is well-known for his architectural photographs of the 1970s, which allowed him to create a synthesis between spatial elements and the documentary function of photography. Cumming lives in Massachusetts.

• C —

Cunningham, Imogen (1883–1976) American fine art and portrait photographer, and a founding member of the modernist → Group *f*.64. She became interested in photography early in her life, studying chemistry and photography in the United States and Germany. From 1907 to 1909 she worked in → Edward Sheriff Curtis's studio, where she learnt → platinum printing techniques, after which she opened a successful portrait studio in Seattle. Her early → Pictorialist

Donigan Cumming,
Untitled, 1991

style eased her acceptance into West Coast art circles, but her marriage to Roi Partridge and family responsibilities obliged her to put her professional career on hold until the 1930s, though she continued to take notable images of plants and her children. She eventually returned to professional portraiture work, making images for publications such as *Vanity Fair*, and is noted for her tactile dance, nude and botanical photography.

Curtis, Edward Sheriff (1868–1952) American photographer celebrated for his portrayal of Native Americans. Following an apprenticeship with a photographer in St Paul, Minnesota,

Curtis opened his own studio in Seattle in 1896. He became interested in American Indian cultures and drew up a proposal to conduct a census of the native tribes. After meeting the ethnologist George Bird Grinnell, Curtis joined the Harriman Expedition to Alaska in the role of official photographer (1899). On his return, he undertook what was to be his life's work: the inventory of eighty Native American tribes. Financed partly by the industrialist John Pierpont Morgan and backed by the president, Theodore Roosevelt, Curtis set out to document the everyday lives, habitats and religious rites of the American Indian population. Curtis devoted thirty years of his life to the project,

Imogen Cunningham,
Two Sisters, 1928

taking over forty thousand images and recording languages, dialects and religious songs on wax cylinders. The material he gathered gave rise to his principal publication, *The North American Indian*, of which twenty volumes appeared between 1907 and 1930. It was an extremely lavish edition for the time, and each copy came with a portfolio containing thirty or so → photogravures. These prints, imbued with a → Pictorialist aesthetic, were sometimes retouched in order to erase all traces of modern life; ultimately they presented a constructed image of the ideal Native American, proud and strong. Curtis also made the film *In the Land of the Headhunters* (1914), now known by the more conventional title of *In the Land of the War Canoes*.

Cuvelier, Eugène (1837–1900) French photographer. Cuvelier learnt photography and painting from his father, Adalbert Cuvelier, who also introduced him into artistic circles. Married to the daughter of an innkeeper in Barbizon, he settled nearby. Cuvelier's photographic production was concentrated on views of the Forest of Fontainebleau and the surrounding area. He preferred → negatives on paper but abandoned them in the 1860s in favour of the → collodion process. Cuvelier sold his images commercially and distributed them among his friends.

Cyanotype (blueprint; ferro-prussiate process)
Discovered in 1842 by → Sir John Herschel, the cyanotype process uses iron salts to create a direct → positive image. The paper is sensitized using potassium ferricyanide. Although a shade of yellow when dry, the paper turns blue when passed through a water bath. Cheap, simple to use and very stable, this process was used widely to print architectural plans before it was taken up by amateur photographers in the second half of the 19th century.

Edward Sheriff Curtis,
Quilcene Boy, 1913

• C —

D

Daguerre, Louis [Louis-Jacques-Mandé Daguerre]
(1787–1851) French painter, inventor and
photographer. Daguerre developed the first
photographic process used in France, the
→ daguerreotype. A painter specializing in theatre
sets, he was the proprietor of the Diorama, a
popular Parisian spectacle featuring theatrical
scenery and lighting. In 1826 he met → Nicéphore
Niépce through the optician → Charles Chevalier.
Daguerre used a → camera obscura to design
sets for his shows and became interested in
the possibility of capturing images formed by
sunlight. In a contract signed on 14 December
1829, Daguerre and Niépce established a
partnership for ten years to develop their ideas.
When Niépce died in 1833, Daguerre remained
in control of the contract, then entered into
partnership with Isidore Niépce, the inventor's
son. He improved on Niépce's experiments with
photography by exposing a silver-plated sheet
of copper to iodine fumes and then developing
the image with mercury vapour. Fixing was
achieved by washing the image in salt water.
As Daguerre modified the chemical substances,
he identified a new process, which he christened
the 'daguerreotype' in 1839. Well connected
with the court of Louis-Philippe, he persuaded
→ François Arago, a renowned physician and
member of the Académie des Sciences, to
announce the discovery on 7 January 1839
without divulging its secrets. After a fire at
the Diorama on 8 March 1939, a bankrupt
Daguerre placed his hopes on his discovery.
In exchange for the rights to the daguerreotype,
the government agreed to pay him a lifetime
annuity of 60,000 francs; Isidore Niépce received
4,000 francs. On 19 August 1839, at a combined
meeting of the Académie des Sciences and the
Académie des Beaux-Arts, Arago revealed the
process in public. The news spread throughout
France and abroad. Wishing to market his
discovery, Daguerre published a pamphlet
entitled *Historique et description des procédés
du daguerréotype et du Diorama*, which
ran to thirty-two editions in French and six
in other languages over eighteen months.
In 1839 his photographic oeuvre amounted to
less than twenty-five daguerreotypes, mainly
→ still-lifes, views of Paris and images of fossils
and shells. When others began to improve

Louis Daguerre,
The Artist's Studio, 1837

on the daguerreotype and to develop other photographic processes, Daguerre retired to Bry-sur-Marne in 1840 and took up painting once more.

Daguerreotype The first reliable photographic process, announced to the public in 1839. Named after its inventor, → Louis Daguerre, it was based on earlier work by his colleague and partner → Nicéphore Niépce. The daguerreotype was a unique → positive image, made using a silver-plated copper plate that was sensitized with iodine fumes, placed in a camera and exposed for several minutes. The → latent image was developed by exposing the plate to mercury fumes. Daguerre fixed the developed image using a salt solution; → Sir John Herschel later discovered an alternative fixing method that utilized a solution of sodium thiosulphate, or

'hypo'. The advantage of the daguerreotype lay in its ability to capture fine detail and a broad tonal range. Its disadvantages were the weight (50 kg, or 110 lb) and the cost (400 gold francs) of the equipment, the long exposure times required (15 to 30 minutes at first) and the unique nature of each image, which could not be reproduced. The fragility of the silvered surface meant that daguerreotypes were generally presented in glazed frames, which were often richly decorated. The images were initially available in a standard format (21.5 × 16.5 cm; 8½ × 6½ in.), then later in half- and quarter-size plates. Scarcely ten years after its introduction, the daguerreotype's popularity had already peaked. In Europe it fell out of favour in the early 1850s and was replaced by the → calotype, but it remained in use in the United States. It finally disappeared around 1865.

Louise Dahl-Wolfe,
Twins at the Beach, 1955

Dahl-Wolfe, Louise (1895–1989) American fashion and portrait photographer. Having studied art, she went on to work in design and decoration. In 1921 she became interested in photography under the influence of Anne Brigman and from 1933 worked freelance on advertising assignments, for which her husband, a sculptor, designed most of the backgrounds. Between 1936 and 1958 she was employed by → *Harper's Bazaar*, where she established her own style, taking images outdoors and displaying a skilful handling of natural light. Known for her work in both black and white and colour, she helped shape the image of women in the post-war period, making her mark on fashion photography and influencing the next generation, including → Richard Avedon and → Irving Penn.

D'Alessandri, Antonio (1818–1893) **and Paolo Francesco** (1824–1889). Italian brothers, considered the first Roman photographers. Antonio, a priest, was granted the privilege of taking portraits of Pope Pius IX, and the brothers became photographers to the Roman nobility. From 1862 they were also present on the battlefield, making them among the first Italian war reporters. They won a silver medal at the Rome Exhibition of the Arts and Industry in 1890.

D'Amico, Alicia (1933–2001) Argentinian photographer. Professor of Drawing at the National School of Fine Arts in Buenos Aires, D'Amico began to learn photography in 1957. She opened her own studio in 1960 and founded the first publishing house specializing in Latin American photography, La Azotea, in 1973. Her photographic work consists primarily of black-and-white portraits of South American writers.

Darkroom A room or space that can be made completely dark in order to process light-sensitive photographic material. Some forms of darkroom have been in existence since the earliest days of photography. Examples range from elaborately rigged laboratories to the mobile or makeshift darkrooms used by travelling photographers and photojournalists.

Antonio and Paolo Francesco D'Alessandri, *Maria Sophia, Queen of the Two Sicilies*, 1860s

DATAR A long-term photographic project with the objective of 'creating new images of French territory to capture a particular moment in its development', established in 1984 and funded by the Délégation à l'Aménagement du Territoire et à l'Action Régionale. This programme, which was remarkable for both its ambition and scale, was directed by Bernard Latarjet and → François Hers. Twenty-eight emerging or already well-established photographers from France and abroad travelled the length and breadth of France for four years. From 1985 their work was shown to the public, and two catalogues were published under the title *Paysages, Photographies* in 1985 and in 1989. The project's collection of photographs has resided at the Bibliothèque

Davanne, Alphonse

Nationale de France, Paris, since 1988. Inspired in particular by works shown in the landmark → *New Topographics* exhibition (1975), these images have an artistic dimension that helped revitalize the → landscape genre in Europe. Among the participating photographers were Dominique Auerbacher, Lewis Baltz, → Gabriele Basilico, Bernard Birsinger, Alain Ceccaroli, Marc Deneyer, → Raymond Depardon, Despatin & Gobeli, → Robert Doisneau, → Tom Drahos, Philippe Dufour, Gilbert Fastenaeken, → Pierre de Fenoyl, → Jean-Louis Garnell, Franck Gohlke, Yves Guillot, Werner Hannapel, François Hers, → Joseph Koudelka, Suzanne Lafont, Christian Milovanoff and Vincent Monthiers.

Davanne, Alphonse (1824–1912) French photographer. Davanne is known for his work to secure recognition for photography on an institutional level. A founding member of

the → Société Française de Photographie, he was a pioneer in the teaching of the medium and published several technical treatises. He specialized in the production and modification of positive prints. Davanne also created a lithography process using bitumen of Judea.

Davidson, Bruce (b. 1938) American photojournalist. He began exploring the neighbourhoods of his native Chicago with a camera at an early age, and furthered his studies at Yale University and at the Rochester Institute of Technology, where his thesis project was published by → *Life* in 1955. While stationed in Paris with the US army, Davidson met → Henri Cartier-Bresson and, in 1958, following a year of freelance work, he joined the → Magnum agency. He is noted for his intimate and direct portraits, exemplified by the series *Brooklyn Gang* (1959), and for his work on the civil rights

Bruce Davidson, *Brooklyn Gang,*
Coney Island, 1959

movement during the 1960s. Davidson has received numerous awards and fellowships, including a Guggenheim Fellowship, and he has been the subject of exhibitions at the → Museum of Modern Art, New York. He continues to photograph, publish and exhibit his work.

Davies, John (b. 1949) British photographer. Davies studied at Trent Polytechnic, Nottingham. Between 1976 and 1981 he produced black-and-white images of rural landscapes in Britain and Ireland before turning to landscapes and towns historically shaped by industry in the north of Britain and continental Europe, often including panoramic views. In 2006 the exhibition and book *The British Landscape* brought together a selection of his photographs taken since 1979.

Davison, George (1854–1930) British photographer. Davison took up photography in 1885. He joined the London Camera Club and in 1886 became a member of the → Royal Photographic Society. Influenced by the theories of → Peter Henry Emerson, he created impressionistic landscapes using a → pinhole camera. A founding member of the → Brotherhood of the Linked Ring in 1892, he became a champion of → Pictorialist photography. Davison also had a career working for → Kodak.

Day, Corinne (1965–2010) British fashion and documentary photographer. Day began her career as a model, learning photography on the job. In 1990 she was the first to photograph the model Kate Moss. Her direct style, inspired by documentary photography, marked the beginning of grunge fashion photography, which featured thin, provocatively posed models who often appeared as though drugged. Day also photographed her own life and her friends in the same grunge style, publishing her private images in *Diary* in 2000.

De Biasi, Mario (b. 1923) Italian photographer. Deported to Germany during World War II, De Biasi took his first photographs in Nuremberg using makeshift equipment he found in the

Corinne Day, *Kate Moss*, 1993

• D —

city's ruins. In 1953 he established a career as a photographer with the magazine *Epoca*, for which he produced a report on the Hungarian Uprising of 1956 that is still remembered today.

Deakin, John (1912–1972) British photographer. After World War II, Deakin took portraits of celebrities for → *Vogue*. Frequenting the artistic circles who gravitated around the Colony Room in Soho, he was known primarily for his collaboration with Francis Bacon. During the 1950s the painter commissioned him to produce many images that he subsequently used in his paintings. Deakin is also known for his street photography taken in Paris and Rome in the early 1950s.

Deal, Joe (1947–2010) American photographer and educator. He received his BFA from Kansas City Art Institute in 1970, an MA from the University of New Mexico in 1974, and an MFA from the

— D •

Joe Deal, *Watering, Phillips Ranch,
California*, 1983

same institution in 1978. Deal participated in
the seminal exhibition → *New Topographics:
Photographs of a Man-Altered Landscape* in 1975,
contributing his black-and-white photographs
of the American West. He taught at the University
of California, Riverside, Washington University
and Rhode Island School of Design.

Dean, Tacita (b. 1965) British artist. Dean studied
painting at the Falmouth School of Art and
the Slade School of Art, London. Principally a
filmmaker, she also uses photography and sound
recordings in her work. She is interested in
marine motifs and cinematic narration. In 2001,
for the series *The Russian Ending*, she collected
Russian postcards she found in flea markets,

reproducing them as enlarged → **photogravures**
and superimposing them onto handwritten notes
that recalled film directions.

DeCarava, Roy (1919–2009) American
photographer. In 1952 he became the first
African-American photographer to win a
Guggenheim Fellowship. Known for his
documentary images of life in Harlem during
the 1950s, in 1955 he published *The Sweet Flypaper
of Life* in collaboration with Langston Hughes:
a visual homage to his neighbourhood. Aesthetic
experimentation played a notable role in
DeCarava's photography. In 1996 a retrospective
of his work was held at the → **Museum of Modern
Art, New York.**

Decisive moment A term coined in 1952 by
→ Henri Cartier-Bresson in his book *Images à
la Sauvette*, published in English as *The Decisive
Moment*. He was trying to define the specific
qualities of photography as an artistic practice,
and placed a special emphasis on the moment
a photograph was taken. The true photographer
was the person who was capable of seizing
the 'decisive moment', which involved 'the
simultaneous recognition, in a fraction of
a second, of the significance of an event as well
as of a precise organization of forms which give
that event its proper expression'. This concept
has had a lasting influence on photography and
is especially evident in the work of → humanist
photographers.

Delahaye, Luc (b. 1962) French photographer. He
started his career as a war photographer, earning
international acclaim. He also pursued several
personal projects, including *L'Autre* (1999)
and *Winterreise* (2000), before leaving → Magnum
Photos and → photojournalism. In a radical
formal change, he began making large-scale
colour pictures depicting conflicts, news events
or social issues, showing them in museums.
His works are characterized by their detachment
and directness – a documentary approach that

Tacita Dean, *The Sinking of the SS Plympton*,
from *The Russian Ending*, 2001

• D —

is countered by a dramatic intensity and
narrative structure.

Delamotte, Philip Henry (1820–1889) British
photographer. The son of the lithographer and
landscape painter William De La Motte, Philip
changed his name to Delamotte in 1852 when
he published a book on photography. Using
the → calotype and → collodion processes and
→ stereoscopic views, he produced many images
of landscapes and architecture, notably Crystal
Palace in London. Delamotte also organized the

Luc Delahaye, *Taliban*, 2001

art section of the Art Treasures Exhibition held in Manchester in 1857.

Delano, Jack [Jacob Ovcharov] (1914–1997) American photographer. Born in Ukraine, Delano arrived in the United States in 1923. He trained as a draughtsman at the Pennsylvania Academy of Fine Arts and was hired as a photographer by the → Farm Security Administration in 1940. Delano is known for the classicism of his compositions. In 1947 he moved to Puerto Rico, where he produced films for the Ministry of Education.

Delius, Charles [Karl Ferdinand Delius] (1877–1962) German photographer. Following his studies in art and photography, he founded a professional photographic agency with offices in Paris (1908) and Genoa (1920). His striking images and those taken by his sons cover all aspects of political, economic and social life. The Delius archive constitutes an important visual record of Europe in the 20th century, and its photographs are currently distributed by Leemage.

Delpire, Robert (b. 1928) French publisher and exhibition curator. Delpire was one of the key figures in French photography in the second half of the 20th century. Passionate about graphic design and the image, and a champion of social themes, he introduced contemporary photographers to the French and European public. Particularly significant were his publication of → Robert Frank's *The Americans* in 1958 and the creation of the Photo Poche series in 1981. He began by establishing high-quality illustrated magazines (*Neuf*, *L'Œil*) and publishing books on the great names in photography. In 1963 he opened a gallery, one of the very few in France at that time to exhibit not only photography but

Jack Delano, *At the Bus Station in Durham,
North Carolina*, 1940

also the graphic arts. From 1982 until 1986 Delpire was director of the Centre Nationale de la Photographie, which he developed as part of his mission to promote photography to the wider public – a task he achieved by publishing photography books in pocket format, producing television programmes on photography and mounting many themed and single-artist shows. He curated exhibitions in France and abroad, in some of the world's most prestigious museums, all of which combined a scientific rigour with the desire to communicate with the general public. Delpire also produces commercial films.

Demachy, Robert (1859–1936) French photographer. Born into a family of bankers, Demachy was able to live comfortably on private means. Passionate about motorcars, he also devoted himself to music, drawing and, from 1880, photography. In 1894 he joined the → Pictorialist movement, becoming its principal advocate in France alongside → Constant Puyo. Demachy promoted the medium's artistic qualities and used various painterly techniques, including → gum bichromate and → bromoil prints. He had a brilliant career, exhibiting in London and New York, and his work appeared in the Pictorialist magazine → *Camera Work*. Demachy was a member of the → Société Française de Photographie and the → Brotherhood of the Linked Ring, and the founder of the Paris Photo Club, in addition to writing many articles on Pictorialism and colour processes. He abandoned his photographic career abruptly in 1914.

Demand, Thomas (b. 1964) German photographer. He trained as a sculptor at the Kunstakademie Düsseldorf and is famous for his unique approach to photography. Demand constructs life-size cardboard replicas of politically, historically or socially meaningful locations, using existing images as a guide, in order to photograph them anew. His large-format photographs – all that remain of this elaborate work process – trigger reflections on the factual and fictional content of media events between the poles of individual and collective memory.

Thomas Demand,
Bathroom, 1997

Denderen, Ad van (b. 1943) Dutch photojournalist. Van Denderen chooses to work on long-term projects that focus on social issues. These eventually culminate in books, exhibitions and documents on his own website. The main themes addressed in his extensive oeuvre are the consequences of apartheid in South Africa, the never-ending conflict in the Middle East, and the problems currently posed by immigration in Europe. On this last subject he has completed two in-depth multimedia photo and research projects entitled *GoNoGo* (2003) and *So Blue So Blue: Edges of the Mediterranean* (2008). In 2001 Van Denderen became the first Dutch photographer to win the Visa d'Or at the Perpignan International Photojournalism Festival.

Depardon, Raymond (b. 1942) French photographer. Born into a rural family, Depardon

— D •

Raymond Depardon,
Argentina, Patagonia Region, 1999

was briefly apprenticed to a photographer and arrived in Paris in 1958, where he soon became a reporter for the Dalmas agency. He carried out his first assignment in the Sahara in 1960, subsequently travelling the globe to cover conflicts and current affairs as well as general interest stories. He co-founded the → Gamma agency in 1966 and joined → Magnum Photos in 1978. Although he has had major scoops as a photojournalist (such as an interview with a female ethnologist being held captive by rebels in the Sahara), he nevertheless prefers to explore topics such as rural life, the land and identity. In 1969 he made his first documentary (*Jan Palach*). This was followed by his celebrated film *1974, une partie de campagne*, on Valéry Giscard d'Estaing's presidential election campaign; it was filmed with permission but later banned by the newly elected president. (It was eventually released in 2002.) Depardon has made a series of documentaries on insanity, the press, justice, the police and rural life, as well as advertisements and full-length features. His influential photography books also included travel photographs, thus introducing a documentary element to his fictional narrative. Depardon's powerful body of work has increased in depth and coherence over time, and is a synthesis between what Michel Guerrin described as the classicism of → Henri Cartier-Bresson and the eye of → Robert Frank.

Depth of field *see* **Iris diaphragm**

Derges, Susan (b. 1955) English photographer. Derges studied painting at the Chelsea School of Art, London, and earned her master's degree from the Slade School of Fine Art, London, in 1979. In the early 1980s she worked in Japan, researching at Tskuba University (1982–83) and exploring notions of natural order, chaos and visual metaphor. Her work combines elements of science and art, recording our world's most mysterious and invisible natural processes. She is best known for her pioneering use of the → photogram technique to capture the movement of water, immersing photographic paper directly into rivers and shorelines. Her work reflects the very earliest processes in the field of photography

Susan Derges, *Observer and Observed No. 16*, 1991

but is injected with contemporary awareness and conceptual meaning.

Developing process The chemical process that turns a → latent image into a visible image. The exposed sensitive surface is dipped into a series of chemical baths. The first is the developer, which makes the image visible by turning the silver halides that have been exposed to light into metallic silver. The second is the → stop bath, which halts the development. Next is the fixer, which stabilizes the image by dissolving the unexposed silver halide. Finally the image is washed with water to remove any remaining chemical traces. The developing process is the same for → negatives and → positives.

Diamond, Hugh Welch (1809–1886) British photographer and psychiatrist. Diamond was a founding member of the Photographic Society of London in 1853 and editor of the *Journal of the Photographic Society* for a decade.

He produced his first images three months after the announcement of → William Henry Fox Talbot's invention in 1839. During the 1840s he formed a friendship with → Frederick Scott Archer, inventor of the → collodion process. Between 1848 and 1858 he worked in the Surrey County Asylum in Springfield, capturing the facial expressions of the patients. Interested in physiognomy, Diamond believed that these photographs could reveal mental deficiency and held a conference in 1856 entitled 'On the Application of Photography to the Physiognomic Mental Phenomena of Insanity'. Between 1858 and 1859 the psychiatrist John Conolly used these images to illustrate a series of articles in the *Medical Times and Gazette*, under the title 'The Physiognomy of Insanity'.

Dibbets, Jan (b. 1941) Dutch artist. Dibbets began his studies in Tilburg in the Netherlands (1959–

Roodborst territorium/Sculptuur 1969
Robin Redbreast's Territory/Sculpture 1969
Domaine d'un rouge-gorge/Sculpture 1969
Rotkehlchenterritorium/Skulptur 1969

JAN DIBBETS

Jan Dibbets, *Robin Redbreast's Territory/Sculpture 1969*

63) and then enrolled at Saint Martin's School of Art in London. In the early 1970s he began to combine photography, drawing and painting, conveying his interest in space, perception and time through illusionistic effects and montage (*Big Comet*, 1973).

DiCorcia, Philip-Lorca (b. 1951) American photographer. He studied at the School of the Museum of Fine Arts in Boston and then at Yale University. In the 1970s and 1980s, in parallel with work for various magazines, he began to photograph moments from the everyday lives of his circle of friends in an extremely detailed, almost cinematographic style. He then went to Hollywood to photograph male prostitutes, captured in a space between fantasy and reality. The importance of lighting effects and the violence of flash are exploited in his photographs of passers-by, whom he takes by surprise in the street, thus creating an impression of unreality that each viewer must interpret individually. Situated between documentary and fiction, his images transcend categorization.

Didi-Huberman, Georges (b. 1953) French philosopher and art historian. The holder of a residency at the French Academy in Rome (Villa Médicis, 1984–86) and at Villa I Tatti in Florence (the Harvard Center for Italian Renaissance Studies), since 1990 Didi-Huberman has taught at the School for Advanced Studies in the Social Sciences in Paris. His research, primarily based on the theory of images, has resulted in approximately thirty works since the publication of his first book in 1982, *L'Invention de l'hystérie*. These included the essay entitled *L'Oeil de l'histoire* (begun 2009), in which he reflected critically on the legibility of images in a world that is saturated with them.

Dieulefils, Pierre (1862–1937) French photographer. A volunteer in the army, Dieulefils travelled to Tonkin in present-day Vietnam, where he began to take photographs. In 1888 he opened a professional photography studio in Hanoi. From 1889 he exhibited his photographs of landscapes, towns, ethnic tribes and colonial construction projects at world fairs.

● D —

Philip-Lorca diCorcia, *Marilyn,
28 Years Old, Nevada, $30*, 1990–92

His considerable oeuvre included postcards, which he began to produce in 1902.

Dieuzade, Jean (1921–2003) French photographer. After being rejected by the Saint-Cyr military academy, Dieuzade turned to photography. His first → reportage, in August 1944, showed the liberation of Toulouse. His interest in Catalan religious architecture and Roman art earned him the Prix Nadar in 1961. In 1971, following a serious road accident, his photography moved towards a form of abstraction and he began to concentrate on → still-lifes. A co-founder of the Rencontre d'Arles, the first festival in France devoted to photography, Dieuzade opened the Château d'Eau gallery in Toulouse in 1974.

Digital photography A form of photography that first became widespread in the second half of the 1990s. In digital cameras, a sensor takes the

place of light-sensitive film; when a picture is taken, the image is turned into an electronic file and stored on a memory card, which can then be viewed on a computer screen or transferred to other devices. Photographs taken with a digital camera can be manipulated easily using editing software. When digital photography was first introduced commercially, there were fears that analogue photography would die out, but this did not happen since the image → resolution of early digital cameras was relatively poor. Although these issues have now been resolved, digital photography has not completely replaced its analogue counterpart: the two techniques coexist, with digital photography still seeking to define its own visual language.

Dijkstra, Rineke (b. 1959) Dutch photographer and video artist. Since the 1990s Dijkstra has achieved an international reputation for her

Rineke Dijkstra, *Odessa,*
Ukraine, August 4, 1993

series of full-length colour portraits of young people. Her most famous series, *Bathers*, shows adolescents on the beach and contrasts their awareness with their vulnerability. Other series of uncompromising and intense portraits feature mothers who have just given birth and soldiers from various forces before and during action. The concept of changes in identity brought about over time or by events is central to her work, as are the influences of → Diane Arbus and → August Sander, whom Dijkstra often quotes.

Disdéri, André-Adolphe-Eugène (1819–1889) French photographer. In the mid-19th century Disdéri was responsible for changing the direction in which photography was developing, leading it along an industrial path. After studying chemistry and physics as applied to the arts, Disdéri developed an instantaneous → collodion process, reducing exposure time to two seconds. In 1854 he popularized the photographic portrait through his innovative techniques: he replaced metal plates with glass → negatives, reduced their size (to 8.5 × 6 cm, or 3⅜ × 2⅜ in.) and invented a camera that could be fitted with four, six or eight → lenses. This equipment, eminently suitable for making multiple images, allowed for up to eight similar or different shots to be taken on the same support at a reduced cost. Disdéri thus patented the invention of the photographic → *carte-de-visite* and launched a fashion for these portraits with the opening of his studio in 1855. The director of the most prosperous establishment in Europe, Disdéri sold up to 2,400 photographs per day, achieving a record in 1859 when he produced copies of the *carte-de-visite* portraits of Napoleon III and Empress Eugénie in their tens of thousands. An official photographer to the courts of France, Spain, Great Britain and Russia, Disdéri also proposed an army photographic service to the French Ministry of War and suggested reproducing the paintings in the Louvre. In 1862 he recorded his ideas about photography in the book *L'art de la photographie*. The same year he registered a further patent for the *carte mosaïque* (mosaic card), a *carte-de-visite* showing multiple portraits of celebrities or artists. But Disdéri was a victim of his own success: he was widely imitated and,

from 1870 onwards, faced heavy competition from other photographers, dying penniless in 1889.

Disfarmer, Mike [Mike Meyer] (1884–1959) American photographer. Between the 1920s and the 1950s, Disfarmer photographed the inhabitants of the little town of Heber Springs in Arkansas. These studio portraits, which take the form of frontal views, severe in style, are a testament to the daily life of a rural community. Anonymous families, couples and individuals assume poses that are sometimes awkward: their gaze, fixed on the camera, emphasizes the austerity of the scenes.

● D —

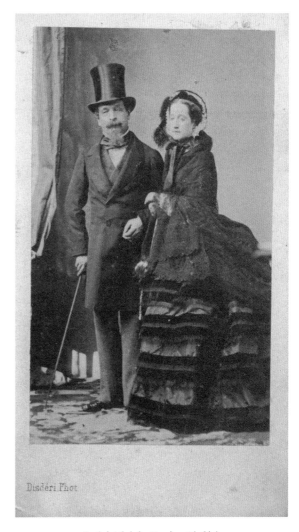

André-Adolphe-Eugène Disdéri,
*Emperor Napoleon III
and Empress Eugénie, c.* 1865

131

Dłubak, Zbigniew

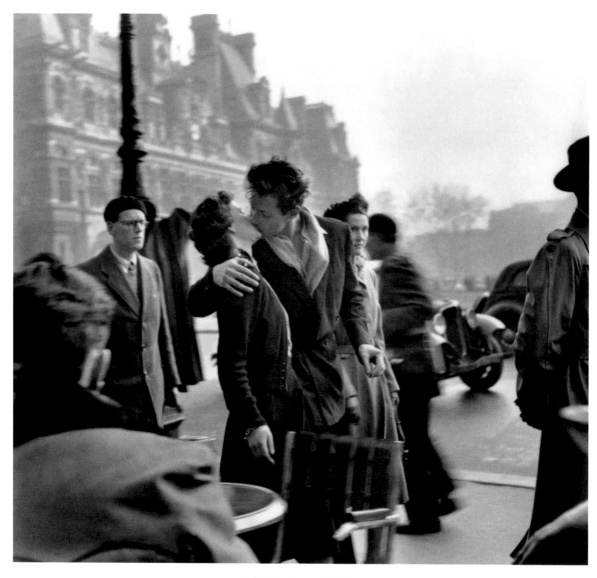

Robert Doisneau, *The Kiss
by the Hôtel de Ville*, 1950

Dłubak, Zbigniew (1921–2005) Polish photographer and painter. After World War II, Dłubak, a member of the avant-garde, experimented with the sharpness of his photographic images and produced macroscopic views and → solarizations that verged on abstraction. Over the course of decades he documented the interior of his studio, photographing objects and nudes. In 1981 he moved to France and worked on a series entitled *Asymétrie*. He also published several theoretical essays on photography. Between 1953 and 1972 Dłubak was the chief editor of the magazine *Fotografia*.

Documentary photography Any photograph that constitutes a visual record. The term may refer to images taken with a didactic or critical purpose, whose aim is to document a state of affairs, but which may be considered to possess an aesthetic value beyond their documentary function. More specifically, the term refers to a particular approach that emerged in the mid-20th century, typified by formal conventions such as clarity, frontality, centred images and static poses, and a socially or politically motivated engagement with reality. The documentary style was extremely successful

up until the 1940s and had a lasting influence on photography.

Dohnány, Miloš (1904–1944) Slovak photographer. Dohnány was born in Lienz, Austria. He was one of the first Slovak critics of photography and a leading figure in the burgeoning → amateur photography movement. His family moved to Bratislava in 1919, where he studied at the Realgymnasium and, in 1923, attended the Vocational School of the Czechoslovak Railways in Olomouc (today in the Czech Republic). He worked at the railways until his sudden death and practised photography only in his spare time. From 1932 to 1934 he pursued evening courses on photography led by → Jaromír Funke at the School of Applied Arts in Bratislava. His images, including the object studies he called 'compositions', showed Funke's avant-garde influence. Dohnány's first works were in the spirit of the → New Objectivity movement, Constructivism and modernism. He was interested mainly in technique, composition and aesthetics, and was also a notable follower of the New Photography movement, recording elements of contemporary urban life and taking modern-style portraits. He promoted the teachings of the New Photography not only through his own images, but also by taking on an active teaching role. At the beginning of the 1930s Dohnány became a member of the most significant photography association in Slovakia, the Association of Amateur Photographers YMCA in Bratislava. From 1931 to 1933 he established and wrote a regular advice column for amateurs in *Vesna* magazine, the first of its kind in Slovakia, and in 1934 he organized photography courses for film, photography and radio enthusiasts. During the 1930s he published his photographs and articles in many periodicals, including *Pestrý týden*, *Lidové noviny*, *Nový svet* and *Slovenský hlas*. For a short time in 1936 he was on the editorial board of a magazine for amateurs, *Fotografický obzor* ('Photographic View'). Dohnány's inventive talent was rare in 20th-century Slovakia. He died in a car accident in 1944.

Doisneau, Robert (1912–1994) French photographer. A graduate of the École Estienne (1926–29), Doisneau began his career as a cameraman for André Vigneau before publishing his first photo-reportage in *Excelsior* (1932) and working for Renault as an industrial photographer (1934–39). After the war he collaborated with the great magazines of the time (*Regards*, → *Life*, → *Vogue*) and joined the Rapho agency (1946) and the Groupe des xv. The author of many books, in 1949 Doisneau published *La Banlieue de Paris* with Blaise Cendrars. His international reputation was established when, alongside → Brassaï, → Henri Cartier-Bresson, → Willy Ronis and → Izis, he took part in the exhibition *Five French Photographers* at the → Museum of Modern Art, New York (1951), thus becoming one of the principal exponents of French → humanist photography. Seeking out the anecdotal and the witty, Doisneau promoted his own humorous yet melancholy vision of post-war Parisian life. Many of his most famous black-and-white images have become iconic – *The Kiss by the Hôtel de Ville* (1950), for instance – making Doisneau one of the best-known photographers to the general public.

Domon, Ken (1909–1990) Japanese photographer. One of the most celebrated Japanese photographers of the 20th century and a staunch proponent of realism, Domon began to study photography in 1933 after initially training as a painter. He specialized in portraiture at the same time as working as a studio assistant in Tokyo. From 1935 to 1939 he worked for the Nippon Kobo agency. After collaborating with other agencies and associations, he turned freelance after the end of World War II. Alongside his work on social issues, documenting the realities of the time (life for survivors of the atomic bomb in Hiroshima; the consequences of coal mine closures in Chikuho), Domon was also interested in culture. He photographed architecture – especially Buddhist temples – and took portraits of contemporary figures in the art world. He won many prizes during his career, notably the Mainichi Photography Award for his book *Hiroshima* in 1958, and the Arts Award from the Ministry of Education in 1959. From 1960 he was forced to change his working practices after health problems left him partially

• **D** —

— D •

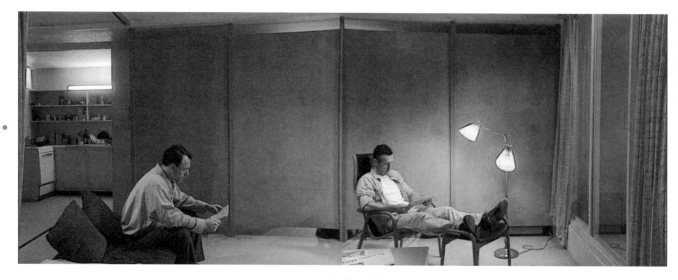

Stan Douglas, still
from *Win, Place, or Show*, 1998

paralysed, but he continued to photograph from his wheelchair. A prestigious photography award bearing his name has been presented annually since 1982.

Dondero, Mario (b. 1928) Italian photojournalist. After the war, Dondero worked for the daily newspapers *L'Unità*, *Avanti* and *Milano Sera*. He moved to Paris in 1955, becoming famous for his portraits of *nouveau roman* writers. A freelance photographer known for his political engagement, he worked on → reportage projects across the world, including Africa, South America and Russia. Influenced by → Henri Cartier-Bresson and → Robert Capa, Dondero's photography is social and humanist in character.

Donovan, Terence (1936–1996) British fashion and portrait photographer. With → David Bailey and Brian Duffy, Donovan made his mark on the Swinging London of the 1960s. After an apprenticeship as a lithographer, he became an assistant photographer at *Fleet Illustrated* then worked for the fashion photographer John French. In 1959 he opened his own studio. From 1961 until his death, he collaborated on the editorial pages of → *Vogue*. Such was his fame that he also photographed members of the British royal family, including Diana, Princess of Wales. He also pursued a career as a filmmaker.

Douglas, Stan (b. 1960) Canadian photographer, filmmaker and multimedia installation artist. He studied at the Emily Carr Institute of Art and Design, Vancouver, graduating in 1982. His work explores themes of collective memory, social alienation and racial conflict. Since 1981 Douglas has exhibited nationally and internationally. Works such as *Win, Place, or Show*, *Der Sandmann* and *Nu•tka•* challenge traditional modes of narrative filmmaking.

DPI and PPI Common terms used to measure → resolution. PPI (pixels per inch) refers to the number of → pixels to be found along a 1-inch vertical or horizontal line within a digital file, which determines the file's density and thus its output quality. If a file has too few pixels per inch, individual pixels will become visible to the naked eye, producing jagged-looking low-quality prints. DPI (dots per inch) refers to the number of dots of ink produced by a printer on a sheet of paper. High DPI values will allow more dots of ink per inch and, by extension, a broader, smoother range of colours and a higher quality.

Drahos, Tom (b. 1947) Czech-born French photographer. Drahos learnt photography from → Josef Sudek before studying film in Paris. Using a multimedia approach, he experiments with the physical presence and materiality of

photographs. His photographic installations, large-scale → Cibachrome prints and CD-ROM works are inspired by video, theatre, dance, sculpture, literature and digital technologies. Their subjects range from Indian Jainism to the Avenue des Champs-Elysées, Paris. Drahos's work was included in the 11th Paris Biennale in 1980.

Draper, John William (1811–1882) English-born American photographer, scientist, philosopher, physician, chemist and historian. He emigrated to the United States in 1832. After improving on → Louis Daguerre's process, he became the first to create a clear photograph of a female face (1839–40), detailed photographs of the moon (1840) and the Great Nebula of Orion (1880), and the first images of ultraviolet rays, infrared rays and the solar spectrum. Draper was the first president of the American Chemical Society (1846) and a founder of the New York School of Medicine, where he became president in 1850. While he was a professor of chemistry at New York University in 1840, he and Samuel F. B. Morse established one of the world's first portrait studios on the university's roof. Draper published *Remarks on the Daguerreotype* (1840), *On the Process of Daguerreotype and its Application to taking Portraits from the Life* (1840) and many scientific textbooks.

Drégely, Imre (b. 1960) Hungarian photographer. Drégely's approach is to combine different photographic media to create → collages and fractal compositions, → sequences and matrices. His work pays homage to the aesthetics and philosophy of Pop and Op Art. He creates multi-layered, absurd and futuristic images from photographs of the environment and everyday objects. His exhibitions have included *Monoszkóp* (Budapest, 2006), *Photomatrix* (London, 2008) and *Távmérő* (Eger, 2012), and he has published in *Silvershots* magazine (2008). He received the Rudolf Balogh Prize in 2007. Drégely currently teaches at the Moholy-Nagy University of Art and Design, Budapest.

Drtikol, František (1883–1961) Czech photographer. Although he wanted to study painting, Drtikol was encouraged by his father to train as a

photographer. He served an apprenticeship with a local photographer and spent two years studying at the Institute of Teaching and Photographic Research in Munich. He opened his own studio in Prague, establishing a reputation for his portraits of local figures. At the same time he focused on the female nude, a theme he continued to address throughout his career. Highly innovative, these images reflected Drtikol's principal sources of inspiration, namely literature, dance, and artistic movements including Symbolism and Art Nouveau. They also show how his photography developed: after 1923, for example, it displayed some of the ideals of the Czech avant-garde, such as a taste for geometric compositions and the rejection of → Pictorialist techniques in favour of → straight photography. Although the quality of his work was widely acknowledged and he received several awards, Drtikol lost interest in photography. He sold his studio in 1935 and

● **D** —

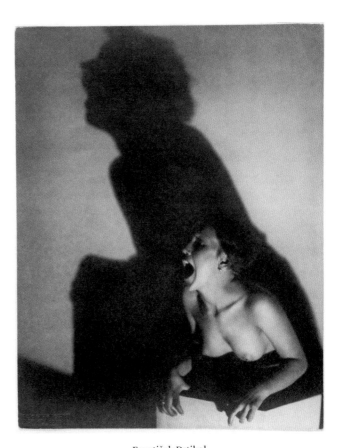

František Drtikol,
Vykrik Noci, c. 1927

135

subsequently dedicated himself to spiritual issues as well as painting.

Dry-plate process A major 19th-century development in photography, the dry-plate process was first marketed in 1880 and would come to replace the → collodion process. Earlier photographers had to be equipped with portable laboratories because they needed to prepare wet-collodion plates immediately before use. In 1871 Richard Leach Maddox replaced collodion with a → gelatin solution that held silver bromide in suspension. This light-sensitive layer could be applied to a plate and left to dry. From that point on, photographers were able to prepare their plates in advance. More sensitive and more convenient than wet collodion, gelatin silver bromide was further refined during the 20th century and led to the rise of mass-market photography, placing the medium within the reach of amateurs for the first time.

Du Swiss cultural monthly magazine, founded in 1941 in Zurich by Arnold Kübler, the former chief editor of the *Züricher Illustrierte*. Renowned for its thematic supplements and the prominent position it accorded to photography and reproductions of works of art in general, the magazine attracted many celebrated photographers (including → Werner Bischof, → René Burri and → Marc Riboud) and soon earned an international reputation.

Du Camp, Maxime (1822–1894) French journalist, photographer and man of letters. Between 1849 and 1851 Du Camp travelled in Egypt and the Near East, accompanied by his friend Gustave Flaubert. With the aim of publicizing his

Maxime Du Camp, *Cairo,
Mosque of Sultan Kansou el-Gouri*, 1852

project, he became interested in photography and requested the French Ministry of Public Education to back an archaeological mission. Prior to his departure he learnt the techniques of photography from → Gustave Le Gray. This was Du Camp's only foray into the medium, but he returned from his travels with 214 paper → negatives, 125 of which were published in the form of an album, *Égypte, Nubie, Palestine et Syrie, dessins photographiques recueillis pendant les années 1849, 1850, 1851*, published by Gide & Baudry in 1852. This work established him as one of the first photographic reporters.

Duchenne de Boulogne, Guillaume-Benjamin
(1806–1875) French scientist. A renowned neurologist, Duchenne de Boulogne discovered the importance of photography in documenting scientific experiments. In 1852 he studied the contraction of the facial muscles using electrotherapy. Photography, which he had learnt from → Nadar, enabled him to formulate an accurate typology of expressions. He believed that each facial muscle signified an emotion and considered the photographic portrait a faithful mirror of 'the signs of the silent language of the soul'. By using electricity and photography, Duchenne de Boulogne adopted the cutting-edge technologies of his time to investigate the body. The results appeared in his book *Mécanisme de la physionomie humaine, ou Analyse électro-physiologique de l'expression des passions* (1862). His work gave rise to the development of several other photographic methods of documentation.

Ducos du Hauron, Louis Arthur (1837–1920) French pioneer of → colour photography. The colour process had already been partially explored by Henri Becquerel (1848), → Claude Félix Abel Niépce de Saint-Victor (1851), James Clerk Maxwell (1861) and → Alphonse Louis Poitevin (1865). In 1859 du Hauron began to devote his time and energy to the question of colour photography. The heliochrome process he developed reproduced colours by means of three → filters (green, purple, red/orange) or the superimposition of → negatives printed in red/orange, blue and yellow. On 7 May 1869, the day

Guillaume-Benjamin Duchenne de Boulogne and Adrien Tournachon, illustration from the *Mécanisme de la physionomie humaine* (1862)

on which he presented his invention of trichrome photography by the → subtractive method to the → Société Française de Photographie, Charles Cros publicized his own research. Cros had arrived at the same conclusions and claimed precedence as far as scientific recognition was concerned. In 1869 du Hauron published *Les couleurs en photographie et en particulier l'héliochromie au charbon*, which included some of his own experiments. In 1864 he had invented a complex camera intended to capture movement. Using a 'transforming' camera with diaphragm pierced by a slit that could be moved in different ways, he created distorted images, including caricatures of his own face. In 1891 du Hauron also developed the anaglyph: a process that resulted in images with a three-dimensional appearance. His contribution to the development of colour photography was recognized by the French government, who awarded him the title of Chevalier of the Légion d'Honneur in 1912.

Dührkoop, Rudolph (1848–1918) German → Pictorialist photographer. He worked initially as a railway employee and salesman but opened a photographic studio in 1883. He was active as a portrait photographer and, like his non-professional counterparts, favoured nature as a subject matter. He also specialized in theatre and dance photography, and belonged to the → Brotherhood of the Linked Ring and the British → Royal Photographic Society, among other associations. His work was included in the German journal *Die Kunst in der Photographie*, edited by Frank Goerke.

Duncan, David Douglas (b. 1916) American photographer. After studying archaeology, zoology and Spanish at the universities of Arizona and Miami, Duncan became a freelance photographer. In 1943 he enrolled in the US navy, marking the beginning of his career as a war reporter. From 1946 he worked for → *Life*. During this period he covered many conflicts, including the Korean War. His images of Korea were published in 1951 under the title *This is War!* In 1956 Duncan once again became a freelance photographer and published many books. That same year he began to document the life and work of Pablo Picasso – a project that would last seventeen years, until the artist's death.

Dupain, Max (1911–1992) Australian photographer. Dupain took up photography in 1924 when his parents gave him a camera. He trained at the Photographic Society of New South Wales in Sydney. Between 1930 and 1934 he worked as assistant to Cecil Bostock, one of the great figures

Louis Arthur Ducos du Hauron,
View of Agen showing the Cathedral of St Caprais, 1877

• **D** —

in Australian → Pictorialist photography. He was also interested in → commercial photography, graphic design and illustration. Dupain opened his own studio in Sydney in 1934. His pictures show the daily life of the city's middle class, particularly hobbies and leisure activities based around the sea. He produced carefully composed documentary images devoid of any social comment. In the 1950s Dupain began to devote more time to more commercial photography, working for advertising agencies and industrial clients and also photographing architecture.

Duplicate (dupe) A copy of a → positive or → negative image, made in the same size, and with the same polarity, as the original. A dupe is different from a reprint because it is not taken from the original negative. In the fields of archiving and conservation, duplicates often take the place of damaged originals, thus preventing further damage through handling. They can also be incorporated into the creative process.

Durand, Régis (b. 1941) French art critic. A specialist in literature, in the 1980s Durand turned his interest to contemporary art and photography in particular. After a period at the Ministry of Culture (1993–96), he became director of the Centre Nationale de la Photographie (1996–2003) and of the Jeu de Paume (2003–06). The curator of many exhibitions and the organizer of the Cahors photography festival, he has also written four books reflecting on the photographic image from a critic's point of view and drawing on work on Michel Foucault, → Walter Benjamin and → Jean-Marie Schaeffer. His writings set out the debates that have animated the photographic scene over the last three decades and aim to describe the singularity of the photographic experience.

Durandelle, Louis-Émile (1839–1917) French photographer. The proprietor of a photography studio from 1860, which he shared with Hyacinthe-César Delmaet, Durandelle received commissions from the government departments of the Second Empire and the Third Republic. Specializing in architectural photography, the

David Douglas Duncan, *Captain Ike Fenton, Commanding Officer of Baker Company, 1st Battalion, 5th Marine Regiment, 1st Provisional Marine Brigade, Receives Reports of Dwindling Supplies during the Battle to Secure No-Name Ridge along the Naktong River, Korea*, 1950

studio followed the construction of the Opéra Garnier in Paris (1865–72), the restoration of Mont Saint-Michel, and the construction of the Bibliothèque Nationale, the Sacré-Cœur (1877–90) and the Eiffel Tower (1887–89). Durandelle's name is often mentioned on its own, and very little is known about his collaboration with Delmaet. Following the latter's death in 1862 Durandelle married his wife, Clémence, with whom he worked in partnership. When she died in 1890, Durandelle gave up his long photographic career.

Duroy, Stéphane (b. 1948) French photographer. A member of the Vu agency, Duroy gave up photojournalism in order to pursue a more personal path. He is interested in memory and the traces left by history, particularly in Germany, Eastern Europe and France – a journey he recounts in *L'Europe du silence* (2000). Calm and poetic, his images offer a behind-the-scenes view

Louis-Émile Durandelle, *Eiffel Tower,*
September 1888

of history in both black and white and soft, often
monochrome colours.

Düsseldorf School Photography movement
closely linked to the Kunstakademie in
Düsseldorf. Already in the vanguard thanks to
Joseph Beuys, who taught there, from the late
1970s the Kunstakademie was the setting for
a radical new aesthetic that would have a major
influence on contemporary → art photography
worldwide. The teaching of → Bernd Becher,
who held the chair of photography at the
Akademie from 1976 to 1996, and other favourable
circumstances allowed for the emergence of
a whole generation of photographers who would
achieve great success and whose works helped
establish photography's status in museums and
on the art market. The distinctive work produced
by Bernd Becher and his wife, Hilla – based on
a typology of industrial buildings and influenced
by both → New Objectivity (Neue Sachlichkeit)
and → conceptual art – was already celebrated
when Bernd took up his teaching post. His
students followed the same path, aiming at
technical perfection in the service of a cold and

objective worldview, and often choosing → series
over individual images. One of the movement's
most representative figures is → Andreas Gursky,
whose work is characterized by the use of very
large formats. His art has received unprecedented
international acclaim and has achieved record
prices on the art market, thus increasing the
recognition of the Düsseldorf photographers.
→ Candida Höfer, → Thomas Ruff, → Thomas
Struth and → Petra Wunderlich are also key
practitioners of the Düsseldorf School, while
the second generation includes → Jörg Sasse,
→ Elger Esser, → Laurenz Berges, → Axel Hütte
and Simone Nieweg. None of these
photographers acknowledges membership of
a movement, and the label does not take into
account the notable differences in form and
content. Nevertheless, they share a particular
vision of the world, at once realist and reflective,
and sometimes tinged with cynicism, but often
also poetic and melancholy.

Dye transfer Dye transfer, or dye imbibition,
is a → subtractive colour assembly process based
on the principle that → gelatin can soak up
and release dye. Three separation → negatives
are made from a colour transparency; each is
translated through an → additive colour → filter
and then printed onto a separate sheet of matrix
→ film. When processed, the matrices' gelatin
→ emulsion selectively hardens in proportion
to the level of light exposure, resulting in a
low-relief image. Each matrix is then soaked in
a corresponding subtractive colour dye. One at
a time the soaked matrices are placed in register,
and the dye is transferred to a gelatin-coated
receiving paper, creating a full-colour image.
The process was popular in the advertising
and fashion industries in the 1940s and 1950s.
It was utilized by documentary photographers
in the late 1950s and 1960s, and by artists from
the 1970s.

E

Eakins, Thomas (1844–1916) American painter.
Interested in the study of anatomy, Eakins
founded his art on scientific principles.
He drew inspiration from professional
photographs and those he took himself, using
them in his paintings. At the Pennsylvania
Academy of the Fine Arts, where he became
a professor in 1876 and director in 1882, he
encouraged his students to use nude models
(advice that would lead to his dismissal in 1886).
Fascinated by human locomotion, he made
contact with → Eadweard Muybridge, who had
been concentrating on this theme since 1877.
Eakins persuaded the University of Philadelphia
to provide him with equipment that enabled
a photographer to carry out a systematic study
of humans and animals in motion. Following
the technique established in France by
→ Étienne-Jules Marey, Eakins took instantaneous
photographs using fast shutter mechanisms
and also developed his → chronophotograph,
which allowed different phases of movement
to be captured on the same plate. These
experiments prefigured cinematography by
several years.

Eastlake, Elizabeth [née Elizabeth Rigby]
(1809–1893) British author and photographer.
She was known for her reviews of the visual arts
and photography in the *Quarterly Review*, having
discovered the → calotype process in → Hill and
Adamson's studio in 1843. On her marriage
to Sir Charles Eastlake, director of the National

Thomas Eakins, *Study in Human Motion, c.* 1885

Harold Edgerton,
Milk-Drop Coronet Splash, 1936

Gallery, in 1849 she became Lady Eastlake. In 1857 she published an influential article, entitled 'Photography', on the relationship between the medium and the fine arts.

Eastman, George (1854–1932) American industrialist. A manufacturer of dry plates in Rochester, New York, Eastman simplified the photographic process and in 1888 launched a hand-held camera activated by the pressing of a button. Christened the 'Kodak', it sold for \$25 and came with a 100-exposure roll of → film. Once the last shot had been taken, the owner returned the camera to the manufacturer and received his or her → prints in return, along with the same camera pre-loaded with new film. Eastman developed → emulsion-on-celluloid roll film that was wound on a reel and layered with black backing paper. The Eastman Kodak Company acquired an international reputation

and, in 1900, produced a camera that was even easier to use: the Brownie. Photography now became accessible to millions of people across the world, who began to use it to record significant moments in their lives.

École Nationale Supérieure de la Photographie, Arles (ENSP) The only national higher educational school in France devoted to photography, founded in 1982 on the initiative of the Rencontres Internationales de la Photographie festival in Arles. Alain Desvergnes set up its teaching programme with the aim of creating 'image-aware people', offering students a multidisciplinary training in all areas relating to photography, including technical, theoretical and artistic. The school in Arles has influenced French → landscape photography, established the photographer as author and artist, and created generations of professionals active in all areas of photography.

Eder, Josef Maria (1855–1944) Austrian chemist. Eder became interested in photography through the scientific experiments he carried out at the end of the 19th century, which were dedicated to the study of optical and chemical phenomena. He made a name for himself through his X-ray → photogravures and his numerous publications, including his *Geschichte der Photographie* ('History of Photography'), which appeared in 1905. Eder co-founded the Institute of Graphic Design in Vienna in 1888 and taught there for thirty years.

Edgerton, Harold Eugene (1903–1990) American scientist and photographer. Edgerton graduated in electrical engineering at the University of Nebraska (1925), gaining a master's degree (1927) and then a doctorate (1931) at the Massachusetts Institute of Technology, Cambridge. At MIT, where he was appointed professor in 1948, he developed the stroboscope, which permitted the observation of phenomena invisible to the human eye. Using extremely fast electronic flashes emitted at regular intervals, Edgerton was able to capture images such as the splash of a drop of milk, the impact of a bullet shot through an apple or the trace of an athlete's

movements. Edgerton's invention was related to the research conducted by the 19th-century photographers → Thomas Eakins, → Étienne-Jules Marey and → Eadweard Muybridge.

Edinger, Claudio (b. 1952) Brazilian photographer. Edinger became recognized in the field of contemporary photography following his first solo exhibition at the Art Museum in São Paulo. From 1996 until 2000 he lived in New York, where he produced → reportages and → photographic essays for periodicals including *Folha de São Paulo*, *Time*, *Newsweek* and → *Life*. Whether in black and white or colour, his work is characterized by its use of wide angles.

Eggleston, William (b. 1939) American photographer. Born in Memphis, Tennessee, Eggleston grew up on a cotton plantation in Mississippi. In 1957 he acquired his first camera,

then bought himself a → Leica the following year. His early photographs in black and white show the influence of → Walker Evans and → Henri Cartier-Bresson. In 1965 and 1966 he carried out his first experiments with colour print film, then with colour slides. Everyday life in the southern United States became the subject of his photographs. In 1967 he met → Diane Arbus, → Lee Friedlander and → Garry Winogrand in New York, who encouraged him to show his work to → John Szarkowski, director of the department of photography at the → Museum of Modern Art in New York. According to Szarkowski, Eggleston was the first to master the constraints of colour photography. In 1976 Szarkowski offered him his first major exhibition at the museum, *William Eggleston's Guide*, in which he included seventy-five images taken between 1969 and 1971 with colour slide film. Until then, colour had been restricted to amateur, advertising and fashion

William Eggleston, *Untitled*
('The Red Ceiling', Greenwood, Mississippi), 1973

— E •

Alfred Eisenstaedt, *V-J Day
in Times Square*, 1945

photography. With Eggleston, it came into the museum and achieved artistic recognition. Between 1973 and 1974 he taught at Harvard and discovered → dye transfer printing. This was the process he chose to print his famous image *Red Ceiling* (1973). In 1974 he was awarded a Guggenheim Fellowship, and in 1983 he was invited to photograph Elvis Presley's former home, Graceland. Other assignments have taken him to Kenya, China, Japan, Russia and Mexico.

Eisenstaedt, Alfred (1898–1995) German-born American press photographer. Born in Dirschau, West Prussia, he moved to Berlin with his family in 1906. From 1929 until he fled Nazi Germany for the United States in 1935, Eisenstaedt captured the politics of Europe in the lead-up to World War II. His work includes a stark photograph of the Nazi propaganda minister Joseph Goebbels in 1933, and the first meeting between Hitler and Mussolini in 1934. In Germany he published in the *Berliner Illustrirte Zeitung* and *Weltspiegel*, among other periodicals. In the United States, Eisenstaedt was hired as one of the four original → *Life* staff photographers in 1936. On the staff of *Life* for four decades, he published 90 covers and worked on 2,000 assignments. He is remembered for his early use of the miniature camera and his preference for natural light, and is often referred to as the father of → photojournalism.

Eliasson, Olafur (b. 1967) Danish-Icelandic artist. He studied at the Royal Danish Academy of Fine Arts in Copenhagen (1989–95). His work, which involves architecture, sculpture and photography, is planned from his studio in Berlin. Ceaselessly interested in light and visual effects that alter perception, such as in *The Weather Project* (2003), he develops works *in situ* to exploit the exhibition space as an essential source of inspiration.

Elk, Ger van (1941–2014) Dutch artist. Van Elk studied art history, first in Los Angeles and then in Groningen, the Netherlands, from 1961 until 1966. Through photography and painting he developed critical ideas surrounding the art of the 17th century, and especially Dutch genre painting. His work challenges the codes that govern images in order to highlight their

artificial nature. Accentuating the materiality of photographs, he played with ideas of symmetry and perspectival distortion, sometimes using paint to gradually obscure his images.

Elsken, Ed van der (1925–1990) Dutch photographer and film director. Born in Amsterdam, Van der Elsken studied to be a sculptor before he turned to photography. Between 1950 and 1955 he lived in Paris, where he mixed with and photographed a group of young dropouts who frequented the cafés in Saint-Germain-des-Prés. → Edward Steichen showed a selection of these photographs in the exhibition *Post-War European Photography* at the → Museum of Modern Art, New York (1953). Van der Elsken published *Love on the Left Bank* in 1956, which was remarkable for its film-like design, narrative thread and successful portrayal of the post-war spirit. His resolutely subjective approach and the attention he gave to

• E —

Olafur Eliasson, *The Unilever Series: Olafur Eliasson, The Weather Project*, 2003–04

E •

Peter Henry Emerson, *A Dame's School*,
from *Pictures from Life in Field and Fen* (1887)

each individual were hallmarks of all his work, whether travel reports, books (*Bagara*, 1958; *Jazz*, 1959; *Eye Love You*, 1977; *Hallo!*, 1978) or films.

Emerson, Peter Henry (1856–1936) British writer and photographer. Born in Cuba, he spent his early years in the United States before moving to England in 1869. Emerson studied medicine and was interested in the natural sciences and the history of art. He used photography in his study of birds. A lover of the countryside, in 1885 he devoted himself entirely to photography in order to capture landscapes and rural life. These images were published in his book *Life*

and Landscape on the Norfolk Broads (1886). Emerson advocated a type of photography that was immediate and free of → retouching, convinced that it could express artistic truth. The founder of the London Camera Club, in 1889 Emerson formulated his ideas in *Naturalistic Photography for Students of the Art*, in which he affirmed photography's place among the fine arts. Influenced by Hermann von Helmoltz's theories on human vision and by naturalist painting, especially artists such as Jean-François Millet and Jean-Baptiste-Camille Corot, Emerson developed an aesthetic approach to photography that was akin to Impressionism. Although he

was a spokesman for naturalist photography during the 1880s, he later began to question the medium's artistic potential on account of its technical limitations. In 1890 he published *The Death of Naturalistic Photography*, and from that point on accepted retouching and other types of manipulation. Two years later, having helped found the → Brotherhood of the Linked Ring, he was acknowledged as the precursor and spiritual father of → Pictorialism. In 1900 he ceased to exhibit or publish new works, though he continued to practise photography.

Emulsion In photographic terms, a light-sensitive coating on paper, → film, plate or other support, containing a silver compound suspended in → gelatin or other type of colloid. Commercial gelatin silver photographic emulsions were first introduced in 1874, but as they improved in quality they became popular for both photographic → negatives and → prints.

Engström, J. H. (b. 1969) Swedish photographer. A graduate of Gothenburg University, he began his photographic career as an assistant to → Mario Testino and → Anders Petersen. Engström's second book, *Trying to Dance*, which featured a stream-of-consciousness sequence of autobiographical photographs, was released to considerable critical acclaim in 2004. *Haunts* (2008), his next title, continued the autobiographical impulse and established his reputation as a leading contemporary photographer.

Eperjesi, Ágnes (b. 1964) Hungarian photographer. She graduated in photography at the Hungarian Academy of Crafts and Design in 1991 and achieved a doctorate at the Hungarian Fine Arts Academy in 2010. Having concentrated on → photograms in her early career, she later began to experiment with photo-manipulation, which remains characteristic of her work and straddles the borderline between graphic design and photography. She uses her images to explore typically female themes, ranging from housework to the problems of choosing a partner. Eperjesi often combines decorative visual elements with typographical motifs. Her important works

include *Newborns* (1996), *Busy Hands* (2000/2002), *Family Album* (2004), *There Will Always Be Fresh Laundry* (2009) and *Colour Matters* (2010).

Erfurth, Hugo (1874–1948) German photographer. A student at the Dresden Academy of Art from 1892 to 1896, Erfurth began working as a portraitist. A skilful handler of natural light and adept in the technique of → oil pigment printing, he seemed to comprehend the psychology of his sitters intuitively. Erfurth was to photograph many artists, including Paul Klee and Oskar Kokoschka. Much of his work was destroyed during World War II.

Errazuriz, Paz (b. 1944) Chilean photographer. A co-founder of the Asociación de Fotógrafos Independientes (AFI), Errazuriz has worked with the magazine *Apsi* as well as several press agencies. Self-taught, she attended the International Center of Photography in New York in 1993. Since the 1980s her images have had a social dimension and are aimed at highlighting her country's minorities and marginalized communities. Her portraits, which are exhibited worldwide, have won many awards.

Erwitt, Elliott [Eli Romano Ervitz] (b. 1928) French-born American humanist press photographer. Erwitt spent his childhood in Italy before emigrating to the United States in 1941. He studied at the Los Angeles City College and the

Elliott Erwitt, *Paris*, 1989

New School for Social Research, New York, in the late 1940s. He photographed for the US Army Signal Corps in Germany and France between 1951 and 1953. In 1953 he joined the → Magnum photography agency. Freelance work included projects for *Collier's*, *Look* and → *Life*, among others. Erwitt's images infuse the everyday with a unique sense of humour and irony; his street-life photographs of people and their pets, for instance, turn the banal into the extraordinary.

Escher, Károly (1890–1966) Hungarian photographer and specialist writer. From 1909 he worked as a draughtsman. During the Hungarian Soviet Republic of 1919, he became a cameraman and stills photographer for feature films. Owing to a crisis in silent-movie production, his interest turned towards photographs. From 1928 Escher worked as

a photojournalist for different newspapers, including *Est*, *Híd* (from 1939), *Film-Színház-Irodalom*, *Képes Világ* and *Hungarian Foreign Trade*. He worked in different genres but is known primarily as a photojournalist, combining objectivity with a characteristic, highly individual visual language. Escher's photographs capture both drama and humour. He produced portraits of the famous people of his age, such as the painter Gyula Derkovits, Walter Gropius and the Prince of Wales. In 1964 Escher received the highest award of the International Federation of Photographic Art (FIAP).

Espino Barros y Rebouche, Eugenio (1883–1978) Mexican photographer. Espino Barros began his career in 1900 while working at the Buenavista railway station. He set up a studio in Tuxpan in 1929. The following year he moved to the town of Nuevo León and founded a

Elger Esser,
Sacramento River, 2007

company, Los Panoramas de México. At the beginning of the 1960s he settled in Puebla and worked as a documentary photographer for companies including Hysla, Volkswagen and the American Photo Company, for which he created → photomurals. In 1974 he returned definitively to Monterrey, and the following year received an award from the Professional Photographers of America for the technical and artistic excellence of his work. Espino Barros was also the first photographer to receive an award established by the Mexican Society of Professional Photographers.

Esser, Elger (b. 1967) German photographic artist. Raised in Rome, Esser studied at the Kunstakademie Düsseldorf from 1991 to 1997 with → Bernd Becher. He taught photography at the University of Arts and Design in Karlsruhe from 2006 to 2009. His atmospheric architectural views and land- and seascapes possess a contemplative, timeless beauty. Through his sophisticated application of both 19th-century and modern photographic techniques, Esser's images are often referred to as anachronistic, exhibiting both nostalgic romanticism and documentary objectivity.

Ethnology and photography Just as the medium of photography was being presented to the world, a new learned society was also taking its first steps: the Société Ethnologique de Paris. The new science of ethnology and → Louis Daguerre's invention appeared to have many things in common. Both offered representations of the 'other' and were careful observers of the world. It was only natural that photography should become one of the ethnologist's tools. Photographers were often called upon to carry out ethnographic work, and travellers, the armed forces and missionaries supplied other images that were used for research. Its detractors maintained that photography was dangerous, since it never made sense on its own and ignored the important question of context. Nonetheless, ethnographic photographs soon entered the collections of universities, museums and learned societies, while illustrated books and articles confirmed the important role

Frank Eugene,
Adam and Eve, 1910

that photography had to play in the field of ethnographic research.

Eugene, Frank [Frank Eugene Smith] (1865–1936) American photographer. Eugene was a prominent → Pictorialist and an educator in photography. A founding member of the → Photo-Secessionists and a member of the → Brotherhood of the Linked Ring, he was known particularly for his painterly style and his hand-worked negatives. In 1901 Eugene moved to Germany, where he began to teach Pictorial photography in Leipzig, eventually assuming one of the first professorships in photography.

Evans, Frederick H. (1853–1943) British photographer. In 1885 poor health forced Evans from his profession as a bank clerk into bookselling. He met many important figures

— E •

through the trade, such as George Bernard Shaw, Arthur Symons and Aubrey Beardsley, whom he photographed. In 1898 he retired from bookselling to devote more time to his photographic work. Known primarily for his exquisite architectural photographs of English and French cathedrals, Evans also produced portraits and landscapes. In 1900 he was elected a member of the → Brotherhood of the Linked Ring, and between 1902 and 1905 he designed and hung the annual Photographic Salon. Evans was considered a purist for advocating → straight photography at a time when manipulated images were popular. In 1903 he was the first British photographer to be included in → *Camera Work*, which devoted an issue to his architectural images. A prolific writer, he contributed articles to photographic periodicals such as → *Amateur Photographer*, *Camera Work* and *Photography*. Evans received a roving commission from *Country Life* and contributed photographs to the magazine between 1904 and 1912.

Frederick H. Evans, *Stairway to the Chapter House, Wells Cathedral*, 1903

Evans, Walker (1903–1975) American photographer. Born in St Louis, Missouri, Evans studied literature and languages with the intention of becoming a writer. From 1926 to 1927 he attended the Sorbonne in Paris before settling in New York, where he met his mentor, Lincoln Kirstein, the director of the magazine *Hound & Horn*. Self-taught, Evans began his career with assignments that enabled him to refine his documentary style. He covered the whole of the United States, taking an interest in architecture, everyday objects, advertising billboards and portraits. In 1931 he photographed Victorian architecture with Kirstein and John Brooks, for a series that was exhibited at the → Museum of Modern Art, New York, in 1933. Between 1935 and 1937 he worked for the → Farm Security Administration (FSA) but went against Roy Strycker's directives, turning his back on any form of political engagement and producing an unbiased survey of Americans and their environment. In 1938 the Museum of Modern Art, New York, exhibited some of the photographs he had taken for the FSA in show entitled *Walker Evans: American Photographs*. The accompanying catalogue, which featured an essay by Kirstein, would prove a milestone in the history of photography and was subsequently reprinted three times. Alongside his commissioned work, Evans began a fruitful collaboration with → *Fortune*, subsequently joining the magazine as its picture editor between 1945 and 1965. His book *Let Us Now Praise Famous Men* (1941), which followed the lives of three sharecropping families, was the result of an assignment for *Fortune*. From 1938 to 1941 Evans produced a series of portraits taken on the New York subway, which he published in 1966 under the title *Many Are Called*. He worked for *Time* magazine as a writer between 1943 and 1945. In 1965 he became a professor of photography at Yale University. In 1971 the Museum of Modern Art, New York, staged a retrospective of his work.

Experimental photography It was thanks to experimentation that photography was invented in the first place, and throughout the 19th century experiments with new techniques laid the foundation for the

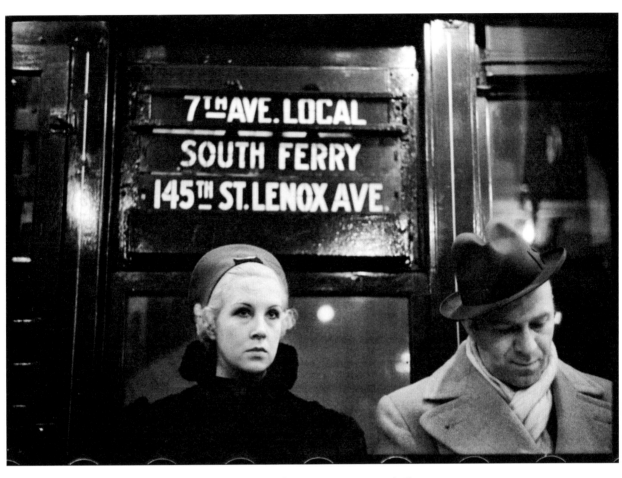

• E —

Walker Evans, *Subway Passengers, New York City: Woman and Man Beneath '7th Ave. Local' Sign*, 1938

medium's development. However, experimental photography truly began only after the technology had become established. For the avant-garde, it became a tool for questioning the dominant approach of realistic representation, as demonstrated by the work of → Christian Schad, → Man Ray, → Raoul Ubac and others, who created → photograms and used the techniques of → solarization, montages and → overexposure. At the end of the 20th century, following a lull, experimental photographers – especially → Vilém Flusser and → Franco Vaccari – increasingly focused their attention on their equipment rather than the subject. Contemporary experiments explore the different parameters of photography: the camera (Steven Pippin, → Miroslav Tichý), including the → pinhole camera, → lenses and perspective (→ Garry Fabian Miller and → Floris Neusüss), time (→ Paolo Gioli), → film (Silvio Wolf,

Alison Rossiter) and chemical techniques (Pierre Cordier, → Nino Migliori). By pushing the limits of the apparatus and materials they use, these photographers deconstruct the process of photography in order to reveal and express the medium's true essence. Experimentation with the photographic process continues with digital photography, as software is used to manipulate the image and thus modify the representation of reality.

Exposure The amount of light that is allowed to reach a light-sensitive surface. In the case of → film, the → latent image thus formed remains invisible until it is developed.

151

F

*f.*64 *see* **Group *f.*64**

Faas, Horst (1933–2012) German photojournalist
and photo editor. He produced his most famous
→ reportage work in Vietnam, where he acted
as the Associated Press's chief photographer
for South-East Asia. After being paralysed in a
grenade attack, he worked as a picture editor and
earned a reputation for publishing controversial
images. He wrote several books, among them
Requiem, featuring the work of photographers
who were killed in Vietnam. Faas won the
Pulitzer Prize twice.

Facio, Sara (b. 1932) Argentinian photographer.
She worked in the studio of Luis D'Amico
from 1957, joining Alicia D'Amico's studio in
1960. Facio is known for her many black-and-
white portraits of important figures from both
Argentina and abroad.

Faigenbaum, Patrick (b. 1954) French
photographer. Families and genealogy lie
at the centre of Faigenbaum's work, and he
uses photography to describe physiognomies
and capture likenesses. In the early 1970s he
focused on portraying the human figure, taking
portraits of those close to him. At the beginning
of the 1980s he travelled to Italy several times,
photographing descendents of the illustrious
families who had made their mark on the Italian
Renaissance. He began in Florence in 1983 and
continued to Rome, where he photographed
busts of Roman emperors from the collections
of the Vatican and the Capitoline Museums;
the project was called *Vies parallèles*, after the
series of biographies by the Greek historian
Plutarch.

Family of Man, The Exhibition organized in
1955 by → Edward Steichen, the director of the
department of photography at the → **Museum
of Modern Art** in New York. The photographer
Wayne Miller and his wife helped Steichen
to select the images, and the architect Paul
Randolph designed the exhibition. A total
of 503 images (mainly documentary) from
68 different countries presented a portrait
of humanity in which each individual shared
the same concerns as his fellow human

being. Steichen skilfully orchestrated a three-dimensional set for the exhibition that was designed to elicit an immediate emotional response in the spectator. Conceived as a journey, the exhibition showed the cycle of life. To Steichen, photography was a means of mass communication capable of drawing large crowds; → *The Family of Man* attracted 250,000 visitors in New York, and between 7 and 9 million visitors in 37 other countries over the next seven years. Since 1994 a restored version of the travelling exhibition has been on show at the Château de Clervaux in Luxembourg. In 2003 the collection of images was listed on the UNESCO Memory of the World Register. The original edition of the exhibition catalogue has been reprinted regularly since 1955.

Farkas, Antal Jama (1960–2012) Hungarian photographer. He studied photography at the Hungarian Academy of Crafts and Design, graduating in 1989. Farkas's style was determined by his interest in painting; he created still-lifes, portraits, nudes and interiors in wholly analogue works that concerned the relationship between reality and fiction. He played with perspective to create an atmosphere of uncertainty, and employed specially prepared objects, mirrors and even structures made of decomposing organic materials in his photography, all without the use of manipulation. Sometimes his titles included touches of humour. His biographical monograph, *Munkakönny* (2007), is completely self-designed. Farkas received the Rudolf Balogh Prize in 2007.

Farm Security Administration The Farm Security Administration (FSA) was established in 1935 in the United States under President Franklin D. Roosevelt. Its purpose was to aid relief efforts following the 1929 stock market crash. Through Roosevelt's New Deal programme, the government hoped to help farmers suffering from the economic effects of the Depression by creating group farms for more efficient farming efforts. Under the direction of → Roy Stryker, photographers were employed by the FSA to document the devastation faced by these American citizens, and their resettlement

experiences. This was the first government organization to publicly fund the documentation of American life. Photographers who worked with the FSA included → Dorothea Lange, → Walker Evans, → Arthur Rothstein, → Russell Lee, → Marion Post Wolcott, → Jack Delano, → Gordon Parks, → Carl Mydans and → Ben Shahn, among many others. The aim was that these photographers, sent on field assignments to document rural America, would reveal the plight faced by impoverished farming families. The project later expanded to include photographic documentation of both rural and urban areas throughout the United States. Images distributed by the FSA to the general public were evidence of the use of government funding and enhanced the acceptance of the New Deal programme. Funding for the FSA began to decrease in the early 1940s, when the documentary project ended. The FSA's collection of photographs was transferred to the Library of Congress in 1944; it includes 164,000 black-and-white film negatives and transparencies, colour transparencies and over 100,000 black-and-white prints.

Fashion photography A branch of → commercial photography that promotes the latest fashion designs in specialist magazines (→ *Vogue*, → *Harper's Bazaar*) and, more recently, in blogs. Its evolution has always depended largely on a collaboration between editors-in-chief, artistic directors (notable examples include → Alexey Brodovitch and → Alexander Liberman) and photographers. It reflects not only the influence of different artistic and aesthetic movements, but also the social and cultural context of the period in question. The widespread adoption of fashion photography is closely linked to the invention of the halftone process, which allowed for the mass reproduction of images in an increasing number of magazines that catered for a burgeoning middle-class female readership. Fashion photography began to replace engravings in the late 19th century, though for the most part preserved its predecessor's essentially informative character. From the 1910s the predominant aesthetic owed much to → Pictorialism, as reflected in the work of → Baron Adolph de Meyer, but in the second half of the

● **F** —

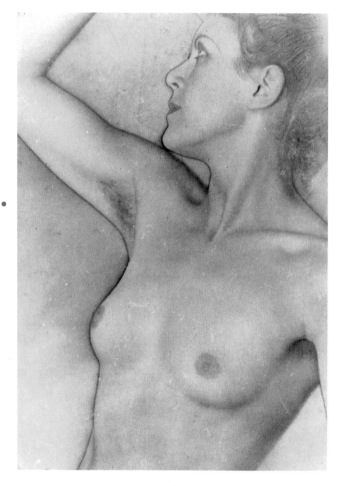

Gertrude Fehr,
Solarized Nude, 1936

1920s this gave way to modernism (→ Edward Steichen, → George Hoyningen-Huene), which in turn gave way to realism (→ Martin Munkácsi) during the 1930s. The second half of the 20th century was greatly influenced by the personalities and individual styles of → Richard Avedon and → Irving Penn. During the 1960s fashion photographers became celebrities in their own right and mirrored popular culture's defiance of established conventions. → Helmut Newton and → Guy Bourdin exploited this unprecedented freedom of expression by introducing a powerful element of eroticism that is still in vogue today. The boundary dividing commercial photography from art is frequently challenged, so that the work of photographers including → Jürgen Teller and → Terry Richardson may be regarded as both fashion photography and a form of artistic expression.

Fastenaekens, Gilbert (b. 1955) Belgian photographer. Known for his work on urban landscapes by night, Fastenaekens participated in the nationwide French → DATAR project in 1984. In 1986 he was awarded the Prix Kodak de la Critique Photographique in France. Between 1990 and 1996 he took a series of images in black and white looking at the development of the urban fabric in Brussels (*Site*). Since 1993 he has also worked as a publisher of books focusing on contemporary landscape photography.

Faucon, Bernard (b. 1950) French photographer. After gaining a master's degree in philosophy from the Sorbonne, Paris, in 1973, he turned to painting and photography. His unique artistic world, which hovers between realism and dreamlike fantasy, was already evident in his first series (*Les grandes vacances*, 1979), and he became an expert in → *mise-en-scène*. He has published many books, including *Les chambres d'amour* (1987), *Les idoles et les sacrifices* (1991) and *La fin de l'image* (1997). In 1995 Faucon stopped producing his own work in order to manage photographic projects with young people.

Faurer, Louis (1916–2001) American commercial and street photographer. Although primarily remembered for his street views of New York and Philadelphia from the 1940s to the 1960s, Faurer also shot fashion photography for → *Vogue*, → *Harper's Bazaar*, *Glamour*, *Look* and → *Life*. He was born and raised in Philadelphia but moved to New York shortly after taking up photography. Despite his introverted nature, he cultivated relationships with colleagues such as → Robert Frank and → Walker Evans. An exacting photographer and a perfectionist in the darkroom, Faurer quickly became an insider sensation within the photography world. After a brief stint abroad, he returned to the United States, where he taught at the Parsons School of Design, New York, and elsewhere. After being struck by a car and sustaining serious injuries in 1984, Faurer ceased photographing entirely.

Fehr, Gertrude [née Gertrude Fuld] (1895–1996) German photographer. Having worked as a successful theatre photographer in Germany,

in 1934 Fehr and her husband, a Swiss painter, set up a photography school in Paris; called Publiphot, it taught commercial art and photography, both of which were undergoing rapid expansion at the time. Influenced by the → New Vision and → Surrealism, its photographic curriculum covered traditional disciplines such as the → portrait, → architecture and the → still-life, as well as new fields and techniques including → reportage, → sports photography, → solarization and double exposure. In 1940 the couple sought refuge from World War II in Lausanne, where they established a new school of photography, which later became part of the Centre d'Enseignement Professionnel in Vevey in 1945. The best-known photography school in French-speaking Switzerland, it has produced several well-known photographers, including → Jeanloup Sieff and → Luc Chessex.

Fei, Sha (1912–1950) Chinese photojournalist. He was known for his photographic documentation of the Sino-Japanese War (1937–45) and the effects of the Socialist Revolution on China's countryside. Having begun his career in an army telegraph office, he became interested in photography in the early 1930s and enrolled in the Western painting department of the Shanghai Art Academy (1936). His work was influenced by foreign → photojournalism and, despite its often propagandistic nature, shares both aesthetic and documentary qualities. Fei's photographs are some of the only existing images of this poorly documented period.

Feininger, Andreas (1906–1999) American press photographer. Born in Paris to German-American parents (his father was the painter Lyonel Feininger), he moved with his family to Berlin in 1908 and to Weimar in 1919, where he trained as a cabinetmaker at the → Bauhaus. In 1923 he relocated to Zerbst, near Dessau, to study architecture. Feininger's interest in photography developed from his use of the medium as an architectural tool. Unable to work in Germany, he moved to Stockholm in 1933 and found success as an architectural photographer. He emigrated to New York in 1939 and began shooting for → Black Star, becoming a → *Life* staff photographer in the

early 1940s. Feininger published more than sixty photography books and photographic textbooks, and was the inventor of a swivelling enlarger and a five-legged tripod.

Fekete, Alexandra Kinga (b. 1969) Hungarian photographer. After studying law in Budapest, Fekete attended photography classes at Bournemouth and Poole College of Art and Design. She began her photographic career in London, mostly producing portraits and fashion shoots for magazines. She portrays her subjects in locations that lend a characteristic staged atmosphere. Female sexuality and identity play a central role in her private work, which is published internationally in such periodicals as *Dazed & Confused*, British → *Vogue*, *GQ*, German *Vanity Fair* and the *Süddeutsche Zeitung*. Fekete has taken part in several noteworthy exhibitions,

• F —

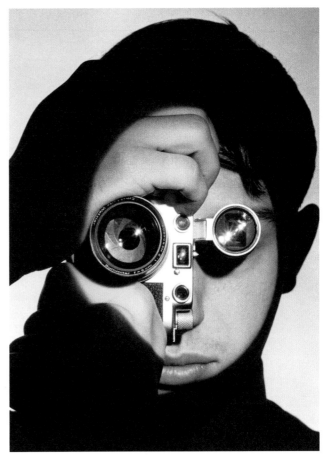

Andreas Feininger,
The Photojournalist, 1951

including the John Kobal Photographic Portrait Award at the National Portrait Gallery, London (2001), and shows at the Centro per l'Arte Contemporanea Luigi Pecci, Prato (2003), and Pavlov's Dog Gallery, Berlin (2011).

Feldmann, Hans-Peter (b. 1941) German photographer and sculptor. Feldmann studied painting at the University of Arts and Industrial Design in Linz, Austria – a medium he would abandon in 1968. Adopting a conceptual approach that challenged the iconography of contemporary photography, he collected found amateur photographs (culled from books, magazines or advertisements) and arranged them into thematic series, combining them with his own images to produce → collages, wall hangings and books. The little booklets that formed the *Bilder* series, made between 1968 and 1976, brought together photographs of the same subject in predefined numbers, for example three chairs, six animals or eleven female knees.

He exhibited at Documenta 5 in Kassel in 1972. During the 1980s he gradually stopped producing work for public consumption. Feldmann was awarded the Hugo Boss Prize in 2011.

Felizardo, Luiz Carlos (b. 1949) Brazilian photographer. Felizardo studied architecture at the University of Rio Grande do Sul in Porto Alegre from 1968 to 1972 but abandoned his degree in order to concentrate on photography instead, specializing in landscape and architecture. His work was included in the Pirelli Collection at the Museum of Contemporary Art, São Paulo, in 1991, and in 1992 Felizardo took part in the collective exhibition *La Fotografía Iberoamericana* in Madrid. He was awarded a fellowship from the Funarte Foundation in 2008 and was a guest of honour at the fifth International Festival of Photography at Porto Alegre in 2011, when the Santander Cultural art centre organized a retrospective exhibition entitled *A fotografia de Luiz Carlos Felizardo*.

— F •

Pierre de Fenoyl, *Chemin de Croix d'Aniane, Lodève, France*, 1984

Fenoyl, Pierre de (1945–1987) French photographer. A self-taught practitioner, de Fenoyl fought for the medium to be recognized formally by art institutions. In 1975, at the age of 30, he became the first director of the Fondation Nationale de la Photographie, and in 1977 became head of the photography department at the Centre Pompidou. His own body of work was principally a reflection on the passing of time, most notably the black-and-white landscapes published in *La Chronophotographies, ou l'Art du temps* (1986).

Fenton, Roger (1819–1869) British photographer. A founding member of the Calotype Club (1847) and the → Royal Photographic Society (1853) in London, Fenton practised photography for over a decade. A lawyer by profession, he studied painting in the Paris studio of Paul Delaroche alongside → Gustave Le Gray and → Henri Le Secq. Like them, he was drawn to photography. In 1852 he travelled to Russia, returning with photographs of Kiev, St Petersburg and Moscow. In 1854 Fenton left for the Crimea to report on the war against Russia, much contested by the press. Ill with cholera, he brought back images of army camps and officers rather than of death and destruction caused by the war. Exhibited in London, these photographs helped change public opinion; for the first time photography had become a tool for propaganda, showing a partial, limited and partisan point of view. From 1853 Fenton was formally engaged by the British Museum to reproduce its collection. In 1854 he was appointed photographer to the royal family and was received regularly at Windsor. From 1856 he devoted his time to landscape, architectural views, still-lifes and a series of romanticized Orientalist portraits in a painterly style. Between 1860 and 1862 he made series of → albumen prints of still-lifes that display a strong sense of composition. He abandoned the profession in 1862 as photography became more industrialized, selling some of his equipment to → Francis Frith.

Ferrez, Marc (1843–1923) Brazilian photographer. He opened a studio, Marc Ferrez & Cia, in 1862. Alongside the production of portraits – especially

Roger Fenton,
Valley of the Shadow of Death, 1855

• F —

for the Brazilian court – he also favoured the views and landscapes of Brazil. Following a fire at his studio in 1873, he began to take an interest in the latest technical developments, importing all his equipment from Europe. In 1875 he became part of the Geological Commission of the Empire of Brazil, led by the Canadian geologist Frederick Hartt. Ferrez was thus the first to photograph the Amerindian Botocudo tribe in the southern part of the state of Bahia. His work constitutes a valuable archive of the period of the Empire and First Republic (1865–1918) and documents the urban development of Rio de Janeiro, the former capital of Brazil, during the second half of the 19th century. Ferrez participated in the international exhibitions in Philadelphia (1876) and Paris (1878). He was the only professional to be recognized as the official photographer of the Royal Navy in 1880. The Instituto Moreira Salles in Rio de Janeiro acquired the Marc Ferrez and Gilberto Ferrez collections, which comprised over 5,500 prints, in 1998.

Ferro-prussiate process *see* **Cyanotype**

Ferrotype (tintype) A one-off photographic image printed onto a thin iron plate that has been coated with an opaque black or brown lacquer. The thin → collodion negative appears positive against the dark coating, creating an image.

Ferrotypes first emerged in the United States in 1856 and were considerably less expensive than daguerreotypes and ambrotypes, and more durable. Extremely popular for portraiture, they were often housed in simple paper mounts.

Festivals In the field of photography, temporary festivals serve two purposes: to show and promote new talent, and to provide an overview of photographic developments worldwide or in a particular field (for instance → fashion photography in Hyères and Moscow, → reportage at Visa pour l'Image in Perpignan, → advertising at Novo Mesto in Slovenia, or → photography books in Kassel, Hamburg and Vienna). Prizes are often awarded to photographers who have made a special contribution in a particular area. International festivals mostly take the form of biennials (FotoFest, Houston) closely linked to specific towns (the festivals at Deauville or PhotoIreland in Dublin, for example), or summer events. Among the oldest and most celebrated is the Rencontres d'Arles, which was established in 1970 on the initiative of the photographer → Lucien Clergue, the writer Michel Tournier and the historian Jean-Maurice Rouquette.

Fieret, Gerard Petrus (1924–2009) Dutch photographer. Also a painter and poet, Fieret studied and taught drawing at the Royal Academy of Arts, The Hague. A retiring artist, he is known primarily for his voyeuristic photographs of the female body, but also for his contempt for meticulous photographic processes and his obsession with stamping 'Copyright' on his prints.

Film Thin, fine sheets of cellulose nitrate, cellulose acetate or polyester coated with light-sensitive → emulsion. Film can be used to make either a negative image, for enlargement onto photographic paper, or a positive image, as with transparency or → slide film. The first transparent, flexible film was made from a base of cellulose nitrate and was in use between *c.* 1889 and *c.* 1950. This highly flammable material presented both safety and preservation issues, and from the 1920s was gradually replaced by cellulose acetate film. Though acetate film

does not present the flammability hazards of nitrate film, it still presents preservation issues since the acetate base tends to break down and release acetic acid. Polyester film, first introduced in 1955, is the most stable of these film bases, but because of its limited flexibility it is mainly used for sheet film. Film is manufactured in three typical formats: standardized 35mm, medium (such as 120 or 220 film) and large (4 × 5, 5 × 7 or 8 × 10 inches).

Film speed A measurement of the sensitivity of a photographic → film or digital image sensor. The greater the speed of a film, the less light is required for exposure. Formerly, when film speeds were defined by individual manufacturers, the two most commonly used standards were ASA and DIN. The ASA standard, created by → Kodak in the United States, was an arithmetic scale: a 200 ASA film was twice the speed of a 100 ASA film. The DIN standard, developed by Agfa in Germany, was a logarithmic scale: a rise of 3 DIN signified a doubling of speed. A third standard, called GOST, was used in the Soviet Union and was similar to the ASA standard. These different standards have now been replaced by the ISO international standard, which combines both the old ASA and DIN standards. For example, 100 ASA film, which was equivalent to 21 DIN, is now designated as 100/21 ISO film.

Film und Foto An exhibition organized by the Deutscher Werkbund (German Association of Craftsmen) in Stuttgart and shown from 8 May to 7 July 1929. It offered an international overview of the different genres and types of photography. Its originality lay in the way it brought together the work of well-known figures, examples of the latest photographic techniques (→ photograms, → photomontage, → solarization, etc.), press photographs and images from the fields of medicine and science. Approximately 1,200 photographs and 60 silent films were exhibited.

Filter A transparent element made of glass or plastic – or occasionally → gelatin – that is usually positioned in front of the camera lens. Filters create their effect by modifying the light that enters the camera. For example, they may be

Larry Fink, *Russian Ball, New York*, 1976

• F —

used to make colours more or less intense, to eliminate reflections from shiny surfaces or to achieve a softening effect. When → digital photography arrived, many filters fell out of use because the same results could be obtained with image-editing software. Nonetheless, there are still some filters, such as polarizing filters, whose effects cannot easily be replicated with software.

Fink, Larry (b. 1941) American photographer. Fink was taught by → Lisette Model and → Alexey Brodovitch. Alongside his teaching career, he works for magazines while pursuing his own projects, which are influenced by social and political photography. Middle-class and rural cultures come face to face and are examined through their social rituals, from birthdays on a farm in Pennsylvania to glitzy private views, and from the world of fashion to boxing matches; taken together, they supply a framework for the critical investigation of class issues. Fink's skilful use of → flash and high contrast between black and white heighten the emotional impact of his images.

Finsler, Hans

Finsler, Hans (1891–1972) Swiss photographer. When he was appointed to teach the history of art at the Academy of Fine Arts in Halle, Germany, in 1923, Finsler began to take photographs to illustrate his course. Graduating from amateur to professional photography, he concentrated on commercial still-life photography. In 1927 he established the first photography course at the Academy of Fine Arts and won his first photographic commissions from industrial firms. Characterized by their extreme clarity and precision, careful composition and investigation of light and contrast, his images of objects were perfectly in line with the avant-garde style advocated by the → New Vision and the → Bauhaus. In 1932 Finsler joined the University of Applied Arts in Zurich, where he established a photography department – the first and only one of its kind in Switzerland. Subtleties of lighting, the successful rendering of material and a realist style were central to his teaching approach. Through his position and his writing, Finsler's influence on photography was considerable, and many great Swiss photographers studied in the photography department in Zurich, including → Werner Bischof (one of the first to graduate, in 1935), Emil Schulthess, Ernst Scheidegger and → René Burri.

Fischer, Arno (1927–2011) German photographer. A sculptor by training, Fischer became known in the 1950s for his politically engaged → reportage – especially in post-war Berlin – and his fashion photography. His career was marked by long periods teaching at art institutions in Berlin-Weissensee, Leipzig and Dortmund, and at the school run by the Ostkreuz photo agency, which he founded with his wife, the photographer → Sibylle Bergemann.

Fischli & Weiss Swiss sculptors, artists and photographers. Peter Fischli (b. 1952) and David Weiss (1946–2012) formed the Fischli & Weiss partnership in 1979, at the time of the alternative Zurich-based Bewegung movement. They adopted a range of media – including film, photography and sculpture – to call the world's established order into question, resorting to irony, derision and scepticism. Their use of cheap materials (*Sausage Series*, 1979; *Quiet Afternoon*, 1984–85) and their subject matter were evidence of a desire to evoke spaces that were immediately recognizable and easily accessible. The spectator is bombarded with images of everyday scenes and places, their banality sometimes reinforced by the intentional use of 'bad' photographs or generic images of a 'universal' experience. By examining the art world and the roles of artist and spectator, the duo critiqued a consumer society saturated with images, in which the impossibility of looking at an image independently is proof of an excessive level of production and consumption. Their quest for truth and balance in what they saw as the chaos of everyday life took various forms: the film *The Way Things Go* (1987), for instance, follows random interactions between ordinary objects

Hans Finsler, *Electric Bulb*, 1928

while at the same time raising questions of a metaphysical nature. The works often employed text, which helped steer a viewer's interpretations but stopped short of making direct correlations: the duo's implicit aim was to instil doubt. Fischli & Weiss created the illusion of a new reality, raising questions about what is true and what is false.

Fish-eye lens A lens with a very short → focal length that creates very wide angles of view (usually between 100 and 180 degrees). Originally used in meteorology to photograph the whole sky, it was nonetheless adopted by amateur photographers. Whether circular in shape or full-frame rectangular, images taken with a fish-eye lens are progressively distorted towards the edges of the field, so that any straight lines that do not pass through the centre appear severely curved.

Fizeau, Hippolyte (1819–1896) French physician. Fizeau was able to devote himself entirely to scientific research thanks to the support of Léon Foucault. His research led to the improvement of the → daguerreotype and the development of a new printing process adopted by Noël Paymal Lerebours in his *Excursions daguerriennes* (1841–64). In 1845 he succeeded in capturing the first image of the sun, and also worked with Foucault on measuring different light sources in photography.

Flash A fast and intense burst of light that allows a photograph to be taken in dark conditions. As early as the 1860s magnesium ribbons were burned to create light. In 1887 Adolf Miethe and Johannes Gaedicke invented what is considered to be the first flash, by combining magnesium powder with an oxidizing agent. In 1925 Paul Vierkötter created a flash from a piece of aluminium foil inside a glass bulb. In 1929 → Harold Edgerton invented the electronic strobe light: a piece of equipment that emitted extremely short bursts of light at regular intervals that could be used to capture very fast events, such as the movement of a droplet of milk. Modern flashes are electronic and use a gas, usually xenon, to produce light.

Fleischer, Alain (b. 1944) French writer, photographer, filmmaker and visual artist. After studying literature, linguistics, → semiotics and anthropology at the Sorbonne and the École des Hautes Études en Sciences Sociales in Paris, Fleischer taught at various universities and art, photography and cinema schools. Awarded the Prix de Rome in 1985, he was resident at the Villa Médicis until 1987. He now directs Le Fresnoy Studio National d'Art Contemporain, which he founded in 1997 with the backing of the French Ministry of Culture. Fleischer is also the author of approximately thirty novels and collected essays, and he has made numerous full-length films, works of experimental cinema and art documentaries that have been shown at festivals around the world. His art and photography are often exhibited in exhibitions in France and abroad. In 2003 the Maison Européene de la Photographie and the Centre Pompidou dedicated a major retrospective to his work.

Fleischmann, Trude (1895–1990) Austrian-born American photographer. Fleischmann photographed artists, intellectuals and performers. She worked under Hermann Schieberth and Madame D'Ora. In 1920 she opened a portrait studio in Vienna; she was among the first to photograph modern dancers, and in 1925 produced sensational nude portraits of Claire Bauroff that were confiscated by Berlin police from a theatre. She encouraged → Marion Post Wolcott to pursue photography. Of Jewish heritage, Fleischmann emigrated to the United States with her companion, Helen Post, after the Anschluss. She later opened a photography studio with Frank Elmer.

Florence, Hércules [Antoine Hércules Romuald Florence] (1804–1879) French-born Brazilian inventor and photographer. Florence emigrated to Brazil in 1824. His first experiences in the darkroom date to 1833 and are described in his book *Livre d'Annotations et de premier matériaux*, which contains the pioneering use of the term 'photography'. His investigations were recognized in 1843 by the Academy of the Sciences and the Arts in Turin.

• F —

Thomas Florschütz, *Untitled (15.XI.85)*, 1985

Florschütz, Thomas (b. 1957) German photographer and associate of the Academy of Arts, Berlin. Florschütz's first exhibition was held in a youth club on Wilhelm-Pieck-Strasse in Berlin. In 1987 he was awarded first prize at the Young European Photographer Awards in Frankfurt. Between 1993 and 2000 he took part in numerous exhibitions and worked in New York, Brazil and California. Further awards followed, including the German Critics' Prize for Visual Art (2004). In one early series he photographed parts of his own body, using the motif of fragmentation to question the idea of surface appearances, and by extension, the two-dimensional surface of the photograph itself. His later series *enclosure* pursues the theme of fragmentation and visual selectivity in a set of images taken inside the Neues Museum in Berlin.

Flusser, Vilém (1920–1991) Czech-born Brazilian writer and philosopher. Born in Prague to a German-speaking Jewish family, Flusser fled Nazism in 1939 and settled in Brazil in 1940 before returning to Europe in 1972. He taught philosophy – in particular at the University of São Paulo – and, inspired by phenomenology, worked on the theory of communication and the philosophy of artistic creativity, principally in art and photography. Adopting an extremely free style, he wrote several essays that were viewed as provocative by the scientific community. In addition to his writings on photography and his book *Ins Universum der technischen Bilder* (1985), he expounded his theory on photography in his brief essay *Towards a Philosophy of Photography* (1983). According to Flusser, photography induces a break in the way the world is represented, because it relies on a camera, which predefines the parameters of the photograph. The pre-programming (technical, social and cultural) of the apparatus determines the type of photograph that will be taken; the photographer, who has become a 'functionary' of the camera, is obliged to operate within the limitations circumscribed by this programming. Only truly experimental

photographers succeed in liberating themselves from the camera and work in opposition to their equipment.

Focal length A measurement defined as the distance between the centre of a camera lens and the rear focal plane, i.e. the photosensitive surface or sensor. It is designated by the letter f and is usually measured in millimetres. Wide-angle lenses have a very short focal length, while telephoto lenses have a very long focal length. The focal length may be fixed or variable, as with some → zoom lenses.

Fontana, Franco (b. 1933) Italian photographer. He took up photography in 1961, soon becoming interested in landscapes and in colour. He became an undisputed master of line and abstraction, eliminating any natural element from his images that might disrupt their harmony and the balance. The visual perfection of these pieces and his highly methodical approach have earned him considerable international acclaim, and he is much in demand in the worlds of fashion and advertising. Fontana also collaborates regularly with the ECM jazz label by contributing images for their album covers, thus making his work accessible worldwide.

Fontcuberta, Joan (b. 1955) Spanish artist. Fontcuberta studied communications before teaching at the University of Barcelona. In 1980 he helped establish the first master's degree in photography, cinema and video in Spain, and founded the magazine *Photovision*. Fontcuberta's highly provocative photographs appear to prove the existence of fantastical creatures, exploiting the supposed authenticity of the photographic image in order to question the spectator's beliefs. In his *Herbarium* series (1982–84), which parodied → Karl Blossfeldt's celebrated plant portraits, he photographed exotic plants made from a variety of materials in the style of the German photographer. *Constellations*, begun in 1993, appeared to show the sky at night but was actually a series of photos of his insect-splattered car windscreen. *The Artist and the Photograph* (1995) questioned the power of

museums to canonize artists and artworks, impeding the spectator's critical sense. One of his later projects, *Sirens* (1995), showcased the remains of 'Hydropithecus', a fossilized mermaid who was supposedly the missing link between water-based life forms and those on land. Fontcuberta's acts of forgery appropriate the rhetoric and cataloguing methods of scientific and museological research to create playful and witty works that invite an element of suspicion. Aside from his photography, Fontcuberta is the author of works on aesthetics and the teaching of photography, and he has curated several exhibitions. His own photographs are exhibited in some of the most prestigious museums worldwide.

Format A predetermined set of measurements that defines the size and shape of photographic → film. When photography was first invented, a photographic plate would produce a printed photograph of exactly the same size, because reproductions were made as → contact prints. With the arrival of techniques for enlarging

• F —

Joan Fontcuberta,
Giliandria Escoliforcia, 1984

— F •

Samuel Fosso, *The Chief
(Who Sold Africa to the Colonists)*, 1997

photographs, → print formats began to diverge from plate and film formats. Nonetheless, there is still a correlation between the two: the larger the film, the more detailed the image, which in turns allows for a larger print to be made. In analogue photography, formats are determined by film size and divided into three main categories: small format uses 35mm film and produces 24 × 36 mm → negatives; medium format uses 120 film, which is 6 cm wide, and produces a negative that usually varies between 6 × 4.5 cm (2⅜ × 1¾ in.) and 6 × 9 cm (2⅜ × 3½ in.); and large format refers to anything bigger. In digital photography, image format is measured in → pixels.

Fortune American magazine established in 1930 by Henry Luce. *Fortune* is North America's oldest business publication and is part of the Time Warner group, which also comprises → *Life*, *Time* and *Sport Illustrated*. The magazine is characterized by its large format and the quality of its illustrations. Some of the great names in photography have worked for the publication, including → Margaret Bourke-White (1929–35) and → Walker Evans (1945–65). Originally a monthly, *Fortune* has been published every three weeks since 2009.

Fosso, Samuel (b. 1962) Cameroonian photographer. He was born in Kumba and at the age of 10 went to live with his uncle in Bangui, the capital of the Central African Republic, where he served an apprenticeship with a Nigerian photographer before opening his own portrait studio in 1975. He took his first self-portraits at this time: in these black-and-white images he would dress up, assuming different identities against the painted background of a photographer's studio. In 1994 he participated in the first photography biennial in Bamako, which earned him international recognition. His work continues to focus on issues of identity and self-representation, particularly in relation to African political and cultural history (*African Spirits* series, 2008). Fosso currently lives in Bangui.

Fraga, Voltaire (1912–2006) Brazilian photographer. Fraga acquired his first camera in 1927. An amateur photographer, in 1939 he began to document the city of Salvador, its rituals and other local customs. His work constitutes one of the most important collections in the city's archive. The Pinacoteca of São Paulo dedicated an exhibition to his work in 2008.

Franck, Martine (1938–2012) Belgian photographer. Having studied the history of art and journeyed to Asia in 1963, where she took up photography, Franck became an assistant to Eliot Elisofon and

Martine Franck, *Tulku Khentrul Lodro Rabsel
with his Tutor in a Nepalese Monastery*, 1996

Robert Frank, *Trolley,*
New Orleans, 1955

→ Gjon Mili on → *Life* magazine in Paris. With their encouragement she developed her own practice. A friend of the stage director Ariane Mnouchkine, she soon became interested in theatre photography. She was also well known for her portraits of artists and writers. Her images, which are classical in style, often displayed a social conscience and treated such themes as the old, the poor and children in Asia, where she travelled extensively. She was the co-founder and president of the Henri Cartier-Bresson Foundation, having married the photographer in 1970.

Frank, Robert (b. 1924) Swiss-born American photographer and filmmaker. He began to train as a photographer with Hermann Segesser in 1941, also studying under Michael Wolgensinger until 1944. He left Switzerland for the United States in 1947, where → Alexey Brodovitch hired him to work for → *Harper's Bazaar*. Frank

travelled to Peru and to post-war Europe, taking many photographs of the streets of Paris. In 1953 he settled in the United States, where he met → Walker Evans. Awarded a grant by the Guggenheim Foundation to produce a photographic study of American life, he spent almost two years travelling across the country, taking thousands of black-and-white pictures. *The Americans* was first published in France by → Robert Delpire (1958); the American edition, which came out in 1959, featured an introduction by the Beat writer Jack Kerouac. The book caused some controversy as it showed a foreigner's view of the New World: Frank revealed what normally remained hidden – the failure of the American dream – while pushing the boundaries of the documentary genre. Using → blurring, multiple perspectives and innovative framing techniques, he tackled his theme in a subjective manner, entirely changing the way in which photography was perceived. In the late 1950s he began to

concentrate on film (*Pull My Daisy*, 1959), though occasionally returned to photography (*The Lines of My Hand*, 1972).

Franklin, Stuart (b. 1956) British photographer. Having trained in film and photography at the West Surrey College of Art and Design, in 1997 Franklin returned to education, reading geography at Oxford University and completing a thesis in 2002. He began his career as a photojournalist for British newspapers, subsequently working for the Sygma agency between 1980 and 1985 and travelling to Niger, Lebanon, Sri Lanka, Northern Ireland and Sudan. In 1985 he joined → Magnum Photos, becoming its director from 2006 until 2009. In 1989 he won a World Press Photo Award for his image of a demonstrator facing a column of tanks in Tiananmen Square. Between 1990 and 2004 he produced approximately twenty major

→ reportages for → *National Geographic* and has since worked on various long-term projects.

Freed, Leonard (1929–2006) American photographer. After working as a graphic designer, he discovered photography during a trip to the Netherlands. Returning to America, he attended the courses held by → Alexey Brodovitch. Travelling between Europe and the United States, he developed a style that straddled press photography and documentary. He was an active member of → Magnum Photos from 1972, tackling such themes as Jewish communities, the civil rights movement, war and revolution, violence, poverty and the police force, at the same time pursuing a search for the simple moments of everyday life. The central role he ascribed to the human figure demonstrated his keenness to address social issues without pathos or moralizing.

Leonard Freed, *Martin Luther King Being Greeted
on his Return to the US after Receiving the Nobel Peace Prize,
Baltimore, 31 October 1964*

Fresson process The proprietary name for a direct → carbon printing process invented in 1899 by Théodore-Henri Fresson as an improvement to the Artigue process. Fresson printing paper was commercially available until World War II. The Fresson family in France and Louis Nadeau in Canada retain the technical details of this process, which are kept secret, and continue to make prints for artists. The paper contains a pigment suspended in a dichromated colloid that hardens when exposed to light. The unhardened areas are subsequently removed by pouring a mixture of water and sawdust over the print.

Freund, Gisèle (1908–2000) German photographer. Born in Berlin, Freund studied sociology. A militant socialist, she took up amateur photography for political purposes. In 1933 she escaped to France, where she frequented literary circles and took portraits of famous writers and artists, some in colour. She became one of the few female photojournalists to work for → *Life*. During World War II, she went to Argentina, where she continued her → reportages. She was a member of → Magnum Photos between 1948 and 1954. During the latter part of her life, she wrote one of the first works on the sociology of photography, *Photographie et société* (1974). An intellectual and artist, she never ceased to promote the notion of photography as a tool for communication and social struggle.

Friedlander, Lee (b. 1934) American photographer. A preference for outdoor shots in an urban environment made him one of the principal exponents of → street photography in the 1960s and 1970s. His early work is characterized by his passion for jazz, and he ceaselessly photographed its performers. In 1955 Friedlander went to New York, where he worked for various magazines until the 1970s. He formed friendships with, among others, → Garry Winogrand, → Robert Frank, → John Szarkowski (who included his work in the → *New Documents* exhibition at the → Museum of Modern Art in 1967) and → Walker Evans, who became his mentor and helped him obtain three grants from the Guggenheim Foundation (1960, 1962 and 1977). A lover

Gisèle Freund, *Virginia Woolf in front of a Fresco by Vanessa Bell*, 1939

• F —

of photography books, he was particularly influenced by Robert Frank's *The Americans* (1958) and Walker Evans's *American Photographs*. In 1970 he published *Self-Portrait*, the first in a long series of books, which was characterized by an interest in the effects of light and shade, the presence of objects in the foreground, and the fragmentation of the composition by means of reflections. *The American Monument* (1976) featured a gallery of commemorative statues he had encountered on his travels, portrayed with humour and tenderness. He later worked on many projects simultaneously, using different photographic genres (→ nude, → still-life, → landscape) and tackling specific themes (people at work, → portraits of friends and family, → self-portraits). Deeply rooted in American

— F •

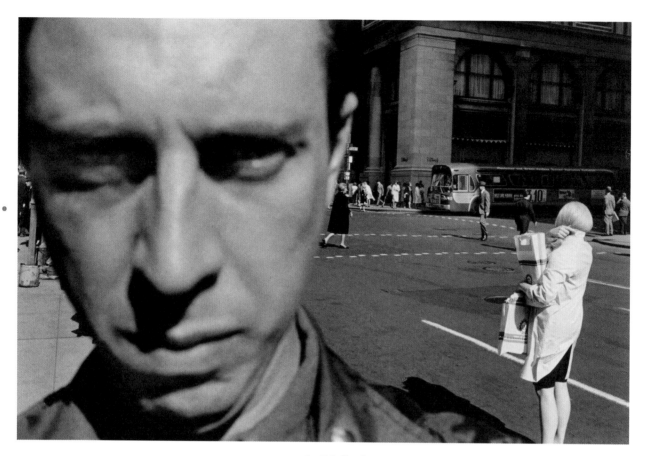

Lee Friedlander,
New York City, 1966

society, his entire oeuvre testifies to an interest in the individual and a constant need for renewal.

Frima, Toto (b. 1953) Dutch photographer. A self-taught artist, Frima lives and works in Amsterdam. In 1979, encouraged by Manfred Heitung, the head of Polaroid Creative Design Europe, she made the → Polaroid her camera of choice. Her work is an inquiry into her own corporality, resulting in self-portraits that are intimate and sensual.

Frith, Francis (1822–1898) British photographer. A printer who took up photography in 1853 and helped to found the Liverpool Photographic Society that same year, Frith produced photographs of landscapes and travels abroad. Between 1856 and 1860 he began to make a name for himself with the images he brought back from Egypt, Syria and Palestine. His most famous

book, *Egypt and Palestine Photographed and Described* (1858–60), was the result. In 1859 he opened a studio, Frith & Co., in Reigate with the aim of selling photographs and albums with pasted-in illustrations. His views were marketed to the wider public, which enabled the business to prosper. Known for the quality of his images and encouraged in his venture by clients, in 1860 he began an ambitious project to photograph the whole of the United Kingdom. His firm also produced photographs of Italy, Scandinavia, Japan, China and India. The business remained in the Frith family, closing its doors for the last time in 1971.

Frizot, Michel (b. 1945) French historian of photography. The director of research at CNRS, the French National Centre for Scientific Research, Frizot teaches at the École des Hautes Études en Sciences Sociales at Paris-Sorbonne University (Paris IV) and at the École

du Louvre. Between 1982 and 1990 he was head of programmes at the Centre Nationale de la Photographie, where he organized several exhibitions and commissioned the Photo Poche series. He also edited an encyclopaedia on the history of photography, the *Nouvelle histoire de la photographie* (1994).

F-stop *see* **Focal length**

Fujiwara, Shinya (b. 1944) Japanese photographer and writer. He was born in Fukuoka Prefecture. After leaving the department of painting at Tokyo National University of Fine Arts and Music, he travelled throughout Asia. In 1971 he published his photographs and essays from his days in India as *Exploring India*. He received the Kimura Ihei Award in 1978. In recent years, Fujiwara has focused on the young people living in Tokyo.

Fukase, Masahisa (1934–2012) Japanese photographer. A native of the island of Hokkaido, Fukase began his career as an → advertising photographer after graduating from Nihon University. He was featured in the landmark 1974 exhibition *New Japanese Photography* at the → Museum of Modern Art, New York, which travelled widely throughout North America and introduced a selection of Japanese photographers to a Western audience. His best-known and most highly regarded book of photographs, *Karasu* ('Ravens'), was first published in 1986. It features a dark, impressionistic sequence of photographs that fluctuate between images of ravens – both in flight and dead – and other desolate subjects, such as a homeless man drinking alcohol. In 1992 Fukase suffered severe brain injury after a fall and remained in a coma until his death in 2012.

Fulton, Hamish (b. 1946) British conceptual artist, painter and photographer. Fulton studied at Saint Martin's School of Art in London (1966–68) and at the Royal College of Art (1968–69). His artistic career can be linked to both conceptual and → land art. Fulton roams the world on foot, photographing the landscapes he encounters but without intervening in any way, creating images that convey his physical and emotional experiences. In his exhibitions and books, he maintains a careful dialogue between word and image: sometimes pictures are accompanied by descriptive captions and sometimes by longer texts, thus adding a subjective, even poetic, gloss to his long walks. Fulton's work has been the subject of many solo exhibitions.

Funke, Jaromír (1896–1945) Czech photographer and theoretician. After failing to complete his studies in medicine, law, philosophy and history of art, Funke turned to photography in the 1920s. An influential member of the Czech photography avant-garde, he created a body of work that is characterized by a desire to experiment with the medium in order to highlight its potential. Excluded from the amateur photographic clubs of Prague in 1924, along with → Josef Sudek and Arnold Schneeberger he founded the Czech Society of Photography, which held its

• F —

Francis Frith, *View at Girgeh*, 1857

— F •

Jaromír Funke,
Composition, 1927

first exhibition in 1926. During the same period he became acquainted with the avant-garde collective Devětsil and published his works in the magazines *ReD* and *Index*. His images displayed the influences of Cubism, the → New Objectivity, Constructivism, the → Bauhaus and the → Surrealists. In the 1920s they were for the most part still-lifes of a random selection of objects in which light and shade produced an almost abstract effect similar to the → photogram. In the 1930s he turned to a so-called 'emotive' photography, which was inspired by Surrealism. In addition to his photographic work, Funke influenced Czech photography as a theoretician and professor. He taught at the Bratislava School of Arts and Crafts (1931–35) and at the School of

Graphic Art in Prague (1935–44) while continuing to contribute to specialist journals.

Furuya, Seiichi (b. 1950) Japanese photographer. Furuya was born in Shizuoka Prefecture. After graduating from the Tokyo College of Photography in 1973, he headed for Europe on the Trans-Siberian Railway. In 1975 he moved to Graz, Austria. There he met Christine Gössler, who provided him with his principal subject: they were married in 1978, and their son was born in 1981. In late 1982 Gössler began to develop schizophrenia, and three years later she took her own life. After her death, Furuya began working on a series, called *Mémoires*, that featured his wife. In other projects he has

concentrated on borders and their surroundings, such as the Berlin Wall. Furuya was one of the co-founders of the photography magazine *Camera Austria*, and has also curated exhibitions introducing Japanese photographers to Europe.

Fuss, Adam (b. 1961) British photographer. Fuss worked initially as an apprentice with the advertising agency Ogilvy & Mather in Australia. His first solo exhibition was held at the Massimo Audiello Gallery in New York in 1985. Using early photographic techniques including the → pinhole camera, → daguerreotype and → photogram, he produced elaborate formal compositions that played with water, transparency and light to depict christening robes, clothes, flowers, skulls, snakes, smoke and chrysalises. For a work called *Invocation* (1992) he placed a newborn baby onto light-sensitive paper immersed in a shallow tub of water and exposed it to a → flash, obtaining a silhouette surrounded by ripples of liquid that evoked a sort of photographic baptism.

Futurism An art movement that originated in Italy in the early 20th century. It was prompted by the publication of Filippo Marinetti's 'Futurist Manifesto' in 1909, which glorified youth, technology, modernity, violence and the city, and rejected traditional political and artistic ideals, which it regarded as hypocritical and outmoded. Works by Giacomo Balla, such as *Abstract Speed + Sound* (1913–14), are representative of this new credo. Futurism advocated new approaches to art, but regarded photography, even though it was modern, with mistrust. Nonetheless, the medium was championed by → Arturo and Anton Giulio Bragaglia, and their resulting book of 1913, *Fotodinamismo Futurista* ('Futurist Photodynamism'), brought it into the fold. The outbreak of World War I and internal schisms caused the movement to splinter by 1915, but its ideas continued to resonate and influenced later art movements.

• **F** —

Adam Fuss,
Invocation, 1992

Galella, Ron (b. 1931) American photographer. He began his career in 1950 as an aerial photographer with the US army during the Korean War. In 1955 he enrolled at the Art College Center in Los Angeles, graduating in 1958 and moving to New York, where he worked as a photographer's assistant and laboratory technician. From 1967 until 1982 Galella ceaselessly photographed the subject that was to become the symbol of his work: Jackie Kennedy Onassis. Christened the 'Godfather of the US paparazzi culture', he worked for *Time* and *Vanity Fair*. He became famous for a lawsuit he brought against Jackie Onassis in 1972; it ended only in 1982, when he was given a solid restraining order and fined $10,000. His friendships, as well as his altercations, with celebrities have earned him much publicity. He has published six books and his photographs have been exhibited all over the world.

Gallery 291 Art gallery founded in New York in 1905 by → Alfred Stieglitz and → Edward Steichen, originally known as the 'Little Galleries of the Photo-Secession'. Located in Steichen's former apartment at 291 Fifth Avenue, it was pioneering in numerous respects. Considered as one of the first galleries to promote → art photography, 291 was initially the headquarters of the members of the → Photo-Secession. It subsequently became one of the showcases for modern art in the United States, presenting more than seventy exhibitions of American and European artists. The gallery at 291 was also groundbreaking in laying the foundations for the modern exhibition space – simple, spare decoration, greater distances between the works and a linear hanging – making it suitable for the thoughtful contemplation of the works.

Galton, Francis (1822–1911) British scientist. Considered as the founder of eugenics, Galton used photography as a scientific tool for his research into physiognomy and his aim of defining the typologies of different populations. In 1877 he unveiled a project for classifying groups of people based on their physical resemblances and personalities. He is best known for his → composite portraits, a term he adopted for the first time in 1878. This technique involved superimposing portraits of different

individuals, taken under the same conditions, on the same light-sensitive plate. The result was a composite portrait of merged faces that Galton thought would allow him to discern the 'average' features of a group of people – particularly 'outsiders' like criminals and medical patients.

Gamma A French photo agency founded in 1967 by Hubert Henrotte, Hugues Vassal, → Raymond Depardon and Léonard de Raemy, who soon sold his share to → Gilles Caron. Equal shareholders, the founders set up an innovative system that allowed photographers to retain the rights to their works: the agency benefited solely from the use of signed and captioned images. Gamma became one of the most important photographic archives and had many prestigious contributors, including → Sebastião Salgado and → Abbas), who covered world conflicts as well as social events. In the wake of internal discord, Henrotte left the agency in 1973 and founded Sygma. Depardon, who had assumed the directorship of Gamma, felt hampered by financial constraints that he deemed contrary to his values and also resigned (1978). After several acquisitions, Gamma merged with the Rapho agency in 2010 at the instigation of the photographer François Lochon.

Garanger, Marc (b. 1935) French photographer and film director. Between 1960 and 1962, as a young conscript in Algeria, Garanger took photographs of army action on the ground. He also took identity photos of Algerian women who removed their veils for the occasion; some 2,000 of these images were published in one of his most celebrated books (*Algerian Women*, 1982). At the end of his military service he established a career as a reporter, travelling all over the world.

García, Romulado (1852–1930) Mexican photographer. García opened his first photography studio in 1878 in Guanajuato, his native town, at the same time continuing his apprenticeship with the celebrated photographer Vicente Contreras until 1914. García achieved national and international acclaim, receiving the bronze medal for photography at the Paris Exposition Universelle of 1889.

Marc Garanger,
Algerian Girl, 1960

• G —

García Rodero, Cristina (b. 1949) Spanish photographer. García Rodero's images constitute an inventory of Iberian traditions and transformations in rural Spain. She is also known for her *España Oculta* ('Hidden Spain') series, which documents sacred and profane rituals in a surrealist, poetic way. A member of → Magnum Photos, she has travelled in Haiti and India, portraying the intensity of popular festivals that unite the quotidian and the fantastical.

García-Alix, Alberto (b. 1956) Spanish photographer and film director. In 1976 he opened his first studio in Madrid with Fernando País. An enthusiast of photography, García-Alix had his first images published the same year in the magazine *Star*. In 1977, together with the illustrator Ceesepe, he founded the Cascorro Factory collective. In 1981 he visited an exhibition of works by → August Sander at the German Institute in Madrid and the exhibition *Mirrors and Windows – Fotografía norteamericana desde 1960* at the Fundación Juan March. Both were to prove crucial to his concept of photography, which celebrates the genre of → portraiture. In his images, internal narratives and atmosphere are as important as the subjects being represented.

Gardner, Alexander (1821–1882) Scottish-born American photographer. Raised in Scotland, Gardner trained as a journalist and worked as a reporter for the *Glasgow Sentinel* newspaper. Emigrating to the United States in 1856, Gardner – whose reputation preceded him – accepted an invitation to work in → Mathew B. Brady's New York studio. By 1858 Gardner was working as head of the studio in Washington. In 1862 he decided to leave Brady's employment and to open his own studio in Washington in partnership with → Timothy O'Sullivan. He directed a group of photographers assigned to accompany Union troops during the American Civil War (1861–65). In 1865 he published two volumes entitled *Gardner's Photographic Sketch Book of the War*, with the aim of showing its horrors. Accompanied by captions, his photographs depicted blasted landscapes and waiting troops. There were also details of the fighting, including the scattered and broken bodies of the fallen soldiers. It was the first conflict to receive such extensive coverage, and images of the massacres were widely distributed. Whether or not his images were staged (the question has been raised), for the first time photography made an enormous impact. In 1867 Gardner was appointed official photographer of the Union Pacific Railroad. During the course of a journey across Kansas, Texas and

Alexander Gardner, *Antietam, Maryland: Confederate Soldiers as they Fell near the Burnside Bridge*, 1862

California, he took many landscape views and portraits of Native Americans. Suffering from tuberculosis, he returned to Washington and was forced to abandon his career as a commercial photographer in the early 1870s.

Garduño, Yanez Flor (b. 1957) Mexican photographer. Garduño studied at the Academy of Fine Arts of the Autonomous University of Mexico (1976–78) under the photographers Katin Horna and → Mariana Yampolsky. His oeuvre is dedicated primarily to rural life and the cultures of the various Mexican ethnicities, with a particular focus on portraits of women. His first

Jean-Louis Garnell,
Diptyque No. 1, 1998

G

Jean Gaumy, *On Board the
Spanish Trawler 'Rowanlea'*, 1998

solo exhibition was held at the Antiguo Colegio San Ildefonso in Mexico City in 2011.

Garnell, Jean-Louis (b. 1954) French photographer. After studying computer engineering, Garnell turned to photography. He worked for → DATAR in 1985–86, and for the Cross Channel Photographic Project in 1989. Initially influenced by the formalism of the New Topographics movement, he gradually moved towards → conceptual art, producing complex collections of images in which the narrative dimension played an increasingly important role.

Gasparian, Gaspar (1899–1966) Brazilian photographer. An amateur, Gasparian joined the Bandeirante Photo Club in São Paulo in 1942, and in 1950 founded a short-lived photographic association, the Group of Six. He participated in the International Exhibition of Photography in Rio de Janeiro in 1952. The São Paulo Museum of Image and Sound (MIS) presented a retrospective

of his work in 1990. In 2001 Gasparian's images entered the photography collection of the São Paulo Museum of Art.

Gasparini, Paolo (b. 1934) Venezuelan photographer. Between 1961 and 1965 Gasparini lived in Cuba, where he worked for the writer Alejo Carpentier at the National Council for Culture. He emigrated to Venezuela in 1995, where he began his professional career, principally photographing architecture. He focuses on many of the world's megacities, including Mexico City, São Paulo and Los Angeles, adopting a neo-realist style. His research was supported by the Centro di Ricerca e Archiviazione della Fotografia in Spilimbergo, Italy, and published in 2000.

Gaumy, Jean (b. 1948) French photographer. Specializing in → photojournalism since the early 1970s and a one-time member of several agencies (→ Gamma, 1973; → Magnum Photos,

1977), Gaumy has become known for his long-term projects on 'hidden' institutions and environments: hospitals (1976), prisons (1976–83), deep-sea trawlers and tug boats (1986–2001; Prix Nadar 2001) and Iraq (1986–97). He has also made documentary films.

Geddes, Anne (b. 1956) New Zealand photographer. She is known internationally for her highly stylized studio photographs of babies and motherhood. Her work is often digitally manipulated to create fantasy images of babies within flowers, shells, eggs and other natural forms. The photographs have appeared as books, posters, greeting cards, calendars and other merchandise in 83 countries; Geddes's books alone have sold more than 19 million copies and have been translated into 23 languages.

Gee, Helen (1919–2004) American gallery owner. Trained as a photographer, Gee founded the Limelight Gallery in New York in 1954. A pioneering venue in terms of its exhibitions and sale of prints, the gallery survived thanks to its adjacent café. In its professionalism and impact, and the fact that it operated in a market still in its infancy, Limelight followed in the tradition of → Gallery 291 and the Julien Levy Gallery.

Gelatin A viscous substance obtained from animal tissue, one of whose uses is to create a photographic → emulsion for → film or paper. Gelatin forms the base of the emulsion for every major commercially available non-digital photographic process. It is used to make both film and paper for black-and-white and colour photography.

Gelatin silver print The standard process for producing black-and-white prints throughout the 20th century, first created in the 1870s. A layer of silver salts suspended in → gelatin is applied to paper; silver bromide, silver chloride or silver iodide may be used, though the greater light sensitivity of the first renders it most suitable for producing enlargements. Depending on the pigment used for → toning, the overall hue of the photograph may range from warm black (chlorobromide) to cool or neutral (bromide).

Bromide and chlorobromide papers were the first photographic papers sensitive enough to be exposed using darkroom enlargers rather than the earlier contact printers and solar enlargers. They quickly replaced chloride developing-out and printing-out papers as the principal medium for photographic printing, and allowed for faster and more efficient darkroom printing. The widespread use of enlargers also accounted for the emergence of new darkroom printing techniques, including dodging and burning.

Gelatin silver printing-out paper A commercially produced paper with an → emulsion of silver chloride suspended in → gelatin over a → baryta layer. Before → toning, the colour of a printing-out paper print is a warm reddish-brown colour. After the print has been toned with gold chloride, the image shifts to a more neutral tone; it still remains warm, however, and can range from a reddish-grey to a purple-grey colour. *See also* → printing-out processes.

General Idea A collective consisting of three Canadian artists: Felix Partz, Jorge Zontal and A. A. Bronson. Based primarily in Toronto and active between 1969 and 1994, the group was known for its conceptual media-based art and for its work addressing the AIDS crisis. It produced and published *FILE* magazine (1972–89). In 1994 Partz and Zontal died of AIDS. The General Idea archive is housed in the library of the National Gallery of Canada, Ottawa.

Genthe, Arnold (1869–1942) German-born American photographer. Having gained a doctorate in philosophy from the University of Jena, Genthe emigrated to the United States in 1895. Two years later he opened his first studio in San Francisco. He made his name with his images of the Chinese neighbourhood, which he published in 1908 as *Pictures of Old Chinatown*. In 1911 he moved to New York, where he specialized in dance photography, also immortalizing celebrities including Greta Garbo, Theodore Roosevelt and John D. Rockefeller. His autobiography, *As I Remember*, was published in 1936.

Gernsheim, Helmut (1913–1995) German photographer and photography historian. He studied art history at the University of Munich and photography at the State School of Photography, Munich. Gernsheim emigrated to England in 1937 and was employed by the National Gallery in London to photographically reproduce a portion of their holdings. He also worked for the Warburg Institute in 1941, recording historic buildings in London that were at risk of damage or destruction during the war – a commission that resulted in several exhibitions and an appreciation of his architectural photographs. His early studies in photography history, *New Photo Vision*, were published in 1942. At the end of World War II, Gernsheim met → Beaumont Newhall, the American historian of photography, who encouraged him to follow the same path. In 1945 he began collecting images that would illustrate the medium's development. In 1952 Gernsheim and his wife, Alison, discovered that the world's first photograph had been created by → Nicéphore Niépce, not → Louis Daguerre, as previously believed. He produced a critical body of work encompassing over two-dozen monographs, articles and, following twenty years of study, his *Concise History of Photography* (1955). Through his acquisitions, research and writing, he helped to establish the foundations of the modern study of the history of photography. The Gernsheims sold their collection of 33,000 photographs and 4,000 books to the Harry Ransom Center, University of Texas at Austin, in 1963. Gernsheim continued his studies and writings until his death in 1995.

Gerz, Jochen (b. 1940) German artist. After finishing university Gerz became an artist. He focuses on the subjects of memory and monuments, producing black-and-white photographs often accompanied by text. Through these images he questions the relationship between reality and representation. Gerz lives in Ireland.

Ghirri, Luigi (1943–1992) Italian photographer. Ghirri studied in Modena and worked as a surveyor before taking up photography in 1970. He exhibited his first series, entitled *Paesaggi*

Luigi Ghirri, *Orbetello*, 1974　　　• **G** —

di cartone ('Cardboard Landscapes'), in Milan in 1973. In 1978 he published *Kodachrome*, a work in colour that combined the tradition of → travel photography with a desire to portray everyday life. He laid claim to the heritage of → Walker Evans but superimposed the authenticity of the direct experience, with an added dose of irony. Although Ghirri rejected any form of academicism, his writings as well as his images contributed to a revival of Italian → landscape photography. In 1984 he initiated the *Viaggio in Italia* project, which involved twenty or so young photographers. A major work entitled *Paesaggio italiano*, which he had begun in 1980, was interrupted only by his death.

Ghisoland, Norbert (1878–1939) Belgian photographer. For over forty years Ghisoland, who is today considered an 'involuntary anthropologist', immortalized his contemporaries with elegance and dignity. Himself the son of a miner, Ghisoland opened a studio in Frameries and took portraits mainly of members of the working class, who turned to him in order to preserve the happy moments that punctuated their lives. Some 45,000 of Ghisoland's plates were found by chance in 1969 and have since been exhibited internationally.

Giacomelli, Mario (1925–2000) Italian photographer. Born in Senigallia in 1925, he remained in the town all his life. At the age of 13 Giacomelli became an assistant in a printing

works, while at the same time practising poetry and painting. Following World War II he worked as a typesetter before opening his own printing shop in 1950. In 1953 he bought his first camera and learnt the rules of photography from Ferruccio Ferroni. Encouraged by Giuseppe Cavali, he won many national awards. His most famous series are *Verrà la morte e avrà i tuoi occhi* (1954–68), *Scanno* (1957), *Lourdes* (1957), *I Pretini* (1961–63) and *Presa di Coscienza sulla Natura* (1977–2000). His dramatic photographs, with their graphic compositions and strong contrasts of black and white, most often tackle the themes of time, illness and death.

— G •

Gibson, Ralph (b. 1939) American photographer. Gibson was an assistant to → Dorothea Lange in 1960 and worked with → Robert Frank. He photographed his first nudes in 1961, concentrating on anatomical details. He also produced a trilogy of books – *The Somnambulist* (1970), *Déjà-Vu* and *Days at Sea* (1972) – published by his own Lustrum Press. Gibson was briefly a member of → Magnum Photos.

Gidal, Tim [Nachum Ignaz Gidalewitsch] (1909–1996) Israeli photographer. A self-taught photographer, he is considered one of the forefathers of → photojournalism. Between 1928 and 1935 Gidal studied at the universities of Munich, Berlin and Basel. Using the small cameras that followed the introduction of the → Leica in 1924, Gidal worked for illustrated magazines such as the *Münchner Illustrierte Presse* from 1929 to 1933, bringing previously inaccessible scenes of daily life into the field of photojournalism. In the years that followed he travelled around the world, visiting Palestine, Poland, Germany, India and the United States, documenting major moments of modern history.

Gilbert & George A British artistic duo comprising Gilbert Proesch (b. 1943) and George Passmore (b. 1942). Their collaboration began in 1967, when they met at Saint Martin's School of Art in London. Presenting their everyday life as a work of art in itself, the recipients of the 1986 Turner Prize initially appeared in performance pieces and videos, turning to → photomontages in the

1970s. These works are usually characterized by their vivid tones and their slogans, and can be read as highly political statements. Their work takes the form of large panels in which the duo portray themselves according to the theme being addressed. Sexuality, terrorism, death and religion all serve as sources of inspiration for their provocative → mises-en-scène. They live and work in London.

Gilden, Bruce (b. 1946) American photographer. He took up photography after studying sociology. From 1981 he devoted himself to → street photography for more than twenty years, working mainly in New York. Between 1984 and 1994 he documented voodoo rites in Haiti. His → reportages have taken him to France, Ireland and Japan. Gilden has been a member of → Magnum Photos since 1988.

Gimpel, Léon (1873–1948) French photographer. Beginning his career as an amateur, from 1904 Gimpel worked for the → illustrated press, including *L'Illustration*, for whom he produced images of great visual inventiveness. He is known particularly for his colour photographs of Parisian life during the Belle Époque, a technique still in its infancy at the time.

Gioli, Paolo (b. 1942) Italian photographer. Gioli experiments mainly with → pinhole cameras and large-format → Polaroids. Inspired by 19th-century photography, he describes himself as a handyman interested in raw images free of technical artifice. Gioli has also made experimental films, some using a pinhole.

Glanville, Toby (b. 1961) British photographer. Known for his food photography and his portraiture, Glanville has numerous works in the National Portrait Gallery and the Victoria and Albert Museum, London. His book *Actual Life* (2002) records the places and people of the county of Kent. Glanville also has several cookbooks, including *The Lebanese Kitchen*, to his credit.

Gloeden, Baron Wilhelm von (1856–1931) German photographer. After studying art history, von

Wilhelm von Gloeden,
Reclining Male Nude Beside Vase, 1890s

Gloeden travelled in Italy, mainly for health reasons. In 1878 he settled in Taormina, Sicily, where he took up photography and established a studio. He used young Sicilian boys as models, posing them nude or semi-clothed against natural backgrounds in a classical style. These staged images were characterized by their homoerotic sensuality. His work achieved great success and was exhibited across Europe. In 1895 he was obliged to make photography his chief source of income and also became correspondent for a German newspaper. Von Gloeden was visited by celebrities including Oscar Wilde and Edward VII, and was honoured during his lifetime with many awards. After his death, however, the Fascist authorities destroyed a large amount of his work.

Godwin, Fay (1931–2005) German-born British photographer. In 1969 she separated from the publisher Tony Godwin and started a career as a professional photographer. Taking advantage of her literary network, she photographed British writers. She was struck by cancer in 1976, an ordeal that led her to begin photographing landscapes. Taken in black and white, her poetic works display a skilful handling of tones and natural light. In 1979 Godwin illustrated Ted Hughes's collection of poems entitled *Remains of Elmet*.

Goldberg, Jim (b. 1953) American photographer. Adopting a social documentary style, Goldberg portrays people on the margins of society. His principal work, *Rich and Poor* (1985), examines

G

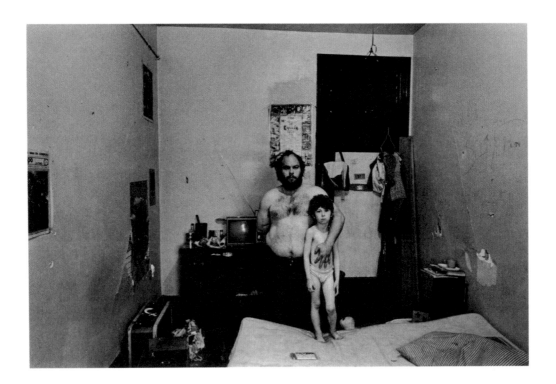

I LOVE DAVID. BUT HE IS TO fragile for A Rough father Like ME

Jim Goldberg, *'I love David. But he is to fragile for
a rough father like me'*, 1979

social classes while using the narrative device of text handwritten by his subjects to put forward a view of the self in relation to its portrayal. He has been a member of → Magnum Photos since 2006.

Goldberg, Vicki American critic and photography historian. Goldberg regularly contributes articles to major American magazines and newspapers. She is the author of a biography of → Margaret Bourke-White and of *The Power of Photography* (1991), which has now become a classic history of photography. In this work, she sets out her concept of photography as a social object, a product of its times and a major influence in shaping our political perception of the world around us. While she is no stranger to aesthetic hierarchies, particularly in her journalism and

her contributions to exhibition catalogues, it is the social aspect of the image that guides her historical work on the medium. She has also curated many exhibitions.

Goldblatt, David (b. 1930) South African photographer. After completing his degree in business studies at the University of Witwatersrand, Goldblatt began to work as a press photographer. Since the early 1960s he has focused his attention on the political and social landscape of his country, showing the effects of apartheid and the ravages of AIDS (*South Africa: The Structure of Things Then*, 1998). In the course of his socially engaged work he founded the Market Photography Workshop in Johannesburg in 1989, which he conceived

• **G** —

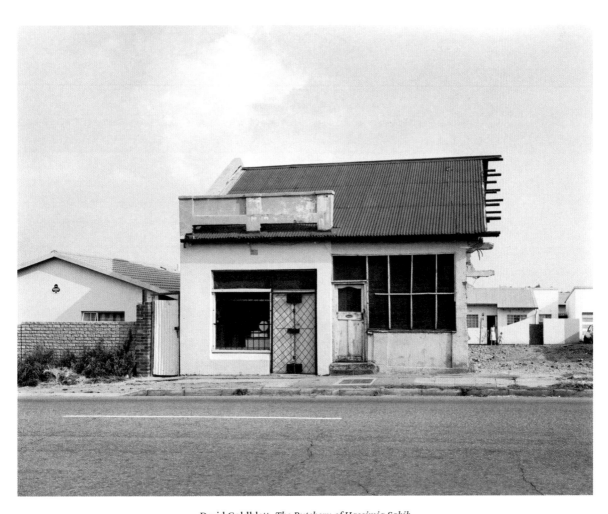

David Goldblatt, *The Butchery of Hassimia Sahib,
who Resisted Forced Removal,
with New Housing for Whites*, 1986

as a photography school and a gallery. Having photographed systematically in black and white, he turned to colour towards the end of the 1990s. The first South African artist to be the subject of a one-man exhibition at the → Museum of Modern Art, New York (1998), he has received numerous awards, including the Hasselblad Prize (2006).

Goldin, Nan (b. 1953) American photographer. A graduate of the School of the Museum of Fine Arts in Boston, Goldin is recognized as a member of the → Boston School. Deeply affected by the suicide of her sister during her adolescence, she used photography to preserve memories of people and places. She photographs the intimate private lives of her friends and family and her own daily life, adopting a → snapshot style.

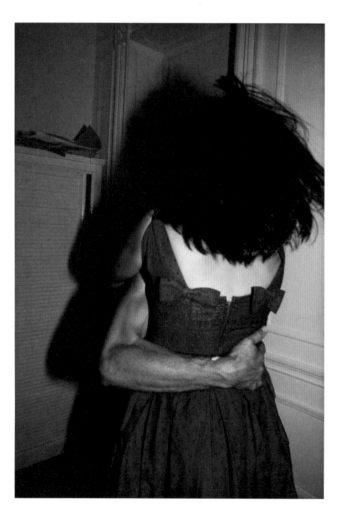

Nan Goldin, *The Hug,*
NYC, 1980

Sex, parties, drugs, transvestites and misfits are presented in the form of evolving audio slideshows, the most famous being *The Ballad of Sexual Dependency* (1981–). Although for a long time her work focused on painful moments, including such images as a self-portrait taken after she had been assaulted by a boyfriend, it has gradually begun to display a lighter mood.

Goldsworthy, Andy (b. 1956) British land artist. Goldsworthy uses natural objects and materials to create sculptures and installations, often in the open air. Photography plays an important role in his art, allowing him to document his works in colour and add captions describing how they were made. These pictures document the construction process and show different views of a work, taken from close up and afar.

Golestan, Kaveh (1950–2003) Iranian photographer. After finishing high school in England, Golestan returned to Iran, where he worked as a freelance photographer. In 1972 he covered the paramilitary conflict in Northern Ireland and became a reporter. In 1979 he documented the Islamic Revolution for *Time* magazine and then the Iran–Iraq War for various international agencies. In 1984 he went into exile in London, where ten years later he was employed as a cameraman for the Associated Press Television Network. He died in 2003 in northern Iraq after stepping on a landmine.

Gomes, Alair (1921–1992) Brazilian photographer. A civil engineer by training, from 1966 Gomes devoted himself entirely to photography. Between 1968 and 1970 he collaborated with the landscape architect Roberto Burle Marx to create a botanical archive in Barra de Guaratiba, Rio de Janeiro. In 1977 he founded the department of photography at the Visual Arts School of Parque Lage in Rio de Janeiro. His homoerotic body of work, which captured the young men who frequented the famous beaches of Copacabana and Ipanema in black and white, is preserved in the photographic collection of the Museum of Modern Art in Rio. It was exhibited at the Maison Européene de la Photographie, Paris, in 2009.

Gomis, Joaquim (1902–1991) Spanish photographer. A friend of Joan Miró and a supporter of the art revival in Catalonia, Gomis embodied Spanish photographic modernity, particularly in his use of low angles and oblique axes for his images of American skyscrapers or the Eiffel Tower. From 1940 he published his 'fotoscops': themed books in which the camera dissected a subject matter from all angles.

Gonnord, Pierre (b. 1963) French photographer. Self-taught, Gonnord is known for his portraits of individuals on the margins of society. With their dark backgrounds and sombre lighting, these images link contemporary subjects with the Spanish Baroque tradition of portrait painting. Gonnord's subjects have included Eastern European immigrants, gypsies in Seville, Jews living in Venice, farmers of rural Spain, Portuguese villagers, and residents of the South in the United States.

Goodwin, Henry B. [Henry Buergel Goodwin] (1878–1931) German-born Swedish photographer. He arrived in Sweden in 1905 as a lecturer in German at Uppsala University. In 1914 he set himself up as a full-time photographer and opened a studio called 'Kamerabilder' ('camera pictures') in Stockholm. Some of his portraits of artists, views of Stockholm and flower studies were published in a series of exquisite books. Goodwin's nude studies are the most intriguing part of his output, and included the *Wet Hair* series. Goodwin was part of the → Pictorialist movement and belonged to the London Salon of Photography.

Gosani, Bob (1934–1972) South African photographer. Gosani began his career as a laboratory assistant at *Drum* magazine under the guidance of → Jürgen Schadeberg. He continued to work for the publication throughout his career. His works, which aimed to highlight the injustices of the apartheid regime, are widely known in South Africa.

Gossage, John R. (b. 1946) American photographer. Gossage is known for his publications, and for *The Pond* (1981–85) in

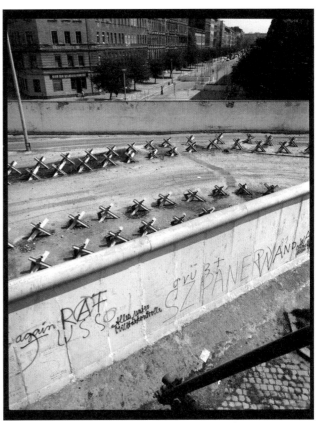

John R. Gossage, *Bernaurerstr.*, 1982

particular: a work that resulted in both a book and a portfolio of fifty-two → gelatin silver prints. Primarily self-taught, he began working professionally as a photographer for local newspapers at the age of 14. In the early 1960s he studied briefly with → Lisette Model, → Alexey Brodovitch and → Bruce Davidson. He has concentrated on art publishing since 1990.

Gowin, Emmet (b. 1941) American photographer. Taught by → Harry Callahan at the Rhode Island School of Design, Gowin discovered his first source of inspiration in his marriage, which took place in Virginia in 1964, photographing his wife, Edith, and members of her family. He worked as a portrait photographer and from the 1980s took up → aerial photography, depicting landscapes ravaged by human intervention. Gowin works in Pennsylvania.

Graeff, Werner F. (1901–1978) German artist, educator and inventor of one of the world's first

• G —

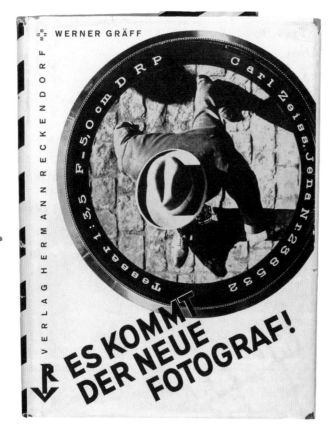

Werner F. Graeff, *Es kommt der neue Fotograf*, Berlin, 1929

mini-cameras. In 1921 he joined the → Bauhaus in Weimar and studied under Johannes Itten and Theo van Doesburg. He was also a member of the De Stijl group and a follower of Constructivism. His artistic inspiration often came from the modern world, and subjects such as trains and cars. Graeff was a member of the Deutscher Werkbund and published the books *Bau und Wohnung* and *Innenräume* to accompany Werkbund exhibitions. In 1931–32 he began to teach and founded his own photography school, the Berliner Fotoschule. In 1934 he fled the Nazi regime and went to Spain and then to Switzerland. In 1950 Graeff took up painting once more, and from 1951 to 1959 taught at the Folkwang School in Essen.

Graham, Dan (b. 1942) American artist. During the 1960s Graham was one of a group of artists interested in conceptualism and in experimenting with a combination of techniques,

notably video and photography. He also practised performance art and made films. In 1966 Graham conceived a photographic work entitled *Homes for America*. Published in *Arts Magazine*, this project was as much a critique of the consequences of modernist architecture as of the workings of advertising and commercialism. His work is represented in the collections of many museums, including Tate, London, the Chicago Art Institute, and the Musée National d'Art Moderne in Paris.

Graham, Paul (b. 1956) British photographer. He studied at the Royal College of Art in London and works in the United States. In 1981 Graham began to introduce colour into social → documentary photography, capturing the environs of the A1 motorway in England. He went on to document employment offices and the traces that the Northern Ireland conflict left on the landscape. The series *American Night* (1998–2002) consists of a number of overexposed, almost white photographs of American suburbs.

Graham, Rodney (b. 1949) Canadian conceptual artist, associated with the → Vancouver School. He studied at the University of British Columbia from 1968 to 1971. His diverse and complex oeuvre includes film and video installations, photography, music and sculpture. Graham often features in his own work as a fictional character or performer. *Vexation Island*, shown at the 1997 Venice Biennale, features an endless loop, one of his most recognizable motifs.

Greene, John Beasley (1832–1856) American photographer. Greene learnt photography from → Gustave Le Gray. Despite his death at the early age of 24, he left an extensive collection of dry → waxed paper negatives representing landscapes, monuments and ancient inscriptions. His images of Egypt and Algeria reveal his passion for archaeology.

Greenfield, Lauren (b. 1966) American photographer and filmmaker. Since graduating from Harvard in 1987, Greenfield has created a body of photographs and film that considers

the influence of mass culture and the media on our images. Her preferred themes are youth culture (particularly adolescents from affluent backgrounds), gender studies and representations of the female body in contemporary society.

Griffin, Brian (b. 1948) British photographer. Griffin graduated from Manchester Polytechnic in 1972. In his commissions for companies and magazines, he stands out for his non-conformist take on the institutional portrait, documenting working-class labour and office

• **G** —

Rodney Graham, *Artist's Model Posing for 'The Old Bugler, Among the Fallen, Battle of Beaune-la-Roland, 1870', in the Studio of an Unknown Military Painter, Paris, 1885*, 2009

Brian Griffin,
Self-Portrait, 1988

workers. He recorded the construction of the Channel Tunnel, employing dramatic → *mises-en-scènes* and depicting the labourers in a heroic light.

Groebli, René (b. 1927) Swiss photographer. Groebli studied photography with → Hans Finsler at the Zurich University of the Arts in 1945–46. He then trained as a cinematographer until 1949. He became a photographer for the → Black Star agency in 1951, carrying out → reportages in Africa and the Near East. At the beginning of the 1950s he also worked as a reporter for magazines such as → *Life* and *Picture Post*. Between 1955 and 1981 he acquired a commercial photography studio and worked as a freelancer. Groebli was one of the first photographers to make creative use of the blurring effect caused by movement. His images appeared in the books *Rail Magic* (1949) and *The Eye of Love* (1954).

Gros, Jean-Baptiste Louis (1793–1870) French photographer. Little is known about Gros's beginnings in photography, but it appears that he started to use the → daguerreotype in the early 1840s. Thanks to his career as a diplomat, he travelled to many countries where, attracted by its precision, he used photography to document the local architecture. In 1845 he created some astronomical images in collaboration with Eugène Durieu. During his time in Paris he frequented its institutions and learned societies. In 1851 he became president of the → Société Héliographique and helped found the → Société Française de Photographie in 1854. Gros appears to have given up photography after 1857.

Grossman, Sid (1914–1995) American photographer. In 1936 Grossman co-founded the → Photo League of New York alongside Sol Libsohn. He taught → documentary photography there and established a 'Documentary Group' with which he carried out several urban projects. In 1940 his photographs of trade unions attracted the attention of the FBI. In 1949 he moved to Provincetown, where he opened his own school of photography and developed a more abstract style.

Group *f*.64 A collective of artists espousing the aesthetics of a new, American photographic modernism in reaction to the continued popularity of → Pictorialism. Named after the smallest → aperture available on a large-format camera, the group embraced the type of clarity, definition and vast → depth of field captured by photographs using that setting. These crisp photographs were the formal opposite of the much-maligned Pictorial 'fuzzygraph'. Under the guidance of → Willard Van Dyke and → Ansel Adams, the first show at the M. H. de Young Memorial Museum, San Francisco (1932), consisted of work by a core group of seven photographers: → Imogen Cunningham, John Paul Edwards, Sonya Noskowiak, Henry Swift, → Edward Weston and the group's two founders. Strongly influenced by Western landscape and themes, the group foundered during the Depression and had ultimately dissolved by 1935.

Gruber, Leo Fritz (1908–2005) German photographer. In the course of his studies, Gruber founded two periodicals: the *Kölner*

Kurier and the *Westdeutscher Kurier*, both openly anti-Nazi. In 1933 the two papers were banned and Gruber went into exile in London, where his underlying interest in photography followed a more concrete path. He contributed to the annual publication *Modern Photography*. In 1949 he returned to Cologne, where the following year, together with Bruno Uhl, he established Photokina, which is still considered one of the photographic industry's most important trade fairs.

Gruyaert, Harry (b. 1941) Belgian photographer. Introduced to photography by his father, Gruyaert studied at the École de Photographie et de Cinéma in Brussels from 1959 to 1962. In 1963 he became a director of photography for Flemish television, a position he was to hold for three years. At the same time he also produced fashion and commercial photographs and → reportages, particularly in Paris, where he met → Robert Delpire. Influenced by the

works of → Stephen Shore and → William Eggleston, Gruyaert is considered one of the first photographers to explore the full potential of colour photography. In 1972 he made *TV Shots*, a series of images of television screens in which the reworked colours assume saturated, acidic tones. His work, marked by frequent journeys to the US, the UK, India and Morocco, has received many awards and has given rise to many exhibitions and publications. Gruyaert has been a member of → Magnum Photos since 1981.

Guerra, Jorge (b. 1936) Portuguese photographer. Guerra was influenced by the humanist approach popular in European photography. He photographed Lisbon in 1967, documenting life under the country's dictatorship. He made extended trips to Angola, the United Kingdom, Italy, Mexico and Canada. Settling in Montreal in 1970, he founded and co-edited the Canadian photographic magazine *OVO* from 1974 to 1988.

• **G** —

Harry Gruyaert, *Bowl of Marinated Lemons used in Traditional Cooking, Souk, Meknes*, 1988

Ara Güler, *Boys Playing Marbles in the Courtyard
of the Fethiye Mosque in Istanbul*, 1968

Guibert, Hervé (1955–1991) French writer and journalist. Aside from producing works of fiction and autobiography, Guibert also explored the field of photography as both writer and artist. A cinema and photography critic for *Le Monde* (1977–85), he produced an influential book on photography called *L'image fantôme* (1981). Suffering from AIDS, he committed suicide at the age of 36.

Guidi, Guido (b. 1941) Italian photographer. After studying architecture in Venice, Guidi has spent his career photographing the ever-changing landscape and architecture of Italy through the lens of an 8 × 10 view camera. While Guidi's early work investigated the country's contemporary, man-altered landscapes, he has also focused on various architectural subjects, particularly ageing Modernist buildings.

Güler, Ara (b. 1928) Turkish–Armenian photographer. After studying economics, Güler became a photojournalist for the Turkish press at the age of 20, going on to work for international magazines including *Time*, → *Life* and *Paris Match*. After meeting → Henri Cartier-Bresson in 1961 he joined → Magnum Photos. In addition to his portraits of famous personalities, he is known primarily for his → reportages on Istanbul, which earned him the nickname 'the eye of Istanbul'. In the light of the Turkish capital's transformation during the 1950s and 1960s, he documented the life of its neighbourhoods and inhabitants with an empathetic and nostalgic eye. He has achieved notable international success and has been the subject of exhibitions at the → Museum of Modern Art, New York, and the Photokina in Cologne.

Gulyás, Miklós (b. 1957) Hungarian photographer. Following his graduation from the Hungarian Academy of Crafts and Design in 1989, Gulyás has concentrated on → street photography. His photographs are subjective views of the ordinary, everyday lives of the Hungarian people. They combine dramatic and satirical effects, and demonstrate a highly individual visual language. Gulyás's work mainly features Budapest's crowded public places: stations, trams,

bathhouses and horseracing tracks. He teaches at the Moholy-Nagy University of Art and Design in Budapest and is the editor of www.fotografus.hu. His monographs include *1 másodperc* (2002) and *Hon* (2007). He received the Rudolf Balogh Prize in 2003.

Gum bichromate process The simplest of the pigment printing processes, based on research carried out by → Alphonse Louis Poitevin in 1855 and developed by John Pouncy in 1858. Similar to the → carbon process and notable for tonal contrasts and softness of detail, the process was popularized by the printer A. Rouillé-Ladevèze and the → Pictorialist → Robert Demachy at the end of the 19th century. The paper is brushed with a mixture of gum arabic (as a binder), potassium bichromate and a pigment (usually a watercolour pigment), then contact-printed with the negative. The gum hardens in proportion to the amount of light it receives through the negative and retains the pigment accordingly. Unexposed areas do not harden and are washed off with warm water. The potential for manually manipulating the image while the gum was still soft, using a brush or scraper, allowed for the creation of colour or composite effects and resulted in images with a velvety quality. It was popular with the Pictorialists at the turn of the 20th century, owing to its soft, painterly qualities and the ease with which the developing image could be manipulated. The gum bichromate process does not involve silver salts and is thus very stable.

Gum platinum process A combined process, popular with the → Pictorialists of the early 20th century, in which a layer of → gum bichromate was applied to platinum paper. It allowed for subtle gradations of tone and areas of intense shadow to be achieved in the same image.

Gundlach, F. C. [Franz Christian Gundlach] (b. 1926) German photographer. Gundlach is considered one of the most significant German fashion photographers. His work is characterized by its spare and graphic style, which he also adopted for his photographs of architecture,

Andreas Gursky,
Chicago Board of Trade II, 1999

celebrities and → reportage. He is also known as a gallery owner and collector. Since 2003 he has directed the House of Photography at the Deichtorhallen Hamburg.

Gursky, Andreas (b. 1955) German photographer. He studied under → Otto Steinert and → Michael Schmidt at the Folkwangschule in Essen (1977–80), and with → Bernd Becher at the Kunstakademie Düsseldorf (1980–87) – the school with which he is most commonly associated, and which played an important role in securing photography's acceptance by the art world. In the 1980s Gursky principally photographed landscapes associated with leisure (mountains, countryside and swimming pools, for instance), in which the tension between humankind and our environment – central to Gursky's work – is already apparent. In the 1990s he started to create tableaux using digital editing software, adopting increasingly large formats. His images are characterized by their full-frontal, two-dimensional viewpoints, saturated colours, and a marked contrast between wide camera

angles and microscopic details; they thus constitute a formal break with the matter-of-fact approach of traditional German → documentary photography. In the 2000s Gursky primarily documented the effects of globalization and wealth, creating visually seductive, iconic pictures (Formula 1 racing, the London Stock Exchange, the consumption of luxury goods) that address the homogenization of images in the context of global visual culture.

Gutmann, John (1905–1998) German-born American photographer. Gutmann left Germany in 1933 for the United States. He travelled across the country chronicling the urban scene and popular American culture, presenting a spontaneous and ironic view of life in the 1930s. His work was influenced by the modern photojournalist style that developed in Germany at the end of the 1920s, but also by the European avant-garde and Expressionism. Gutmann was professor at San Francisco State College until 1973.

Haas, Ernst (1921–1986) Austrian-born American photojournalist. He studied medicine in Vienna until 1940, then took up photography at the city's Graphic Arts Institute in 1941. Haas gave photography classes between 1943 and 1945 at the American Red Cross headquarters, where in 1947 he exhibited images of wartime Vienna. His photographs of prisoners of war returning to Austria were published in *Heute* and → *Life* magazines in 1949. He left Vienna for New York in 1950. A → Magnum photographer from 1949 to 1962, Haas published in *Life*, *Esquire*, *Look*, *Holiday* and *Paris Match*. A pioneer of colour press photography (an early example is the story entitled 'Images of a Magic City', *Life*, 1953) and of colour motion studies ('Beauty in a Brutal Art', *Life*, 1957), Haas is known for his experimental use of soft, selective focus and → overexposure. The exhibition 'Ernst Haas: Color Photography', curated by → Edward Steichen, was held at the → Museum of Modern Art, New York, in 1962.

Hagemeyer, Johan (1884–1962) Dutch-born American photographer. A meeting with → Alfred Stieglitz persuaded Hagemeyer to give up horticulture and to become a photographer instead. He might thus have become the first East Coast representative of anti-Pictorialism, but his photographs remained resolutely imbued with a dreamlike romanticism. Initially a close friend of → Edward Weston, he refused to join → Group *f*.64 and remained fiercely independent. Between the 1920s and 1940s, Hagemeyer photographed many major personalities of his time in his studios in San Francisco and Carmel, which was then a fashionable seaside resort.

Hajek-Halke, Heinz (1898–1983) German photographer. Self-taught, this Berliner made a name for himself during the 1920s for his innovative → photomontages. He worked as a commercial photographer in journalism and advertising, as well as being an artist, and helped photography achieve recognition as a fully fledged art. His most notable works are perhaps his black-and-white nudes of the early 1930s. After World War II he devoted himself entirely to art, was one of the founders of the Fotoform group, and became one of the most prominent representatives of the experimental Subjektive

— H ●

Heinz Hajek-Halke, *Nude, Printed by Twice
Exposing the Same Negative, Once Flipped*, 1933

Fotografie movement. From 1955 he taught
graphic design and photography at the Academy
of Fine Arts in Berlin.

Halawani, Rula (b. 1964) Palestinian photographer.
Halawani was educated in Canada and London,
and currently lives in East Jerusalem. She
is the founder and director of the photography
department of the University of Bir Zeit in
Ramallah. Initially a press photographer, she
now works more in the field of the visual arts,
recording everyday life in Palestine under the
Israeli occupation with a subjective approach
that is often poetic and unavoidably political.

Halsman, Philippe (1906–1979) Latvian-born
American portrait and press photographer.
Born in Riga, then part of the Russian Empire,
Halsman studied architectural engineering

in Germany in the mid-1920s before running
a portrait studio in Paris between 1932 and
1940. He published his work in → *Vogue* and
→ *Vu*. Having left Europe for New York in 1940,
he signed on with → Black Star and freelanced
for → *Life* (for which he produced a record 101
cover photographs), *Look*, *Saturday Evening Post*,
Ladies' Home Journal, Pond's, Elizabeth Arden,
NBC and Ford, among others. He distinguished
himself by producing a vast gallery of celebrity
portraits, including actors, industrialists,
politicians, scientists and writers; some, such
as his images of Audrey Hepburn, Marilyn
Monroe, Winston Churchill and Albert Einstein,
became iconic. Halsman met the Surrealist
painter Salvador Dalí in 1941; the artist turned
out to be a perfect accomplice, and the pair
worked together for thirty-seven years.

Hamaya, Hiroshi (1915–99) Japanese photographer
and → photojournalist. Hamaya worked as
a freelancer and also with → Magnum Photos
– their first Japanese member. Trained as a
photographer and originally specializing in
aerial views, he was best known for his images of
everyday life in Japan and its surviving ancestral
traditions. He favoured remote locations,
taking portraits of people in rural areas, and
was interested in the close relationship between
the way of life on the islands of Japan and the
extremes of nature. An excellent example of this
was his series *Yukiguni* ('The Land of the Snow'),
published in 1956, which depicted New Year
celebrations in a region that is often covered
in heavy snow. Born in Tokyo, he photographed
the city often, beginning in the years preceding
World War II and continuing into the post-war
period. In 1960 he covered the demonstrations
and riots that followed the renewal of the
security treaty between Japan and the United
States. Over the course of his career Hamaya
won many national and international awards.

Hamilton, David (b. 1933) British photographer.
He studied architecture and graphic design in
London before turning to photography. Hamilton
went to Paris in 1959 and worked on the magazine
Elle, but then returned to London, where he
was appointed art director of *Queen*. He became

Hiroshi Hamaya, *Woman Hurrying on the Snow Road,*
Taugaro, Japan, 1956

H •

Richard Hamilton, *Interior*, 1964

famous during the 1970s for his masterly soft-focus female nudes.

Hamilton, Richard (1922–2011) British artist. From the mid-1950s Hamilton explored the different visual forms that can coexist within a single image. In 1955 he joined the Independent Group in London, which paved the way for European Pop art, and he helped to organize the exhibition *This is Tomorrow*, for which he designed the poster. The work, entitled *Just What Is It That Makes Today's Homes So Different, So Appealing?* (1956), was a → collage of photographs cut out from mass-circulation magazines. It is still famous for celebrating the modernity of the 1950s while at the same time offering a critical

view. Hamilton gradually moved away from the spirit of Pop art and in the late 1980s made simpler images, though they still retain their hybrid form.

Hannon, Édouard (1853–1931) Belgian photographer. Born into an upper middle-class family, Hannon studied engineering at the University of Ghent, but his artistic aspirations revealed themselves very early on. By the age of 21 he was already a founder member of the Association Belge de Photographie. He worked for the chemical products company Solvay, of which he was managing director from 1907 until 1925, and he profited from all the travelling this involved to bring back photographs of the

places he had visited. In 1894 he was one of five Belgian participants in the first exhibition of the Photo-Club de Paris, where he was awarded the gold medal. He was one of those amateur photographers who were able to devote their time and talent to their great passion, and he perfected sophisticated printing techniques with the avowed aim of enabling photography to take its rightful place as one of the fine arts.

Hanzlová, Jitka (b. 1958) Czech photographer. Hanzlová was granted asylum in Germany in 1982, and from 1987 until 1994 she studied visual communications at the University of Essen, specializing in photography. Her works, which take the form of → series, are based on personal experience, and explore the relationship between individual identity and the environment in which it evolves. Examples include *Rokytnik* and *Bewohner* (both 1994–96), *Female* (2000) and *Forest* (2005).

Hardy, Bert [Albert Hardy] (1913–1995) British photographer. From the age of 14, Hardy worked as a laboratory assistant in a photography agency. From 1941 until 1957 he was engaged by *Picture Post*, and he served in the Army Film and Photography Unit from 1942 until 1946. He documented the Normandy landings, the liberation of Paris, and the concentration camp at Belsen. When *Picture Post* closed down in 1957, he worked in advertising.

Harper's Bazaar Fashion magazine founded in 1867 and, along with → *Vogue*, a dominant force in the fashion world since the 1930s. Its prestige stems from the quality of its editors-in-chief and art directors, all of whom made their individual mark and also engaged the services of the finest photographers of the time, such as → Man Ray and → Diane Arbus. When Carmel Snow was appointed editor-in-chief (1933–57), the magazine's aesthetic moved away from the modernist approach represented by → George Hoyningen-Huene towards the realism of → Martin Munkácsi. Snow's collaboration with → Alexey Brodovitch and then Marvin Israel as art directors introduced a period of innovation to the world of → fashion photography and magazine

design; in turn, this encouraged and influenced a whole generation of photographers, including → Richard Avedon, → Irving Penn and → Hiro.

Hartwig, Edward (1909–2003) Polish photographer. Initially a → Pictorialist, Hartwig studied under Rudolf Koppitz in Vienna. In addition to such themes as landscape, architecture and the theatre, he later worked in an increasingly graphic style, publishing the results in a number of albums. This work, which combines artistic and avant-garde approaches, was shown in many exhibitions in Poland and abroad. In 1947 Hartwig was a co-founder of ZPAF (the Union of Polish Art Photographers).

• **H** —

Hawarden, Lady Clementina [née Clementina Elphinstone Fleeming] (1822–1865) British photographer. Hawarden was one of those passionate amateurs whose privileged position enabled them to make photography their hobby. She set up a studio in the family home in South Kensington, where her principal models were her children, especially her elder daughters. They

Lady Clementina Hawarden, *Isabella Grace and Florence Elizabeth Maude, 5 Princes Gardens; Photographic Study*, c. 1863–64

would pose as innocent dreamers or sensual sirens, wearing indoor clothing, elegant dresses or historical costumes. Some of Hawarden's portraits may be seen as studies, some contain metaphorical allusions, and some are like the genre paintings that were very popular in Victorian times. Her compositions are always carefully arranged, usually include domestic features such as furniture, a window or a balcony, and make use of the contrasts offered by natural lighting. Hawarden's talent was recognized by the Photographic Society of London, which awarded her silver medals in the amateur category in 1863 and 1864.

— H ●

Hasselblad A Swedish manufacturer of camera equipment. It is best known for a type of medium-format camera first developed by Victor Hasselblad at the request of the Swedish

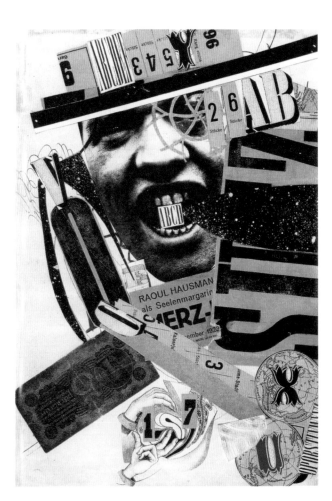

Raoul Hausmann, *ABCD*, 1923–24

government, for use by the air force during World War II. This model became available to the general public in 1948 but was used mainly by professionals. The camera had a modular structure, meaning that all of its parts – → lens, cartridge, viewfinding system – were interchangeable. From 1962 onwards it was used on NASA's manned flights: it was a Hasselblad that took the first photographs of man on the moon during the Apollo 11 mission of 1969.

Hatekeyama, Naoya (b. 1958) Japanese photographer. Hatekeyama was born in Rikuzen Takata, Iwate Prefecture. He studied art and design at the University of Tsukuba, receiving a master's degree in 1984. His large-scale colour photographs explore the relationship between man and nature, and the lengths humanity will go to control and shape nature to its will. Hatekeyama works in his native Japan, but has also executed large projects in France and Germany. The artist received the prestigious Kimura Ihei Award in 1997 and represented Japan at the 49th Venice Biennale in 2001.

Hausmann, Raoul (1886–1971) Austrian artist and photographer. Born in Vienna, Hausmann was one of the founders of the Dada group in Berlin, and took up photography in 1927. In 1933 he fled Nazi Germany for Spain, and then took refuge from the Civil War in Zurich and Prague before finally settling in France in 1938. He is regarded as one of the major figures of avant-garde photography during the inter-war period, and especially of the → New Vision movement. Hausmann carried out innumerable technical experiments involving superimposition, → photograms, → photomontages and unusual perspectives, constantly testing and extending the viewer's visual perception. He also wrote many texts on photography and carried out research into infrared. His black-and-white compositions helped to establish photography as a major art form.

Hausswolff, Annika von (b. 1967) Swedish artist. Von Hausswolff belongs to the generation of Swedish photographic artists who emerged in the early 1990s, inspired by postmodernist

art and theory. Several of her early works deal with the vulnerability of women. Violence is a recurring theme, exemplified by the large-format photograph *Hey Buster! What Do You Know About Desire?* (1995), which features a lifeless female body and a guarding German shepherd dog on a beach. In recent years, she has developed the psychoanalytical undercurrent in her works and also explored sculpture, fabric and installations. Having worked with staged scenarios throughout her career, she returned to the → documentary genre in 2011 and began using digital technology in a project to investigate how the financial crisis has affected the industrial landscape. Von Hausswolff represented Sweden at the Venice Biennale in 1999.

Hayashi, Tadahiko (1918–1990) Japanese photographer. Hayashi was born in Tokuyama, Yamaguchi Prefecture, into a family of commercial photographers. He graduated from the Oriental Photo School in Tokyo in 1938. During World War II he served as an auxiliary at the Japanese Embassy in Beijing, having recently formed the North China Public Relations Photography Association. He was also founder of the Japanese Professional Photographers Society in 1950. Hayashi is best known for his documentary photographs of post-war Japan between 1946 and 1955.

Heartfield, John [Helmut Herzfeld] (1891–1968) German publisher, graphic artist and stage designer, famous for his anti-Nazi → photomontages. Having studied graphic design in Munich, he initially worked in advertising, and throughout his career designed sets for film and theatre. In 1916 he anglicized his name in protest against wartime anti-British nationalist sentiment. The following year Heartfield and his brother founded the publishing firm of Malik Verlag, producing highly original book covers that featured photomontages. In 1918 he joined the Communist Party and, alongside his friend George Grosz, played a central role in the development of the Dada movement in Germany, again producing many photomontages. In 1927 he joined the weekly newspaper → *Arbeiter Illustrierte Zeitung (AIZ)*, for which he created

ADOLF – DER ÜBERMENSCH

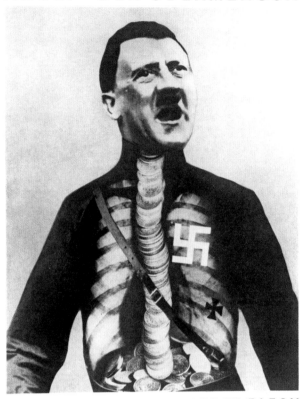

SCHLUCKT GOLD UND REDET BLECH

John Heartfield, *Adolf the Superman: Swallows Gold and Spits Junk*, 1932

237 satirical photomontages criticizing political inertia, the rise of Hitler's party, corruption and capitalism. In his visual attacks on political leaders, Heartfield's acerbic juxtapositions denounced the absurdity of war and nationalism. In 1929 his work was given an entire room of its own in the famous exhibition → *Film und Foto* in Stuttgart. In 1933 he emigrated to Prague but continued to work for *AIZ* until it closed in 1938, the year he fled to London. He returned to Germany in 1950, and continued to design stage sets and book covers for the rest of his life. In 1960 he became a professor at the Academy of Fine Arts in Berlin.

Heinecken, Robert (1931–2006) American photographer. Born in Denver, Heinecken grew up in Riverside, California. He attended the University of California in Los Angeles (UCLA)

but left to join the Marines in 1953. When Heinecken was released from service he returned to UCLA, where he received both his bachelor's and master's degrees in art. After graduating in 1960 he was hired by the UCLA art department, where he taught until 1991. In 1963 he founded the university's photography programme. Although described as a photographer, he seldom used a camera to create his work, instead appropriating photographs and mixing them with other media. Lauded and denigrated for this unconventional approach, Heinecken was nonetheless a forerunner and an influence on the postmodern photographers who followed.

Heinrich, Annemarie (1912–2005) German-born Argentinian photographer. Heinrich emigrated to Argentina in 1926. During the 1930s she specialized in nudes and portraits of Argentinian actors. In 1953 she helped to found the Carpeta de Los Diez group of professional photographers, and was also co-founder of the Argentinian Council of Photography in 1979.

Heliography A term, meaning 'sun drawing', coined by → Nicéphore Niépce in 1824 to describe the process that would later become known as photography. Niépce was the first to fix an image obtained from a → camera obscura, using the action of light alone with no human intervention. The process he used to achieve a → positive image was to combine bitumen of Judea with lavender oil and spread it in a thin layer on a metal (pewter) or glass plate to form a photosensitive varnish. He then placed the plate inside a camera obscura. Where light fell on the plate, the bitumen turned hard and pale. In the areas of shadow, it remained soft and could be washed away with a solvent. The disadvantage of bitumen of Judea was that it was not very sensitive and therefore required an exposure time of several hours to create an image. This photographic process was developed further when Niépce went into partnership with → Louis Daguerre. When Niépce died in 1833, his partner went on to invent an alternative based on different chemicals, calling it the → daguerreotype.

Henderson, Nigel (1917–1985) English photographer. After studying biology, Henderson turned to painting and → collages. At the end of World War II, he studied at the Slade School of Art, London, and in 1952 joined the modernist Independent Group, thus participating in the launch of Pop art. His work is devoted mainly to experimentation with → photograms, the manipulation of → negatives and painting on photographs. Between 1965 and 1982

Robert Heinecken,
Costume for Feb '68, 1968

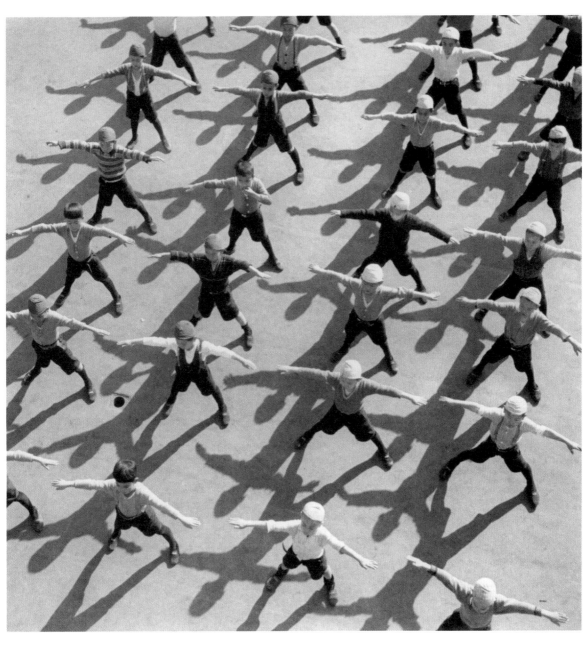

Fritz Henle,
The Boy with the Apple, 1936

• H —

Henderson was twice director of the photography department at the Norwich School of Art.

Henle, Fritz (1909–1993) German-born American photographer. Henle studied at the Bavarian Institute of Photography from 1930 to 1931. He was an advertising photographer for the Lloyd Triestino shipping company between 1934 and 1936, and published *Das ist Japan* in 1936. He fled to New York in 1936, becoming

a photographer for → Black Star (1936–42), an associate photographer at → *Life* (1937–41) and a staff photographer at the Office of War Information (1942–45). Henle worked as a fashion and industrial photographer in the late 1940s and 1950s, and a travel photographer in the late 1950s and 1960s.

Henneberg, Hugo (1863–1918) Austrian scientist. As an amateur, Henneberg was initially interested

H •

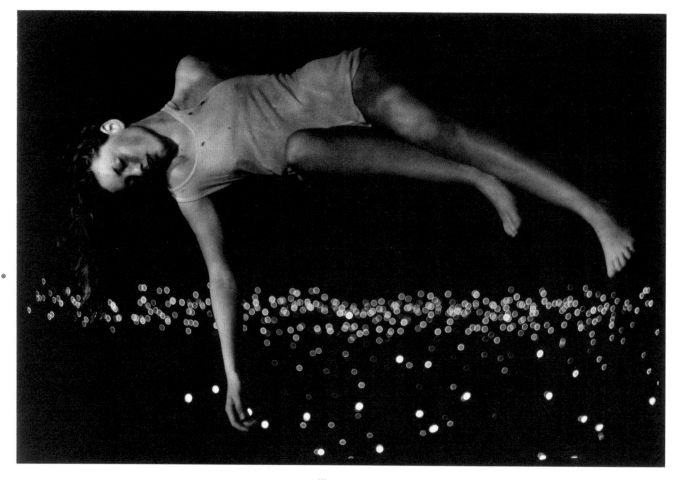

Bill Henson,
Untitled, 2000–01

in the technical aspects of photography. His knowledge of chemistry helped him to become an outstanding photographer owing to the high quality of his → gum bichromate prints. His romantic landscapes were particularly successful, and, along with his compatriots → Heinrich Kühn and Hans Watzek, he is regarded as one of the principal representatives of the → Pictorialist movement in Austria.

Henri, Florence (1893–1982) Swiss photographer and painter. Henri was born in New York to a French father and a German mother. She studied painting at the → Bauhaus in Weimar and at André Lhote's and Fernand Léger's schools in Paris. She began to experiment with photography during summer courses at the Bauhaus in Dessau in 1927, and took it up full time in 1928. That same year, she created her famous series of

portraits and self-portraits using a mirror. Her work immediately won the plaudits of her artist friends and critics, and she became a leading figure in avant-garde photography during the inter-war period. From 1929 onwards her work featured in numerous exhibitions (including → *Film und Foto* in Stuttgart) and publications.

Henson, Bill (b. 1955) Australian photographer. Born in Melbourne, he studied photography for two years at the city's Prahan College before receiving his first solo exhibition at the National Gallery of Victoria at the age of 19. While his early images depicted various subjects – among them ballerinas – in soft focus and subdued colour, his following bodies of work switched to a brooding black-and-white style. Among them is a series of photographs made on crowded city streets with a telephoto lens, which allowed him to focus

on unknowing commuters seemingly caught in moments of inner drama, surrounded by hustle and bustle. In the late 1980s Henson began to return to colour photography, producing images of suburban landscapes and portraits of youths in the late afternoon and dusk hours. These themes were pushed further in the following years with his best-known body of work, which depicts adolescents, often nude, interacting with one another in darkly lit landscapes that appear to be on the fringe between urban and suburban. In 2008 Henson became involved in a high-profile legal case after police shut down an exhibition of his work at a Sydney gallery and seized several pieces amid controversy over the photograph of a naked 13-year-old girl. It sparked a major national debate on the artistic merit of the photographs and the role of state censorship, though authorities ultimately deemed the images acceptable.

Hers, François (b. 1943) Belgian photographer. Hers regards himself as an artist who uses photography rather than as a photographer. His work essentially represents his role as a producer of images and an 'intermediary'. In 1972 he co-founded the Viva agency, and in 1983 created the → DATAR project in order to make an inventory of French territories. He is currently director of the Fondation Hartung Bergman.

Herschel, Sir John [John Frederick William Herschel] (1792–1871) English physicist and astronomer. A renowned scientist, Herschel made numerous discoveries that were essential to the development of photography. He helped to perfect photography on paper, a process first invented by → William Henry Fox Talbot. In 1834 he recommended that Talbot use soda hyposulphite (sodium thiosulphate) as a fixative. Discovered in 1819, this mix had the property of dissolving silver chloride. In a letter to Talbot dated 13 February 1839, Herschel was the first to use the word 'photography' (from the Greek, meaning 'writing in light'), and he also developed the concepts of → positive and → negative. In 1842 he invented the process known as the → cyanotype or 'blueprint', in which a positive

image is obtained through the action of light on potassium ferricyanide, which causes the formation of an insoluble dye known as Prussian blue.

Hervé, Lucien [László Elkán] (1910–2007) Hungarian-born French photographer. After an eclectic education in Hungary, Elkán worked in Paris as a designer for several well-known couturiers. In 1938 he began to contribute to *Madame* magazine, first supplying texts and then photographs. Having become a French citizen in 1937, after the war he adopted the name he had used as a resistance fighter: Lucien Hervé. He is noted principally for his photographs of architecture, in particular the works of Le Corbusier between 1949 and 1965. In contrast to the purely informative style of photography then in vogue, Hervé tried to capture the complete essence of a building. Incorporating close-ups, high- and low-angle shots, cropped frames and oblique views, his black-and-white

• **H** –

Sir John Herschel,
Lady with a Harp, c. 1842

works created an aesthetically refined vision of his encounters with architecture.

Hido, Todd (b. 1968) American photographer. After obtaining his master's degree in fine arts at Oakland (1996), Hido taught at the California College of Art in San Francisco. Influenced by → Dennis Hopper and David Lynch, he favours night-time subjects: suburban houses lit up but empty, interiors, naked women. The long exposure times (four to ten minutes), which require the use of a tripod, produce an effect of supernatural light. His melancholy images – a counter to the American dream – are never retouched.

Hill and Adamson A partnership formed by the Scottish photographers David Octavius Hill (1802–1870) and Robert Adamson (1821–1848).

Hill and Adamson, *Sandy (or James) Linton, his Boat and Bairns*, c. 1843–46

The → calotype, perfected by → William Henry Fox Talbot and presented to the public in 1839, was made popular in Scotland through their work. Hill, the son of a publisher based in Edinburgh, practised lithography and painted landscapes. He helped to found the National Gallery of Scotland, which opened in 1859. In 1843 he was commissioned to create a monumental record of the more than 400 founders of the Free Church of Scotland, which had just broken away from the Church of England. He sought the assistance of Adamson, a chemist who also practised photography. Hill chose to fulfil his commission by taking a series of photographic portraits of both individuals and groups. Between 1843 and 1847, in Edinburgh and the village of Newhaven, Hill and Adamson took open-air photographs of the gentry and local fishermen, and a few architectural views and genre scenes. They were pioneers in the expressive use of the calotype and took great care over the composition of their photographs. From that time on, they devoted themselves exclusively to photography, which had become a genuine passion rather than just a means of documentation. After Adamson's premature death, however, Hill returned to painting and was rapidly forgotten. The first major retrospective exhibition of Hill and Adamson's photographs took place in 1898 at the Crystal Palace in London. The 3,000 calotypes listed all dated from the four years in which the two men collaborated. Rediscovered at the end of the century by the → Pictorialists, Hill and Adamson were among the great 'primitives' of photography.

Hilliard, John (b. 1945) British photographer. Hilliard trained at the Lancaster College of Art, Pennsylvania, and Saint Martin's School of Art, London. Initially, he used photography as a means of documenting his ephemeral installations, but from 1970 onwards it became his primary working method. By varying the framing, the movement of the camera and the → depth of field, he juxtaposes different versions of the same subject in order to explore the nature of representation. In *She Seemed to Stare ...* (1977), for instance, he photographed a painting three times but modified the focus between shots,

202

• H —

John Hilliard, *Blonde*, 1996

in one image catching passers-by reflected in the glass. His experiments with form explore the technical potential of photography and, by destabilizing images, expose their subjectively orientated nature.

Hine, Lewis Wickes (1874–1940) American photographer. Having trained as a sociologist, Hine pursued a teaching career in Chicago and New York, convinced of the need for education and information in the city's poorer areas. In 1903 he used a camera as an educational tool for social → reportage. Although still an amateur, he photographed the appalling conditions of immigrants who had just arrived at Ellis Island. In 1908, revolted by the exploitation of small children made to work up to twelve hours a day, Hine became the official photographer of the National Child Labor Committee, travelling the length and breadth of the United States with his camera, which he regarded as a vital weapon in the battle against social injustice. His photographs, taken from the front and depicting children in their workplaces (mines, cotton mills, farms) with emotional detachment, were made incognito and published in the press. In 1914 his work culminated in a law that placed limits on the use of child labour. During World War I, Hine was commissioned by the American Red Cross to travel across Europe, including the devastated Balkans. On his return to New York, he photographed the construction of the Empire

H •

Lewis Wickes Hine,
Steamfitter, 1921

State Building, symbol of an aesthetic that glorified technology and manual labour. This idealization of modern urban life forms the basis of his book *Men at Work* (1932). In 1936 Hine was the official photographer of the Works Progress Administration, but he was now receiving fewer and fewer commissions. He faded into oblivion and died in poverty. → Berenice Abbott mounted a major retrospective of his work in 1939.

Hiro [Yasuhiro Wakabayashi] (b. 1930) American fashion photographer, born in Shanghai to Japanese parents. After emigrating to the United States, Hiro worked as an assistant to → Richard Avedon, whom he greatly admired. A brilliant student of → Alexey Brodovitch's, he worked with him on → *Harper's Bazaar* from 1957 until 1975, and at the same time created beautifully designed advertisements. A master of colour and lighting, Hiro produces images whose composition is both simple and elegant.

Höch, Hannah [Johanna Höch] (1889–1978) German artist. Höch was the sole female member of the Dada circle in Berlin and a pioneer of → photomontage along with her partner, → Raoul Hausmann. She received a traditional education in the applied arts at the Berlin College of Arts and Crafts, and from 1912 to 1915 studied under Emil Orlik at the National Institute of the Museum of Arts and Crafts. Höch went on to work as a dress and pattern designer for women's magazines until 1926. In her well-balanced photomontages, Höch combined photographs and typographic elements cut out of newspapers into powerful, sometimes radical, messages of social criticism. Her imagery deals with the woman's role in a male-dominated art world, and social injustice and political disorder in pre- and post-war Germany. During the Third Reich Höch's work was condemned as degenerate.

Hockney, David (b. 1937) British artist. He lives and works partly in Los Angeles and partly in Yorkshire. After attending art school in Bradford, Hockney studied at the Royal College of Art, London, under Roger de Grey, Ceri Richards and Ruskin Spear. A leading light in modern English figurative painting and the

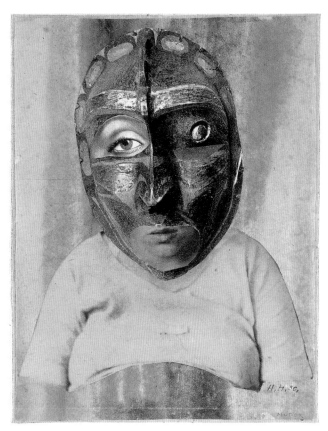

Hannah Höch,
Mutter, 1930

• H —

Pop art of the 1960s, Hockney is interested in all kinds of representational media. Initially, he used photography as an aide-mémoire, but it became central to his work in the period 1982–86. Dissatisfied with the monocular vision of the → lens, he created a series of → Polaroid → photocollages, fragmenting the subjects by means of multiple viewpoints before reassembling them in compositions that broke away from linear perspective. In 1982 these first works were brought together in the exhibition *Drawing with Photography* at the Centre Georges Pompidou, Paris. However, feeling that he had exhausted the potential of this process, he then exchanged his Polaroid camera for a 35mm → reflex camera. Freed from the white frame characteristic of Polaroid photographs, his compositions took on a new life. Although eventually he abandoned photography, it allowed him to explore new problems arising from the mechanics of perception, the repercussions of

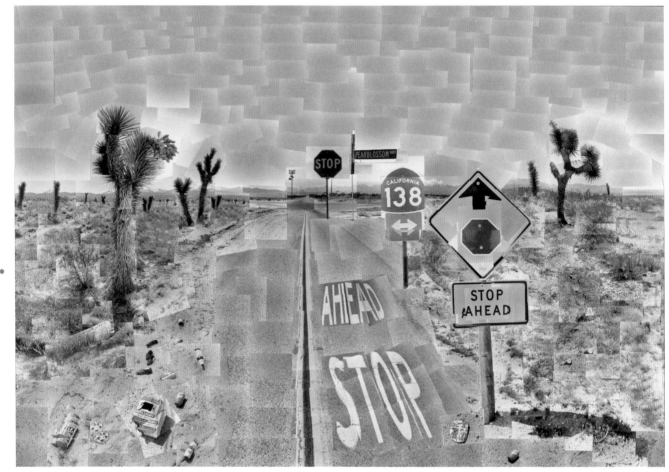

David Hockney, *Pearblossom Hwy,*
11–18th April 1986 (Second Version), 1986

— H •

which can be seen throughout his work. In 2001 the Museum of Contemporary Art in Los Angeles mounted a retrospective of his photography. In the same year he published *The Secret Knowledge*, in which he traced the use of mirrors and lenses by artists since the 15th century.

Hoepker, Thomas (b. 1936) German photographer and documentary filmmaker. The work of this self-taught photographer was already being published in the early 1960s, and Hoepker was the first West German journalist to achieve accreditation in what was then East Germany. He is both a reporter and a portraitist (known particularly for his images of Muhammad Ali), and has also been the art director of various magazines, including *Stern* (Germany) and *Geo* (United States). → Magnum Photos, which has

been distributing his work since 1964, made him its president from 2003 until 2006. He now lives in New York.

Höfer, Candida (b. 1944) German documentary photographer. She studied under → Bernd Becher at the Kunstakademie in Düsseldorf (1976–82), a school of photography with which she is still associated and which helped to establish the medium as an art form. Following a series on the Turkish population in Germany, Höfer devoted her attention to large-scale architecture, producing straightforward interior views of places linked to culture and learning (museums, libraries, concert halls, and so on), completely devoid of human figures. She was a professor at the University of Arts and Design, Karlsruhe, from 2000 until 2003.

Hofer, Evelyn (1922–2009) German-born American photographer. When the Nazis came to power in Germany, Hofer and her family moved to Geneva, then to Madrid and eventually to New York. It was there that she began her career as a photographer at → *Harper's Bazaar*. In the early 1960s she became one of the first art photographers to use colour film, although she also continued to work in black and white. Hofer turned everyday moments into balanced compositions; in addition, her photographic gaze was sensitive and successfully conveyed the relationships between sitters.

Hoffmann, Heinrich (1885–1957) German photographer. After opening his own studio, Hoffmann turned to press photography. Following World War I, his extreme right-wing views led him to sympathize with Adolf Hitler, whose official photographer he became in 1923. His explicitly propagandist images contributed to the myth of the Führer and the National Socialist movement, and documented its mass demonstrations.

Hofmeister, Theodor (1868–1943) **and Oskar** (1871–1937). German photographers. Born into a middle-class family, the Hofmeister brothers showed an early interest in → Pictorialist photography while still pursuing their respective careers in the business and legal professions. As amateurs, they were able to devote their time and money to their passion and to the numerous experiments that arose out of it, in due course achieving recognition by their peers. This encouraged them to found the Hamburg School for Art Photography.

Holdt, Jacob (b. 1947) Danish photographer. Holdt left the family home in 1970 after a dispute with his father, a pastor, and went to Canada. From there he decided to travel overland to Chile, but while en route through the United States he was shocked by the poverty he saw there. He eventually spent five years travelling round the country, sharing the daily lives of both the underprivileged (black communities and drug addicts, for instance) and those who were better off. He recorded these social inequalities with an ordinary, cheap camera, publishing *American Pictures* in 1978. Since then he has given illustrated lectures at many conferences, denouncing the different forms of poverty, violence and racism that he has encountered all over the world.

Holland Day, Fred (1864–1933) American photographer, publisher and collector. Day was an intellectual from Boston, with a reputation as an eccentric dandy. A friend of → Clarence H. White, Aubrey Beardsley and Oscar Wilde, he was profoundly influenced by the Decadent movement. His photographs are very much in the → Pictorialist style, often sophisticated and erudite, with subjects drawn from myth, literature and religion, and including a number of male nudes. In 1898 he undertook a huge project devoted to religious themes, for which he produced no fewer than 250 negatives. His decision to pose as Christ himself attracted

• **H** —

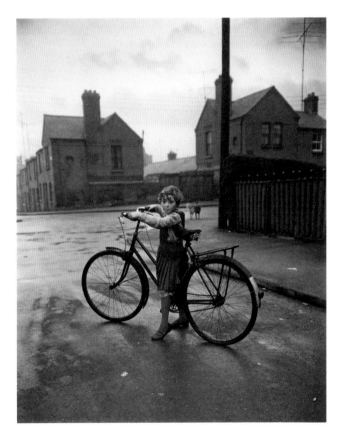

Evelyn Hofer, *Girl with a Bicycle, Dublin*, 1966

— H •

virulent criticism. His masterpiece, *The Seven Last Words* (1898), is a series of self-portraits in the role of Christ: a unique work in the history of photography, it demonstrates close links between photography, literature, painting and cinema. Like → Alfred Stieglitz, Day was a great champion of the artistic qualities of photography and threw himself into promoting American photography overseas. In 1900 he organized the exhibition *The New School of American Photography* at the → Royal Photographic Society in London. In 1904 his studio in Boston burned down, destroying much of his photographic work – a devastating event that discouraged him from pursuing his career any further. He retired to Norwood, his home town.

Hollyer, Frederick (1837–1933) British photographer. Hollyer is best known for his reproductions of paintings. These he first engraved – a technique he learnt from his father

Fred Holland Day,
The Seven Last Words, 1898

– but from 1860 he began to use photography. He was close to the Pre-Raphaelite group and documented the different stages of their work, also taking many portraits of the artists themselves. Hollyer exhibited his work alongside the → Pictorialists at their first photographic exhibition in 1894.

Hologram A two-dimensional image that appears three-dimensional owing to the refraction of light. Although invented by Dennis Gabor in 1947, the first successful holograms were not created until the invention of the laser in the early 1960s. In order to create a hologram, a laser beam must be divided in two using a beam splitter, a device made from prisms or a half-silvered mirror. One beam is reflected off the object being reproduced and onto a photosensitive surface, while the other beam hits the photosensitive surface directly. It is the interference between these two beams that creates the illusion of three-dimensionality.

Homma, Takashi (b. 1962) Japanese photographer. A graduate of Nihon University, Tokyo-born Homma has been among Japan's leading contemporary photographers since the release of his first book, *Babyland*, in 1995. *Tokyo Suburbia*, his notable publication from 1998, presented deadpan views of commercial buildings in suburban Tokyo and the youths who frequented them. More recently, Homma has focused on increasingly personal subject matter, including his home and daughter.

Hoppé, E. O. [Emil Otto Hoppé] (1878–1972) German-born British photographer. By 1920 Hoppé was regarded as 'the most famous photographer in the world'. As a portraitist of the Edwardian era, he photographed a virtual *Who's Who* of important personalities in the arts, literature and politics in Great Britain, continental Europe and the United States. Sitters included George Bernard Shaw, H. G. Wells, T. S. Eliot, Rabindranath Tagore, W. Somerset Maugham, Albert Einstein, Vaslav Nijinsky and the dancers of the Ballets Russes. During the 1920s and the 1930s, he travelled the world making comprehensive topographic and

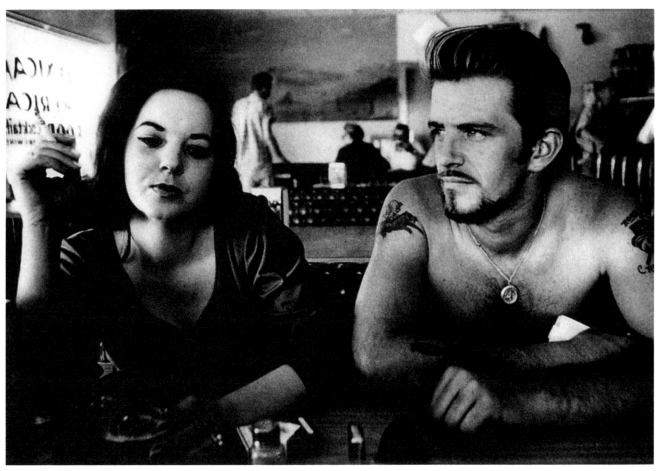

Dennis Hopper, *Biker Couple*, 1961

● H —

typological studies of the places and peoples of many different countries, including Great Britain, Germany, the United States, Italy, Australia, New Zealand, India, Indonesia and Africa, which he published in a steady stream of beautifully illustrated books. Hoppé's virtuosic photographs of the 1910s and 1920s pushed the boundaries of modernism, as he introduced elements of typology and serialism that would come to dominate photographic practice in the late 20th century.

Hopper, Dennis (1936–2010) American actor, director, artist, photographer and collector. Self-taught, Hopper took his first photographs in New York towards the end of the 1950s. Until the release of his cult film *Easy Rider* in 1968, he spent his time frenetically photographing and documenting street scenes, the artists' milieux in Los Angeles and New York, and political events, including Martin Luther King's Selma to Montgomery civil rights march in 1965.

Horsfield, Craigie (b. 1949) British photographer and artist. Horsfield enrolled at Saint Martin's School of Art, London, in 1968, and during the 1970s settled in Poland. On his return to London he became a central figure of contemporary photography. During the 1990s he worked on collective projects, using an art form that combined different media. His work explores concepts of 'slow time', memory and reality.

Horst, Horst P. [Horst Paul Albert Bohrmann] (1906–1999) German-born American photographer. Having studied art in Hamburg,

209

Horst P. Horst,
Mainbocher Corset, 1939

he went to Paris to take up an apprenticeship with Le Corbusier, but was disappointed with both the work and the man himself. Horst frequented intellectual circles in Paris and posed for → George Hoyningen-Huene, who had a profound influence on him. He developed a style that was masterly in its use of light and composition, and was also interested in the

history of art, with a special predilection for antique sculpture and → Surrealism. In 1932 Horst embarked on a long and fruitful collaboration with → *Vogue*, and was a leading light in → fashion photography throughout the 1930s and 1940s, creating an image of women that was sculptural and inaccessible (*Mainbocher Corset*, 1939). At the same time he produced outstanding portraits

Frank Horvat, *Givenchy Hat at
the Longchamp Racetrack, Paris*, 1958

of prominent cultural and political figures.
Horst emigrated to the United States in 1939,
photographed interiors for *House and Garden*,
and continued to work for *Vogue.*

Horvat, Frank (b. 1928) Italian photographer.
He became a freelance photographer in 1949,
compiling → reportages from abroad for various
magazines. His fashion photographs of the late
1950s and early 1960s were widely recognized as
having helped redefine the image of the modern
woman. Notable personal projects include
*Sculptures by Degas, Romanesque Sculptures,
1999: A Daily Report* and *La Véronique.*

Hosoe, Eikoh [Toshihiro Hosoe] (b. 1933)
Japanese photographer. After graduating from
the Tokyo College of Photography in 1954, Hosoe
soon abandoned the documentary style that
dominated post-war Japanese photography
in favour of a more dramatic visual language,

marked by influences such as theatre and
dance. In 1956 he held his first solo exhibition,
An American Girl in Tokyo. In 1959 he became
a founder member of the Vivo cooperative, along
with five other photographers (→ Kikuji Kawada,
Akira Sato, Akira Tanno, → Ikko Narahara and
→ Shomei Tomatsu). The writer Yukio Mishima
played a prominent role in Hosoe's work.
In 1961 Hosoe photographed Mishima in a
number of darkly bewitching scenes to illustrate
his book *Barakei* ('Ordeal by Roses'), published
in 1963, and these portraits became his best-
known works. He also collaborated with the
dancer Tatsumi Hijikata, most notably on the
series *Kamaitachi* (1969), inspired by a folktale
about a mythical demon. Other published works
include *Man and Woman* (1961) and *The Cosmos
of Gaudí* (1984). The director of the Kiyosato
Museum of Photographic Arts in Hokuto, Hosoe
has won many photography awards and is also
renowned as a teacher. In 1975 he was appointed

211

a professor at his former college, and he has also led workshops in the United States and Europe.

Howlett, Robert (1831–1858) British photographer. Initially an accomplished amateur, in 1856 Howlett became one of the first commercial photographers in Great Britain. He and his partner soon accepted commissions from the royal family as well as from eminent artists of the era, and the same year he published *On the Various Methods of Printing Photographic Pictures upon Paper, with Suggestions for Their Preservation*. He was an early innovator of the environmental portrait, producing dockside images of soldiers returning from the Crimean War. His work for *The Times* newspaper led to the creation of his most famous photograph, which depicts Isambard Kingdom Brunel and the SS *Great Eastern* (1857). Howlett was respected by his peers, and upon his death was praised by the *Illustrated Times* as 'one of the most skilful photographers of the day'.

Hoyningen-Huene, George (1900–1968) Russian-born American fashion photographer. He fled to London in 1917, moving to Paris in 1920, where he worked in cinema and fashion illustration. In 1924 he became partners with → Man Ray, styling Parisian beauties for the photographer and catching the attention of → *Vogue*, which hired him as an illustrator and photographer's

Eikoh Hosoe, *Barakei
(Ordeal by Roses) No. 32*, 1961

assistant. Huene's first fashion photographs were published by Condé Nast in *Vogue* and *Vanity Fair* in 1926 and 1927 respectively. Influenced by his early work in cinema, the Parisian avant-garde and the images of → Edward Steichen, Hoyningen-Huene's fashion photographs became synonymous with the stylish grace of the 1920s and 1930s. He left Condé Nast in 1935 for the Parisian edition of → *Harper's Bazaar*, where he worked until 1946, often shooting in New York. He relocated to California in 1947, where he taught at the Art Center School in Los Angeles and published in *Flair* magazine.

Hubmann, Franz (1914–2007) Austrian photographer and documentary filmmaker. In 1954 Hubmann founded the cultural magazine *Magnum* in Vienna, contributing to it as a photojournalist until 1962. He is remembered for his → humanist photographs, his chronicles of Vienna and his portraits of artists – the most famous of which is a series featuring Pablo Picasso. He wrote many documentaries and essays, and was a professor at the Vienna University of Applied Arts from 1983 until 1985.

Hugo, Pieter (b. 1976) South African photographer. Hugo was born and raised in Cape Town. His work primarily relates to the events and people of the African continent, including such subjects as Nigerian entertainers (*The Hyena and Other Men*, 2007), the Nigerian film industry (*Nollywood*, 2009) and the disposal of electronic waste in Ghana (*Permanent Error*, 2011).

Huguier, Françoise (b. 1942) French photographer. Huguier focuses on sociological subjects. Her publications include *Sur les traces de l'Afrique fantôme* (1990), documenting travels across Africa; *En route pour Behring* (1993), which chronicles a journey to Siberia; *Sublimes* (1999), on → fashion photography from 1983 to 1998; *J'avais huit ans* (2005), which revisits her experience as a childhood prisoner of the Viet Minh in Cambodia; and *Kommounalki* (2008), for which she spent years photographing communal apartments in St Petersburg. Huguier founded the Biennial of African Photography in Bamako in 1994.

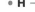

George Hoyningen-Huene, *Georgia Graves,
Swimwear by Lelong, Paris*, 1929

Hujar, Peter (1934–1987) American photographer. In 1976 he made a name for himself with his first book, entitled *Portraits in Life and Death*, with a preface by the critic → Susan Sontag. Death was a recurrent theme in his work, which also includes a series of intimate portraits of figures from the Manhattan underground during the 1970s and 1980s. Hujar died of AIDS at the age of 53.

Humanist photography A photographic movement that developed between the 1930s and 1960s, its principal representatives being the Parisian photographers → Robert Doisneau, → Henri Cartier-Bresson, → Édouard Boubat and → Willy Ronis. Their concept of humanism was to focus on people and their relationship to the world. In the historical context of post-war reconstruction, their iconography – which was closely tied to France and to Paris in particular – was imbued with pacifism and internationalism. The black-and-white images, intended for publication, are characterized by a form of 'poetic realism' that combines a reporter's approach with the aesthetic sense of a poet. The movement reached its apogee with the exhibition → *The Family of Man* at the → Museum of Modern Art, New York, in 1955.

Humbert de Molard, Louis Adolphe (1800–1874) Pioneering French photographer. A lawyer with a passion for chemistry, Baron Humbert de Molard learnt photography in 1840 in the studio of → Hippolyte Bayard. He produced → daguerreotypes and especially → calotypes before joining → Claude Félix Abel Niépce de Saint-Victor in the development of a process that used glass plates coated with → albumen.

Louis Adolphe Humbert de Molard,
Louis Dodier as Prisoner, 1847

He also invented a bellows-based camera design and experimented with improving exposure times. A founder member of the → Société Française de Photographie, Humbert de Molard exhibited, published and helped to establish genre photography. In his country house he staged scenes of rural life, asking his family and servants to pose for him. He was inspired by Dutch genre painting, and his photographs bear a resemblance to the paintings of Courbet, who was resolutely opposed to romantic art.

Hunter, Tom (b. 1965) British artist. A graduate of the London College of Printing and the Royal College of Art, Hunter is the first photographer to have had a solo exhibition at the National Gallery, London (2006). His photo series combine portrayals of everyday life in his home district of Hackney, in the east of London, with motifs referring to celebrated paintings by Vermeer and the Pre-Raphaelites. Hunter aims to give status, dignity and a sense of beauty to marginalized local people and their overlooked environments.

Hurley, Frank (1885–1962) Australian photographer, cinematographer and adventurer. Having begun his career in the postcard industry, Hurley subsequently established a reputation as a pioneer of polar photography. He travelled to the Antarctic region six times and was the photographer on Douglas Mawson's 1911–13 expedition and Ernest Shackleton's famous Trans-Antarctic Expedition of 1914–16, in which the ship *Endurance* was crushed. Hurley was an official war photographer, photographing the battlefields in France in World War I and the Middle East in World War II. He also worked as a cinematographer on Australian films during the 1930s. He travelled extensively in Australia until late in life and published numerous books of photographs of landscapes and cities. His films include *Home of the Blizzard*, *In the Grip of the Polar Ice* and *Pearls and Savages*. Hurley's prints, negatives and films are held in various public collections in Australia.

Hütte, Axel (b. 1951) German documentary photographer. He studied under → Bernd Becher at the Kunstakademie in Düsseldorf (1976–81),

Axel Hütte, *Jacobigarten*, 2008

● **H** —

a school of photography with which he is still associated and which played an important role in the establishment of the medium as an art form. Hütte's main fields of interest are architecture (especially underground), interiors, night views of cities, and landscapes (mountains, glaciers and forests). His large-size photographs are organized by type and presented in → series. By using large-format analogue cameras and concentrating on photography's descriptive abilities, Hütte focuses on formal outcomes rather than purely objective depiction, resulting in images that sometimes come close to abstraction.

Hyperrealism *see* **Photorealism**

Ignatovich, Boris Vsevolodovich (1899–1976)
Russian photographer. Ignatovich worked as
a journalist and editor of various newspapers
and magazines until 1923, when he discovered
photography. In 1926 he settled in Moscow,
where he became a director of the Association
of Press Photographers. He was also editor-in-
chief of the newspaper *Bednota* and worked
with a number of illustrated journals. His
meeting with → **Alexander Rodchenko** had a
major influence on his life; together they led the
October group, which encouraged the expression
of a modern vision of photography through
choice of subject matter, framing and viewpoint.
He created several → **series** documenting the
new construction projects that mirrored the
country's increasing industrialization, focusing
on images of men and technology; the results
were published in the journals *Dajes* and *USSR
in Construction.* Between 1930 and 1932 he made
several documentary films. From 1937 until
1941 he collaborated on the magazine *Moscow in
Reconstruction.* During World War II he worked
for the newspaper *Boyevoye Znamya* as
a photojournalist covering the frontline.

Ilfochrome *see* **Cibachrome**

Illustrated press When photographs first
appeared in the pages of the illustrated press
– the earliest instance being in *Illustration*
(1843) – they were indistinguishable from other
visual elements. They did not yet have any
status as 'evidence': belief in their inherently
truthful nature came later and was the result
of a cultural construct. Initially, such images
were reproduced in the form of engravings
based on photographic material. As such, they
were often modified in order to correspond
with the journal's expectations: additional
figures whose movements prevented them from
being captured on the → **daguerreotype** plate
would be added, for instance. Until the 1880s
photography was considered simply as a useful
form of representation that gave images an
added aura of realism and also saved time. In
1888 the advent of halftone engraving permitted
text and photographs to be printed together,
simultaneously. This allowed the photograph to
be incorporated within a page of text, although
the services of a draughtsman were still required.

Boris Ignatovich,
Regulators for Trams, 1930s

It was not until 1898 that illustrated magazines began to use photography exclusively, bringing about a change in design. Between the wars, press photography became a veritable industry, aided by the creation of photographic agencies and improvements in camera technology. In 1928 the new weekly magazine → *Vu*, founded by → Lucien Vogel, used photography as the principal means of conveying information, deploying the full potential of the heliogravure technique to create an impact. The magazine may be viewed as the first to treat the photographic image as a mass medium.

Infrared photography A technique using negative film sensitive enough to capture light originating from near the infrared end of the spectrum, typically invisible to the human eye. Light from the infrared spectrum is significantly less intense than light typically captured by panchromatic

film, and it was not until 1910 that infrared photography was introduced to the public. Since that time, various commercial films have filled the demand from military, astronomy, artistic and other quarters.

Inkjet printing A type of digital printing technology that has developed alongside → digital photography. Unlike impact printers, inkjet printers do not rely on any direct contact with the printing surface; instead, ink is released from small nozzles as droplets. One of the advantages of this contact-free method is that it can be used to print on a variety of supports, including paper, glass and textiles. Inkjet printing is used by both amateur and professional photographers, who are able to print their photographs without sending them to a lab.

Iris diaphragm An opaque disc with an adjustable central → aperture. It is positioned inside the → lens assembly of a camera and regulates the amount of light that enters. Opening the diaphragm affects the depth of field: the more closed the diaphragm is, the greater the depth of field, and vice versa. The illustration below shows how the lens diaphragm aperture decreases in size as the f-stop number increases.

Ishimoto, Yasuhiro (1921–2012) Japanese-American photographer. Born in San Francisco to Japanese parents, Ishimoto spent much of his early life in Japan before returning to the United States in 1939. However, soon after America's entry into World War II, he was forced into an internment camp. Once the war had ended, Ishimoto was

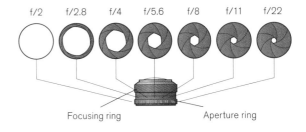

Iris diaphragm: A typical lens iris diaphragm showing f-stop numbers.

released and enrolled at the Chicago Institute of Design, where he studied under → Harry Callahan and → Aaron Siskind. Recognized today as an important link between Japanese and American photography, Ishimoto's first book, *Someday, Somewhere* (1958), presented photographs that showed few discernable differences between the two countries. In addition to work exploring both nations, Ishimoto photographed throughout Asia, the Americas and the Middle East during his illustrious career.

Ishiuchi, Miyako (b. 1947) Japanese photographer. Ishiuchi was born in Gumma Prefecture. In 1970 she left the textile department at the Tama Art University, Tokyo. Her first solo exhibition, entitled *Photographic Effects*, was held in 1975 at Gallery Shimizu in Tokyo. Ishiuchi began to attract attention with her solo exhibition in 1977 called *Yokosuka Story* and her book *Apartment*, published in 1978. She won the Kimura Ihei

Award in 1979. *Yokosuka Story* is a collection of photographs of the town of Yokosuka, where Ishiuchi grew up near a US naval base. In *Endless Night*, published in 1981, she photographed the districts around brothels throughout Japan. In another → series, she has focused on the skin of human body and its scars; the results were published as *1.9.4.7* in 1990 and *Hands, Feet, Flesh, Body: Hiromi 1955* in 1995. In a recent work, entitled *Mother's*, Ishiuchi photographed her mother's belongings after her death.

Itier, Alphonse Eugène Jules (1802–1877) French photographer. Itier began to make → daguerreotypes in the early 1840s. Between 1842 and 1846, thanks to his work as a customs officer, he was able to travel all over the world and always took his camera with him. He took pictures in Senegal, India, French Guiana, Sri Lanka and Guadeloupe, and was the first to photograph China, in 1844 and 1845. He returned to France in

Yasuhiro Ishimoto, *Chicago*, 1959–61

1846, where he continued to practise photography until the late 1850s.

Iturbide, Graciela (b. 1942) Mexican photographer. Iturbide studied at the Centre of Cinematographic Studies at Mexico University, where she became friends with her future mentor, the photographer → Manuel Álvarez Bravo. She soon became interested in the cultures of native Mexicans, as well as everyday urban life in Juchitán and Oaxaca. A major influence on her work is feminism. She has continued to photograph, addressing such subjects as the Mexicans who live in the White Fence Barrio neighbourhood in the east of Los Angeles, publishing the results as *A Day in the Life of America* (1987). A founder member of the Mexican Council of Photography, Iturbide was awarded the Hasselblad Award in 2008. She is considered to be one of the most influential figures in contemporary photography. Her photographic style is based on striking black-and-white contrasts that give powerful expression to her explorations of the culture, everyday life and rituals that permeate modern existence.

Izis [Israëlis Bidermanas] (1911–1980) Lithuanian-born French photographer. Bidermanas went to Paris in 1930, where he worked as a retoucher in a photographic laboratory before opening his own studio. He fought in the Resistance, took refuge in Limousin, adopted the name 'Izis' and took portraits of his fellow Maquis. On his return to Paris, he contributed to the → humanist movement by publishing his melancholy vision of the capital in *Paris des rêves* (1950) and by participating in the exhibition *Five French Photographers* (→ Museum of Modern Art, New York, 1951) alongside → Brassaï, → Henri Cartier-Bresson, → Robert Doisneau and → Willy Ronis. He worked for the magazine *Paris Match* from 1952 until 1969, and took numerous portraits of artists and intellectuals he knew personally, including Jacques Prévert and Marc Chagall.

Jaar, Alfredo (b. 1956) Chilean architect, artist and filmmaker. He incorporates photographs into his highly sophisticated installations to express his political and social interests.

Alfredo Jaar,
The Sound of Silence, 2006

• J —

He explores the modes of visual representation that have arisen out of the West's domination of the rest of the world, drawing attention to their prejudices and deficiencies. In response to the incoherence caused by a surfeit of images, in *The Rwanda Project* (1994–2000) he adopted an inverse strategy, enclosing pictures in black boxes to hide them from view, making their absence all the more provocative in the light of the texts that replaced them. In the face of shocking images, Jaar simultaneously questions the power of photography, the status of the viewer and the possibility of ethical representation (*The Sound of Silence*, 2006).

Jackson, William Henry (1843–1942) American photographer. Born in Keeseville, New York,

— J •

William Henry Jackson,
Great Falls of the Yellowstone River, 1872

Jackson owed his early interest in the visual arts to his mother, a skilled watercolourist. In 1862 the 19-year-old Jackson joined the Union Army to fight in the American Civil War, where he spent much of his free time drawing scenes of camp life. After the war, he lived briefly in Vermont before heading westward in 1866. He eventually settled in Omaha, Nebraska, the following year, starting a photography business soon thereafter. An early commission came from the Union Pacific Railroad, which hired him to record scenery along the company's various railway lines. In 1870 Jackson participated in the first of several geological surveys led by American geologist Ferdinand Hayden. These assignments allowed him to create early photographs of various, now iconic, Western landmarks that were widely seen and admired by the general public. Throughout these trips – despite his large cameras, the challenging working conditions and the difficulties involved in the wet → collodion process – Jackson managed to make well-crafted photographs that would cement his reputation as a leading American landscape photographer. Following these surveys he made additional landscape photographs and, in the early

1890s, was commissioned to travel the world photographing and gathering specimens for the Field Museum of Natural History, Chicago. After 1897 he focused his efforts primarily on publishing, handing his archive of → **negatives** over to the Detroit Publishing Company. Jackson died in 1942 at the age of 99, having received many honours, including having a mountain in Yellowstone National Park named after him.

Jacobi, Lotte (1896–1990) German photographer. From a family of photographers, Jacobi learnt the trade from her father before attending a school of photography. She became a great portraitist, working initially in the Weimar Republic and then as an exile in the United States, where she photographed many major figures from the worlds of literature, art and science. Her work was shown in numerous exhibitions and widely published.

Jäger, Gottfried (b. 1937) German photographer and theorist. He trained as a photographer, studying at the Higher National Technical School for Photography in Cologne, and was a professor of photography at the Bielefeld University of Applied Sciences. Jäger established a non-representational style of photography using photomechanical and photochemical processes that foreshadowed computer-based art, for which he coined the term *generative Fotografie* ('generative photography') in 1968. It became an important movement in Germany and had a major influence on contemporary abstract photography. *See also* → concrete photography.

Jammes, André (b. 1927) French collector. Jammes is a passionate writer and promoter of the history of photography, focusing on the artists themselves and on masterpieces that range from → vintage prints to the major works of the modern era. He was responsible for introducing the European 'primitives' to the American public. In 2008 Jammes and his wife, Marie-Thérèse, organized the sale of their legendary collection, which was begun in the mid-1950s.

Japonisme The influence of Japanese art and aesthetics on the Western world following the

Gottfried Jäger,
Photowork V, 1986

country's opening to trade in 1854. After a series of treaties had been negotiated, Europe was flooded with Japanese woodblock prints and other goods that heavily influenced Impressionist and Post-Impressionist artists. → **Pictorialist** photographers also incorporated many of the compositional features and themes prevalent in woodblock prints into their art, including asymmetry, aerial perspective, genre scenes depicting women, the use of negative space, and abstraction. The influence of Japanese art stretched well into the 20th century.

Jiang, Jian (b. 1953) Chinese photographer. Jiang was born in Kaifeng, Henan Province. During the Cultural Revolution his family was banished to a rural village in north-eastern China. He trained as a musician, and his first experience with a camera came in 1984 when he was assigned a national research project on Chinese folk arts. He continues to photograph orphans, musicians and peasants. Jiang's work is evidence of his abiding affection for China's common people.

Jiménez, Agustín (1901–1974) Mexican photographer. Jiménez studied photography at the former Academy of San Carlos, Mexico, during the post-revolutionary period. He produced surprising images that brought him very much in line with avant-garde movements in Europe and North America. His work quickly

• J —

earned him the praise of critics and of Sergei Eisenstein, → Tina Modotti and Jean Charlot.

Jodice, Mimmo (b. 1934) Italian photographer. After working in experimental, conceptual and humanist styles, in 1980 Jodice adopted a purer approach in order to emphasize the beauty of Mediterranean civilizations. His 50mm photographs are in black and white. He was given the Feltrini Prize in 2003 and awarded an honorary degree by the University of Naples Federico II in 2006. Jodice sees his photographs as 'voyages of memory' that uncover the enigmatic side of Naples and other Italian cities. In 2011 he was invited to participate in a contemporary art programme at the Louvre, Paris. Aesthetically, his work is characterized by its restraint and its use of light to magnify subjects.

Johnston, Frances Benjamin (1864–1952) American photographer, photojournalist and artist. She studied at the Académie Julian in Paris between 1883 and 1885, and learnt photography in Washington, D.C., in order to supply articles for magazines. She opened a portrait studio in 1894, where she photographed many political figures. Johnston joined the → Photo-Secession in 1904. She received grants from the Carnegie Foundation to document historic gardens and architecture in the American South. The Library of Congress in Washington, D.C., holds most of her → negatives, prints and correspondence, including several self-portraits.

Jokisalo, Ulla (b. 1955) Finnish artist. Jokisalo graduated from the University of Art and Design in Helsinki in 1983 and has become one of the leading expressionist innovators in Finnish photography. Using her highly characteristic visual language, she addresses themes ranging from the aesthetics of cruelty and the quest for female pleasure to a nostalgic investigation of memory. Jokisalo combines photographic images with unique paper cut-outs, needlework, embroidery and object assemblages. She received the Finnish State Award for Visual Art in 1984 and 2001, and the Pro Finlandia Medal of the Order of the Lion in 2010. She held the post

of artist professor from 2004 to 2009 at the University of Art and Design, Helsinki.

Jones, Sarah (b. 1959) British photographer. Jones studied art and dance at Goldsmith's College, London (1996). She choreographs her images, visualizing a parallel world in which time seems to stretch out or to freeze. Her images have captured various themes, including adolescence, a world padded with psychiatrists' couches, and an enigmatic mountain of roses. She has a predilection for emotionally charged colours, especially different shades of blue.

Jones Griffiths, Philip (1936–2008) British photographer. While he was still studying pharmacy in Liverpool and London, Jones Griffiths was already employed as a part-time newspaper photographer by what was then the *Manchester Guardian.* In 1961 he joined the *Observer* full time, and in 1962 he visited Algeria. He became a member of → Magnum Photos in 1966, travelling to Vietnam soon after, where he stayed until 1971. He covered the Yom Kippur War of 1973 and the end of the civil war in Cambodia (1973–75). From 1980 until 1985 he was president of Magnum Photos. In total he visited over 120 countries. Jones Griffiths was always a staunch defender of human dignity; one typical feature of his war → reportage was the perspective of civilians caught up in conflict. During the last years of his life, he continued to work for magazines such as *Geo* and → *Life.*

Jonsson, Sune (1930–2009) Swedish photographer. He made his breakthrough with the photo book *Byn med det blå huset* ('The Village with the Blue House', 1959), which contained stories about his home community, Nyåker, in northern Sweden. Jonsson began photographing while studying at university. He had an internship for a few summers at the *Västerbottens-Kuriren* newspaper before securing a job in 1968 as a field ethnologist and photographer at the Västerbotten Museum in Umeå. Throughout his career, Jonsson wrote prolifically and promoted → documentary photography in various contexts. He received the international Hasselblad Award in 1993.

Valérie Jouve, *Untitled*, 2001–09

Josephson, Kenneth (b. 1932) American photographer. Josephson studied at Rochester Institute of Technology and the Illinois Institute of Technology before accepting a job teaching photography at the Art Institute of Chicago in 1967, where he took up a thirty-year tenure. A founding member of the Society for Photographic Education, Josephson is well known both as a prolific educator and for his conceptually driven photographs.

Jouve, Valérie (b. 1964) French photographer. Jouve has been actively engaged in photography since the mid-1990s. Her monumental works, set in urban and suburban landscapes, often feature people leaping around or adopting unusual poses, with their mouths open. These images frequently evoke an atmosphere of suspense or precariousness. Although Jouve's treatment of space and positioning of her subjects are highly characteristic, her work also addresses serious sociological issues.

JPEG (jpeg, jpg) A popular format for digital image files. The term is an acronym for 'Joint Photographic Experts Group', the committee who invented the standard. The JPEG code is used to compress existing digital files in order to make them easier to send or receive electronically. When they are made too small, however, JPEG files lose a significant amount of detail and quality.

Kállay, Karol (1926–2012) Slovak photographer. Born in Čadca, Kállay was one of the nation's most significant documentary, art, fashion and → reportage photographers of the 20th century. His first significant encounter with photography occurred in around 1937, when his parents gave him a camera, which he used to record family gatherings. In 1942 his photograph *Asphalters* won the gold medal during a photography exhibition in Bratislava. In 1945 he became a photojournalist for an illustrated weekly magazine, *Domov a svet*. In the years following World War II he met → Karol Plicka and became an assistant director for Czechoslovak State Film in Prague and Bratislava. After the Communists took power in 1948 Kállay was unable to continue his career as a professional photographer, but in 1955 he nonetheless began to produce images for *Móda* magazine, one of the most respected fashion publications in the Eastern Bloc. His wife was his principal model. He was accepted into a society of Slovak amateur photographers in 1956. Aside from pursuing fashion photography, Kállay also documented the beauty of Slovakia and published many books on the country's landscape, among them *Slovenské rieky* ('Slovak Rivers', 1954) and *My Bratislava* (2012). He also shot for *Geo Saison* and worked for the Bilderberg photo agency.

Kálmán, Kata (1909–1978) Hungarian photographer. She received a gold medal at the Milan Photo Triennale in 1935 for her photography, which treated the harsh social conditions of the time with a new objectivity. Her most famous photograph, taken in 1931, of a child eating a slice of bread became an iconic portrayal of poverty. In 1937 she published the album *Tiborc*, followed by *Szemtől szemben* in 1939. Her photographs demonstrate her deep empathy for the country's peasants and manual labourers, and these books exerted a strong influence on Hungarian folk sociology. In 1955 she published the album *Tiborc új arca*, containing images made in the Hungarian countryside. Kálmán received the Balázs Béla Award in 1984 and was recognized as an Artist of Merit by the Hungarian state in 1976.

Kannisto, Sanna (b. 1974) Finnish artist. Kannisto studied photography at the University of Art and Design in Helsinki from 1998 to 2002. Since 1997 she has spent several months each year living alongside biologists in the rainforests of Brazil, Peru, French Guiana and Costa Rica. Adopting elements from scientific methodology, Kannisto has developed her own form of visual research, extending her depictions of flora and fauna beyond the confines of the natural sciences. In her *Fieldwork* series, she tackles the constraints imposed by photography and science alike, investigating the concept of truth in photography in order to challenge the way we perceive the natural world. Her work has been exhibited in more than twenty-five countries worldwide, and at venues including the Centre Pompidou and Maison Européenne de la Photographie, Paris, and the Fotomuseum Winterthur.

Karsh, Yousuf (1908–2002) Turkish-born Canadian portrait photographer. Karsh emigrated to Canada to live with his uncle, a photographer, in 1924. He then moved to Boston, Massachusetts, to undertake an apprenticeship with the photographer John H. Garo. In 1931 he moved back to Canada and settled in Ottawa, where he established a portrait studio in 1932. He was appointed official portrait photographer to the Canadian government and to the prime minister, Mackenzie King, in 1935. His portrait of Winston Churchill (1941) brought him international fame and was published in → *Life* magazine. Karsh, known for his skilful compositions and dramatic lighting techniques, went on to photograph some of the world's most iconic and influential figures, including Audrey Hepburn, Pablo Picasso, Albert Einstein and Ernest Hemingway.

Käsebier, Gertrude (1852–1934) American photographer. In 1889, at the age of 36, Käsebier began to study painting at the Pratt Institute in Brooklyn, New York. In 1894 she travelled to Europe and learnt the techniques of photography. On her return to the United States, she opened a portrait studio and built up a solid reputation, displaying talent combined with a sound business sense. In 1899 her photographs – which were very much in line with → Pictorialist

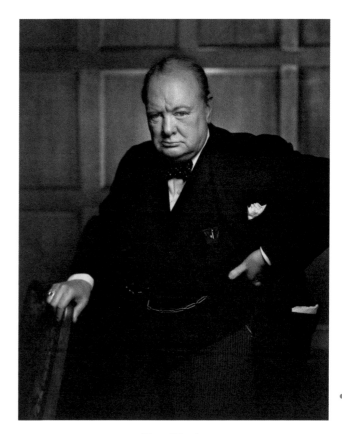

Yousuf Karsh,
Winston Churchill, 1941

aesthetics – were exhibited at the Camera Club in New York. → Alfred Stieglitz considered her to be the finest portrait photographer of the time. The following year, Käsebier became the first female member of the → Brotherhood of the Linked Ring in London. A second trip to Europe led to her meeting the Pictorialist photographers → Robert Demachy and → Edward Steichen, who then belonged to Rodin's circle. Once back in New York, she and Stieglitz founded the → Photo-Secession movement, and Käsebier published photographs in the first edition of → *Camera Work* (1903). She enjoyed international success: her photographs (most frequently portraits of women and children in the form of → gum bichromate prints) won universal approval in all the photographic salons and especially at Stieglitz's → Gallery 291. In 1910 she became president of the Women's Federation of the Professional Photographers of America. When Stieglitz changed direction and began to follow the path of more realistic → straight

• K —

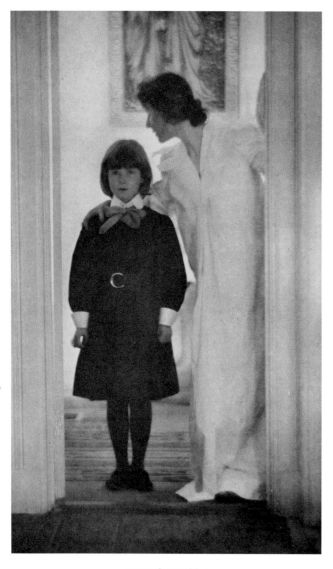

Gertrude Käsebier,
Blessed Art Thou Among Women, 1899

— K •

photography, she distanced herself from him. In 1916, together with → Clarence H. White, → Alvin Langdon Coburn and → Karl Struss, she started a new movement, the Pictorial Photographers of America. They published a magazine, *Platinum Print*, with the avowed intent of joining the Pictorialist movement. In the 1920s, however, she was forced to close her studio as Pictorialism went out of fashion.

Kawada, Kikuji (b. 1933) Japanese photographer. A self-taught photographer, Kawada studied economics at Rikkyo University in the early 1950s. Upon graduating, he started his career as a staff photographer at a publishing house before receiving his first solo exhibition, *Sea*, in 1959. This exhibition, which focused on nuclear testing, established nuclear weaponry as one of the major themes in his work. His 1965 publication *Chizu* ('The Map') was released on the 20th anniversary of the bombings of Hiroshima and presented a series of dark, grainy images punctuated by photographs of the walls and ceilings of the Hiroshima Bomb Dome. Kawada was a founding member of the influential, albeit short-lived, Vivo photo agency and taught at the Tama Art University, Tokyo.

Kawauchi, Rinko (b. 1972) Japanese photographer. Kawauchi graduated in 1993 from the Seian University of Art and Design in Shiga. In 2001 she published three series of works that propelled her to the forefront of contemporary Japanese photography: *Utatane*, *Hanabi* and *Hanako*. A striking feature of these photographs is their attention to the most minutely detailed fragments of everyday life. Her world often appears permeated by a diaphanous, radiant light that translates forms into patterns of colour, either faded or intense. She captures ephemeral moments when they first appear, and it is this transience that lies at the heart of works such as *Cui cui* (2005), *Semear* (2007), *Murmuration* (2010) and *Illuminance* (2011). In 2009 the International Center of Photography presented her with the 25th Annual Infinity Award in the artistic category.

Keetman, Peter (1916–2005) German photographer. Like → Otto Steinert, Peter Keetman was part of the New Photography movement. In 1935–37 he attended the Bavarian State College for Photography. Keetman was conscripted into the German army in 1940 and was seriously wounded during World War II. In 1949 he became a founding member of the *fotoform* group. In the 1950s he worked as an advertising photographer. One of his most famous works is a series produced during a week-long visit to a Volkswagen factory.

Keiley, Joseph Turner (1869–1914) American photographer. A Wall Street lawyer, Keiley was an active champion of artistic photography. He was a founder member of the → Photo-Secession, the

American branch of → Pictorialism. Together with his friend → Alfred Stieglitz, he also edited *Camera Notes* in 1897 and → *Camera Work* in 1903.

Keïta, Seydou (1921–2001) Malian photographer. He began photographing his family after he received a Kodak Brownie camera from his uncle in 1935. More than a decade later, in 1948, Keïta opened a commercial studio in Bamako. As the studio's popularity grew, he increased his stock of European-made accessories and props, which became a distinguishing feature of his photographs. Years later, in 1990, the French photojournalist → François Huguier arranged for Keïta's work to be shown outside of Africa; in the years that followed, it was widely praised in the Western world for its modern qualities but also became the subject of an intense legal dispute concerning rights and distribution. Today, many value Keïta's commercial portrait photographs as both valuable cultural artefacts and distinguished works of art.

Kerekes, Gábor (1945–2014) Austrian-born Hungarian photographer. Kerekes's abstract, experimental images are highly characteristic. Drawing on the strangeness of everyday life, he created an unworldly, melancholic record of late Socialist society in the 1970s and 1980s. In 1990s he became more interested in the

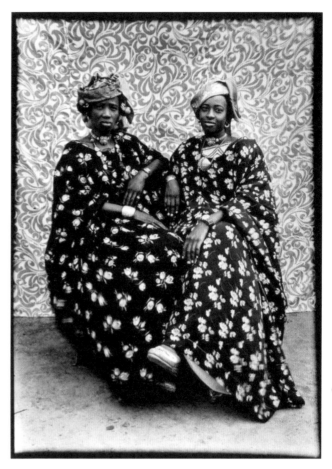

Seydou Keïta,
Untitled, 1956

• K —

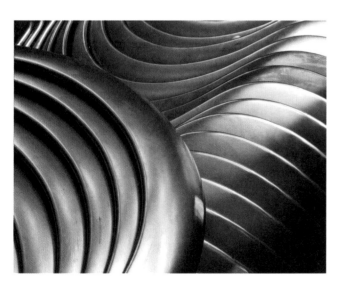

Peter Keetman, *Volkswagen Factory (Rear Wing)*, 1953

relationship between art and science. Using archaic photographic techniques combined with → pinhole and large-format cameras, he investigated the themes of birth, existence and death. In his last series he reworked images downloaded from the internet. He exhibited at the Musée de l'Élysée, Lausanne (1973), the Robert Koch Gallery, San Francisco (1997 and 2011), Musée Reattu, Arles (1999) and Paris Photo (2001). He received the Béla Balázs Prize in 1990 and became an Artist of Merit in 2009.

Kertész, André [Andor Kertész] (1894–1985) Hungarian-born American photographer. Kertész taught himself photography at the age of 18. Although he was employed at the stock exchange in Budapest and enlisted in the infantry during World War I, he continued to photograph the people and places around him. In 1925, though

he was still an amateur, recognition of his talents at home encouraged him to try his luck as a professional photographer in Paris. Although something of a loner, he did join a circle of Hungarian immigrants that included → Brassaï, with whom he would spend time at the Café du Dôme, then an important meeting place for artists. From 1926 onwards, Kertész published large numbers of photographs in French and German magazines such as → *Vu*, *Art et Médecine* and *Der Querschnitt*. In 1928 he bought a hand-held → Leica. Always attentive to details, he took photographs of daily life with a freedom of style that rendered him unclassifiable. Paris was one of his favourite subjects, but portraits, still-lifes and interiors were also important elements in his often humorous and dreamlike work. In 1933 he produced his series of *Distortions*, photographing nude bodies reflected in distorting mirrors. He left Paris for New York in 1936, having been given a one-year contract by the Keystone photo agency. World War II forced him to stay in the United States and marked the beginning of a period of disillusionment in which his talents were given scant recognition. Nevertheless, he worked with → *Harper's Bazaar* in 1937, and signed an exclusive contract with *House and Garden* during the 1940s. In 1979, using a → Polaroid SX-70, he produced his last major series in memory of his wife.

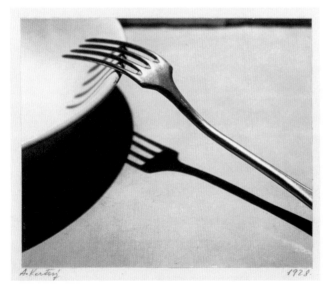

André Kertész,
Fork, 1928

Kessels, Willy (1898–1974) Belgian photographer. Born into a military family, Kessels went to the Académie des Beaux-Arts, Ghent, in 1916 to study architecture. In 1919 he began a highly successful career as an architect and designer in Brussels, under the aegis of Georges Hobé. His interest in photography came to the fore in 1926, when he began to record his many projects. He rapidly took up photography as a career, putting together a number of → series devoted mainly to architecture, but also touching on social matters, tourism and nudes. In 1932 he took part in the international exhibition of photography at the Palais des Beaux-Arts, Brussels. World War II had an adverse effect on his productivity and kept his work out of the public eye, and his close ties with the Verdinaso – an extremist Flemish movement – lost him the respect of the general public.

Keuken, Johan van der (1938–2001) Dutch filmmaker and photographer. He made his debut at the age of 17 with a photo book entitled *Wij zijn* ('We Are', 1955), which caused a stir by depicting his own age group as rebellious, chain-smoking alcoholics. A year later, he went to Paris on a scholarship to the Institut des Hautes Études Cinématographiques (IDHEC) film school, an experience that confirmed a life-long interest in the time-based arts. In 1963 he published *Paris Mortel*, a book of black-and-white photographs that offer a darkly romantic view of the city. After completing his studies, Van der Keuken made over fifty experimental films and documentaries. In the 1990s he worked increasingly on three-dimensional installations (e.g. *Body and City*, 1998), in which still and moving photographic images were brought together in a dynamic physical environment composed of light, form and movement. In 2000, having been diagnosed with cancer, Van der Keuken made a travel documentary called *The Long Holiday* (2000), an impressively unsentimental testament to his highly personal and complex view of the world.

Khaldei, Yevgeny (1917–1997) Russian photographer. When he was still a child, Khaldei made his first camera out of a cardboard box and his grandmother's glasses. In 1932 his first photographs were published in local Ukrainian

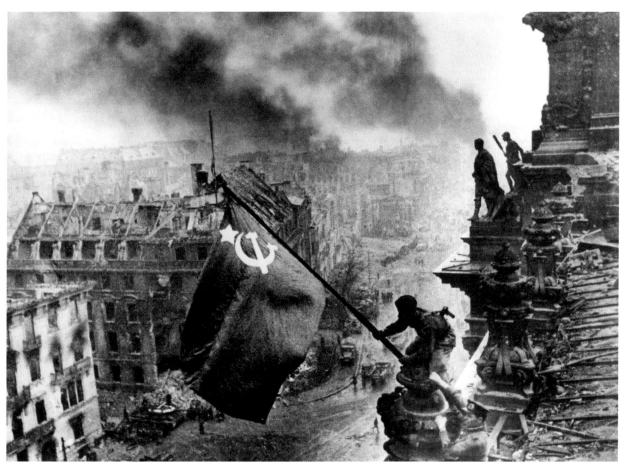

Yevgeny Khaldei,
Raising the Flag on the Reichstag, 1945

magazines, and in 1936 he started work as a photojournalist for the TASS press agency in Moscow. During World War II he documented the advance of the Red Army and the liberation of countries including Romania, Bulgaria and Austria. One of his most famous photographs shows a Russian soldier placing the flag of the Soviet Union on the Reichstag during the capture of Berlin in 1945, symbolizing the fall of the Nazi regime. After the war, he was dismissed by TASS because of his Jewish blood. From 1957 until 1972 he worked for *Pravda*, and then from 1973 for *Sovetzkaya Kultura*. In 1995 he was named a Chevalier de l'Ordre des Arts et des Lettres by the French government.

Al-Kharrat, Ayman Egyptian photographer. Born in Alexandria, he studied cinematography at Helwan University, Cairo. His Coptic, Greek and Lebanese origins encouraged an interest in world travel and a critical view of the ways in which technology affects traditional ways of life. He is currently based in London but visits Egypt regularly in search of inspiration. His photographic work is augmented by a career in documentary filmmaking.

Killip, Chris (b. 1946) British photographer. From 1964 to 1968 he worked as an assistant in London for various advertising photographers, but in 1969 he returned to his birthplace, the Isle of Man, in order to photograph. This work was published in *Isle of Man* in 1980. Killip moved to Newcastle-upon-Tyne in 1975, where in 1977 he was a co-founder and then director of the Side Gallery. His book *In Flagrante* (1988), a collection of his photographs of north-east England, is considered a masterpiece of its kind.

K •

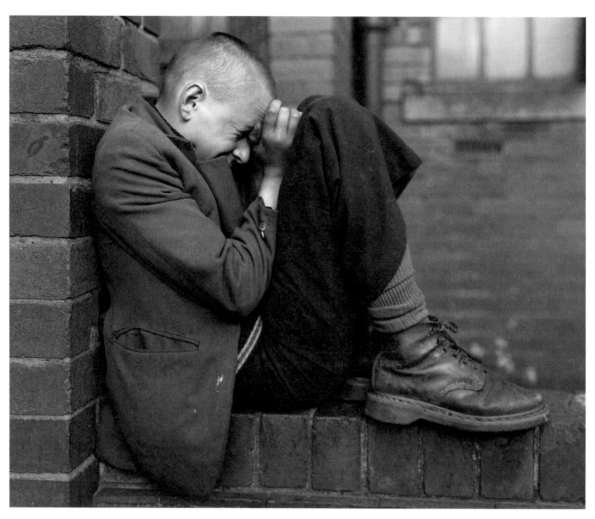

Chris Killip, *Youth on a Wall,*
Jarrow, 1976

Kimura, Ihei (1901–1974) Japanese photographer.
A self-taught artist, Kimura was regarded as one
of Japan's greatest photojournalists, as well as
being one of the finest Japanese photographers
of the 20th century. After studying business, he
joined various photographic clubs and opened
his own studio in Tokyo in 1924. Kimura was
interested in capturing everyday life with realism
and spontaneity, working primarily with a
→ Leica that he bought in 1930. In 1932, together
with → Yasuzo Nojima and → Iwata Nakayama,
he founded the influential magazine *Koga*. In
1933 he became a founder member of the photo
agency Nippon Kobo. In the same year he found
success with an exhibition of portraits of literary
celebrities taken with his Leica. During World
War II he worked for the publishing house

Tohosha. In the 1950s he began a famous series of
photographs of Akita, a rural area in the north of
Honshu, Japan's largest island. He also began to
visit Europe, including France and Italy. During
these trips Kimura photographed Paris and its
people on many occasions; these images were
later published in the book *Pari* (1974). An annual
Japanese photography award is named after him.

Kitajima, Keizo (b. 1954) Japanese photographer.
Kitajima was born in Nagano Prefecture. In
1975 he took → Daido Moriyama's class at the
Workshop Photography School. The following
year he established the Image Shop Camp gallery
with Moriyama and other photographers in
Shinjuku. In 1979 Kitajima came to attention for
a series of solo exhibitions entitled *Photo Express:*

Tokyo and their accompanying booklets. For
New York, published in 1982, he captured city
residents on high-contrast black-and-white film;
the book went on to win the Kimura Ihei Award.
In *A.D. 1991* (1991), Kitajima photographed views
of the world's largest cities. He continues to focus
on portraiture. In 2009 a solo show, entitled *Keizo
Kitajima 1975–1991: Koza/Tokyo/New York/Eastern
Europe/USSR*, was held at the Tokyo Metropolitan
Museum of Photography.

Kivijärvi, Kåre (1938–1991) Norwegian
photographer and photojournalist. Kivijärvi
began his photographic career as an apprentice
journalist on the *Vest-Finnmark Arbeiderblad* in
the 1950s. In 1959 he started training under the
German photographer → Otto Steinert, first at
the Staatliche Schule für Kunst und Handwerk
in Saarbrücken, then at the Folkwangschule
in Essen. A large body of Kivijärvi's work was
exhibited at the Oslo Kunstforening in 1960.
He accepted a position at the *Helsingin Sanomat*
newspaper in Finland in the early 1960s, and
between 1961 and 1967 he produced numerous
→ reportages for the women's magazine *Me
Naiset* and the weekly magazine *Viikkosanomat*.
He travelled as a photojournalist to the Soviet
Union, Afghanistan, Nepal, India and Greenland
from 1963 to 1967, also working for Norwegian
newspapers and magazines. In 1971 Kivijärvi was
the first Norwegian photographer to show at
the Høstutstillingen annual art exhibition – an
important early sign of photography's acceptance
as a distinct art form in Norway. He is especially

Ihei Kimura, *Young Men, Niida, Akita*, 1952

renowned for his expressive, large-scale, black-
and-white images of the people, harsh climate
and fishing communities in the northern parts
of the country: a notable example is his reportage
of fishermen working on trawlers in the Barents
Sea, published in *Nå* magazine in 1962.

Klauke, Jürgen (b. 1943) German photographer.
Klauke's photographs are meditations, both
philosophical and ironic, on our modern way
of life. Part burlesque, part poetry, and often
incorporating the artist himself, they examine
states of suspension or limbo, be it physical,
mental or temporal. Klauke creates a kind
of unsteady balance between the people and
the objects he photographs, setting them
against a neutral background that is bathed

• **K** —

Jürgen Klauke,
Formalized Boredom, 1980–81

William Klein,
Grace, New York, 1955

in a mysterious light. The titles he gives to
his polyptychs – *Formalisierung der Langweile*
('Formalization of Boredom', 1980–81), for
instance, or *Desaströses Ich* ('Disastrous Self',
1996–2000) – reflect the conceptual basis of
his work.

Klein, Steven (b. 1961) American fashion
photographer. Having studied painting,
Klein rapidly made his mark by redefining
the established codes of → fashion and
→ portrait photography. Latent and provocative
sexuality, violence and brooding atmospheres
are characteristic of his images, which are
meticulously staged and often contain
a narrative dimension. He is equally at home
with videos and multimedia installations.

Klein, William (b. 1928) American photographer,
film director and painter. Klein was born and
raised in New York, joined the army in 1946, and
spent seven years in Paris, during which time he
studied painting under André Lhote and Fernand
Léger, who encouraged him to find his subject
matter out in the streets. He began his career
as a photographer while continuing to paint.
In 1954 he was invited by → Alexander Liberman
to work for → *Vogue*, and photographed New York
with unique energy and style, giving rise to his
cult book *Life is Good and Good for You in New
York: Trance Witness Revels* (1956), the layout
of which was also strikingly original. This work,
published shortly before → Robert Frank's
The Americans, was a major influence on post-war
→ street photography, especially in 1960s Japan.
Further publications followed, including *Rome*
(1958), *Moscow* (1964) and *Tokyo* (1964). Aside
from these personal projects, Klein had a big
impact on → fashion photography, owing to his
humorous approach and innovative perspectives
(he used a telephoto lens, very acute angles
and → retouching). His first feature-length film,
Who Are You, Polly Maggoo? (1966), provides
an ironic view of the fashion world, which

he abandoned until the 1980s, when he once more began to produce advertisements and documentaries. In between, his main occupation was making documentary films that included *Far From Vietnam* (1967), *Muhammed Ali, the Greatest* (1964–74) and *Grands soirs et petits matins* (1968–78).

Klemm, Barbara (b. 1939) German photographer. Klemm's career has been closely bound up with her work for the daily *Frankfurter Allgemeine Zeitung*; initially engaged in 1959 as an assistant, since 1970 she has compiled stories for the newspaper's cultural and political sections. She is well known for her portraits and records of major events. Klemm is a professor of photography at the University of Applied Sciences in Darmstadt and a member of the Academy of Fine Arts in Berlin.

Klutsis, Gustav (1895–1938) Latvian artist. Klutsis was a major figure of Russian Constructivism, who specialized in using → photomontage as a propaganda tool. A fervent champion of Communism who produced large numbers of political posters, he nevertheless fell victim to Stalin's purges. He studied art in Riga and Petrograd (1913–17), and took part in the October Revolution. He attended courses with Kazimir Malevich and created some Suprematist compositions, such as *Dynamic City* (1920), before switching to Constructivism on account of his connection to artists in the LEF (Left Front of the Arts) and October group, including → Alexander Rodchenko and → El Lissitzky. He promoted the use of photomontage in his writings and produced work that was composed of dynamic graphic lines, strong colours and powerful slogans, defying accusations of formalism and shaping it to the rising 'cult of personality' and Socialist Realism.

Knapp, Peter (b. 1931) Swiss artist. Knapp studied at the School of Applied Arts in Zurich and the Académie des Beaux-Arts in Paris. He was art director of the Galeries Lafayette (1955) and of the magazine *Elle* (1960–66 and 1974–77); painted for a period (1955–66); worked as a freelance photographer for various magazines,

including → *Vogue*, the *Sunday Times Magazine* and *Stern*; and has made numerous films and videos. He also has a large body of art photographs to his credit.

Knight, Nick (b. 1958) British fashion and portrait photographer. After graduating from the Bournemouth and Poole College of Art and Design, Knight published his first work, *Skinhead*, in 1982. From 1983 onwards he contributed regularly to the magazine *i-D*, as well as to → *Vogue*, *Dazed & Confused* and *Visionaire*. It was his collaboration with the couturier Yohji Yamamoto in 1986 that propelled him to the forefront of the international scene. In 1997 he published *Flora*, a series of photographs illustrating plant specimens conserved at the National History Museum, London. In 2000 he founded SHOWstudio.com, a pioneering internet site for the distribution of videos and fashion photographs.

• **K** —

Knorr, Karen (b. 1954) German-born American photographer. Knorr studied art in the United Kingdom, and one of her first photographic

Nick Knight, *Yohji Yamamoto: Susie Smoking*, 1988

233

Kodak No. 1 camera, 1889

projects was *Gentlemen* (1981–83), which illustrated traditional British values. In 1986 her series *Connoisseurs* explored Western ideas of cultural heritage, notably in the context of institutions and museums. Later works, such as *Academies* (1994–2001) and *Fables* (2004–8), have pursued similar themes through a combination of installation, video and photography.

Knudsen, Knud (1832–1915) Norwegian landscape photographer. After training in horticulture in Reutlingen, Germany, Knudsen opened a studio in Bergen in 1864. Together with Marcus Selmer, he was the most important photographer then working in the city. Knudsen was a pioneer in the genre of 'tourist photography', documenting large parts of Norway. He was especially influential in presenting landscapes in the western part of the country as typically Norwegian. Answering to the demands of the tourist market, Knudsen focused on the landscape's dramatic features and on local people dressed in national costume. Although he borrowed motifs from Romantic painting, he succeeded in translating nationalist subjects into postcard form, adapting them to commercial ends. Knudsen is also known for his humble portraits of peasants going about their daily chores. His images of farmers in his home town of Tokheim are documentary in style, showing the harvesting of fruit, the slaughtering

of sheep and the spreading of fertilizer on the fields. The University of Bergen holds a large collection of his → negatives and → albumen prints.

Kodachrome A colour-reversal film manufactured by Eastman → Kodak, first made available to the public in 1935. Unlike the → autochrome before it, Kodachrome was a → subtractive colour process; however, like the autochrome it still required transmitted light in order to be viewed. The popularity of Kodachrome → slide film led to the emergence of a new kind of family entertainment: the slide show. The declining consumer base for Kodachrome and other transparency films, combined with the transition to → digital photography, eventually led to the film's demise, despite its continued popularity for → commercial photography.

Kodak An American company (properly the Eastman Kodak Company) producing imaging materials and supplies. → George Eastman, the founder, invented the slogan 'You press the button, we do the rest' in 1888, launching a camera designed to use the roll film he had brought to the market three years earlier. Eastman intended to simplify photography and to introduce it to a mass market. The Brownie camera, introduced in 1900, was a simple, low-cost appliance that achieved enormous commercial success, with 150,000 units shipped in its first year alone. Kodak continued to market the Kodak line of cameras until the 1960s, often targeting children as potential users. The company introduced → Kodachrome, a 35mm colour transparency film, in 1935, and Kodacolor, a 35mm colour negative film, in 1942. Both brought colour photography to the mass market; furthermore, Kodachrome introduced a new way of viewing photographs to the family: the 35mm slide → projector. Kodak controlled a large share of the imaging market in the mid-20th century and included under its aegis the Tennessee Eastman Company (now the Eastman Chemical Company), which supplied photographic chemicals to Kodak. At present, Kodak has discontinued its cameras and certain types of film, including Kodachrome.

Kolehmainen, Ola (b. 1964) Finnish photographer. Architecture provides the inspiration for Kolehmainen's photographic compositions. They are generally abstract, focusing especially on reflections and the effects of perspective, as well as the buildings' spatial and structural qualities. A member of the Union of Photographic Artists in Helsinki, Kolehmainen lives and works in Berlin.

Kollar, François (1904–79) Slovakian-born French photographer. Kollar worked in advertising, especially for fashion (Chanel, Lanvin) and luxury goods (Cartier, Van Cleef & Arpels), and contributes to various magazines (→ *Harper's Bazaar*, → *Vu*). He also entered the field of → documentary photography with a series called *La France travaille* (1931–34) for Horizon publications. Aesthetically, his work is notable for its use of form and lighting effects.

Kollár, Martin (b. 1971) Slovakian photographer. born in Žilina, he studied at the Academy of Performing Arts in Bratislava and has been working as a freelance photographer and cinematographer since he graduated. A significant figure in the field of Slovak colour → documentary photography, he gently and humorously presents the reality of everyday life in Europe and elsewhere. With an ironic rather than heroizing approach, he aims to record changes in traditional values in the face of commercialism and new lifestyles. He has received several grants and awards, including the Fuji Film Euro Press Photo Award and the Backlight Photography Award in Finland. His work has been exhibited all over the world. Kollár has published several photography books, including *Nothing Special* (2008), *Cahier* (2011) and *Field Trip* (2013), and has also worked on several films and documentaries.

Konopka, Bogdan (b. 1953) Polish photographer. The principal subject of Konopka's black-and-white photographs is the urban environment. He began his career in his native city of Wrocław, later travelling to Angers, Paris, and various cities in Eastern Europe and China. His nostalgic photographs are small in format, and produced exclusively in tones of grey and sepia. He has lived in France since 1989.

Koo, Bohn-Chang (b. 1953) South Korean photographer. Koo studied business administration in Yonsei University. Following his graduation, he began to learn photography in Hamburg. In the late 1980s he led the 'constructed photography' movement in Korea, carrying out experiments to discover new possibilities offered by the medium. Koo has been described as one of Korea's most influential photographers. He has been the subject of over thirty solo exhibitions around the world, at venues including the Peabody Essex Museum, Massachusetts (2002), Camera Obscura, Paris (2004), the Kahitsukan Kyoto Museum of Contemporary Art (2006), the Philadelphia Museum of Art (2010) and the Kukje Gallery, Seoul (2011).

Kopek, Gábor (b. 1955) Hungarian photographer, media artist and educationist. In 1984 Kopek established the first university photography course in Hungary; the majority of present-generation Hungarian photographers studied the subject along the lines he set out three decades ago. From 1990 he spent time abroad, mostly in Germany and the Netherlands. In 2000 he returned to the Moholy-Nagy University of Art and Design, Budapest, becoming rector in 2006. His work is known above all for its simple, pared-back aesthetic: Kopek displays only what is necessary at all times, creating installations that include a minimum amount of light and acoustic elements. Aside from exhibiting in Hungary and abroad, Kopek works as a visual designer for theatrical performances.

Korda, Alberto [Alberto Diaz Gutiérrez] (1928–2001) Cuban photographer. Korda is known all over the world for *The Unknown Warrior* (1960), a portrait of Che Guevara that has become one of the most iconic images in history. He began his career offering his services for weddings, baptisms and so on, but later opened a studio in Havana where he specialized in advertising and fashion.

Korniss, Péter (b. 1937) Hungarian photographer. Korniss took part in the Hungarian Uprising of 1956 as a member of the university's

● **K** —

— K •

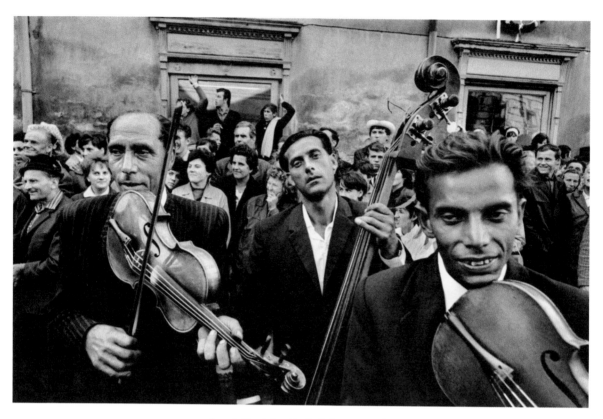

Joseph Koudelka, *Festival of Gypsy Music,*
Strážnice, Czechoslovakia, 1966

revolutionary committee and was expelled
from his law studies. He first took up work
as an unskilled labourer, but in 1958 applied
to become a photographer's assistant. He
worked for decades as a photojournalist and
additionally, from 1986, as an art editor. Korniss
was interested in presenting the Transylvanian
and Hungarian peasant's way of life, and the
changes it underwent during modernization. His
was a classic style of → documentary photography
combined with an empathetic approach; some
of his photographs have become iconic. For
one project he shadowed a worker for ten years,
recording his daily existence; the resulting
images became Korniss's most famous series,
called *A vendégmunkás* (1988). He is also well
known for his photographs of dancers. Between
1977 and 1980 Korniss was on the jury of World
Press Photo and a consultant committee member
of the Eugene W. Smith Foundation. He has
exhibited in sixteen countries, and his most
important publications are *Elindultam világ útján*

(1975), *Múlt idő* (1979), *Leltár* (1998) and *Kötődés*
(2008). Korniss has received the Bela Balázs Prize
(1975), the Kossuth Award (1999) and the Pulitzer
Prize (2004).

Koudelka, Joseph (b. 1938) Czech photographer.
Having trained as an aeronautics engineer,
Koudelka took up photography full time in the
late 1960s. His photographs of the Prague Spring
of 1968, which at the time were distributed
anonymously, won several awards and were
republished under his name in 2008. He left
Czechoslovakia in 1970 and became a member
of → Magnum. Initially he specialized in portraits,
and in 1975 published *Gypsies*, followed in 1988
by *Exiles*. In 1986–87 he participated in a mission
to record French landscapes, using a → panoramic
format for his black-and-white pictures. These
images were later incorporated into a series
entitled *Chaos*, published in 1999. There have
been several retrospective exhibitions of his work
all over the world.

Kouyaté, Adama (b. 1928) Malian photographer. Born in Bougouni, in the Sikasso region, Kouyaté is a studio photographer. In 1940 he settled in Bamako and was apprenticed to Bakary Doumbia. Encouraged by his fellow apprentices → Seydou Keïta and → Malick Sidibé, he joined the French colonial photographer Pierre Garnier in his studio, the Photo Hall Soudanais. Kouyaté then set up on his own, establishing Photo Hall studios in Kati (1949), Ouagadougou in Burkina Faso (1964) and Ségou (1968). Partly owing to a limited working space – a room at the back of a shop – his portraits are very much in an early 20th-century style, but they are distinguished by the attention he pays to minute details such as ornaments, colours, gestures or expressions. This approach helps convey a sense of liberty and modernity, in keeping with the tone of Malian society just after independence.

Kracauer, Siegfried (1889–1966) German sociologist and critic. Having trained as an architect, Kracauer became a journalist and essayist with links to the Frankfurt School of critical theory. He developed theories about the relationship between the photographic image and reality, maintaining that the former always contained an element of the unintentional and arbitrary. He also believed that modern photography had widened the framework of human perception.

Kratsman, Miki (b. 1959) Argentinian-born Israeli photographer. Kratsman is director of the photography department at the Bezalel School in Jerusalem. He started out as a photojournalist but turned to politically engaged documentary work in order to make Israelis aware of everyday life for Palestinians under the occupation. The photographer's moral viewpoint and his obligation to bear true witness are fundamental principles of his work.

Krauss, Rosalind E. (b. 1940) American critic, art historian and professor at Columbia University, New York. Alongside her academic career, Krauss has contributed to *Artforum* since 1966. She also founded the magazine *October* in 1976. Interested mainly in the theory and history of modern and postmodern art, she has studied, among other subjects, photography and its links with indexicality, and the concept of optical unconsciousness. A collection of her writings, *The Originality of the Avant-Garde and Other Modernist Myths*, was published in 1985.

Krims, Les [Leslie Robert] (b. 1942) American photographer. A native of Brooklyn, New York, Krims is known for his conceptually driven, often humorous collections of photographs. Throughout the 1970s, Krims's various self-published books and portfolios, which focused on subjects ranging from his topless mother making chicken soup to heavily manipulated → Polaroid SX-70 prints, were widely circulated and discussed.

Kruger, Barbara (b. 1945) American artist. Kruger studied at Syracuse University, New York, and took courses with → Diane Arbus and Marvin Israel at the Parsons School of Design, New York. She worked in advertising as a graphic artist and contributed to various magazines while at the same time honing her artistic skills. From the 1980s onwards she turned her attention to political and social themes. Her work has been widely reproduced by the media. Her images,

• **K** —

Barbara Kruger, *Untitled (Your body is a battleground)*, 1989

which are composed according to the rules of advertising and are predominantly in red, black and white, are rounded off by slogans that have a forceful impact on the viewer. She uses public spaces such as galleries, parks and billboards to highlight problems connected with feminism, the abuse of power, stereotypes and the damaging consequences of a consumer society.

Krull, Germaine (1897–1985) German photographer. Now associated with the → New Vision movement, she was born in East Prussia, she moved to Munich in 1912, and in 1915 began to attend the photography school there. Two years later she opened her own photography studio, although she was forced to close it a year later. In Munich she moved in the same artistic circles as Rainer Maria Rilke and Thomas and Katja Mann. Influenced by socialist ideology, Krull took part in the November Revolution of 1918–19 and was subsequently expelled from Bavaria. She moved to Moscow and then to Berlin, Amsterdam and Paris. Her photographic

— K •

Germaine Krull,
Jean Cocteau, 1929

style was often compared to that of → August Sander and → Karl Blossfeldt. Krull earned her living primarily as a photographer for fashion magazines. Her relationship with modern advances in technology was marked by a combination of fascination and repulsion, a view reflected in her book *Metal*, which brought her great acclaim as well as commissions from firms such as Peugeot and Citroën. From 1929 onwards, she took part in major exhibitions, including *Fotografie der Gegenwart* and the Werkbund exhibition → *Film und Foto*. Alongside her work as a photojournalist, she experimented with → photomontages and multiple exposures. She also took portraits of André Malraux and Jean Cocteau. While working for *France Libre*, Krull journeyed to Africa and Brazil in 1942–43. In 1945 she travelled to Asia as a war correspondent. By chance, she ended up taking a job as manager of the Oriental Hotel in Bangkok and remained in Asia for over twenty years, eventually settling in India. Her body of work was bequeathed to the Museum Folkwang in Essen.

Krzywoblocki, Aleksander (1901–1979) Polish photographer. Born in Lvov, Krzywoblocki studied at the city's Polytechnic School and earned his living as an architect. In 1928 he began to practise photography and in 1929 co-founded the Artes group of artists. From that point on he experimented with staged compositions that were strongly influenced by → Surrealism. One series of images, created between 1929 and 1936, juxtaposed everyday objects with parts of the body (especially the hand). They broke the mould of conventional portraiture, and with the aid of mirrors brought out the duality of the sitter's character. In 1946 Krzywoblocki settled in Wrocław, where he ran a restaurant and devoted less and less time to art. In one of his last series of → photomontages, produced in 1948–49, he used reproductions of fragments from buildings, monuments and Greek statues. In 1975 the National Museum of Wrocław organized his first retrospective, *Aleksander Krzywoblocki: Photomontages*. After his death, Krzywoblocki's work was displayed in several major exhibitions of Polish art from between the wars.

Heinrich Kühn,
Fishermen on the Canal, 1908

Kudoyarov, Boris (1898–1974) Uzbekistan-born Russian photojournalist. After serving in the Red Army (1917–20), Kudoyarov was employed as a professional photojournalist by the Russfoto agency and later became an international correspondent for Soyuzfoto (1931). He also joined the avant-garde October group of artists, whose Constructivist style influenced his black-and-white images – particularly his → reportage on the siege of Leningrad. After World War II, he continued to work as a photojournalist for the Russian agency ITAR-TASS.

Kühn, Heinrich (1866–1944) Austrian photographer. Kühn founded the Trifolium group in 1895 and exhibited with the Viennese Secession. His work, based mainly on family life, reflected the artistic principles of → Pictorialism and placed him among the movement's most talented figures at the beginning of the 20th century. Kühn's images invited the comparison of photography with painting through their large formats, composition and impressionistic effects. Under the influence of → Alfred Stieglitz, Kühn subsequently moved from romantic Pictorialism to a style that was purer in its use of light and colour. He was also a masterly exponent of the → autochrome.

Lacan, Ernest (1828–1879) French critic and editor. In the early 1850s, when photography criticism was beginning to take shape, Lacan was one of the leading champions of utilitarianism, in contrast to the ideals of the → Société Française de Photographie, which stood up for the medium's artistic status. Lacan published the first studies on photography and was editor-in-chief of → *La Lumière*, the first journal devoted entirely to photographic matters and the latest technical developments. He was also the author of a celebrated book entitled *Esquisses photographiques à propos de l'Exposition universelle et de la guerre d'Orient* (1856), in which he examined the relevance of photography to art. In 1861 he left *La Lumière* to become chief editor of the *Moniteur de la photographie.* Lacan's principal aim was to help photographers sell their work. He also wanted to see the new medium expand beyond the purely private sphere, so that, through the reproduction of artworks, it could be used for the promotion of culture.

LaChapelle, David (b. 1963) American photographer and filmmaker. LaChapelle studied at the North Carolina School of the Arts, and at the School of Visual Arts and the Art Students League in New York. Invited to work for the magazine *Interview* by → Andy Warhol, LaChapelle began to take his first portraits of celebrities – a genre he has developed through the years. He is known for placing famous personalities – including musicians (Marilyn Manson, Courtney Love), actors (Uma Thurman) and models (Naomi Campbell) – in weird and wonderful surroundings, full of garish colours and contrasts. His photographs, which often contain references to biblical iconography, art history and the cinema, explore the fashion and art worlds, holding up a critical, and often humorous, mirror to contemporary popular culture.

Lake Price, William Frederick (1810–1896) British photographer. Lake Price began to practise photography in 1854, while working as a watercolour painter. He joined the Photographic Society of London, and was soon exhibiting his genre scenes and portraits. His image of *Don Quixote in his Study* was shown at the exhibition of *Photographic Art Treasures* in Manchester

(1857) and became emblematic of photography's aspirations to be seen as an art form.

Land art An art movement that began in the United States in the late 1960s. Prominent practitioners, such as → Robert Smithson, coined the phrase to describe installations in which art and nature were inextricably linked. Famous examples of land art, such as Smithson's *Spiral Jetty* (1970), were difficult to access or built to disappear over time (or both). Photographing the sites was one way of making this work accessible to an audience and ensuring its preservation for posterity.

Land, Edwin Herbert (1909–1991) American scientist and founder of the → Polaroid Corporation. Among other achievements, he invented → filters for polarizing light (1939) and the instant photograph (1947).

Landscape An artistic genre in which natural scenery provides the main subject. The concept of landscape is a cultural construct, which in the pictorial tradition originated in Flanders in the late 15th century. From the perspective of an observer, it consists of a framed view of the land that is ordered and harmonious. This perceptual experience brings cultural values into play that are not only visual, but also symbolic and political. The history of photography begins with a landscape: *Le Point de vue du Gras*, taken by → Nicéphore Niépce in 1826. It was also an urban landscape, *La Vue du Boulevard du Temple*, that → Louis Daguerre presented in 1839 as evidence of his invention. During and after the 1850s photographers set out to capture classical landscapes showing the countryside and the sea, but also to explore other territories (such as mountains and glaciers) from a new perspective. The photographs taken by the → Mission Héliographique in 1851, including → Gustave Le Gray's *Les Marines* and works by the → Bisson brothers, created a photographic aesthetics of the landscape. In the United States at the end of the 19th century, photographers were closely associated with the opening up of the West through their → photographic surveys. Their images contributed to the creation of an

Robert Smithson, *Hypothetical Continent (Icecap of Gondwanaland), Yucatán, Mexico*, 1969

imaginary American land that is still influential today. Although the landscape tradition endured in America, in Europe it faded away until the 1980s, when new photographic missions brought about a resurgence. Landscape is now firmly established on the contemporary art scene.

Lange, Dorothea (1895–1965) American photographer. Born in Hoboken, New Jersey, she trained as a primary school teacher, but her main interest lay in photography. She studied under several photographers, including → Arnold Genthe, and attended seminars given by the → Pictorialist → Clarence H. White at Columbia University. In 1918, having settled in San Francisco, she opened a portrait studio that was frequented by the city's high society. The economic crisis of the late 1920s and the victims she saw in the streets inspired her to engage in a different kind of photography: social documentary. In 1935 she divorced her first husband, the painter Maynard Dixon, and married the economist Paul Taylor, with whom she collaborated on several publications, the most famous being *An American Exodus* (1939). That same year she was recruited by

• **L** —

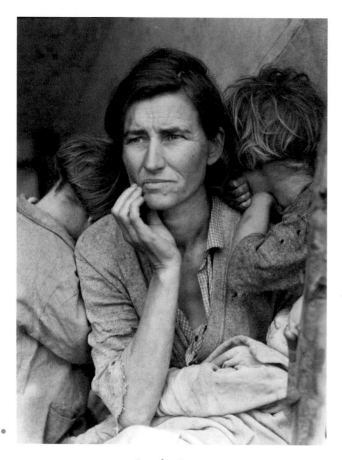

Dorothea Lange,
Migrant Mother, 1936

→ Roy Stryker on behalf of the historical section of the Resettlement Administration, later renamed as the → Farm Security Administration (FSA). Her resilient nature, together with her sensitivity to the expression of human suffering, made her one of the most valuable members of the FSA team. Her work was not, however, limited to images of migrant workers in the western and south-western states. During World War II she produced two photo stories that have gone down in history: one on the internment of Japanese-Americans, and the other on women doing war work. Lange was co-founder of the magazine → *Aperture* (1952) and, in spite of serious health problems, continued right up until her death to engage in projects that included series on the United States, Asia and the Middle East.

Larrain, Sergio (1931–2012) Chilean photographer. Larrain bought his first → Leica in 1949 and

the following year enrolled at the University of Michigan to study photography. He worked as a freelance photographer for the Brazilian magazine *O Cruzeiro*. In 1956 the → Museum of Modern Art, New York, acquired two of his prints. Three years later he met → Henri Cartier-Bresson, who encouraged him to join → Magnum Photos. Although he always maintained ties with his home country, Larrain proceeded to file stories from all over the world. During the 1980s he chose to withdraw to the Chilean countryside in order to meditate and to draw. His publications included *El rectángulo en la mano* (1963), *Chile* (1968) and *Valparaiso* (1991), on which he collaborated with Pablo Neruda.

Lartigue, Jacques Henri (1894–1986) French photographer. Lartigue took his first photographs at the age of 6, the same time as he began the diary he would keep until he died. Collected in 130 albums, his photographs bear witness to the society and events of his time, ranging from the beginnings of aviation and the promenades in the Bois de Boulogne that formed part of his childhood to his meetings with numerous artists and the journeys he undertook in old age. His collection of photographs was conceived as a private visual diary that captured fleeting moments, but at the same time it also reveals his artistic talent. Lartigue set out to be a painter, but it was as a photographer that he made his mark: in 1963 the → Museum of Modern Art, New York, staged an exhibition of his work, which was also published in → *Life*. International recognition came with his books *Un album de famille* (1966) and *Diary of a Century* (designed by → Richard Avedon, 1978), and a retrospective at the Musée des Arts Décoratifs, Paris, in 1975. In 1974 he took the official portrait of the then French president, Valéry Giscard d'Estaing.

Latent image An image created when photographic film or paper is exposed to light. The image is considered to be latent because it remains invisible to the eye until processed in the photographic developer.

Laughlin, Clarence John (1905–1985) American photographer. At the age of about 20, Laughlin

had a passion for literature, especially Baudelaire and the Symbolists. When he failed to fulfil his literary ambitions he turned to photography in 1936, taking architectural photographs for the department of engineering in New Orleans. Between 1949 and 1967 he documented Victorian America, but his most famous work was *Ghosts Along the Mississippi* (1948), which was partly documentary and partly a surreal record of the plantations of his native Louisiana. Often using strange frames and reflections in mirrors, he was well known for his mysterious superimpositions. In around 1970 he classified his works into twenty-three groups, mainly according to their subject and symbolic content.

Le Gac, Jean (b. 1936) French artist. In 1968, while working as an art teacher, Le Gac decided to abandon painting and to turn to photography instead. He produced a work entitled *Bâches* (1968), to which he added a text, publishing the result as *Les Cahiers* (1968–71). This series enabled him to develop features that would become central to his work: a narrative influenced by his love of popular literature and photo novels; the idea of the artist's depression, told by means of a labyrinthine piece in which Le Gac's fictional doubles and real biographical facts are intertwined; and the incorporation of his own creations into his artworks (*Les Anecdotes*, 1973). He was the subject of an exhibition at the Musée National d'Art Moderne, Paris, in 1978 and published a compendium of his work entitled *Et le peintre* (2004). His art links up with the → narrative art movement and was featured in *Individual Mythologies*, a section in the Documenta 5 exhibition in Kassel, curated by Harald Szeemann (1972).

• L —

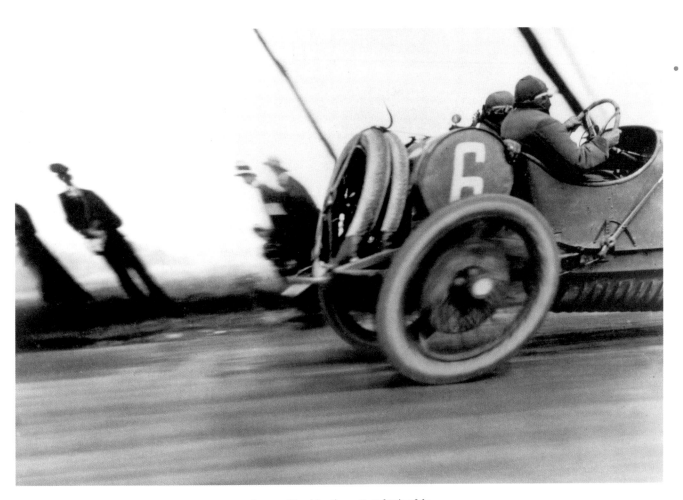

Jacques Henri Lartigue, *Grand Prix of the Automobile Club of France, Course at Dieppe*, 1912

Gustave Le Gray,
The Great Wave, Sète, 1856–59

Le Gray, Gustave (1820–1884) French
photographer. Le Gray dominated the French
photographic scene during the 1850s.
He studied painting under Paul Delaroche,
alongside → Charles Nègre, → Henri Le Secq and
→ Roger Fenton, and his work was exhibited
at various salons between 1843 and 1853.
However, having learnt early processes from
the chemist → Alphonse Louis Poitevin, in 1847
he decided to pursue a career in photography.
He was as interested in the chemical aspects
of photography as its aesthetic side, and
perfected the → calotype by coating the surface
of the negative paper with wax to make it more
transparent but at the same time more conducive
to clarity of detail and variety of tone. This
technique was the subject of his *Traité pratique de
photographie sur papier et sur verre,* published in
1850. Le Gray used the dry → waxed paper process
to photograph the forest of Fontainebleau in 1851.
That same year the → Mission Héliographique
commissioned him and his pupil Augustin
Mestral to photograph the historical monuments
of Touraine and Aquitaine. In 1856 he exhibited
some marine studies in London, for which
he used → collodion plates, and prints on
→ albumen coated paper. These seascapes were
produced from a combination of two → negatives,
one for the sky and one for the sea, with a
different exposure time for each. Napoleon III

commissioned Le Gray to photograph life at the
new military camp of Châlons in 1857. In 1860,
when visiting cards with portraits suddenly
became popular, he went into hiding for financial
reasons, left Paris and embarked on a journey
to the Mediterranean and the Near East, during
which he photographed the barricades that
had been set up in Palermo during the Italian
nationalist struggle. In 1864 he took a job as an
art teacher in Cairo, where he died in 1884.

**Le Secq, Henri [Henri Jean-Louis Le Secq
Destournelles]** (1818–1882) French painter and
photographer. Le Secq studied painting under
Paul Delaroche at the same time as → Roger
Fenton, → Gustave Le Gray and → Charles Nègre.
His paintings were exhibited at various salons
throughout his career, but he never achieved the
success he had hoped for. In 1848, after studying
with Le Gray and on the advice of his friend
Nègre, he turned to photography. Most of his
work focused on architecture, in accordance
with the new medium's learned aspiration to
record the national heritage for posterity. Le Secq
participated in the → Mission Héliographique
of 1851, photographing views of architecture
in Champagne, Lorraine and Alsace, as well as
producing a series on the demolitions under
way in Paris in 1852. He had a passion for Gothic
churches and took many photographs of the
cathedrals in Chartres, Amiens, Reims and
Paris prior to their restoration. He also loved
to experiment with different genres, evaluating
his work according to painterly criteria: he
produced → still-lifes in the Flemish style,
portraits, views of the forest of Montmirail,
and reproductions of sculptures and paintings.
In terms of technique, he made only → negatives
on paper, which on Le Gray's advice was waxed.
However, in 1856 he abandoned photography
to pursue his career in painting and to gratify
another of his passions, which was to collect
objects in wrought iron. This collection was
bequeathed to the city of Rouen.

Lebeck, Robert (b. 1929) German photographer.
Born in Berlin, Lebeck trained as an ethnologist.
He began his career as a photographer by
contributing to the German magazines *Revue*

Henri Le Secq, *Tower of the Kings,*
Reims Cathedral, 1851

Russell Lee, *Jack Whinery, Homesteader, and his Family, Pie Town, New Mexico*, 1940

and *Kristall*. For the next thirty years he worked for *Stern* and was editor-in-chief of the monthly magazine *Geo*. Although he is best known to the general public for his images featuring the actress Romy Schneider, he is also greatly admired by his peers for his → reportage, including his great series on the independence of the Congo (*Afrika im Jahre Null*, 1960) and post-war Germany (*Nachkriegsdeutschland*, 1955).

Lee, Russell (1903–1986) American photographer. After a brief career as a chemical engineer, Lee turned first to painting and then to photography. In 1936 he was recruited by → Roy Stryker to work for the → Farm Security Administration and proved to be one of its star performers, travelling the length and breadth of the United States. Following the war, having produced several stories on the coalmines of the Rockies and Appalachians, he joined up with Stryker once more to work for Standard Oil of New Jersey. He then turned freelance and produced a great deal of industrial photography. In 1965 he became the first professor of photography at the University of Texas in Austin. His images, greatly influenced by the aesthetics of → Walker Evans and → Dorothea Lange, combine formal discipline and documentary accuracy.

Lehnert & Landrock A company formed by the Austrian artist Rudolf Lehnert (1878–1948) and the

German entrepreneur Ernst Heinrich Landrock (1878–1966). Both loved the Mediterranean and the Far East and, when they met in 1903, they decided to leave Europe for Tunisia. Lehnert, who had graduated from the Institute of Applied Graphic Arts in Vienna, found his inspiration in Tunis and Carthage, and in the oases and deserts of Algeria and Tunisia. Landrock ran the business side of the enterprise. They produced postcards, photographic prints and albums that enjoyed great international success. The outbreak of World War I interrupted their first, extremely productive period (1904–14): Landrock left Tunisia for Switzerland, and Lehnert was taken prisoner of war. A medical prisoner, Lehnert was transferred to Switzerland, where he met up again with Landrock. When the war ended, they founded the Orient Kunst Verlag in Leipzig, with a view to resuming their printing and publishing activities. In 1923 they moved to Cairo and began what might be called their second period of production (1923–30). Lehnert travelled all over Egypt and Palestine, and the company profited from the increased interest in Egypt, particularly after the discovery of the tomb of Tutankhamun. In 1930 Lehnert sold his shares to Landrock, who continued to make a commercial success of the photographic collection. Lehnert went back to Tunisia, where his last works (1930–39) were mainly portraits. Lehnert & Landrock photographs are marked by their historical context, displaying elements of Orientalism, colonialism and ethnography, and halfway between art and industrial reproduction.

Leica I camera, 1925

Lehnert & Landrock,
Bedouin in the Desert, Tunisia, c. 1903

Leibovitz, Annie [Anna-Lou Leibovitz] (b. 1949) American photographer. In the early 1970s, while still a student at the Art Institute of San Francisco, Leibovitz began an association with the magazine *Rolling Stone* that would continue until 1983. She also worked for *Vanity Fair* and → *Vogue*, specializing in portraits of celebrities that have often had an iconic impact. Among the best known are those of John Lennon and Yoko Ono, taken only a few hours before the former was murdered (1980), and of Demi Moore, naked and pregnant, which appeared on the cover of *Vanity Fair* (1981). In parallel with her commercial career, Leibovitz has also worked on personal, private projects, most notably her photographs of her partner, → Susan Sontag, which are to be found in *A Photographer's Life: 1990–2005* (2006).

Leica A camera made by the Ernst Leitz optics company in Wetzlar, designed by Oskar Barnack in 1914 and mass-produced from 1924. Small, light and easy to handle, the Leica rapidly became very popular and revolutionized the world of → photojournalism. It was the favourite camera of many photographers, including → Henri Cartier-Bresson, → Robert Capa and → Gisèle Freund, and was a huge success: in 1932 some 90,000 were sold worldwide, and by 1961 the number had risen to 1 million. In essence it consisted of a simple camera body with a fixed → lens, a focal-plane → shutter and a viewfinder, but the system also underwent major technological developments, and the introduction of rangefinders (as in the legendary M3, launched in 1954) constituted a major advance. The first compact was launched

247

in 1989, and a digital version (the Leica Digilux) in 1998.

Leipzig School Originally referring to a movement in painting that flourished in the second half of the 20th century, the term was subsequently extended to include photographers who attended the Leipzig Academy of Visual Arts. The leaders of this movement were Evelyn Richter and → Arno Fischer, who founded a social documentary style. The group's images focused on the world of work, industrial landscapes and everyday life.

Leiris, Michel (1901–1990) French ethnologist and writer. After participating in the → Surrealist movement, Leiris turned his attention to anthropology (*L'Afrique Fantôme*, 1934), promoting photography and the cinematic image as proper tools for scientific research. He was a distinguished writer and critic of modern art and founded numerous magazines.

Leiter, Saul (1923–2013) American painter and photographer. First noticed in the 1950s by → Edward Steichen, the director of the → Museum of Modern Art, New York, Leiter is now regarded as one of the pioneers of colour photography in the United States. He made his name as a fashion photographer, and it was not until late in his life, during the 1990s, that his numerous series on urban life in Manhattan – with their original stylistic effects – became famous.

Lekegian, Gabriel (d. 1925) Armenian photographer. His exact dates remain obscure, though he was active in Egypt from the 1860s to the 1890s. Lekegian is known mostly for his photographs of archaeological sites such as pyramids, temples and statues. He styled himself as 'Photographer to the British Army of Occupation', and annotated his photographs with the motto 'Photographie Artistique' to emphasize his claim to be taken as an artist.

Lekuona, Nicolás de (1913–1937) Spanish photographer. After studying drawing in San Sebastián, Lekuona turned to photography.

Influenced by Expressionist cinema, the → New Vision and the → Bauhaus, he adopted special lighting effects and bold compositions. His → photomontages of women were poetic and → Surrealist, but those depicting labourers and the country's conflict had a political edge and were frequently Dadaist in style. He died in the Spanish Civil War at the age of 23.

Lemagny, Jean-Claude (b. 1931) French art critic and theorist. The son of the engraver Paul Lemagny, he spent his entire career working in the print room of the Bibliothèque Nationale in Paris until he retired in 1997. He aimed to expand the range of contemporary photography by encouraging artists to lend or donate their works, thereby creating a photography gallery. He was a central figure on the French photographic scene from the 1970s until the 1990s, supported many young artists, organized numerous exhibitions and was an active participant in several significant projects, including the Rencontres d'Arles photo festival and the Cahiers de la Photographie book series. He also wrote several works on the concept of the image: his approach – which, inspired by philosophy and art history, was far from doctrinaire – granted central roles to the creative artist, with all his mystery and resilience, and to the viewer's all-important reaction to the image.

Lemos, Fernando (b. 1926) Multi-disciplinary Portuguese artist and photographer. Lemos created → Surrealist photographs in Portugal between 1949 and 1952. His works achieved greater recognition thanks to the 1977 exhibition *A Fotografia na Arte Moderna Portuguesa*, and in 2001 he received the annual photography prize from the Portuguese Centre for Photography. Lemos was an opponent of the Salazar regime and emigrated to São Paulo, Brazil, in 1953, where he focused his efforts on drawing, graphic design and painting. Banned from returning to Portugal until 1974, Lemos wrote for *Portugal Democrático*, a newspaper for political exiles in Brazil, from 1955 to 1973.

Lendvai-Dircksen, Erna (1883–1962) German photographer. After studying painting and

– L •

photography, she set up her own studio. Among her notable achievements were her portraits of farming communities taken all over Germany. She was a member of the Nazi party and agreed to let them use her photographs as a means of spreading their folkloristic iconography.

Lens A lens, or lens assembly, focuses the light entering a camera so that a photograph can be taken. The use of lenses pre-dates the invention of photography. The first use of a simple lens to improve the image projected by a → **camera obscura** was made by William Hyde Wollaston in 1812; this lens was not achromatic and therefore produced an image that was distorted at the edges. In 1830 → **Charles Chevalier** created double achromatic lenses, which were employed for early → **daguerreotypes**. Throughout the 19th century, the science of optics worked to correct aberrations by experimenting with the shape and positioning of the lenses. The most important parameters of a lens are → **focal length**, maximum → **aperture** and angle of field. Lenses may be fixed or movable. Movable lens systems allow the focal length to be changed and are used in → **zoom lenses**.

Leonard, Zoe (b. 1961) American photographer and artist. Self-taught, Leonard began her career as a feminist activist, sometimes using installations and sometimes photographs to convey her message. In 1998 she started work on the series *Analogue* (1998–2007), from which a selection was exhibited at Documenta 12 in Kassel (2007). Her work explores questions of genre, the exchange networks of consumer goods, and changes in the urban landscape.

Lerner, Nathan (1913–1997) American photographer. The son of Ukrainian immigrants, Lerner studied painting at the Art Institute of Chicago and photography at the → **New Bauhaus** in the same city. His work is split between photographs of social conditions in the immigrant quarters of the city and more abstract images as promoted by the teachings of → László Moholy-Nagy. Lerner also taught and did administrative work at the New Bauhaus, which was renamed the School of Design

in 1939, before opening a print room in 1949. His photographs have been exhibited in many different museums since 1973.

Lerski, Helmar [Israel Schmuklerski] (1871–1956) Swiss photographer. Born in Strasbourg, Lerski was brought up in Zurich and emigrated to the United States in 1893, where he worked as an actor in Milwaukee and New York. He opened his photography studio in Milwaukee, specializing in theatre portraits. In 1915 he moved to Berlin, where he worked as a cameraman in a Berlin film studio. From 1929 he specialized in → **portrait photography**, and in 1931 published *Köpfe des Alltags* ('Everyday Heads'), a series of outstanding close-up portraits, mostly of men. The same year he emigrated to Palestine, where he worked in film and on the *Verwandlungen durch Licht* ('Transformations through Light') photography project (1936), returning to Zurich in 1948. In 1982 the Museum Folkwang in Essen organized an important exhibition of his work.

Lessing, Erich (b. 1923) Austrian photojournalist. Lessing worked with the British army in Palestine (1939–47) before joining the Associated Press and → **Magnum** photo agencies. He specialized in political → **reportage** from the United States and Europe for leading magazines of the time (→ *Life*, *Picture Post*, *Epoca*, *Paris Match*) and covered the Hungarian Uprising of 1956. From the mid-1950s he abandoned photojournalism and worked on a number of different projects, most notably the Hollywood film of *Moby Dick* (1956).

Levine, Sherrie (b. 1947) American artist and photographer. Following a postmodernist approach, Levine uses different media, including painting, sculpture and photography, to question the concept of representation in a history of art based mainly on a masculine point of view. By re-photographing some of → **Edward Weston's** and → **Walker Evans's** photographs (*After Walker Evans*, 1981), she juggles with notions of the original and the copy, author identity and artistic ownership, while at the same time exploring the medium's intrinsic capacity for reproduction. Levine extended this method of appropriation

● **L** —

Sherrie Levine,
After Walker Evans, 1981

with *After Stieglitz* (2007), which presents eighteen photographs pixelated to such a degree that they are barely recognizable, having been transformed into squares in varying tones of black and white.

Levinstein, Leon (1910–1988) American photographer. Levinstein studied photography in the late 1940s, first at the → Photo League in New York, and then at seminars given by → Alexey Brodovitch, → Lisette Model and → Sid Grossman. He remained a freelance amateur photographer and earned his living as a graphic artist. For more than thirty years he devoted himself to → street photography, taking close-range shots of people living on the streets of New York. He was awarded a Guggenheim Fellowship in 1975.

Levinthal, David (b. 1949) American artist. He graduated in photography at Yale University. Together with artists including → James Casebere and → Laurie Simmons, he belongs to a first generation of American post-war photographers who staged toy figurines against miniaturized backdrops. He started his career in 1975 with his series *Hitler Moves East*. The subject matter of his large-format → Polaroids ranges from war to aspects of American culture. Levinthal's photographs evoke recollections of childhood and play, but also criticize the secondhand experiences offered by mass media.

Levitt, Helen (1913–2009) American photographer. Born into a moderately well-to-do family, Levitt had neither the need nor the desire to study, but she became an apprentice to a commercial photographer. After taking her first portraits, she met → Henri Cartier-Bresson in 1935 and → Walker Evans in 1937, who approved of her work. Under the influence of Cartier-Bresson she soon developed her own personal style, displaying an acute sense of movement and a profound interest in the social conditions of her subjects. She is best known for the pictures she took in the streets of working-class districts of New York, as well as for her striking and insightful portraits of children. She continued to take photographs for most of her life, although her most famous works date from the late 1930s and 1940s.

Levy, Julien (1906–1981) American gallerist and art dealer. A graduate of Harvard University, he opened the Julien Levy Gallery, New York, in 1931. It remained active until 1949. Levy was a dealer in → Surrealist and Cubist art, among other styles, and was an early promoter of photography and film, exhibiting them as art forms in their own right. He held the first New York shows of European artists including → Eugène Atget, → Nadar, → Henri Cartier-Bresson, Salvador Dalí, Max Ernst and René Magritte, and is credited with elevating the city's cultural reputation.

Lewczynski, Jerzy (1924–2014) Polish photographer. After studying at the Polytechnic School in Silesia, in 1951 Lewczynski was appointed to the post of designer at the office of industrial construction projects in Gliwice. When not engaged in this work, he devoted his time to photography and in 1956 joined ZPAF (the Association of Polish Art Photographers). His first works showed the influence of

→ Pictorialism, which was highly regarded in Poland after World War II. Towards the end of the 1950s, however, he broke away from the cult of the fine image and began to document everyday life with photographs that were symbolic and conceptual. Depicting workers without faces, or with heads cut off or hidden by spades, was his artistic response to Communist propaganda, which required Socialist images to celebrate workers as heroes. He joined an informal group of artists that included Zdzisław Beksiński and Bronisław Szlabs, and organized several exhibitions in Gliwice. Since the early 1970s Lewczynski has devoted himself completely to the 'archaeology of photography'. Photographic archives recovered from barns and family albums dug out of attics serve as a point of departure for a historical narrative. In this work, he analyses forgotten images, often anonymous, and attempts to reconstruct a link between the photographic present and the past. Lewczynski is the author of the *Anthology of Polish Photography 1839–1989*, published in 1999.

Liberman, Alexander (1912–1999) Russian-American art director, graphic artist, photographer and painter. Born in Kiev, Liberman emigrated with his parents first to London and then to Paris (1921). He studied architecture, became art director of the magazine → *Vu* and came into contact with various members of the Parisian avant-garde. He emigrated to the United States in 1941, where he was recruited by Condé Nast for → *Vogue*, of which he became art director two years later. He subsequently became editorial director of all Condé Nast publications (1962–94). He imposed a resolutely modern and effective style on his

● L —

Helen Levitt, *New York*, c. 1940

251

magazines, introducing a keen artistic sense and a fresh approach to → fashion photography thanks to the originality and spontaneity of photographers such as → Irving Penn, → Richard Avedon and → William Klein. Liberman's taste for art and culture is illustrated by the books *The Artist in His Studio* (1960), *Marlene* (1992) and *Then* (1995).

Life An American picture magazine established by Henri R. Luce, the founder and editor of *Time* and → *Fortune*. It was published weekly from 23 November 1936 to 29 December 1972. Its roster of staff photographers included Peter Stackpole, → Alfred Eisenstaedt, Thomas D. McAvoy, → Margaret Bourke-White, → W. Eugene Smith, Ralph Crane, → Robert Capa and → Henri Cartier-Bresson. The pages of *Life* featured images relating to current events, science, human-interest stories and the world of entertainment, both as standalone illustrations and as part of → photographic essays. The magazine became synonymous with the photographic documentation of World War II.

Light meter An instrument used to ascertain the required exposure time for a photograph, consisting of a photosensor and a calculator. There are two main types: incident-light meters, which measure the light falling on the subject, and reflected-light meters, which measure the light that bounces off the subject.

Lindbergh, Peter (b. 1944) German photographer. Born in Duisberg, Lindbergh worked first as a conceptual artist – a career that lasted until 1971 – before earning a reputation as one of the most influential fashion photographers of the 1980s and 1990s who helped define the concept of the supermodel. His portraits of women bring out their natural strength by focusing on their expressions and creating a kind of narrative tension.

Lindström, Tuija (b. 1950) Swedish photographer. Lindström was born in Kotka, Finland, and has lived and worked in Sweden since the 1980s. She was part of the circle surrounding the influential photographer → Christer Strömholm

and developed her own soft, enigmatic, black-and-white style of photography, based on the themes of the body and her own situation as a woman. Between 1992 and 2002 she was Sweden's first female professor of photography, teaching at the School of Photography and Film at Gothenburg University. During her time there, the school changed its curriculum, moving from a vocationally oriented education to a more theoretical and critical approach to the medium.

Lindt, John William (1845–1926) German-born Australian photographer. Lindt began his career in Grafton, New South Wales. His portfolios *Australian Aboriginals* (1873–74) and *Characteristic Australian Forest Scenery* (1875) brought him early and international recognition. Thereafter he contributed to all of the major international exhibitions until the 1890s. Following his relocation to Melbourne in 1876, he ran a successful portrait studio from 1877 to 1894 and produced several series of the landscapes in Victoria. He famously photographed the aftermath of the siege and capture of the Kelly Gang in 1880, and in 1885 was commissioned to document the peoples and scenery of newly annexed New Guinea. The resulting publication, *Picturesque New Guinea* (1887), was widely praised. Lindt later photographed in the New Hebrides (1890) and Fiji (1892). Moving to Black's Spur, east of Melbourne, in 1894, he established a popular guesthouse, The Hermitage, where he remained until his death. Together with fellow photographer Nicholas Caire he published the popular *Companion Guide to Healesville* (1904), later continuing his landscape interests in the context of the developing → Pictorialist style.

Linked Ring, Brotherhood of the A group of photographers, founded in Britain in 1892, who shared a wish for photography to be appreciated as one of the fine arts. In opposition to the → Royal Photographic Society's scientific approach, and inspired by the concept of an artistic brotherhood, Alfred Maskell, → Henry Peach Robinson, → George Davison, Henry Hay Cameron and Alfred Horsley Hinton established this elitist circle and organized an

annual exhibition dedicated to → Pictorialist photography. Membership was not confined to the British: there were also photographers from France (→ Robert Demachy, → Constant Puyo and Pierre Dubreuil) and the United States (→ Alvin Langdon Coburn, → Fred Holland Day, → Frank Eugene, → Edward Steichen, → Gertrude Käsebier and → Alfred Stieglitz). With the aim of educating both photographers and the general public, the group published a newsletter called the *Linked Ring Papers*. In conjunction with the Salon of Pictorial Photography, it presented the work of European and American Pictorialists. The Linked Ring inspired the creation of the Photo-Club de Paris and the → Photo-Secession in New York. The circle broke up in 1909 as a result of divisions between two groups: the Pictorialists remained faithful to their original principles, while the modernists advocated an ever 'purer' form of photography.

Lippmann, Gabriel (1845–1921) French physicist. After defending his thesis on electrocapillarity in 1875, Lippmann embarked on a brilliant scientific career. From 1886 onwards he conducted experiments on how to capture and fix colours in photography. In 1891 he presented his 'interferential' process to the Académie des Sciences. Its originality lay in its ability to reproduce true colours as opposed to three-colour and → autochrome processes. It was too complex to be commercially viable, however.

Lissitzky, El [Lazar Markovich Lissitzky] (1890–1941) Russian photographer. Lissitzky studied architecture in Moscow, graduating in 1915. In 1919 he was invited by Marc Chagall to teach at the Vitebsk School of Art. There he met Kasimir Malevich and was converted to the theories of Suprematism, creating his first abstract design, called a 'proun'. His interest in photography began in the early 1920s, but in 1921 he returned to Moscow to direct the faculty of architecture at the Vkhutemas school of art. He moved to Berlin in 1922, where he got to know the artists of the → Bauhaus. In 1923, together with Vilmos Huszar, he created a → photogram for the magazine *Merz*. As part of his publicity work for Pelikan, in 1925 he became the first artist

to use the photogram in the field of advertising. In 1927 he wrote an essay, *The Artist in Production*, outlining his ideas on the use of photography, → photomontage and photogram in creative typography. Lissitzky was on the selection committee to choose Russian representatives for the trade exhibition *Pressa*, held in Cologne in 1928. The following year he participated in the exhibition → *Film und Foto* in Stuttgart and wrote the essay *Fotopis*, in which he asserted that photography was 'an expressive means of making an impact on consciousness and the emotions'.

List, Herbert (1903–1975) German photographer. List began his career as a photographer in 1936, having abandoned the family coffee business. Initially, his work showed some affinity with the aesthetics of → Surrealism. His photographs were published in numerous magazines, including → *Du*, → *Life* and → *Harper's Bazaar*, and in books relating to his travels. He was a member of → Magnum Photos from 1952 until 1959, but towards the end of his life he devoted himself mainly to his collection of valuable Old Master drawings.

Liu, Zheng (b. 1969) Chinese photographer. Born in Hebei Province, Liu grew up in the Chinese mining town of Datong, Shanxi Province. He studied optical engineering at the Beijing Institute of Technology and worked as a photojournalist for *Worker's Daily*, one of China's most widely distributed newspapers, from 1991 to 1997. Influenced by Western photographers such as → Diane Arbus, → Robert Frank and → August Sander, Liu's series *The Chinese* uses photography as a tool to expose and romanticize the harsh realities of Chinese society. Internationally recognized, his work has been shown at the Venice Biennale and the Rencontres d'Arles photo festival.

Łódź Kaliska An avant-garde Polish group formed in 1979 by Marek Janiak, Andrzej Kwietniewski, Adam Rzepecki, Andrzej Swietlik and Andrzej Wielogorski. The group put on performances and staged photographic scenes, their first project being a provocative series of works criticizing the Communist system and also religion. Since

2000 they have focused their satirical eye on such subjects as mass culture, national emblems, feminism and sex.

Lomography A photography movement that began in the 1990s and takes its name from the Lomo LC-A, a rudimentary analogue camera first made in Russia in 1983. The Lomo LC-A became fashionable alongside other very cheap cameras, such as the Chinese-made Diana (first introduced in 1960s) and the Holga (1980s). The primary attraction of these cameras is their poor image quality: soft focus, vignetting and colour → saturation are deliberately exploited as a low-fi aesthetic.

Londe, Albert (1858–1917) French photographer. Londe was a member of the → Société Française de Photographie, director of the photography department at La Salpêtrière in Paris (a clinic for diseases of the nervous system) and the inventor of technical improvements to photography that he used in his medical examinations. Jean-Martin Charcot was the first to make medical use of the medium, in 1878; Londe followed his example and made La Salpêtrière one of the best-equipped photographic laboratories of its time. In order to make photographic records as an aid to diagnosis and medical research, and building on the work done by → Étienne-Jules Marey and → Eadweard Muybridge, in 1883 he adapted a → chronophotographic camera with nine → lenses that enabled him to analyse movement. In 1891 a camera fitted with twelve lenses allowed him to study not only the physiology of the human body in motion, but also various pathological forms of behaviour, such as manifestations of hysteria and epilepsy. This research culminated in the publication of the *Nouvelle iconographie de la Salpêtrière* (1888–1904), which reproduced pathological cases photographed at different stages. With his passion for photography, Londe made improvements to certain types of camera, founded the Société d'Excursion des Amateurs de Photographie (1887) and in 1897 opened the first → radiography laboratory. He was the author of numerous works, including *La photographie instantanée* (1883), *La photographie moderne*

(1888), *La photographie médicale* (1893), *La radiographie et ses diverses applications* (1899) and *La photographie à la lumière artificielle* (1914).

Long, Chin-san (1892–1995) Taiwanese photographer. Born in Zhejlang Province, mainland China, Long was a pioneer of Chinese → photojournalism and of modern photographic education in China. During his lifetime, he founded the Asia Association of Photography and the Photography Society of China. He is best known for his → photomontages, which integrate the aesthetics of traditional Chinese painting with modern photographic techniques. Long has been included in hundreds of photographic exhibitions and has won a number of internationally recognized photographic prizes.

Long, Richard (b. 1945) British artist. Long studied at the West of England College of Art in Bristol and at Saint Martin's School of Art, London (1966–68). He belongs to the generation that redefined the limits of art in the 1960s. He takes control of the landscape by virtue of his long walks, which he documents by means of photographs. Long's work is a combination of → conceptual art and → land art. He lives and works in the United Kingdom, and has exhibited all over the world since 1968.

López, Nacho [Ignacio López Bocanegra] (1923–1986) Mexican photographer. Unlike many photographers of his time, López refused to portray Mexico as an exotic country. His preferred subjects were ordinary people as well as the social and political elite. He studied photography at the Institute of Cinematic Arts and Sciences in Mexico City from 1945 to 1947. Apart from portraits, he was interested in architecture, ethnography, jazz and contemporary dance. Most of his work was produced between 1949 and 1955. He was employed as a photojournalist by magazines including *Pulso*, *Mañana*, *Hoy*, *Rotofoto*, *Presente* and *Siempre!*, and paid particular attention to the negative effects of economic growth. His natural scepticism as a reporter drove him to reject mainstream revolutionary propaganda, in which sense he shared similarities with → Manuel Álvarez Bravo.

Ken Lum, *Hum, hum, hummmm*, 1994

• L —

Lorant, Stefan [István Reich] (1901–1997). American editor-in-chief, author and film director, born in Hungary. Lorant left Hungary for Germany in 1919, where he made several films and worked for publications including the *Münchener Illustrierte Presse* (1928–33). He fled from the Nazi regime to Great Britain, where he edited the *Weekly Illustrated* (1934) and founded *Lilliput* magazine (1937–40). In 1938 he and Sir Edward G. Hulton co-founded the famous illustrated *Picture Post*. Lorant emigrated to the United States in 1940, where he concentrated on producing illustrated books.

Lorca, German (b. 1922) Brazilian photographer. In 1949 Lorca joined the Foto Cine Clube Bandeirante in São Paulo, together with Thomaz Farkas and → Geraldo de Barros. He photographed diverse aspects of the city, focusing especially on its centre. He opened

his own studio in 1952 and was appointed official photographer for the commemoration of São Paulo's 400th anniversary. He still works in advertising photography.

Lotar, Eli [Eliazar Lotar Teodorescu] (1905–1969) French photographer. Born in Paris to Romanian parents, he spent his childhood in Romania but returned to Paris in 1924 to work in the cinema and to join the → New Vision movement. In 1926 he was apprenticed to the photographer → Germaine Krull, and they became lovers for a brief time. Aside from his film photography and photographic → reportage, Lotar is known mainly for the work he produced for various magazines, the most notable being → *Vu*.

Lum, Ken (b. 1956) Canadian → conceptual artist, teacher and curator associated with the → Vancouver School. Lum received a master's

Urs Lüthi,
Lüthi Also Cries for You, 1970

— **L** •

degree from the University of British Columbia, Vancouver, in 1985. His diverse work focuses on the notion of public and private identity in relation to globalization and politics, often juxtaposing portraiture and text. He is also known for his performances, sculptures and international public art commissions.

Lumière, Auguste (1862–1954) **and Louis** (1864–1948) French inventors. In 1883 Antoine Lumière and his two sons, Auguste and Louis, opened a factory for the manufacture of photographic products. Antoine was a painter and photographer, Auguste a chemist, physicist and botanist, and Louis, after studying at the École Technique de la Martinière, carried out research on the manufacture of gelatin bromide plates in 1880. In 1882 Louis began to sell dry plates, which he called 'blue label' plates, which were fast and more convenient to use. Thanks to their factory's

success, the two brothers were able to finance further research. After travelling to Paris, where he learned of Thomas Edison's kinetoscope, Antoine convinced his sons that they could improve on this process. Images no longer had to be produced within a box, he reasoned, but could be projected. In February 1895 the brothers unveiled their new invention, the cinematograph, which projected pictures onto a screen, unlike the kinetoscope, which obliged the viewer to peer inside a box. The Lumière brothers also made their mark on the history of photography by creating a new colour process, demonstrating their → autochrome to the Académie des Sciences in 1904. Commercialized in 1907, the process – which used grains of potato starch – enjoyed great success thanks to its natural colour and simplicity compared to the Lippmann process. In 1913 the factory was producing 6,000 plates a day. Amateur photographers chose autochrome to record their family life and leisure activities. The process was used to record the expansion of the automobile and aviation industries, while the → Pictorialists chose it for its aesthetic qualities.

Lumière, La The first weekly journal in Europe devoted to photography, published by the → Société Héliographique. The first issue appeared on 9 February 1851, with subsequent issues appearing weekly until November 1851, and then fortnightly until 1867. The journal featured articles about art as well as science, creating a bridge between the two spheres. Initially it was under the direction of Marc Antoine Gaudin, who was succeeded by his brother Alexis. Among the contributors were → Ernest Lacan, Paul Nibelle and → Francis Wey.

Luminosity A measurement of brightness. In photography, the term generally refers to the brightness of various tonal values within an image. In → Photoshop software, the use of different luminosity masks can allow users to adjust precisely the luminosity of different tones to their exact requirements.

Lüthi, Urs (b. 1947) Swiss artist and photographer. Lüthi studied at the School of Applied Arts in Zurich. From 1968 he created photographic

self-portraits in black-and-white that blurred the borders of the genre and concepts of sexual identity: wearing women's clothes or completely nude, he used his body to pose fundamental questions about the representation of a generic self. From 1973 on he created photographic polyptychs in which his portraits faced images of women or interiors, and during the 1980s he expanded his range of expression to include painting, sculpture and installation. In the course of the following decade he returned to photography but abandoned his concept of the body as the vehicle of sexual ambiguity. Instead, the artist, now bald and pot-bellied, poses with an ironic sense of detachment (*Trash and Roses*, 2002).

Lutter, Vera (b. 1960) German artist. She studied sculpture at the Academy of Fine Arts in Munich, and Photography and Related Media at the New York School of Visual Arts. She is famous for her large-scale → camera obscura photographs, which she retains as → negative images. Turning

Loretta Lux,
The Drummer, 2004

shipping containers into huge → pinhole cameras, Lutter captures views of cityscapes, industrial buildings and archaeological sites. Since she uses long exposure times, the fascination of her images lies in their multi-layered recording of time, space and movement. Lutter currently lives and works in New York.

Lux, Loretta (b. 1969) German artist and photographer. Lux takes portraits of children which she retouches digitally, thereby creating images from a mysterious and somewhat disturbing dreamworld. The neutral backgrounds, devoid of any intrusive elements, accentuate the children's artificially enlarged features and translucent skin. Their gaze is fixed to an almost unhealthy extent, an effect that contrasts with the images' gentle pastel shades.

Lynes, George Platt (1907–1955) American photographer. From 1933 until 1953 Lynes was a master of studio photography. His fashion photographs were published in → *Vogue* and → *Harper's Bazaar*, and he was especially famous for his → Surrealist images and his portraits of the greatest dancers of his time, including George Balanchine's American Ballet company. From 1946 he worked in Hollywood, photographing celebrities, but returned to New York in 1948. He is also well known for his private images of male nudes, which he produced from the beginning of his career and which were a major source of inspiration for → Robert Mapplethorpe, → Bruce Weber and → Herb Ritts.

Lyon, Danny (b. 1942) American photographer, film director and writer. After studying history at the University of Chicago, Lyon joined the Student Nonviolent Coordinating Committee in 1963, taking large numbers of photographs on their behalf. Heavily committed to the field of the social documentary, he is a great believer in the active role of the photographer, who should immerse himself in communities frequently left on the margins of society. His work covers the everyday lives of motorcyclists (*Bikeriders*, 1968), prisoners (*Conversations with the Dead*, 1971; *Like a Thief's Dream*, 2007) and his own children (*I Like to Eat Right on the Dirt*,

• **L** —

Danny Lyon, *Sparky and Cowboy (Gary Rogues),
Schererville, Indiana*, 1965

1989) – Lyon presenting a deliberately subjective view of them that borders on the intimate. He usually combines photographs with texts and documents, and he approaches his subjects in a manner that establishes links between the personal vision and documentary realism.

Lyons, Nathan (b. 1930) American photographer, curator, writer and educator. Lyons attended Alfred State Technical Institute, New York (1948–50), then transferred to Alfred University in 1950. He finally graduated with a bachelor's degree in 1957. Lyons was hired at George Eastman House as director of information that year, and also worked as assistant editor of *Image* magazine. In 1962 he organized the first invitational teaching conference, during which the Society for Photographic Education (SPE) was formed. He continued to work at George Eastman

House until 1969, holding additional positions as curator of photography and associate director. After leaving the institution, he founded the Visual Studies Workshop, an artist-run educational and support centre for photography and other media arts. In 1983 he helped organize Oracle, an annual meeting of photographic curators.

M

Maar, Dora [Henriette Theodora Markovitch]
(1907–1997) French photographer. Maar attended
several art schools and trained as a photographer
and painter, most notably under André Lhote,
through whom she met → Henri Cartier-Bresson.
With the encouragement of → Emmanuel Sougez,
she finally opted for photography and opened
a studio with Peter Kéfer in 1931. She accepted
commissions from the worlds of fashion
and advertising, but also created → Surrealist
→ photomontages and → photograms that
included some of the movement's most famous
images. A friend of → Brassaï, she was also close
to André Breton and → Man Ray, whom she met
in 1934. In 1936 she was introduced to Pablo
Picasso, who became her lover for ten years,
and whom she photographed painting *Guernica*
at every stage. She gradually turned away from
photography and went back to painting.

McAlinden, Mikkel (b. 1963) Norwegian
photographer. McAlinden received his master's
degree in photography from Bergen National
Academy of the Arts in 1996. His early work
plays with art historical references. The series

Intimitet (1994), a group of self-portraits, recalls
the *memento mori* tradition of Dutch painting
through its inclusion of symbolic objects from
everyday life. In the late 1990s McAlinden began
to produce digitally composed photographs.
Undertow (2003) is one of his huge landscape
pictures, in which a large number of negatives
produces multiple perspectives and an uncanny
→ depth of field. *The Anticipants* (2010) traces
global political events through a series of large-
scale works, including an image composed of
multiple shots that depicts Democrat supporters
waiting for Obama's platform speech in
2008. McAlinden is represented in numerous
Norwegian collections.

McCartney, Linda (1941–1998) American
photographer. Having studied art history,
McCartney taught herself photography. Her
portraits of rock stars and members of her family
display a deep understanding of her models. Her
images record her passionate engagement with
the musical scene of the 1960s in which she was
an active participant, mixing with all the leading
stars, including her husband, Paul McCartney.

McCausland, Elizabeth (1899–1965) American historian of photography and art critic. After graduating from Smith College, Northampton, McCausland worked as a journalist for the *Springfield Republican* from 1923 until 1946. Initially she supported modernism and looked to → Alfred Stieglitz as an example, but from 1935 onwards she advocated the use of photography as an implement of social change. She wrote the texts for *Changing New York* by → Berenice Abbott (1939) and contributed regularly to the journal *Photo Notes*.

McCullin, Don (b. 1935) British photojournalist. McCullin made a mark on the history of → war photography with his numerous → reportage series on the subject. Among the conflicts he witnessed were those in Vietnam, Congo, Cuba, Biafra, Cambodia, Bangladesh, Iran, El Salvador and Afghanistan. In 1959, after he had completed his military service in the Royal Air Force as an aerial reconnaissance photographer, the *Observer* published his first photographs, a series portraying 'The Guv'nors', a London gang. Following this success, newspapers and magazines including → *Life*, the *News Chronicle*, the *Sunday Graphic* and the *Sunday Times* were quick to offer him work. But it was his reportage on the construction of the Berlin Wall in 1961 that won him his first prize: the British Press Award. His first war photograph was taken in Cyprus in 1964 for the *Observer*, a subject that also brought him the World Press Photographers' Award and the Warsaw Gold Medal for photography. In 1969 and 1977 he was once again the recipient of a World Press Photographers' Award for the pictures he took in Biafra and Beirut. Alongside the war photography for which he is famous, there are plenty of other subjects that interest McCullin: people at work, artists, religious ceremonies and pilgrims on the shores of the Ganges in India, Ethiopian tribes and AIDS sufferers. In the course of his career he has produced a number of important books, the first of which, *The Destruction Business*, was published in 1971.

McDean, Craig (b. 1964) British photographer. With a passion for motorcars, McDean began work as a mechanic before enrolling at Mid Cheshire College, where he took courses in photography. After working as an assistant to → Nick Knight, he went freelance in the early 1990s, and his first fashion photographs were published by *i-D* and *The Face*. As a sideline to his commercial work, McDean published *I Love Fast Cars* in 1999 and *Lifescapes* in 2004.

Macdonald, Ian (b. 1946) British photographer. Macdonald studied visual communications at the Cleveland College of Art and painting at the University of Sheffield. He then went into teaching and produced black-and-white images of his students. During the 1970s and 1980s, his main subject was the north-east of England around the River Tees, his home region. He documented the landscapes, fishing and heavy industry that was often under threat.

Macijauskas, Aleksandras (b. 1938) Lithuanian photographer. Self-taught, Macijauskas still lives in his home town of Kaunas in Lithuania, where during the 1960s he belonged to a clandestine photographic club before joining the daily newspaper *Vakariniunaujienu* (*Evening News*). This gave him the wherewithal to explore the hinterland for his own private work: equipped with → lenses that allowed for distortion and adopting avant-garde approaches to his subjects, Macijauskas photographed rural life, inventing a dialogue between humans and animals with a humour bordering on derision. His first exhibition outside the USSR was at the Bibliothèque Nationale, Paris, in 1974.

Macrophotography A technique that produces an image at the same scale as the subject itself. The term is also often used to refer to images of a subject that are shown far larger than life-size. Frequently employed for scientific and didactic purposes, macrophotographs have also been used to great effect by artists such as → Frederick H. Evans and → Laure Albin-Guillot.

Madoz, Chema (b. 1958) Spanish photographer. Madoz distorts objects for his photographs, giving them a humorous slant or making them into visual *haikus*. The symmetry, repetition,

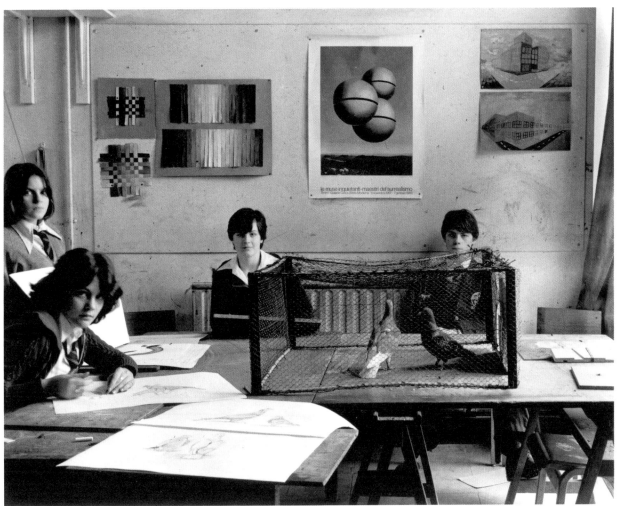

Ian Macdonald,
Teaching Practice, Preston, 1977

• M —

reflections, variations of scale and playful juxtapositions in his work create an atmosphere of absurdity, accentuated by Madoz's distinctive use of black and white. In the tradition of the → Surrealists, Madoz questions the border between reality and fiction – an approach exemplified by one of his photographs that shows a ladder leaning against a mirror.

Magnum (Magnum Photos, Inc.) Photographic → agency founded in May 1947 by the press photographers → Robert Capa, → Henri Cartier-Bresson, → George Rodger and → David 'Chim' Seymour. Originally based out of New York and Paris, Magnum now has editorial offices also in Tokyo and London. A cooperative owned by

its members, Magnum was established on the principle that its photographers would be encouraged to follow their individual photojournalistic pursuits and would always retain copyright of their images. Its roster of photographers has included → Eve Arnold, → Werner Bischof, → René Burri, → Cornell Capa, → Elliott Erwitt, → Jim Goldberg, → Ernst Haas, → Philippe Halsman, → Susan Meiselas, → Martin Parr, → Marc Riboud and → W. Eugene Smith, among others.

Mahr, Mari (b. 1941) Chilean-born British photographer. Mahr worked as a press photographer in Hungary before moving to England in the 1970s. Her poetic, dreamlike work

– consisting of cut-out, layered images in black and white – reflects the European and South American currents in her life. She has produced numerous books, including *A Few Days in Geneva* (1985) and *Between Ourselves* (1998).

Malík, Viliam (1912–2012) Slovak photographer. Malík was one of the most important representatives of modern photography in Slovakia in the 1930s and 1940s. Like most amateur photographers he shot a wide range of subjects, but from the very beginning he was attracted to live → documentary photography. He became a member of the Association of Amateur Photographers YMCA – at the time the most important photography group in Slovakia – in 1932. For most of the 1940s he also led a large association of non-professional photographers known as the Fotozbor KSTL ('Club of Slovak Tourists and Skiers'). From 1936 he collaborated with the Prague-based Czechoslovak News Agency as a filmmaker and photojournalist, reporting on events in Bratislava and the surrounding area. After the establishment of the Slovak Republic in 1939, he photographed for the Slovak press department for two years but later ended the cooperation. He was not the only representative of modern → photojournalism in Slovakia but stands out in comparison with his colleagues for his comprehensiveness of subject matter.

Mama Casset (1908–1992) Senegalese photographer. Born in Saint-Louis, Mama Casset went to Dakar in 1920, where he was apprenticed to the French photographer Oscar Lataque. From

— M •

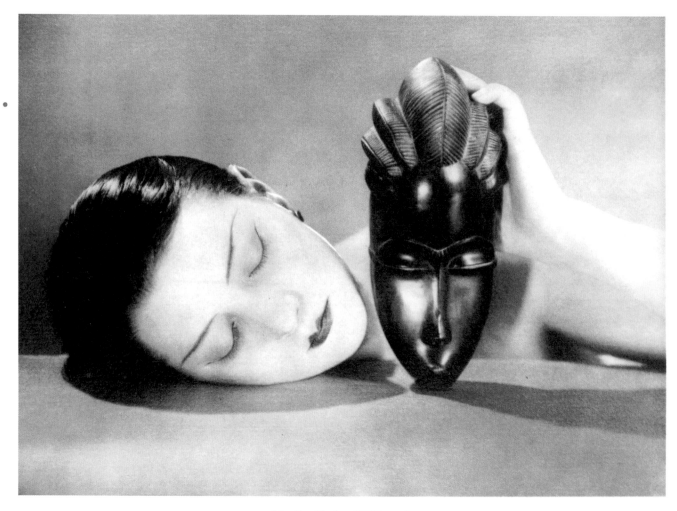

Man Ray, *Black and White*, 1926

1925 he worked for the Comptoir Photographique de l'Afrique Occidentale Française. It was not until after World War II that he opened his own portrait studio. His distinctive viewpoints and use of perspective exploit the dynamics of composition while enhancing the expressiveness of the sitters, who stemmed mainly from the Senegalese middle classes.

Man, Felix H. [Hans Felix Sigismund Baumann] (1893–1985) German-born British photographer. One of the pioneers of → photojournalism, Man studied history of art and painting in Berlin and Munich, but the outbreak of World War I interrupted his studies. He produced his first → photographic essays on the Western Front and also worked as a press illustrator. In 1928 he worked as a freelance photojournalist for the Berlin press and the Dephot agency, an association founded by Simon Guttman to bring journalists and photographers together. Between 1929 and 1931 Man produced over eighty photo essays for the *Münchner Illustrierte Presse* and over forty for the *Berliner Illustrirte Zeitung*, the world's largest illustrated weekly. He is known for the series *Ein Tag im Leben von Mussolini* ('A Day in the Life of Mussolini', 1931), published in Germany and elsewhere. Recognized as the founder of German photojournalism, he emigrated to London in 1934 and established the *Weekly Illustrated* with → Stefan Lorant, with whom he had worked in Germany. Man was chief reporter for the *Picture Post* from 1938 to 1945 and was still very active after the end of the war, producing images for → *Life* and the *Sunday Times*, among other publications.

Man Ray [Emmanuel Radnitsky] (1890–1976) American painter, photographer, film director, designer and interior decorator. Man Ray was one of the most influential artists of the inter-war period. He was raised in New York, took courses in drawing and worked for an engraver before entering the world of advertising. Influenced by the Cubists and the works exhibited at → Gallery 291, he became a painter and learnt photography only in order to make reproductions of his paintings. In 1915 he met Marcel Duchamp and developed an enthusiastic interest in Dadaism. His paintings did not sell well, so in 1917 he turned to photography using glass negatives. In 1921 the publication of the first issue of *New York Dada* was singularly unsuccessful, and Man Ray moved to Paris along with Duchamp and Francis Picabia. He began to photograph his friends' paintings and in due course turned professional, specializing in portraits and fashion. By chance, he discovered the technique of the → photogram (which he called 'rayography'). Man Ray believed that photography represented a means of revitalizing visual art. He became the favourite photographer of the → Surrealists, worked for → *Vogue*, made films and photographed the transient artistic world of Montparnasse. → Berenice Abbott and → Bill Brandt learnt photography in his studio, and with → Lee Miller, his assistant and model, he perfected the technique of → solarization. During the 1930s he made all kinds of photographic experiments (including superimposition, distortion and → blurring), exhibiting his photographs all over Europe. In 1940 he fled from Paris to Los Angeles, where he taught photography and once more turned his hand to painting. Eleven years later he returned to Paris. The Venice Biennale awarded him the gold medal for photography in 1961, following which he was given several retrospective exhibitions.

Manen, Bertien van (b. 1942) Dutch documentary photographer. Van Manen uses an ordinary pocket camera to produce highly personal travel pictures that deliberately ignore professional standards of technical precision. Brought together in carefully composed books and exhibitions, her hundreds of casual colour snaps produce an associative and poetic visual narrative that reveals the photographer's intense emotional relationship with her subjects. Van Manen's principal photo books are *A Hundred Summers, A Hundred Winters* (1994), about daily life in Russia post-1989, and *East Wind, West Wind* (2001), based on her many trips to different parts of China.

Mann, Sally (b. 1951) American photographer. Mann studied photography at the Putney School, Vermont (1966–69), and took various courses

• M —

— M •

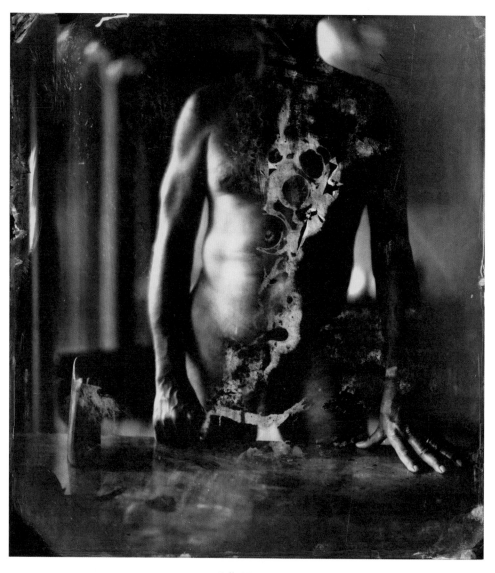

Sally Mann,
Hephaestus, 2008

in photography (1971–73), most notably at the Ansel Adams Yosemite Workshop in California. In 1975 she completed a master's degree in creative writing at Hollins College, Virginia. She is best known for her series *Immediate Family* (1984–94) – black-and-white photographs of her three children – and for *Mother Land* (1996) and *Deep South* (1998), which comprises landscapes made in the American South. She uses a large-format camera and has recently worked with 19th-century materials and processes.

Männikkö, Esko (b. 1959) Finnish photographer. His breakthrough came in 1995 with the *Female*

Pike documentary series, which portrays people in and around their homes in the north of Finland. Männikkö believes in the power of the documentary photograph. He spends a lot of time getting to know his subjects, often joining them on hunting or fishing trips or drinking with them before he makes his melancholy and dignified portraits. Männikkö's relationship with art history is evident in the composition of his images and the frames in which he exhibits them. The latter, which he finds in flea markets, form part of the works and create a sense of crossing a threshold into a different world. Männikkö received the Ordóñez-Falcón

International Photography Award in Spain in 2006 and the Deutsche Börse Prize in 2008.

Mapplethorpe, Robert (1946–1989) American photographer, famous for his portraits and male nudes in black and white. Mapplethorpe attended the Pratt Institute in Brooklyn but abandoned his study of graphic art in 1969. His first photographs, taken with a → Polaroid, were displayed at the Light Gallery in New York in 1973, his first solo exhibition. Two years later he acquired a wide-angle → Hasselblad, with which he photographed mostly friends and acquaintances (artists, composers, pornographic film stars and customers of underground sex clubs). He also worked on various commercial projects, such as record sleeves for his friend Patti Smith, and portraits commissioned by the magazine *Interview*. He took part in the Documenta 6 exhibition in Kassel in 1977, and the following year his work was exhibited by the Robert Miller Gallery in New York. Mapplethorpe's favourite subjects were male and female nudes, floral still-lifes and studio portraits. He liked using different formats and techniques, including shooting with large-format Polaroid cameras, photo-engraving and → Cibachrome. In 1988 he held his first retrospective at the Whitney Museum of American Art, New York, and created the Robert Mapplethorpe Foundation to promote the art of photography and to support medical research in the battle against AIDS, of which he was a victim. He died the following year at the age of 42. Since his photographs offer an aesthetics of sexuality, they have always been associated with controversy and scandal.

Marey, Étienne-Jules (1830–1904) French physiologist. After meeting the American photographer → Eadweard Muybridge, Marey decided to apply photography to the study of different forms of animal locomotion and invented a series of devices for this specific purpose. In 1882 he invented a photographic gun, which captured twelve images a second, and in 1887 the → chronophotograph. This apparatus, with its mobile → shutter, enabled him to inscribe onto a single plate a whole sequence of images taken within fractions of a second. A visual record of the successive stages of movement could thus be fixed onto the same support. He also perfected the geometric chronophotograph, placing his subjects against a dark background, dressed in black and wearing white bands on their limbs. In 1888 Marey adapted → Kodak's transparent celluloid film, using it to take chronophotographs. Men walking, running and jumping, horses racing, birds in flight, balls bouncing – whatever remained imperceptible to ordinary vision became observable in the photograph. Marey regarded photography as a scientific record that needed to be published and distributed. Nevertheless, his work had an effect on art, since it inspired many photographers associated with the Futurist movement. Director of the Station Physiologique du Parc des Princes, president of the → Société Française de Photographie (1894–96) and professor at the Collège de France, Marey had a profound influence on the development of cinematography.

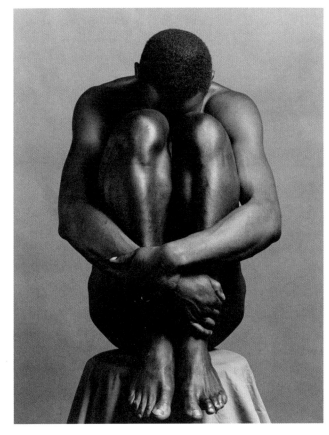

Robert Mapplethorpe,
Ajitto, 1981

• M —

In 1890 he published *Le Vol des oiseaux*, which had a direct bearing on aviation, and in 1894 *Le Mouvement*, a book that summed up the fruits of his research.

Marissiaux, Gustave (1872–1929) French-born Belgian photographer. He settled in Liège in 1899 and opened a photography studio there. He began his career producing portraits and photographs taken in the coalmines. He soon acquired a name for himself among his colleagues at the Association Belge de Photographie, especially for his mist-covered landscapes and his nudes in colour. From 1902 onwards, he and → Léonard Misonne belonged to an international movement of photographers who sought to impose → Pictorialist aesthetics on the medium and to have it recognized as one of the fine arts. In 1905 he undertook a long journey across Italy, returning with many images, and in 1908 he published *Visions d'artistes*.

Mark, Mary Ellen (1940–2015) American photographer. After studying → photojournalism at the Annenberg School for Communications, University of Pennsylvania, Mark became a freelance photographer in 1966. She travelled the world, photographing circuses in India, film sets (such as that of Fellini's *Satyricon*, 1969)

and Mother Teresa's charity missions. In the tradition of American social and → documentary photography, she recorded – mostly in black and white – the everyday lives of people living on the margins of society: a psychiatric hospital for women; prostitutes in Bombay; teenagers trying to survive on the streets of Seattle; shelters for homeless families and children. The humanism underlying her portraits bears witness to the photographer's personal engagement and her desire to arouse emotion and empathy.

Marker, Chris [Christian-François Bouche-Villeneuve] (1921–2012) French novelist, essayist, film director and photographer. During the 1950s, Marker made his name as a writer, most notably for the magazine *Esprit*, and as editor of the Petite Planète series of travel guides. In 1962 he achieved international recognition with *La Jetée*, a short science fiction film consisting only of still photographs. His varied oeuvre, which includes documentaries, feature films, digital multimedia and books, is threaded with themes of memory, travel, time and personal commitment.

Market In photography, the arena in which art photographs are sold commercially. As in the wider art market, prices within the photography market fluctuate according to

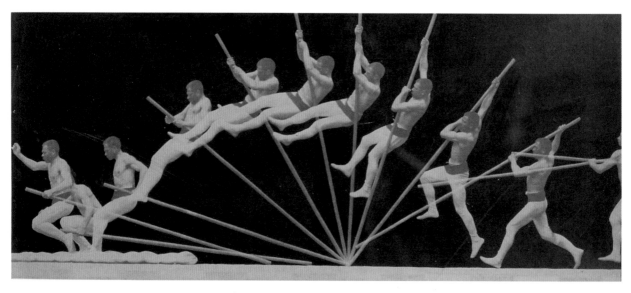

Étienne-Jules Marey, *Chronophotographic Study of Man Pole-Vaulting*, 1890–91

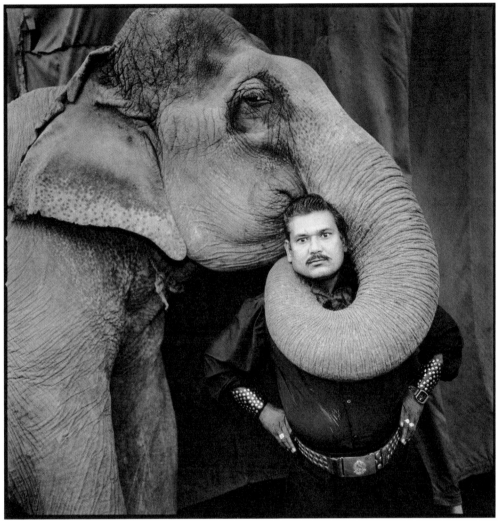

Mary Ellen Mark, *Indian Circus, Fall '89*, 1989

• M —

supply and demand. As a reproducible art form, photography in principle lacks the qualities of rarity and uniqueness that confer economic value on other forms of art. The market has therefore developed conventions to create rarity where none previously existed: as a rule, only signed, limited-edition → prints can claim the status of art. Among the many types of print that are available, buyers prefer → vintage prints – that is to say, those made by or under the supervision of the photographer. Economic value is also linked to artistic value. However, no work of art has an intrinsic artistic value: it is the evaluation of those around it that causes an artistic value to be attributed to a work. Many factors may play

a role in an artist's reputation: the exhibition of their works by institutions, festivals and biennials; the acquisition of these works by reputable collectors; and the opinions of art historians and critics who evaluate the work by situating it within a contemporary or historical context. A network of galleries and auction houses also play a key role as intermediaries. The market for photographic works grew in the 1970s, along with a rise in the number of galleries that specialized in photography. Photography auctions also continued to rise in number throughout the 1980s. This market reached maturity in the 1990s when the major art fairs opened photography sections. The subsequent

267

surge in prices benefited both contemporary photographers and the market for vintage photographs.

Markov-Grinberg, Mark (1907–2006) Russian photographer. In 1925 Markov-Grinberg was given his first job as a photographer by the newspaper *Sovetski Yug*, contributing photographs to the illustrated journal *Ogonyok* at the same time. In 1926 he moved to Moscow, where he was employed by several syndicated newspapers and the magazine *Smena*. In 1930 he was commissioned to report on a day in the life of the miner Nikita Izotov, an embodiment of the ideal Socialist hero. Markov-Grinberg was called up to join the army in 1941, and in 1943 became a correspondent for the military newspaper *Slovo Boitsa*.

Martin, Paul (1864–1942) British photographer. Trained as an engraver, Martin documented official events, such as parades, but also photographed London street scenes and Victorian beaches with the aid of his 'Facile Hand Detective Camera', made by Jonathan Fallowfield. Portable and discreet, resembling a simple wooden box held under the arm, this camera enabled him to take photographs that seemed totally natural and spontaneous. In 1895–96 he created a series of London by night, lit by the gas lamps in the streets, and was awarded a medal by the → Royal Photographic Society. Some of his photographs are held in the Victoria and Albert Museum's collection in London.

Martinček, Martin (1913 – 2004) Slovak photographer. Martinček was a significant

— M •

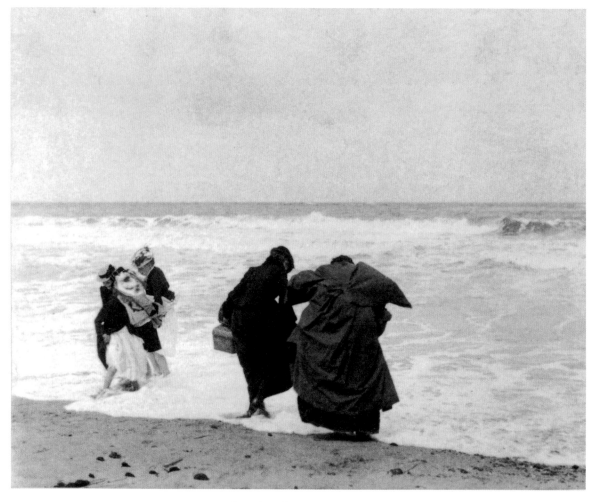

Paul Martin, *Trippers at Cromer*, 1892

figure in 20th-century Slovak photography. In periods of personal difficulty he found refuge and inspiration in the country's forests and mountains. He produced numerous series of black-and-white landscapes, as well as colour studies of natural phenomena such as water, flowers and sunlight taken on his everyday outings. His work appeared in many books, including works by writers, poets and academics. Portraits of his father's and grandfather's contemporaries were reproduced in *Respect Belongs to You* (1966). He also collaborated with his friend Milan Rúfus on the poetry volumes *People in the Mountains* (1969) and *Cradle* (1972). Martinček sometimes worked closely with his wife, Ester Šimerová, with whom he exhibited once in Prague.

Marucha [María Eugenia Haya Jiménez] (1944–1991) Cuban photographer. After studying at the Cuban Institute of Cinematography and the University of Havana, Marucha took up photography full time. She recorded the social and political upheavals in Cuba during the 1960s, thus preserving images of a major historical event for posterity. A great portrait and documentary photographer, she was also a fine lecturer and historian, and director of the national photographic archive, the Fototeca de Cuba.

Marville, Charles [Charles François Bossu] (1813–1879) French painter, engraver, photographer and illustrator. Marville was one of the first French photographers to make paper → prints. Around 1851 he was already working as an official photographer for the Louvre, where he recorded French and Italian sculptures and drawings. When → Louis-Désiré Blanquart-Evrard recruited a number of photographers for his photographic press in Lille, Marville appears to have been his most prolific collaborator. Marville's first photographs appeared in collections from 1851 onwards. He compiled a complete album entitled *Bords du Rhin*, and contributed more than one hundred views of Paris to a book entitled *Mélanges photographiques*. Blanquart-Evrard's press closed its doors in 1855. Marville adopted the → collodion process, which resulted in perfectly clear glass-plate negatives. In 1865

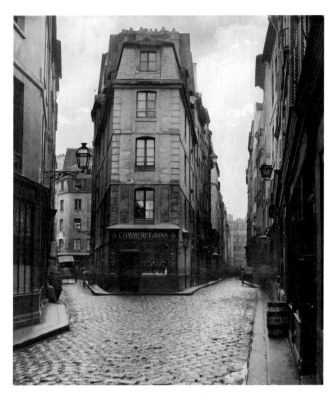

Charles Marville, *Rue de la Petite-Truanderie et de la Grande-Truanderie, 1st Arrondissement, Paris*, 1865–68

• **M** —

he set up his own business and became the first official photographer for the city of Paris. He was commissioned by the Service des Travaux Historiques to document the original layout of the capital before it made way for the great avenues constructed by Baron Georges Eugène Haussmann. By photographing a city on the verge of transformation, he enabled the state to preserve the image of its past. Marville continued to record these large-scale demolitions and reconstructions right up until his death.

Masats, Ramón (b. 1931) Spanish photographer. Following his first photo → reportage in the 1950s, on the subject of Las Ramblas in Barcelona, Masats became a member of several photographic groups, including the Catalan AFC and La Palangana in Madrid. He documented Spanish festivals and processions, and was particularly interested in producing sequences of images showing his subjects in action – a focus that led him to make documentaries and films such as *Topical Spanish* (1970).

Masclet, Daniel (1892–1969) French photographer, critic and theorist. Having been introduced by → Robert Demachy to → Baron de Meyer, Masclet became the latter's assistant on → *Harper's Bazaar*. With his portraits, views of Paris and still-lifes, Masclet favoured a subjective style of photography during the 1950s. He curated the exhibition *Nus: la beauté de la femme* in Paris (1933) and retrospectives for → Berenice Abbott and → Edward Weston.

Matiz, Leo (1917–1998) Colombian photographer. After studying at the School of Fine Arts in Bogotá, Matiz began his career as a photojournalist by travelling to Mexico, where he met many prominent cultural figures, including Frida Kahlo and Pablo Neruda. He was specially chosen by → *Life* to cover the

L. PIERSON, PHOT.

Déposé Garanti d'après nature.

Mayer & Pierson,
Richard Wagner, mid-1860s

liberation of Paris in 1944 and the Bogotá riots of 1948. He developed a way of photographing landscapes and architecture that emphasized abstraction and geometric forms.

Matter, Herbert (1907–1984) Swiss photographer. Matter studied painting at the École des Beaux-Arts in Geneva (1925–27) and took courses given by Fernand Léger and Amédée Ozenfant at the Académie Moderne de Paris (1927–29). He became a self-taught photographer and freelance graphic artist. In 1932 he went to Zurich, where he designed posters for the Swiss National Tourist Office, but in 1936 he emigrated to the United States. There he designed exhibitions, including the Swiss Pavilion at the New York International Exhibition of 1939. His work showed a great deal of experimentation in the fields of both art and commerce. His first solo exhibition was held at the Pierre Matisse Gallery, New York, in 1943. He worked with Charles and Ray Eames (1943–46), Condé Nast (1946–57) and Knoll International (1946–66). Yale University – where he taught photography from 1952 until 1976 – organized a retrospective in 1978, which was repeated at the Kunsthaus in Zurich.

Mayall, John Jabez Edwin (1813–1901) British photographer. Mayall began his career in the United States at the beginning of the 1840s. From 1843 onwards he championed the cause of photography as an art form, illustrating prayer books, poetry and other forms of writing. On his return to England in 1846 he was briefly assistant to the French-born photographer → Antoine Claudet, but then opened his own studio, specializing in visiting cards. In 1860 he was commissioned to take portraits of the royal family.

Mayer & Pierson A firm founded by the French photographers Louis Frédéric Mayer (1822–1913), Léopold Ernest Mayer (1817–1865) and Pierre-Louis Pierson (1822–1913). The Mayer brothers joined Pierson in 1855. Specializing in portraits retouched in watercolours or oils, they served the emperor's family, the aristocracy and cultural figures between 1855 and 1862. The Countess of Castiglione commissioned

— M •

Ralph Eugene Meatyard,
Untitled, c. 1955

more than 500 portraits from Pierson between 1856 and 1899, in which different people were posed in *tableaux vivants* according to her predilections at the time. He exhibited a portrait of the countess dressed as the Queen of Hearts at the Paris Exposition Universelle of 1867. The three photographers all used portable decor, lights and accessories in their work, and their clientele expanded with the arrival of the photographic visiting card. Pierson joined Maison Braun in 1874 and photographed 7,000 works for the Louvre.

Mayito [Mario Garcia Yoja] (b. 1939) Cuban photographer. Mayito studied at the Academy of Fine Arts in San Alejandro, and at the department of Hispanic language and culture at the University of Havana in 1978. Since 1966 he has worked as director of photography on more than ninety short and full-length films. He was also one of the co-founders of the Cuban national photography archive.

Mayne, Roger (1929–2014) British photographer. While still studying chemistry at Oxford, Mayne published his first photographs in *Picture Post* (1951). In 1954 he went to London and set himself up as a freelance photographer. In 1956 he had his first solo exhibition at the Institute of Contemporary Arts, London, and began his celebrated series on Southam Street, which took him fifteen years to complete. Apart from his work for the British press and his photographs of street scenes and children, Mayne was interested in leisure activities, portraits, landscapes and family life in Great Britain. Following in the footsteps of → Bill Brandt, Mayne is recognized as providing a vivid record of British society during the 1950s and 1960s. He was given a retrospective at the Victoria and Albert Museum, London, in 1986.

Meatyard, Ralph Eugene (1925–1972) American photographer. An optician by profession, Meatyard acquired his first camera in 1950 in order to photograph his elder son. Attracted by the medium, he joined the Photographic Society of America and the Lexington Camera Club in 1954, where he met Frank Van Deren Coke. The two of them enrolled at the University of Indiana in Bloomington to attend courses given by Henry Holmes Smith, → Aaron Siskind and → Minor White. Meatyard's work reflects the various sources of his inspiration, which include painting, literature, theatre, philosophy and jazz. He staged scenes using people in his immediate circle, often masking them and surrounding them with different objects. He also experimented with techniques such as → blurring and superimposition, though they remained secondary to the content. Meatyard's work became widely known through exhibitions including *Creative Photography* at the University of Kentucky (1956), which also presented photographs by → Ansel Adams and → Edward Weston, and *Sense of Abstraction* at the → Museum of Modern Art in New York (1959). After Meatyard's death Jonathan Williams published *The Family Album of Lucybelle Crater*, which had been the photographer's last project.

 • M —

Medicine and photography Photography played an important role in capturing and disseminating medical information from as early as the 1840s. Despite the bulkiness of the equipment and the need for long exposure times, → Albert Southworth and Josiah Hawes documented a demonstration of the use of ether to anaesthetize a patient in Boston, Massachusetts, in 1846. An unknown daguerreotypist photographed an amputation during the Mexican–American War one year later. In France, the haematologist Alfred Donné was one of the first doctors to employ photomicrographs in medicine (1844–45), rapidly followed by the eminent neurologist → Guillaume-Benjamin Duchenne de Boulogne, who used photography to record and study facial expressions in the early 1860s. Photography augmented rather than replaced existing forms of medical illustration. In medical publications, photographic images often required hand-colouring or other types of adaptation to make the illness or disorder legible to the viewer. However, the medium's ability to transcribe visual information quickly and accurately, and changes in technology that made it easier, faster and less expensive to use, led to its widespread adoption. By the 1860s and the arrival of the American Civil War, medical photographs were a staple in the medical profession.

Meene, Hellen van (b. 1972) Dutch portrait photographer. Van Meene came to international attention in the late 1990s with her meticulously staged colour portraits of adolescent girls. Her formal approach, with its close attention to framing, texture and lighting, forms an interesting contrast with the uncertainty and vulnerability apparent in the body language of

— M •

Susan Meiselas, *Car of a Somoza Informer Burning in Managua, Nicaragua*, 1978–79

her juvenile models. The portraits of dogs that she published in 2012 (*Dogs and Girls*) make it touchingly clear that feelings of awkwardness when faced with the portraitist's camera are not confined to otherworldly young girls.

Méhédin, Léon-Eugène (1828–1905) French photographer, archaeologist and architect. During the Crimean War, he photographed the aftermath of the Siege of Sebastopol in the company of the battlefield painter Jean-Charles Langlois. He also captured the Italian Campaign of 1859 and took views of Magenta, Milan, Melegnano, Desenzano, Valeggio and Villafranca. Méhédin was the first to produce images using artificial light at the Temple of Abu Simbel, Egypt. On an archaeological dig commissioned by the Scientific Commission of Mexico in 1865 he used photography to document the ruins of Xochicalco and Teotihuacán, and took casts of bas reliefs.

Meisel, Steven (b. 1954) American fashion photographer. Having studied at the Parsons School of Design in New York, Meisel worked as an illustrator for the stylist Roy Halston Frowick. At the end of the 1970s he turned to fashion photography and received his first commissions from *Seventeen*, *Self* and → *Vogue* magazines. *Vogue Italia* engaged him to design all their front covers from 1988 onwards. In 1992 he collaborated with Madonna on her book *Sex*.

Meiselas, Susan (b. 1948) American photographer. Having studied at Harvard University, she began to teach photography in 1972. At the same time she took pictures and made audio recordings of carnival strippers in the north-east United States. In 1978–79 her images of the Nicaraguan Revolution appeared in magazines worldwide. She then spent a decade working as a photojournalist, co-directing films and curating photography shows throughout Central and Latin America. Between 1991 and 1997 she undertook a colossal project called *Kurdistan: In the Shadow of History*. Having started life as a book recording the visual heritage of the Kurdish people, it evolved into a travelling exhibition and the seminal website www.akaKurdistan.com.

Annette Messager,
My Vows, 1988–91

● **M** —

In 2004 Meiselas returned to Nicaragua with the photographs she had taken during the revolution, placing them in the landscape where they had been shot and examining the role of the photograph as historical document.

Messager, Annette (b. 1943) French artist. Messager studied at the École des Arts Décoratifs in Paris. She was inspired by feminism and types of popular culture, especially advertising and illustrated magazines. In 1970 she started her *Collections*: → collages of photographs and press cuttings that she stores in files. In addition to these detailed inventories, she creates installations by combining photography, texts, drawing, knitting, fragments of cloth, toys and other found objects to create a discourse on individuality by means of collective references. Since 1976 photography has played an increasingly important role in her work. Messager carries out experiments on a monumental scale (such as *Chimères*, 1980) and has focused her attention on the human body

Ray K. Metzker,
Frankfurt, 1961

(*Trophées*, 1986), as well as on fairy tales (*Untitled*, 1993). She was awarded the Golden Lion at the Venice Biennale in 2007.

Metadata Information that allows a digital file to be identified. This may include the name of the artist or photographer, the title of the image, a description of its contents, the date on which it was taken and the GPS location, the camera that was used or copyright information. Metadata plays a key role in image archiving, picture research, image processing and web development.

Metzker, Ray K. (1931–2014) American photographer. He studied at the Institute of Design in Chicago, where he was profoundly influenced by → Harry Callahan, and graduated from the department of photography in 1959 with a master's degree. Metzker immediately had his work exhibited in some of the most prestigious museums in the United States. He left to travel throughout Europe and began to teach photography on his return, a career that lasted for more than twenty years. He received constant recognition for his work, winning prizes, artists' residences and grants, including two from the Guggenheim Foundation, and was exhibited at major institutions such as the → Museum of Modern Art and the International Center of Photography in New York. Metzker worked on experimental series since the mid-1960s, notably

with *Double Frame*, *Composites* and *Couplets*, using bold combinations of → negatives (as in *Sand Creatures* and *City Whispers*) that provided unexpected views of beach attendants and city dwellers respectively. A master of black and white, and of landscapes both rural and urban, Metzker produced highly sophisticated compositions that exploited the technical, aesthetic, poetic and humorous potential of the medium.

Meyer, Baron Adolph de (1868–1946) French photographer. Regarded as the first fashion photographer, he was born in Paris, raised in Dresden and moved to London in 1895, where he adopted a → Pictorialist style. In 1899 he married Olga Caracciola, goddaughter of the future Edward VII, who opened doors to an aristocratic clientele as well as nourishing his taste for art. Meyer's friend → Alfred Stieglitz published his photographs in → *Camera Work* (1903–07). He was recruited by Condé Nast to be the official photographer for → *Vogue US* and *Vanity Fair* (1913–21), and made a big impact by using many of his aristocratic acquaintances as his models, photographing them in luxurious surroundings against ethereal, hazily lit backdrops. The Russian dancer Vaslav Nijinsky was immortalized *con brio* (1921). Meyer's move to → *Harper's Bazaar* in 1922 caused a major stir, but following the rise of photographic modernism in the late 1920s his work was increasingly seen as outdated.

Meyer, Elisabeth (1899–1968) Norwegian photographer and journalist. Meyer travelled as one of the first Western women to Iran in 1929. Her photographs and her account of her journey were published as *En kvinnes ferd til Persia* ('A Woman's Journey to Persia') the following year. She also travelled to India, Mexico, the United States, Palestine and Tibet. A second volume, *En kvinnes ferd gjennem India* ('A Woman's Journey through India'), came out in 1933 and includes photographs of the Gandhi family. Meyer joined the Oslo Camera Club in 1932. During the late 1930s and 1940s she worked all over Europe: in 1937 she studied at the Reimann School of Art and Design in Berlin under → Walter Peterhans and Otto Croy, and assisted the Hungarian photographer → József Pécsi in Budapest during

the autumn and winter of 1938–39. In 1941 Meyer wrote several articles in Finnmark in the north of Norway and produced unique pictures of the region before it was burned to the ground by retreating German troops. Meyer's work was mostly forgotten until 2000, when 37,000 of her images were donated to the Preus Museum in Horten.

Meyer, Pedro (b. 1935) Mexican photographer. Meyer is the founder and president of the Mexican Council of Photography, and organized the first three conferences on Latin American photography. In 2007 his contribution to the field of photography was recognized in a special edition of the photographic journal *Nueva Luz.*

Meyerowitz, Joel (b. 1938) American photographer. Meyer studied painting and illustration, and worked as an art director in advertising. At the same time, under the influence of Robert Frank, he launched himself into a photographic career, adopting the practice of → street photography then in full swing in the United States. In the mid-1960s he abandoned black and white for colour 24 × 36 mm film, which made him a pioneer in the use of colour for creative photography. In 1976 he switched to a large-format 8 × 10 inch camera. He established his reputation as a master of colour, combining extreme precision, tonal richness, and depth created by long exposure times, with the publication of a series made at Cape Cod during the summers of 1976 and 1977 (*Cape Light*, 1978). The Meyerowitz style became highly influential. In 2001, following the attacks on the World Trade Center in New York, he embarked on a series about Ground Zero and over several months put together an archive of 8,000 images relating to their aftermath. This project was supported by the Museum of the City of New York. He was commissioned by the New York park services

• **M** —

Joel Meyerowitz, *Camel Coats, New York*, 1975

275

Duane Michals,
Magritte with Hat, 1965

— M •

to record the city's green spaces, publishing the results in 2009 under the title *Legacy*. Meyerowitz also works as a freelance commercial photographer. He has twice been awarded a Guggenheim Fellowship.

Michals, Duane (b. 1932) American photographer. Michals first discovered photography during a visit to Russia. Having studied at the Parsons School of Design in New York, he worked as art director of the magazine *Dance* and as a graphic artist for *Time* before becoming a fashion and portrait photographer for a number of different publications, including → *Vogue*, *Esquire* and the *New York Times*. He also taught at various universities and art schools. His work, which led to numerous awards and exhibitions worldwide, combines photography, texts (prose and poetry) and sometimes painting. His subtly poetic images frequently use superimposition and are accompanied by handwritten captions, communicating a powerful spiritual dimension. In the late 1960s Michals began to combine single works in order to augment their narrative power. His sources of inspiration are mythology,

religion, art and literature, as well as his own personal reflections on art and life. His fictions are cleverly staged: they use a realist approach appropriate to photography but also incorporate abstract ideas, appealing to the viewer's imagination through stories rich in emotion, humour, drama and philosophy.

Micrography The practice of using a microscope to create a photograph. Scientists often use the technique to record experiments or to analyse an image, though art photographers such as → Laure Albin-Guillot and → Frederick H. Evans have also taken advantage of micrography's ability to produce abstract patterns.

Migliori, Nino (b. 1926) Italian photographer. Self-taught, libertarian and non-conformist, Migliori practised – and indeed invented – numerous forms of cameraless photographic experimentation: oxidation, pinhole photography, luminograms (images made with a small flashlight), pyrograms (made from burnt film), cellograms (made with cellophane), hydrograms (produced with drops of water) and

so on. He constantly looks to free his creativity from the technical constraints of photography.

Mikhailov, Boris (b. 1938) Ukrainian photographer. Mikhailov trained and worked as a technical engineer until he was fired after the KGB discovered nude pictures of his wife in his office. In the late 1960s he decided to devote himself to photography full time and took part in several clandestine exhibitions, mounted in secret because artistic production was state-controlled. He gradually began to acquire a reputation and met the Russian artist Ilya Kabakov, who introduced him to artistic and dissident circles in Moscow. Mikhailov's first → series were influenced by Socialist Realism (*Red Series*, 1968–75; *Luriki*, 1971–85; *Sots Art*, 1975–86). During the 1980s he showed the failure of the revolutionary utopia through series such as *Unfinished Dissertation* (1985) and *Salt Lake* (1986). Following Ukraine's declaration of

independence in 1991, Mikhailov documented the consequences of the fall of Communism and the advent of capitalism (*By the Ground*, 1991; *At Dusk*, 1993). The series *Case History* (1997–98), comprising nearly 500 photographs, is his most famous and also his most controversial work. It portrays homeless people in a documentary style, but sometimes he paid and directed his subjects. Mikhailov is regarded as one of the major photographers of the post-Soviet era. His work takes the form of photographic series that mix portraits, scenes that are sometimes distressing, → conceptual art and documentary. It is often disturbing, subversive and critical, offering the viewer an uncompromising view of contemporary Ukrainian society.

Mili, Gjon (1904–1984) Albanian-born American photographer. Mili emigrated to the United States in 1923. While he was studying electrical engineering at the Massachusetts Institute

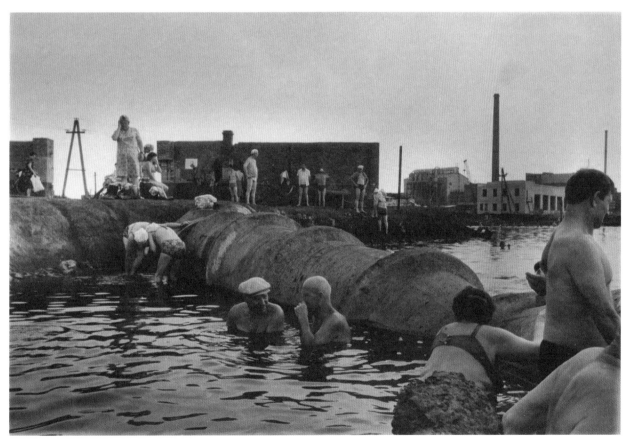

• M —

Boris Mikhailov, *Untitled*,
from the *Salt Lake* series, 1986

of Technology (1923–27), he met the scientist → Harold Edgerton and became interested in photography. In 1939 he settled in New York and became a freelance photographer. His best-known pictures were made using the stroboscopic process (lit by a sequence of electronically generated flashes) and were published regularly in → *Life*.

Miller, Garry Fabian (b. 1957) British photographer. A self-taught experimentalist, Miller – whose father was a commercial photographer – works without a camera. He shines light through glass, liquids, plants or objects onto sensitized paper, thereby creating simple geometric or organic images whose warm colours resemble abstract paintings.

Miller, Lee (1907–1977) American photographer and model. Famous for her ethereal beauty, Miller began her career as a model for Condé Nast, who featured her in → *Vogue* and other magazines. She was much admired by great photographers including → Edward Steichen, and when she went to Paris in the late 1920s she became the muse and model of the → Surrealists. Companion and assistant to → Man Ray, she took her place on the other side of the camera to experiment with numerous Surrealist processes. From 1940 onwards she became a freelance photographer for *Vogue* and worked as a war correspondent for the American army and, after the Normandy landings, also for the allied troops in Europe. A multifaceted artist, Miller was the embodiment of the independent woman, free-spirited, creative, courageous and talented.

Min, Byeong-Heon (b. 1955) Korean photographer. Min works in black and white, rejecting digital techniques in favour of traditional analogue photography and relying on classic printing techniques to fine-tune exposure levels. His works are graphic and frequently abstract; his landscape photographs often look like paintings in ink. Min's works have been exhibited at the Los Angeles County Museum of Art, the Museum of Fine Arts, Houston, the San Francisco Museum of Modern Art and the Santa Barbara Museum of Art, among other venues.

Minkkinen, Arno Rafael (b. 1945) Finnish-born American photographer. In 1971 Minkkinen began to take nude self-portraits, sometimes with his wife and sometimes also with his son, as both a child and a teenager. Minkkinen uses his body as an object, posing creatively in natural settings (including lakes, trees or rocks) under the mysterious, cold light of the Finnish landscapes, often playing with reflections on water. The timeless, magical quality of his work has resulted in numerous exhibitions and invitations to teach.

Miot, Paul-Émile (1827–1900) West Indies-born French photographer. Travelling as an officer of the French navy, from 1857 Miot produced some of the earliest photographic documentation of the topography and inhabitants of Cape Breton Island, Polynesia, the Marquesas Islands, and Saint Pierre and Miquelon. Photographs from his mission to Newfoundland were published in the periodical *Le Tour du Monde* in 1863. In addition, Miot created the first photographic record of Atlantic Canada, and his images chart his various journeys to Senegal, Peru, Chile and Oceania.

Mise-en-scène In photography, the careful disposition of elements within a composition to produce a desired dramatic effect. The staged photograph has been a standard method of creating an image since photography's inception and owes its existence to popular forms of entertainment and the limitations of the photographic process in the 19th century. In Victorian culture the *tableau vivant* was a form of entertainment in which a group of professional or amateur models would restage popular paintings – complete with costumes and sets – for the benefit of an audience, holding absolutely still for the duration of the presentation. In 1840 → Hippolyte Bayard staged his *Self-Portrait as a Drowned Man*, complete with a narrative explaining why he had drowned himself. Other notable 19th-century photographers who utilized the technique of the staged photograph include → Hill and Adamson, → Julia Margaret Cameron, → Oscar Gustav Rejlander and → Henry Peach Robinson.

— M •

Lee Miller, *Self-Portrait*, 1933

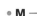

The artworks they created using this method were theatrical images with implicit narratives. Advertising in the 20th century consistently used photographic *mises-en-scène*, creating elaborate stage sets and alluring narratives that would entice consumers. In the 1960s conceptual photographers embraced staged photography, producing images that challenged the popularity of → straight photography. Postmodernist photography also adopted the *mise-en-scène*: one prominent example is → Cindy Sherman's series *Untitled Film Stills*. Today the trend inspires contemporary photographers, such as → Jeff Wall, → Yasumasa Morimura and → Gregory Crewdson,

to create elaborate fictional images that reference art history and modern film.

Miserachs, Xavier (1937–1998) Spanish photographer. During the 1960s Miserachs put together an important series of neo-realist photographs of Barcelona. He also illustrated Mario Vargas Llosa's novella *Los Cachorros*. He worked as a reporter and covered the events of May 1968. Together with Oriol Maspons and Ricard Terré, Miserachs represented the so-called Barcelona School, and was one of the first photography teachers at the city's School of Art and Design.

Misonne, Léonard (1870–1943) Belgian photographer. After studying engineering at the University of Leuven, Misonne instead decided to pursue a career in painting, photography and playing the piano. The son of a lawyer, he had no financial worries and used the family funds to indulge his different passions. From 1900 he was considered to be the leader of the → Pictorialist movement in Belgium, and his assured handling of atmosphere led to him being dubbed the 'Corot of photography'. Despite severe respiratory problems, he cycled the length and breadth of Belgium (winning a few races on the way); the pictures he took en route are now regarded as his finest. Eventually, however, his asthma put an end to his photography, and he remained housebound for the last few years of his life.

Misrach, Richard (b. 1949) American photographer. He studied psychology at Berkeley,

Lisette Model, *Promenade des Anglais, Nice, c.* 1934

University of California (1967–71), before becoming a freelance photographer specializing in landscapes. From 1978, alongside → Stephen Shore and → William Eggleston, he made a major contribution towards the recognition of colour photography as an art form. He has published numerous books, including *Desert Cantos* (1987) and *Petrochemical America* (2012), and has received many awards, including National Endowment for the Arts Fellowships (1973, 1977, 1984, 1992) and a Guggenheim Fellowship (1978).

Mission Héliographique An official campaign established by the French government in 1851 to record the country's historic architecture ('heliography' being a synonym for photography). In 1839, two months after the announcement of the invention of the → daguerreotype, the Commission des Monuments Historiques (itself an important development in the concept of national heritage) envisaged the creation of an archive documenting older French monuments prior to their restoration, using not drawings but photographs. Since the daguerreotype produced an unclear image and was not reproducible, the idea had to be shelved until the arrival of the → calotype, which expanded the medium's potential applications. In 1851 the Administration des Beaux-Arts commissioned five well-known photographers (→ Édouard-Denis Baldus, → Hippolyte Bayard, → Henri Le Secq, → Gustave Le Gray and Auguste Mestral) to photograph French architectural heritage. Five itineraries were planned, covering more than 120 sites: Baldus started out from Fontainebleau to cover Burgundy, the Dauphiné and Provence; Bayard went to Normandy (these → negatives have never been found); Le Secq was sent to Champagne, Lorraine and Alsace; and Le Gray was given the Loire Valley, Touraine and Aquitaine. Mestral, a student of Le Gray's who travelled together with his mentor, was entrusted with Languedoc and Auvergne. The project did not, however, lead to any kind of publication. The Commission des Monuments Historiques was content simply to add the photographs to its archives. Nevertheless, the mission created a large store of calotypes and had a profound influence on the careers of those who participated, most

of whom went on to specialize in → architectural photography.

Miyamoto, Ryūji (b. 1947) Japanese photographer. Born in Tokyo, Miyamoto studied graphic design at the Tama Art University in 1973. In the 1990s he travelled to New York on a grant from the Asian Cultural Council. He is best known for his photographs of architecture and his ability to capture moments of change and the passage of time. He is currently a professor at Kobe Design University.

Model, Lisette (1906–1983) Austrian-born American photographer. Born into an affluent Austrian family of Jewish descent, Model trained as a musician and singer in Vienna before moving to Paris in 1922. After early difficulties with her musical career, Model was introduced to photography by her sister and encouraged by a friend who, pointing to rising tensions in Europe and the possibility of war, suggested the importance of learning a portable skill. In 1937 Model emigrated to New York, where her work earned her immediate critical attention from → Beaumont Newhall, → Ralph Steiner and others. This critical success lasted well into the 1940s, and she was soon a celebrated figure in New York photography circles. An active member of the → Photo League from the 1940s and a known leftist, Model and her husband, Evsa, were investigated by the House Un-American Activities Committee for possible Communist sympathies between 1953 and 1954. Several prominent American magazines that had used Model's freelance work blacklisted her, including → *Harper's Bazaar* and *Flair*. In 1950 Model began teaching at the New School for Social Research, where she remained until her death in 1983. Model's students include → Robert Frank and → Diane Arbus. Her body of work, consisting largely of black-and-white → street photography, includes celebrated images of tourists in Nice and people in the Lower East Side and Coney Island. Her signature photographs, of idiosyncratic subjects caught unguarded in revealing moments, influenced many street photographers of the 1970s, most famously Diane Arbus.

Modotti, Tina [Assunta Adelaide Luigia Modotti Mondini] (1896–1942) Italian photographer. Modotti was a revolutionary anti-Fascist, Communist artist. Among her friends were Frida Kahlo and → Manuel Álvarez Bravo. Her favourite subjects included popular art, social inequality, peasants and workers. For a time she was → Edward Weston's mistress and was greatly influenced by his style before turning to the revolutionary *nueva expresión*, as practised by Diego Rivera and José Clemente Orozco in their murals at the Universidad Autónoma de Chapingo (Mexico).

Moffatt, Tracey (b. 1960) Australian photographer, video artist and filmmaker. Moffatt graduated in visual communication at Queensland College of Art, Brisbane, in 1982. She started her career as director of film and experimental music videos before becoming known for her artificially staged photographs. Influenced by film vocabulary and popular culture, her images oscillate between a documentary approach and visual storytelling. Her principal subjects are emotional examinations of childhood and adolescence, and the recent Aboriginal history of Australia, with which the artist is closely connected.

Mofokeng, Santu (b. 1956) South African photographer and researcher. He started out as an amateur street photographer and then worked as an assistant in various laboratories. In the 1980s he became a freelance photographer in a country where such a career was extremely difficult for blacks. In 1984 he joined the Afrapix agency and also worked on the magazine *Drum*, where he met → David Goldblatt. In 1988 he was appointed researcher and photographer at the African Studies Institute (ASI), a post he held for ten years. During apartheid, he documented the daily lives of black farmworkers and communities, producing → photographic essays that he compiled for his own satisfaction away from the violence (*Train Church*, *Rumours*, *The Bloemhof Portfolio*). After 1994 Mofokeng's photographic essays took on a more personal slant, with particular emphasis on the links between landscape, memory and spirituality

● **M** —

— M •

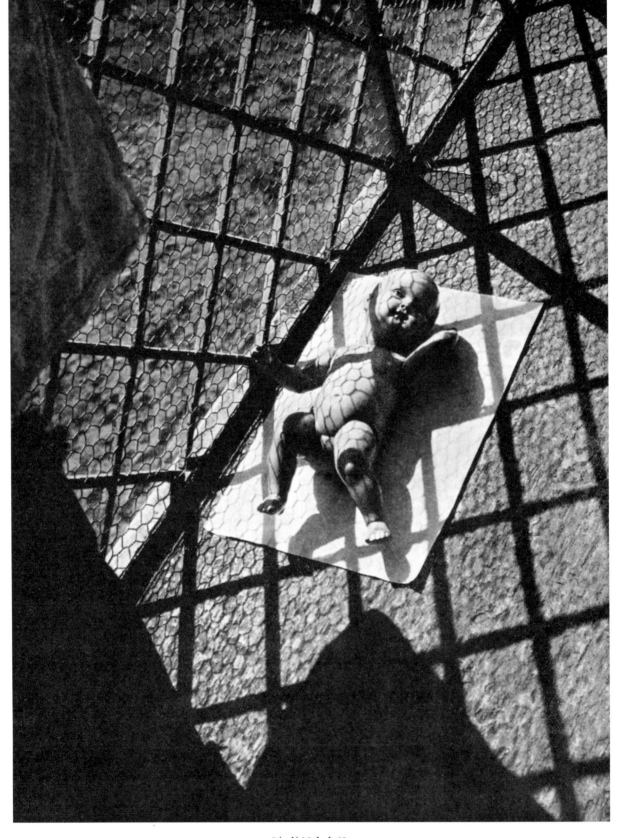

László Moholy-Nagy,
Dolls, 1926

(*The Black Photo Album – Johannesburg 1890–1950, Chasing Shadows, Radiant Landscapes*). His work has received many distinctions and has been exhibited all over the world.

Moholy, Lucia [née Lucia Schulz] (1899–1989) Czech-born British photographer. Moholy is known mainly for her connection with the → Bauhaus. In Prague she studied the humanities, particularly art history and philosophy, and then trained in photography. She married the photographer → László Moholy-Nagy (they later separated) and accompanied him to Weimar when he was appointed professor at the Bauhaus school in 1923. She herself became one of the major photographers in the movement, first in Weimar and then in Dessau, until she broke away in 1928. In 1923 she opened a portrait studio and photographed many people with links to the Bauhaus. Tightly framed and looking almost as if they were sculpted from light, these portraits capture the individuality of her subjects' faces. Moholy was also a photographer of architecture (both interiors and exteriors) and the decorative arts.

Moholy-Nagy, László (1895–1946) Hungarian-born American painter, sculptor and photographer. Moholy-Nagy is regarded as one of the most important avant-garde artists of the 20th century. He is as well known for his art as for the theories he promulgated when teaching. Initially training as a painter, he first became interested in photography in the late 1910s. After studying in Budapest, he launched his career in Germany, where in 1923 he joined Walter Gropius in the → Bauhaus school of design at Dessau. He directed preparatory courses until 1928 and published numerous treatises on photography, light, design and typography, which were brought together in his book *Malerei, Fotografie, Film* (1925). Characteristic of his work is a taste for experimentation with abstraction (notably in colour photography), compositions based on geometric forms, and framing. At first he restricted himself to → photograms and → photomontages (called 'Fotoplastiks' and inspired by the Dadaists), but later developed richer forms of photography.

Moï Ver, *Paris: 80 Photographies* (1931)

There is a clear distinction between his colour prints, which he reserved for experimental work and advertising commissions, and his black-and-white photographs, which he considered a major part of his art. More generally, we can discern a special interest in light as an element of composition and a desire to exploit the full potential of the medium. After brief stints in Amsterdam and London, Moholy-Nagy settled in the United States in 1937 and was appointed professor at the Institute of Design in Chicago. He summed up his conceptual and practical approach to photography in his last book, *Vision in Motion*, which was published in 1947, a few months after he died.

Moï Ver [Moshé Raviv Vorobeichic] (1904–1995) Lithuanian photographer and painter. Moï Ver studied painting and photography at the → Bauhaus (1927–29), and subsequently at the École Louis Lumière and the Académie Moderne de Fernand Léger in Paris. He belonged to a circle of photographers of all kinds who had settled in Paris, including → Germaine Krull

• M —

and → Brassaï, among others. He put together a few → reportages for various magazines and agencies, but it was three works produced in 1931 that made his name: *Ein Ghetto im Osten Wilna*, *Paris: 80 Photographies* and *Ci-contre*. Taking full advantage of all the possibilities offered by montage, superimposition and layout, his photographic compositions demonstrate an unprecedented sophistication and poetic power, with visual effects and stylistic devices that capture the dynamism of urban life as well as conveying a brooding melancholy.

Molder, Jorge (b. 1947) Portuguese photographer. Molder contributed a photograph from his series *Provisional Records* (2003) to UNESCO's art collection – the first Portuguese artist to do so, and the first digital piece of art to be included.

Recognized for his dark, enigmatic photographs, he has focused primarily on self-portraits since the 1980s. He was guest artist at the São Paulo Biennale in 1994 and represented Portugal at the Venice Biennale in 1999. Molder was director of the Modern Art Centre at the Calouste Gulbenkian Foundation, Lisbon, from 1994 to 2008.

Molinier, Pierre (1900–1976) French photographer. Molinier began his career in Bordeaux as a painter but after the war joined André Breton's → Surrealists. He made his name with → photomontages that reconfigured the norms of the genre: he dressed up as a woman, endowed his own body and those of his friends with features that were sometimes feminine, sometimes masculine, and played highly erotic

Inge Morath, *Marilyn Monroe, Eli Wallach and Clark Gable Rehearsing the Dancing Scene between Roslyn and Guido*, 1960

games with mirrors. Molinier committed suicide in 1976.

Monti, Paolo (1908–1982) Italian photographer. Monti studied economics at Bocconi University in Milan and embarked on a career in industry. He loved photography, however, and in 1953 decided to devote himself full time to the medium. His particular interest was architecture, and he was commissioned by the municipal authorities in Bologna to make a complete topographical survey of the city. The result was a street-by-street portrait, empty of traffic, that spontaneously developed into the kind of abstraction that characterized his personal work.

Moon, Sarah (b. 1941) French photographer. She began her career as a model but in 1966 started working as a fashion photographer for several prestigious brands. Her images won many awards, but she switched from → commercial to → art photography in the 1980s, creating her own dreamlike, fantastical aesthetic. Moon takes great care over the technical aspects of her photography, developing her own negatives.

Moore, David (1927–2003) Australian photographer. After studying under the renowned photographer → Max Dupain, Moore moved to London in 1951, where he worked for several newspapers and magazines including the *New York Times*, *Time* and the *Observer*. In 1955 his documentary series on living conditions in Redfern, an impoverished area of Sydney, was shown at the famous → *Family of Man* exhibition organized by → Edward Steichen (→ Museum of Modern Art, New York, 1955). Moore returned to Australia in 1958, where he continued his career as a → photojournalist. He joined the → Black Star agency and during the 1970s was a major figure in Australian photography. He helped to establish the Australian Centre for Photography in Sydney.

Moore, Raymond (1920–1987) British photographer. He trained as a painter at the Royal College of Art, London, and founded the department of photography at Watford College. He also taught at the University of Trent in Nottingham. The son of an architect, he was particularly interested in photographing buildings, but he also recorded landscapes in black and white. Photography received little attention in England at the time, and his first major exhibition did not take place until 1970, at the Art Institute of Chicago.

Mora, Gilles (b. 1945) French historian and photography critic. After studying literature, Mora discovered photography during a stay in the United States. He decided to pursue a career as a photography critic alongside his teaching activities. He co-founded the Cahiers de la Photographie series with → Claude Nori, → Bernard Plossu, → Jean-Claude Lemagny and → Denis Roche; published several monographs; worked as an editorial director; and organized exhibitions, including the Rencontres d'Arles photo festival (1999–2001). He is a specialist in → Walker Evans and the southern states of the US, and has been profoundly influenced by the American counterculture. Mora is a leading light in the critical field of the 'photobiography': the use of photographs to reveal aspects of a person's life story. This approach goes beyond the images themselves and encourages exploration of the relationship between the photographer and the world he or she photographs.

Moral, Jean Arsène Gaston Jacques (1906–1999) French photographer. Moral started his career in advertising as a designer, graphic artist and photographer. His aesthetic approach showed similarities with the → New Objectivity movement. During the 1930s he worked for several magazines, including *Paris Magazine* and → *Vu*, took part in exhibitions and concentrated on → fashion photography, which brought him international recognition. Towards the end of his life Moral abandoned photography and took up drawing instead.

Morath, Inge [Ingeborg Mörath] (1923–2002) Austrian-born American photographer. After studying languages in Berlin (1943–45), Morath worked as a translator and journalist for *Heute*, and provided the captions for photographs by → Ernst Haas. She was one of the first women

• M —

Yasumasa Morimura,
Self-Portrait (Actress) / After Elizabeth Taylor 2, 1996

— **M** •

to join the → Magnum agency, initially as an editorial assistant (1948), then as a photographer (1953) and member (1955). She learnt photography from Simon Guttmann in London, and from then on produced several photographic series, collaborating most notably with → Henri Cartier-Bresson. While covering the making of *The Misfits* she met Arthur Miller, whom she married in 1962. They worked together on several projects that combined text and photographs (*In Russia*, 1969; *Chinese Encounters*, 1979). Morath died of cancer in 2002. Magnum introduced the Inge Morath Award in her memory.

Morgan, Barbara (1900–1992) American photographer. Morgan studied painting at the University of California, Los Angeles (1919–23), where she also taught (1925–30). After meeting → Edward Weston in 1930 she switched direction, embarking on a career in photography in 1935. She made her name with → photomontages, light drawing and images of dancers such as Martha Graham and Merce Cunningham. Her first solo

exhibition took place in New York in 1938. She was a co-founder of the magazine → *Aperture*.

Morimura, Yasumasa (b. 1951) Japanese photographer. Born in Osaka, Morimura graduated from Kyoto City University of Art in 1978 and studied in the United States at Philadelphia College of Art and Columbia University in the 1980s. Provocatively, he addresses questions of identity by reconstructing classical images from art history, mass media and pop culture as self-portraits. He masterfully composes his scenes using props, costumes, make-up and digital manipulation, and then inserts himself in the role of art historical heroines and silver-screen goddesses. His photographs address postmodern issues of originality and self, as well as the roles of gender, race and sexuality in art. Morimura's work challenges the assumptions placed on such images in the West and Japan's absorption of Western culture.

Moriyama, Daido (b. 1938) Japanese photographer. Moriyama works in Japan and New York. He joined Vivo, a group of independent photographers based in Tokyo, as an assistant to → Eiko Hosoe in 1961 before setting up on his own two years later. He is a member of the group Provoque, and is best known for his high-contrast, grainy street photographs in black and white.

Morris, Wright [Wright Marion Morris] (1910–1998). American photographer and writer. In 1940 Morris began to collate his writings and poetic images in what he called 'photo-texts'. Constantly in search of a lost childhood, he reproduced objects that were used, worn out, broken or abandoned, creating atmospheric images of everyday life marked by the passage of time. These were taken mainly in Nebraska and the Midwest, but also in the southern states and California. His body of work, which represents an important record of American society, received proper recognition towards the end of the 1960s, thanks largely to → John Szarkowski, then curator at the → Museum of Modern Art, New York.

Morrison, Hedda [Hedda Hammer] (1908–1991) German-born Australian documentary photographer. Diminutive, determined and with a slight limp caused by childhood polio, she studied photography at the State School of Photography in Munich. She then left for China in 1933. There she found her life's vocation, recording the life of 'old Peking' and other parts of China. Following her marriage to Alastair Morrison, which largely freed her from the need to earn a living, she photographed Hong Kong. Then, between 1947 and 1967, she devoted herself to photographing the peoples of Sarawak and other parts of Asia. After her experiences in Sarawak, Morrison settled in Canberra and published numerous books of her photographs,

all recording Asian societies in a period of transition.

Moulène, Jean-Luc (b. 1955) French artist. After a career in business, Moulène devoted himself to art. He combines photographs and other media, forcing the viewer to consider the act of creation and the images' often political symbolism. Moulène's works have been exhibited internationally.

Mthethwa, Zwelethu (b. 1960) South African photographer. Mthethwa received a Fulbright scholarship to study image arts at Rochester Institute of Technology, New York. Returning to South Africa, he was a key figure in the

• M —

Zwelethu Mthethwa,
Untitled, from the *Interior* series, 2000

Vik Muniz, *Narcissus,*
after Caravaggio, 2005

— M •

burgeoning → art photography movement that
emerged after the fall of apartheid. Mthethwa
is best known for his large-format colour
prints that co-opt the aesthetics of Western
documentary and African commercial studio
photography.

Mudford, Grant (b. 1944) Australian photographer.
Born in Sydney, Mudford studied architecture in
the mid-1960s before becoming a photographer
of structures and spaces both for commercial
clients and as an artist. In 1974 he moved to
Los Angeles, where he began an epic series
of photographic road trips. Crisscrossing the
United States for the next five years, he created a
masterful body of work that depicts anonymous
examples of vernacular American architecture
bathed in a harsh light but also describes a rich
semiotic landscape. Mudford's virtuosic view of
America reveals the sublime in the most unlikely
of places, such as Las Vegas and Los Angeles
International Airport. His fellow Australian

Robert Hughes described his oeuvre as 'an
elegant blend of formalist precision and cultural
irony'. Mudford is prolific, and his subsequent
bodies of work featured colour abstraction (his
Paint Tubs, for instance), painterly formalism
(seen in *Shipping Containers*), and, shot in
studios that seem like hermetic worlds in
themselves, a large series of portraits of mostly
West Coast artists.

Muholi, Zanele (b. 1972) South African
photographer. Muholi received advanced training
in photography at the Market Photo Workshop
in Newtown, Johannesburg. She calls herself
a 'visual militant' and uses photography to fight
against the homophobia that is rife in South
Africa. Focusing mainly on black women, her
work seeks to draw attention to marginalized
communities and to denounce the violence of
which they are victims.

Mulas, Ugo (1928–1973) Italian photographer.
After breaking off his law studies, Mulas enrolled
in drawing classes at the Brera Fine Arts Academy
in Milan (1951–52) and then taught himself
photography. In 1954 he turned professional,
documenting the Venice Biennale until 1972.
He is known internationally for his portraits
of artists taken in New York between 1964 and
1967 and published as *New York: arte e persone*
(1967). In 1970 Mulas began his last series,
Verifiche, a conceptual study of the medium
of photography.

Muller, Nicolas (1913–2000) Hungarian-born
Spanish photographer. Muller settled in Spain
in 1944 after practising photography in Vienna,
Paris (where he worked with → Brassaï), Lisbon
and Tangier. Following the trend for social
photography, he depicted the rural world of
Asturias but also took very fine portraits of the
Spanish intellectual elite, including Eugenio
d'Ors and José Ortega y Gasset.

Müller-Pohle, Andreas (b. 1951) German
photographer, artist and publisher. After
studying economics and communications at
the universities of Hannover and Göttingen,
Müller-Pohle founded the magazine *European*

Photography in 1979. He published works by → Vilém Flusser. A pioneer in experimenting with new technologies, he creates images based on codes (genetic or digital codes, for instance) that explore the nature of flux and the relationship between fixity and movement.

Muniz, Vik (b. 1961) Brazilian artist. Muniz uses ephemeral, everyday materials to re-create images drawn from the arts, the media and his own works, of which he keeps a photographic record. He painted the *Mona Lisa* using jam, for instance, and the *Raft of the Medusa* in chocolate. His extraordinary artworks, which are technical as well as intellectual achievements, explore the circulation, popularizing and reappropriation of images, as well as highlighting their powers of illusion. Muniz's art is also socially committed – especially his film *Waste Land* (2011) – and his juggling with different media throws into question the traditional distinctions between low and high culture.

Munkácsi, Martin [Martin Marmorstein] (1896–1963) Hungarian-born American photographer. Born in Kolozsvár (present-day Cluj, in Romania), Munkácsi became a sports photographer at the age of 25, mainly for the *Berliner Illustrirte Zeitung*, which sent him to New York in 1933. There he met Carmel Snow, editor-in-chief of → *Harper's Bazaar*, who persuaded him to switch to fashion. He rapidly acquired a reputation in this field, conveying a sense of action and movement, and he was one of the first photographers during the 1930s to leave the studio and photograph his models outdoors. Following a heart attack in 1943, he stopped working as a photographer and turned to poetry and the cinema instead.

Muñoz, Isabel (b. 1951) Spanish photographer. Muñoz decided to take up photography in 1979 and studied at the Visual Studio in New York (1982–86). Her distinctive use of → platinum prints in medium format (80 × 120 cm) makes her work easy to recognize. Her photographs on the themes of dance and sensuality have achieved international recognition. She lives and works in Madrid.

Muray, Nickolas (1892–1965) Hungarian-born American commercial photographer. He learned engraving and lithography at a graphic arts school in Budapest, then studied photochemistry and colour processes in Berlin. Muray emigrated to the United States in 1913 and was naturalized in 1918. Initially he was employed as a photo-engraver and colour-separation technician. In 1920 he opened a studio, and between 1920 and 1940 became known for his portraits of celebrities and his advertising work in colour. He worked for → *Harper's Bazaar*, *Vanity Fair*, → *Vogue* and other popular magazines. He is perhaps most famous for his photographs of the Mexican artist Frida Kahlo, with whom he conducted an affair.

Museum of Modern Art, New York The Museum of Modern Art (MoMA), New York, opened its doors to the public in 1929, quickly gaining international recognition for its landmark

• **M** —

Nickolas Muray,
Frida Kahlo, 1939

exhibitions on Van Gogh and Picasso. The museum moved to its permanent home on 53rd Street in 1939. It began collecting photography in 1930, establishing a dedicated department of photography ten years later. → Beaumont Newhall, then librarian of the museum, was invited to prepare an exhibition and publication of its photographic holdings, resulting in a show entitled *Photography 1839–1937* (1937). Other early curators included → Edward Steichen, who curated → *The Family of Man* for the museum in 1955. At present the museum holds more than 25,000 photographic works, making it one of the most important collections of modern photographs anywhere in the world.

Muybridge, Eadweard [Edward James Muggeridge] (1830–1904) English-born American photographer. Muybridge emigrated to San Francisco around 1850. Following a stagecoach accident he took up photography full time and was one of the first topographical photographers of the American West. Between 1860 and 1873 he published *Scenery of the Yosemite Valley*, took part in a military expedition to Alaska and photographed the Pacific coast. In 1872 Amasa Leland Stanford, former governor of California

— M •

Eadweard Muybridge,
Man and Horse Jumping a Fence, 1887

Carl Mydans,
Douglas MacArthur in Luzon, 1944

and president of the Central Pacific Railroad, asked him to photograph his galloping horse, to prove that, for a fraction of a second, all four of the animal's hooves were off the ground. Muybridge responded by producing one of the first instances of a live-action photograph. He did not devote himself fully to the photography of locomotion until 1877, however, following his trial for the murder of his wife's lover (he was acquitted on grounds of 'justifiable homicide') and a period of four years in exile. Using a camera equipped with twelve and, later, twenty-four → lenses, he was able to capture the different phases of animal movement in just a few fractions of a second. He displayed his results with a zoopraxiscope, a stroboscopic cylinder that created the first animated images prior to cinematography. In 1881 Muybridge gave lectures in London and Paris, and met → Étienne-Jules Marey. On his return to the United States, at the instigation of → Thomas Eakins, professor of drawing at the University of Philadelphia, he photographed nearly 2,000 men, women and animals. Starting out with 20,000 negatives, he published *Animal Locomotion* in 1887, a selection of 781 plates collected in 11 volumes. This work remains the most comprehensive scientific study ever carried out on the movements of live beings. Two books for laymen appeared in England: *Animals in Motion* (1899) and *The Human Figure in Motion* (1901).

Mydans, Carl (1907–2004) American photographer. For a short time he worked for the → Farm Security Administration, but in 1936 he joined → *Life* when the magazine was relaunched. He covered the war in the Pacific, where he was a Japanese prisoner of war for two years, and in Europe. Through his life Mydans was first and foremost a journalist, the written word being just as important to him as the image.

Nachtwey, James (b. 1948) American photographer. Having studied art history and political science, Nachtwey chose to become a photojournalist and has travelled the world campaigning against conflict and social injustice. Always close to the scene of the action, Nachtwey challenges the viewer with images that are often deeply disturbing. A member of → Black Star (1980–85) and → Magnum (1986–2001), he co-founded the VII agency in 2001.

Nadar [Gaspard-Félix Tournachon] (1820–1910) French photographer. Born into a family of printers, Nadar studied medicine in Lyon. In 1842 he settled in Paris, tried his hand at journalism, and published literary and political caricatures in opposition newspapers. In 1854, under a pseudonym he had used since the age of 18, he drew the *Panthéon Nadar*, which comprised more than 250 celebrities. He had become interested in photography in 1849 and persuaded his brother Adrien to open a photographic studio. In 1854 Nadar learnt the → daguerreotype process and carried out research on wet → collodion, though he never gave up writing or producing

cartoons. His studio became a meeting place for the intellectual elite, and in 1874 he held the first public exhibition of Impressionist paintings there. Nadar's portraits of writers, artists, musicians and political figures were half-length, devoid of any irrelevant accessories and set against a plain background. He was also interested in dirigible airships, and in 1858 took the first aerial photograph from the gondola of a balloon. He filed a patent on aerostatic photography and made a balloon himself, named *Le Géant*, which crashed in Germany two weeks after its inaugural flight, in 1863. Nadar experimented with artificial lighting and perfected a form of magnesium lighting so that he could photograph the catacombs and sewers of Paris. Assisted by his son Paul, in 1886 he conducted the very first photographic interview with the chemist Eugène Chevreul, who was celebrating his 100th birthday. That same year, he gave up photography and began to write an autobiography, *Quand j'étais photographe*, which was published in 1899. He moved from Paris to Marseille in 1895, leaving the field to his son Paul Nadar.

Nagano, Shigeichi (b. 1925) Japanese photographer. After graduating in economics in 1947, Nagano worked as an editor in Tokyo while continuing to practise photography. In 1954 he became a freelance photographer, working in the documentary style. Among the subjects he covered were the aftermath of the atomic bomb on Hiroshima, urban life, the booming economy of post-war Japan, and the daily lives of its so-called 'salarymen'.

Nakahira, Takuma (b. 1938) Japanese photographer. After graduating in Spanish Studies at the Tokyo University of Foreign Studies in 1963, Nakahira worked as an editor at the magazine *Gendai no me* ('The Modern Eye') and came to know the influential photographer → Shomei Tomatsu. Under Tomatsu's influence, Nakahira began taking photographs. In 1965 he quit his job and began working on the exhibition entitled *One Hundred Years of Photography* (1965), curated by the Japan Professional Photographers Society. The same year Nakahira, together with the critic Taki Koji, the photographer Takanashi Yukata and the poet Okada Tadahiko, published a photography magazine called *Provoke*. Later the photographer → Daido Moriyama joined the group, and their grainy, blurred styles influenced other photographers. In 1970 *Provoke* broke up, and Nakahira published his work from the *Provoke* era as *For the Language to Come*. After recovering from illness in 1978, Nakahira began to work prolifically. In 2003 his first major solo exhibition, entitled *Nakahira Takuma: Degree Zero – Yokohama*, was held at the Yokohama Museum of Art.

Nakayama, Iwata (1895–1949) Japanese photographer. In 1918 Nakayama became one of the first generation of photography graduates from the School of Fine Arts in Tokyo. He then moved to the United States and opened a portrait studio in New York in 1921. In 1926 he travelled to France and spent a year living in artistic circles in Paris, where he met famous figures such as → Man Ray. He returned to Japan in 1927, where he became a leading photographer and helped to create a number of studios, groups, clubs and exhibitions. In 1932, together with → Yasuzo

Nadar, *Charles Baudelaire, c.* 1860

Nojima and → Ihei Kimura, he founded *Koga*, a magazine that was influential in the growth of the → New Objectivity movement in Japan.

● **N** —

Namuth, Hans (1915–1990) German-born American photographer. Having studied at the Humboldt-Oberrealschule in Essen, in 1935 Namuth went to Paris and worked as a freelance photographer, particularly for magazines such as → *Vu* and → *Life*. He covered the Spanish Civil War and emigrated to the United States in 1941. In 1950 Namuth met Jackson Pollock and began to photograph more than 200 cultural figures, including John Cage, Alexander Calder, Joseph Cornell and Hans Hofmann.

Nappelbaum, Moisey Solomonovich (1869–1958) Russian photographer. In 1884 Nappelbaum served an apprenticeship in the studio of Biretti, an Italian firm in Minsk, after which he travelled extensively in the Soviet Union and abroad. He moved to St Petersburg in 1920 and worked for the newspaper *Solntse Rossii*. In 1919 his studio in Moscow was the first to be recognized by the state, and throughout the 1920s he

photographed the local intelligentsia, including Alexander Blok, Maxim Gorky, Vladimir Tatlin, Nadezhda Krupskaya, Anatoly Lunacharsky and Lenin. He took part in the exhibition *Ten Years of Soviet Photography* in 1928. In 1958 he published a book entitled *From Craft to Art*. Through his work, Nappelbaum had a profound influence on the evolution of photographic portraiture in the Soviet Union.

Narahara, Ikko (b. 1931) Japanese photographer. Narahara was born in Fukuoka Prefecture. After graduating in law at Chuo University in 1954, he acquired a reputation for his first solo exhibition, entitled *Human Land*, held in 1956 at the Matsushima Gallery in Tokyo. Narahara received a master's degree in art history from Waseda University in 1959. The same year he founded a self-managed photography agency, called Vivo, alongside other photographers who had participated in the *Eyes of Ten* exhibition (1957) at the Konishiroku Photo Gallery, Tokyo. After the breakup of Vivo in 1961, Narahara lived in Paris from 1962 to 1965, and in New York from 1970 to 1974. He joined the *New Japanese Photography* exhibition at the → Museum of Modern Art in 1974. The following year, Narahara published *Where Time Has Vanished*, a compilation of images from his time in New York. After returning to Japan, he continued to produce several series. In 1996 Narahara received a medal of honour from the Japanese government.

Narrative art An international movement that arose out of a section of the Documenta 5 exhibition in Kassel (1972), organized by Harald Szeemann. It was first highlighted, under the name 'Story Art', in a portfolio of works by → John Baldessari, Roger Welch and Didier Bay reproduced in an issue of the German art journal *Interfunktionen*. The term has also been attributed to the German artist Michael Badura, but it was, above all, two exhibitions held by the New York gallerist John Gibson in 1973 (*Story Art*) and 1974 (*Narrative Art*) that gave prominence to the form. It combined photography and text into a narrative that focused on an individual's experience of everyday life. During the years that followed, it was the subject of numerous

exhibitions – generally featuring the same artists – in Europe (Italy, Belgium, Germany and the Netherlands) and North America (Canada and the United States). However, by 1979 it had faded out. Other photographers who worked in the genre include → Jean Le Gac and → Christian Boltanski (from France), Bill Beckley, → Robert H. Cumming and → William Wegman (United States), Peter Hutchinson and Mac Adams (Britain), → Franco Vaccari (Italy), David Askevold (Canada) and → Jochen Gerz (Germany).

Nash, Paul (1889–1946) British artist. Born in London, Nash initially studied photo-engraving and lithography at the London County School before enrolling at the Slade School of Fine Art, London, where he met a number of avant-garde artists. He took part in both world wars as an artist and photographer. Nash's aim was to depict the horrors of conflict, and he adopted an expressive, → Surrealist style to do so.

Natalia LL [Natalia Lach-Lachowicz] (b. 1937) Polish photographer. In 1961, while studying at the State High School of Fine Arts in Wrocław, Natalia LL took her first portraits. She subsequently set out to photograph parts of the human body, using the medium as a means of recording reality and documenting the different phases of the sexual act. In 1970, together with Andrzej Lachowicz, she created *Permanent Registrations*, in which she analysed the passing of time by depicting the dial of a watch or kilometres flashing past on a motorway. The following year, the Gallery Permafo in Wrocław (which she co-founded) opened its doors with *Intimate Photography*, an exhibition of her erotic photographs. Two years later she exhibited her best-known cycle, *Consumer Art* (1970–75), at the same gallery. Multiplied or juxtaposed in accordance with the strict rules of → conceptual art, these portraits of herself and other women portray the simple act of eating foods such as bananas, yoghurt or jelly. Her next cycle, entitled *Post-Consumer Act*, consisted of close-ups of the women's mouths dripping with jelly and other sweets. Although Natalia LL has never explicitly expressed a desire to treat sex as her subject matter or to adopt a critical view

Charles Nègre,
Chimney-Sweeps Walking, c. 1851

of men, she nevertheless soon became an icon of feminist art in Poland. Aside from her work's focus on the body, which invites comparisons with body art, she also explores the theme of nature. Since 2004 Natalia LL has taught at the Academy of Fine Arts in Poznań.

National Geographic A magazine founded in 1888 by the National Geographic Society. Initially it only appeared sporadically, and was meant for a specialized readership. It began to make photographs an integral part of its content in 1895. Owing in part to its early use of colour photography, it soon began to appeal to a much wider public and was published monthly. It includes stories on nature, current affairs and scientific missions.

Negative A unique image created within a camera from which multiple → positive images can be printed. In black-and-white negatives, the image is produced by particles of light-sensitive silver salts (silver halides) suspended in → gelatin. Since

exposure to light causes the silver halides to darken, the negative will show a bright subject as dark, and vice versa. Colour negatives also make use of light-sensitive silver salts, but chromogenic dyes form around the silver particles during processing and the silver is subsequently bleached out. Here, too, the tones and colours of the original subject are reversed when captured on the negative but restored when a positive print is made from it. Different substrates have been used for negatives over the years, including paper, glass and a variety of plastics.

Nègre, Charles (1820–1880) French photographer. At the age of 19, Nègre began to study painting under Paul Delaroche, followed by Jean-Auguste-Dominique Ingres. Encouraged by Delaroche to learn photography, Nègre made his first → daguerreotypes in 1844, but continued to pursue his career as a painter, which brought him success in the salons of 1851 and 1852. By 1847 he was devoting most of his time to photography, however, initially as research tool

● **N** —

for his paintings. He was one of the first street photographers, using an optic system with additional → lenses and the → collodion process to create his images. In 1852 he photographed the south of France for a two-volume publication called *Le Midi de la France*, but the project failed to come to fruition. In 1856 Nègre took out a patent on a photo-engraving process with a view to reproducing his work. He presented the resulting heliogravures for a competition held by the Duc de Luynes; they were considered remarkable, but won only second prize. Nevertheless, the Duc de Luynes commissioned a book of heliogravures to be made from Nègre's images of Palestine. The *Voyage d'exploration à la mer morte* was published in 1871–75. Nègre went on to receive numerous public commissions, including a series of photographs of Chartres Cathedral and a story on everyday life at the imperial residence in Vincennes. He left Paris in 1863 and settled in Nice, where he taught drawing at the Lycée Impérial.

Neshat, Shirin (b. 1957) Iranian photographer and video-maker. Born in Qazvin, Neshat left for the United States in 1974 in order to study art. During the 1990s she returned several times to her native country, which she found had been transformed by the Islamic Revolution of 1979. Her awareness of this transformation was the starting point for her series *Women of Allah*, which made her name, and for many other subsequent works. She does not set out to be polemic but uses her work to ask questions about Islamic culture, and in particular about the status of Iranian women at the heart of that culture. A recurrent feature of her photographs is bodies covered with Persian calligraphy. She was awarded the Golden Lion at the 48th Venice Biennale (1999) for her video *Turbulent*. Neshat lives and works in New York.

Neue Sachlichkeit *see* **New Objectivity**

Neusüss, Floris (b. 1937) German photographer. Neusüss first studied painting but later became a pupil of → Heinz Hajek-Halke. Neusüss is one of the most important contemporary experimental photographers: his life-size

→ photograms of nudes, nocturnal photograms and abstract chemical 'landscapes' are all the opposite of the representational photographs usually taken with a camera. As a teacher in Kassel he has trained many young photographers, including Thomas Bachler and Tim Otto Roth.

New Bauhaus A school established by → László Moholy-Nagy in 1937 in Chicago. It closed a year later, reopened in 1939 as the School of Design, was renamed the Institute of Design in 1944, and was ultimately incorporated into the Illinois Institute of Technology in 1949. The school followed the original → Bauhaus model and emerged as a locus of creative activity, paying particular attention to photography as a new visual language closely related to the modern world. It proffered a vision of photography as capable of engaging with the emotional aspects of human experience during a time when post-war photographers on the East Coast were exploring → documentary photography and its unique capacity to present the world 'as it is'. Key teachers at the school included Moholy-Nagy, → Harry Callahan and → Aaron Siskind.

New Color Photography An American movement of the 1970s that aimed to challenge the established belief that black-and-white → gelatin silver printing was the only technique suitable for → art photography. At the same time it sought to distinguish itself from colour → commercial photography of the early 20th century, and to bring colour images into art galleries and museums. It was championed by → John Szarkowski, Max Kozloff and others, and its practitioners included photographers such as → Stephen Shore and → William Eggleston.

New Documents An exhibition curated by → John Szarkowski at the → Museum of Modern Art, New York, in 1967, which included ninety photographs by → Diane Arbus, → Lee Friedlander and → Garry Winogrand. Previously, documentary photographers had tended to use their work to condemn social, economic or political injustice. These three photographers, however, preferred to focus on scenes of everyday life, mainly in the

streets of New York, without seeking to deliver a message. They opened the way for a new genre of → documentary photography in which personal expression took precedence over everything else. Despite the criticism that was heaped on this exhibition, Szarkowski ensured that Arbus, Friedlander and Winogrand took their places in the pantheon of great photographers.

New Objectivity An artistic movement characterized by an interest in the mechanical qualities of photography and a direct, natural approach that avoids artifice. In technical terms, this approach required a high degree of craftsmanship. Running counter to the Symbolist aesthetics that were in vogue at the beginning of the 20th century, the movement emerged in the 1910s and played a key role in photography's recognition as a truly artistic means of expression. In the United States, the term → 'straight photography' became associated with the work of → Paul Strand around 1915: a well-structured composition and a faithful rendering of reality were typical features of his work. The same approach can be seen in the photographs of his compatriot → Edward Weston, whose demand for precision and neutrality are evident in his images of everyday objects. In contemporary photography, New Objectivity is associated with the → Düsseldorf School of photography that grew up under the influence of → Bernd and Hilla Becher, who taught photography at the Kunstakademie in Düsseldorf between 1977 and 1996. Following in the tradition of the Neue Sachlichkeit of the 1930s, represented by → Karl Blossfeldt and → Albert Renger-Patzsch, the Bechers' quasi-documentary approach is apparent in their work from the 1960s onwards. In the 1980s it came to serve as a manifesto for a new generation of artists. Strict framing, a spare aesthetic, distance and precision were the style's distinguishing features, which was developed further by their students, among them → Andreas Gursky, → Candida Höfer, → Jörg Sasse and → Thomas Ruff.

New Topographics An exhibition curated by William Jenkins in 1975 at George Eastman House, Rochester, New York. *New Topographics:*

Photographs of a Man-Altered Landscape included the work of → Robert Adams, → Lewis Baltz, → Bernd and Hilla Becher, → Joe Deal, Frank Gohlke, → Nicholas Nixon, John Schott, → Stephen Shore and → Henry Wessel. Although the show was not well attended, it marks a significant and influential moment in the history of photography. The term 'New Topographics' refers both to the 1975 exhibition and to a certain approach towards landscape that it served to highlight. What linked the photographers was an aesthetic that dismissed notions of the picturesque and sublime, instead focusing on vernacular and mundane architecture within both urban and rural settings. As a style, it straddles both documentary and conceptual approaches within its practice.

New Vision A photographic movement that began in the 1920s as part of avant-garde developments in Europe. In their quest for a new visual language, artists turned to the medium of photography. At the time, it was widely regarded as inferior to art, but it appeared to open up new fields of experience. Using diverse processes such as the → photogram, the → photomontage and unusual perspectives, artists were able to produce unconventional images, owing largely to the arrival of effective artificial lighting and manoeuvrable cameras such as the → Leica. Experiments in form particularly favoured high- and low-angled shots, graphic compositions, the fragmentation of subjects, the interplay of reflections and the image-within-an-image. In general, these works tended towards an abstraction of the subject and undermined our normal perceptions. The major representatives of the movement assembled in 1929 for the exhibition → *Film und Foto* in Stuttgart. Their leading light was → László Moholy-Nagy, but also present were the Russian Constructivist → Alexander Rodchenko, the Americans → Man Ray and → Edward Steichen, and many others, including → Edward Weston, → El Lissitzky and → Germaine Krull. This event marked the climax of the movement but, paradoxically, it was also the beginning of its decline. The experimentation fizzled out, and the movement seemed to lead into a new form of academicism.

• N —

Arnold Newman, *Igor Stravinsky,*
New York City, 1946

Newhall, Beaumont (1908–1993) American curator and historian of photography. Newhall studied art history at Harvard University (1930–31), taking courses given by Paul J. Sachs on museology, and then furthered his studies at the Institute of Art and Archaeology in Paris (1933) and at the Courtauld Institute of Art, London (1934). As far as the history of photography was concerned, however, he was self-taught. In 1935 he was employed by Alfred Barr as librarian at the → Museum of Modern Art, New York. Two years later Barr made use of Newhall's knowledge of photography by asking him to organize an exhibition. Entitled *Photography 1839–1937*, it was the springboard for the opening of a department of photography at the museum. In the accompanying catalogue, Newhall raised photography to the status of art and wrote a eulogy of the style known as → straight photography. The catalogue soon went out of print but, reissued under the title *Photography: A Short Critical History*, it became a standard reference work on the history of the medium. In 1949 it was renamed *The History of Photography: From 1839 to the Present Day*, remaining in print until 1982. In 1940 Newhall was appointed curator of the Museum of Modern Art's new department of photography. He organized several large-scale monographic exhibitions on artists including → Walker Evans and → Henri Cartier-Bresson, and assembled the museum's first collection of photographs. During World War II he signed up as a reconnaissance photographer; his wife, Nancy, took charge while he was away. Unhappy at the choice of → Edward Steichen as head of department, Newhall left the museum in 1947. In 1948, however, he renewed his career as a curator at George Eastman House, which had just been founded. He was its director from 1958 until 1971. He founded the magazines *Image* and → *Aperture* in 1952, and taught the history of photography at the Rochester Institute of Technology, New York (1956–58), and at the University of New Mexico (1971–84).

Newman, Arnold (1918–2006) American photographer. In 1936 Newman began to study art at the University of Miami Beach but was soon obliged to break off owing to financial difficulties. He found employment

at a photography studio in Philadelphia and, inspired by → Walker Evans, started taking street photographs. In 1941 → Beaumont Newhall and → Alfred Stieglitz encouraged him to pursue a career in photography. That same year he took his first portraits, and in 1942 he opened a portrait studio in Miami Beach. He moved to New York in 1946, where he was given commissions by → *Harper's Bazaar*, → *Fortune*, → *Life* and *Look*. Newman's trademark was the 'environmental portrait', in which he placed his subjects in their familiar surroundings. Newman photographed many great figures of the 20th century from the worlds of art, politics and economics.

Newton, Helmut (1920–2004) German-born Australian photographer. Born in Berlin, Newton learnt photography in the studio of the German photographer → Yva (1936–38). As a Jew, he was forced to leave Germany in 1938 and settled in Australia in 1940, becoming an Australian citizen in 1946. In 1948 he married June Brunell, an actress and photographer, who would remain his companion for the rest of his life. Now specializing in → fashion photography, he moved to London in 1956, where he had been given a one-year contract by the British edition of → *Vogue*. He subsequently moved to Paris and until the end of the 1970s received numerous commissions from magazines such as *Vogue*, *Elle* and *Stern*. However, following a heart attack in 1971, he decided only to accept commissions that would enable him to work freely in his own individual style. Famously provocative, he defied many taboos: during the early 1980s he produced the series *Big Nudes*, which caused a scandal on account of its life-size portraits of women both clothed and naked. His works, in black and white, are immediately recognizable: mixing nudity, seductiveness, luxury, money and power, they project an image of the *femme fatale*, bourgeoise, proud of her body and conscious of her sexual attraction. Newton was killed in a road accident in 2004, since when there have been several retrospectives (notably Berlin in 2010 and Paris in 2011). The Helmut Newton Foundation in Berlin was created at the request of the artist himself, who left all his work to the city.

Niedermayr, Walter (b. 1952) Italian photographer. Niedermayr is recognized internationally for his large-scale multi-panel photographs featuring mountainscapes or architectural constructions. His work is presented on a monumental scale, inviting the viewer to contemplate the space as a reality evolving alongside man's relationship to the environment. In 2011 Niedermayr was appointed professor for fine art photography at the Free University of Bolzano.

Niépce, Nicéphore [Joseph Niépce] (1765–1833) French inventor and pioneer of photography. Niépce is considered the father of photography, his earliest experiments dating back to 1816. Self-taught and passionate about the sciences, he worked with his brother Claude on several projects, including a combustion engine, a hydraulic engine and woad-based dyes. After his brother moved to England, Niépce worked with his son, Isidore, on a method, based on lithography, that would capture the direct action of light on a pewter plate. Niépce experimented with bitumen of Judea, a light-sensitive substance, which he applied in thin layers to a silver-coated pewter plate. With the intention of developing a photomechanical means of reproducing engravings, from 1824 he began to produce heliographic engravings such as *Cardinal d'Amboise* (1826) and *The Holy Family* (1827). He also experimented with capturing images with a → camera obscura, including *View from the Window at Le Gras* (rediscovered in 1952 by → Helmut Gernsheim and considered the earliest known photograph) and *The Set Table*. In 1826, through the optician → Charles Chevalier, he met → Louis Daguerre, who was working on similar projects. Niépce entered into a partnership with Daguerre with the intention of improving his invention; the contract was signed on 14 December 1829. At Daguerre's request, Niépce wrote a *Notice on Heliography* in which he explained his process. While Niépce continued his experiments with bitumen of Judea, Daguerre used light-sensitive silver iodide with mercury vapour as a developer. When Niépce died on 5 July 1833, Daguerre remained in charge of the contract, now sharing it with Niépce's son. Daguerre had its terms altered in order to

• N —

recognize the fact that two separate processes existed: the one developed by Niépce, which was not marketable and produced poor-quality images, and his own, which in 1838 he named the → daguerreotype.

Niépce de Saint-Victor, Claude Félix Abel (1805–1870) French physicist and chemist. Niépce de Saint-Victor, a cousin of → Nicéphore Niépce, developed the heliogravure printing process. In 1847 he began to develop a technique based on glass-plate → negatives with a coating of → albumen (egg white), which was adhesive and permeable, allowing an even layer of silver salts to be created. The use of glass as a support for the negative was in itself an important step. Because of its transparency, the glass plate allowed a precise image to be obtained, but some substance and atmosphere were lost in comparison with paper negatives. Niépce de Saint-Victor's process was also slower than the → calotype. The albumen glass-plate negative was quickly superseded by the → wet-plate collodion process, developed by → Frederick Scott Archer in 1849 and marketed from 1851.

Nieweg, Simone (b. 1962) German photographer. Having studied at the Kunstakademie in Düsseldorf, where one of her teachers was → Bernd Becher, Nieweg has concentrated on a single subject since the late 1980s: allotments. Referencing the genres of → landscape and → still-life, she takes large-format colour photographs of fruit and vegetables, sometimes with a glimpse of a shed or a wall, but never any human beings. Nevertheless, the viewer

— N ●

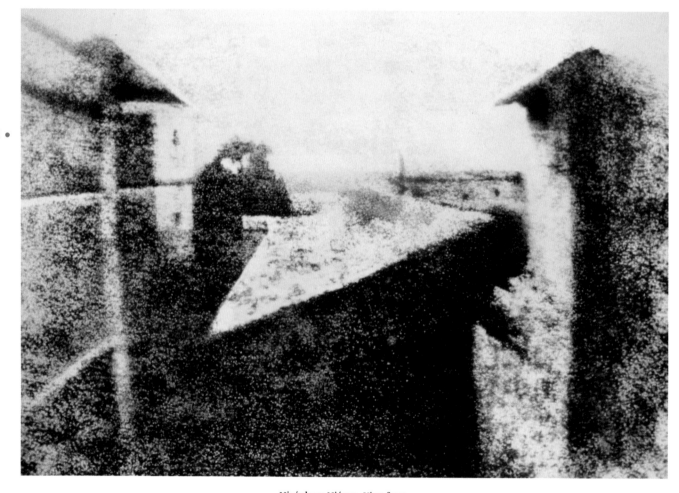

Nicéphore Niépce, *View from the Window at Le Gras*, 1826–27

is aware of the human hand, and its invisible, tranquil workings behind the scenes.

Nilsson, Lennart (b. 1922) Swedish photographer and film director. A pioneer of medical photography, Nilsson was the first to photograph a human embryo, in 1953. He worked for → *Life* from 1965 until 1972, and in 1965 published a book entitled *The Drama of Life before Birth*. He took these spectacular photographs using an electron microscope that showed tiny objects in three dimensions. The images, originally in black and white, were coloured in the laboratory during the printing process. After the advent of digitalization, Nilsson used the new technology to obtain different visual effects. He is also well known for his documentary films for television. He continues to create studies of the human body and of the animal and vegetable worlds.

Nixon, Nicholas (b. 1947) American photographer. Now working extensively in → landscape and → portraiture, Nixon studied photography at the University of New Mexico, receiving his master's degree in 1974. The following year he participated in the landmark → *New Topographics* exhibition. His photographic practice has focused on documentary work using an 8 × 10 view camera. *The Brown Sisters*, which he began in 1975, is an ongoing series documenting of his wife and her siblings, and represents one of his most recognized works.

Noble, Anne (b. 1954) New Zealand photographer. Noble's first sustained series was a collection of evocative, moody images of the Whanganui river, published in 1982. Others that followed have included *In the Presence of Angels* (1989), on the Tyburn Convent in central London; *Ruby's Room* (1998–2007), featuring lurid colour close-ups of her daughter's mouth; and photographs of and about Antarctica (published as *Ice Blink* in 2011).

Noise A form of interference that affects the quality of a photograph, causing loss of clarity and detail. Borrowed from the field of acoustics, the term can be applied to any unwanted electronic signal. It is principally associated with → digital photography, in which interference takes the form of light or dark → pixels that may appear in a regular pattern or randomly across an image. The intensity of noise depends on a variety of factors, including the sensitivity or size of the image sensor, light levels and temperature. In silver halide photography, noise is visible as distinct grains or a uniform haze that reduces image contrast.

Nojima, Yasuzo (1889–1964) Japanese photographer and painter. At the beginning of his artist career, Nojima's style was primarily → Pictorialist. After failing to complete his studies in economics, he opened a photography studio in Tokyo in 1915 and an art gallery in 1919. The following year he had to close both establishments, but nevertheless continued to act as patron to both arts, a role that he greatly enjoyed, most notably by opening another photography studio. In the 1920s and 1930s his style changed under the influence of European photography. In order to bring the new modernist visual language to Japan, in 1932 he co-founded the magazine *Koga* with the photographers → Iwata Nakayama and → Ihei Kimura. Despite its short existence, *Koga* marked an important step in the development of the → New Objectivity movement in Japan.

● N —

Norfolk, Simon (b. 1963) British documentary and landscape photographer. Born in Lagos, Nigeria, Norfolk studied at the universities of Oxford and Bristol, earning degrees in both philosophy and sociology. Beginning his career as a photojournalist for far-left publications, in 1994 he decided to focus on landscape photography. His work examines the theme of war and its manifold effects on the natural environment, cities, social memory and more. Some of his most recognized images were produced in Afghanistan and Bosnia. Norfolk has published numerous monographs. Aside from his work for a variety of journals, including → *National Geographic*, he received the Prix Dialogue at the Rencontres d'Arles (2005), the Infinity Prize from the International Center of Photography, New York (2004), the Foreign Press Club of America Award (2003) and the European Publishing Award (2002).

Nori, Claude (b. 1949) French photographer and publisher. Nori made a substantial mark on the photographic scene during the 1970s and 1980s with the creation of Contrejour, a gallery and publishing house that became the rallying point for contemporary French photography. As publisher, author and photographer, Nori champions the cause of photobiography, in which the camera is a means of connecting with the world at large, and particularly with women, one of his favourite subjects. Together with → Jean-Claude Lemagny, → Gilles Mora, → Bernard Plossu and → Denis Roche, he also co-founded the Cahiers de la Photographie publishing series.

Notman, William (1826–1891) British-born Canadian photographer. Notman emigrated to Canada in 1856 and established a photographic studio in Montreal. He had great success in the portrait industry, but was recognized also for his landscapes, street views, composite images and scenes of Canadian life. In 1858 the Grand Trunk Railway commissioned Notman to document the construction of the Victoria Bridge in Montreal; at the government's request, he combined the photographs into a commemorative portfolio that was presented to the Prince of Wales. Notman was subsequently declared 'Photographer to the Queen' (1860). He was a savvy businessman, and his enterprise expanded across Canada and the United States to include studios in Toronto, Halifax and Boston.

Nude photography The history of photographing the naked human figure is closely linked to painting. In the 19th century photographers such as → Wilhelm von Gloeden, → Fred Holland Day

Claude Nori,
Biarritz, 1980

and → Thomas Eakins took their inspiration from painted allegorical or mythological subjects. At that time, photographs of the nude also served as models for anatomical drawings or were for private use only. Small-format → daguerreotypes, showing women in lascivious, erotic poses, first appeared in the 1840s. During the 1920s the nude became the subject of formal explorations before the arrival of the modernist and → Surrealist movements, and major practitioners including → Bill Brandt, → Imogen Cunningham, → Man Ray, → Brassaï and → André Kertész. From the 1960s onwards, the genre began to use the representation of the naked body as an exploration of identity or feminism, as in the work of Hannah Wilke. The nude gave way to nudity, in so far as contemporary photography has detached itself from its historic precedents. Today nudity has become an element of works in which naked bodies are simply shown as they are (→ Larry Clark) or in fragments (→ John Coplans). Although nude photography, generally in black and white, predominantly consists of pictures taken by men of the female body (Ruth Bernhard is one of the few women to have photographed female nudes), sometimes with erotic or even pornographic connotations (as in the work of → Nobuyoshi Araki), there are also nude images of males, by such figures as → George Platt Lynes and → Robert Mapplethorpe. Nude images of children and adolescents – those by → Edward Weston, Jock Sturges and → Sally Mann, for instance – are less common and frequently controversial, owing to the sexual implications with which the genre of the nude is often spontaneously associated.

Nueva Lente (1971–1983) During the 1970s militant Spanish photographers, anxious to play a role in the counterculture of the day, founded the magazine *Nueva Lente* ('New Lens') and developed a form of disruptive photography that was characterized by parody, irony, ambiguity, a degree of anarchy and, above all, powerful imagination. Originally edited by Pablo Pérez-Mínguez and Carlos Serrano (1971–75), and then by Jorge Rueda, Luis Pérez-Mínguez and → Joan Fontcuberta (1975–78), the magazine had the watchword: 'Vale todo'

William Notman, *Self-Portrait*, 1866–67

● N —

('Anything goes'). This creative freedom was used to open up the photographic field to cover history and semiology, to pit the medium against other artistic disciplines, and to enhance the impact of underground culture by creating → photomontages of great visual violence, akin to Dadaist works and the Spanish fantastical tradition embodied by Francisco Goya and Salvador Dalí.

OP

Oil pigment print A process invented by André Hachette, and derived from G. E. H. Rawlins's oil process of 1904. The oil pigment process required good-quality paper and was able to produce multiple → prints. The look of the final print was affected by the type of press being used and the quantity of ink that had been applied. It was, for a time, one of the most popular print processes in the early 20th century, but went out of fashion with the decline of → Pictorialism.

Ojeikere, J. D. 'Okhai (1930–2014) Nigerian photographer. Ojeikere worked for West African Publicity (1963–75) before opening his own studio, Foto Ojeikere. From 1968 he organized a photo library of Nigerian culture systematically divided up into themes. His 'collective work', *Hairstyles*, comprises over 1,000 prints of women's hair taken with a → Rolleiflex 6 × 6, generally from behind, so that it resembles abstract sculpture.

Olaf, Erwin (b. 1959) Dutch photographer. Olaf won first prize in the Young European Photographer competition with his *Chessmen*

(1998). He has twisted the aesthetic conventions of → fashion photography with several provocative → series full of sophisticated images and subtly staged scenes (*Fashion Victim*, 2006; *Grief*, 2007), combining photographs and videos that explore perception, the unspeakable, emotions, conventions and issues of marginality.

Olson, Lennart (1925–2010) Swedish photographer. Olson is known for his abstract style and his pictures of bridges, a theme he explored until the 1990s. A pivotal point in his career was a visit to Paris in the 1950s, where he became friends with the abstract artist Olle Baertling and the first director of the Moderna Museet in Stockholm, Pontus Hultén. These contacts inspired him to develop the photographic medium towards abstraction and non-figurative art. Olson was a member of the Ten Photographers group, founded in 1958. In the 1960s he made several documentaries for Swedish television.

Onodera, Yuki (b. 1962) Japanese photographer. In 1984 Onodera graduated from the Kuwasawa Design School in Tokyo. After receiving the

Gabriel Orozco,
Cat in the Jungle, 1992

New Cosmos of Photography Award in 1991, she moved to Paris. In 1995 she came to attention after her solo exhibition *Down*, held at three different locations in Tokyo. The same year, she began exhibiting her series *Portrait of Second-Hand Clothes*. In 2003 Onodera received the Kimura Ihei Award.

Orive, María Cristina (b. 1931) Guatemalan photographer. Born in Antigua, Orive is Guatemala's first, and arguably most famous, female professional photographer. She trained as a journalist and spent fifteen years working as a newspaper and television correspondent in Paris before beginning her career as a photojournalist. In 1973 Orive founded La Azotea together with the Argentine photographers → Sara Facio and → Alicia D'Amico. Based in Buenos Aires, it was the first female-owned and -operated photography publishing firm in Latin America, and continues to promote the work of

female Latin American photographers as well as pioneers of Latin American literature. The book *Actos de fe en Guatemala* (1980) is Orive's best-known photographic work. A collaboration with Facio, the volume was published by La Azotea and documents the indigenous beliefs of Guatemala.

Orozco, Gabriel (b. 1962) Mexican artist. Orozco studied at the National School of Plastic Arts in Mexico (1981–84). His work is based on two main ideas – movement and symmetry – which are conveyed by simple gestures and a variety of media (principally sculpture, photography, installations, drawings and paintings). He focuses a poetic gaze on familiar objects (*Atomist*, 1996), blurring the borders between art and everyday reality. His nomadic way of life, chance encounters and the use of *objets trouvés* play an important role in his art (*Yielding Stone*, 1992). Photography presents him with a means of

● O —

seizing on these accidental associations, which often lead to photographs within photographs. In 2009 the → Museum of Modern Art in New York mounted a large-scale solo exhibition of his work.

Ortiz-Echagüe, José (1886–1980) Spanish photographer. A leading light of → Pictorialism, Ortiz-Echagüe projected a glorious image of Spain by focusing on its traditions and folklore, as can be seen from his four major publications: *Tipos y Trajes* (1930), *España, Pueblos y Paisajes* (1939), *España Mística* (1943) and *España, Castillos y Alcázares* (1956). He preferred rustic scenes, remote from contemporary preoccupations. Aside from their refined quality, his photographs contributed to the politics of national representation, which made them a model

for the official iconography of the Franco regime.

O'Sullivan, Timothy (1840–1882) American photographer. O'Sullivan took his first photographs towards the end of the 1850s, when he was employed by → Mathew B. Brady to work in his Washington studio, under the direction of → Alexander Gardner. It was as a member of this team that he took his first pictures of the American Civil War. He collaborated once again with Gardner when the latter opened his own studio in Washington. A number of O'Sullivan's war photographs appeared in the book *Gardner's Photographic Sketchbook of the War*, which Gardner published in 1865. O'Sullivan was invited to join Clarence

Timothy O'Sullivan, *A Harvest of Death,
Gettysburg*, 1863

King's exploratory expedition along the 40th parallel, between the Sierra Nevada and the Rocky Mountains (1867–69). This project was financed by the war department. Between 1871 and 1873 he accompanied George Wheeler on a geological expedition west of the 100th meridian, in the region of the Grand Canyon and Death Valley. In the quest to assess the land's potential for settlement and the exploitation of natural resources, he was the first photographer to do a complete → photographic survey of Nevada, Utah, Colorado, Idaho and Wyoming. His images of desert landscapes and his portraits of the Navajo Indians, published in various albums when he returned home, made him famous.

Ouka Leele [Bárbara Allende Gil de Biedma] (b. 1957) Spanish photographer. Ouka Leele was one of the major figures in the Movida Madrileña, the outpouring of creativity that followed the death of Franco. Her famous series *Peluquería* portrays people with fantastic coiffures crowned with lemons, iguanas and so on. She coloured the images by hand in the acidic tones of the Pop generation, following the conventions of advertising and illustration, both of which she practises.

Outerbridge, Paul (1896–1958) American photographer. Outerbridge was one of the most gifted artists of his era. With their natural sense of style, precision and formal elegance, his black-and-white cubist compositions of household objects are today counted among photography's greatest masterpieces. His combination of high style and product marketing brought Outerbridge great success in New York, where was a pioneer in → advertising photography. Moving to Paris in 1925 and meeting fellow artists including → **Man Ray**, Francis Picabia, Georges Braque, Igor Stravinsky, Pablo Picasso and others, he enjoyed a brilliant social life, taking in Berlin and London as he made photo illustrations for fashion magazines and tried his hand in the movie industry. In 1929 he returned to New York, where he worked on the tri-colour → carbro printing process, and for the next decade he photographed exquisitely staged

studio depictions of modern urban life as cover illustrations for the new colour magazines. Privately he made masterful nudes and still-lifes that were charged with an erotic decadence that connected him to the Bohemian scenes of Paris and Berlin. In 1943 Outerbridge moved to California, where he explored a new visual language, taking colour photographs in the streets of California and Mexico. This endeavour was cut short by his premature death at the age of 62.

Overexposure A problem that occurs when a photosensitive surface (either → emulsion or a digital sensor) is exposed to more light than is required to take a clear picture. Overexposure results in a → positive image that is too pale.

Page, Tim (b. 1944) British photographer. During the 1960s Page covered various conflicts in Vietnam, Cambodia, Laos and Thailand. A dedicated photojournalist, he has been wounded several times. Most of his photographs are in colour, and he has published several books, including *The Mindful Moment* (2001), in which his photographs are accompanied by a personal account of his work as a photojournalist.

Paillet, Fernando (1880–1967) Argentinian photographer. Born in the town of Esperanza, Paillet learnt photography at the studio of Julio Enrique Polzinetti and then travelled to Santa Fe in 1898 to work in the studio of Augusto Lutsch. Paillet photographed his subjects both in the studio and outdoors, becoming well known for his social realist documentation of the town of Esperanza. His images constitute a valuable historical archive.

Painlevé, Jean (1902–1989) French film director. Painlevé was famous for his documentaries on marine creatures such as the seahorse, which were recognized as much for their artistic as for their scientific qualities. A man of many facets, he soon turned to photography to enrich his cinematic work. He made around 200 films that take us into a mysterious, unknown world of strange forms and poetic beauty.

• P —

Palladium process (palladiotype) A monochrome non-silver photographic process that uses palladium, a metal found in copper and nickel ore, to produce a photographic image through a → contact printing process. Known for its warmer tones and for being a more cost-effective alternative to its platinum counterpart, the palladium print is highly regarded for its chemical stability and permanence.

Palma, Luis González (b. 1957) Guatemalan photographer. One of Central America's most important artists, Palma originally trained to be an architect although he has since made a name for himself as a self-taught photographer. As a *mestizo*, or person of mixed Maya and European heritage, Palma is interested in unearthing the legacy of colonial racism and subjugation that still affects Guatemala's indigenous peoples. His portraits of Maya often incorporate religious or iconic imagery, such as angel wings or thorns. Through this symbolism, Palma explores the liminal realm between mysticism and violence historically inhabited by the Maya, aiming to elevate and give voice to an oppressed culture. Palma, who describes himself as a romantic Postmodernist, sometimes manipulates the surface of his prints, scratching or tearing them, using → collage or adding layers of pitch to achieve a characteristic sepia tone.

Pam, Max (b. 1949) Australian photographer. Feeling bored and disenfranchised growing up in well-to-do suburban Melbourne, Max Pam left his native Australia in 1969 to seek adventure in foreign countries. Travelling through Asia, Pam documented his encounters with an extraordinarily diverse series of locals, from priests to prostitutes. Making photographs that were forensic and evidential in nature but fictional in intent, Pam recorded a series of experiences that seemed as fascinating as those of Tintin and other heroes of children's literature. His journal, portions of which are written directly on his photographs, provides a finely crafted dramatic narrative that is as enigmatic and dreamlike as the photographs. Using plastic cameras and creating close-up, distorted portraits of his subjects, Pam discovered how to make his journeys into a stage for a photographic soliloquy about his encounters with the exotic 'other'. Pam currently teaches photomedia at Edith Cowan University, Perth.

Panoramic photography A technique that produces photographs with a field of view of between 100° and 360°. Panoramic photographs can consist either of multiple images stitched together or single images taken with a panoramic camera. These may have a rotating → lens (also called a swing lens), or the entire camera may rotate (slit-scan photography). Although usually horizontal, panoramic images can also be vertical.

Paparazzo A photographer who specializes in capturing images of celebrities going about their everyday lives. Paparazzo photography combines → street photography, → photojournalism, → documentary photography, celebrity photography and surveillance. It has its roots in Italy in the 1960s, when film stars were photographed in Rome, especially on the Via Veneto, and the term is derived from the name of a photographer in Federico Fellini's film *La Dolce Vita* (1960). This style of photography is characterized by its speed, indiscretion, disregard for privacy, and even for its violence. It has introduced new codes into the aesthetic of photographic realism: images that are off-centre, grainy or blurred encourage viewers to believe that they are seeing a stolen moment. Despite its claims of truthfulness, paparazzo photography also courts controversy, since apparently 'real' scenes sometimes turn out to be staged. While the paparazzi are often seen en masse, the pursuit of exclusive stories leads to fierce competition between individual photographers, and their images are often the subject of lucrative business deals with agencies.

Pardington, Fiona (b. 1961) New Zealand photographer. She is known for her romantic, sensuous images. Her early work, often erotically charged, focused on the male body. Since 2000 she has photographed Maori items in museum collections. In these images she counters the decontextualizing effect of museums by

Trent Parke, *Outback, New South Wales. Menindee. Midnight,*
Australian Photographer Trent Parke by Himself, 2003

bestowing on the objects a sense of living energy. Her more recent work depicts life casts taken during early voyages of exploration in the Pacific.

Parke, Trent (b. 1971) Australian photographer. He is known for his distinctive personal projects and for his photojournalism. He began his career photographing sporting events. He joined → Magnum Photos in 2002 and became the only Australian full member in 2007. In 2003 Parke was awarded the W. Eugene Smith Award for *Minutes to Midnight*, a personal body of work shot over the course of two years as he travelled across Australia. His photojournalism has received several prizes from World Press Photo and other organizations.

Parkinson, Norman [Ronald William Parkinson Smith] (1913–1990) British photographer.

Parkinson is considered to be one of the founding fathers of modern → fashion photography. He is noted in particular for being the first to take fashion photographs outside the studio, in commissions for → *Life* and → *Vogue* during the 1940s and after. His long collaboration with fashion magazines had begun with → *Harper's Bazaar* following his establishment of a London studio with Norman Kibblewhite in 1934, and his work later took him to all corners of the globe. Some of his images became classics in their own right, showing models posing in the street or in exotic settings. Parkinson was also well known for his photographs of celebrities, and he was appointed official photographer to the royal family.

Parks, Gordon (1912–2006) American photographer. Parks was one of the first African-

● P —

Martin Parr, *Benidorm*, 1997

American photographers to achieve international recognition. Self-taught, he acquired his first camera in 1937. Well known for his fashion photographs, he also contributed to the → Farm Security Administration project in 1942. But above all he was famous for his numerous black-and-white studies of the harsh living conditions endured by African Americans and their fight against segregation (he covered the deaths of Malcolm X, Martin Luther King and others), which were published in → *Life* from the 1940s to the 1960s. He founded the magazine *Essence* and took portraits of many celebrities, including Muhammad Ali. In his later years Parks turned to still-lifes and landscapes in colour.

Parr, Martin (b. 1952) British photographer. Parr studied photography at Manchester Polytechnic (1970–73) and has been a member of → Magnum since 1994. Although his field is → documentary

photography, he plays with the boundaries and conventions of his chosen genre in order to present his own personal view of contemporary society in Britain and around the world. He records the banal actions of everyday life, humorously highlighting the individual habits and shortcomings of individuals or groups. His exaggerated colours and contrasts, and his regular use of close-ups, enable him to accentuate the grotesque elements of a scene at the same time as producing sharp-eyed but subtle sociological portraits. His ironic approach to different types of consumerism – tourism, food, leisure, shopping, fashion, luxury and communications – implicitly raises questions about the contradictions inherent in globalized society. His images encourage viewers to reconsider their own behaviour and preconceptions, as well as helping them to laugh at themselves. Boredom (*Bored Couples*, 1993),

overeating (*Common Sense*, 1999) and mobile telephones (*The Phone Book*, 2002) are common to all social classes. Parr's gaze spares neither the conventions of the middle classes nor the excesses of the affluent (*Luxuries*, 2009). But he refrains from passing summary judgments and seeks to show social ambiguities through a perspective that, even if at times it can be witheringly ironic, is nevertheless imbued with a degree of tenderness.

Parry, Roger (1905–1977) French photographer and illustrator. Experimenting with different photographic processes, Parry worked as an assistant to → Maurice Tabard, with whom he designed covers and advertising posters for the *Nouvelle Revue Française*. His real breakthrough in publishing came in 1930, when he illustrated Léon-Paul Fargue's *Banalité*. At that time he was also the official portraitist for the Gallimard publishing house. In 1959 he worked on André Malraux's 42-volume collection *L'Univers des formes*, for which he designed the dummies and eventually became technical director.

Patellani, Federico (1911–1977) Italian photographer. After World War II, Patellani joined forces with the magazine *Tempo* to immortalize the innumerable beauty contests that were being held all over Italy. These spectacles produced future stars such as Gina Lollobrigida and in turn lured Patellani back to his first love, the cinema. From 1950 onwards he drew on the world of film for inspiration and documented many of the movies that made their mark on the history of Italian cinema.

Pécsi, József (1889–1956) Hungarian photographer and writer. Pécsi studied at art school in Munich. In 1919 he was awarded first prize in the International Photo Exhibition in Budapest. In his studio, which he opened in 1911, Pécsi produced mainly portraits and images for advertising purposes, but also nudes and ethnographic photographs. He experimented with archaic techniques, including the → bromoil, → albumen and → palladium processes, though his aesthetic was influenced by modernist styles. His photographs are characterized by the natural

poses of his models and his skilful combinations of light and shadow. Pécsi exhibited in New York, London and Cologne. He achieve worldwide recognition with his book *Fotó és reklám* ('Photography and Advertising'), published in Berlin in 1931.

Peirce, Charles Sanders (1839–1914) American logician and philosopher. Founder of the philosophy of pragmatism, Peirce was a pioneer of modern logic and → semiotics. After studying at Harvard, he entered the US National Geodetic Survey. His theory of signs and his notion of the index had an important impact on theories of photography during the 1970s.

Pellegrin, Paolo (b. 1964) Italian photographer. Pellegrin trained at the Italian Institute of Photography in Rome. He produced numerous → reportage series, most notably from the Balkans, Africa and Libya, was a member of the

Roger Parry, illustration from
Léon-Paul Fargue's *Banalité* (1930)

• P —

agency Vu (1991–2001) and has been a member of → Magnum since 2005. His work has won many prizes, including a World Press Photo Award and the Robert Capa Gold Medal, and is frequently exhibited.

Penn, Irving (1917–2009) American photographer. Penn is known principally for his fashion photographs, portraits and still-lifes. He studied design under → Alexey Brodovitch at the Philadelphia Museum School of Industrial Art (1934–38). While he was still a student, Brodovitch helped him have his drawings published in → *Harper's Bazaar*, and Penn subsequently designed advertisements for Saks in New York (1940–41). In 1942 he went to Mexico in order to paint, and on his return to New York he was engaged by the artistic director of → *Vogue*, → Alexander Liberman, to design its covers. Liberman encouraged him to take his own

photographs. His first cover, on the issue of 1 October 1943, showed a colour still-life – a genre of which Penn remained a master throughout his career. A year later he took his first fashion photographs. This was the beginning of a fruitful collaboration with *Vogue* and other Condé Nast publications, interrupted only by military service from 1944 to 1946. In 1950 he married the model Lisa Fonssagrives, and with her created several iconic fashion images. He followed a particular photographic procedure right through to the day he died. No matter whether his subjects were celebrities, models or Mr and Mrs Average, he photographed them in the studio against a neutral background and under natural light. He also used a portable studio, especially during his journeys to Cameroon (1969), New Guinea (1970) and Morocco (1971), where he took portraits of indigenous peoples. After 1964 Penn printed all his photographs using the → platinum process.

— P •

Gilles Peress, *Rioters Throw Stones at a British Armoured Car, Derry*, 1972

Peress, Gilles (b. 1946) French photographer. Peress became a photographer after studying political science and made his name with in-depth → reportages from zones of conflict, most notably the Troubles in Northern Ireland, the genocide in Rwanda and the war in Bosnia. His coverage of the Islamic Revolution in Iran led to the publication of *Telex Iran* (1979), in which he offered a vision of events that was both documentary and subjective, halfway between historical and personal. Peress has been a member of → Magnum since 1971 and is currently a professor of photography and human rights at Bard College, New York.

Pérez Bravo, Marta María (b. 1959) Cuban photographer. Born in Havana, Pérez Bravo studied at the Fine Arts Academy in San Alejandro from 1975 until 1979, and then at the National Art School in Havana from 1979 until 1984. She now works in Mexico and is well known for her black-and-white photographs that reveal her own body and Afro-Cuban origins.

Pérez Siquier, Carlos (b. 1930) Spanish photographer. Co-founder of the AFAL group and its eponymous magazine in the 1950s, Pérez Siquier first made his name with his → humanist photographs of the district of La Chanca in Almeria. During the 1960s, he used colour and close-ups to photograph the first sun-worshipping tourists to flock to the Spanish coasts. His witty images recall the aesthetics of Pop art and → Photorealism.

Performance and photography Since the 1960s and 1970s the term 'performance' has been used to designate ephemeral artistic practices including Happenings, Fluxus events and other live actions. The use of photography in performance art has grown since its early days. Above all, the photograph is a document that allows for the recording, distribution and reproduction of performances designed to take place in a single location, at a single time, with or without an audience. Artists such as Allan Kaprow, Chris Burden, Rudolf Schwarzkogler and Yves Klein were fully aware of photography's documentary function, as well as its artistic

potential, and used it to ensure that a visual record of their works would survive. Indeed, some images have become veritable icons, generating all kinds of myths surrounding the performance, as with Chris Burden's *Trans-Fixed* (1974). In addition to serving as a record, the photograph often assumes the status of a work of art in itself when it plays an integral role in the creative process, especially for artists such as Gina Pane, → Urs Lüthi and → Gilbert & George.

Peryer, Peter (b. 1941) New Zealand photographer. Peryer came to prominence in the mid-1970s with his blurry, highly personal images taken on a toy Diana camera. His subsequent, harder-edged work has covered a wide range of subject matter and is less easy to categorize, although there are some consistent themes. These include unsettling ambiguities of scale, a focus on solitary, human-like objects, and evocations of utilitarian forms of photography such as scientific and technical images. The focus of his body of work continued unchanged after Peryer adopted colour → digital photography in the 2000s. His major publications are *Second Nature* (1995) and *Peter Peryer: Photographer* (2008).

Peterhans, Walter (1897–1960) German photographer and teacher. After studying mathematics, philosophy and art history in Göttingen and photographic techniques in Leipzig, Peterhans opened his own portrait and commercial studio in Berlin in 1927. On the invitation of Hannes Meyer, he joined the → Bauhaus to become professor of photography (1929–33) and director of the photography department. When the school closed in 1933 he continued to teach in Germany before eventually emigrating to the United States in 1938, where he gave courses at the Illinois Institute of Technology, Chicago.

Petersen, Anders (b. 1944) Swedish photographer. From 1966 until 1968 Petersen studied at the Fotoskolan photography school and from 1973 until 1974 at the Institute for Cinema, Radio, Television and Theatre, both in Stockholm. In 1967 he and Kenneth Gustavsson founded

• P —

the Saftra group, which later became the Mira Bildarkiv agency. During the 1970s Petersen compiled photo stories for several Swedish magazines. He became famous for his encounters with men and women who led unconventional lives, whom he met and photographed in black and white in a Hamburg bar. He has taught photography at various schools and is regularly seen in studios in Sweden and abroad, especially at the Rencontres d'Arles photo festival. He has exhibited his work all over Europe and was the subject of a retrospective at the Hasselblad Center in Gothenburg in 1997. Petersen lives and works in Stockholm.

Petit, Pierre (1832–1909) French photographer. Petit learnt photography in 1849 in the studio of → André-Adolphe-Eugène Disdéri. In 1859 he began work on the huge *Galerie des hommes du jour*, a collection of portraits showing figures of the day, with accompanying biographical notes, which was published in 1861. He also took more than 2,500 portraits of bishops and clergymen.

Petrusov, Georgy Grigorievich (1903–1971) Russian photojournalist. Born into an Armenian family in Rostov-on-Don, Petrusov became a photojournalist in 1924 and worked for magazines published by trade unions in the chemistry and metal industries. He was a member of the October group, compiled many stories on industrial themes and also covered the fall of Berlin in 1945. His work is striking for its Constructivist style and its perfect control of composition and contrast.

Petschow, Robert (1888–1945) German photographer. Petschow was a self-taught photographer who loved hot air balloons, pursued a military career and was an aerial observer in both world wars. He was a pioneer of → aerial photography and of the documentary landscape. Petschow's images were displayed in the → *Film und Foto* exhibition (Stuttgart, 1929) and elsewhere. He was also editor of the magazine *Die Luftfahrt* and illustrated Eugen Diesel's highly successful book *Germany and the Germans* (1931).

Petzvál, József Miksa (1807–1891) Hungarian-born mathematician, inventor and lecturer. In 1840 Petzvál's studies in the field of optics led him to invent the first geometrically corrected achromatic high-speed photographic → lens, the so-called 'Petzvál lens' (1:3.5, f = 16 cm). This invention reduced exposure time from minutes to seconds, making it the first special 'portrait lens'. Today streets in Budapest and Vienna bear Petzvál's name.

Photo-booth (photo kiosk) A machine first patented in 1924–25 (under the name 'Photomaton') by the American Anatol Marco Josepho. It automatically takes, develops and prints photographs – generally between three and six small-format portraits, printed in a strip or square – inside a booth that serves as both a studio and a lab. It is used primarily to take passport and identity photos or for entertainment. Originally producing only black-and-white prints, photo-booths converted to colour in the 1970s. By the late 1990s they were equipped with a digital camera, a video screen and a thermal printer. The potentially playful quality of the pictures, the intimacy of the closed booth and the serial nature of the images have led many artists – including the → Surrealists, → Andy Warhol, Francis Bacon and Susan Hiller – to embrace photo-booth pictures as a means of expression.

Photo League A cooperative of American documentary photographers founded in New York in 1936. Its purpose was to give the medium a significant role in the era's social and political struggles. During the 1940s the League opened itself up to new approaches, promulgating the view that photography was a medium for subjective expression. It provided laboratories, meeting places, a gallery for exhibitions, and courses in photography. It also financed projects, such as → reportages documenting the different districts of New York, and published a periodical called *Photo Notes*. Because of its desire for social engagement, however, it fell victim to McCarthyism and in the late 1940s was blacklisted as a subversive organization. The League responded by mounting the exhibition

Anders Petersen, *Mental Hospital,*
Drevviken, 1995

This Is the Photo League in 1949, which was finally forced to shut down in 1951. Many great names had been members and had exhibited their works there, including → Paul Strand, → Aaron Siskind, → Berenice Abbott and → Ansel Adams.

Photogenic drawing A photographic image that reproduced the outlines of an object without the use of a camera. An ancestor of the → photogram, it was discovered by → William Henry Fox Talbot in 1834, who placed various items and botanical specimens on a sheet of paper that had been sensitized with an → emulsion of salt and silver nitrate. After exposure, the paper darkened in the areas that had been exposed directly to the light, while the areas obscured by the objects remained white. The resulting negative image was then fixed using a saline solution. Following

these early experiments Talbot developed a paper negative process, the → calotype, in 1839.

Photogram A photographic print made without a camera by placing an object between a light-sensitive surface and a light source. The object prevents the light from reaching the surface and thus creates a pale silhouette against a dark background. The photogram technique predates the invention of photography: as early as 1802, → Thomas Wedgwood and Humphry Davy had published a method for copying images onto leather or paper impregnated with silver nitrate. The images created in this way could not, however, be fixed. In 1839 → William Henry Fox Talbot produced photograms that could be fixed once the image had been developed. He placed plants and flat objects on light-sensitive paper

• **P** —

and called the results → 'photogenic drawings'. At around the same time → Hippolyte Bayard used an identical process to reproduce plants, feathers and fabrics. In the 20th century, photograms were made by → Christian Schad, → László Moholy-Nagy and, perhaps most famously, → Man Ray, who called them → 'rayographs'.

Photographic essay A method of publishing photographs in → series that first appeared in the → illustrated press of the early 20th century. The American picture weekly → *Life* ran a section called 'The Photographic Essay' or 'The Pictorial Essay' from 1937 to 1962. By publishing such photographic essays as 'Country Doctor' (1948) and 'Nurse Midwife' (1951), both by → W. Eugene Smith, *Life*'s editors in effect defined the term, which today is understood to mean a series of photographs that present a point of view about a subject or an event, wherein the text is supplementary to the images.

Photographic News British weekly magazine published between 1858 and 1908. *Photographic News* was launched in September 1858 and was unaffiliated with any of the → photographic societies. Its main focus was technical advances in the medium, though it also included reviews of exhibitions and literature about photography. It remained the most influential photography journal until the mid-1880s. In 1908 it merged with → *The Amateur Photographer*.

Photographic societies Organizations that, together with camera clubs, provided → amateur photographers with a forum for communication, exhibitions and publications. The first clubs appeared in the 1840s as loosely organized groups, one example being the Photographic Club in England. By the 1850s more organized photographic societies, such as the → Société Héliographique and the Photographic Society (later called the → Royal Photographic Society), had formed. These organizations emphasized both the science and art of photography. The Photographic Society also contained within its fold the Photographic Exchange Club, in which the members of this select group made enough prints to exchange with their fellows. With the

László Moholy-Nagy,
Photogram, 1926

advent of roll film and the democratization of photography in the 1880s, amateur artists banded together to form camera clubs. Like their predecessors, these clubs provided a forum for the exchange of ideas, published journals and organized photography exhibitions. However, their focus was primarily on promoting photography as art, and they championed the → Pictorialist style. Clubs operated worldwide, with the most influential being the Photo-Club de Paris, formed in 1888; the → Brotherhood of the Linked Ring, formed in England in 1892; and the → Photo-Secession, established in the United States in 1902.

Photographic survey A project intended to document a particular location or community, usually involving multiple photographers. It is distinct from a commission in that the photographers are usually granted greater freedom while operating within certain set boundaries. In the broadest sense, the remit of the photographic survey generally covers

P •

the genres of → landscape and/or → portraiture. Historically, surveys of this kind were often commissioned by a region's governing institutions, with the aim of establishing or promoting a local identity: surveys may thus display political as well as aesthetic aspects. Photographic surveys began in the 19th century with the → **Mission Héliographique** in France (1851); this was followed by surveys of the American West in the late 19th century and, later, by the photographic department of the → **Farm Security Administration** (1935–43). In the last two decades of the 20th century, France in particular saw the genesis of a number of surveys led by → DATAR: notable among these were the Mission du Conservatoire du Littoral (1985 onwards), Quatre Saisons du Territoire (1987–90), the Mission Transmanche (1988–2006), and the Observatoire National du Paysage (1994 onwards). Similar surveys have been carried out in Italy, the Netherlands, Belgium and Germany.

Photographie plasticienne A concept developed by the French art critic Dominique Baqué and explored in two books, *La Photographie plasticienne, un art paradoxal* (1998) and *Photographie plasticienne, l'extrême contemporain* (2004). These followed up ideas raised in exhibitions curated by Michel Nuridsany (*Ils se disent peintres, ils se disent photographes*, 1980) and → Jean-François Chevrier (*Une autre objectivité*, 1980). Dominique Baqué offers an analytical overview of photographic practices that began in the 1970s and became integrated into the realm of contemporary art. The term 'photographie plasticienne' is used to cover a multiplicity of practices whose shared features are the rejection of any utilitarian purpose, a break from the concept of the → 'decisive moment' and a shift away from → art photography. The camera is integrated into these art practices as a tool. Baqué traces the origins of this use of photography to the art movements of the 1960s, most notably the practices of → conceptual art, → land art and body art. Photography, which was originally used as a way to document these artistic acts, gradually became the means through which this art existed. The umbrella heading of 'photographie

plasticienne' groups together the appropriation art practised by → Sherrie Levine and → Barbara Kruger, the highly personal works of → Nan Goldin and → Sophie Calle, the explorations of memory carried out by → Christian Boltanski, the critique of stereotypes presented by → Cindy Sherman and Orlan, and the tableau-style photographs of → Jeff Wall and → Andreas Gursky. In her second book, Baqué broadened the field of discussion, to include works that explore the representation of the city and the land, the 'post-human' aesthetic, and the revival of → documentary photography by means of → portraiture.

Photography books A branch of publishing that could be understood as including a variety of publications, ranging from books that contain just a few photographs to illustrated titles created especially to highlight the medium. This entry is concerned only with the latter. Compared with the illustrated magazine, which developed during the 19th century, the greater flexibility offered by book publishing made it a veritable laboratory for the photographic image. As the medium of communication *par excellence*, it rapidly became an instrument of legitimization rather than just a means of distribution. Photographers took full advantage of the book format to promote the quality of their work by presenting sequences of images and paying attention to page layout and the interplay between text and image. Publications of this kind first entered the scene in the mid-1840s, with → William Henry Fox Talbot's *Pencil of Nature.* From then on, photographers were keen to follow suit and claim a greater status for their medium through such books as → Peter Henry Emerson's *Life and Landscape on the Norfolk Broads* (1886), → László Moholy-Nagy's *Malerei, Fotografie, Film* (1925) and → Henri Cartier-Bresson's *Images à la Sauvette* (1952). Some photographers join up with other talents to produce true 'artist's books', formed according to their own concepts of the book in relation to photography; a good example is → Kikuji Kawada's *Chizu* (1965). With the recent boom in self-publishing, there has been a marked increase in works of this type, surely connected with the great switch to

• P —

digitalization and improvements to all aspects of the medium.

Photography industry The commercial aspects of photography, which can usefully be divided into categories: the technical and the cultural. The former encompasses technological services, with a focus on mass production: the manufacture of cameras, → lenses and other equipment, printing services, etc. The latter refers to the commercial role of photography in the media, including press, publishing and advertising. The industrialization of photography began in the late 19th century. Following the foundation of → Kodak in 1888, photography became accessible to the general public. The craftsmanship of early photographic techniques did not disappear completely, but their place was taken by standardized mass production. Lightweight cameras, roll film and print-on-demand services appealed to both amateurs and professionals. In the press and publishing fields, it was the development of → photolithography that first made the mass distribution of photographs possible. The analogue photography industry prospered for a century, until the 1990s and early 2000s, when the advent of → digital photography took the industry into a period of major change. The boom in sales of digital cameras, image-editing software and printers has had a damaging effect on traditional businesses, whereas new businesses that benefit from strong online presences work more closely with the digital photography industry.

Photogravure An intaglio mechanical printing process for reproducing photographs, used since the late 19th century. A light-sensitive copper plate is placed in contact with a transparent → positive and exposed to light. The plate is then put through successive acid baths until it has obtained a depth of etching that will make it capable of reproducing the continuous tones of a photographic image. The engraved plate is inked and wiped, and the remaining pigment is then printed onto a paper support. The photogravure process became well known owing to the excellent tonalities published in → Alfred Stieglitz's journal → *Camera Work*, and

the → Pictorialists in particular appreciated its soft, velvety quality. While rare, the photogravure is still in use for high-end reproduction.

Photojournalism The use of photography to record current events for publication. The adoption of photography by the press at the turn of the 20th century resulted in the creation of a new profession: that of the photojournalist. The news photographer Erich Salomon was one of the first to define the photojournalist's scope. With the rapid expansion of the → illustrated press in Europe during the 1930s, photographers banded together to form agencies, and the profession developed an economy of its own. Light and manoeuvrable cameras such as the → Leica (1924) and the → Rolleiflex (1929) gave the photographers far more mobility and led to an 'on the spot' aesthetic, right at the centre of the action. The photojournalist became an almost mythical figure during and after the Spanish Civil War (1936–39), notably in the person of → Robert Capa, who embodied the ideal of the adventurer scouring the world in quest of an image. This was the beginning of a golden age that lasted until the end of the war in Vietnam (1955–75). Thereafter photojournalism went into decline, partly because of the rise of television and partly because photographers were frequently excluded from scenes of conflict. Fearing that military action would be unpopular with the general population, combatants were keen to control the images that the public saw and preferred to use their own operators. During the 1990s, faced with increasing economic and political problems, some photojournalists turned towards the world of art, publishing and galleries, developing an aesthetic based on their experiences out in the field. Since 1999 the Visa International Festival of Photojournalism has provided a showcase and a meeting place for those engaged in the profession.

Photolithography A technique, first developed in the 1850s, that used the same supports, inking process and printing methods as lithography to produce a printed photographic image. In photolithography, a photographic impression was made by exposing a sensitized stone or

P •

plate under a → negative. Although the process did not allow text and images to be printed at the same time, it nevertheless became the first photomechanical reproduction process to be used industrially to make illustrated books. It also became the basis for several other printing processes, thanks in large part to research carried out by → Alphonse Louis Poitevin, who was awarded the Prix du Duc de Luynes for his work in 1867.

Photomechanical processes Mechanical methods of reproducing a photograph. The term first appeared in the late 19th century, but the concept predates the invention of photography. In the 1820s → Nicéphore Niépce invented → heliography and went into partnership with → Louis Daguerre in 1829. This was followed by attempts to develop a technique that could reproduce a photograph

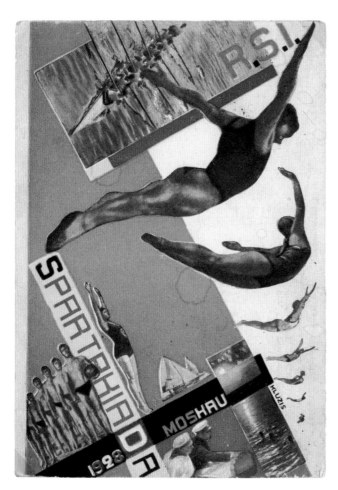

Gustav Klutsis, *Postcard for the All Union Spartakiada Sporting Event*, 1928

simply and cheaply. Early trials were based on the → daguerreotype, but it was not until the invention of the negative–positive process in the 1850s that major advances were made. Research focused on two possible supports (metal plates and lithographic stone) and two substances (bitumen of Judea and gelatin bichromate). In 1855 the Frenchman → Alphonse Louis Poitevin developed a method that combined lithographic plates with gelatin bichromate. He was awarded the Prix du Duc de Luynes for this technique in 1867 by the → Société Française de Photographie, but it remained unsuitable for mass-market reproduction. A similar process, patented by Walter B. Woodbury in 1864, allowed for reproductions of continuous-tone images that were very faithful to the photographic original. Known as the → phototype or Woodburytype, this process reached the crucial stage of being taken up by industry. Current methods of photomechanical reproduction can be divided into three categories: intaglio processes (halftone engraving, heliographic engraving, rotogravure, helioplastic engraving, photoglyphic engraving), planographic processes (offset lithography, Photochrom, → photolithography, screen printing) and relief processes (gillotage, relief halftone, photo-galvanography).

Photomontage A technique that combines two or more photographs from different sources. There are several methods of producing photomontage: several negatives can be developed on the same paper support; images can be cropped and stuck together, and the resulting composite image photographed; and photographs can be manipulated digitally. Photomontage first appeared as a solution to problems of lighting and the need for varying exposure times for different areas within the same photograph, as can be seen in the complex compositions of Victorian photographers such as → Oscar Gustav Rejlander and → Henry Peach Robinson. Many landscape photographers also used the technique to add a cloudy sky to a view created from a separate negative. During the 20th century photomontage was often associated with a critical view of war, but it was also used to create absurd, random juxtapositions, first by

• P —

the Berlin Dadaists (Johannes Baader, George Grosz, → Hannah Höch, → Raoul Hausmann, → John Heartfield) and then by the → Surrealists (Salvador Dalí, → Man Ray, → László Moholy-Nagy). Alongside this experimentation, photomontage became a means of communication for politics and advertising. It was a particularly effective medium for → propaganda in Russia under the influence of Constructivism (→ Gustav Klutsis, → El Lissitzky, → Alexander Rodchenko), and in fascist Germany, Italy and Spain. Its powers of persuasion make it a fascinating subject for study, and numerous theories of montage were developed in both photography and the cinema (Sergei Eisenstein, Lev Kuleshov, Sergei Tretyakov, Walter Benjamin, Bertolt Brecht, Louis Aragon). During the 1960s it reappeared in the work of Pop artists in Britain (→ Richard Hamilton, → David Hockney), and in the United States during the 1970s (→ Jerry Uelsmann and → Martha Rosler, an opponent of the war in Vietnam).

Photomural A photographic print in a very large format, generally used as part of an architectural feature. It became popular between the two world wars. Designed to be seen by large crowds, it can be regarded as a mass medium for publicity, educational or political purposes.

Photorealism An art movement that began in the mid-1960s, mainly in the United States, in which its practitioners broke away from → conceptual art and abstraction and returned to realism. In order to reproduce their subjects as accurately as possible, they used photography. Some artists worked by projecting a photographic slide onto a canvas and tracing the image in paint, while others transferred the image with the help of a grid. Neutrality and objectivity were their buzzwords, and they made great play of the so-called veracity of photography, which was still safely anchored in popular belief.

Photosculpture A technique for producing accurate portrait sculptures. It was invented and patented by the French sculptor and photographer François Willème in 1860. To create a photosculpture, twenty-four photographs were

taken of a sitter simultaneously and from all sides, using a special glass dome with twenty-four camera → lenses embedded in the wall. The resulting photographs were projected onto a screen; the outlines of the subject were then transferred by means of a pantograph, one after another, onto a block of clay that was rotated between each frame. The result was manually smoothed and retouched, cast in plaster and reproduced as a statuette, medallion or bust. Aside from its temporary popularity and the fascination it exerted, photosculpture failed in its aim of enabling the production of cheap sculptures and opening up the mass market. Always considered to be a technique rather than art, it can be understood as an early antecedent of digital 3D printing and rapid prototyping technologies. In the context of 20th- and 21st-century art, the term can also refer to the production of three-dimensional works from photographs or prints.

Photo-Secession Founded by → Alfred Stieglitz in 1902, the Photo-Secession was a group of → Pictorialist photographers that included → Edward Steichen, → Clarence H. White, → Gertrude Käsebier, → Frank Eugene, → Fred Holland Day and → Alvin Langdon Coburn. Its aim was to promote photography as an art form and in particular to champion Pictorialism. It organized exhibitions and in 1903 founded the magazine → *Camera Work* as its mouthpiece. In 1905 it opened the Little Galleries of the Photo-Secession, better known as → 291 (its address on Fifth Avenue, New York), as an exhibition space for its members and avant-garde artists from America and Europe. In 1910, before it closed down for good, the Photo-Secession held its last major exhibition at the Albright Art Gallery in Buffalo, New York. The gallery and magazine continued to exist until 1917.

Photosensitivity The property of certain materials that react to light. In a → gelatin silver print, for example, the photosensitive film is coated with tiny particles of silver that turn dark when exposed to light. In → digital photography, these silver particles are replaced by an electronic sensor.

— P •

Photoshop Image-manipulation software published by Adobe. Developed by the brothers Thomas and John Knoll in the late 1980s, this program, originally called ImagePro, was used to create greyscale images to view on a monochrome display. Adobe bought the licence in 1988, and the first version of Photoshop for Macintosh computers was marketed in 1990. In the digital era, terms such as 'Photoshopping' and 'Photoshopped' have become part of everyday vocabulary, reflecting the new accessibility of digital → retouching to the public.

Phototype An early photomechanical process, developed in the 1860s and designed to overcome the disadvantages of unwieldy stone supports used in → photolithography. The phototype process replaced these supports with copper plates, which speeded up the process of creating matrices and enabled consistent printing. The phototype process played a role in the photography boom of the late 19th century, most notably the rise of printed postcards.

Pictorialism An artistic movement that championed photography as art. The movement emerged in the late 19th century as a response to the accessibility of photography to the masses following the invention of the → Kodak box camera and flexible film. In an effort to differentiate themselves, Pictorialist photographers adopted the means and aesthetics of other arts. They would often use specific lenses to produce soft-focused images, and manipulate both → negatives and → prints to create painterly effects. Craft was a significant element of Pictorialism, and photographers favoured aspects that were difficult to master or required manual intervention, such as → gum bichromate, → bromoil, → photogravure and pigment prints. The decision to use these complicated processes set their work apart from their snapshot counterparts, resulting in images that were grounded in emotion and aesthetic experience rather than simple factual records. Pictorialists often enhanced their work further by displaying it within specialized mounts and frames, which were considered fundamental to the overall artistic effect. Within Pictorialism

there were two distinct camps: those who favoured painterly effects, such as → Heinrich Kühn and → Frank Eugene; and photographers such as → Alfred Stieglitz and → Frederick H. Evans who believed in producing unadulterated prints from untouched negatives. Regardless of their approach, both factions strove to highlight personal expression through their art, ultimately aiming to secure the acceptance of photography as an art form on a level with painting, drawing or watercolour. The popularity of Pictorialism lasted past World War I, although by that time many of the movement's aesthetes had moved on to modernism, rejecting their Pictorialist past.

Pierre et Gilles An artistic partnership formed by the French photographers Pierre Commoy (b. 1950) and Gilles Blanchard (b. 1953). They met in 1976 and began to work together the following year as Pierre et Gilles. The former takes the staged photographs while the latter paints the enlarged prints. The duo's work therefore combines two media. Most of their images are portraits set against an imaginary backdrop and often inspired by fashion or biblical or mythical characters. Their unique style has sometimes been described as kitsch.

Pigment processes A class of non-silver photographic processes that include → gum bichromate, carbon and → carbro. Each use pigments suspended in a dichromated colloid to obtain the final image. Since dichromated colloids (gum arabic or → gelatin treated with a dichromate, which hardens when exposed to light) are naturally colourless, the pigment acts as the image-bearing element. The effect of light on dichromates was discovered in 1839 by Mungo Ponton, and the use of dichromated colloids was first described in 1855 by → Alphonse Louis Poitevin. The first pigment process, carbon, was introduced in 1855, followed by the gum bichromate process in 1858 and carbro in 1905. Pigment processes are more permanent than silver-based processes and allow for greater control over the final appearance of the image.

Pinhole camera A primitive photographic technique derived from the → camera obscura.

• **P** —

A tiny hole in a dark box allows light to pass through, which projects an inverted image onto a sensitized surface at the back of the box. The image is thus created without a → lens, which allows for a very wide field of vision. The small size of the hole necessitates a long exposure time, but it also creates excellent → depth of field. The pinhole camera dates back to 1856, when it was mentioned in the work of the scientist → David Brewster. It became very popular in the late 19th century and is still in use.

Pinkhassov, Gueorgui (b. 1952) Russian-born French photographer. Pinkhassov studied at the National Institute of Cinematography in Moscow (1969) and worked for the production company Mosfilm. In the USSR he practised → street photography and also documented the filming of Andrei Tarkovsky's *Stalker* (1979). He settled in Paris in 1985 and joined → Magnum Photos in 1988 – a collaboration that has brought about several photographic books, including *Nordmeer* (2006). Pinkhassov also compiles photographic reports for international magazines such as *Geo* and the *New York Times Magazine.*

Pixel The smallest discernable element of a digital image file. Pixels are small, square units that contain a single, solid colour. Images are composed of pixels arranged in rows and stacked in columns, often in the hundreds of thousands. Each pixel is assigned a reference number according to its coordinates within the file.

Plachy, Sylvia (b. 1943) Hungarian-born American photographer. She fled to New York with her family following the Hungarian Uprising of 1956. She studied art at the Pratt Institute, Brooklyn, and was mentored by → André Kertész. Her widely diverse and often nostalgic, romantic or melancholy portraits and cultural snapshots have appeared in over fifty publications, including the *Village Voice*, the *New Yorker* and the *New York Times*. Plachy's award-winning monographs include *Unguided Tour* (1990) and *Self Portrait with Cows Going Home* (2004), which recounts her return to Hungary.

Platinum print (platinotype) A photographic process invented in 1873 by William Willis, platinum prints were most popular between 1880 and 1920, when the demand for platinum made their cost prohibitively high. The process was based on the light-sensitivity of iron salts combined with platinum. The paper was treated with potassium chloroplatinate and iron oxalate, and then exposed under a → negative to create the print. It was developed in a solution of potassium oxalate, which dissolves the iron and reduces the chloroplatinate salt to pure platinum. The print is then dipped in a bath of very weak hydrochloric acid, washed and dried. A platinum print is notable for its subtle tonal variations, precision and detail, and is more stable over time than → gelatin silver prints. Unlike print types that feature a coating of → emulsion (gelatin, collodion), it has a matt surface, and the image seems absorbed within the paper itself. A hybrid process called gum platinum, which combined a layer of → gum bichromate with platinum paper, was popular among the → Pictorialists. When the platinum process became too expensive, it was replaced by the → palladium print.

Plicka, Karol (1894–1987) Slovak photographer. Born in Vienna to Czech parents, Plicka mastered various art forms with a view to conserving and sharing the Slovak heritage. To this end he used photography, but also recorded popular Slovak songs in Czechoslovakia and elsewhere. He co-founded the FAMU film school in Prague but left in 1950 in order to devote himself completely to photographing landscapes and politically neutral architecture. Plicka's works are all very carefully composed.

Plossu, Bernard (b. 1945) French photographer. Plossu discovered photography in 1958 during a journey to the Sahara with his father. At the age of 20 he embarked on a series of journeys, first to Mexico, then around France and the rest of Europe, followed by the United States and Africa. On his travels he produced a number of personal photographs and also numerous photo stories, which were published in travel magazines and in the few French photographic magazines of the time. Between 1977 and 1985 he lived in Taos,

Polaroid Model 95 camera, 1948–53

New Mexico. At the end of the 1970s, together with → Gilles Mora, → Claude Nori, → Jean-Claude Lemagny and → Denis Roche, he founded the Cahiers de la Photographie series of books. He experimented with various genres (in particular a style called 'foto povera') and used the → Fresson process for some of his prints. With a passion for the desert, travel and the cinema, Plossu is not a storyteller but a sensitive photographer of what could be described as the 'non-decisive moment'.

Poitevin, Alphonse Louis (1819–1882) French photographer. Poitevin learnt how to use the → daguerreotype process in 1842 while he was training to be an engineer. Apart from his views of Paris and his portraits, he is known for his work on the stability and mass reproduction of photographs. After creating several processes allowing the reproduction of daguerreotypes on paper (including galvanography in 1848 and gelatin negatives in 1850), he demonstrated the process of → photolithography at the

Exposition Universelle in 1855. In 1860 he invented the process of carbon prints fired onto enamel. Poitevin promoted his own discoveries through lectures and articles for → photographic societies. In 1862, and again in 1867, he was awarded the Prix du Duc de Luynes in recognition of his contribution to the development of → photomechanical processes and non-fading prints.

Polaroid A trademark of the US-based Polaroid Corporation, the term today refers to an instant photography process carried out by a specialized camera – the first to produce a dry and stable image without separate developing and printing processes. The name was originally applied to a type of plastic sheet, patented in 1929 by → Dr Edwin Herbert Land and used as a polarizing filter for products such as sunglasses. The first Polaroid photographic film to be sold, a roll film known as 'type 40', came onto the market in 1948 alongside the Model 95 camera. In 1963 the process was adapted for colour photography and Polacolor film was launched; it became entirely automatic in 1972 with the advent of the SX-70 Polaroid Land camera. Over a period of sixty years, almost 100 different camera models were released as the technology improved. The Polaroid camera became a 20th-century cult object, especially with → amateur photographers, but it was used by professionals predominantly as an intermediate tool for taking test shots. However, encouraged by Land, artists including → Ansel Adams, → Andy Warhol, → David Hockney, → Lucas Samaras and → Robert Mapplethorpe began to experiment with the Polaroid process. Driven out of the market by competition from digital cameras, the firm stopped producing Polaroid cameras in 2007 and Polaroid film a year later. In 2010 the production plant was bought up by a group of former employees, who began to sell Polaroid-compatible instant film under the name of The Impossible Project.

Police photography The use of photography in police investigations and other legal contexts dates from the mid-19th century. It was standardized and incorporated into the

• P —

Sigmar Polke, *Untitled (Willich)*, 1972

anthropometric identification system devised in 1882 by → Alphonse Bertillon, who set up the first police laboratory in Paris in 1870 for the purpose of identifying criminals. At the beginning of the 20th century the theoretical basis for its use was defined by Archibald Reiss in *La photographie judiciaire* (1903). Police photographs were taken with the aid of specialized equipment, such as chairs with headrests and tripods that could hold the camera vertically, so that the photographer's involvement was kept to a minimum and the picture of the criminal or crime scene was as objective as possible, resulting in an archival document. There were three main subjects: the crime scene, the criminal and the evidence. The aesthetics of modern identity photographs are based on the model of the police 'mug shot'.

Polidori, Robert (b. 1951) Canadian photographer. Polidori is well known for his travel and architectural photographs, and for his large-scale projects that can take several years to complete. As a conceptual documentarist, he often photographs interiors that have been changed by the passage of time, human occupation (Versailles, Cuba), wars (Beirut) or catastrophe (Chernobyl, Pripyat, Hurricane Katrina in Louisiana). Polidori divides his time between New York and Paris.

Politics and photography The political dimension of photography varies according to the content of the image, its use and function, and its intended audience. As far as content is concerned, very early in its history photography was used to produce portraits of politicians. One of the first to record political life in this way was → Nadar, who put together his *Panthéon* during the 1850s. At the same time, established powers began to use photography as a means of influencing the public's perception of events. During the 1850s, → Roger Fenton was encouraged by the British government to go to the Crimea and create a favourable image of the conflict. This use of images for propaganda purposes was subsequently taken to extremes by totalitarian regimes during and after World War II. A photograph can also be viewed as political as soon as it attacks the established order

and aims to make visible something that was invisible. Political photography includes a vast range of different styles but is usually closely linked to social → documentary photography.

Polke, Sigmar (1941–2010) German painter and photo artist. He studied at the Kunstakademie Düsseldorf from 1961 to 1967 with Gerhard Hoehme and Karl-Otto Götz. Between 1977 and 1991 he taught at the Academy of Fine Arts in Hamburg. Polke has participated three times in the Documenta exhibition, Kassel, and represented Germany at the 1986 Venice Biennale. In 1963, along with Konrad Lueg and → Gerhard Richter, he coined the term 'Capitalist Realism' (*kapitalistischer Realismus*), as an ironic response to the East German art movement of Socialist Realism and a wish to seize on American Pop art and its critical view of mass consumption and industrial progress. Apart from his famous screen-dot paintings, Polke has produced a vast photographic oeuvre. He began with still-life scenes and snapshots of everyday life and travels, but in the 1970s developed a series of photographic experiments that were more abstract in quality, making use of over- and multiple exposures, blow-ups, soft focus, the manipulation of negatives and various photochemical approaches.

Ponting, Herbert George (1870–1935) British photographer and film director. Ponting photographed the war between Russia and Japan (1904–05), and also his journey through Asia for the British press. He is best known for capturing the Terra Nova expedition of 1910–12, which Robert Falcon Scott led to the South Pole. Following its tragic outcome, he published *The Great White South* (1921) and made two films in memory of Scott and the two other explorers who died.

Portrait photography The use of photography to record and communicate a sitter's appearance and personality. The photographic portrait has been an important genre since the invention of the medium, and it differs from other genres by the sheer diversity of its application. Early photographic portraits created a keen

interest in the medium and quickly popularized it. Traditionally viewed as a mimetic art, photography established itself as a favourite mode of portraiture and also gave new life to the pictorial aspects of the genre, though it initially remained dependent on codes inherited from painting. During the 1840s portraits were made using the → daguerreotype or → calotype processes and required long exposure times. In New York the people to go to were Jeremiah Gurney and → Mathew B. Brady; in London it was → Antoine Claudet and Nicolaas Henneman; in Edinburgh, → Hill and Adamson. In Paris, early pioneers such as → Charles Chevalier and Jean-Baptiste Sabatier-Blot made way in the 1850s for the great names of → André-Adolphe-Eugène Disdéri, → Mayer & Pierson and → Nadar. Production intensified, and the expansion of the genre was given a huge boost by the wet → collodion process, which allowed for the production of multiple prints. In 1854 Disdéri patented the → *carte-de-visite*: a small-format portrait that enjoyed great success because of its low cost and ease of distribution. The photographic portrait, initially reserved for the middle classes and celebrities, became increasingly popular. It was not restricted to the studio but was also employed in the fields of criminology, ethnography and anthropology. Many famous people (Victor Hugo, Napoleon III, Maximilian I) were even photographed on their deathbeds. After World War I, fashion magazines reproduced numerous portraits taken by such great names as → Edward Steichen, → Cecil Beaton and → Horst P. Horst) but, with the advent of documentary realism and the portraiture of specific social types (→ Paul Strand, → August Sander), the medium had already begun to ask questions of itself. During the 1940s → Arnold Newman introduced a new style of portrait, depicting the sitter in his or her natural environment. → Irving Penn and → Richard Avedon took numerous portraits in addition to their fashion photographs, and from the 1980s → Diane Arbus focused on unusual people or those living on the margins of society. Since the 1980s the portrait has followed numerous, challenging paths: intimate (→ Nan Goldin), fictitious (→ Jeff Wall, Keith Cottingham), in series (→ Rineke Dijkstra), or focusing on neutral expressions (→ Thomas Ruff) or family groups (→ Thomas Struth).

Positive An image on film or paper that reflects the same tonal values as the scene that was photographed, such that highlights appear bright and shadows are dark. A positive can be produced by inverting a → negative or through direct processes such as → daguerreotypes and dye-diffusion transfer prints.

Post Wolcott, Marion (1910–1990) American photographer. Born into a progressive middle-class family, Post Wolcott became a primary school teacher then studied in Vienna during the 1930s. Upon her return to the United States she discovered photography. She joined the → Photo League, where she was noticed by → Ralph Steiner, who recommended her to → Roy Stryker. As one of the → Farm Security Administration team, she was the only photographer to document the leisured classes as well as poor rural areas, especially in Florida. She left the project in 1941 in order to get married. She never practised professionally again, but for the rest of her life she continued to take photographs during her many travels and remained in touch with the photographic community. Her photographs reveal an acute awareness of injustice.

Post-production In photography, the term refers to any process of editing or manipulation carried out on a photograph after it has been made. 'Post-production' could refer to a variety of digital techniques, such as editing out unwanted blemishes in → Photoshop, or to traditional, analogue processes performed in a → darkroom, such as printing multiple images onto one sheet of photographic paper.

PPI *see* **DPI**

Prince, Richard (b. 1949) American painter and photographer. Prince is an artist with a reputation for controversy. He is famous for appropriating advertisements, particularly those that idealize the figure of the cowboy.

By re-photographing iconic images taken from the mass media, he creates a powerful critique of the American dream. Prince lives and works in New York.

Print An image formed on a sheet of paper by one of a number of different processes, either chemical or photomechanical. A photographic print is made by the action of light on the surface of a sheet of paper treated with a light-sensitive coating. In most processes, the print is produced through → contact printing or enlarging a → negative in a → darkroom; it is then developed and processed to preserve the image and to remove any remaining light-sensitive chemicals. Photomechanical reproduction does not rely on light-sensitive chemistry to produce the final image; instead, ink or pigment is applied to the paper by mechanical means.

Printing paper Paper used as a support for the printing of photographs. The chemical characteristics of printing papers vary according to the photographic process being used (salt paper is used for → calotypes and → cyanotypes; → albumen paper and collodion paper for glass-plate collodion images; and platinum paper for → platinum prints). There is a huge range of light-sensitive papers available, all of them prepared with different sensitizing agents. In 1873 Peter Mawdsley invented paper with a silver gelatin → emulsion. This could take two forms:

• P —

Marion Post Wolcott,
Post Office, Belle Glade, Florida, 1939

Printing-out processes

→ printing-out paper (POP) and developing-out paper (DOP). The latter, manufactured industrially, was pre-sensitized with a solution of silver nitrate and sodium chloride, and was marketed and used from 1885 onwards. Developing-out paper went on to become the favoured support for → gelatin silver prints, the most popular photographic process of the 20th century. With the development of → digital photography, photographic paper has adapted to suit the different types of print that may be created from an image file.

Printing-out processes Processes in which a photographic image is formed without the use of a chemical developer. Unlike developing-out processes, printing-out processes produce an image immediately after exposure to light, which therefore needs only to be toned, fixed and washed during processing. The most common printing-out processes are → gelatin silver, → collodion, → albumen and → salted paper printing. The term POP (for 'printing-out paper') most commonly refers to → gelatin silver printing-out paper, since this was the last of the printing-out processes to be commercially available and widely used.

Projector An apparatus that projects photographic slides or moving → film onto a wall, screen or other smooth, light-coloured surface. It is constructed along the lines of the magic lantern. Light passes through a condenser, which spreads it evenly over the surface of the slide or film and allows it to be projected through a → lens. To project digital images, a digital projector is used. The two main technologies are LCD (liquid-crystal display) and DLP (digital light processing). In the former, light is separated onto three LCD panels – red, green and blue – where individual → pixels can be opened to allow light to pass through. Light that passes through the panels is combined to produce a projected colour image. DLP technology uses a spinning colour wheel to filter red, green and blue light. This light is then directed onto micro-mirrors, each representing one or more pixels, that can be positioned to reflect light towards the projection surface.

Propaganda Any form of communication designed to spread a political point of view and influence an audience. Photography has proved a popular tool for this purpose. When used as a mass medium, it has many suitable attributes: it is reproducible, speaks a universal language, and is simultaneously documentary but open to interpretation. During the second half of the 19th century political powers used it to denounce, reassure or control their subjects. During and after the 1920s, totalitarian regimes perfected the use of photography as a propaganda tool, especially the Soviet Union, Italy, Germany and China. This is evident in exhibitions of the time, in which → photomontages and → photomurals were carefully staged in order to guide the visitor's interpretation. Classic examples are the *Mostra della Rivoluzione Fascista* (Rome, 1932), *Die Kamera* (Berlin, 1933), and the Spanish Pavilion at the 1937 Paris Exposition Internationale, all of which drew on the work of → El Lissitzky for inspiration. At the same time, the use of photography in illustrated magazines was expanding. → *Life* and *Paris Match* frequently published illustrated stories on social inequality. However, there was a good deal of → retouching, reframing and misuse of images, which led some photographers to protect their work following the example of → Henri Cartier-Bresson, who added a black keyline around his photographs and insisted on writing his own captions.

Pruszkowski, Krzysztof (b. 1943) Polish photographer. Trained as an architect, Pruszkowski divides his time between France and Poland. He began his photographic career in fashion and advertising. In 1975 he began to develop a technique for superimposing images. His first photosyntheses were portraits (heads of state, famous couples or unknown sitters), since when he has superimposed images of towns, architecture and, since 1990, Egyptian art and monuments linked to historic events.

Punctum A term used by the semiologist and literary critic → Roland Barthes in his book *Camera Lucida* (1980) to refer to a touching detail within a photograph that affects the viewer. He

names three participants in the photographic process: the *operator* (the photographer), the *spectrum* (the subject of the photograph) and the *spectator* (the viewer of the photograph). From his own viewpoint as spectator, Barthes notes that he likes only some images taken by a particular photographer, and so he tries to understand what it is that attracts him. This leads him to discern two aspects of the image: the *studium* and the *punctum*. The former (from the Latin, meaning 'study' but also 'attention' or 'taste') refers to the degree of interest an image arouses in the *spectator*. This will be 'without any particular intensity', and more intellectual than emotive. By contrast, the *punctum* (from the Latin meaning 'prick', 'small hole' or 'small cut') is what troubles the *spectator* and disturbs his *studium*: 'The *punctum* comes from the most unexpected places ... and at the most propitious moment for it to reach the *spectator*'s heart and arouse an emotion far stronger than words and meanings. The *punctum* is a phenomenon that cannot be understood but can be perceived; we can pinpoint it, but we cannot name it. It is the *je ne sais quoi* that both fascinates and disturbs the *spectator*.'

Puranen, Jorma (b. 1951) Finnish artist. Puranen was born in Pyhäjoki, in western Finland, and lives in Helsinki. He studied photography from 1973 to 1978 at the University of Art and Design in Helsinki, where he also held the post of professor between 1995 and 1998. For almost thirty years he has worked on various projects relating to the Nordic regions, which reflect his relationship with history and the arctic landscape. He delved into the history of the Sami people in the 1970s, uncovering proof of discrimination in archival images. In his portrait series *Imaginary Homecoming*, Puranen's pictures of the Skolt group of Sami are juxtaposed with ethnographic photographs from the 1880s. Reflecting on the traces left by peoples and cultures in both history and nature, Puranen found an artistic and ideological response to a type of photography that was once a tool for colonialism. He was awarded the Pro Finlandia Medal of the Order of the Lion in 2005.

Puskailer, Bohumil (1939–2013) Slovak photographer. Originally trained as a dentist, he began his photographic career producing photo → reportage while working in the editorial office of the magazine *Život*. In 1965 he became a member of the Slovak Foundation of Visual Arts (SFVU). He photographed views of old Bratislava, hippies and famous Slovak cultural figures, many of them then at the beginning of their careers. His photographs stand out for their ability to capture the zeitgeist, with all its contrasts and contradictions. In the late 1960s he emigrated to Canada and then moved to the Netherlands. He returned to Slovakia in 1989.

Puyo, Constant [Émile Joachim Constant Puyo] (1857–1933) French photographer. Puyo studied at the École Polytechnique in Paris and then trained at a military academy. Following a military career he developed a passion for photography, and from the end of the 19th century until the 1930s he was one of the leading lights of French → Pictorialism. In 1894 he joined the Photo-Club de Paris, of which he became president in 1921. He published numerous theoretical writings, especially in *La Revue française de photographie*. A great technician, Puyo was interested in the uses of → gum bichromate and → oil pigment processes, optical anomalies, and in → blurring and nocturnal effects. His favourite subjects were the nude, female portraits, middle-class life in Paris, and landscapes.

• P —

Radiography The process of creating an image on a sensitized surface using other types of radiation than visible light. On 22 December 1895 → Wilhelm Conrad Röntgen, who had just discovered the X-ray, took the first radiograph. The X-rays passed through his wife's hand and onto sensitized → film, forming an image that revealed the internal structure of the hand without the need for any surgical intervention. Since Röntgen's discovery, radiography has been used in medicine, science and many branches of industry. In the field of the arts, it was featured in the → *Film und Foto* exhibition in Stuttgart (1929), which brought together all genres of photography, including medical photography. By revealing new views of the human body and different objects, radiography also stimulated the imagination. Its contrasting black-and-white tones, transparency and near abstraction inspired a number of artists, including Marcel Duchamp, Naum Gabo and → Robert Rauschenberg.

Rainer, Arnulf (b. 1929) Austrian artist. Rainer's work displays many influences, including → Surrealism, Tachisme and Art Informel. His drawings of the 1950s were inspired by late Surrealism, but Rainer soon began to develop his own pictorial language, mirroring his strong artistic personality. This led him to break away from the Art-Club, the Surrealist group then dominant in Austria, and to found his own association, known as the Hundsgruppe. Still painting in a Surrealist style, in 1951 Rainer first experimented with *Blind Drawings*, which he produced with his eyes closed. His changing techniques led him to create two series called *Microstructures* and *Centralizations*. His *Groundpaintings* and *Reductions* (1953–59) paved the way for his *Overpaintings*. During this period Rainer began to take his first photographs. In the series *Face Farces* (1970s), two dominant facets of his artistic practice were evident: the introspection of → self-portrait photography on one hand, and physical automatism of the kind practised in the *Overpaintings* on the other. Rainer continued to develop these ideas by using his hands and feet to apply paint. In his most recent photographic works, which he describes as *Malerfotografie* ('painter's photography'), he

places transparent coloured → filters in front of the camera lens to exploit the effects of refraction.

Rangel, Ricardo (1924–2009) Mozambican photographer. Born into a multicultural family, Rangel became a self-taught photojournalist who was profoundly aware of the political potential of his black-and-white images of everyday life under colonial rule. With his highly charged photographs he played a part in Mozambique's campaign for independence. He spent his entire life in Maputo, working first for the Portuguese press, and then for his own magazine *Tempo* and the photography school he founded in 1983.

Ranney, Edward (b. 1942) American photographer. After studying at Yale University, Ranney became well known for his photographic studies of pre-Columbian art and architecture, which emphasized the link between monuments and their geographical environment. He is also famous for his photographs of Charles Ross's monumental earthwork *Star Axis*, and of landscapes in Britain and the United States, especially New Mexico, where there is nearly always some connection with ruins and ancient history.

Rauschenberg, Robert (1925–2008) American painter, photographer, sculptor, printmaker and performance artist. He studied at the Kansas City Art Institute and the Académie Julian, Paris. In 1948 he returned to America to attend Black Mountain College in North Carolina, where he was taught by Josef Albers, among others. Between 1949 and 1952 he studied painting at the Art Students League of New York. Considered a Neo-Dadaist, Rauschenberg used found material in his paintings and combines (three-dimensional → collages). He often borrowed popular imagery from magazines or newspapers, or transferred photographs onto the surface of his work using various means. Iconoclastic in many aspects, Rauschenberg used photographic imagery in conjunction with other media, adding visual metaphors and layers of meaning to the complex images he created.

Robert Rauschenberg,
Japanese Sky, 1988

Rawlings, John (1912–1970) American fashion and portrait photographer. Rawlings was noticed by Condé Nast in 1936 and employed as an assistant in one of → *Vogue*'s photographic studios in New York. He published his first photographs in the magazine that same year. From 1937 until 1940 he was director of the photography department of British *Vogue*. On returning to the United States in 1940 he remained faithful to Condé Nast, although he opened his own studio in 1945. In a career spanning thirty years, he produced 200 covers for *Vogue* and *Glamour*.

Ray-Jones, Tony [Holroyd Antony Ray-Jones] (1941–1972) British photographer. While studying at Yale University, Ray-Jones was influenced by American street photographers, especially → Joel Meyerowitz. On his return to England in 1965, he began to photograph popular pastimes in black and white, always with an ironic eye. He played an important role in securing the

• R –

331

Tony Ray-Jones, *Beauty Contest, Southport*, 1967

recognition of photography as a serious art form in the United Kingdom. In 1971 he and Enzo Ragazzini, → Dorothy Bohm and → Don McCullin exhibited at the Institute of Contemporary Art in London, which had never before staged a photography exhibition. His work influenced a generation of English documentary photographers. Ray-Jones returned to the United States in 1971 and taught at the Art Institute of San Francisco. His negatives and rights are now controlled by the National Media Museum in Bradford, which staged a retrospective in 2004.

Rayograph A variety of → photogram, or paperless photographic image, invented in 1922 by the photographer → Man Ray. He would place objects directly onto → photographic paper and expose them to light. Photograms have been used

since the beginning of photography, but the creative potential they offered was an exciting discovery for Man Ray, who named his version the 'rayograph' and used it often in Dada and → Surrealist publications.

Reflector A piece of equipment used to redirect light onto the subject of a photograph. Reflectors can intensify or control natural or artificial light depending on their colour, which is often white, silver or gold.

Reflex camera A camera equipped with a retractable mirror and a pentaprism (five-sided prism), which are used to flip the image that passes through the → lens so that it can be viewed the right way up. The most popular type of reflex camera is the single-lens reflex (SLR), which uses the same lens both to view the image and

to capture it. Twin-lens reflex cameras are also available: they use one lens as a viewfinder and another to take the picture. When the picture is taken, the mirror retracts and the → shutter opens, allowing the image to be recorded directly onto the film or image sensor. After exposure, the mirror returns to its original position. The reflex system ensures that the image that the photographer sees will be reproduced exactly. The most commonly used formats are 24 × 36 mm and 6 × 6 cm.

Regnault, Henri Victor (1810–1878) French chemist and physicist. Regnault became the first president of the → Société Française de Photographie in 1854 and was a member of the Académie des Sciences, director of the Manufacture de Sèvres and a calotypist. He realized that the new medium, which up to that point had been essentially technical, also held the potential for creative artistic expression. He took portraits of his colleagues at the Académie and photographed his wife and children. These images were realistic in style, and careful lighting played an integral role in their overall effect. His landscapes anticipated the great works of Impressionism by a good twenty years. Typical features of his photographs are their aesthetic qualities, high-angle perspectives and disciplined composition.

Rejlander, Oscar Gustav (1813–1875) Swedish-born British photographer. Rejlander studied painting in Rome and copied many works by the great masters. After settling in Britain, he used photography to help him achieve greater anatomical realism in his paintings. He also provided other artists with photographic studies of the nude. His allegory entitled *The Two Ways of Life*, inspired by Raphael's *School of Athens*, was conceived as a 'photographic picture': the image consists of a → photomontage of approximately thirty different → negatives. His submission for a competition at the *Art Treasures Exhibition* in Manchester in 1857, it posed the question whether photography could be regarded as an art form, since the aesthetics of photography depended on particular technical skills, such as the use of several negatives

or → retouching. Rejlander's allegory was commended because of the moral values it embodied: it showed the battle between good and evil, and between hard work and discipline versus laxity and dissoluteness. Queen Victoria bought three copies, one of which she gave as a gift to her husband, but many viewers considered the composition disturbing and indecent. Rejlander, who by now had his own studio, managed to earn a living from his portraits (sitters included → Lewis Carroll and Gustave Doré). In 1863 he went to the Isle of Wight. He taught → Julia Margaret Cameron the basics of photography and in 1872 collaborated with Charles Darwin on the illustrations for his book *The Expression of Emotion in Man and Animals* (1872). *Ginx's Baby*, his shot of a baby in tears, sold more than 300,000 copies. Rejlander was an expert in photomontage and superimposition, and

Henri Victor Regnault,
The Ladder, 1853

• R —

Oscar Gustav Rejlander,
Two Ways of Life, 1857

he viewed photography as a step towards the imaginary. His work is a mixture of dream and reality.

René-Jacques [René Giton] (1908–2003) French photographer. René-Jacques opened his photographic studio in 1932 after studying law. His various activities included providing illustrations for literary works, taking advertising photos and making stills for the film industry. His work was published in many magazines, including *Plaisir de France* and → *Harper's Bazaar*. He was very involved in the profession's struggle for recognition and belonged to the Groupe des XV, whose aim was to draw attention to France's photographic heritage. He retired in 1975.

Renger-Patzsch, Albert (1897–1966) German photographer. At the end of World War I, he went to Dresden to study chemistry and photography. He worked as a freelance photographer for the press and in advertising. In 1928 he published his magnum opus, *Die Welt ist schön*, which became the manifesto of the → New Objectivity movement. The work brought together a hundred photographs that displayed great technical mastery and covered subjects as diverse as nature, architecture and everyday objects. Renger-Patzsch's aim in the book was to highlight a sense of harmony based on similarities of form and composition. He also took part in the famous → *Film und Foto* exhibition in 1929. He later became a war correspondent but thereafter concentrated more on personal photography.

Reportage The use of photography to report current events. Historically, it is associated most closely with the work of certain European photographers, such as → Henri Cartier-Bresson, who combined a documentary intent with a deliberate style, their images serving as both eye-witness evidence and personal acts of expression. In the 1980s, in the face of competition from television, some began to make a distinction between reportage and → photojournalism. The latter term was associated with a superficial coverage of events, producing striking images that were nonetheless often interchangeable. By contrast, reportage was viewed as a

more prestigious photographic practice that emphasized the photographer's social commitment and required personal investment and risk-taking. Photojournalism was a product of the media industry, while reportage was seen as an act of artistic creation. Reportage images are now found in museums, galleries, art books and auction houses. Affirming their subjective viewpoint, a number of reportage photographers have also become authors.

Resolution The amount of detail that an image contains. In printed images, resolution is generally expressed in terms of number of dots per unit of surface area: the greater the number of dots, the higher the resolution and the higher the quality of the image. In → gelatin silver prints, resolution is dependent on the size of the silver grains. The resolution of digital files is expressed as → pixels per inch (PPI).

Retouching The technical correction or aesthetic or illustrative enhancement of a photograph, photographic negative or digital photographic file. The practice of retouching has been current since the 19th century, in areas of photography including portraiture, press, science, landscape, fine art and fashion. Pins, pencils, inks, paints and the airbrush have all been used to retouch analogue photographs, whereas → digital photographs are manipulated by means of imaging software such as → Photoshop.

Rey, Guido (1861–1935) Italian photographer and writer. An experienced climber, Rey loved the mountains and took many photographs of the Alps on his expeditions. He also photographed dramatic scenes inspired by → Pictorialism, using models and actors in costume to restage famous paintings by the Old Masters and classical compositions from ancient Greece and Rome.

• R —

Albert Renger-Patzsch,
Snake Head, 1928

In 1898 his photographs were shown at the National Exhibition in Turin, and in 1902 he took part in the Turin International Exhibition of Decorative and Modern Art.

RGB An → additive colour system that mixes red, green and blue light in different intensities to produce what the eye sees as a broad range of secondary colours. Today this method is widely used in electronic displays, including computer monitors and mobile phones.

Rheims, Bettina [Caroline Germaine Rheims] (b. 1952) French photographer. Since first taking photography in 1978, Rheims has pursued a dual career in art and commerce. Made famous by her official photograph of the French president Jacques Chirac in 1995, Rheims has continued to follow her own course by exploring female nudity. She has often aroused controversy, most notably with *I.N.R.I.* (1998), a photographic series about the life of Christ.

— R •

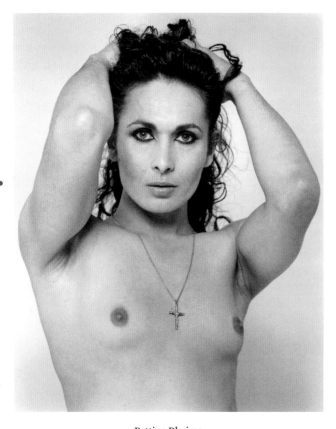

Bettina Rheims,
Erica, 1991

Riboud, Marc (b. 1923) French photographer. From an upper middle-class family in Lyon, Riboud studied to be an engineer but abandoned this career in 1951 in order to devote himself full time to photography. Introduced into the → Magnum circle by some family members, he was fully admitted in 1953. He then embarked on a long series of journeys round the world, taking in London, India, Africa and Vietnam, and was also one of the first European photographers to photograph the new Communist China. Riboud sets himself the highest standards, following in the disciplined footsteps of → Henri Cartier-Bresson, and as a → humanist portraitist he is against all violence and is a strong advocate of multiculturalism. This is clear from his photographs, many of which have won awards and have become icons in their own right.

Richards, Eugene (b. 1944) American photographer. A sometime member of → Magnum and the VII photo agency, Richards originally studied photography under → Minor White and then went to Arkansas to work for VISTA (Volunteers in Service to America), a national programme created to fight poverty. Regarded as the archetypal committed photographer, Richards has mainly tackled social and political subjects: drugs, racism, poverty, war – all viewed from a perspective that is full of compassion but uncompromising in its principles. Oscillating between → reportage and social documentary, his work usually takes time to complete and is published in the form of → series – mostly in black and white – that encompass the complexities of the subjects he deals with. Accompanying texts provide an additional, complementary perspective.

Richardson, Terry (b. 1965) American photographer. Self-taught, Richardson began his career photographing the punk and alternative milieux in Hollywood and New York. He soon turned his attentions to fashion, and held his first exhibition at the Alleged Gallery, New York, in 1989 (*These Colors Don't Run*). The instigator of 'porn chic', he blurs the frontiers between fashion, art and pornography with his subversive photographs. Pale lighting and settings that

Marc Riboud, *An American Girl, Jan Rose Kasmir,*
confronts the American National Guard outside the Pentagon
during the 1967 Anti-Vietnam March, 1967

evoke a trashy, everyday banality provide
the backdrop for his explicitly sexual images,
which are devoid of all artifice. Richardson's
photographs represent the opposite of an
aesthetic of perfection and are shocking in
the way they reveal the most intimate details.
He combines humour, exhibitionism and
provocation in his almost obsessive approach
to image-making, and sometimes uses himself
as a subject.

Richter, Gerhard (b. 1932) German painter,
sculptor and photographer. Richter is a major
figure on the contemporary art scene and the
living artist most highly valued by the art market.
He studied painting at the Dresden Academy of
Fine Arts. His pictorial work can be divided into
abstract and figurative, and photography plays

a central role in both. *Atlas*, the appropriated
work he began in the 1960s, comprises a visual
and historical archive of found photographs
(amateur, publishing and advertising) or
photographs taken by himself. These formed the
iconographic source for numerous hyperrealistic
paintings, and the whole project was exhibited
in 1972 as an autonomous work. His series of
Overpainted Photographs uses photographs as
a physical support for painting. Richter taught
at the Kunstakademie, Düsseldorf (1971–93),
where one of his most outstanding students was
→ Thomas Struth.

Riefenstahl, Leni [Helene Bertha Amalia
Riefenstahl] (1902–2003) German actress, film
director and photographer. Born in Berlin,
Riefenstahl studied painting in 1918 and received

• R —

an education in dance, but had to abandon her career owing to a knee injury. She was engaged as an actress in adventure films from 1925. Her successful directing debut, *Das blaue Licht* ('The Blue Light', 1932), attracted Adolf Hitler's admiration. She became the Third Reich's de facto film director between 1932, notably producing *Triumph des Willens* ('Triumph of the Will') in 1935, a propaganda film recording the 1934 Nuremberg Rally. In 1938 she filmed the two-part *Olympia*. Perceived as controversial on account of her closeness to National Socialism and her fascist aesthetics, Riefenstahl was shunned after World War II. Photographs of the Sudanese Nuba tribe helped resurrect her career in 1966. She worked as an underwater photographer well into old age.

Riis, Jacob A. (1849–1914) Danish-born American photographer. Riis originally trained as a carpenter in Copenhagen. Arriving in the

Leni Riefenstahl, *Javelin-Thrower*, from the *Olympia* series, 1936

— R •

United States in 1870, he endured three tough years of unemployment and homelessness, battling also against suicidal tendencies. In 1873 he found a job as a newspaper reporter. He wandered the poor districts of New York and denounced the appalling conditions in which his fellow immigrants lived. Convinced that these conditions were the cause of crime and the districts' high mortality rate, he engaged professional photographers to produce irrefutable evidence that might influence public opinion and thus encourage social reform. Riis then began to take his own photographs spontaneously, often by night and with the use of a → flash, and frequently entered the basements of the Lower East Side. His images are not posed or deliberately composed. They were collected in 1890 in *How the Other Half Lives*, the first major publication to use photographs as a means of social criticism. The book was an immediate success. Theodore Roosevelt, who was then chief of police in New York, offered his support to the photographer and to the first legislative attempts at relieving the suffering that blighted the poorer quarters of the city. They were eventually demolished to make way for social centres. Riis published four more books: *The Children of the Poor* (1892); *Out of Mulberry Street* (1898); his autobiography, *The Making of an American* (1901); and *Children of the Tenements* (1903). His work (some 250 photographs taken over the course of ten years) was not rediscovered until the 1940s.

Rio Branco, Miguel (b. 1946) Brazilian photographer, cinematographer and painter. He studied photography in 1966 at the New York Institute of Photography and then attended the School of Industrial Design in Rio de Janeiro. From 1969 until 1981 he made experimental films and worked as cinematographer for the directors Júlio Bressane (1946) and Gilberto Loureiro (1947). He later became a correspondent for → Magnum Photos in Paris (1978–82). His work is especially noteworthy for its use of colour → saturation. Since 1980 Rio Branco has made many installations, combining photography, painting and film. He has won numerous awards, including the Kodak Prize for photographic

Jacob A. Riis, *Police Station Lodgers*
in Oak Street Station, 1890

● R —

criticism in 1982 and the national photography
prize given by the Brazilian National Foundation
of Art (Funarte) in 1995.

Ristelhueber, Sophie (b. 1959) French artist.
Having studied literature, Ristelhueber began
her career in press and publishing but turned
to photography in the early 1980s. Her launching
pad was undoubtedly the series *Beirut* (1984).
This was a photographic reflection that focused
on the scars left on landscapes and the human
body by war. All of her work, which takes
the form of → series, videos and installations,
bears witness to the artist's intense involvement.

Experience of the terrain is an essential
element of her art, which constitutes a critical
analysis of contemporary conflicts and their
cruel aftermath.

Ritts, Herb (1952–2002) American photographer.
Ritts studied economics at Bard College, New
York. In 1978 he made his mark with photographs
of a young actor named Richard Gere that were
published in *Mademoiselle*, → *Vogue* and *Esquire*.
In the 1980s and 1990s, when Ritts was at the
pinnacle of his career, his images contributed to
the fame of celebrities including Madonna and
Michael Jordan. On a more personal and private

Herb Ritts,
Fred with Tires, 1984

level, he also produced homoerotic photographs along similar lines to those of → Bruce Weber and → Robert Mapplethorpe.

Rivas Ribeiro, Humberto Luis (1937–2009) Argentinian photographer. The military dictatorship forced Rivas Ribeiro to leave Argentina for the United States in 1976. He worked for an advertising agency but was spotted by Juan Carlos Distéfano, who invited him to run the photography department at the Center of Contemporary Art in Buenos Aires. He later went to Spain, where he helped to launch the Barcelona Photographic Spring festival in 1982.

Riwkin-Brick, Anna (1908–1970) Russian-born Swedish photographer. She opened a studio in 1928 and took several classic portraits of contemporary Swedish authors. Through its editor, Carl-Adam Nycop, she produced assignments for the illustrated magazine *Se*. After 1940 she devoted herself solely to → reportage photography. She achieved her greatest success with her nineteen photo books about and for children, the first of which, *Elle Kari* (1951), concerns a Sami girl. Riwkin-Brick's photographs were donated to the Moderna Museet, Stockholm.

Robakowski, Józef (b. 1939) Polish photographer and video-maker. Robakowski studied fine arts at the Nicolaus Copernicus University, Toruń (1965), and at the National School for Cinema in Łódź (1970). His name is associated with the avant-garde artists of the 1960s and 1970s. Robakowski's work focuses mainly on his quest to discover the absolute limits of photography, and on the language of photography and the cinema. A highly versatile artist, he takes images of himself, reuses prints from archives, creates → photomontages and interactive installations, and transforms screen-captures into pixellated images. His photographic oeuvre ranges from conceptual works in black and white (*Photo-Actions*, 1959) to almost commonplace images of clouds (*Photography of 'Nothing'*, 2001). Robakowski has co-founded several groups, the best known being Zero-61 (1961–69) and the Film Form Workshop (1970–77).

James Robertson, *Mosque of Soliman the Magnificent, Solimanyah, Constantinople*, 1855

Robertson, James (1813–1888) British photographer. Robertson's name is closely linked to that of → Felice Beato, whom he met in Malta in 1850. Beato became his assistant and then his associate before setting himself up as a freelance photographer. Together with Beato, Robertson photographed Malta, Palestine, Naples, Cairo, Smyrna and Constantinople, where in 1841 he worked as an engraver at the imperial mint. Robertson and Beato (by this time his brother-in-law) were sent to Sebastopol in 1855 to report on the Crimean War, which united France, Turkey and Britain against Russia. Robertson did not photograph the action but was more interested in the ruined buildings and the state of the trenches after the Siege of Sebastopol. These images, which did not show any corpses, nevertheless conveyed a vivid impression of the countless victims of the war. Robertson and Beato were made official photographers for the British army in 1857 and, following the Indian Rebellion in Lucknow that same year, showed human bodies for the first time. It is sometimes difficult to distinguish between Robertson's photographs and Beato's. Those that were taken at the studio in Constantinople (1854–67) bear both signatures.

Robinson, Henry Peach (1830–1901) British photographer. Robinson was a major force in

• **R** —

Henry Peach Robinson,
Fading Away, 1858

the emergence of English → Pictorialism. He studied painting, and from the 1850s onwards worked in the same spirit as his former teacher, → Oscar Gustav Rejlander. He liked to use all kinds of technical manipulation (→ photomontage, superimposition, multiple negatives, → retouching), and to combine painting and photography as means of image-making. In *Fading Away* – his first major work, which he exhibited in 1858 at the Crystal Palace – Robinson depicted the last breaths of a young woman suffering from tuberculosis using a total of five negatives. He ran his own photographic studio and made his mark by publishing eleven books and numerous articles. He was a member of the Photographic Society for thirty years and its vice-president from 1887 until 1892. During the last years of his life, he played an important part in creating the → Brotherhood of the Linked Ring and in helping to develop Pictorialism. His pioneering book *Pictorial Effect in Photography*, published in 1869 and translated into French and German, forged an essential link between

the genre scenes of the 1860s and the Pictorialist works that followed. For Robinson, photography was associated always with the imagination and not with the reproduction of reality. He was one of the first to talk of 'pictorial photography', and to his dying day he remained a champion of the movement's principles.

Roche, Denis (b. 1937) French writer, poet and photographer. The starting point for Roche's work is the personal, autobiographical world, which leads to reflections on the photographic act and the passing of time. His images, which appear simple, in fact harbour a formal and reflexive complexity that enriches the dialogue between literature and photography. Roche created the book series Fiction & Cie (Editions du Seuil) and was a founder member of Cahiers de la Photographie (along with → Gilles Mora, → Claude Nori, → Bernard Plossu and → Jean-Claude Lemagny). The recipient of several awards, he has published and exhibited widely.

Rodchenko, Alexander (1891–1956) Russian photographer, painter and sculptor. Rodchenko studied at the Kazan School of Art (1910–14) and at the Stroganov School in Moscow. He became a leading figure of the Russian avant-garde from the late 1910s, first experimenting with → Futurism and gradually moving on to Suprematism and Constructivism. He met Kazimir Malevich in 1915 and Vladimir Tatlin the following year, both of whom had great influence on his work. He helped to set up the IZO fine arts department at the People's Commissariat for Enlightenment, where he drew, painted and created objects. In 1920 he was one of the founders of the Inkhuk research institute, and he also taught at the Vkhutemas school of art. From 1923 onwards Rodchenko worked for some of the most important Soviet periodicals of the period, including the magazines *Lef* and *Novy Lef*. His interest in photography began when he used some of Abram Petrovich Sterenberg's → photomontages to illustrate Vladimir Mayakovsky's poem *Pro Eto*, published in 1926. With their dynamic compositions and strong diagonal accents, Rodchenko's images evoked the Constructivist aesthetic by focusing on the positioning and movement of objects in space. In 1928 he took part in the exhibition *Ten Years of Soviet Photography* in Moscow, and in 1930 he joined the October group, which had an important influence on the cinema and photography of the time. He and his wife, Varvara Stepanova,

George Rodger, *Hassau Chieftains Demonstrate their Superb Horsemanship in a 'Fantasia'*, 1941

collaborated on the magazine *USSR Under Construction* in 1933, for which they produced photo reports (a series on the White Sea, for example) and designed the layouts and covers. Rodchenko gave courses on composition at the Photographic Union, and as a theorist on modern photography he inspired and influenced many photographers. Among his students were → Boris and Olga Ignatovich, Ivan Halip and → Georgy Petrusov.

Rodger, George (1908–1995) British photojournalist. As a photojournalist Rodger worked for the BBC and for → Black Star before becoming a correspondent for → *Life* in London during the Blitz (1940–41). He worked extensively in Europe, Africa and Asia, covering World War II in French West Africa, Abyssinia and Burma, among other countries. Following the liberation of France and the Low Countries, Rodger was the first photographer to make images at the Bergen-Belsen concentration camp, an experience that affected him profoundly. After the war he continued to freelance, and in 1947 formed → Magnum Photos with fellow photographers → Henri Cartier-Bresson, → Robert Capa and

• R —

Alexander Rodchenko, *Stairs*, 1930

→ David 'Chim' Seymour. He continued to photograph and to publish books and articles until his death, focusing on the people and landscape of Africa for a variety of journals, including → *National Geographic.*

Rolleiflex A twin-lens reflex camera, first produced in 1929 by the German company Franke & Heidecke (later renamed Rollei). It was notable for its unusual design, particularly its aluminium casing and Tessar lens. The first roll-film reflex camera, it produced 6 × 6 cm negatives, then 4 × 4 cm negatives after 1931. It was extremely popular with professional photographers throughout the 20th century.

Rondepierre, Éric (b. 1950) French artist. After graduating from the École des Beaux-Arts in Paris and the University of Paris I, Rondepierre worked as an actor between 1975 and 1980. In the late 1980s he began to photograph films as they were broadcast on television, the cinematographic image being his main source

Rolleiflex twin-lens reflex camera, 1939

of inspiration. His series *Moires* consists of a sequence of → photograms based on damaged film. In *Stances* (1998), Rondepierre took a series of images from a moving train, creating landscapes that were distorted by speed.

RongRong [Lu Zhirong] (b. 1968) Chinese photographer. Born in Fujian Province at the end of the Cultural Revolution, RongRong graduated from Fujian Industrial Art Institute in 1986 and in 1992 relocated to Beijing. His photographs of the gritty lifestyle of artists in Beijing's East Village brought him to prominence in the 1990s. RongRong met his wife and artistic partner, Inri, in 2000, and the second stage of his career is marked by their artistic collaborations. The couple founded the prominent Three Shadows Photography Center, with its artist residency programme, in the Caochangdi district of Beijing.

Ronis, Willy (1910–2009) French photographer. A member of the Rapho agency and the Groupe des XV, Ronis made his name by producing Parisian street scenes with a → humanist sensitivity. He not only taught photography but also wrote several books on the subject, including *Ce jour-là* (2006), in which he told his life story using a selection of his own works.

Röntgen, Wilhelm Conrad (1845–1923) German professor of physics. Röntgen discovered the X-ray in 1895 while undertaking research on the application of cathode rays and phenomena of luminescence. It was from this new, invisible form of radiation, able to penetrate solid matter, that → radiography emerged. His discovery, which revolutionized physics and medicine, earned Röntgen the Nobel Prize for physics in 1901.

Rosenblum, Walter (1919–2006) American photographer. Rosenblum was a member of the → Photo League, where his mentors were → Paul Strand and → Lewis Hine. He became president of the League, editor of *Photo Notes* and also taught there. Between 1943 and 1945 he worked for the Army Signal Corps and became the most decorated war photographer. Between 1947 and

– R •

Willy Ronis, *Provençal Nude,*
Gordes, 1949

• R —

Martha Rosler, *Cleaning the Drapes*, from the series
House Beautiful: Bringing the War Home, c. 1965–72

1977 he taught photography at Brooklyn College
and the Yale Summer School of Music and Art.

Rosenthal, Hildegard (1913–1990) German-born
Brazilian photographer. Rosenthal emigrated to
Brazil in 1937 and began her photographic career
as a correspondent for the Press Information
agency. She worked on the newspaper *O Estado
de São Paulo* and the magazine *A Cigarra*. Until
1950 she took portraits of many major figures
in Brazilian culture. In 1996 her work entered the
photographic collection at the Moreira Salles
Institute, Rio de Janeiro.

Rosenthal, Joe (1911–2006) American
photojournalist. Rosenthal started working for
the *San Francisco News* in 1932. He failed his army
medical because of his poor eyesight, but went
on to cover World War II for Associated Press
(AP). On 23 February 1945 he took the iconic

image *Raising the Flag on Iwo Jima*, which won
him the Pulitzer Prize. After the war he joined the
San Francisco Chronicle, where he worked until
his retirement in 1981.

Rosler, Martha (b. 1943) American artist. Rosler
is the creator of countless performances, essays,
videos, → **photomontages** and installations that
have been exhibited worldwide. She graduated
from Brooklyn College and from the University
of California, San Diego (1974). Rosler produced
her first photomontages as a protest against
the Vietnam War, combining war scenes with
American interiors, as in *House Beautiful:
Bringing The War Home* (c. 1965–72). In 2004–08
she used the same method to denounce the
wars in Iraq and Afghanistan. In 1974–75, in her
work *The Bowery in two inadequate descriptive
systems*, she combined images of storefronts on
the notorious Bowery in New York with groups

Henryk Ross, *Ghetto Life, Łódź*, 1940–44

of words on the theme of drunkenness. Her video *Semiotics of the Kitchen* (1975) is considered a feminist classic. Recurrent themes in her work are everyday life, women, public spaces, housing, urbanism, transport, the media and war.

Ross, Henryk (1910–1991) Polish photojournalist. Born in 1910 in Warsaw, Ross was sent to live in the Łódź ghetto in 1940 following Poland's occupation by the Nazis. Commissioned by the Jewish Administration, Ross documented the ghetto's administrators, workers and buildings for the statistics department. At the same time he secretly photographed everyday life as experienced by the ghetto's inhabitants. Hearing in 1944 of the ghetto's imminent closure, Ross buried his negatives within its boundaries in the hope of preserving a historical record for the Jewish people. He unearthed his cache in 1945.

Ross's photographic works provide a valuable record of life in the ghetto as witnessed by an inhabitant. He published his photographs in book format in the 1960s, but they were not viewed again until after his death. The collection was acquired by the Archive of Modern Conflict, London, in 1997, which organized an exhibition and accompanying publication. The archive now resides in the Art Gallery of Ontario, Toronto.

• R —

Rössler, Jaroslav (1902–1990) Czech photographer. Rössler left school to become an apprentice in → František Drtikol's Prague studio in 1917, where he remained as his assistant until 1925. These years of training left an indelible mark on his work, especially in his use of → pigment processes. In 1923 he met → Karel Teige, who was impressed by Rössler's minimalist photographs and encouraged him to join the Devětsil

Arthur Rothstein, *Farmer and Sons Walking in the Face of a Dust Storm,
Cimarron County, Oklahoma*, 1936

group. He thus became their only professional photographer. After a brief stay in Paris in 1926, Rössler moved there permanently in 1927 and was employed in Lucien Lorelle's new studio. His work included advertising photography, in which he experimented with avant-garde techniques and processes. In 1935 he was arrested when photographing a demonstration. Deeply shocked by this event, he returned to Prague where he opened his own studio, working almost exclusively on commission.

It was not until the late 1950s that he again began to work for himself. His personal photographs are characterized by the use of many different, sophisticated techniques, and they enabled him to take his place once more on the Czech artistic scene.

Rostain, Pascal (b. 1958) French photographer. He joined *Paris Match* in 1980, where he met Bruno Mouron. Together the two of them founded the press agency Sphinx in 1986.

A paparazzi duo, they took a famous photograph of Cécilia Sarkozy, then married to the French president, and Richard Attias in New York in 2005. Rostain and Mouron together published *Paparazzi* (1988) and *Scoop* (2007), were consultants for the film *Paparazzi* (directed by Alain Berbérian, 1998) and had their work exhibited at the Maison Européenne de la Photographie, Paris, in 2007 under the title *Trash*.

Rothstein, Arthur (1915–1985) American photographer. A student of → Roy Stryker's at Columbia University, New York, Rothstein began his career as a photographer working for the → Farm Security Administration. Following World War II he became chief photographic editor for *Look*. When the magazine closed in 1971, he joined *Parade*. The author of many books of and about photography, he also taught several generations of budding photographers.

Rouillé, André (b. 1947) French photography historian and critic. Having trained as a mathematician, Rouillé initially became interested in photography's earliest years; today he is fascinated by all periods, and in particular the tension between art and industry that photography exemplifies. He is a firm believer in the role of books in the circulation of ideas. In 1986 he founded the magazine *La Recherche photographique*, which he ran until 1997, and he also assembled collections for different publishing houses. He subsequently turned his attention to new media and runs a website on contemporary art in Paris. He currently gives courses in the history of photography at the University of Paris VIII.

Al Roumi, Mohamed (b. 1945) Syrian photographer and director. Since the 1970s Al Roumi has participated in photographic and archaeological projects aimed at recording his country's heritage. As the head of the Souria Houria (Syria Freedom) organization, he has fought for his people's freedom since the beginning of the Syrian civil war in 2011.

Rousse, Georges (b. 1947) French photographer and painter. Rousse's sources of inspiration are → land art and abstract art. He constructs and paints large artworks, generally in abandoned locations, and then photographs them *in situ*. Both the artwork and the photograph share a single perspective, which lends support to the overall composition and unites his geometrical ensembles. He lives and works in Paris.

Rovner, Michal (b. 1957) Israeli photographer. Rovner studied film and philosophy at the University of Tel Aviv before graduating in art and photography at the Bezalel Academy, Jerusalem, in 1985. In 1978 she and the artist Arie Hammer founded the first school of photography in Tel Aviv, called Camera Obscura. She moved to New York in 1987 and continued her career in photography and the cinema, also producing video installations. In her photographic work Rovner looks for new ways to use → negatives, which frequently results in distorted images.

Royal Photographic Society An association founded in London in 1853 by → Roger Fenton. Originally known as the Photographic Society of Great Britain, it earned the patronage of Queen Victoria in 1894. Its collection of more than 120,000 photographs and 60,000 cameras and other pieces of equipment was assembled through the donations of many photographers and their descendants. Much of it goes back to the 19th century and to English → Pictorialism. Fenton was the first honorary secretary; → William Henry Fox Talbot refused the presidency, which was taken up by Sir Charles Eastlake, who was also president of the Royal Academy. The society was established for 'the promotion of the Art and Science of Photography, by the interchange of thought and experience among Photographers'. It encouraged research and the circulation of photographs as well as organizing exhibitions. Few photographs were acquired during the 19th century, apart from → calotypes by → Hill and Adamson, Fenton's album on the Crimean War, and an album of Talbot's → salted paper prints. John Dudley Johnston amassed the bulk of the collection between 1923 and 1955, acquiring many works by the Pictorialists and asking descendants of society members to donate prints

• R —

and equipment. It now contains major works of British photography from throughout the 19th century by such figures as William Henry Fox Talbot, Hill and Adamson, Roger Fenton, → Oscar Gustav Rejlander, → Julia Margaret Cameron, → Frederick H. Evans, → Alvin Langdon Coburn, → Samuel Bourne, → Francis Frith and → Felice Beato. In 1970 the Royal Photographic Society left London for Bath.

Ruff, Thomas (b. 1958) German photographer. Ruff was taught by → Bernd Becher at the Kunstakademie in Düsseldorf (1977–85), a school of photography with which he is still associated and which played an important role in establishing photography as an art form. During the 1980s Ruff produced plain portraits, taken face-on, and images of refined interiors and architecture in line with the conceptual documentary style practised by Bernd and Hilla Becher. In the 1990s his work became more complex: he created images inspired by science (the *Sterne* series) or the media (the *Nächte* series); digitally manipulated abstract photographs (the *Sunstrat* and *Zycles* series); retouched images taken from the internet and new media (the *Jpeg* series); and pornographic photographs (the *Nudes* series). Together with his fellow graduates from Düsseldorf, he has helped to popularize the use of large-format photography. He taught at the Düsseldorf Kunstakademie from 1998 until 2006.

Ruka, Inta (b. 1958) Latvian photographer. Ruka began her photographic career at the end of the 1970s. Between 1983 and 2000 she created *My Country People*, a series of portraits taken in the region where she lived. With a deep concern for humanity, she captures her subjects' personalities, photographing them in their own environment. Her preference for black-and-white images, taken with a → Rolleiflex, means that her work resembles → documentary photography from the 1930s.

Ruscha, Ed (b. 1937) American artist. With many books to his name, Ruscha is an influential figure in the field of photography. In 1956 he studied painting, photography and graphic art at the Chouinard Art Institute in Los Angeles (now called CalArts). Known principally for his paintings based on vernacular American culture, which are classified as Pop art, he took up photography during the 1960s and produced many small-format books that influenced several generations of artists. His first publication, *Twentysix Gasoline Stations* (1963), opened the way for fifteen more, including *Some Los Angeles Apartments* (1965), *Every Building on the Sunset Strip* (1966), and *Nine Swimming Pools and a Broken Glass* (1968). According to Ruscha, photography is simply an excuse for making books. He attaches little importance to the actual process of shooting photographs, and deliberately chooses banal and easily accessible subjects such as gas stations and streets. For *Thirtyfour Parking Lots in Los Angeles* he even hired an aerial photographer to do the work.

Thomas Ruff, *Portrait I (Igraw)*, 1988

R •

STANDARD, AMARILLO, TEXAS

Ed Ruscha, *Standard Station,*
Amarillo, Texas, 1962

Originally produced in print runs of between 400 and 2,000 copies and cheaply priced, his books are now rare, collectible items. During the 2000s Ruscha again combined the concepts of book and photography with *On the Road* (2009), in homage to the famous novel by Jack Kerouac.

Rydet, Zofia (1911–1997) Polish photographer. Having graduated from Snopkov Agricultural College in Ukraine in 1934, Rydet came to photography comparatively late in life. It was not until she was 40 years old that she bought her first camera, an Exacta, and began to enter amateur competitions. She is best known for her series of sociological reports. In her first work, entitled *Little Man* (1952–61), she showed a deep empathy with children and the situation of childhood. She took her photographs mainly in Silesia and the region of Podhale, but she also travelled extensively in Eastern Europe,

Egypt and Lebanon. Rydet's *Sociological Record* (1978–90) documented the rural world of southern Poland and provided a veritable atlas of ethnography with its frontal portraits of elderly countryfolk posing in their homes.

● **R** —

S

Saanio, Matti (1925–2006) Finnish photographer. He became known in the 1950s as a photographer of the people and natural scenery of Lapland. He documented changes in society and in the landscape, especially in northern Finland. Saanio's work on the Arctic comprises more than 230,000 negatives, 11 illustrated books, and hundreds of exhibitions in Finland and elsewhere in Europe. He has received the Finnish State Prize for Photography three times, as well as the Pro Finlandia medal. He was the first to become a professor of photography in Finland, working at the University of Art and Design, Helsinki, from 1986 to 1989. Saanio was editor-in-chief of *Valokuva* magazine between 1976 and 1984.

Sabatier effect *see* **Solarization**

Salas Freire, Osvaldo (1914–1992) Cuban photographer. Salas Freire's family emigrated to New York where, in addition to producing photographs, he worked as a welder for the International Company of Telegraphs and Telecommunications. In 1955 Fidel Castro organized a fundraiser for the Cuban Revolution and asked Salas Freire to take a series of pictures for his poster campaign. At Castro's request, he travelled to Cuba in 1959, taking his 18-year-old son, Roberto, with him and producing historic images of the revolution's final months. The two were subsequently promoted by Castro to supervise the photography section of the newspaper *Revolución*, for which they continued to photograph new subjects.

Salgado, Sebastião (b. 1944) Brazilian photographer. Salgado became a professional photographer in 1973, joining the Sygma (1974–75), → **Gamma** (1975–79) and → **Magnum** (1979–94) agencies before opening his own in 1994 (Amazonas Images). Alongside his agency work, Salgado has tackled various long-term documentary projects that have helped to establish his reputation. For seven years he travelled through Latin America, photographing the ancestral tradition of the Indians (*Other Americas*, 1986); he covered twenty-six countries for a project devoted to the disappearance of manual labour (*Workers*, 1993); and he recorded mass population displacements in *Migrations*,

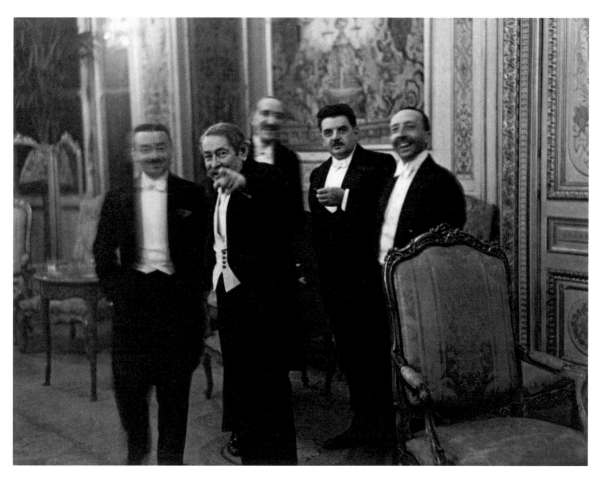

Erich Salomon, *Aristide Briand pointing
at Erich Salomon and saying, 'Ah! There he is!
The king of the indiscreet!'*, 1931

2000. Salgado has sometimes been accused
of exploiting human misery for aesthetic and
commercial ends, but his skill and personal
engagement have been widely recognized.
He is the recipient of many awards and prizes.

Salomon, Erich (1886–1944) German
photographer. Born into a rich Berlin family,
Salomon obtained his law doctorate in 1914.
During the 1920s he had a succession of jobs: at
the Berlin stock exchange, in a piano factory and
as a chauffeur in a car hire firm he set up himself.
In 1925 he joined the publicity department of
the publishers Ullstein, and it was for them
that he took his first photographs. It was not
until 1928, however, and the publication of his
photographs documenting a trial in the *Berliner
Illustrirte Zeitung*, that he took up professional
photography full time. Salomon developed
a method that would make him famous and,
for many people, mark him out as the founding
father of modern → **photojournalism**: using
his connections, he was able to gain entry to
milieux that were traditionally hidden from
view, where he secretly recorded aspects of
political and social life that had never before
been seen in public. Ignoring the protocol of
official photography, and with the surest of
touches, Salomon presented to the world a new
image of the European elite, taken on the spot.
His approach is exemplified by his book *Famous
Contemporaries in Unguarded Moments* (1931).
He remained unobtrusive thanks to his choice
of small, portable cameras (the Ermanox and
→ **Leica** I, for example), which he could conceal
easily and also use in natural light. He published

• S —

Auguste Salzmann, *The Church
of the Holy Sepulchre, Jerusalem*, 1854

much of his work in the international press and became one of the best-known European photographers between the wars. When Hitler came to power, Salomon fled from Berlin and settled with his family in The Hague. In 1939 Germany invaded the Netherlands, and Salomon was denounced to the Nazi authorities. He was deported with his wife and younger son, and died in Auschwitz in 1944.

Salted paper print The earliest method of making positive prints, invented by → William Henry Fox Talbot in 1840. A sheet of paper was coated first with a solution of salt and then a solution of silver nitrate. The silver combined with the chloride to form light-sensitive silver salts. After the paper had dried, it was placed in contact with a → negative (a → calotype) and exposed to ultraviolet light, which produced a positive print. Since salted paper was a → printing-out

process, it required no development stage for the image to form. Instead, it was simply fixed using a salt solution (later replaced by 'hypo', or sodium thiosulphate), frequently toned with gold, and then washed. After dyeing, the resulting print had a matte surface and ranged in colour from reddish brown to purplish brown. Used in the 1840s and 1850s, salted paper prints were gradually replaced by → albumen prints.

Salzmann, Auguste (1824–1872) French photographer. Having trained to be a painter, Salzmann turned to photography because of his passion for archaeology. In 1853 he went to the Holy Land, and in 1858 and 1865 journeyed to the island of Rhodes. The expedition to Jerusalem was inspired by his interest in ruins that the antiquary Louis-Félicien de Saulcy believed to date back before the Roman Empire. Salzmann was fascinated by this controversial

theory, and together with his assistant, Rudolph Durheim, aimed to use photography to arrive at the archaeological truth. Four months after his arrival, illness forced him to return to France. Nevertheless, the expedition led to the publication of two luxurious volumes containing 174 → salted paper prints in 1854 and 1856, printed by → Louis-Désiré Blanquart-Evrard. Some archaeologists were sceptical, but critics declared that it was one of the finest photographic accomplishments of its time.

Samaras, Lucas (b. 1936) Greek-born American artist. Samaras graduated from Rutgers University, New Brunswick, in 1959, attended courses given by Meyer Schapiro at Columbia University, New York, and studied under Stella Adler at the Conservatory of Dramatic Art in New York (1961). He began his career as a painter, sculptor and performer but took up photography in 1969. Winner of the Infinity Award for Art in 1986, he represented Greece at the 53rd Venice Biennale in 2009. His work consists mainly of self-portraits, taken with the aid of a vast collection of → Polaroid cameras. Apart from

the various poses and identities he adopts, he also subjects the materials of photography to all kinds of experiments and distortion. Samaras continues to conduct these experiments using digital technology.

Sammallahti, Pentti (b. 1950) Finnish artist. He made his first photographs at the age of 11, inspired by → *The Family of Man* exhibition then touring in Helsinki. Sammallahti's breakthrough work, *Cathleen Ní Houlihan – An Irish Portfolio* (1979), revealed an aesthetic that accentuated the pictures' tonality and the photographer's inner experience. The characteristic inclusion of dogs in his images points up the shared nature of the earth with a gentle humour. Between 1974 and 1991 Sammallahti taught at the University of Art and Design, Helsinki, where he helped establish a culture of high-quality photographic printing. In 2004 the French photographer → Henri Cartier-Bresson ranked Sammallahti among his hundred favourite photographers for his foundation's inaugural exhibition in Paris. He was published as part of the Photo Poche book series in 2005 and had a solo exhibition at the

• S —

Lucas Samaras, *Panorama*, 1983

Sandberg, Tom

Rencontres d'Arles photo festival. Sammallahti's major retrospective held in Arles in 2012 was accompanied by a monograph, *Here Far Away*.

Sandberg, Tom (1953–2013) Norwegian photographer. He trained in photography at Trent Polytechnic, Nottingham, and at Derby College of Art and Technology under Thomas J. Cooper, Paul Hill and John Blakemore, finishing in 1976. He planned to continue his studies in the United States with → Minor White after meeting the photographer, but the latter died soon after. Sandberg began his artistic career in the 1980s with solo shows at the Fotogalleriet (1980) and the Henie Onstad Art Centre (1985) in Oslo. Although his subjects are diverse, Sandberg's work has been consistent throughout his career. His black-and-white photographs are shot with small-format cameras, which emphasize contrast and grain. He is a master in transforming ordinary objects through photography. One early example is his *Untitled* (1980), a close-up of a ripple on the surface of a dark sea. Sandberg is also well known for his monumental close-up portraits of the American composer John Cage (1985) and the Polish punk musician Andrej Nebb (1980). In 2007 the PS1 Contemporary Art Center in Long Island, New York, held a retrospective show of Sandberg's work, presenting his photographs to a larger, international audience. In addition to his earlier images, it featured many photographs relating to travel – including aerial pictures of clouds, vapour trails and aeroplanes barely discernible on a fogbound runway – in which his lyrical, almost mystical view of the everyday was evident. Sandberg is represented in numerous Norwegian collections.

Sander, August (1876–1964) German photographer. Sander is closely associated with the → New Objectivity movement. His first contact with photography came when, as a young man, he assisted a photographer working at the local iron-ore mine. With the financial support of his uncle, he bought his first camera, and in 1897 he began to train as a photographer under Georg Jung. He went on to study at the Royal Art Academy and School of Applied Art in Dresden, and in 1902 began working for the Photographische Kunstanstalt Greif in Linz, Austria. His work included portraiture, landscape and architectural photography. In 1910 Sander returned to his family home in Cologne and set up his own studio. He was called up as a soldier during World War I. In 1920 he started work on his best-known series, *People of the 20th Century*, which was first exhibited in 1927 at the Kunstverein, Cologne. In this series, Sander photographed people from different social classes and professions, producing portraits that were of documentary and sociological significance. In 1929 he published his first book, *Face of Our Time*, made up of sixty portraits from the *People of the 20th Century* series. The book was subsequently banned by the Nazi regime and its printing plates seized. During the same period Sander's son Erich was imprisoned by the Nazis for his Socialist

— S •

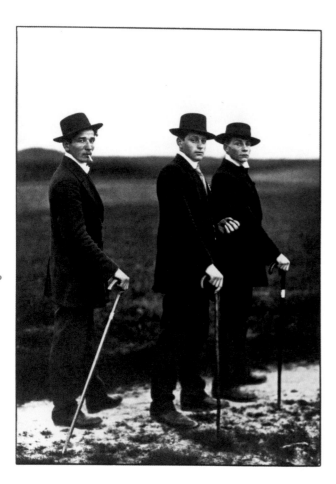

August Sander,
Young Famers, 1914

beliefs. In 1942 Sander and his wife fled Cologne with some of his photographic negatives, but the archives that were left behind were later destroyed. After the war he set up a new studio in Kuchhausen. His work has featured in countless exhibitions, including → *The Family of Man* at the → Museum of Modern Art, New York (1955).

Sasse, Jörg (b. 1962) German photographer. Sasse studied under → Bernd Becher at the Kunstakademie Düsseldorf (1982–87), a school of photography with which he remains associated. During the 1980s Sasse's work was mainly documentary and explored modes of spatial construction. Since the mid-1990s he has based his work on found photographs which he manipulates with the aid of a computer. He taught → documentary photography at the University of Duisberg-Essen from 2003 to 2007.

Sassen, Viviane (b. 1972) Dutch photographer. Sassen studied both fashion (at Arnhem) and photography (at Utrecht). Since 2000 she has divided her time between commissions for fashion houses (including Miu Miu, Diesel and Adidas) and fine art photography, displaying a meticulous sense of colour, form, contrast and poeticism in both genres. She has published two books of her work: *Flamboya* (2008) and *Parasomnia* (2011). Sassen's mildly surreal style, the result of a complex array of non-digital techniques, harks back to the fascinating and disconcerting inventions of such photographers as → Man Ray and → Guy Bourdin.

Saturation Saturation refers to the intensity of colour. The more saturated a colour is, the purer it is. Likewise, the less saturated a colour is, the more grey it contains. A completely desaturated colour is nothing more than a shade of grey, such that desaturation of an entire image produces a greyscale image.

Saudek, Jan (b. 1935) Czech photographer. Saudek began to take photographs at the age of 16, when his father gave him his first camera. From 1950 until 1952 he studied at the School of Industrial Photography in Prague. His work has been profoundly influenced by his personal

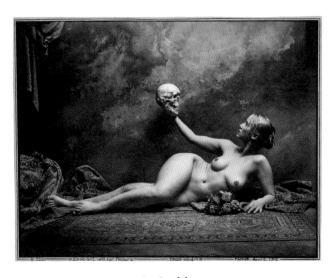

Jan Saudek,
The Slavic Girl with her Father, 1998

experiences and by the exhibition → *The Family of Man*. It uses contrasts to explore the relationship between men and women, nudity, childhood, death, and tenderness and violence – all with an atmospheric ambiguity that lies somewhere between the romantic and the erotic. Most of his photographs are staged in the same setting. The wall of his studio, crumbling and stained with damp, forms a backdrop for his sitters, who pose singly or in groups, either naked or in costumes. His images were initially in black and white, but in 1977 Saudek began to colour his prints by hand, making each one unique. Always controversial, his work achieved recognition abroad before it found acceptance in the Czech Republic. Today it can be seen all over the world, in exhibitions and publications.

• S —

Schad, Christian (1894–1982) German painter and photographer. Schad was one of the most important painters of the → New Objectivity movement in Germany and a re-inventor of the → photogram technique, which he named 'Schadography'. Having contented himself with studying for one semester at the Art Academy Munich in 1913, he escaped military service in World War I and introduced himself to the Dada movement in Zurich. Introducing artistic refinements to → William Henry Fox Talbot's technique of the → photogenic drawing,

357

Christian Schad,
Amourette, 1918

he developed his first Dadaist and abstract 'Schadographs' in 1918. During the 1920s Schad turned to a realist, old-masterly style of painting and began his famous series of metropolitan portraits and erotic scenes. He continued to promote the acceptance of the photogram as an art form, exhibiting his cameraless work at the → Museum of Modern Art, New York, in 1937. Returning to photograms in the 1960s, this time he explored a less abstract but more fantastical and mythical body of imagery.

Schadeberg, Jürgen (b. 1931) German-born South African photographer. Schadeberg studied at the School of Optics and Phototechnology in Berlin before becoming an apprentice photographer at a press agency in Hamburg. In 1950 he left Germany and settled in Johannesburg. He joined the magazine *Drum* and worked freelance for other magazines such as *Time*, → *Life* and

Stern, as well as for the → Black Star agency. He was thus in a privileged position to capture the events and main characters in the history of South Africa's black communities, especially during the struggle against apartheid. Forced to leave the country in 1964, he nevertheless remained in close contact with it and returned several times to compile reports, documentaries and works of fiction. He also helped to develop South African photography, mentoring photographers including Peter Magubane, → Bob Gosani and → Santu Mofokeng, and is regarded as one of its most important figures. He is a seasoned traveller, and has lived and worked in the United Kingdom, Germany, Spain and the United States. Among his many achievements he is known for his work as a publisher (*Camera Owner*), photojournalist (for the *Times*, *Observer*, *Sunday Times* and *Die Zeit*, among other publications), teacher

(at the Central School of Art and Design, London, and the New York School) and exhibition curator.

Schaeffer, Jean-Marie (b. 1952) French philosopher. A specialist in aesthetics and genre studies, Schaeffer's interest in photography is explored in *L'Image précaire* (1987). Relying heavily on analytical philosophy, and in particular on the work of → Charles Sanders Peirce, he advocates a return to a form of photography defined by the photographic device as a way of maintaining distance. Faced with a surfeit of interpretations, he describes photography as a 'lay art' that offers 'much to see, but ... little to say'.

Schall, Roger (1904–1995) French photographer. Schall was trained by his father, a professional photographer. In 1931 he opened his own studio in Paris, which soon functioned as an agency, employing about fifteen people. Schall was much in demand by French and international magazines, including *Paris Match*, → *Vu* and → *Life*, and his photographs of Paris under occupation were a huge success. After the war, he confined himself to advertising and finally abandoned photography in 1967.

Schatzberg, Jerry (b. 1927) American photographer and film director. He began his career at the age of 27 as a photographer's assistant, set himself up independently in 1956 and was spotted by → Alexander Liberman, who encouraged him in his career by publishing his fashion photographs in → *Vogue*. Schatzberg's studio welcomed a succession of celebrated cultural figures in the 1960s, all immortalized in naturalistic portraits that bear witness to their close relationship with the photographer.

Schmidt, Michael (b. 1945) German photographer. A self-taught artist, Schmidt was one of the most important photographic chroniclers of Germany in the post-war and reunification periods. He is best known for his black-and-white series *Waffenruhe* ('Ceasefire', 1985–87) and *EIN-HEIT (U-NI-TY)* (1991–94). He is mostly concerned with the effects of political and social conditions on public and private spaces, focusing on his home town of Berlin. Schmidt also addresses issues surrounding the medium of photography itself, particularly through his publications.

Schuh, Gotthard (1897–1969) Swiss photographer. Schuh commenced his studies in painting at the École des Arts et des Métiers in Basel (1916) and after two years' military service returned to complete the course in 1919. Following several years in Munich, he moved to Zurich in 1927. He joined the Basel-based Rotblau group and began his photographic career in 1928. He was helped and encouraged by Arnold Kübler, who in 1929 became photographic editor of the *Zürcher Illustrierte*, for which Schuh produced most of his work. Schuh's photographs were subsequently published in magazines including → *Vu*, *Berliner Illustrirte Zeitung*, *Paris Match* and → *Life*. Between 1941 and 1960 he worked for the *Neue Zürcher Zeitung*. His main interest lay in social themes, such as the miners of Charleroi, Belgium, and in major historical events including the meeting between Benito Mussolini and Adolf Hitler in Berlin in 1937. During his career Schuh published books about Zurich (1935), Italy (1953) and Ticino (1961). → Edward Steichen selected some of his work for the → *The Family of Man* exhibition (New York, 1955), and he was given a retrospective entitled *Frühe Photographien 1929–1939* in Zurich in 1967.

Scianna, Ferdinando (b. 1943) Italian photographer. Scianna studied philosophy and art history at the University of Palermo before publishing his first collection of photographs, *Feste religiose in Sicilia*, in 1965. A collaboration with the writer Leonardo Sciascia, this work documented the fervour of religious festivals in Sicily using the aesthetic codes of Italian neo-realism. This was the first of Scianna's projects with different authors, who included Jorge Luis Borges, Milan Kundera and André Pieyre de Mandiargues. In 1973 Scianna left Italy for Paris, where he joined → Magnum Photos in 1982, becoming a full member in 1989. In 1987, encouraged by Domenico Dolce and Stefano Gabanna – both completely unknown at the time – he tried his hand (very successfully) at → fashion photography. Since then he has

• S —

Scientific photography

gained an international reputation, alternating between → photo-reportage and fashion.

Scientific photography Photography has always had close ties with science. Indeed it was a scientist who first publicly announced the invention of the medium, at the Académie des Sciences, Paris, in 1839. Photography serves science just as scientific research has served to further the development of photographic technology. Until the end of the 19th century photography was a tool of discovery, used in many domains. The variations in scale and different perspectives the medium can provide (such as → Nadar's aerial views, taken in and after 1858) all offered a new way of seeing the world. The first research into microphotography and astronomical photography took place in the 1840s. → Louis Daguerre himself set out to photograph the moon, and → John William Draper succeeded in doing so in 1840, while → Hippolyte Fizeau and Léon Foucault produced the first → daguerreotype of the sun in 1845. From the 1870s onwards → gelatin emulsions and faster → exposure times allowed for new forms of exploration. The research carried out by → Étienne-Jules Marey and → Eadweard Muybridge on animal locomotion was extended by → Harold Edgerton's invention of the stroboscopic process (1931). The discovery of X-rays in 1895 by → Wilhelm Röntgen, and of radioactivity by Henri Becquerel in 1896, reinforced the idea that photography was able to record phenomena invisible to the naked eye, as the astronomer Jules Janssen had already demonstrated in the 1870s. → Radiography, which reveals the inner workings of the body, seemed to echo the spiritualist photographs of the late 19th century that set out to capture a person's aura or the ghosts of the dead. In 1898 Secondo Pia photographed the Turin Shroud, the negative of which revealed a positive image of a man's body imprinted on the cloth, thus apparently demonstrating that photography could provide proof of miracles. The medium was also used in ethnography (in the experiments of → Francis Galton and Arthur Batut, for instance), criminology (→ Alphonse Bertillon, Cesare Lombroso) and psychiatry (as in the

clinical photographs taken by Désiré-Magloire Bourneville, Paul Regnard and → Albert Londe). Photography also had a role to play in zoology, archaeology, medicine, anthropology, geology and cartography. Various technical developments during the 20th century (such as → colour and → digital photography) extended these scientific applications still further. As recently as 2012, the robot Curiosity photographed views of Mars that had never been seen before.

Seawright, Paul (b. 1965) British photographer. In 1988, after attending courses at the West Surrey College of Art and Design, he compiled his famous series *Sectarian Murders*, for which he photographed locations around Belfast where sectarian violence had taken place during the Troubles. He juxtaposed these images with quotations from contemporary newspapers. Since then, he has continued to document the aftermath of the conflict in Northern Ireland, but has also worked in Afghanistan and taken photographs of the post-industrial Welsh landscape by night.

Sébah, Pascal (1823–1886) **and Jean-Pascal** (1872–1947) French photographers. Pascal, the father, was born in Turkey (his own father was Syrian) and worked in Constantinople from 1868 and in Cairo from 1873. He produced exotic views for tourists, designed to complement explorers' accounts of their travels. When he died, his son Jean-Pascal took over the business and established a studio in partnership with Polycarpe Joaillier. They became official photographers to the Ottoman Sultan Abdulhamid II.

Secchiaroli, Tazio (1925–1998) Italian photographer. Secchiaroli began his career as a street photographer in Rome from 1944 until 1952. He worked for the VED agency in 1952, but went on to found the Roma Press Photo agency in 1955 alongside Sergio Spinelli. Between 1960 and 1983 he took still photographs of Federico Fellini's films and became Sophia Loren's official photographer. The 'miracle' and striptease scenes in Fellini's *La Dolce Vita* (1960) were based on photographs Secchiaroli had taken two years

previously. Although another photographer, Quinto Felice, influenced the portrayal of the character known as Paparazzo, Secchiaroli's special relationship with Fellini before and during the shooting suggests that he was the real model. The titles given to later publications and exhibitions in France and Italy – *Tazio Secchiaroli: The Original Paparazzo*; *Tazio Secchiaroli, le photographe de La Dolce Vita*; *Tazio Secchiaroli: Paparazzo?* – bear this out.

Seeley, George Henry (1880–1955) American photographer. Seeley was a prominent member of the → Photo-Secession. He was a student of painting and drawing in Boston when he befriended → Fred Holland Day, who introduced him to photography. Seeley exhibited fourteen photographs in the First American Photographic Salon in New York, 1904, and his work attracted the attention of → Alfred Stieglitz. He joined the Photo-Secession and contributed regularly to → *Camera Work*. Seeley's career ultimately suffered with the decline of → Pictorialism.

Sekula, Allan (b. 1951) American photographer, critic and essayist. Sekula's montages of texts and images focus on the world of work, the mechanics of globalization, and frontiers. In 1972 he produced a series of slides showing workers leaving an aeronautics factory in San

• S —

Paul Seawright,
from the series *The Forest*, 2000

Diego at the end of the day (*Untitled Slide Sequence*). The images, taken from the top of a staircase that the employees were climbing, showed the difficulty of applying a common identity to a class of workers. In 1979 his essay *Dismantling Modernism, Reinventing Documentary* was a politicized, critical history of the documentary format. *The Body and the Archive*, a work he published in 1986, dealt with the institutional and legal functions of → documentary photographs since the 19th century and with the anthropometric techniques espoused by → Alphonse Bertillon and → Francis Galton. Sekula studied the concept of the archive in his book on the coalmines of Cape Breton, Canada (1983). He next turned his attention to the maritime world and the fishing industry in *Fish Story* (1989–95) and *Titanic's Wake* (1998–2000), in which he focused on the image of the sea in society, using the set of the eponymous film as his starting point (it had been built on the frontier between Mexico and the United States – another of his key subjects). In 1999 he again used slide projections to present images of anti-globalization protesters at the World Trade Organization conference in Seattle. Here he explored the political and visual structure of political identity in groups and crowds.

Self-portrait A work in which an artist or photographer sets out to portray his or her own appearance. Owing to the creative freedom it offers, photography has lent itself to the genre of the self-portrait since its earliest days. In 1840 → Hippolyte Bayard took the first staged photographic self-portrait, *Self-Portrait as a Drowned Man*, which embodies the genre's fundamental feature: the → *mise-en-scène* of the artist's self, with the aim of recording and conveying a sense of personality and character. Photographers have used it to affirm their social status, for advertising purposes (as with Warren Thompson, *c.* 1855) or to record their own lives (as in → Oscar Gustav Rejlander's *The Artist Introduces the Volunteer*, 1871). It was the → Pictorialists, especially → Edward Steichen and → Edward Weston, who enabled the photographic self-portrait to acquire an aesthetic value, following which it became a favoured technique among a new generation of avant-garde artists:

Allan Sekula, *Panorama: Mid-Atlantic, November 1993*,
from the series *Fish Story*, 1989–95

Marcel Duchamp (*Rrose Selavy*, 1921); followers of the → New Vision such as → Man Ray, → László Moholy-Nagy, → Umbo (who recorded his own face) and → Herbert Bayer; and the → Surrealists, with their playful use of → photo-booths. The self-portrait became established as a popular genre in the 1960s and 1970s. It offers great potential for the exploration and depiction of the body and face, allowing artists to record reflections in a mirror (→ Florence Henri, *Self-Portrait in Mirror*, 1938), their own shadows (→ André Kertész, *Self-Portrait*, 1927; → Lee Friedlander, *Philadelphia, Pennsylvania*, 1967) or abstract, fragmented views of their own bodies (→ John Coplans, → Arno Rafael Minkkinen). It is also a means of recording the passage of time and the march towards the inevitable, for which artists either stage their own ends (→ Peter Beard with *Self-Portrait in Mouth of Crocodile*, 1965; → Duane Michals, *Self-Portrait As If I Were Dead*, 1968; → Dieter Appelt, *Self-Portrait in the Mirror*, 1978) or take moving self-portraits shortly before death (→ Robert Mapplethorpe, *Self-Portrait with Cane*, 1988). The photographic self-portrait also acts as a mirror in which artists question their identity by dressing up in fantastical ways (→ Pierre Molinier, → Urs Lüthi) and undergo self-examination (→ Claude Cahun, → Cindy Sherman, → Yasumasa Morimura). In this respect, the self-portrait can be compared to the fields of autobiography and documentary (→ Robert Frank, → Nan Goldin), literature (→ Hervé Guibert, → Denis Roche) and fiction (→ Jean Le Gac, → Christian Boltanski, → Sophie Calle).

Sella, Vittorio (1859–1943) Italian mountaineer and photographer. At a very young age, Sella was already fascinated by mountaineering and photography. He combined his two passions by exploring the Swiss, French and Italian Alps before travelling to the mountains of the Caucasus and Nepal, which at that time were still completely unknown. Sella's photographs opened up new worlds, allowing a wider public to see peaks that until then had been the exclusive domain of explorers.

Sellerio, Enzo (1924–2012) Italian photographer. Although he studied law, Sellerio turned to

Vittorio Sella, *Grand Sagne and Ecrins, Alps*, 1888

→ photo-reportage in 1952 and published his first images in 1960 in the Zurich magazine → *Du*. In 1969 he and his wife, Elvira, founded the Sellerio publishing house in Palermo, which specializes in thrillers. Among their most famous authors are Leonardo Sciascia and Andrea Camilleri.

Semiotics The branch of philosophy that studies the theory of signs and symbols, named after the Greek *semeion*, meaning 'sign'. It was founded on the ideas of the American philosopher → Charles Sanders Peirce in the early 20th century. In the same period, the Swiss linguist Ferdinand de Saussure developed a theory of language as a system of signs and laid down the framework for the field he called semiology, of which linguistics is a subdiscipline, in his posthumous work *Course in General Linguistics* (1916). The terms 'semiotics' and 'semiology' are now often used interchangeably.

• S —

Paul Senn, *Lunch at a Mountain School,*
Adelboden, Bernese Oberland, Switzerland, 1935

Semiotics is sometimes divided into two
broad areas. The first of these, the semiotics of
communication (Eric Buyssens, Georges Mounin,
Jeanne Martinet, Louis Prieto) is concerned
with the transmission of codes or signals.
The second field, the semiotics of signification
(Roman Jakobson, Louis Hjelmslev), considers
the intention behind this transmission. It was
the latter field, which includes the semiotic
potential of non-linguistic systems, that
led to the development of visual semiotics.
Work in this field includes → Roland Barthes
on photography and Christian Metz on
cinema, Umberto Eco on the visual sign, and
the Belgian Groupe µ on the plastic sign.

Senn, Paul (1901–1953) Swiss photographer.
Having studied graphic art in Berne (1917–21),
Senn worked as an advertising consultant and
graphic artist in France, Spain, Belgium and
Germany from 1922 to 1930. In 1931 he embarked
on a collaboration with Arnold Kübler, who
had been photographic editor at the *Zürcher
Illustrierte* since 1929. He produced numerous
→ reportages, most notably on the Spanish
Civil War. In 1939 he travelled to the United
States and on his return worked for a number
of magazines, including the *Berner Illustrierte*
and *Sie und Er*, and for newspaper syndicates.
During World War II he was employed by the
Swiss army as a military photographer. In 1946

he returned for a period to the United States, where he filed reportages for the *Schweizer Illustrierte*. In 1951 he joined the Kollegium Schweizerischer Photographen, a group of Swiss artists whose members included → Werner Bischof, Walter Läubli, → Gotthard Schuh and → Jakob Tuggener. Together they mounted an exhibition of new Swiss photography in Zurich.

Sensitized plate A plate of metal or glass that has been sensitized to the action of light through chemical means. The image thus formed may be either positive (as with → daguerreotypes or → ferrotypes, for example) or negative (as with wet → collodion or → gelatin dry plates).

Sequence A series of images that follow one after another in a repetitive pattern or logical order. This process can capture movement, break it down into still images (as in → Eadweard Muybridge's study of *The Horse in Motion* of 1878) or convey a narrative (as in → Duane Michals's *Chance Meeting*, 1970). The concept of sequence is integral to the medium of photography itself, since photographic → film and → contact sheets essentially consist of rows of numbered images.

Series Two or more related photographs that appear together in a publication, exhibition, portfolio or body of work. A series may be thematic, chronological or aesthetic in origin: for example, → Cindy Sherman is known to produce photographs in the form of thematically related series, such as her *Untitled Film Stills*. A series may also comprise images by more than one artist, and may be the creation of a photo editor. The publication of journalistic photographs in series began in the → illustrated press in the early 20th century. The word is also used to describe a collection of press or → documentary photographs published either in print or online.

Serrano, Andres (b. 1950) American photographer. After studying at the Brooklyn Museum Art School, Serrano created photographic → series in colour whose content is often controversial. His focus is on the human body, which is defined through its fluids and excretions (semen, excrement or urine, in which various

religious symbols are immersed) or through sexuality, or shown in its ultimate state in the morgue. Symbols, iconographic references and the unconscious all play a role in questioning the ambiguities of society. Taken in the studio against a background of saturated colours, portraits of the Ku Klux Klan, the homeless and other people who embody the various facets of American society defy any simple, Manichaean interpretation.

Sewcz, Maria (b. 1960) German photographer. Born in Schwerin, in the former East Germany, Sewcz studied photography at the Academy of Visual Arts, Leipzig, where she took her master's degree before going on to teach at the University of Brunswick. Her artworks take the form of → series – initially in black and white, but later

Andres Serrano, *Piss Christ*, 1987

David 'Chim' Seymour, *The Port of Cartagena: The Revolt of Pro-Franco Officers is Silenced by Republican Marines on the Battleship 'Jaime 1'*, 1936

in colour. Carefully composed and with surprising contrasts of colour, form and message, they document details of her daily life in the places she has lived, including Berlin and Rome.

Seymour, David 'Chim' [David Szymin] (1911–1956) Polish-born American press photographer and president of → Magnum Photos. Born David Szymin into a Polish family of Jewish descent, he studied bookmaking and graphic arts in Leipzig before enrolling at the Sorbonne, Paris, in 1931 to study chemistry and physics. He quickly took up → photojournalism to provide for his family as their finances suffered under the Nazi regime. By 1933 he was working for the Alliance Photo agency. Publishing under a newly adopted name, Chim covered the emergence of fascism in Europe and the Spanish Civil War. When war broke out in the United States, he enlisted in the US army as a photographer. In 1947 he co-founded Magnum alongside → Henri Cartier-Bresson, → Robert Capa and → George Rodger, acting as president after Capa's death. Chim was killed on assignment in Egypt in 1956 while covering the Suez Crisis ceasefire.

Shadbolt, George (1830–1901) British photographer. He was a pioneer in the field of microphotography and → combination printing,

and in the 1850s exhibited his architectural photography and portraiture. He was a founding member of the Photographic Society as well as the first editor of the *London & Manchester Photographic Journal*. The demands of his family's timber business forced Shadbolt to retire from the → *British Journal of Photography* in 1865.

Shafran, Nigel (b. 1964) British photographer. A noted fashion photographer in the 1990s, Shafran has produced numerous series documenting everyday life at home and in the world around him, including *London Tree Photographs* (1993) and *Ruthbook* (1992–2004). He has published his work as *Ruth on the Phone* (2012), *Flowers for ___* (2008) and *Dad's Office* (1999), among other titles.

Shahbazi, Shirana (b. 1974) Iranian photographer. Born in Iran, Shahbazi studied photography at the University of Applied Sciences and Arts in Dortmund, and at Zurich University of the Arts. Her analogue photographs of landscapes, portraits and still-lifes quote from classical art history. Exploring the borderline between representation, abstraction and the cultural ascription of images, she commissioned carpet-weavers and billboard-painters to translate her work into different media. She later focused on abstract work and the transformative potential of the photographic medium, capturing colourful geometric forms she had arranged in her studio.

Shahn, Ben (1898–1969) Lithuanian-born American painter, graphic artist and photographer. Having studied art at the National Academy of Design, New York, he was employed as a photographer by the → Farm Security Administration thanks to his friend → Walker Evans. His career was brief, but he produced a number of images that were important because of their modern approach to composition, their harshness and their undeniable polemic power, testimony to Shahn's social engagement.

Shaikhet, Arkady Samoylovich (1898–1959) Russian photographer. Shaikhet settled in Moscow in 1918 and began his career as a

portrait photographer and retoucher in 1922 before becoming a photojournalist for *Rabochaya Gazeta*. From 1924 he worked for the weekly magazine *Ogonyok*. In 1928 he showed more than thirty documentary and genre photographs in the exhibition *Ten Years of Soviet Photography*. His primary interest was social iconography, and he expressed his poetic and symbolic sentiments through themes such as peasants seeking work in the city, orphanages, the first electric light bulb and peasant delegations being received by Mikhail Kalinin. Through his photographs on themes such as the construction of the Turkestan–Siberian Railway and peasants discovering machinery, including motorcars, for the first time, Shaikhet presented technology as a means of discovering the world. During the 1930s he collaborated with the journal *USSR in Construction* and → *Arbeiter Illustrierte Zeitung* in Berlin. In 1931,

in collaboration with → Max Alpert and Solomon Tules, he produced *24 Hours in the Life of the Filippov Family*, his first → photo-reportage. During World War II he was a correspondent for the newspaper *Frontovaya Illyustratsiya*, for which he covered the Battle of Stalingrad, the liberation of Kiev and the Soviet Army's capture of Berlin. After the war Shaikhet worked once more for *Ogonyok*.

Sheeler, Charles (1883–1965) American painter and photographer. Sheeler studied at the Philadelphia School of Industrial Design and the Pennsylvania Academy of Fine Arts. In 1913 his work was exhibited at the Armory Show in New York, and in 1921 he worked with → Paul Strand on the film *Manhattan*. He took a series of photographs of the new River Rouge factory in Michigan for the Ford Motor Company in 1927. Sheeler was interested mainly in industrial

• S —

Ben Shahn, *Itinerant Photographer*
in Columbus, Ohio, 1938

Charles Sheeler, *Criss-Crossed Conveyors,*
Ford Plant, Detroit, 1927

— S •

scenes and machinery, but he also sometimes photographed more everyday subjects. His style, which had some affinity with geometrical abstraction and Cubism, bears the hallmarks of Precisionism, a form of art that was deliberately cold and sharply drawn, and that focused on modern technology or the uniquely American nature of new industrial landscapes.

Sherman, Cindy (b. 1954) American artist and photographer. After graduating from Buffalo University, New York, in 1976, Sherman settled in New York City and began a black-and-white series of *Untitled Film Stills*. In this ironic critique of the stereotypes associated with white middle-class American women, she used codes of representation drawn from the cinema of the 1950s and 1960s. She has continued to explore issues of female identity, and the way in which it is presented, through photographic → series in colour. She takes portraits only of herself, but she uses her image not as an autobiographical record

but as a generic model of the female. She invokes television, cinema, fashion and pornographic magazines in order to challenge the conventional views of women purveyed by the media. To this end, she has frequently adopted disguises and prostheses to emphasize the erotic aura imposed on women throughout the history of art (*History Portraits*, 1989–90). Humans disappear, to be replaced by mannequins with dislocated limbs (*Sex Pictures*, 1992) or a morbid vision of fake sexual organs or monstrously disfigured beings (*Horror and Surrealist Pictures*, 1994–96). After filming *Office Killer* (1997), Sherman returned to photography by once more portraying herself, heavily made up, in a further exploration of feminine identity and female stereotypes (*Hollywood Hampton Types*, 2000–02). Her phantasmagorical *Clowns* (2003–4), set against a lurid, multi-coloured background, embody the ambiguity of identities and explore the concept of masks and artifice. The interplay between seeming and being is also central to her murals, which superimpose black-and-white landscapes with coloured figures of women in disguise.

Shibata, Toshio (b. 1949) Japanese photographer. Shibata trained at the Tokyo National University of Fine Arts and Music. Strongly influenced by a period of study at the Royal Academy of Ghent, Belgium, he returned to Japan with a more acute appreciation of the landscapes of his native country. His most recognized photographic works depict the unpopulated countryside of rural Japan, and the conflict between natural forces and man-made structures.

Shiihara, Osamu (1905–1974) Japanese artist. Born in Osaka, he studied Western painting at the Tokyo National University of Fine Arts and Music. Following his graduation in 1932, Shiihara relocated to Hyogo Prefecture to set up a painting studio. Around this time he became interested in photography and joined the Tampei Photography Club. He produced many experimental works using → photograms and → solarization, also exploring the relationship between drawing and photography, which he called 'photo painting'. After World War II, Shiihara returned to Osaka

S —

Cindy Sherman,
Untitled Film Still No. 6, 1977

and was a founding member of the Spiegel Photographers Association.

Shinoyama, Kishin (b. 1940) Japanese photographer. While Shinoyama was still studying at the University of Nihon, he began to work for the agency Light Publicity. He then set himself up as a freelance photographer, working mainly in black and white, and creating intricate images in which the human body forms the centre of the composition.

Shore, Stephen (b. 1947) American photographer. From 1956 to 1967 Shore documented the activities of → Andy Warhol's Factory in black and white. His colour series *American Surfaces* (1972–73), taken with a Rollei 35mm camera, and *Uncommon Places* (1973–82), shot with a view camera, contributed to the recognition of → colour photography as an art form. The result of several journeys through the United States, they constitute a kind of traveller's diary, recording the places and everyday objects Shore encountered along the way: hotel rooms, cars, post-industrial landscapes. In 1975 he took part in the collective exhibition → *New Topographics: Photographs of a Man-Altered Landscape* at George Eastman House, Rochester, New York. Since 1982 he has been in charge of the photography programme at Bard College, Annandale-on-Hudson, New York.

Shterenberg, Abram Petrovich (1894–1979) Russian photographer. Between 1917 and 1919, Shterenberg worked in B. Tapuskyansky's studio in Tashkent before leaving for Moscow. In 1928 about fifty of his photographs, most of them portraits, were presented at the exhibition *Ten Years of Soviet Photography*. Unlike → Moisey Solomonovich Nappelbaum and → Pavel Semyonovich Zhukov, he never retouched the background of his photographs to give them a pictorial look. During his career Shterenberg worked for several different agencies, including Russfoto, Inifoto, Soyuzfoto and Novosti.

Shulman, Julius (1910–2009) American architectural photographer. Shulman was known for his widely published photographs of

Californian mid-century architecture, mostly in black and white. His photographic style emphasized the transparency, lightness and clarity of Modernist architecture. Shulman was highly instrumental in raising the profile of buildings by John Lautner, Richard Neutra, Frank Lloyd Wright and Pierre Koenig, for whom he shot his best-known photograph: *Case Study House #22, Los Angeles, 1960, Pierre Koenig, Architect*.

Shutter The camera mechanism that exposes the photographic film or sensor to light for a set length of time, in order to capture an image. A focal-plane shutter is positioned close to the light-sensitive surface; its speed may vary from several seconds to 1/4000 s. A leaf shutter or central shutter is positioned within a → lens assembly, and its speed can be up to 1/1000 s.

Shutter speed *see* **Exposure, Shutter**

Sidibé, Malick (b. 1935) Malian photographer. Sidibé studied jewelry at the School of Sudanese Craftsmen, Bamako. After working for five years at the Studio Photo Service in Bamako, he opened his own business, Studio Malick, in 1962, mainly taking black-and-white portraits of the capital's residents. The middle classes and their children came to pose for him, and he would also follow them on their Sunday outings, compiling stories based on their activities. In 1994 his work was exhibited for the first time at the Rencontres Africaines de la Photographie in Bamako. This event earned him the recognition he has enjoyed ever since. He was given the Hasselblad Award in 2003 and the Golden Lion at the Venice Biennale in 2007.

Sieff, Jeanloup (1933–2000) French photographer. Born in Paris, Sieff was already taking photographs at the age of 14. He spent a brief time studying at the Vaugirard photography school in Paris (1953) and in Vevey, Switzerland (1954), before enrolling at the Centre de Formation des Journalistes. His career began in earnest at the beginning of the 1960s, when he became a fashion photographer for → *Vogue*, *Elle*, *Le Jardin des Modes* and → *Harper's Bazaar*,

Malick Sidibé, *Yokoro*, 1970

as well as working in advertising. He excelled in → reportage, portraits, landscapes and dance photography, and published several books. For some years a member of → Magnum, he was named a Chevalier de l'Ordre des Arts et des Lettres in 1981 and a Chevalier de la Légion d'Honneur in 1990.

Siegel, Arthur (1913–1978) American photographer. In 1937 Siegel studied photography under → László Moholy-Nagy at the → New Bauhaus in Chicago. From 1938 he worked for

the press (→ *Life*, → *Fortune*) and for the Office of War Information and the US Army Air Corps. From 1946 until 1949 he taught at the Institute of Design in Chicago, where he was appointed as a professor in 1967. He was best known for his experimental images, his colour photography and his documentary work.

Sieverding, Katharina (b. 1944) Czech-born German photo and video artist. Sieverding studied stage design and sculpture at the Kunstakademie Düsseldorf under Theo Otto

371

Katharina Sieverding,
Stauffenberg-Block II/IX B, 1969

and Joseph Beuys (1964–72). She has participated in the Documenta exhibitions and was the German representative at the 1997 Venice Biennale, together with Gerhard Merz. Sieverding revolutionized → art photography with her large-format works. She is known mostly for her self-portraits and her photographic reflections on issues of political and gender identity.

Silva, António Sena da (1926–2001) Portuguese artist, photographer, architect and designer. Silva studied architecture at the School of Fine Arts, Lisbon. He began his photographic career working for his father's company, A. A. Silva/Autosil, in 1942. He produced a series of book covers designed by Sebastian Rodrigues for the publishing company Ulisseia in 1958. His first photographic exhibition was held at the Ether Gallery, Lisbon, in 1987. Silva was president

of the Portuguese Centre for Design from 1989 to 1994. In 1990 the Serralves Foundation in Porto presented a retrospective of his work.

Silva Meinel, Javier (b. 1949) Peruvian photographer. Silva Meinel began his career in 1973. He was a founder member of the Secuencia Fotogalería, the first gallery in Peru dedicated to modern and local → documentary photography, and was awarded a Guggenheim Fellowship in 1999 in recognition of his work on Andean ritual practices. These photographs were published in *El Libro de los Encantados* (1993), which provided a panoramic view of the beliefs and rituals of different peoples in the Andes.

Silver processes Processes for producing black-and-white → negatives and → prints that rely

on the light-sensitivity of silver compounds to produce an image. There are a number of different techniques and supports. Paper (commonly used 1841–*c*. 1865), collodion on glass (1851–*c*. 1885), → gelatin dry plate (*c*. 1878–*c*. 1925), black-and-white cellulose nitrate film (*c*. 1889–*c*. 1950), black-and-white cellulose acetate film (*c*. 1925–present) and black-and-white polyester film have all been used to make negatives. → Positive images have been created using the following processes: → daguerreotype (1840–65), → salted paper prints (1840–65), → ambrotype (1851–*c*. 1860s), → ferrotype (1855–60s), → albumen prints (1855–1920), → gelatin silver printing-out paper (1885–1920), collodion printing-out paper (1885–1920) and gelatin silver developing-out paper (1885–present). In all of these processes, the light-sensitive silver compound is exposed to light, either inside a camera or in the → darkroom, resulting in a photographic image composed of metallic silver on a support. In order to stabilize the image following any development that has taken place, the print or negative is fixed with hypo (fixing agent) and washed. The image's exact colour is dependent on the size and shape of the silver particles. → Printing-out processes are generally warmer in tonality than developing-out processes, since the silver particles are smaller and rounder than the filamentary silver particles formed during the development of a → latent image in a print or negative.

Silvy, Camille (1834–1910) French photographer. Initially a lawyer and diplomat, he visited and photographed Algeria in 1857. In 1859 he opened a studio in London, where he helped popularize the portrait → *carte-de-visite* and enjoyed great success with his widely distributed portraits of actors and other celebrities. His work also included French landscapes and urban scenes.

Simmons, Laurie (b. 1949) American artist. Simmons graduated from the Tyler School of Art, Philadelphia. Together with the artists → James Casebere and → David Levinthal, she belongs to a first generation of American post-

war photographers who arranged toy figurines in miniaturized environments. She started off her career in 1976 with a series of dolls-house interiors, in which a female figure performs the everyday actions of middle-class domesticity. Today Simmons continues to work with figurines, ventriloquist's puppets and life-size dummies. Her work reveals stereotyped gender models and betrays a scepticism about photographic and media representation.

Simpson, Lorna (b. 1960) American photographer. Born in Brooklyn, Simpson studied at the School of Visual Arts in New York. She made a name for herself in the mid-1980s with her first works, which combined black-and-white photographs with text. Her art is rooted in American culture, the political and social needs of minorities, and problems of race, gender and identity. Her first retrospective took place at the Museum of Contemporary Art in Chicago in 1992. In 2013 her first European retrospective was held at the Jeu de Paume in Paris.

Camille Silvy, *Miss Booth*, 1861

Siskind, Aaron (1903–1991) American photographer and teacher. Born and educated in New York, Siskind began his career teaching English in schools. Presented with a camera as a wedding gift in 1929, he quickly became interested in photography both as an art and as a social tool. In 1932 he joined the → Photo League, which was committed to the ideals of socialist documentary, and from 1936 to 1940 he led the Feature League, a subgroup devoted to creating politically inspired photo essays. Noteworthy bodies of work from this period include Siskind's *Harlem Document*. In the early 1940s Siskind experimented with abstract photography, using found and discarded items as his subjects. From 1947 he began exhibiting at the Charles Egan Gallery, largely a centre for Abstract Expressionism. He also started to cultivate friendships with artists of the New York School, most notably Franz Kline. A passionate educator, Siskind taught photography at the Trenton Junior College, New Jersey, in 1947, and in 1951 started teaching at the Institute of Design in Chicago. In 1971 he moved to the Rhode Island School of Design, where he taught until his retirement in 1976. Siskind was a founding member of the Society for Photographic Education and the Visual Studies Workshop in Rochester, New York. His early work in social → documentary photography is complemented by his later experiments in Abstract Expressionism. Important later projects include his *Hommage to Franz Kline* and *The Pleasures and Terrors of Levitation*, and the work that he directed as a professor, including a series of photographs recording over sixty

Aaron Siskind, *Chicago 30*, 1949

buildings by Louis Sullivan, taken between 1952 and 1954. Siskind died in 1991, leaving behind an eponymous trust devoted to promoting contemporary → art photography.

Slide film A type of → film that allows an image to be reproduced on a transparent support, primarily for the purposes of projection. Colour slide film (also known as 'colour reversal' or 'colour transparency' film) was introduced in 1936 following a century of experimentation with colour photographic processes. → Kodak and Agfa first released 35mm → subtractive colour reversal films for still photography in 1936, and Agfa-Ansco released Anscolor in 1941. Initially promoted to the vernacular market for use with slide → projectors, it became popular with American military photographers during World War II. The popularity of colour slide film continued throughout the 20th century, even after the invention of colour negative film in 1942. By the 1950s, fashion and advertising photographers relied on 120mm colour transparencies; 4 × 5 inch and 8 × 10 inch transparencies were also common in commercial environments. Slide film is based on a process that reverses the captured → negative image, resulting in the formation of a → positive transparent image upon completion of development. Colour transparencies are composed of three superimposed layers of subtractive dye: the top layer is yellow dye, the middle layer is magenta, and the bottom layer is cyan. When exposed to light, the red, green and blue layers record information as a black silver negative image, and the unexposed silver halides produce a black silver positive. During processing, the black silver positive is coupled with the coloured dyes to produce a colour positive, the colour dyes being distributed according to the density of the black silver positive. The black silver image is then bleached, fixed and rinsed away, leaving a positive colour image on a transparent film base.

SLR *see* **Reflex camera**

Smith, Graham (b. 1947) British photographer. Smith studied at the Cleveland College of Art

W. Eugene Smith, *Dr Ceriani Resting in his Kitchen, After Having Spent the Night Operating*, 1948

and at the Royal College of Art, London. During the 1970s and 1980s he documented working lives in his home town, Middlesborough, and helped found the Side Gallery in Newcastle in order to promote English social → documentary photography. In 1990 he retired from photography to concentrate on woodworking and writing.

Smith, W. Eugene (1918–1978) American press photographer. Born and raised in Kansas, Smith became interested in photography as a teenager. His first published photographs, of sporting events and the Midwestern drought, appeared in 1934 in the *Wichita Eagle* and the *New York Times*, respectively. He went to the University of Notre Dame, Indiana, in 1936 on a scholarship as the university's photographer, transferring to the New York Institute of Photography in 1937. By the late 1930s, Smith was publishing in *Newsweek*, → *Life* and *Colliers*. He joined → Black Star in 1938, leaving the photographic

• S —

agency to become a *Life* staff photographer in 1945. Smith is renowned for his World War II photographs of the battles in the Pacific and for the many → photographic essays that he published in *Life*, such as 'Country Doctor' (1948), 'Spanish Village' (1951), 'Nurse Midwife' (1951) and 'A Man of Mercy' (1954). He was on the staff of *Life* intermittently until 1954 when, after 170 assignments, he resigned over the magazine's unflinching editorial controls and his dissatisfaction with its treatment of 'A Man of Mercy'. Smith joined the → Magnum agency in 1955 and was hired to photograph the city of Pittsburgh by the editor → Stefan Lorant. In the early 1970s the photographer and his wife, Aileen Mioko Smith, documented the chemical-ravaged town of Minamata, Japan, publishing their findings as *Minamata* (1975). He joined the faculty of the University of Arizona in 1977.

Smithson, Robert (1938–1973) American artist. After studying painting at the Art Student's League in New York, and the Brooklyn Museum School, Smithson turned to sculpture at the beginning of the 1960s. He became an emblematic figure in → land art and found photography to be an essential tool. Photographs or filmic images sometimes represent the only surviving record of an artist's intervention in the landscape, as was the case with *Spiral Jetty* (Salt Lake, 1970), an enormous spiral of earth that was destroyed by flooding two years after its creation. Smithson was also an important theorist: his reflections on earthworks and on the concept of entropy ('ruin in reverse') were included in *The Selected Writings* (1966).

Snapshot Any photograph taken quickly, usually by an amateur. The concept of snapshot photography became widespread with the release of the Brownie camera by the Eastman → Kodak company in 1900. Its convenient size and ease of use allowed many amateurs to take photographs for the first time. Over the years, the advertising concept of the 'Kodak moment' helped to associate the idea of the snapshot with everyday situations and subjects (family, pets, holidays), as well as technical imperfections (→ blurring, poor framing, → overexposures and

underexposures). These formal elements began to fascinate professional photographers in the second half of the 20th century; the result was a 'snapshot aesthetic' within contemporary → art photography, in which the speed of execution and the concept of chance are consciously embraced. Snapshots are now taken with digital cameras, particularly those on mobile phones.

Snowdon, Earl of [Antony Armstrong-Jones] (b. 1930) British photographer. Snowdon studied architecture at the University of Cambridge and then trained as a photographer in 1951. Known mostly for his portraits, he is also an outstanding fashion and documentary photographer whose work has been published in the *Sunday Times*, → *Vogue*, *Tatler*, → *Harper's Bazaar* and the *Daily Express*. During his prolific and eclectic career, he has made several documentary films and also designed the aviary at London Zoo. He was married to Princess Margaret from 1960 to 1968 and was elevated to the peerage in 1961.

Société Française de Photographie The oldest photographic association in France, founded in 1854. The Société Française de Photographie was keen for photography to be accepted as an art form, but used painting as its ultimate reference point rather than establishing a separate identity for photography. During this period, both those who criticized → art photography and those who supported it looked to the fine arts as a comparison. The association became a gathering point for 'aesthetic' photographers, and in 1859, following long deliberation, its campaign to see photography accepted by the Salon des Beaux-Arts was successful. In 1856 Eugène Durieu, the society's president, was alone among its members in insisting on the specificity of the 'photographic art'. He was opposed to → retouching, which he believed turned photographs into hybrid products.

Société Héliographique The first association dedicated to the study of photography, it was founded in France in 1851 on the initiative of Baron de Montford. It brought together photographers, painters, writers and scientists, and led to the → Mission Héliographique, for

— S •

Frederick Sommer, *Max Ernst*, 1946

which five members were given the task of compiling a photographic inventory of the monuments of France. In 1854 it was replaced by the → Société Française de Photographie.

Solarization The deliberate → overexposure of a light-sensitive surface in order to create an image in which the tones are reversed. A similar effect can be obtained by means of the Sabatier effect (also called 'pseudo-solarization'), which involves re-exposing a sensitized surface to light during development. As with solarization, this reverses the light and shade in an image, and can also create white outlines that separate the light and dark areas. Practised in the 1930s, these processes resulted in a new kind of image that expanded the potential of photography, demonstrating that optical and chemical effects could be used

to alter the representation of reality. Solarization and the Sabatier effect were embraced by the → Surrealist movement because of their ability to make real-world objects seem unreal by changing their outlines and altering their shapes, tones and contrasts, turning the photographic image into a vehicle for the imagination. Like → photomontage, these processes served to increase the distance between photography and painting, and were practised by artists including → Maurice Tabard, → Man Ray and → Raoul Ubac.

Sommer, Frederick (1905–1999) Italian-born American photographer. The young Sommer travelled a great deal on account of his father's career as a horticulturalist. In 1927 he obtained a master's degree in landscape architecture from Cornell University, Ithaca, New York, and moved

• S —

to Rio de Janeiro to become business partners with his father, who had a thriving landscape architecture firm. In 1930 Sommer contracted tuberculosis; while recovering, he studied philosophy and avant-garde painting in Europe. In 1932 Sommer and his wife moved to Tucson, Arizona, where he painted while teaching art and design. In 1935, after showing → Alfred Stieglitz his watercolours, Sommer began working with photography, seeing the potential for creating intellectually challenging work with the medium. The general public found his photographs, which were often esoteric and controversial, difficult to understand. The Center for Creative Photography in Tucson holds his archive.

Sommer, Giorgio (1834–1914) German photographer. He began his career in Switzerland before settling in Naples in 1857. From 1860 until 1872 he worked with Edmondo Behles, who was based in Rome; their partnership was prolific. Sommer produced mainly portraits and images of ruins, landscapes and objets d'art. He became the official photographer to Vittorio Emanuele II of Italy.

Søndergaard, Trine (b. 1972) Danish artist. She studied painting and drawing before graduating from Fatamorgana, the Danish School of Art Photography in Copenhagen, in 1996. She is noted for her pictorial landscape photographs and introspective portraits, which are distinguished by their reduced colour palette and, in the case of the latter, their sensitive portrayal of the sitters' inner state of mind. Addressing the notion of time, she equips her models with traditional costumes or focuses on the theme of decay in nature and architecture. She was awarded the Albert Renger-Patzsch Prize in 2000. Søndergaard has worked in collaboration with the Danish artist Nicolai Howalt for many years and participated in the major photography project known as *Denmark in Transition* (2010).

Sontag, Susan (1933–2004) American writer. Sontag studied humanities at Harvard University and St Anne's College, University of Oxford. She owes her fame to the publication of many articles and novels. Between 1973 and 1977 she wrote six essays on photography that were published in the *New York Review of Books* and later collected as *On Photography* (1978). In these, she offered a series of ideas concerning the omnipresence of the photographic image, its uses and status, and the powers attributed to it, but she retracted some of her arguments in *Regarding the Pain of Others* (2004). Between 1969 and 1983 she made four films, including *Brother Carl* (1971). Sontag and the photographer → Annie Leibovitz were companions from the late 1980s. Her work is characterized by her resolutely left-wing political convictions.

Soth, Alec (b. 1969) American photographer. Through his portraits and landscapes, Soth creates a poetic vision of the ordinary world in which the private, the real and the ideal are intermingled. He reveals the extraordinary in places that hover between the everyday and the world of dreams and hallucinations. His series reveal a narrative thread that subtly expresses the uniqueness of individual meetings and moments while at the same time creating a powerfully symbolic whole.

Sougez, Emmanuel (1889–1972) French photographer. Having studied at the École des Beaux-Arts, Bordeaux, in 1919 Sougez began to work in advertising as a freelance photographer, shooting images for companies such as Nestlé and Rodier. At the same time he started to reproduce works of art (including Rodin's sculptures), architectural monuments and carefully lit, artfully framed still-lifes. He was a leading figure in the *photographie pure* movement, the French equivalent of the German → New Objectivity. Sougez championed a purist style and a complete mastery of technique rather than subjective photography. He favoured large formats and was a member of the French 30 × 40 group. He also contributed to the development of → colour photography by perfecting the Finlay process. He founded the photography department of *L'Illustration* (1926), was co-founder of the group Le Rectangle (1937) and published photographs in the magazine → *Arts et Métiers Graphiques*.

Southworth & Hawes,
Untitled (Two Women Posed with a Chair), c. 1850

Southworth & Hawes A partnership formed by the American photographers Albert Sands Southworth (1811–1894) and Josiah Johnson Hawes (1808–1901). In 1840 François Gouraud, → Louis Daguerre's agent in the United States, gave public talks to publicize the invention of the new technique. Hawes, a carpenter who painted portraits in his spare time, and Southworth, who owned a pharmacy, both attended a lecture given in Boston. Southworth subsequently travelled to New York in 1840 in order to learn the → daguerreotype process from Samuel Morse. He opened his own studio with Joseph Pennell in Cabotville (now Chicopee), Massachusetts, and then in Boston in 1841. In 1843, following Pennell's retirement, he joined forces with Hawes. Their studio, which they named Southworth & Hawes in 1845, also operated as a gallery, sold materials and gave courses on photographic processes. Sitters were obliged to remain static, but Southworth and Hawes resolved the challenges this posed through their subtle and inventive control

of lighting, careful posing of the model and use of accessories. They even succeeded in taking shots outside the studio by reducing exposure times. In 1849 Southworth left Boston to seek his fortune in California, but returned to resume his photographic career two years later. From that moment on, the Southworth & Hawes portrait studio became the most important in the United States. The daguerreotype reached its zenith in the United States through their work. Over the course of twenty years they made over 10,000 daguerreotypes, the vast majority portraits. Southworth finally left the studio in 1861, but Hawes carried on until he died in 1901.

Spirit photography A form of trick photography that purports to capture spectral figures from the spirit world. William H. Mumler took the first recorded spirit photograph in 1860: although he was later exposed as a fraud, the practice of spirit photography flourished, encouraged by a widespread belief in spiritualism. Plagued by controversy and discredited by most, the practice has nonetheless continued since 1860.

Sports photography A branch of photography that covers sporting events. Most often the term refers to images taken by professional photojournalists, but can apply equally to amateur photographs. Sports photography includes shots of athletes in motion and spectators' reactions, as well as preparations and celebrations leading up to and following an event. Professional sports photographs often appear in newspapers, magazines and advertisements, both in print and online. Today's demand for instantaneous access to information makes → digital photography the preferred method for professionals shooting at sporting events. Sports photographers normally use cameras with the capacity to record images at high frame rates and with good autofocusing ability, favouring digital → SLRs with a variety of interchangeable → lenses. The resulting images are characteristically dynamic, appear to stop events in mid-motion and are often captured from a distance using a telephoto lens, to better isolate a subject

• S —

Chris Steele-Perkins,
Red Deer, Croydon, 1976

against the background. Both athletes and spectators are caught in moments of exhilaration, frustration or concentration, and clear, strong compositions allow the viewer to gauge the situation instantly.

Stankowski, Anton (1906–1998) German photographer. Stankowski worked in typography and advertising before becoming interested in painting and photography. He was a graphic artist for Max Dalang in Zurich for a few years before opening his own studio in Stuttgart. His designs, which reflected a Constructivist style, made extensive use of photographs and → photomontages. He was drafted into the German army in 1940 and held as a prisoner of war in Russia until 1948. When he was freed, he returned to Stuttgart and worked in advertising as a graphic artist.

Steele-Perkins, Chris (b. 1947) British photographer. Steele-Perkins studied psychology at Newcastle University. He began his career in England, producing works that focused on urban poverty, and became a member of the Exit group in 1975. He joined the Viva agency in 1976 and → Magnum in 1979, of which he became president (1995–98). He travelled to Africa, Central America and the Lebanon, and worked in Afghanistan during the 1990s and Japan during the 2000s. In England he photographed themes including Teddy Boys, the young dandies who set

out to shock and who often turned to violence (*The Teds*, published in 1979), leisure activities (*The Pleasure Principle*, 1989) and rural life (*Northern Exposures*, 2007). All these works were published together as *England, My England* (2009), an anthology of photographs taken over a span of forty years that amounted to a personal history of modern English culture.

Steichen, Edward [Eduard Jean Steichen] (1879–1973) American photographer, painter and curator, born in Luxembourg. Steichen moved with his family to the United States in 1881. Having opened his first portrait studio in Milwaukee in 1896–97, he became affiliated with → Alfred Stieglitz in New York in 1900, while on his way to study art in Paris. He participated in *The New School of American Photography* exhibition organized by → Fred Holland Day at the → Royal Photographic Society, London, in 1900. The same year he began working on his series *Great Men*, and was elected a member of the → Pictorialist → Brotherhood of the Linked Ring in 1901. Steichen's first solo exhibition of paintings and photographs, *Monsieur Eduard J. Steichen*, was held in Paris in 1902. He moved to New York in 1902, opening a studio at 291 Fifth Avenue; in 1905, with the help of Stieglitz, it became the Little Galleries of the → Photo-Secession (later known as 291). He published → *Camera Work* with Stieglitz between 1903 and 1917. His work was featured in Stieglitz's *Photo-Secession: A Collection of American Pictorial Photographs*, held in Washington, D.C., in 1904. In Paris in 1907, Steichen witnessed the → Lumière brothers' presentation of the → autochrome, becoming an exponent of the early colour process. As chief photographer at → *Vogue* and *Vanity Fair* from 1923 to 1937, he brought an unprecedented artistic sensibility to commercial → portraiture and modernized → fashion photography. He was the director of the department of photography at the → Museum of Modern Art, New York, from 1946 to 1962, where he curated forty-six exhibitions, including → *The Family of Man* (1955). Steichen also worked as a photographer with the US army during both world wars and was an award-winning horticulturalist.

Edward Steichen, *The Flatiron*, 1904

Steidl, Gerhard (b. 1950) German printer and publisher. Gerhard Steidl is the founder of Steidl, a publishing house based in Göttingen, Germany. As a teenager, he began printing posters for artists before founding his printing and publishing house in 1972. In the following decades Steidl produced publications on various topics before focusing his efforts on a rigorous, world-class photography and art book programme in 1996.

Steiner, Ralph (1899–1986) American photographer. Regarded as an avant-garde photographer and film director, Steiner was one of the founders of the New York Film and → Photo League. After studying at the → Clarence H. White School of Photography in New York in the early 1920s, he embarked on a photographic career in journalism and advertising. He was also interested in urban architecture, machinery and manufactured objects. Stylistically he was at ease with modernism, and his clear images were composed with great care, depicting everyday American life through its details,

textures and geometrical forms. After the 1960s Steiner photographed nothing but clouds, and in 1985 he published a book of his studies, called *In Pursuit of Clouds*.

Steinert, Otto (1915–1978) German photographer. Steinert made his mark on post-war German photography after abandoning a career in medicine. From 1948 he taught photography at the Arts and Crafts School in Saarbrücken, and in 1949 he co-founded the Fotoform group. This advocated a return to the expressive and creative potential of the medium, which had been handed down by the avant-garde photographers of the inter-war period but suppressed by the Nazis. Steinert's work ranged from portraits to urban landscapes, encompassing technical experiments (→ photograms, → solarization, superimposition, → blurred movement, positive and negative inversion) and the many poetic and surreal effects that photography offers. As the exhibitions he organized in the 1950s make clear, he was closely associated with the Subjektive Fotografie movement, which favoured a subjective approach over documentary realism. From 1959 until his death he taught photography at the Folkwangschule in Essen.

Stereoscopic photography A process that creates an illusion of three-dimensionality. A camera with twin → lenses and two → films or sensors is used to capture two versions of a single subject that are slightly offset in relation to each other. The resulting pair of images, which may be glass or film slides, or prints mounted on card, are then viewed through a device that allows each eye to see a separate image. This reproduces the mechanism of binocular vision and produces an illusion of depth.

Stern, Bert (1929–2013) American photographer. Following several assignments for the magazine *Look* and a period as artistic director for *Mayfair*, Stern went into → commercial photography in the late 1950s. During the 1960s he played a major role in the development of modern → advertising photography. His series of portraits of Marilyn Monroe, taken only a few weeks before her death in 1962, is his most famous work.

Otto Steinert, *Call*, 1950

Stern, Grete (1904–1999) German photographer. Stern followed courses at the School of Applied Arts in Stuttgart before studying photography in Berlin under → Walter Peterhans (1927–28). She enrolled at the → Bauhaus, where she met her future husband, → Horacio Coppola. The rise of fascism forced them to flee to Argentina in 1935, where a meeting with Victoria Ocampo led Stern to collaborate on the magazines *El Sur* and *Idilio*, and above all to organize the first exhibition of modern photography in Argentina.

Sternfeld, Joel (b. 1944) American photographer. A self-taught artist, Sternfeld is one of the pioneers of → colour photography alongside → William Eggleston and → Stephen Shore. Irrespective of whichever project he is engaged on, his material is always the same: the United States, its inhabitants and the landscapes changed by man. He has created a comprehensive image of America over the last forty years – an image always tinged with irony. He lives and works in New York.

Stettner, Louis (b. 1922) American photographer. Born in Brooklyn, Stettner studied and taught photography at the → Photo League in New York. After the end of World War II he moved to Paris, where he still lives, and graduated from the Institut des Hautes Études Cinématographiques (IDHEC). He helped to introduce → humanist French photography to the United States and is best known for his many images of Paris and New York, both of which he has photographed throughout his long career. Partly aesthetic and partly political, his street photography simultaneously evokes the dynamism and melancholy of urban life.

Stieglitz, Alfred (1864–1946) American photographer, critic, publisher and gallerist. Stieglitz fought ceaselessly for the recognition of photography as an art form, and with his passion for the medium he constantly defied its technical limitations. He was born in Hoboken, New Jersey, to German parents, and studied mechanical engineering and photochemistry at the Berlin Institute of Technology under Hermann Wilhelm Vogel (1882–86). He moved

Alfred Stieglitz, *Georgia O'Keeffe*, 1918

to New York in 1890 and worked for a photo-engraving company until 1895, when he devoted himself to photography full time. He won numerous photographic competitions in Europe and the United States, and earned himself a reputation internationally. Between 1893 and 1896 he worked as editor-in-chief of *American Amateur Photographer*. In 1896 Stieglitz became vice-president of the Camera Club of New York, and edited *Camera Notes* (1897–1902), → *Camera Work* (1903–17) and *291* (1915–16) in succession. He wrote over 260 articles, most of which were published before 1911, and mounted a passionate defence of → Pictorialism. He founded the → Photo-Secession in 1902. Constantly working to promote photography and modern art, he opened and directed many galleries, including the Little Galleries of the Photo-Secession, known as → Gallery 291 (1905–17), the Intimate Gallery (1925–29), and An American Place (1929–46). Having championed Pictorialism until 1910, Stieglitz went on to become an exponent of → straight photography, shunning → retouching

● S —

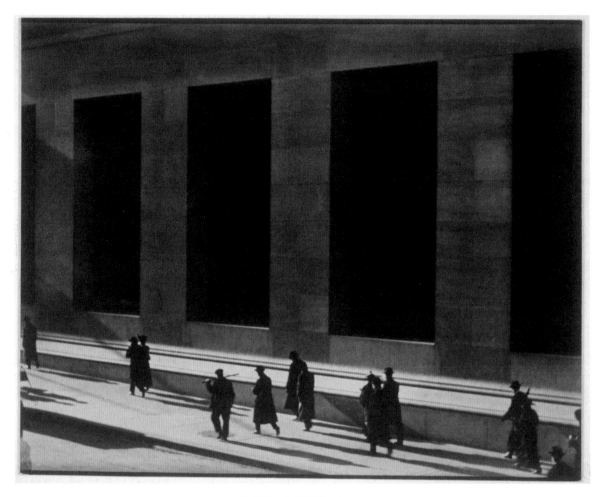

Paul Strand, *Wall Street*, 1915

and other types of manipulation. From 1917 until 1937, when heart problems forced him to give up photography, Georgia O'Keeffe, clouds and New York constituted his main subjects. In 1924 the Museum of Fine Arts in Boston broke new ground by including Stieglitz's photographs in its collection.

Still-life A type of artwork that depicts an arrangement of inanimate objects, such as fruit, flowers or musical instruments, often with symbolic connotations. The genre reached its zenith during the 17th century, most notably in the Netherlands. From the moment of photography's invention it was a favourite subject among practitioners, who found it well suited to the cumbersome nature of their equipment and the need for constant, prolonged pauses. → Hippolyte Bayard, → Adolphe Braun,

→ Louis Daguerre, → Roger Fenton, → Nicéphore Niépce, → Henri Le Secq and → William Henry Fox Talbot all excelled in this field, taking images that generally conformed to the motifs of the 17th century. Photographers later broke away from this painterly model and began to experiment with different formal effects and backgrounds (especially the → Pictorialists, with their liking for blurred images and reflected light). The emergence of → colour photography and photographic → advertising revived the genre. Many famous photographers such as → Edward Steichen and → Irving Penn began to produce enlarged images of consumer products, which were highly successful. In → art photography, too, the still-life was explored by many different movements, from → Surrealism to Pop art; artists either chose a purely photographic perspective or referred back to the genre's painterly traditions.

Stock, Dennis (1928–2010) American photographer. Stock studied photography at the New School for Social Research, New York, and continued his training with → Berenice Abbott and → Gjon Mili. He won a competition for young photographers organized by → *Life* magazine in 1951 and subsequently became a member of the → Magnum agency. He described himself as a 'photographic essayist', and is best known for his images of the jazz world, his portraits of the actor James Dean, and also for his photographs of nature and landscapes.

Stoller, Ezra (1915–2004) American architectural photographer. Originally trained as an architect, Stoller is regarded as a major contributor to the spread of Modernist architecture. His images, which were widely published, included studies of Mies van der Rohe's Seagram Building and Frank Lloyd Wright's Fallingwater, among others. He is said to have 'stollerized' buildings by favourably accentuating their volumes and structures through his photographs, which are often perceived as works of art in their own right.

Stone, John Benjamin (1838–1914) British photographer. Stone was an industrialist whose interest in photography prompted him to collect and then to take photographs himself. Engaged in local political life and an active participant in photographic institutions, he wanted to set up a library of photographs that would document the history of everyday life in England. As president of the Photographic Society of Birmingham, he helped to launch the Warwickshire Photographic Survey, which had precisely this aim. On a broader scale, he founded the National Photographic Record Association in 1897 and thenceforth began to donate images of old buildings, costumes and folklore (a total of 5,883 photographs, of which 1,532 were by Stone himself) to the British Museum.

Stone, Sasha [Alexander Steinsapir] (1895–1940) Russian photographer. After studying to be an engineer in Warsaw, Stone emigrated to the United States and then installed himself in Europe, first in Paris and, later, Berlin. While there he frequented Constructivist circles, which inspired his photographic → reportages, nudes and advertising work. With the rise of fascism, the Jewish-born Stone moved to Brussels at the beginning of the 1930s, opening a studio with his wife. He was obliged to flee from Belgium in 1939 and died the following year in Perpignan.

Stop bath A solution, typically of dilute acetic acid, used to neutralize the further development of photographic material being processed.

Straight photography Also known as 'pure' photography, straight photography was an aesthetic that came to the fore during the 1910s, when the debate about photography as an art form was at its height. The term was coined by Sadakichi Hartmann in an essay entitled 'A Plea for Straight Photography', published in 1904. He called upon photographers to focus on the specific qualities of the medium, such as clarity, precision and framing, and to stop manipulating images during shooting and printing, as was common in → Pictorialist works. → Alfred Stieglitz, → Paul Strand and → Charles Sheeler were the main proponents of this approach on the East Coast of the United States. Formerly an advocate of Pictorialism, Stieglitz championed straight photography with his image *The Steerage* (1907), first published in → *Camera Work* in 1911; an exhibition of Paul Strand's work at → Gallery 291 (1916); and the publication of Strand's photographs in the last two issues of *Camera Work* (1917). Strand himself was vociferous in his defence of objectivity, which he linked to modernism. As with Sheeler, his favourite subjects were factories, machines, everyday objects and consumer goods. On the West Coast of the United States, → Group *f*.64 was established in 1932 by → Edward Weston, → Imogen Cunningham and → Ansel Adams, who drew up precise rules about how to take sharp, realistic photography. In 1952 Adams co-founded the magazine → *Aperture*, advocating pure photography. The art historian → Beaumont Newhall supported *Aperture* and wrote a book that can be viewed as a manifesto for pure photography, entitled *Photography: A Short Critical History* (1937).

• S —

Strand, Paul (1890–1976) American photographer. Strand studied at the Ethical Culture High School in New York (1904–09), where he took courses given by → Lewis Hine. He frequented → Alfred Stieglitz's → Gallery 291 and was fully aware that the medium could be used for aesthetic as well as documentary purposes. In 1912 he became a commercial photographer and later joined the Camera Club of New York (1915), where he learnt complex printing techniques. His work gradually evolved from → Pictorialism towards the → straight photography style (as in *Wall Street*, 1915), and the 291 gallery mounted his first solo exhibition in 1916. Strand's most significant interests were apparent right from the start: social engagement (*The Blind Woman*, 1917), form and abstraction (*Abstraction, Porch Shadows*, 1916), → landscapes and → close-ups, both of which he began to photograph in 1919. He distanced himself from Stieglitz; while the latter developed his concept of 'equivalence', searching for visual equivalents to subjective emotions, Strand focused on social engagement. In 1921 he made his first film, *Manhattan*, with the painter → Charles Sheeler. He continued to work as a film director and freelance photographer, specializing in current affairs documentaries for Pathé, Fox and MGM, but also doing advertising work and continuing his own research. He moved to Orgeval in France and collaborated with the writer Claude Roy (1951), following which he worked with other writers, combining text and image for projects that took him to Italy and Africa. In 1971 the Museum of Philadelphia held a retrospective of his work.

Štrba, Annelies (b. 1947) Swiss photographer. Having served an apprenticeship in photography, since the 1970s Štrba has focused mainly on her private life, recording her everyday activities and in particular those of her two daughters (*Shades of Time*, 1974–97). Since the late 1990s she has used only a video camera, reworking the images digitally to create distinctive, dreamlike effects.

Street photography A form of photography that captures candid, everyday scenes in public areas, typically urban streets. A street photographer almost always chooses strangers as his or her subjects. Emerging as early as the 1890s, street photography reached its peak in the 1970s with practitioners such as → Lee Friedlander and → Garry Winogrand, who brought its somewhat voyeuristic aesthetic into art galleries and museums. While → Louis Daguerre's early street view of a shoe-shiner on the streets of Paris (1839) could be regarded as the first photograph of a busy urban thoroughfare, street photography requires portable cameras and fast film speeds. It was not until the 1890s that people began taking their cameras into the streets to quietly photograph not their friends, but strangers they encountered. Photographers such as → Eugène Atget and → Charles Marville shot street scenes in Paris, bringing their cameras out of the studios and not only documenting the art and architecture of the city, but also capturing some of its public life. → Berenice Abbott, who popularized the work of Atget and printed from his negatives, drew inspiration from his work when she returned to New York. Following Abbott were photographers including → Louis Faurer and → Lisette Model, who took a modernist approach by making occasionally ironic portraits of the subjects they encountered. Faurer and Model, in turn, inspired a new generation of photographers, including Friedlander, Winogrand and → Diane Arbus, who flooded the booming 1970s art market with images of this type. Occasionally prompting debate on the ethics of capturing subjects without their knowledge or prior consent, street photography remains an important genre for artists.

Streuli, Beat (b. 1957) Swiss photographer. Streuli's work is in the tradition of → street photography. It takes the form of portraits of people isolated within an urban crowd, presented as large-format prints, videos, installations and slideshows. His images are achieved through the discreet use of a telephoto lens, which allows him to observe people in a manner normally forbidden by social conventions, in the process giving individuality and expression to crowds that would otherwise remain anonymous and inscrutable. His photographs can thus be seen as portraits of metropolitan multiculturalism.

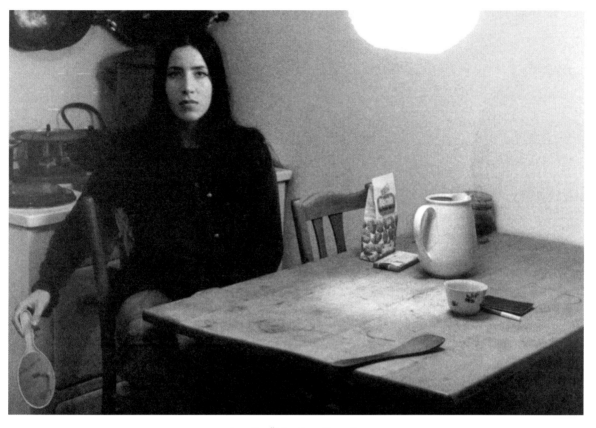

Annelies Štrba, from the series
Shades of Time, 1974–97

Strömholm, Christer (1918–2002) Swedish photographer. After studying in Germany and France, Strömholm learnt photography at the Académie des Beaux-Arts in Paris. He developed an intimate approach to a variety of subjects, ranging from → reportages on Africa and Japan to portraits of transsexuals and artists taken in the 1950s. He founded the School of Photography at the University of Stockholm and was given the Hasselblad Award in 1997.

Struss, Karl (1886–1981) American photographer and cinematographer. Struss began photographing with his brother's 4 × 5 camera in 1896. He later enrolled in → Clarence H. White's photography classes and became a member of the → Photo-Secessionists. In 1909 he invented the 'Struss pictorial lens', which was later adopted for motion pictures. Struss worked as a commercial photographer in New York and was the official photographer for Bermuda in 1914. He co-founded the photography

magazine *Platinum Print* in 1913 and the Pictorial Photographers of America in 1915. He developed a secret → infrared photography process for the US army and moved to Los Angeles in 1919 after being discharged. He went on to photograph over a hundred films; he was one of the first to work in colour for the film *Ben-Hur* (1925), and won the first Academy Award for cinematography alongside collaborator Charles Rosher for the film *Sunrise: A Song of Two Humans* (1929).

Struth, Thomas (b. 1954) German photographer. Struth studied under → Bernd Becher and → Gerhard Richter at the Kunstakademie Düsseldorf, an important school of photography with which he remains associated. Until the mid-1980s he focused mainly on architectural views of Düsseldorf, New York, Rome and Tokyo, methodically creating black-and-white series using large-format cameras. Struth's interest in people is apparent in his portraits of families

• S —

and museum visitors; museums and galleries themselves also became one of his major subjects, underlining our relationship with art. During the 1990s and 2000s he photographed jungles and flowers straight on. Towards the end of the 2000s he started to record laboratories and institutes connected with scientific research projects such as NASA – the first series in which he employed digital → retouching. He has also taught at the University of Arts and Design, Karlsruhe (1993–96).

Stryker, Roy Emerson (1893–1975) American economist, government official and photographer. Stryker directed the historical division of the Resettlement Administration, later renamed the → Farm Security Administration (FSA). Hiring photographers such as → Walker Evans, → Dorothea Lange, → Arthur Rothstein and → Gordon Parks, he supervised the systematic photographic documentation of rural life in the United States from 1935 to 1943. These images comprise some of the best examples of American social → documentary photography, including Lange's iconic *Migrant Mother*.

Studio An artist's workspace, or the people who work within that space. The term is used especially for artists active between the 15th and 19th centuries. The studio provides space for

— S •

Thomas Struth, *National Gallery I, London*, 1989

the production of art, but also for the artist's self-promotion. In the 19th century the studio itself became a popular theme in painting and photography, which showed studio props or the artist at work.

Štyrský, Jindrich (1899–1942) Czech photographer. Štyrský studied at the Fine Arts Academy in Prague before joining the Devětsil group in 1923. After producing paintings inspired by Cubism and Constructivism, → collages, typographic works, photography, poetry and magazine articles, he joined the → Surrealist movement, co-signing the movement's Czech manifesto in 1934. He quickly became one of its most prominent representatives, as did his friend and collaborator Maria Cermínová Toyen. His photographic cycles, such as *Man with Blinkers* and *Frog Man*, were presented at the first Czech Surrealist exhibition, in Prague in 1935. He also edited *Erotic Revue* and *Edition 69*, in which he published some illustrated poems. Towards the end of his life Štyrský began a project called *Sny* ('Dreams'), which he never finished.

Subtractive processes Photographic colour processes based on the absorption (or 'subtraction') of light. The three primary subtractive colours – cyan, magenta and yellow – are complementary colours of the three primary → additive colours: red, green and blue. Each subtractive colour selectively absorbs one additive colour from white light, allowing the other colours to be seen. By combining the three subtractive colours, black is achieved. The most successful colour photographic processes are subtractive colour systems: these include chromogenic colour, → dye transfer, → Cibachrome, → carbro and some digital printing processes. Each process achieves a final subtractive image in different ways. The general principle is that three identical images are made through additive colour → filters and then combined with corresponding subtractive colour pigments or dyes, which are superimposed, thus producing full colour. The illustration above right shows the three primary subtractive colours mixed to create black.

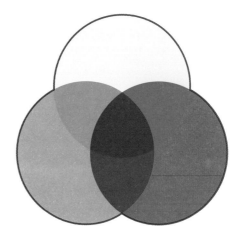

Subtractive processes: Cyan, magenta and yellow, when printed as solid colours and combined, create black.

Suda, Issei (b. 1940) Japanese photographer. Born in Tokyo, Suda graduated from Tokyo College of Photography in 1962. In the late 1960s he worked for the Tenjo Sajiki theatre company. This experience would influence his later works significantly. Suda would travel around Japan photographing diverse subjects, ranging from individuals participating in village festivals to suburban backstreets, that juxtaposed traditional Japanese cultural values with new developments. He currently teaches at the Osaka University of Arts.

Sudek, Josef (1896–1976) Czech photographer. After taking courses in bookbinding, Sudek was sent to the front line in 1915. He was wounded in 1916 and had his right arm amputated. No longer able to practise his profession, he turned to photography, which he practised as an amateur before and during his military service. He trained in Prague in the early 1920s, partly by joining the Amateur Photographers' Club, and partly by enrolling at the School of Graphic Arts, where he took courses given by Karel Novak. In 1924 he and his friend → Jaromír Funke founded the Czech Society of Photography, which mounted his first exhibition in 1926. The following year he opened his own studio in Prague and joined the artists' group Družtevní Práce. In this context he co-edited and illustrated the magazines *Panoram* and *Žijeme*, took portraits and also produced advertising work, notably for

• S —

Sugimoto, Hiroshi

Josef Sudek, *Ladislav Sutnar China: Tea Service Arranged on a Table, Viewed from Above*, 1920s

the Czech designer Ladislav Sutnar. His images became known through various exhibitions, both solo and collective. He was appointed official photographer to the city of Prague thanks to his photographs of the restoration of St Vitus' Cathedral, which were published in 1928 to mark the tenth anniversary of the foundation of the Czech Republic. In 1940 World War II put an end to his public work: when the Nazis occupied Prague, he withdrew to his studio and focused on more private subjects, such as the view from his window and → still-lifes. He also stopped enlarging his images in order to explore the potential of → contact prints. Later he returned to photographing landscapes and became interested in → panoramic views, which he took using an old → Kodak that he had repaired himself. His views of Prague, taken on 100 × 300 mm film, were published in 1959 by the state publishers, which had previously issued three other works by Sudek. During the last decades of his life he was showered with honours, and in 1961 he became the first Czech photographer to be named an Artist of Merit by the Czech government.

Sugimoto, Hiroshi (b. 1948) Japanese photographer. He left Japan in 1970 in order to study photography at the Art Center College of Design in Los Angeles. In 1974 he went to New York, where he came under the influence of minimal and → conceptual art. Produced in 8 × 10 inch format using very long exposure

times, Sugimoto's black-and-white photographs merge traditional techniques, pure aesthetics and an avant-garde approach. They question our notions of time and space, presence and absence, reality and illusion. Since 1976 Sugimoto has produced approximately ten series, including *Theaters* (1978), *Seascapes* (1980) and *Wax Museums* (1994). He lives and works in Tokyo and New York.

Sultan, Larry (1946–2009) American photographer. After graduating in political science at the University of California at Santa Barbara, Sultan obtained his master's degree at San Francisco Art Institute in 1973. He collaborated with Mike Mandel to produce *Evidence* (1977), a collection of archival photographs from various public and private institutions. Taken out of their context and displayed without captions, these images were open to new interpretations. In 1992 Sultan captured the everyday lives of his parents in *Pictures from Home*, combining his own photographs with other visual records from the family archives. Dealing with the successes and failures of the American Dream, *The Valley* (2004) explored the shooting of pornographic films in suburban houses in California, while *Homeland* (2007–09) examined the problems of migrant workers. He has taught at the California College of the Arts (1988–2009).

Sundsbø, Sølve (b. 1970) Norwegian fashion photographer. In 1995 Sundsbø studied at the London College of Printing, after which he became assistant to → Nick Knight. In 1999 he began his career as a freelance photographer and was recognized as a promising newcomer at the International Festival of Fashion and Photography in Hyères. Sundsbø divides his time between commissions for magazines – including *Dazed & Confused*, *Visionaire*, → *Vogue* and the *New York Times* – and advertising work.

Surrealism and photography Defined by André Breton in 1924 as a 'pure psychic automatism, by which one intends to express – whether by word, by writing, or by any other manner – the true functioning of thought', Surrealism seems by its very nature to be the opposite of

— S •

photography. Although no photographer ever officially joined the movement, the medium's capacity to render the invisible visible, together with its mechanical, automatic nature and the ease with which it could be reworked in the laboratory, nevertheless led to the production of certain works that many consider to be among the most perfect examples of Surrealist art. From its earliest days, photographs were to be found in its magazines (*Révolution Surréaliste*, *Documents*, *Minotaure*) and books (*Nadja*, *L'Amour fou*). Compared to the totality of Surrealist production, the photographs do not possess any aesthetic coherence, but they are noteworthy for the different processes and effects that were used, among them → photomontage, → collage, superimposition, → photograms, → solarization, dodging and burning, → negative

prints,→ cliché-verre, multiple exposures, reframing and enlargements. These techniques, both old and new, were used in combination to express the unconscious, as can be seen in the works of → Man Ray. Using the recurrent motifs of Surrealism, such as unusual perspectives, dreamlike atmospheres or the eroticism of the female body, photographers explored the nature of the image and its possible interpretations, particularly in relation to language. Such features permeate the work of figures including → Manuel Álvarez Bravo, → Hans Bellmer, → Bill Brandt, → Brassaï, → Claude Cahun, → Henri Cartier-Bresson, Max Ernst, → Dora Maar, E. L. T. Mesens, → Lee Miller, → Eli Lotar, Paul Nougé, → Roger Parry, → Maurice Tabard, → Karel Teige, → Frederick Sommer and → Jindřich Štyrský.

Hiroshi Sugimoto,
Radio City Music Hall, 1978

● S —

Frank Meadow Sutcliffe, *The Water Rats*, 1886

Sutcliffe, Frank Meadow (1853–1941) British photographer. Sutcliffe first discovered photography while reading a book by → William Frederick Lake Price. Encouraged by his father, a painter and amateur photographer, he began a career in photography. After working for → Francis Frith, he opened his own studio in 1875 in Yorkshire. Outside his commercial work, he recorded landscapes with a → Pictorialist aesthetic and became a founder member of the → Brotherhood of the Linked Ring in 1892. Together with → Frederick H. Evans, he wrote numerous articles in defence of 'pure' photography and criticized the → retouching practised by French photographers. Sutcliffe continued to write and take photographs until the 1930s.

Sutkus, Antanas (b. 1939) Lithuanian photographer. Born near Kaunas, Sutkus studied Russian and journalism in Vilnius, but also taught himself photography. He has been deeply involved in Lithuania's national photography institutions, including the country's Union for Photographic Art and the Society of Photography. His prize-winning images deal with Lithuanians of all generations, whom he photographs in public places. Sutkus's report on the visit of Jean-Paul Sartre and Simone de Beauvoir to Lithuania in 1955 was of outstanding quality. His later work includes very expressive examples of black-and-white portraiture.

Švolík, Miro (b. 1960) Slovak photographer. He belongs to the generations of Slovak

photographers who studied in Prague at the beginning of the 1980s. His work principally consists of → photomontages that show the human figure disposed against the landscape in witty and surprising ways. He belongs to the so-called Slovak New Wave: photographers who, in the middle of the 1980s, tore down the clichés of traditional staged photography. He also is a curator and, since 2009, leader of the Studio of Creative Photography at the Academy of Fine Arts in Bratislava. His work has received awards from the International Center of Photography, New York, and institutions in Prague and Germany.

Szarkowski, John (1925–2007) American curator, critic and photographer. Szarkowski obtained a degree in art history at the University of Wisconsin in 1947 and went on to become a commercial and documentary photographer, also publishing numerous books. In 1962 he succeeded → Edward Steichen as the director of the photography department at the → Museum of Modern Art, New York – a position he was to occupy until 1991. For three decades Szarkowski was enormously influential in the photographic world. The principal changes he brought about at the Museum of Modern Art were the return of monographic exhibitions, conventional hanging, the publication of a large number of books and catalogues, and an expansion of the collection. Extra space was provided in 1964 to house the photographic collection, which grew yet further with acquisition of → Eugène Atget's archive in 1968. The most striking and durable influence Szarkowski exerted on critics and photographers was his formalist vision of photography. With the aim of elevating the medium to the status of an art form, he insisted on its autonomy and independent frame of reference. In his first theoretical work, the exhibition catalogue *The Photographer's Eye* (1964), he defined five formal categories ('the thing itself', 'the detail', 'the frame', 'time' and 'the vantage point') that would allow photography to be studied as a whole. According to Szarkowski, all photographs that contained these characteristics, be they popular, artistic or documentary, were works of art. Among his other influential writings were

Looking at Photographs (1973) and *Mirrors and Windows* (1978). Szarkowski also drew attention to the work of → amateur photographers, including → Jacques-Henri Lartigue. In the exhibition → *New Documents* (1967), he promoted the work of → Diane Arbus, → Garry Winogrand and → Lee Friedlander, who all liked to play with the codes of popular photography. He also discovered → William Eggleston, whose colour photographs he exhibited in 1976.

Szatmári, Gergely (b. 1966) Hungarian photographer. In his early career Szatmári was engaged in → commercial and → fashion photography. From 2006 he turned towards personal themes. He is interested in presenting and criticizing the values of civilized society. His published volumes include *Conventional* (2008), *Meadowlands* (2011) and *American Idler* (2012), and his work is exhibited across Europe and the United States. Working in several different genres and addressing a broad range of topics, Szatmári produces work that is complex and profound. He teaches photography at the Moholy-Nagy University of Art and Design in Budapest.

Szilágyi, Lenke (b. 1959) Hungarian photographer. Szilágyi captured the atmosphere of the last years of the Hungarian Communist regime in the late 1980s, focusing on young intellectuals and those on the margins of society. She took socially themed photographs from a strongly subjective, personal viewpoint. Her characteristically melancholic photographs were taken with simple equipment and on black-and-white film. Since 1990 she has worked for the magazine *Beszélő* and produces cinema stills. Her photographic publications are *Fotóbrancs* (1994), *Látókép megállóhely* (1999), *Fényképmoly* (2004) and *Single Lens* (2007). Szilágyi has received the Rudolf Balogh Prize (1999), the Soros Foundation Székely Aladár Award (1999) and the Kiváló Művesz (Outstanding Artist Award) (2012). In 2008 she was formally recognized by the Hungarian Republic as an Artist of Merit.

• S —

Tabard, Maurice (1897–1984) French photographer. Born in Lyon, Tabard emigrated to the United States in 1914 and in 1918 enrolled at the New York Institute of Photography. In 1922 he took his first portraits and, in the late 1920s, having returned to France, he worked as a fashion and advertising photographer for magazines such as → *Vogue* and *Bifur*. From 1948 he also worked for → *Harper's Bazaar*. Throughout this time Tabard experimented in his laboratory with all kinds of manipulation: → solarization, inversion, superimposition, → photograms and so on. He continued to study composition and the principles of geometry, never leaving anything to chance during the creative process. Tabard's work depicts an ambiguous world that opens up the imagination.

Tableau photography A term that was first used in the late 1970s in connection with artists such as → Jean-Marc Bustamante in France and → Jeff Wall in Canada. The French photography historian → Jean-François Chevrier first used the term 'tableau' in this context in his writings about two exhibitions in 1989: *Une autre objectivité*

(Centre National des Arts Plastiques, Paris) and *Photo-Kunst: Arbeiten aus 150 Jahren* (Graphische Sammlung Staatsgalerie, Stuttgart). In contrast with → Henri Cartier-Bresson's → 'decisive moment', tableau photography refers to the adoption of a painterly approach to produce staged images that borrow from the narrative conventions of fine art. According to Chevrier, the tableau is an autonomous object, conceived and produced for the wall, offering spectators a confrontational experience. Historically, it is a revival of the dialectic between documentary recording and pictorial composition, while also marking the ultimate recognition of photography within the realm of fine art.

Talbot, William Henry Fox (1800–1877) British pioneer of photography. The general acceptance of photography took place only after Talbot's invention of the → calotype, a process that combined the concepts of → negative, → positive and the → latent image. A scholar who was well versed in the natural sciences, ancient history, archaeology, linguistics and the fine arts, Talbot was the archetypal humanist. He knew French,

Italian, Latin, Greek and Hebrew. His first experiments in fixing images produced by the → camera obscura took place in 1834, when he travelled to Italy. He worked on paper and used a mixture of sodium chloride and silver nitrate, whose photosensitive properties were already well known. At the same time he created his first → 'photogenic drawings', made by placing flat objects (a piece of lace, a blade of grass, a flower) on sheets of photosensitive paper and exposing them to sunlight. In January 1839 he learnt that photography had been invented in France. Thinking that the → daguerreotype must be very closely related to his own process, he wrote to France to claim priority. He also informed the Royal Society academy of his process, presenting 'Some Account of Photogenic Drawing, or the process by which natural objects may be made to delineate themselves without the aid of the artist's pencil' on 31 January 1839. He sent samples of his photogenic drawings to France, and wrote two letters in French describing his process on paper and mentioning the assistance of → Sir John Herschel in fixing the image with soda hyposulphite. While → Louis Daguerre was demonstrating his process in France and all over the world, Talbot searched for a method that would be superior to the daguerreotype, realizing that the future of 'photography' (the term was coined by Herschel and mentioned to Talbot in a letter) lay in the multiplication of an image. In 1840, continuing his research, Talbot found that relatively short exposures produced a latent image on sensitized paper – invisible to the naked eye but revealed by applications of gallic acid, which accelerated the darkening of the silver halide coating. On 8 February 1841 he took out a patent on his process, which he called the 'calotype' (from the Greek *kalos*, meaning 'beautiful') or 'talbotype'. From this invention emerged the first illustrated history of the photograph, *The Pencil of Nature*, which alternated between photographic images and texts. In his introduction, Talbot wrote a brief history of the calotype. The book appeared in six parts between 1844 and 1846. In 1850–51, Talbot created the first photographs using the light of an electric spark. He demonstrated a method of photo-engraving in 1852. Two years

William Henry Fox Talbot,
The Open Door, 1844

later he was obliged to withdraw his patent on the negative–positive process and thus made photography available to all. In 1855 he was awarded the Grande Médaille d'Honneur at the Exposition Universelle in Paris, and in 1858 the Photographic Society of Scotland awarded him a gold medal for the invention of photography.

Tandberg, Vibeke (b. 1967) Norwegian photographer. Tandberg obtained her bachelor's degree in photography from the Bergen Academy of Art and Design in 1994 and a master's from the School for Photography and Film at Gothenburg University in 1997. She attracted attention as a student with her series *Bride* (1993), in which she placed ten wedding photographs with ten different men in Norwegian newspapers. In *Ettermæle* ('Posthumous Reputation', 1994), a series of manipulated photographs showing foreign aid workers, Tandberg performed the role of a self-sacrificing nurse working among the poor and sick in Africa. The sequence included a picture of the nurse on her deathbed and concluded with clippings from several Norwegian newspapers in which Tandberg had placed both a death notice and an obituary. In 2005 the newspaper *Morgenbladet* ranked her *Living Together* (1996) as one of twelve most significant 'icons of our time'. In this digitally manipulated series Tandberg portrays two identical young

• T —

Gerda Taro, *Republican Militiawoman
Training on the Beach outside Barcelona*, 1936

women in everyday situations. Her work, like
that of her classmates Ole John Aandal and
→ Mikkel McAlinden, is seen as a prominent
example of staged postmodern photography
in Norway in the 1990s. Since the mid-2000s
she has worked with photocollages, texts
and paintings; one example is her homage to
T. S. Eliot and modernism, called *The Waste
Land* (2007). In 2012 she published her first novel,
Beijing Duck. Tandberg has had an international
career, and her work is represented in the
collections of the Astrup Fearnley Museum
of Modern Art, Oslo; the Museum Folkwang,
Essen; the Stedelijk Museum, Amsterdam; the
Guggenheim Museum, New York; and the Musée
d'Art Moderne, Paris.

Taro, Gerda [Gerta Pohorylle] (1910–1937) German
photographer. She was born in Stuttgart in 1910.
In 1933 she moved to Paris, where she worked
as contract negotiator and caption writer for
the Alliance Photo agency. She became the
companion and agent of André Friedmann in
1934–35, inventing the persona of → Robert Capa
for him and changing her own name to Gerda

Taro in 1936. She photographed the Spanish Civil
War alongside Capa, working for the Alliance and
→ Black Star photo agencies, and publishing her
work in *Ce Soir* and *Regards*, among others, from
1936 to 1937. She was killed in Brunete, Spain, on
25 July 1937.

Taylor-Johnson, Sam [née Samantha Taylor-Wood]
(b. 1967) British artist working in photography,
video and film. In 1990 she graduated from
Goldsmith's College in London. She is known
for her cinematic approach, which often uses
theatrical staging, dramatic lighting, movement
and gesture to convey a narrative. Her work has
consistently dealt with notions of performance,
emotionality and psychological conditions
through portraiture and self-portraiture.
Her video pieces use moving images, often
accompanied by sound, to create complex
meditations on corporality, time and human
endurance. Taylor-Johnson has had numerous
group and solo exhibitions, including the Venice
Biennale (1997) and the Turner Prize (1998).
In 2009 she directed her first full-length movie,
Nowhere Boy, a biopic of the early years of John
Lennon's musical career and the formation of
The Beatles.

Teige, Karel (1900–1951) Czech artist. A dominant
figure in Czech avant-garde circles between
the wars, Teige was a co-founder of the Devĕtsil
group in 1920, of which he soon became the
leader. In 1923 he organized the first avant-
garde exhibition in Bohemia. The following
year, he and Vitezslav Nezval invented the
concept of 'poetism', an artistic trend based on
the principles of hedonism. In 1929 he became
president of the Left Front group and took
charge of the Czech section of the → *Film und Foto*
exhibition in Stuttgart. In the 1930s he joined
the Czechoslovakian → Surrealist movement,
to which he devoted several publications. His
artistic production comprised book covers and
other typographical works, but he was best
known for his → collages, of which his favourite
component was the photograph. Throughout his
career Teige promoted his ideas through journals
(including *ReD*, which he directed between 1927
and 1931) and books.

Sam Taylor-Johnson, *Escape Artist (Primary Colours)*, 2008

Teller, Jürgen (b. 1964) German photographer. In 1984–86 Teller studied at the Academy of Photographic Design in Munich. After graduating he went to London, where he met the photographer → Nick Knight. It was through Knight that Teller received his first commissions to photograph famous musicians. His work includes album covers for artists such as Sinéad O'Connor and Morrissey, and his images of the band Nirvana and their frontman Kurt Cobain confirmed his reputation as a photographer of the zeitgeist. He has shot advertising campaigns for Marc Jacobs and Helmut Lang, as well as working for magazines including *i-D* and *The Face*. Many of his portraits show famous faces without make-up. Teller's work is notable for its clear and direct language, which combines the stillness of → portrait photography with the dynamic movement of the → snapshot aesthetic. Since 2014 he has been a visiting professor at the Academy of Fine Arts in Nuremberg.

Testino, Mario (b. 1954) Peruvian fashion photographer. Born in Lima, he began his educational career studying economics at the University of Lima and international affairs at the University of California, San Diego. In 1976 he moved to London to pursue his passion for photography. As a student and photography assistant, Testino soon exhibited a flair for → fashion photography, finding his own style and making a name for himself among major fashion

• T —

Guy Tillim, *Jean-Pierre Bemba, Presidential Candidate,*
Enters a Stadium in Central Kinshasa Flanked by his Bodyguards, 2006

magazines such as → *Vogue, Vanity Fair* and *V.*
He also photographed for leading fashion houses
including Gucci, Versace and Burberry. In 2002
his exhibition *Portraits* was held at the National
Portrait Gallery, London; their most successful
show to date. Testino has earned awards for
his photography and charity work, as well as
commissions from the British royal family.

Thurston Hopkins, Godfrey (1913–2014) British
photographer. He originally trained as an
illustrator but became a photojournalist in 1936.
From 1950 until 1957 he photographed post-war
life for *Picture Post*, including → photographic
essays on 'The Cats of London', the slum districts
of Liverpool and children playing in the streets.
He travelled widely, producing → reportage
in India, Australia and Africa. During the 1960s
he worked for various advertising agencies,
following which he took up teaching. At the end
of the decade he retired from photography in
order to paint.

Tichý, Miroslav (1926–2011) Czech painter and
photographer. After studying at the Academy
of Fine Arts in Prague, Tichý fled from the
Communist powers in 1950 and returned to his
hometown of Kyjov. Rebelling against the party
line, he deliberately wore dirty, patched clothing.
He abandoned painting in order to make an
improvised camera and enlarger out of old
spare parts. His main subject was women, often
photographed through the bars of the municipal
swimming baths. His blurred, stained images,
retouched with pencil and framed with old boxes,
date back mainly to the 1970s and 1980s. A former
neighbour, Roman Buxhaum, started to collect
and document his work in 1981. This task has
been carried on by the Tichý Oceán Foundation
since his work was belatedly recognized in the
mid-2000s.

TIFF A widely used digital image file format.
The term originally stood for 'Tagged Image
File Format'. The format is popular primarily

because images can be saved and stored without any compression or downsizing, effectively preserving all of the file's original information. The format was developed in the mid-1980s and is still widely used in many fields.

Tillim, Guy (b. 1962) South African photographer. Born in Johannesburg, Tillim began photographing professionally in 1986. A photojournalist and member of the Afrapix agency, he also worked freelance for Reuters and Agence France Presse. In addition to photojournalism, Tillim has undertaken long-term work documenting social inequality in South Africa and, more recently, the crumbling colonial-era infrastructure of African nations.

Tillmans, Wolfgang (b. 1968) German photographer. Tillmans studied in England at the Bournemouth and Poole College of Art and Design. Initially known for his seminal portraits of friends and young people from his immediate surroundings, Tillmans now works in a range of diverse genres. Spanning → portraiture, → still-life, → landscape and abstract photography, his practice directly addresses the photographic process. His work is motivated by aesthetic and political concerns, and by an interest in formulations of reality and truth, particularly in relation to issues surrounding homosexuality and constructions of gender. His photographs are typically exhibited in carefully composed wall installations. Tillmans won the Turner Prize in 2000.

Tintype *see* **Ferrotype**

Tomatsu, Shomei (1930–2012) Japanese photographer. Born in Nagoya, Tomatsu attended Aichi University in the early 1950s. An early career landmark for him was his inclusion in the exhibition the *Eyes of Ten* in 1957. Two years later, in 1959, he, along with five other photographers who also participated in the exhibition, established the revered Vivo photo agency. Much of Tomatsu's early work focused on the increasing Americanization of Japan, brought on by military occupation that followed World War II. From 1960 he worked alongside the photographer → Ken Domon in Nagasaki, which

resulted in the joint publication *Hiroshima-Nagasaki Document 1961* (1961) and his own, now classic, book, *11:02 – Nagasaki* (1966). In addition to publishing elsewhere, Tomatsu ran Shakan, a publishing house, under which he produced *Ken*, a short-lived quarterly journal, and multiple books of photographs. In the 1970s Tomatsu's work began to change after he moved to the island of Okinawa at the end of the long US occupation. He switched almost entirely from his signature grainy, impressionistic monochromatic photographs to colour. This transition was marked by his 1975 book, *The Pencil of the Sun*. In 1974 he was included in the → Museum of Modern Art's ground-breaking exhibition *New Japanese Photography*, which travelled throughout North America and introduced Japanese photography to a Western audience. For the rest of his illustrious

Wolfgang Tillmans, *Jochen Taking a Bath*, 1997

• T —

Toning

career, Tomatsu continued to publish and show his photographs in Japan and internationally, securing his reputation as one of the country's most celebrated photographers.

Toning A chemical treatment that alters the overall colour of a → black-and-white print on paper. Toning takes place during the → developing process and involves converting the silver suspended in the → emulsion into a silver compound through the application of different chemical elements, usually gold, selenium, sulphur, platinum or copper. Some forms of toning, such as gold and selenium, also make the print less fragile. In → digital photography, toning effects can be obtained with the use of image-editing software.

Tosani, Patrick (b. 1954) French artist. Tosani's first works, from the early 1980s, are in the avant-garde tradition of the 1970s. His conceptual and minimalist pieces reveal a constant desire to experiment with the medium, and his colour photographs of everyday subjects play with

Patrick Tosani, *P.T.D.*, 1992

effects of scale, as in *Talons* (1987), a series of oversized prints. His work also focuses on representations of space (*Masques*, 2000), time (*La Pluie seule*, 1986) and the body (*Regards* and *Territoires*, 2001).

Toscani, Oliviero (b. 1942) Italian fashion photographer. Toscani is best known for the advertisements he produced between 1982 and 2000 for Benetton. Tackling socially sensitive themes such as AIDS, racism, war, the death penalty and religion, they caused controversy with every new campaign, sometimes even leading to court cases. Toscani began by giving visual form to the slogan 'United Colors of Benetton' by using striking contrasts (for example, a small black hand being held in a large white hand), but the images became increasingly provocative and further removed from straightforward advertising, entering the realm of social and political engagement (a famous example is the clerical couple in *Kissing Nun*, 1992). These works were criticized by some as a mercenary exploitation of ethical and humanitarian problems, whereas others viewed them as challenging people's attitude towards consumerism. Regardless of such judgments, Toscani's powerful use of the photographic image made people think and talk.

Tournachon, Adrien (1825–1903) French photographer. On the advice of his brother → Nadar, Tournachon abandoned painting and began to learn photography from → Gustave Le Gray. The two brothers opened a studio in 1854, although their relationship was difficult. With Nadar he produced a series of portraits of the mime artist Charles Deburau dressed as Pierrot, also collaborating with the neurologist → Guillaume-Benjamin Duchenne de Boulogne on an attempt to document facial expressions. In 1886 he suffered a mental breakdown, and his brother had him committed to an asylum.

Travel photography The photographic documentation of foreign landscapes, peoples and cultures. Ever since the invention of the → daguerreotype, photography has gone hand in hand with travel. The daguerreotype became

— T •

Shomei Tomatsu,
Christian with Keloidal Scars, 1961

a valuable tool for archaeologists: only three months after its invention had been announced, photographic missions were sent out from Europe to all four corners of the globe. These daguerreotypes, commissioned by governments who saw the medium as a new way of recording distant places, were nothing like what we now consider to be travel photography. Nevertheless, they were the first step in a long tradition. With the invention of more efficient techniques, such as the → calotype and the → collodion process, travellers became photographers and photographers were turned into travellers. Scientists, artists and explorers began to create visual records of their wanderings. → Maxime du Camp is considered one of the pioneers of travel photography, having travelled to the Near East with Gustave Flaubert and brought back a travelogue illustrated with 150 calotypes (1849–51). Until the end of the 19th century, taking photographs on location was fraught with technical difficulties. With the development of reliable, lightweight, portable cameras, however,

the practice became more democratic. In due course even → amateur photographers were able to put the instrument to new use, creating photographs as souvenirs.

Tress, Arthur (b. 1940) American photographer. Since the 1960s Tress has worked on a wide range of subjects, including social documentary and male nudes, photographs of surrealist dream worlds and sculptures made out of found objects. His work often distorts reality, offering a vision that transcends appearances.

Tripe, Linnaeus (1822–1902) British photographer. While pursuing a military career in India, Tripe learnt photography during a visit back to England in the early 1850s. On his return to India, he worked as an official photographer for the East India Company between 1855 and 1857. An expert in the → calotype process, he improved on it in order to meet his own requirements for photographing architectural views. His last known photographs date from 1870.

● T —

Deborah Turbeville, *Bathhouse* series
for *Vogue*, 1975

Trivier, Marc (b. 1960) Belgian photographer. In the late 1970s, while still in his teens, Trivier visited artists and writers he admired with the aim of immortalizing them with an old → Rolleiflex of his father's. The result was a series of portraits that conveyed the sitters' life stories, age and fragility. His work achieved critical recognition in the late 1980s, and in 1988 he was given the Young Photographer of the Year award by the International Center of Photography. Trivier's output is small but of consistent quality. He never retouches or reframes his images, even leaving the black borders of the → negative visible, and treats humans, landscapes and the natural world all with the same scrupulous respect.

Tronvoll, Mette (b. 1965) Norwegian photographer. Tronvoll received her bachelor's degree in photography from Parsons School of Design in New York in 1992. She attracted attention for her life-size portraits, entitled *Couples*, exhibited at the National Museum of Contemporary Art in Oslo in 1996. The *Isortoq Unartoq* series (1998–99) portrays the landscape of Greenland and bathers using its volcanic springs. In *Mongolia* (2004) Tronvoll portrayed Mongolian nomads and their houses. Her series *Rena 006* (2006), featuring elite Norwegian soldiers in camouflage, became controversial when the Norwegian defence authorities forced her to remove the photographs from Paris Photo in 2006, allegedly for security reasons. The artist mentions the German photographer → August Sander as a vital inspiration for her work. Tronvoll's photographs are exquisite and detailed. Her work focuses on what could be described as quiet and alert encounters between the photographer and her subject. She is represented in the Bergen Art Museum;

the Moderna Museet, Stockholm; the National Museum of Art, Architecture and Design, Oslo; the Neues Museum, Nuremberg; the Metropolitan Museum of Art, New York; and the National Museum of Photography, Copenhagen.

Tschichold, Jan (1902–1974) German artist and graphic designer. Influenced by the → Bauhaus, Tschichold looked to simplify typography and integrate it closely with photographic content. He is regarded as one of the most important typographers of the inter-war period and wrote a number of influential books on the subject, including *The New Typography* (1928) and *Photo-Eye* (1929, in collaboration with Franz Roh).

Tsuchida, Hiromi (b. 1939) Japanese photographer. Born in Fukui Prefecture, Tsuchida studied engineering and later earned a second degree from the Tokyo College of Photography in 1966. Despite starting off as a commercial photographer, he quickly developed an individual style and received international recognition with the *New Japanese Photography* exhibition at the → Museum of Modern Art, New York, in 1974. His work explores a myriad of subjects: most notable are his explorations of crowd phenomena, the social implications of the bombing of Hiroshima and scenes of daily life in rural Japan.

Tuggener, Jakob (1904–1988) Swiss photographer. Tuggener learnt technical drawing at the engineering company Maag-Zahnräder AG from 1923 until 1930. From 1930 until 1931 he studied typography, graphic design and cinema in Berlin, but on his return to Zurich began to concentrate on photography. He went freelance in 1932 and focused on industrial photography, publishing several books devoted to Swiss firms including Maschinenfabrik Oerlikon and Bühler. Throughout his career Tuggener also worked on more personal projects, compiling albums of images, without text, that touched on many different subjects, including industrial enterprises (*Fabrik*, 1943), society balls in Zurich, Saint-Moritz and Vienna (1934–50), and Swiss landscapes. Between 1937 and 1970 he made twenty-four films in black and white, all commissioned by industrial firms, as well as

a number of films that he financed himself. In 1951 he helped to found the Kollegium Schweizerischer Photographen. He participated in → *The Family of Man* exhibition, curated by → Edward Steichen at the → Museum of Modern Art, New York, in 1955.

Tunbjörk, Lars (1956–2015) Swedish photographer. Tunbjörk started out as a press photographer at *Borås Tidning* and later moved to *Stockholms-Tidningen*. Since the early 1980s he has worked as a freelance photographer based in Stockholm, and has had some forty solo exhibitions in Sweden and internationally, including *Winter/Home* (2007) at the Moderna Museet, Stockholm. In 1993 he published *Country Beside Itself: Pictures from Sweden*, which included colour photographs of public places and Swedes on holiday. This book, and the accompanying exhibition, were a breakthrough, introducing Tunbjörk's work to a wider audience.

Turbeville, Deborah (1938–2013) American fashion photographer and editor. Turbeville was fashion editor for → *Harper's Bazaar* between 1963 and 1964, and for *Mademoiselle* in 1966. That same year she attended seminars given by → Richard Avedon and Marvin Israel, and immediately embarked on a career as a fashion photographer, working for *Essence*, *Harper's Bazaar* and, later, *Mademoiselle* and *Nova*. In 1975 her first shoot for American → *Vogue* – *Bathhouse* – caused a scandal because of its daring nature.

Turner, Benjamin Brecknell (1815–1894) British photographer. While Turner was painting portraits and running his candle-making business, → William Henry Fox Talbot engaged him to put together his *Pencil of Nature*. Turner loved the → calotype process and used it to photograph landscapes. He also helped to found the Photographic Society in London.

• T —

UV

Ubac, Raoul (1910–1985) German-born Belgian artist. At the School of Applied Arts in Cologne (1932), Ubac became interested in modern photographic techniques. In 1936 he joined the → Surrealist group in Paris. Several of his photographs appeared in the magazine *Minotaure*, including three important → series – *Combats de Penthésilée*, *Combat* and *Photomontages* – in which he explored the disintegration of form.

Udo, Nils (b. 1937) German artist. Originally trained as a painter, Udo turned to photography during the 1970s. His work is akin to → land art, though he has never identified himself formally with the movement. The central focus of his artworks is nature, and he works out in the open, making full use of the shapes and colours offered by the immediate environment (flowers, stalks, ponds, stones, birds' nests, etc.). His installations are delicate structures, carefully balanced, that are transformed and eventually destroyed by the weather. The result of a poetic dialogue between artist and nature, these ephemeral artworks rely on photography to capture them and show

them to a wider public. But each photograph, always immaculate in terms of composition and technique, is also a work in itself, quite independently of the installation it represents. The discrepancy between the works, with their idealization of nature and our relationship with it, and the challenges posed by climate change raises important questions about our society and its ideologies.

Ueda, Shoji (1913–2000) Japanese photographer. After studying photography, most notably at the Oriental School of Photography in Tokyo, Ueda opened his own studio in 1933 in his home region of Tottori. He was a founder member of the Nihonkai Club of Tottori as well as the regional amateur group Chugoku Photographers, and took part in many group exhibitions. He was open to experimentation with different techniques, including → solarization and → backlighting. The photograph *Four Girls* (1939) was the first time that he had deliberately posed his models, and this staged aesthetic became more strongly marked in his famous series *Theatre of Dunes*, which showed people in local costumes

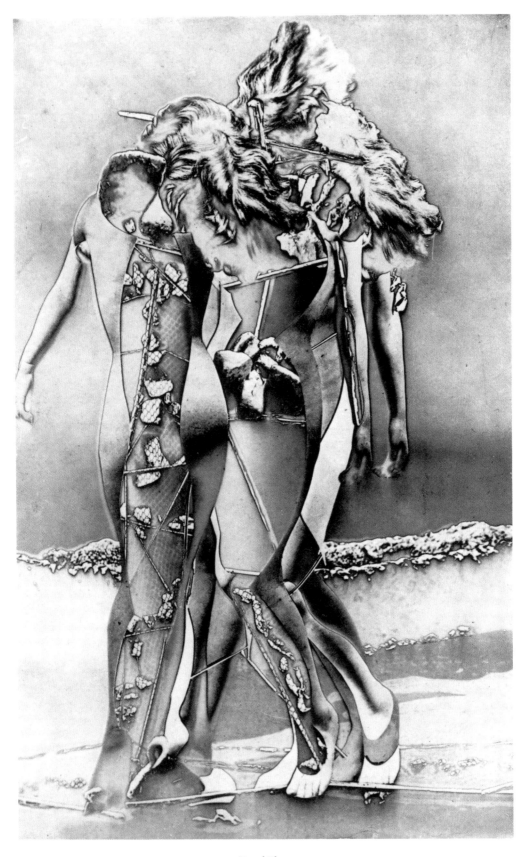

Raoul Ubac,
Le Combat de Penthésilée, 1937

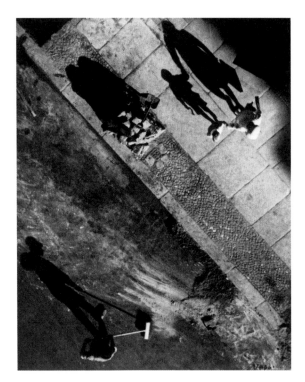

Umbo, *Mystery of the Street*, 1928

(including members of his own family) within the simple setting of the sand dunes of Tottori. All elements are carefully managed in order to create an atmosphere that is often unsettling and poetic, in which time seems to stand still. The same dunes also featured in his later work: in 1951 he photographed nudes there, and used the dunes as the backdrop to a fashion shoot in 1983. *Children the Year Round* is regarded as one of his greatest works. → Edward Steichen recognized his exceptional talent as early as the late 1950s, and Ueda went on to win many awards and to see his work exhibited widely, both in Japan and elsewhere.

Uelsmann, Jerry N. (b. 1934) American photographer. After graduating from the Rochester Institute of Technology, New York, Uelsmann continued his studies at the University of Indiana in 1960 under the guidance of Henry Holmes Smith. His photographic work is experimental and innovative. A master of post-visualization and processing, he uses the → darkroom as a visual laboratory. The resulting composite images, with their psychological

and metaphorical associations, are enigmatic and surrealistic. They reflect the artist's imaginative vision and play with the viewer's preconceptions of reality. Having switched to digital production methods, Uelsmann has continued to create images that explore the paradoxes of time and space. Alongside his artistic career, he has taught photography at the University of Florida since the 1960s.

Umbo [Otto Umbehr] (1902–1980) German artist. After studying at the → Bauhaus between 1921 and 1923, Umbo turned to photography in 1926. He was one of the founders of the Dephot agency, which made a major contribution to the revolution in illustrated journalism that took place between 1928 and 1933. His participation in the → *Film und Foto* exhibition (Stuttgart, 1929) and the publication of → Werner Graeff's *Es Kommt Der Neue Fotograf* established his reputation among the proponents of the → New Vision movement. He was an innovative portraitist, and also excelled in → reportage and the experimental techniques that were in vogue between the wars (→ photomontage, distortions, etc.). When he was capturing towns (his favourite subject) and people, his photographs were always full of affection and humour. Umbo's archives were destroyed in 1943 during an air raid on Berlin, thus obliterating twenty years of work. Some of it, however, was rediscovered in the late 1970s.

Unwerth, Ellen von (b. 1954) German fashion photographer and model. Unwerth was scouted as a model at the age of 16. A self-taught photographer, she received her first photography assignment from French *Elle*, shooting the 17-year-old Claudia Schiffer. Unwerth's fashion work recalls the coolly erotic aesthetic of → Helmut Newton. She has worked for many magazines, such as → *Vogue*, *i-D* and *Vanity Fair*.

Uzzle, Burk (b. 1938) American photographer. A self-taught photographer, Uzzle worked with the → Black Star agency from 1957 to 1962, and then for → *Life* until 1968. In 1967 he joined → Magnum Photos, of which he was president for two years (1979–80). He was awarded a grant

— U •

by the National Endowment for the Arts in 1975. Now a freelance photographer, he presents a sensitive portrait of American society that combines a social conscience with aesthetic refinement.

Vaccari, Franco (b. 1936) Italian photographer and essayist. The son of a professional photographer, Vaccari studied physics. With his *Exhibitions in Real Time*, he practised a form of conceptual, → experimental photography that explored the relationship between the camera and its representation of reality. His best-known work from the series is *Exhibition in Real Time no. 4*, which was presented at the Venice Biennale in 1972 and in which visitors went through a photo-booth and pinned their portraits on the gallery walls. For Vaccari, the process itself is more important than the image, and chance, loss of control and illogicality are essential ingredients. He has written more than twenty books, including the essay *Duchamp and the Concealment of Work* (1978) and his manifesto *Fotografia e inconscio tecnologico* ('Photography and the Technological Unconscious', 1979).

Vachon, John (1914–1975) American photographer. Vachon took up photography while working as a filing clerk for the → Farm Security Administration. He went on to work for Standard Oil of New Jersey and for the United Nations, then became a photographer for *Life* (1947–49) and *Look* (1947–71), ending his career as a freelance. Vachon was trained by → Walker Evans, and his style was very much influenced by his interest in street life.

Van Der Zee, James (1886–1983) American photographer. Van der Zee opened his own studio on 135th Street in Harlem in 1916, and for over sixty years produced nearly all of his work there. His speciality was → portraiture, almost exclusively of the black community. A major figure in the Harlem Renaissance, during which black New Yorkers began to lay claim to their own culture, he made his sitters pose either in the studio or outside; these included African-American celebrities passing through Harlem as well as hundreds of anonymous local residents.

His work evolved into a record of the emergence of a black middle class in New York City.

Van Dyke, Willard Ames (1906–1986) American photographer and filmmaker. Van Dyke began photographing under the tutelage of → Edward Weston and was a founding member of → Group *f*.64. He became a leading figure in American social documentary filmmaking, producing works including *The City* (1939) and *Skyscraper* (1959). He avoided being blacklisted in the 1950s, and from 1965 to 1974 was the director of the film department at the → Museum of Modern Art, New York.

Van Lamsweerde and Matadin Dutch photography partnership consisting of Inez van Lamsweerde (b. 1963) and Vinoodh Matadin (b. 1961). Between 1985 and 1993 Van Lamsweerde studied at the Rietveld Academy in Amsterdam,

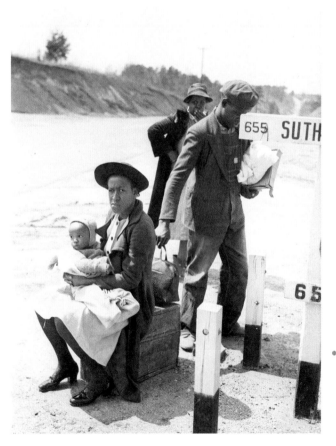

John Vachon, *Negro Family Waiting for Ride into Town, Halifax County, Virginia*, 1941

• **V** —

and then at the PS1 Contemporary Art Center in Long Island, New York. In 1986 she met Matadin, who had just finished his studies at the Fashion Academy in Amsterdam, and the two decided to join forces to pursue a career in commercial and artistic photography. They moved to New York in 1995. Well known for their experiments with digital imagery, they have produced some outstanding → series, such as *Thank You Thighmaster* (1993) and their editorial work for *The Face*. Their photographs have appeared regularly in → *Vogue*, *W Magazine* and → *Harper's Bazaar*. In addition to fulfilling commissions for magazines and advertising, they exhibit their work internationally.

Van Leo [Levon Alexander Boyadjian] (1921–2002) Armenian-Egyptian photographer. Famous for his numerous self-portraits and portraits of the Egyptian bourgeoisie, Van Leo joined the American University in Cairo in 1940 and trained as an assistant to the Armenian photographer Artinian. From 1941 to 1998 Van Leo ran a studio in Cairo. His vast photographic oeuvre documents Egyptian society over the course of half a century.

Vancouver School An unofficial group of Canadian conceptual and post-conceptual photographers who emerged in the 1980s in Vancouver. It includes the artists → Jeff Wall, → Ken Lum, Roy Arden, → Stan Douglas and → Ian Wallace, who are known for their large-scale, colour work that utilizes cinematic and commercial conventions: staged scenes, the use of film and video, and colour transparencies displayed in lightboxes.

Varda, Agnès (b. 1928) Belgian-born French photographer and film director. She was born in Brussels, studied photography at the École des Beaux-Arts in Paris, became a photographer at the Théâtre National Populaire, and then launched a career as a film director. Although she does not agree, her film *La pointe courte* (1955) is generally regarded as a precursor to New Wave cinema. Her films are part fiction and part documentary, and she likes to explore the relationship between the fixed and the moving image.

Ventura, Paolo (b. 1968) Italian photographer. Between 1989 and 1991 Ventura studied at the Brera Fine Arts Academy, Milan. He took part in the Venice Biennale in 2011. His photographs represent carefully constructed 'invented worlds': scenarios staged in miniature that are connected with history, art, nostalgia and the unconscious mind.

Veress, Ferenc (1832–1916) Hungarian photographer, writer and founder of a specialist photographic review. Veress opened a studio in Kolozsvár (present-day Cluj, in Romania) in 1852. He took portraits of famous people and photographed the landscapes of Transylvania. Veress started to experiment with colour photography in 1881 and in 1884 succeeded in making transfers from → positive colour transparency film. He presented these colour copies at the 1889 Paris International Exhibition, which brought him widespread recognition. In January 1882 he launched the publication of *Fényképészeti Lapok*, the first journal in Hungary dedicated to photography.

Verger, Pierre Édouard Leopold (1902–1996) French photographer. Verger began his photographic career as a photojournalist at the age of 30. He specialized in black-and-white portraits and for nearly fifteen years journeyed across four continents. He produced numerous reports for publication in newspapers and magazines including *Paris-Soir*, the *Daily Mirror* and → *Life*. These were sent from places as far afield as Tahiti (1933), India (1936), Senegal (1940) and Brazil (1946), where he finally settled in the town of Salvador, Bahia. Verger had a passionate interest in culture, and especially the history of the African diaspora in the Americas. He was appointed professor at the Federal University of Bahia in 1973, and in 1988 set up the Pierre Verger Foundation, which houses all of his photographs and correspondence.

Vintage print A term used to describe a print made by the photographer, or under the photographer's supervision, during the period in which the picture was taken. It is to be distinguished from later or modern prints,

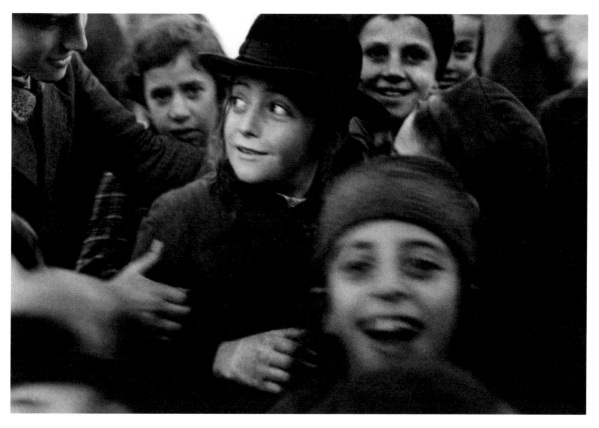

Roman Vishniac, *Jewish Schoolchildren,
Mukachevo, c.* 1935–38

which are made later in the photographer's life, or estate prints, which are made posthumously. These distinctions have been used in the art market since the 1970s to emphasize the value of particular prints. For collectors, vintage prints are the most sought-after, because of their rarity and historical significance.

Vishniac, Roman (1897–1990) Russian-born American press and scientific photographer. He studied science in Moscow, earning a doctorate in medicine in 1920. He moved to Berlin the same year but was under-employed, taking portraits and press photographs to earn a living. He studied Oriental art at the University of Berlin, earning a doctorate but never receiving the degree because of Nazi-enforced restrictions. In *c.* 1935 Vishniac began documenting the lives of Eastern European Jews for the Jewish Joint Distribution Committee. Using a → Leica and a → Rolleiflex, he captured 16,000 images of Jewish life just before World

War II, later publishing his images in *Polish Jews* (1947) and other publications. He fled to France in 1939 and to the United States in 1940, where he worked as a portrait and press photographer in New York, publishing through agencies such as → Black Star. Vishniac also worked as a freelance microphotographer in the 1950s.

Vitali, Massimo (b. 1944) Italian photographer. Vitali is best known for his densely composed → panoramic views of tourist attractions. Generally taken under very bright light, they are marked by the careful selection of elements and human figures. Vitali studied at the London College of Printing and after a career in → photojournalism turned to → art photography in the early 1990s. He lives and works in Lucca and Berlin.

Vogel, Lucien (1886–1954) French art director. Vogel is considered one of the greatest figures in 20th-century French magazine publishing.

• **V** —

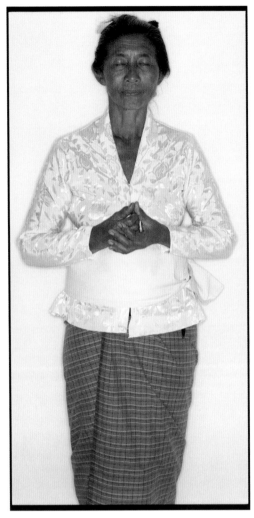
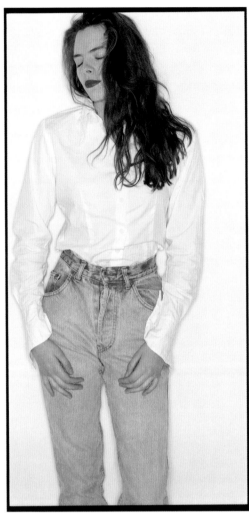

Christian Vogt, *Balinesian Priestess and Zoe Jenny, Novelist*,
from the series *Idem diversum*, 1991–95

Having studied architecture at the École des Beaux-Arts, Paris, he worked as the art director of *Fémina* between 1906 and 1909, following which he was hired as editor-in-chief of *Art et Décoration*. He launched *La Gazette du bon ton* in 1912, *Le Style Parisien* in 1915 and *Feuillets d'Art* in 1919, and was appointed art director of → *Vogue* in 1922. Vogel was co-founder of *Jardin des Modes* in 1922 (first launched in 1929 as *Illustration des Modes*, a fashion supplement for *L'Illustration*). He founded the illustrated weekly → *Vu* in 1928, followed by *Lu*, a topical digest, in 1931. In 1940 he fled to New York, where he worked for Condé Nast, returning to France in 1944 and taking up his old post at *Jardin des Modes*. Vogel is recognized for his contribution to modern publishing through his innovative use of photography, typography, printing techniques and page layout.

Vogt, Christian (b. 1946) Swiss photographer. After studying photography in Basel, Vogt became assistant to the photographer Will McBride. He then opened his own studio, and from the 1970s onwards worked for *Time Life*, → *Camera* and *Photo*. His personal aim is to 'give form to that which one has experienced and about which one cannot speak'. Since the 1960s he has employed a poetic visual language (*Onlookers*, 1977–78). He is fascinated by paradoxical connections, takes portraits of people with their eyes closed (*Idem diversum*, 1995) and explores

the relationship between text and image
by keeping a personal diary (*Photographic Notes*,
begun in 1981). More recently, he has become
interested in mists and capturing them on film
(*Nebelbilder*, 2003).

Vogue (1892, New York) American magazine.
Vogue started off in 1892 as a weekly publication
that targeted New York high society. In 1909 it
was acquired by Condé Montrose Nast, who
transformed it into a fashion magazine in which
culture and art occupied a special place. He
rethought the visual content and progressively
replaced illustration with photographs, attracting
talented practitioners including → Baron
Adolphe de Meyer, → Edward Steichen, → George
Hoyningen-Huene and → Horst P. Horst. *Vogue*
maintained its status as an avant-garde fashion
magazine until the 1970s and launched the
careers of many → fashion photographers, such
as → Irving Penn. Foreign editions followed suit,
and during the 1970s French *Vogue* engaged
future luminaries including → Helmut Newton
and → Guy Bourdin.

Vorticism A British artistic movement that
emerged out of Cubism, → Futurism and
Expressionism. It embraced mainly painting and
graphic art, but also works of literature (it was
the poet Ezra Pound who gave the movement
its name). Featuring bold lines and vibrant
colours, Vorticism influenced photographers
such as → Alvin Langdon Coburn, who exhibited
his abstract 'Vortographs' in London in 1917,
creating a stir.

Vroman, Adam Clark (1856–1916) American
photographer. Born in Illinois, Vroman spent
seventeen years working for railway companies
before taking up photography and moving to
Pasadena, where he opened a bookshop that
also sold photographic materials. With George
Wharton James and Charles Lummis, he shared
an interest in landscapes and the people of the
Southwest. Between 1895 and 1904 he organized
eight photographic expeditions to Arizona and
New Mexico. Vroman was fascinated by history
and archaeology, and is best known for his

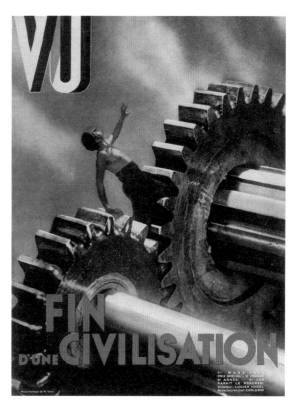

Cover of *Vu*, 1 March 1933

respectful, sensitive portraits of Pueblo Indians,
especially the Hopi and the Zuni.

Vu (1928–40) French magazine founded by
→ Lucien Vogel. First published on 21 March 1928,
Vu was a weekly magazine distinguished by the
central role it gave to photography and by the
dynamic layout designed by its artistic director,
→ Alexander Liberman, who was himself inspired
by the *Berliner Illustrirte Zeitung*. It attracted
many famous photographers, such as → Brassaï,
→ André Kertész, → Henri Cartier-Bresson
and → Germaine Krull, and produced a total
of 600 issues plus various special editions,
sometimes with an international reach
(*Vu au pays des Soviets*, November 1931; *L'énigme
allemande*, April 1932). Vogel was the first to
publish → Robert Capa's legendary photograph
Death of a Spanish Loyalist, in the magazine's
23 September 1936 issue, but he was fired for
appending his own political views. Alfred Mallet
then took over as director until the magazine
closed in 1940.

• **V** —

Walker, Tim (b. 1970) British photographer.
Walker studied at Exeter College of Art.
Having worked as an assistant to → Richard
Avedon he then went solo, taking portraits and
fashion and documentary photographs for the
English press and international publications
(→ *Vogue, Vanity Fair,* → *Harper's Bazaar*). His
unusual compositions often involve surprising
combinations of interior and exterior, changes
of scale and the creation of enchanted scenes
inspired by the weird and wonderful world
of → Lewis Carroll.

Wall, Jeff (b. 1946) Canadian photographer.
Born in Vancouver, Wall held his first exhibitions
while he was still a student of art history at the
University of British Columbia. He was influenced
initially by American trends in art and literature
and by the social movements of the 1960s, and
his first exhibited works were experimental and
self-reflexive. Working in a conceptual style, he
mixed handwritten texts with series of images,
as in *Meaningness* (1969), *Action Photos* (1969) and
Landscape Manual (1969–70). Between 1970 and
1973 Wall studied the history of art and cinema
at the Courtauld Institute of Art in London,
which inspired a return to the image and
the pictorial tradition. In 1978, at the Nova
Gallery in Vancouver, he exhibited the kind of
works that would make him famous. Cleverly
conceived and composed, his photography
from this point on was based on major works
of European painting (especially Delacroix and
Manet) and literature (Baudelaire), but also
borrowed ideas from the cinema and American
billboards. These images, which typically take
the form of meticulously staged large-format
backlit transparencies, show aspects of everyday
life that connect them with the genres of
→ portraiture, history painting and → still-life.
The Destroyed Room (1978), *Picture for Women*
(1979), *Mimic* (1982), *Milk* (1984), *The Storyteller*
(1986) and *A Sudden Gust of Wind (After Hokusai)*
(1993) are all outstanding examples of Wall's
exquisite work.

Wallace, Ian Hugh (b. 1943) British-born Canadian
artist. Having graduated in art history in 1968,
Wallace became a teacher at the Vancouver School
of Art. A prominent figure on the Vancouver art

Jeff Wall, *The Destroyed Room*, 1978

scene, he introduced conceptual photography there and wrote about its theory. His work combines photography and painting, and his students included → Jeff Wall, → Rodney Graham and → Ken Lum.

Wang, Qingsong (b. 1966) Chinese photographer. Wang was born in Heilongjiang Province during the Cultural Revolution. Having trained as a painter at the Sichuan Academy of Fine Arts in 1993, he moved to Beijing and turned to photography in the late 1990s. Often working with theatrical scenes, he produces large-scale colour photographs that juxtapose elements of traditional Chinese artistic culture with the rapid commercialization of contemporary society.

Waplington, Nick (b. 1965) British photographer. He studied at the Royal College of Art in London. In 1991 he created *Living Room*, a work that resembles a family photograph album, featuring ordinary homes in Nottingham. He used it to

depict the uncertainties of post-Thatcherite society as well as the simple pleasures of a British family. The sitters' awkward poses are accentuated by the complex viewpoints (low- and high-angle shots) and → blurring. Waplington does not criticize or seek an emotional response: he simply depicts people who look happy.

War photography Images that capture human conflict and its effects on society and the environment. The first armed conflict to receive systematic photographic documentation was the Crimean War (1853–56), which was photographed most notably by → Roger Fenton. Early war photography was difficult: not only was the equipment unwieldy and the processing of images complicated, but the slow → film speed of → daguerreotypes and paper or wet-plate negatives meant that action photographs were impossible to take. By the time of the American Civil War (1861–65), there was a demand for photographs that could be used

• **W** —

Andy Warhol,
Self-Portrait in Drag, 1981

as source images for newspaper illustrations or standalone engravings (especially battle scenes and portraits of famous generals), collated into presentation albums or presented as stereographic views. Businessmen quickly capitalized on this new market, and studios such as → Mathew B. Brady's flourished, sending skilled photographers to the front. With advances in technology, cameras became smaller and more portable, and the sensitivity of films increased. During World War I, photographers working on the front were able to capture scenes of conflict and actual battles. The Spanish Civil War (1936–39) marked a turning point in war photography. The Republican cause attracted international attention and sympathy from opponents of fascism, prompting photographers including → Robert Capa, → Gerda Taro and → David 'Chim' Seymour to travel to Spain and work alongside the Republican forces. Capa's belief that good photographs require the photographer to 'get closer' was not without danger: all three of these photographers were eventually killed while photographing armed conflict. The Vietnam War

— W •

(1955–75) coincided with a high point in printed journalism. Photojournalists such as Henri Huet and → Larry Burrows created iconic photo essays for → *Life* and other publications, helping bring the reality of a foreign war home. War and conflict continue to draw photographers: there is an emerging market for fine art photography treating the themes of conflict, and many photojournalists are now represented by galleries as well as the more traditional newspapers and photo agencies.

Warhol, Andy [Andrew Warhola] (1928–1987) American artist, printmaker, writer and film director. Warhol's parents were Slovakian immigrants. He took his bachelor's degree at the Carnegie Institute of Technology in Pittsburgh in 1949. Initially an advertising illustrator, he turned to creative art in 1960, and in 1962, along with Roy Lichtenstein and others, he took part in the major Pop art exhibition *The New Realists* in New York. A central figure in the movement, he became famous for his series of silkscreen prints that featured Marilyn Monroe, Elvis Presley, tins of Campbell's soup or bottles of Coca-Cola, and for his portraits. From 1967 until his death, he received commissions for nearly a thousand portraits of celebrities from all walks of life. At the start of his career he used photography as a tool for creating his silkscreen prints, which generally recycled images from the → illustrated press. For a while he was interested in → photo-booth photography but abandoned this technique in the early 1970s after acquiring a Big Shot → Polaroid camera, which was designed to take portraits. Using both of these technologies he invented a new, impersonal, mechanical approach to the photographic portrait. Warhol – himself one of the most photographed artists of his time – consumed a minimum of one film a day throughout the last ten years of his life, and also used his photographs as the basis for half a dozen books and more than a hundred silkscreen works over the course of twenty-five years.

Watkins, Carleton Eugene (1829–1916) American photographer. Watkins contributed to the American → landscape tradition, producing photographs as well known as those of → William

Carleton Eugene Watkins, *Agassiz Rock,*
Yosemite Falls, from Union Point, c. 1878

Henry Jackson, → Eadweard Muybridge and
→ Timothy O'Sullivan. Originally from the state
of New York, he was employed by a Californian
daguerreotypist, Robert H. Vance, who owned
a studio in San José. Watkins quickly learned
the basics of photography and in 1861 opened
his own studio in San Francisco. He earned his
living photographing mining operations, but
also took views of the landscapes of California,
and in particular Yosemite Valley, which he

visited several times from 1861. The result was
his first publication, *Yosemite Valley: Photographic
Views of the Falls and Valley* (1863). Watkins
really made his name, however, with *Yosemite*
in 1867; that year he submitted a series of prints
to the Exposition Internationale in Paris and
was awarded a prize. In 1868 he photographed
Oregon, and in 1876 the Southern Pacific
railroad and Tucson, Arizona. Watkins was one
of the earliest to portray the vast scale of the

● **W** —

Boyd Webb, *Nourish II*, 1984–2006

American landscape. His aim – which reflects contemporary views of the North American continent as virgin territory – was to convey the impression of an Eden-like wilderness. His work in Yosemite Valley was the first he produced in this pioneering spirit. Watkins's financial situation went into decline in the 1870s: his studio fell into debt, his photographs were auctioned off and published, uncredited, by a competitor, and most of his negatives were destroyed in the San Francisco earthquake of 1906.

Watson, Albert (b. 1942) Scottish fashion and portrait photographer. Watson studied at the Duncan of Jordanstone College of Art and Design, Dundee, and at the Royal College of Art in London. In 1970 he began his career in commercial photography in Los Angeles, publishing his photographs in *Mademoiselle*, *GQ* and → *Harper's Bazaar*. In 1976 he moved to New York and became one of → *Vogue*'s star

photographers. Well known for his portraits of Kate Moss, Mike Tyson and Alfred Hitchcock, he was also the official photographer for the wedding of Prince Andrew and Sarah Ferguson in 1986. Since 1994 he has published several books, including *Cyclops* (1994) and *UFO: Unified Fashion Objectives* (2010).

Waxed paper negative A process invented in around 1851 by the French photographer → Gustave Le Gray. In this variation on the → calotype process, paper was waxed before, rather than after, being sensitized. Its great advantage was that the photographer could work with paper that had been prepared well before the picture was taken, instead of having to prepare the paper immediately before use in order to ensure that it was still wet enough to print from. Applying wax to the paper blocked any small holes and gave the negative a consistency and translucency that created a better-quality print. Le Gray's process prolonged the lifespan of the calotype by several years in the 1850s, when it was under threat from → albumen and → collodion plates.

Wearing, Gillian (b. 1963) British artist. Wearing studied at the Chelsea School of Art (1985–87) and at Goldsmiths College, London (1987–90). She belonged to the group of Young British Artists (YBAs) and won the Turner Prize in 1997. With her photographs and videos, she challenges notions of identity, perception and representation. A retrospective of her work was held at the Whitechapel Gallery, London, in 2012.

Webb, Boyd (b. 1947) New Zealand artist. After studying sculpture at the Royal College of Art, London, Webb produced large-format photographs that arrange human figures in bizarre tableaux, creating absurd scenes in which reality and the imagination intermingle. He has held major exhibitions at the Whitechapel Gallery in London (1978, 1987) and represented New Zealand at the Sydney Biennial (2005).

Weber, Bruce (b. 1946) American fashion photographer. During the 1970s Weber attended

— **W** •

416

photography courses given by → Lisette Model in New York. Ten years later he began to work for British → *Vogue* and became well known on the international scene for his advertisements for Ralph Lauren and Calvin Klein. A cult photographer during the 1980s and 1990s, he is also famous for his erotic male nudes.

Wedgwood, Thomas (1771–1805) British scientist. The son of the industrialist Josiah Wedgwood, Thomas was given a sound education in both the arts and the sciences. He was interested in optics and light, and began to experiment with the effects of silver nitrate in the 1790s. He contributed to the invention of photography by publishing an essay on his non-permanent

'silver images' in the *Journals of the Royal Institution of Great Britain* (1802).

Weegee [Usher Fellig; Arthur Fellig] (1899–1968) American photojournalist. Of Jewish-Austrian heritage, Fellig emigrated from Austria to New York in 1910. His first job was assisting a souvenir photographer in the mid-1910s, and by 1917 he was an assistant at the Ducket & Adler photo studio. Fellig worked as a print-dryer at the *New York Times* in the early 1920s, acquiring the nickname 'Squeegee Boy', which later became 'Weegee'. Acme Newspictures employed him in 1924, first as a → darkroom printer and later as a nightshift photographer. He left Acme in 1935 to work freelance. His uncanny ability to arrive

• W —

Weegee, *Lifted into an Ambulance, New York*, 1941

417

swiftly at late-night crime scenes was profiled by → *Life* in a story entitled 'A New York Free Lance Photographs the News' (12 April 1937). A special contributing photographer at New York's *PM Daily* from 1940 to 1945, Weegee used harsh flash lighting to capture late-night arrests, murders, accidents and fires with a brash personal remove. He also shot scenes of human interest, writing his own captions and texts for *PM Daily*. In 1941 he held a solo exhibition, *Murder Is My Business*, at the → Photo League, New York, and also exhibited in group shows at the → Museum of Modern Art (*Action Photography*, 1943; *Art in Progress*, 1944). His first book, *Naked City* (1945), was published to great acclaim and followed up by *Weegee's People* (1946) and *Naked Hollywood* (1953). Weegee lived in Hollywood from 1947 to 1952, playing bit roles in motion pictures, including *The Naked City* (1947). He experimented with darkroom manipulation and nude photography in the 1950s, choosing artistic techniques over the starkness of his earlier work for the press. During the 1950s and 1960s Weegee wrote several darkroom manuals.

Wegman, William (b. 1943) American photographer. Wegman took his bachelor's degree in painting at the Massachusetts College of Art, Boston, in 1965 and went on to do a master's at the University of Illinois in 1967. He subsequently taught painting at the University of Wisconsin until 1970, and then at the University of Long Beach in Los Angeles. It was at this time that he turned to photography and adopted a Weimaraner dog, which he called Man Ray. This was the first of a long line of Weimaraners, which from now on became the focus of his work. Adopting an anthropomorphic approach to the animals, Wegman produced ironic, humorous and challenging images that explore different forms of human behaviour. Wegman has written a large number of children's books and worked in the world of fashion, as well as making numerous short films.

Weissenborn, Thilly [Margarethe Mathilde Weissenborn] (1889–1964) Dutch photographer. Weissenborn is known as one of the foremost photographers of the former Dutch East Indies.

She was born in Indonesia and brought up in The Hague. In 1913 she returned with her brother Theo to Java, where she trained at the Kurkdjian studio in Surabaya under the British photographer George P. Lewis, who specialized in Pictorial-style tropical scenes. In 1917 she moved to a studio of her own in the mountain resort area of Garut, supplying the tourist market with views of Java, Sumatra and Bali. The landscapes produced by her Lux studio have a luminous, quiet beauty, and her portraits of indigenous peoples possess a dignified naturalism. Weissenborn's studio closed in 1942, and her archive was destroyed during World War II. In 1956 she moved back to the Netherlands. Dutch colonial museums and the National Gallery of Australia, Canberra, hold examples of her work.

Welling, James (b. 1951) American photographer. He taught himself developing and printing processes in 1976. His photographic career began in the early 1980s at the inaugural exhibition of Metro Pictures in New York. He has since used both traditional and cameraless techniques, including → Polaroids, 4 × 5 view cameras and digital processes. In his → photograms, architectural photography and abstract compositions, Welling often utilizes simple materials to explore themes of light, movement and time while challenging the technical and conceptual limits of photography. His publications include *Abstract* (2002), *Flowers* (2007), *Glass House* (2011) and *Monograph* (2013).

Wessel, Ellisif (1866–1949) Norwegian photographer, writer and publisher. In 1886 Wessel moved with her husband, a doctor, to the town of Kirkenes in the northern part of Norway. Her photographs from the turn of the century are unique records of the people, houses and landscape of the Sør-Varanger area. Among them are depictions of the Sami people and their culture, and photographs of the poor in Finnmark. In 1902, together with her husband, Wessel published *Fra vor grændse mod Rusland* ('From our Border to Russia'), illustrated with many of her pictures. In 1906 she helped organize a trade union at the A/S Sydvaranger mining company in Kirkenes. In 1914 she published

a socialist journal called *Klasse mot klasse* ('Class Against Class'), and *Den lille socialist* ('The Little Socialist'), a politically themed picture book for children. She taught herself German and Russian in order to be able to pass on new socialist ideas, and translated numerous revolutionary articles into Norwegian after the 1917 Revolution. A recent art project by the Norwegian photographer Morten Torgersrud chronicles one of Wessel's journeys along the Norwegian–Russian border as described in her 1902 book.

Wessel, Henry (b. 1942) American photographer. Wessel graduated from the University of Pennsylvania and from the State University of New York in Buffalo. Greatly influenced by the work of → Robert Frank, → Lee Friedlander and → Garry Winogrand, for nearly thirty years he photographed everyday life in the American West with a combination of humour and lyrical beauty. He first came to the attention of the critics in 1975, when his work was shown at the → *New Topographics* exhibition at George Eastman House, Rochester, and subsequently at the → Museum of Modern Art, New York.

Wessing, Koen (1942–2011) Dutch photographer. Born into an artistically minded family, Wessing became serious about photography at the young age of 15 after an encouraging encounter with the photographer → Ed van der Elsken. After completing his studies at the Rietveld Academy, Wessing assisted Van der Elsken before becoming a freelance photographer. Throughout his career, he photographed a variety of stories worldwide, often focusing on political turmoil in locations such as Afghanistan, China, Albania and Romania. Wessing is perhaps best known for his photographs of Chile in 1973, taken in the aftermath of the military coup that overthrew President Salvador Allende. This work was published under the title *Chili, September 1973* the same year, and is today considered a classic book of humanistic, politically engaged photography.

Weston, Brett (1911–1993) American photographer. The best-known son of → Edward Weston, Brett

Edward Weston,
Pepper No. 30, 1930

specialized in printmaking at a very young age. During the 1950s he produced some 7,600 prints for his father's portfolios. From the age of 13 he had a passion for photography and pursued an independent path, taking landscape photographs throughout his life, with an increasing tendency towards the abstract.

Weston, Edward (1886–1958) American photographer and artist. Weston today typifies the influential West Coast aesthetic that arose in the 1920s and 1930s. He began as a commercial photographer in San Francisco in 1911 but became interested in pursuing photography as an art. In 1915 he started writing his *Daybooks*, a series of journals that would later be published. It was during this time that he collaborated with Margrethe Mather, the first of several determined women who influenced his artistic career. In 1923 he left San Francisco to spend three years in Mexico with → Tina Modotti, where he made

• W —

419

Clarence Hudson White,
Drops of Rain, 1903

portraits of her and other Mexican artists such as Jose Clemente Orozco and Diego Rivera. He also refined his modernist explorations, beginning with *Pipes and Stacks, Armco, Middletown, Ohio* (1922), and the examination of elemental forms found in commonplace items and scenes that would continue throughout his career. Many of his → still-life works from the 1920s and 1930s – *Nautilus* (1927) and *Pepper No. 30* (1930), for instance – are exemplars of photographic modernism. This philosophy crystallized in the formation of → Group *f*.64, which, though short-lived, established the West Coast photographic style. This approach differed from the prevailing Pictorial aesthetic by employing greater tonal contrasts and sharpness of focus across the whole image. In 1937 Weston became the first photographer to receive a fellowship from the Guggenheim Foundation, which he and his second wife, Charis Wilson, used to photograph California and the western United States. Wilson collaborated with Weston as a writer on the resulting books, *Seeing California with Edward Weston* (1939) and *California and the West* (1940), and as a model

for several pioneering nude studies made during their eleven-year marriage. From 1948 the symptoms of Parkinson's disease prevented Weston from photographing, though he continued to supervise the production of prints by his sons, Cole and Brett, until his death.

Wet-plate collodion process *see* **Collodion process**

Wey, Francis (1812–1882) French writer and photography critic. Wey was a founder member of the → Société Héliographique in January 1851, and his writings on photography, published in → *La Lumière* between February and October that year, were among the first to champion the artistic practice of photography. He subscribed to the 'theory of sacrifices', according to which a work's aesthetic unity was more important than sharply defined detail, for that reason regarding the → calotype process as a good alternative to the minutely detailed → daguerreotype. These articles, which still occupy an important position in the history of photography, were little more than a sideline to Wey's literary and institutional career.

Wheatstone, Charles (1802–1875) British physicist. Professor at King's College, London, Wheatstone conducted many experiments on acoustics, optics and electricity. In 1838 he demonstrated a stereoscope to the Royal Society, the earliest prototype of which dated back to 1831. Despite various experiments in which → daguerreotypes and → calotypes were used to create three-dimensional images, his process did not catch on in the field of photography. In 1849 → David Brewster adapted and improved on Wheatstone's invention, enjoying significantly more success.

White, Clarence Hudson (1871–1925) American photographer. Originally an accountant by profession, White spent his spare time practising photography in the → Pictorialist style. In 1898 his work was exhibited at a photography salon in Philadelphia, where he met → Fred Holland Day and → Joseph Keiley. That same year he co-founded the Camera Club in Newark, Ohio, where he was living. From 1899 onwards his photographs – generally → platinum prints –

W

were exhibited as far afield as Boston, New York, Dresden, London, Paris, Turin and Vienna. He became a member of the Camera Club in New York and the → Brotherhood of the Linked Ring in London, and by now he was earning his living exclusively from photography. As part of the circle that included → Alfred Stieglitz, → Edward Steichen and → Gertrude Käsebier, he was a co-founder of the → Photo-Secession in 1902. He moved to New York in 1906, and the following year began teaching photography at Columbia University. In 1907 he and Stieglitz produced a series of nudes, and in 1908 an issue of → *Camera Work* was devoted entirely to him. In 1910 he moved to Maine, where he held summer courses

with Day, Käsebier and Max Weber. He was so successful that he founded the → Clarence H. White School in New York in 1914. Two years later, in order to set himself apart from those now practising → straight photography, he founded the Pictorial Photographers of America movement together with Käsebier, → Alvin Langdon Coburn and → Karl Struss.

White, Minor (1908–1976) Influential American photographer, teacher and writer. Known for his spiritual approach to image-making, White began his career studying photography with → Edward Weston before becoming an assistant to → Ansel Adams, from whom he learnt about

● W —

Minor White, *Vicinity of Cove,*
Grande Ronde Valley, Oregon, 1941

the 'zone system' for assessing and adjusting
→ exposure. As one of the founding members of
the periodical → *Aperture*, White wrote extensively
about photography, eventually becoming the
magazine's editor. He worked at George Eastman
House, Rochester, New York, from 1953 to 1956,
while teaching photography at the Rochester
Institute of Technology. In 1965 he took a
teaching position at the Massachusetts Institute
of Technology, where he taught until his death in
1976. *Mirrors Messages Manifestations*, published
in 1968, is White's most celebrated book and
represents a summary of his approach to
photography. Through his teaching and writing,
White influenced generations of American
photographers.

Wilmer, Valerie Sybil (b. 1941) British
photographer and music critic. Since the late
1950s she has published numerous articles
concerning black musicians. Her literary and

George Washington Wilson, *Queen Victoria
on Fyvie with John Brown at Balmoral*, 1863

photographic work explores the world of jazz,
including such figures as John Coltrane and
Louis Armstrong, and challenges notions of
genre and cultural minority. In 1983 she co-
founded Format, the only exclusively female
photographic → agency in Great Britain.

Wilson, George Washington (1823–1893) British
photographer and publisher. Having begun his
career as a portrait painter in Aberdeen in 1849,
Washington introduced photography into his
commercial practice in 1852. In the mid-1850s
he documented the construction of Balmoral
Castle and became photographer to Queen
Victoria in the 1860s. He was a pioneer in the
mass production of views for travellers during the
rapid growth of Scottish tourism in the second
half of the 19th century.

Winogrand, Garry (1928–1984) American
photographer. A leading light in the → street
photography genre from the 1960s to the 1980s,
Winogrand was born in New York and lived
there all his life. He originally studied painting
but from 1948 devoted himself entirely to
photography. He forged his own style, working
for the press and photographing whatever
caught his eye in the streets. He also attended
courses given by → Alexey Brodovitch at the
Design Laboratory in Philadelphia. Under the
influence of → Walker Evans (in particular his
American Photographs, 1962) and → Robert Frank
(*The Americans*, 1958), Winogrand paid close
attention to framing and attached a great deal
of importance to the meanings suggested by
the interplay between different elements within
a composition. The use of wide-angle shots
and portable cameras helped him to convey
the complexity of the views and situations he
photographed. His images frequently deploy
an ironic streak. In 1955 → Edward Steichen
displayed two of Winogrand's photographs at
→ *The Family of Man* exhibition (Museum of
Modern Art, New York). The exhibitions *Toward
a Social Landscape* (George Eastman House,
Rochester, 1966) and → *New Documents* (Museum
of Modern Art, New York, 1967) brought together
works by Winogrand, → Lee Friedlander and
→ Diane Arbus, all of whom → John Szarkowski

— W •

Garry Winogrand, *Central Park Zoo,
New York City*, 1967

regarded as a new generation of photographers, practising a personal documentary style that transcended the subjectivity of the artists themselves. Winogrand's first book, *The Animals* (1969), was a study of the interactions and similarities between zoo visitors and the animals in captivity. *Public Relations* (1977), which he produced after receiving a second Guggenheim Fellowship, focused on the links between political demonstrations and the media.

Winther, Hans Thøger (1786–1851) Danish-born Norwegian publisher, lawyer and pioneer of photography. Winther conducted early photographic experiments, using the various techniques described in the first Norwegian book on photography, *At frembringe og fastholde Lysbilleder paa Papir* ('To Create and Capture Light Pictures on Paper') published in 1845. He launched several journals on literature, art and photography in the 1820s and 1830s, to which

he was a frequent contributor. Through his writing, such as a poem published in the journal *Ny Hermoder* in 1841 praising → Louis Daguerre's invention, Winther was an important proponent of the photographic medium in his home country.

Witkacy [Stanislaw Ignacy Witkiewicz] (1885–1939) Polish photographer, painter, philosopher and dramatist. Witkiewicz grew up in an artistic and intellectual environment and received a liberal education. He attended the Academy of Fine Arts in Kraków, and prior to 1915 travelled round Europe and to Australia. During World War I he fought for an elite regiment in the Russian army. In 1918 he moved to Zakopane in southern Poland. As an artist he was proficient in many fields and took an interest in photography as a means of documentation. Initially he experimented with perspectives, and as early as 1899 he had taken his first photographs in the

• W —

Wols, *Doll on the Cobbles*, 1938

→ Pictorialist style, capturing the landscapes in and around Zakopane, the Tatra Mountains, steam engines and portraits of his family. He went on to explore different approaches to the self-portrait, and between 1912 and 1914 produced several → series using long-focus lenses, limiting himself to close-ups and accentuating the centre of the face. By concentrating on his eyes and mouth he created original, avant-garde images that broke the mould of conventional portraiture. He never stopped using himself as a subject and often dressed as different historical or fictional characters. Witkiewicz's often grotesque, ironic improvisations, photographed with a rapidity that was again unconventional for his time, constituted an investigation into the nature of reality. In 1928 he founded the portrait company S. I. Witkacy, where photographs served as prototypes for his pastel portraits. Between 1930 and 1931 he produced a large number of self-portraits and also documented his work.

Much of his photographic archive and detailed descriptions disappeared during the Warsaw Uprising of 1944.

Witkin, Joel-Peter (b. 1939) American photographer. Born in Brooklyn to a Jewish father and a Catholic mother, Witkin took sculpture courses at the Cooper Union School in New York (1958–60) before enlisting in the American army, where he learnt photography (1961–64). He then returned to the Cooper Union School and obtained a bachelor's degree in fine art in 1974. That same year he moved to Albuquerque, New Mexico, where he settled. Witkin obtained a master's degree in photography at the University of New Mexico in 1986. He relates how one incident – a road accident he witnessed at the age of 6, in which a young girl's decapitated head rolled towards his feet – had a lasting effect on him and his aesthetic viewpoint. His black-and-white photographs, whose negatives are scratched or bleached, show fragments of bodies, corpses, badly wounded humans or animals, hermaphrodites, physical deformities, amputations and disease – in short, every human shape that falls outside the normal, and every subject that is usually excluded from representation. He creates a space for these bodies, arranging them in baroque, grotesque scenes and employing motifs borrowed from the European pictorial tradition. Deeply influenced by religion, Witkin's works have the impact of a *memento mori* or a *vanitas*, mixing sexuality with death and reinterpreting the great themes of Christianity. The macabre and erotic nature of these photographs makes them not only highly original, but also highly disturbing. They have frequently elicited much discussion and controversy.

Wolf, Michael (b. 1954) German photographer. Born in Munich, Wolf grew up in Toronto and California, where he studied at the University of Berkeley before returning to Germany and taking courses given by → Otto Steinert. It was as a photojournalist working for the magazine *Stern* that he discovered Asia, and in particular Hong Kong, as a rich source of subject matter, including population density and industrial

— W •

mass production. His images and installations never shrink from portraying the inhuman side of all this activity.

Wolff, Paul (1887–1951) German photographer. After studying medicine, Wolff ended up as a photojournalist and played an important role in popularizing small-format photographs. With close ties to the Nazi party, he made his name during the Third Reich by promoting the → Leica and publishing books about photography and treatises on technique.

Wols [Alfred Otto Wolfgang Schülze] (1913–1951) German artist and photographer. Wols developed numerous talents, including painting and photography, during his association with the Paris avant-garde of the 1930s. Certain artists – in particular Joan Miró, Max Ernst, Jean Arp and Alexander Calder – had a major influence on his photographic work. When photographing towns and streets, he had an eye for unusual or striking images: walls plastered with torn posters, shabby tramps, filthy gutters. He also took many portraits, which he exhibited for the first time in 1937 at the Galerie de la Pléiade. That same year, the Paris Exposition Internationale devoted the Pavillon de l'Elégance exclusively to his photography. His still-life paintings reveal a change of style after World War II, when he gave free rein to expressive, poetic abstraction. Wols's photography, which dates to a nine-year period from 1931 to 1940, remains an important part of his artistic oeuvre.

Wunderlich, Petra (b. 1954) German photographer. After studying painting at the École des Beaux-Arts in Paris, Wunderlich joined the Kunstakademie in Düsseldorf to follow → Bernd Becher's courses in photography. Her small-scale, black-and-white photographs take the form of frontal views of churches (often half concealed in the urban sprawl) and the excavated walls of quarries – her two main subjects. Wunderlich's thoughtful approach, which fits in perfectly with her subject matter, invites the viewer to consider what may lie behind these façades.

Wurm, Erwin (b. 1954) Austrian artist. Wurm studied sculpture at the School of Fine Arts in Vienna (1979–82). In his work, he tries to link art with life, both public and private, adopting an approach that is both playful and humorous. Using a camera, he captures himself or his models interacting with everyday objects in a bizarre fashion, creating a laconic record in the process (*One Minute Sculptures*).

Erwin Wurm, from the series
One Minute Sculptures, 1997

• W —

Yalenti, José (1895–1967) Brazilian photographer. Having studied to be a civil engineer, Yalenti worked as a photographer for the municipal government of São Paulo from 1936 until 1965, recording the growth and transformation of the city and its suburbs. He was one of the founders of the Foto Cine Clube Bandeirante de São Paulo in 1939. His work is considered especially innovative for its use of → backlighting and Yalenti's predilection for architectural motifs and geometrical forms, which are thrown into sharp relief by contrasts in lighting.

Yampolsky, Mariana (1925–2002) American-born Mexican photographer. Having studied in Chicago, she emigrated to Mexico in 1944. Once there, she studied painting and sculpture at the National School for Painting, Sculpture and Graphics in Mexico City, where in 1951 she became a founder member of the Salón de la Plástica Mexicana, which promotes contemporary art. She worked in the tradition of → documentary photography, recording the complexities of Mexican culture and the common features of Mexican society, her

main topics of interest. In 2012 she was honoured posthumously by the Instituto Nacional de Bellas Artes for her life's work.

Yanagi, Miwa (b. 1967) Japanese artist. Born in Kobe, Yanagi began her artistic career exploring sculpture, textile and performance. In 1991 she completed a postgraduate degree in photography at the Kyoto City University of Fine Arts. Initially she utilized photography as a documentation tool, but it later became her medium of choice, a way to exercise control over her performances. Yanagi's work is inspired by social roles in contemporary Japan, particularly those of women.

Yasui, Nakaji (1903–1942) Japanese photographer. Yasui was first fascinated by photography as a child and went on to become a major figure in Japanese modernism, although he was connected with other movements too, including → New Objectivity. After graduating from a business school in Osaka in 1921, he joined the family business. At the same time he pursued his passion for photography and exhibited his

Nakaji Yasui,
Gaze, 1931

Pavel Semyonovich Zhukov,
Vladimir Lenin, 1920

work in different venues, joining a number of groups, clubs and associations and beginning to win awards. In 1932 he had the privilege of having his work featured in the influential but short-lived avant-garde magazine *Koga*. In 1941, during World War II, Yasui took part in a group photojournalism project entitled *Wandering Jew*, for which he photographed Jewish refugees in Kobe.

Yevonde, Madame [Yevonde Cumbers Middleton] (1893–1975) British photographer. After serving an apprenticeship with Lallie Charles, Madame Yevonde opened her own studio in London in 1914, taking portraits of society figures. She became a member of the Institute of Incorporated Photographers in 1919, and exhibited her advertising and artistic images at the → Royal Photographic Society and at the Albany Gallery in 1932. In the early 1930s she acquired a Vivex colour camera, which she used to photograph sitters dressed up as mythological figures for her series *Goddesses* (1935).

Yva [Else Neuländer-Simon] (1900–1942) German photographer. She opened her first studio in Berlin in 1925 and became well known as a fashion and portrait photographer. Her photographs appeared in all the major German newspapers and magazines of the period. When the Nazis seized power she was forced to leave her studio and died in a concentration camp in 1942.

Zangaki brothers (active *c.* 1865–1890) Two photographer brothers, probably Greek-Cypriot in origin. It is believed that they initially worked for → Hippolyte Arnoux in Port Said, Egypt, but then branched out on their own, working together in the Mediterranean Basin, mainly in Egypt and Palestine. Their photographs are different from conventional views of the Middle East and form an impressive body of work with both documentary and artistic interest.

Zelma, Georgi Anatolevich (1906–1984) Uzbekistan-born Russian photographer. Zelma moved to Moscow in 1921 but returned regularly to his homeland to document changes in Uzbekistan, an Islamic region of the then USSR. Self-taught, and often working for film studios, Zelma attracted a good deal of attention with his avant-garde → reportage done in black and white or colour – notably his coverage of the Battle of Stalingrad in 1942. After the war he worked for the newspaper *Ogonyok* and, from 1962, for the agency Novosti.

Zhukov, Pavel Semyonovich (1870–1942) Russian photographer. Zhukov learnt photography in the studio of Konstantin Shapiro in St Petersburg. Following the 1917 October Revolution he began to take photographs of leading political figures, and in 1920 photographed more than fifty state officials and heads of the Red Army in Moscow, including a celebrated portrait of Lenin. From 1930 onwards

he produced numerous reports on gigantic Soviet projects such as the Volkhov hydroelectric dam and the naval base in Leningrad.

Zola, Émile (1840–1902) French novelist. An adherent of naturalism in literature, Zola began to practise photography in 1895. He owned approximately ten cameras and had a laboratory in his Paris home and another in his property in Médan, north-west of Paris, both of which he used to produce some 7,000 images, ranging from portraits and landscapes to scenes of daily life. In 1900 he took 700 photographs of the Exposition Universelle from the first and second storeys of the Eiffel Tower. A large part of his collection is stored at his house in Médan (now a museum) and at the Musée d'Orsay in Paris.

Zoom lens A type of camera lens with a variable → focal length. Zooming in or out changes the field of view, allowing the photographer to focus on smaller areas of a subject from a distance.

Zuber, René (1902–1979) French photographer. After graduating in engineering, Zuber went to Leipzig to learn about the book trade. It was there that he discovered photography. In 1929 he took part in the → *Film und Foto* exhibition in Stuttgart, following which he was employed by an advertising agency in Paris. He also produced works in the → New Vision style. In 1934 he and others, including Pierre Boucher, founded the Alliance Photo agency. After 1946 Zuber divided his time between publishing, photography and filmmaking.

Zwart, Piet (1885–1977) Dutch industrial designer, typographer and photographer. Zwart was a leading figure in the New Photography movement in the Netherlands. Inspired by his participation in the German → *Film und Foto* exhibition in Stuttgart (1929), Zwart adopted an experimental, but also informative and functional, style of visual communication in the 1930s. His dynamic artworks – advertisements, book and magazine covers, and postage stamps – were → collages of photographic and typographic elements combined with bold graphic designs in colour. Partly on account of his modernist outlook, which was shared by major commercial clients, Zwart's work reached a wide public and influenced a younger generation of Dutch photographers and graphic designers. His promotional brochure for a cable manufacturer, *Delft Kabels* (1933), is generally recognized as a highlight of 20th-century Dutch modernist typography.

• **Z** —

Picture credits

a=above, b=below

2 Richard Avedon, *Dovima with elephants, evening dress by Dior, Cirque d'Hiver, Paris, August 1955*. Photograph by Richard Avedon. © The Richard Avedon Foundation.
27 Berenice Abbott, *Blossom Restaurant, 103 Bowery, Manhattan*, 1935. © Berenice Abbott/Getty Images.
28 Ansel Adams, *Moonrise, Hernandez, New Mexico*, 1941. © Ansel Adams Publishing Rights Trust/Corbis.
29a Robert Adams, *Colorado Springs, Colorado*, 1968. © Robert Adams, courtesy Fraenkel Gallery, San Francisco and Matthew Marks Gallery, New York.
29b Eddie Adams, *South Vietnam National Police Chief Nguyen Ngoc Loan Executes a Suspected Viet Cong Member*, 1968. © Eddie Adams/AP/ Press Association Images.
30 Drazen Tomic. From *Photography: The New Basics* by Graham Diprose and Jeff Robins, Thames & Hudson Ltd, London, 2012.
31 Antoine d'Agata, *Nuevo Laredo, Mexico*, 1991. © Antoine d'Agata/ Magnum Photos.
32 Laure Albin-Guillot, *Jean Cocteau*, 1935. Roger-Viollet/TopFoto.
33 Fratelli Alinari, *Panorama of Florence with the Ponte Vecchio in the Foreground*, c. 1855. Fratelli Alinari Fotografi Presso Luigi Bardi/Alinari Archives, Florence/Getty Images.
34 Paul Almásy, *The Eiffel Tower Reflected in the Wing Mirror of a Car*, c. 1960. akg-images/Paul Almásy.
35 Manuel Álvarez Bravo, *Good Reputation Sleeping*, 1938–39. © Colette Urbajtel/Archivo Manuel Álvarez Bravo SC.
37 Thomas Annan, *Close No. 75, High Street*, 1868. British Library, London.
38 Nobuyoshi Araki, from *Tokyo Novelle*, 1995. © Nobuyoshi Araki/ Courtesy of Taka Ishii Gallery, Tokyo.
40 John Heartfield, *The Meaning of Geneva: Where Capital Lives, Peace Cannot Live!*, photomontage for the cover of *Arbeiter Illustrierte Zeitung*, 1932. Berlin. Photo Scala, Florence/ BPK, Bildagentur für Kunst, Kultur und Geschichte, Berlin. © The Heartfield Community of Heirs/VG Bild-Kunst, Bonn and DACS, London 2015.
41 Frederick Scott Archer, Untitled portrait, 1845. Science Museum/Science & Society Picture Library.
42 Eugène Atget, *Versailles, The Fountain of Diana*, from the series *Environs*, 1901. Bibliothèque Nationale de France, Paris.
44 Anna Atkins, *Dictyota dichotoma, in the Young State; and in Fruit*, 1843. British Library, London.
45 Aziz + Cucher (Anthony Aziz and Sammy Cucher), *Chris (Dystopia Series)*, 1994. Courtesy of the artists.
47 John Baldessari, *Throwing Three Balls in the Air (Best of 36 Attempts)*, 1973. Courtesy of the artist and Marian Goodman Gallery, New York and Paris.
48a Édouard-Denis Baldus, *Viaduct at La Voulte*, c. 1861–62. The J. Paul Getty Museum, Los Angeles.
48b Dmitri Nikolavich Baltermants, *Soviet Troops Leap over a Foxhole*, 1941. © The Dmitri Baltermants Collection/ Corbis.
49 Lewis Baltz. *Southwest Wall, Vollrath, 2424 McGaw, Irvine*, 1974, from *The New Industrial Parks near Irvine, California*. © Lewis Baltz, courtesy Galerie Thomas Zander, Cologne.
50 Olivo Barbieri, from the *Dolomites Project*, 2010. © Olivo Barbieri.
51a George N. Barnard, *Sherman and his Generals*, from the album *Photographic Views of Sherman's Campaign*, 1864–65. Civil War Wayne Whalen Digital Archive of the Grand Army of the Republic and Civil War Collections, Chicago Public Library.
51b Yto Barrada, *Girl in Red*, 1999. © 2014 Yto Barrada.
53 Gabriele Basilico, *Le Touquet*, 1985. Studio Gabriele Basilico.
54 Lothar Baumgarten, *VW do Brazil*, 1974. Courtesy the artist, Marian Goodman Gallery, New York/Paris and Galerie Thomas Zander, Cologne. © DACS 2015.
55 Hippolyte Bayard, *Self-Portrait as a Drowned Man*, 1840. Société Française de Photographie, Paris.
56 Felice Beato, *Samurai of the Chosyu Clan during the Boshin War period*, 1860s. Alinari Archives/Corbis.
57 Cecil Beaton, *Tilly Losch, wearing a polka dot blouse with a dark jacket, both by Yvonne Carette, and a turban from Boucheron*, from *Vogue*, 10 May 1930. Beaton/*Vogue*; © Conde Nast.
58 Bernd and Hilla Becher, *Water Towers*, 1963–88. Courtesy Sonnabend Gallery, NY. © Bernd and Hilla Becher.
59 Valérie Belin, *Moroccan Brides (Untitled)*, 2000. Courtesy the artist and Galerie Nathalie Obadia, Paris/Brussels.
60 Hans Bellmer, *La Poupée*, 1935. © ADAGP, Paris and DACS, London 2015.
61 E. J. Bellocq, *Storyville Portrait*, c. 1912. Image by E. J. Bellocq © Lee Friedlander, courtesy Fraenkel Gallery, San Francisco.
63 Laurenz Berges, *Krefeld (#2571)*, 2007. Courtesy Galerie Wilma Tolksdorf/© Laurenz Berges, VG Bild-Kunst.
64 Alphonse Bertillon, *Synoptic Table of Nose Shapes*, plate 33 from *Identification anthropométrique: Instructions signalétiques*, 1893. British Library, London.
65 Auguste Nicolas Bertsch, *The Antennae of a Hoverfly*, c. 1853–57. Société Française de Photographie, Paris.
66 Richard Billingham, *Untitled*, 1996. Colour photograph mounted on aluminium. © The artist, courtesy Anthony Reynolds Gallery, London.
67a Werner Bischof, *Peru, On the Road to Cuzco, near Pisac, in the Valle Sagrado of the Urubamba River*, 1954. © Werner Bischof/Magnum Photos.
67b Ilse Bing, *Self-Portrait in Mirrors*, 1931. Courtesy Michael Mattis and Judith Hochberg Collection/© Estate of Ilse Bing.
68 Louis-Auguste and Auguste-Rosalie Bisson, *Mont Blanc*, 1858, from the *Haute Savoie* album. Bibliothèque Nationale de France, Paris.
69 Karl Blossfeldt, *Adiantum pedatum, American Maidenhair Fern, Young Rolled-Up Fronds Enlarged 8 Times*, 1898–1928. British Library, London.
70 Bernhard and Anna Blume, *Kitchen Frenzy*, 1986. © Bernhard and Anna Blume.
71 Erwin Blumenfeld, *Vogue*, March 1945. Blumenfeld/*Vogue*; © Conde Nast.
72 Félix Bonfils, *The Citadel and the Mosque of Muhammad Ali, Cairo*, 1860s–1880s. The Metropolitan Museum of Art, New York.
73 Édouard Boubat, *Little Girl Wearing Dead Leaves*, c. 1946. © Édouard Boubat/ Gamma-Rapho/Getty Images.
74 Guy Bourdin, Unpublished, for Charles Jourdan, 1978. © Estate of Guy Bourdin. Reproduced by permission of Art + Commerce.
75 Margaret Bourke-White, *Fort Peck Dam, Montana*, 1936. © Margaret Bourke-White/Time Life Pictures/ Getty Images.
76 Mathew B. Brady, *Abraham Lincoln*, c. 1863. Library of Congress Prints and Photographs Division, Washington, D.C.
77 Anton Giulio and Arturo Bragaglia, *The Typist*, 1911. The Metropolitan Museum of Art/Art Resource/Scala, Florence. © DACS 2015.
78 Bill Brandt, *Nude, Campden Hill, London*, 1949. © Bill Brandt Archive.
79 Brassaï, *Mme Bijou at the Bar de la Lune, Montmartre*, c. 1932. © Estate Brassaï-RMN-Grand Palais. Photo

Centre Pompidou, MNAM-CCI, Dist. RMN-Grand Palais/Image Centre Pompidou, MNAM-CCI.
82 Balthasar Burkhard, *The Reindeer*, 1996. © Estate of Balthasar Burkhard.
83 René Burri, *Che Guevara*, 1963. © René Burri/Magnum Photos.
84 Edward Burtynsky, *Nickel Tailings, No. 34, Sudbury, Ontario*, 1996. Photo © Edward Burtynsky, courtesy Nicholas Metivier Gallery, Toronto/Flowers, London.
85 Claude Cahun, *Self-Portrait*, 1927. Courtesy of the Jersey Heritage Collections.
86 Harry Callahan, *Eleanor, Chicago*, 1947. © The Estate of Harry Callahan. Courtesy Pace/MacGill Gallery, New York. All rights reserved.
87 Sophie Calle, *Les Dormeurs (The Sleepers)*, 1979. © Calle/ADAGP, Paris 2015. Courtesy Galerie Perrotin.
88 *Camera Work*, Issue No. 1, 1903.
89 Julia Margaret Cameron, *Sir John Herschel with Cap*, 1867. Wellcome Images.
90 Robert Capa, *Death of a Loyalist Militiaman*, 1936. © Robert Capa/Magnum Photos.
91a Cornell Capa, *Senator John F. Kennedy Reaches his Hands into a Crowd while Campaigning for the Presidency, California*, 1960. © Cornell Capa/Magnum Photos.
91b Paul Caponigro, *Two Pears, Cushing, Maine*, 1959. Currier Museum of Art, Manchester, New Hampshire. Gift of Paul Caponigro, photographer, 2011.26.2. © Paul Caponigro.
92 Gilles Caron, *Daniel Cohn-Bendit Confronting a Riot Policeman at the Sorbonne, Paris, 6 May 1968*. © Fondation Gilles Caron/Gamma-Rapho via Getty Images.
94 Lewis Carroll, *Alice Liddell as 'The Beggar Maid'*, 1858. The Metropolitan Museum of Art, New York.
95 Henri Cartier-Bresson, *Behind the Gare St-Lazare*, 1932. © Henri Cartier-Bresson/Magnum Photos.
97 Helen Chadwick, *Meat Abstract No. 8: Gold Ball/Steak*, 1989. © The Estate of Helen Chadwick. Courtesy Richard Saltoun Gallery.
98 Jean-Philippe Charbonnier, *The Swimming Pool at Arles*, 1975. Gamma-Rapho.
99 Luc Chessex, *'Venceremos': Portraits of Fidel, Camilo and Che*, 1961–68. © Luc Chessex.
101 Arnaud Claass, *Untitled (Nice)*, 2003. © Arnaud Claass.
102 Larry Clark, *Untitled*, 1972. © Larry Clark; courtesy of the artist and Luhring Augustine, New York.

103 Chuck Close, *Alex*, 1993. © Chuck Close, courtesy Pace Gallery.
104 Alvin Langdon Coburn, *St Paul's Cathedral, London*, 1908. The Museum of Modern Art, New York/Scala, Florence.
106 Auguste Hippolyte Collard, *The Hôtel de Ville after the Commune*, 1871. The Metropolitan Museum of Art, New York.
107 Calum Colvin, *Narcissus*, 1987. © Calum Colvin.
111 Stéphane Couturier, *Rue Auber, Paris 9*, 1996. © Stéphane Couturier.
112 Gregory Crewdson, *Untitled (Ophelia)*, 2001. © Gregory Crewdson, courtesy White Cube.
113 Donigan Cumming, *Untitled*, 1991. From *Pretty Ribbons*, 1993. Courtesy the artist.
114 Imogen Cunningham, *Two Sisters*, 1928. © The Imogen Cunningham Trust, 2011.
115 Edward Sheriff Curtis, *Quilcene Boy*, 1913. Library of Congress Prints and Photographs Division, Washington, D.C.
117 Louis Daguerre, *The Artist's Studio*, 1837. akg-images.
118 Louise Dahl-Wolfe, *Twins at the Beach*, 1955. Courtesy of the Museum of Contemporary Photography at Columbia College Chicago. © 1989 Center for Creative Photography, Arizona Board of Regents.
119 Antonio and Paolo Francesco D'Alessandri, *Maria Sophia, Queen of the Two Sicilies*, 1860s. National Portrait Gallery, London.
120 Bruce Davidson, *Brooklyn Gang, Coney Island*, 1959. © Bruce Davidson/Magnum Photos.
121 Corinne Day, *Kate Moss* for British *Vogue*, June 1993. © Corinne Day/Trunk Archive.
122 Joe Deal, *Watering, Phillips Ranch, California*, 1983, from the series *Subdividing the Inland Basin*. © The Estate of Joe Deal, courtesy Robert Mann Gallery.
123a Tacita Dean, *The Sinking of the SS Plympton*, from *The Russian Ending*, 2001. Courtesy the Artist, Frith Street Gallery London and Marian Goodman Gallery New York and Paris.
123b Luc Delahaye, *Taliban*, 2001. © Luc Delahaye.
124 Jack Delano, *At the Bus Station in Durham, North Carolina*, 1940. Library of Congress Prints and Photographs Division, Washington, D.C.
125 Thomas Demand, *Bathroom*, 1997. © DACS 2015. Courtesy Sprueth Magers.
126 Raymond Depardon, *Argentina, Patagonia Region*, 1999. © Raymond Depardon/Magnum Photos.

127 Susan Derges, *Observer and Observed No. 16*, 1991. Courtesy Purdey Hicks Gallery.
128 Jan Dibbets, *Robin Redbreast's Territory/Sculpture 1969* (Brest: Zédélé, reprinted 2014). © ARS, NY and DACS, London 2015.
129 Philip-Lorca diCorcia, *Marilyn, 28 Years Old, Nevada, $30*, 1990–92. Courtesy David Zwirner, New York.
130 Rineke Dijkstra, *Odessa, Ukraine, August 4, 1993*. © Rineke Dijkstra.
131 André-Adolphe-Eugène Disdéri, *Emperor Napoleon III and Empress Eugénie*, c. 1865. The J. Paul Getty Museum, Los Angeles.
132 Robert Doisneau, *The Kiss by the Hôtel de Ville*, 1950. © Robert Doisneau/Gamma-Rapho/Getty Images.
134 Stan Douglas, still from *Win, Place, or Show*, 1998. Two-channel video projection, 6 min. (loop), colour, sound. Courtesy the artist and David Zwirner, New York.
135 František Drtikol, *Vykrik Noci*, c. 1927. © Ervina Boková-Drtikolvá, Podebrady. Photo © Centre Pompidou, MNAM-CCI, Dist. RMN-Grand Palais/Jacques Faujour.
136 Maxime Du Camp, *Cairo, Mosque of Sultan Kansou el-Gouri*, 1852. The Metropolitan Museum of Art, New York.
137 Guillaume-Benjamin Duchenne de Boulogne and Adrien Tournachon, illustration from *Mécanisme de la physionomie humaine* (1862). Wellcome Images.
138 Louis Arthur Ducos du Hauron, *View of Agen showing the Cathedral of St Caprais*, 1877. George Eastman House International Museum of Photography and Film, Rochester, New York.
139 David Douglas Duncan, *Captain Ike Fenton, Commanding Officer of Baker Company, 1st Battalion, 5th Marine Regiment, 1st Provisional Marine Brigade, Receives Reports of Dwindling Supplies during the Battle to Secure No-Name Ridge along the Naktong River, Korea*, 1950. The Harry Ransom Center, the University of Texas at Austin.
140 Louis-Émile Durandelle, *Eiffel Tower, September 1888*. The J. Paul Getty Museum, Los Angeles.
141 Thomas Eakins, *Study in Human Motion*, c. 1885. Pennsylvania Academy of the Fine Arts, Philadelphia.
142 Harold Edgerton, *Milk-Drop Coronet Splash*, 1936. © 2010 MIT. Courtesy of MIT Museum.
143 William Eggleston, *Untitled ('The Red Ceiling', Greenwood, Mississippi)*,

1973. © Eggleston Artistic Trust. Courtesy Cheim & Read, New York.
144 Alfred Eisenstaedt, *V-J Day in Times Square*, 1945. © Alfred Eisenstaedt/Pix Inc./Time & Life Pictures/Getty Images.
145 Olafur Eliasson, *The Unilever Series: Olafur Eliasson, The Weather Project*, 2003–04, Turbine Hall, Tate Modern, London. © Tate, London 2014.
146 Peter Henry Emerson, *A Dame's School*, plate 2 from *Pictures from Life in Field and Fen* (1887). British Library, London.
147 Elliott Erwitt, *Paris*, 1989. © Elliott Erwitt/Magnum Photos.
148 Elger Esser, *Sacramento River*, 2007. © DACS 2015.
149 Frank Eugene, *Adam and Eve*, published in *Camera Work*, no. 30, 1910.
150 Frederick H. Evans, *Stairway to the Chapter House, Wells Cathedral*, 1903. Philadelphia Museum of Art.
151 Walker Evans, *Subway Passengers, New York City: Woman and Man Beneath '7th Ave. Local' Sign*, 1938. © Walker Evans Archive, The Metropolitan Museum of Art/Art Resource/Scala, Florence.
154 Gertrude Fehr, *Solarized Nude*, 1936. Musée de l'Elysée, Lausanne. © DACS 2015.
155 Andreas Feininger, *The Photojournalist*, 1951. © Andreas Feininger/The LIFE Picture Collection/Getty Images.
156 Pierre de Fenoyl, *Chemin de Croix d'Aniane, Lodève, France*, 1984. © Pierre de Fenoyl.
157 Roger Fenton, *Valley of the Shadow of Death*, 1855. Library of Congress Prints and Photographs Division Washington, D.C.
159 Larry Fink, *Russian Ball, New York*, 1976. © Larry Fink.
160 Hans Finsler, *Electric Bulb*, 1928. Kunstmuseum Moritzburg Halle (Saale).
162 Thomas Florschütz, *Untitled (15.XI.85)*, 1985. Courtesy DIEHL, Berlin © Thomas Florschütz.
163 Joan Fontcuberta, *Giliandria Escoliforcia*, 1984, from the *Herbarium* series. Courtesy of the artist.
164a Samuel Fosso, *The Chief (Who Sold Africa to the Colonists)*, 1997. © Samuel Fosso, courtesy JM. Patras, Paris.
164b Martine Franck, *Tulku Khentrul Lodro Rabsel with his Tutor in a Nepalese Monastery*, 1996. © Martine Franck/Magnum Photos.
165 Robert Frank, *Trolley, New Orleans*, 1955. © Robert Frank, courtesy Pace/MacGill Gallery, New York.

166 Leonard Freed, *Martin Luther King Being Greeted on his Return to the US after Receiving the Nobel Peace Prize, Baltimore, 31 October 1964*. © Leonard Freed/Magnum Photos.
167 Gisele Freund, *Virginia Woolf in front of a Fresco by Vanessa Bell*, 1939. © RMN gestion droit d'auteur/Fonds MCC/IMEC.
168 Lee Friedlander, *New York City*, 1966. © Lee Friedlander, courtesy Fraenkel Gallery, San Francisco.
169 Francis Frith, *View at Girgeh*, 1857. The Metropolitan Museum of Art, New York.
170 Jaromír Funke, *Composition*, 1927. Museum of Decorative Arts, Prague.
171 Adam Fuss, *Invocation*, 1992. Courtesy Cheim & Read, New York.
173 Marc Garanger, *Algerian Girl*, 1960. © Marc Garanger/Corbis.
174a Alexander Gardner, *Antietam, Maryland: Confederate Soldiers as they Fell near the Burnside Bridge*, 1862. Library of Congress Prints and Photographs Division, Washington, D.C.
174b Jean-Louis Garnell, *Diptyque No. 1*, 1998. Courtesy the artist. © DACS 2015.
175 Jean Gaumy, *On Board the Spanish Trawler 'Rowanlea'*, 1998. © Jean Gaumy/Magnum Photos.
177 Luigi Ghirri, *Orbetello*, from the series *Kodachrome*, 1974. Courtesy Matthew Marks Gallery, © Estate of Luigi Ghirri.
179 Wilhelm von Gloeden, *Reclining Male Nude Beside Vase*, 1890s. The Metropolitan Museum of Art, New York.
180 Jim Goldberg, *'I love David. But he is to fragile for a rough father like me'*, 1979. © Jim Goldberg/Magnum Photos.
181 David Goldblatt, *The Butchery of Hassimia Sahib, who Resisted Forced Removal, with New Housing for Whites, during the Destruction of Fietas under the Group Areas Act, 8 March 1986*. © David Goldblatt.
182 Nan Goldin, *The Hug, NYC*, 1980. © Nan Goldin, courtesy Matthew Marks Gallery.
183 John R. Gossage, *Bernaurerstr.*, 1982. © John R. Gossage.
184 Werner Graeff, *Es kommt der neue Fotograf*, Berlin, 1929.
185 Rodney Graham, *Artist's Model Posing for 'The Old Bugler, Among the Fallen, Battle of Beaune-la-Roland, 1870' in the Studio of an Unknown Military Painter, Paris 1885*, 2009. © the artist; courtesy Lisson Gallery, London.
186 Brian Griffin, *Self-Portrait*, 1988. © Brian Griffin.

187 Harry Gruyaert, *Bowl of Marinated Lemons used in Traditional Cooking, Souk, Meknes*, 1988. © Harry Gruyaert/Magnum Photos.
188 Ara Güler, *Boys Playing Marbles in the Courtyard of the Fethiye Mosque in Istanbul*, 1968. © Ara Güler/Magnum Photos.
190 Andreas Gursky, *Chicago Board of Trade II*, 1999. © Courtesy Sprüth Magers Berlin London/DACS 2015.
192 Heinz Hajek-Halke, *Nude, Printed by Twice Exposing the Same Negative, Once Flipped*, 1933. © Heinz Hajek-Halke Estate/collection Michael Ruetz/Agentur Focus.
193 Hiroshi Hamaya, *Woman Hurrying on the Snow Road, Taugaro, Japan*, 1956. © Hiroshi Hamaya/Magnum Photos.
194 Richard Hamilton, *Interior*, 1964. The Museum of Modern Art, New York/Scala, Florence. © R. Hamilton. All Rights Reserved, DACS 2015.
195 Lady Clementina Hawarden, *Isabella Grace and Florence Elizabeth Maude, 5 Princes Gardens; Photographic Study*, c. 1863–64. Victoria & Albert Museum, London.
196 Raoul Hausmann, *ABCD*, 1923–24. Musée National d'Art Moderne, Centre Georges Pompidou, Paris. © ADAGP, Paris and DACS, London 2015.
197 John Heartfield, *Adolf the Superman: Swallows Gold and Spits Junk*, 1932. © The Heartfield Community of Heirs/VG Bild-Kunst, Bonn and DACS, London 2015.
198 Robert Heinecken, *Costume for Feb '68*, 1968. Courtesy Petzel.
199 Fritz Henle, *The Boy with the Apple*, 1936. © The Fritz Henle Estate.
200 Bill Henson, *Untitled*, 2000–01. Courtesy Bill Henson and Tolarno Galleries, Australia.
201 Sir John Herschel, *Lady with a Harp*, c. 1842. Museum of the History of Science, Oxford.
202 Hill and Adamson, *Sandy (or James) Linton, his Boat and Bairns*, c. 1843–46. Royal Photographic Society/National Media Museum/Science & Society Picture Library.
203 John Hilliard, *Blonde*, 1996. Courtesy the artist.
204 Lewis Wickes Hine, *Steamfitter*, 1921. Library of Congress Prints and Photographs Division, Washington, D.C.
205 Hannah Höch, *Mutter*, 1930. Musée National d'Art Moderne, Centre Georges Pompidou, Paris. © DACS 2015.
206 David Hockney, *Pearblossom Hwy, 11–18th April 1986 (Second Version)*, 1986. © David Hockney. Collection J. Paul Getty Museum, Los Angeles.

207 Evelyn Hofer, *Girl with a Bicycle, Dublin*, 1966. © Evelyn Hofer, courtesy Galerie m Bochum, Germany.
208 Fred Holland Day, *The Seven Lost Words*, 1898. Library of Congress Prints and Photographs Division, Washington, D.C.
209 Dennis Hopper, *Biker Couple*, 1961. © Dennis Hopper, courtesy of The Hopper Art Trust.
210 Horst P. Horst, *Mainbocher Corset*, 1939. Horst/*Vogue*; © Conde Nast.
211 Frank Horvat, *Givenchy Hat at the Longchamp Racetrack, Paris*, 1958. Courtesy of the artist.
212 Eikoh Hosoe, *Barakei (Ordeal by Roses) No. 32*, 1961. © Eikoh Hosoe/ Courtesy of Taka Ishii Gallery, Tokyo.
213 George Hoyningen-Huene, *Georgia Graves, Swimwear by Lelong, Paris*, *Vogue*, 6 July 1929. Hoyningen-Huene/ *Vogue*; © Conde Nast.
214 Louis Adolphe Humbert de Molard, *Louis Dodier as Prisoner*, 1847. Musée d'Orsay, Paris.
215 Axel Hütte, *Jacobigarten*, 2008. Courtesy AKINCI, Netherlands.
217a Boris Ignatovich, *Regulators for Trams*, 1930s. Moscow House of Photography.
217b Drazen Tomic. From *Photography: The New Basics* by Graham Diprose and Jeff Robins, Thames & Hudson Ltd, London, 2012.
218 Yasuhiro Ishimoto, *Chicago*, 1959–61. © Kochi Prefecture, Ishimoto Yasuhiro Photo Center.
219 Alfredo Jaar, *The Sound of Silence*, 2006. Video installation at the École des Beaux-Arts, Paris, 2011. Photography: Charles Duprat. Courtesy Galería Oliva Arauna, Madrid; Kamel Mennour, Paris; Galerie Lelong, New York; Galerie Thomas Schulte, Berlin; and the artist, New York.
220 William Henry Jackson, *Great Falls of the Yellowstone River*, 1872. Library of Congress Prints and Photographs Division, Washington, D.C.
221 Gottfried Jäger, *Photowork V*, 1986. © 2015 Gottfried Jäger, Bielefeld, Germany.
223 Valérie Jouve, *Untitled*, 2001–09. © ADAGP, Paris and DACS, London 2015.
225 Yousuf Karsh, *Winston Churchill*, 1941. Camera Press, London.
226 Gertrude Käsebier, *Blessed Art Thou Among Women*, 1899. Library of Congress Prints and Photographs Division, Washington, D.C.
227a Seydou Keïta, *Untitled*, 1956. Courtesy CAAC – The Pigozzi Collection. © Seydou Keïta/SKPEAC.
227b Peter Keetman, *Volkswagen Factory (Rear Wing)*, 1953. Photo Peter Keetman, © F. C. Gundlach Foundation.

228 André Kertész, *Fork*, 1928. © Estate of André Kertész/Higher Pictures.
229 Yevgeny Khaldei, *Raising the Flag on the Reichstag*, 1945. akg-images.
230 Chris Killip, *Youth on a Wall, Jarrow*, 1976. Courtesy the artist.
231a Ihei Kimura, *Young Men, Niida, Akita*, 1952. © Ihei Kimura, courtesy Mr Takeyoshi Tanuma.
231b Jürgen Klauke, *Formalized Boredom*, 1980–81. Courtesy the artist.
232 William Klein, *Grace, New York*, 1955. Courtesy the artist.
233 Nick Knight, *Yohji Yamamoto: Susie Smoking*, 1988. © Nick Knight/Trunk Archive.
234 Kodak No. 1 camera, 1889. Kodak Collection/NMEM/Science & Society Picture Library.
236 Josef Koudelka, *Festival of Gypsy Music, Strážnice, Czechoslovakia*, 1966. © Josef Koudelka/Magnum Photos.
237 Barbara Kruger, *Untitled (Your body is a battleground)*, 1989. © Barbara Kruger. Collection The Broad Art Museum, Los Angeles, California. Courtesy Mary Boone Gallery, New York.
238 Germaine Krull, *Jean Cocteau*, 1929. The Museum of Modern Art, New York/ Scala, Florence. © Estate Germaine Krull, Museum Folkwang, Essen.
239 Heinrich Kühn, *Fishermen on the Canal*, 1908. Private collection.
241 Robert Smithson, *Hypothetical Continent (Icecap of Gondwanaland), Yucatán, Mexico*, 1969. Collection of the Estate of Robert Smithson. The Holt-Smithson Foundation/Courtesy of James Cohan Gallery, New York and Shanghai. © Estate of Robert Smithson/ DACS, London/VAGA, New York, 2015.
242 Dorothea Lange, *Migrant Mother*, 1936. Library of Congress Prints and Photographs Division, Washington, D.C.
243 Jacques Henri Lartigue, *Grand Prix of the Automobile Club of France, Course at Dieppe*, 1912. © Donation Jacques Henri Lartigue.
244 Gustave Le Gray, *The Great Wave, Sète*, 1856–59. The J. Paul Getty Museum, Los Angeles.
245 Henri Le Secq, *Tower of the Kings, Reims Cathedral*, 1851. The J. Paul Getty Museum, Los Angeles.
246a Russell Lee, *Jack Whinery, Homesteader, and his Family, Pie Town, New Mexico*, 1940. Library of Congress Prints and Photographs Division, Washington, D.C.
246b Leica 1 camera, made by Leitz, 1925. National Media Museum/Science & Society Picture Library.
247 Lehnert & Landrock, *Bedouin in the Desert, Tunisia*, c. 1903. Musée de l'Elysée, Lausanne.

250 Sherrie Levine, *After Walker Evans*, 1981. © Sherrie Levine. Courtesy Paula Cooper Gallery, New York.
251 Helen Levitt, *New York*, c. 1940. Estate of Helen Levitt.
255 Ken Lum, *Hum, hum, hummmm*, 1994. © Ken Lum. Collection of the Vancouver Art Gallery, Gift of Bob Rennie.
256 Urs Lüthi, *Lüthi Also Cries for You*, 1970. © Urs Lüthi.
257 Loretta Lux, *The Drummer*, 2004. © Loretta Lux, courtesy Yossi Milo Gallery, New York.
258 Danny Lyon, *Sparky and Cowboy (Gary Rogues), Schererville, Indiana*, 1965. © Danny Lyon/Magnum Photos.
261 Ian Macdonald, *Teaching Practice, Preston*, 1977. Courtesy of the artist.
262 Man Ray, *Black and White*, 1926. © Man Ray Trust/ADAGP, Paris and DACS, London 2015.
264 Sally Mann, *Hephaestus*, 2008. © Sally Mann. Courtesy Gagosian Gallery.
265 Robert Mapplethorpe, *Ajitto*, 1981. © The Robert Mapplethorpe Foundation. Courtesy Art + Commerce.
266 Étienne-Jules Marey, *Chronophotographic Study of Man Pole-Vaulting*, 1890–91. akg-images.
267 Mary Ellen Mark, *Indian Circus, Fall '89*, 1989. © Mary Ellen Mark.
268 Paul Martin, *Trippers at Cromer*, 1892. Victoria & Albert Museum, London.
269 Charles Marville, *Rue de la Petite-Truanderie et de la Grande-Truanderie, 1st Arrondissement, Paris*, 1865–68. Photothèque de Paris.
270 Mayer & Pierson, *Richard Wagner*, mid-1860s. National Portrait Gallery, London.
271 Ralph Eugene Meatyard, *Untitled*, c. 1955. © The Estate of Ralph Eugene Meatyard, courtesy Fraenkel Gallery, San Francisco.
272 Susan Meiselas, *Car of a Somoza Informer Burning in Managua, Nicaragua*, 1978–79. © Susan Meiselas/ Magnum Photos.
273 Annette Messager, *My Vows*, 1988–91. © ADAGP, Paris and DACS, London 2015.
274 Ray K. Metzker, *Frankfurt*, 1961. Estate of Ray K. Metzker, courtesy Laurence Miller Gallery.
275 Joel Meyerowitz, *Camel Coats, New York*, 1975. Courtesy the artist.
276 Duane Michals, *Magritte with Hat*, 1965. © Duane Michals. Courtesy of DC Moore Gallery, New York.
277 Boris Mikhailov, *Untitled*, from the *Salt Lake* series, 1986. © Boris

Mikhailov; courtesy Pace/MacGill Gallery, New York.

279 Lee Miller, *Self-Portrait*, 1933. © Lee Miller Archives, England 2014. All rights reserved.

280 Lisette Model, *Promenade des Anglais, Nice*, c. 1934. National Gallery of Canada, Ottawa, gift of the Estate of Lisette Model, 1990, by direction of Joseph G. Blum, New York, through the American Friends of Canada. © The Lisette Model Foundation, Inc. (1983). Used by permission.

282 László Moholy-Nagy, *Dolls*, 1926. © Hattula Moholy-Nagy/DACS 2015.

283 Moï Ver, *Paris: 80 Photographies* (1931). British Library, London.

284 Inge Morath, *Marilyn Monroe, Eli Wallach and Clark Gable Rehearsing the Dancing Scene between Roslyn and Guido*, 1960. © The Inge Morath Foundation/Magnum Photos.

286 Yasumasa Morimura, *Self-Portrait (Actress)/After Elizabeth Taylor 2*, 1996. © Yasumasa Morimura; courtesy the artist and Luhring Augustine, New York.

287 Zwelethu Mthethwa, *Untitled*, from the *Interior* series, 2000. © Zwelethu Mthethwa. Courtesy the artist and Jack Shainman Gallery, New York.

288 Vik Muniz, *Narcissus, after Caravaggio*, 2005. © Vik Muniz/VAGA, New York/DACS, London 2015.

289 Nickolas Muray, *Frida Kahlo*, 1939. © Nickolas Muray Photo Archives.

290 Eadweard Muybridge, *Man and Horse Jumping a Fence*, 1887. Plate 640 from *Animal Locomotion* (1887). Stapleton Historical Collection. Photo Scala, Florence/Heritage Images.

291 Carl Mydans, *Douglas MacArthur in Luzon*, 1944. © Carl Mydans/The LIFE Picture Collection/Getty Images.

293 Nadar, *Charles Baudelaire*, c. 1860. akg-images.

295 Charles Nègre, *Chimney-Sweeps Walking*, c. 1851. Roger Viollet/TopFoto.

298 Arnold Newman, *Igor Stravinsky, New York City*, 1946. © Arnold Newman/Getty Images.

300 Nicéphore Niépce, *View from the Window at Le Gras*, 1826–27. Harry Ransom Humanities Research Center, University of Texas, Austin.

302 Claude Nori, *Biarritz*, 1980. Courtesy the artist.

303 William Notman, *Self-Portrait*, 1866–67. McCord Museum, Montreal.

305 Gabriel Orozco, *Cat in the Jungle*, 1992. © Gabriel Orozco, courtesy Marian Goodman Gallery, New York and Paris.

306 Timothy O'Sullivan, *A Harvest of Death, Gettysburg*, 1863. Library of Congress Prints and Photographs Division, Washington, D.C.

309 Trent Parke, *Outback, New South Wales. Menindee. Midnight, Australian Photographer Trent Parke by Himself*, 2003. © Trent Parke/Magnum Photos.

310 Martin Parr, *Benidorm*, from *Common Sense* (1997). Martin Parr/Magnum Photos.

311 Roger Parry, illustration from Léon-Paul Fargue's *Banalité* (1930). Photo © Centre Pompidou, MNAM-CCI, Dist. RMN-Grand Palais/Bertrand Prévost.

312 Gilles Peress, *Rioters Throw Stones at a British Armoured Car, Derry*, 1972. © Gilles Peress/Magnum Photos.

315 Anders Petersen, *Mental Hospital, Drevviken*, 1995. Courtesy the artist.

316 László Moholy-Nagy, *Photogram*, 1926. The Metropolitan Museum of Art/Art Resource/Scala, Florence. © Hattula Moholy-Nagy/DACS 2015.

319 Gustav Klutsis, *Postcard for the All Union Spartakiada Sporting Event*, 1928. The Museum of Modern Art, New York/Scala, Florence.

323 Polaroid Model 95 camera, 1948–53. National Media Museum/Science & Society Picture Library.

324 Sigmar Polke, *Untitled (Willich)*, 1972. Courtesy the estate of Sigmar Polke and Koenig & Clinton, New York.

327 Marion Post Wolcott, *Post Office, Belle Glade, Florida*, 1939. Library of Congress Prints and Photographs Division, Washington, D.C.

331 Robert Rauschenberg, *Japanese Sky*, 1988. Photo Sotheby's. © Robert Rauschenberg Foundation/DACS, London/VAGA, New York 2015.

332 Tony Ray-Jones, *Beauty Contest, Southport*, 1967. © Tony Ray-Jones/National Media Museum/Science & Society Picture Library.

333 Henri Victor Regnault, *The Ladder*, 1853. Bibliothèque Nationale de France, Paris.

334 Oscar Gustav Rejlander, *Two Ways of Life*, 1857. Royal Photographic Society, Bath.

335 Albert Renger-Patzsch, *Snake Head*, 1928. © Albert Renger-Patzsch Archiv/Ann und Jürgen Wilde/DACS, London 2015.

336 Bettina Rheims, *Erica*, 1991. © Bettina Rheims.

337 Marc Riboud, *An American Girl, Jan Rose Kasmir, confronts the American National Guard outside the Pentagon during the 1967 Anti-Vietnam March*, 1967. © Marc Riboud/Magnum Photos.

338 Leni Riefenstahl, *Javelin-Thrower*, from the *Olympia* series, 1936. © Leni Riefenstahl Produktion.

339 Jacob A. Riis, *Police Station Lodgers in Oak Street Station*, 1890. Museum of the City of New York.

340 Herb Ritts, *Fred with Tires*, 1984. © Herb Ritts/Trunk Archive.

341 James Robertson, *Mosque of Soliman the Magnificent, Solimanyah, Constantinople*, 1855. British Library, London.

342 Henry Peach Robinson, *Fading Away*, 1858. The Royal Photographic Society at the National Media Museum, Bradford.

343a George Rodger, *Hassau Chieftains Demonstrate their Superb Horsemanship in a 'Fantasia'*, 1941. © George Rodger/Magnum Photos.

343b Alexander Rodchenko, *Stairs*, 1930. Photo Scala, Florence. © Rodchenko & Stepanova Archive, DACS, RAO, 2015.

344 Rolleiflex twin-lens reflex camera, 1939. Photo Eugene Ilchenko.

345 Willy Ronis, *Provençal Nude, Gordes*, 1949. © Succession Willy Ronis/Diffusion Agence Gamma-Rapho/Getty Images.

346 Martha Rosler, *Cleaning the Drapes*, from the series *House Beautiful: Bringing the War Home*, c. 1965–72. Courtesy the artist and Mitchell-Innes & Nash, NY.

347 Henryk Ross, *Ghetto Life, Łódź*, 1940–44. Agence VU.

348 Arthur Rothstein, *Farmer and Sons Walking in the Face of a Dust Storm, Cimarron County, Oklahoma*, 1936. Library of Congress Prints and Photographs Division, Washington, D.C.

350 Thomas Ruff, *Portrait I (Igraw)*, 1988. Thomas Ruff and Johnen Galerie, Berlin. © DACS 2015.

351 Ed Ruscha, *Standard Station, Amarillo, Texas*, 1962. © Ed Ruscha. Courtesy Gagosian Gallery.

353 Erich Salomon, *Aristide Briand pointing at Erich Salomon and saying, 'Ah! There he is! The king of the indiscreet!'*, 1931. Musée d'Orsay, Paris.

354 Auguste Salzmann, *The Church of the Holy Sepulchre, Jerusalem*, 1854. The Metropolitan Museum of Art, New York.

355 Lucas Samaras, *Panorama*, 1983. The Museum of Modern Art, New York/Scala, Florence. © Lucas Samaras.

356 August Sander, *Young Farmers*, 1914. © Die Photographische Sammlung/SK Stiftung Kultur - August Sander Archiv, Köln/VG Bild-Kunst, Bonn and DACS, London 2015.

357 Jan Saudek, *The Slavic Girl with her Father*, 1998. © Jan Saudek.

358 Christian Schad, *Amourette*, 1918. The Museum of Modern Art, New York/Scala, Florence. © Christian Schad

Stiftung Aschaffenburg/VG Bild-Kunst, Bonn and DACS, London 2015.
361 Paul Seawright, from the series *The Forest*, 2000. © Paul Seawright.
362 Allan Sekula, *Panorama: Mid-Atlantic, November 1993*, from the series *Fish Story*, 1989–95. © The Estate of Allan Sekula.
363 Vittorio Sella, *Grand Sagne and Ecrins, Alps*, 1888. Fondazione Sella.
364 Paul Senn, *Lunch at a Mountain School, Adelboden, Bernese Oberland, Switzerland*, 1935. Bernese Foundation of Photography, Film and Video, Kunstmuseum Bern, deposit Gottfried Keller Foundation. © Gottfried Keller Foundation, Bern.
365 Andres Serrano, *Piss Christ*, 1987. Courtesy the artist.
366 David 'Chim' Seymour, *The Port of Cartagena: The Revolt of Pro-Franco Officers is Silenced by Republican Marines on the Battleship 'Jaime 1'*, 1936. © David Seymour/Magnum Photos.
367 Ben Shahn, *Itinerant Photographer in Columbus, Ohio*, 1938. Library of Congress Prints and Photographs Division, Washington, D.C.
368 Charles Sheeler, *Criss-Crossed Conveyors, Ford Plant, Detroit*, 1927. Lane Collection, Museum of Fine Arts, Boston.
369 Cindy Sherman, *Untitled Film Still No. 6*, 1977. Courtesy the artist and Metro Pictures, New York.
371 Malick Sidibé, *Yokoro*, 1970. © Malick Sidibé. Courtesy of the artist and Jack Shainman Gallery, New York.
372 Katharina Sieverding, *Stauffenberg-Block, II/IX B*, 1969. © DACS 2015.
373 Camille Silvy, *Miss Booth*, 1861. National Portrait Gallery, London.
374 Aaron Siskind, *Chicago 30*, 1949. Courtesy the Aaron Siskind Foundation.
375 W. Eugene Smith, *Dr Ceriani Resting in his Kitchen, After Having Spent the Night Operating*, 1948. © Eugene W. Smith/Magnum Photos.
377 Frederick Sommer, *Max Ernst*, 1946. © Frederick & Frances Sommer Foundation.
379 Southworth & Hawes, *Untitled (Two Women Posed with a Chair)*, c. 1850. Amon Carter Museum, Fort Worth.
380 Chris Steele-Perkins, *Red Deer, Croydon*, 1976. © Chris Steele-Perkins/Magnum Photos.
381 Edward Steichen, *The Flatiron*, 1904. The Metropolitan Museum of Art/Art Resource/Scala, Florence.
382 Otto Steinert, *Call*, 1950. © Estate Otto Steinert, Museum Folkwang, Essen.

383 Alfred Stieglitz, *Georgia O'Keeffe*, 1918. The Metropolitan Museum of Art/Art Resource/Scala, Florence. © Georgia O'Keeffe Museum/DACS, 2015.
384 Paul Strand, *Wall Street*, 1915. The Philadelphia Museum of Art/Art Resource/Scala, Florence. © Paul Strand Archive/Aperture Foundation.
387 Annelies Štrba, from the series *Shades of Time*, 1974–97. © Annelies Štrba.
388 Thomas Struth, *National Gallery I, London*, 1989. Courtesy the artist.
389 Drazen Tomic. From *Photography: The New Basics* by Graham Diprose and Jeff Robins, Thames & Hudson Ltd, London, 2012.
390 Josef Sudek, *Ladislav Sutnar China: Tea Service Arranged on a Table, Viewed from Above*, 1920s. Museum of Decorative Arts, Prague.
391 Hiroshi Sugimoto, *Radio City Music Hall*, 1978, from the series *Theatres*. © Hiroshi Sugimoto, courtesy Pace Gallery.
392 Frank Meadow Sutcliffe, *The Water Rats*, 1886. Royal Photographic Society/National Media Museum/Science & Society Picture Library.
395 William Henry Fox Talbot, *The Open Door*, 1844. British Library, London.
396 Gerda Taro, *Republican Militiawoman Training on the Beach outside Barcelona*, 1936. © Gerda Taro/Magnum Photos.
397 Sam Taylor-Johnson, *Escape Artist (Primary Colours)*, 2008. © Sam Taylor-Johnson. Courtesy White Cube.
398 Guy Tillim, *Jean-Pierre Bemba, Presidential Candidate, Enters a Stadium in Central Kinshasa Flanked by his Bodyguards*, 2006. © Guy Tillim. Courtesy of Stevenson, Cape Town and Johannesburg.
399 Wolfgang Tillmans, *Jochen Taking a Bath*, 1997. © The artist, courtesy Maureen Paley, London.
400 Patrick Tosani, *P.T.D.*, 1992. © Patrick Tosani.
401 Shomei Tomatsu, *Christian with Keloidal Scars*, 1961. © Shomei Tomatsu – interface/Courtesy of Taka Ishii Gallery, Tokyo.
402 Deborah Turbeville, *Bathhouse* series for *Vogue*, 1 May 1975. Turbeville/*Vogue*; © Conde Nast.
405 Raoul Ubac, *Le Combat de Penthésilée*, 1937. © ADAGP, Paris and DACS, London 2015.
406 Umbo, *Mystery of the Street*, 1928. © Phyllis Umbehr/Galerie Kicken Berlin/ DACS 2015.
407 John Vachon, *Negro Family Waiting for Ride into Town, Halifax County,*

Virginia, 1941. Library of Congress Prints and Photographs Division, Washington, D.C.
409 Roman Vishniac, *Jewish Schoolchildren, Mukachevo*, c. 1935–38. © Mara Vishniac Kohn, courtesy International Center of Photography.
410 Christian Vogt, *Balinesian Priestess and Zoe Jenny, Novelist*, from the series *Idem diversum*, 1991–95. © Christian Vogt.
411 Cover of *Vu*, no. 259, 1 March 1933.
413 Jeff Wall, *The Destroyed Room*, 1978. Courtesy the artist.
414 Andy Warhol, *Self-Portrait in Drag*, 1981. Solomon Guggenheim Museum, New York. © 2015 The Andy Warhol Foundation for the Visual Arts, Inc./Artists Rights Society (ARS), New York and DACS, London.
415 Carleton Eugene Watkins, *Agassiz Rock, Yosemite Falls, from Union Point*, c. 1878. The J. Paul Getty Museum, Los Angeles.
416 Boyd Webb, *Nourish II*, 1984–2006. Sonnabend Gallery, New York.
417 Weegee, *Lifted into an Ambulance, New York*, 1941. © Weegee (Arthur Felig)/International Center of Photography/Getty Images.
419 Edward Weston, *Pepper No. 30*, 1930. © 1989 Center for Creative Photography, Arizona Board of Regents.
420 Clarence Hudson White, *Drops of Rain*, 1903. The Museum of Modern Art, New York/Scala, Florence.
421 Minor White, *Vicinity of Cove, Grande Ronde Valley, Oregon*, 1941. Minor White Archive, Princeton University Art Museum.
422 George Washington Wilson, *Queen Victoria on Fyvie with John Brown at Balmoral*, 1863. Scottish National Portrait Gallery, Edinburgh.
423 Garry Winogrand, *Central Park Zoo, New York City*, 1967. © The Estate of Garry Winogrand, courtesy Fraenkel Gallery, San Francisco.
424 Wols, *Doll on the Cobbles*, 1938. Musée National d'Art Moderne – Centre Georges Pompidou, Paris. Photo Centre Pompidou, MNAM-CCI, Dist. RMN-Grand Palais/Georges Meguerditchian. © ADAGP, Paris and DACS, London 2015.
425 Erwin Wurm, from the series *One Minute Sculptures*, 1997. Courtesy the artist and Xavier Hufkens, Brussels. Photo Erwin Wurm Studio.
427 Nakaji Yasui, *Gaze*, 1931. Courtesy Taka Ishii Gallery, Tokyo.
428 Pavel Semyonovich Zhukov, *Vladimir Lenin*, 1920. Moscow House of Photography.

Acknowledgments

The story of this dictionary of photography is a long but ultimately successful one. The idea first emerged in 1998, when I was working at the Musée de l'Elysée in Lausanne, Switzerland. After several discussions with publisher Thames & Hudson, it became clear that such a dictionary would be an invaluable tool for students of photography and art history, for photography lovers and for anyone interested in knowing more about the history of the medium. William A. Ewing, who was then director of the Musée de l'Elysée, and I proposed a small-sized publication that would be easy to handle and to carry. Since then, time has flown and today we are busier then ever looking at our screens rather than at books. However, the need for such a printed dictionary is still clear for photography enthusiasts. Since 1998 I've kept the project alive and continued to compile information for its content. This long-term project is now published and it is tempting to list all those involved over the decades. However, restrictions of space compel me to limit my acknowledgments to the not inconsiderable number of individuals who have been involved in the production of this book.

First of all, I would like to thank the Musée de l'Elysée, who helped me to get the project on track. I would particularly like to thank William A. Ewing. Without his precious advice, this project would have been impossible. Jean-Christophe Blaser and Daniel Girardin were also helpful in the starting phase. In addition to these key people, my research benefited a great deal from my discussions with the following colleagues: Corinne Currat, Lydia Dorner, Pauline Martin, Arianne Pollet, and Johanna Schär. I am grateful to them for helping me to compile lists of entries for this dictionary. I would also like to mention Manon Saudan, who helped in collecting a lot of information for the project.

In order to produce a comprehensive dictionary, I needed photography historians who shared my enthusiasm for the project. Over the years I approached researchers and historians in photography in many different parts of the world and invited them to be involved in the writing phase. Each of the following individuals played a major role in contributing texts to the dictionary, for which I am extremely grateful: Mathilde Arrivé, Elisa Baitelli, Heide Barrenechea, Laetitia Barrere, Hélène Beade, Raphaële Bertho, Muriel Berthou Crestey, Lindsay Bolanos, Michaela Bosáková, Clara Bouveresse, Adrienne Bovet, Natasha Bullock, Alice Carver-Kubik, Nathalie Casemajor Loustau, Héloïse Conésa, Laure Cuérel, Corinne Currat, Nathalie Dietschy, Lydia Dorner, Helen Ennis, Aurore Fossard-De Almeida, Marie Gautier, Stefanie Gerke, William Green, Christine Gückel-Daxer, Claus Gunti, Christine Hansen, Emily Kay Henson, Graham Howe, Takahiro Ito, Min-young Jeon, Samuel De Jesus, Joanne Junga Yang, Jean Kempf, Masha Kreimerzak, Constance Lambiel, Marc Lenot, Véra Léon, Athol McCredie, Emily McKibbon, Jonathan Maho,

Pauline Martin, Gábor Máté, Nolwenn Mégard, Laureline Meizel, Christelle Michel, Marine Nédélec, Nathalie Neumann, Clémentine Odier, Hélène Orain, Ken Orchard, Maude Oswald, Allan Phoenix, Héloïse Pocry, Ariane Pollet, Maud Pollien, Erika Raberg, Anna-Kaisa Rastenberger, Caroline Roche, Anaëlle Rod, Holly Roussell Perret-Gentil, Elisa Rusca, Manon Saudan, Johanna Schär, Danielle Shrestha McAllister, Cécile Simonet, Wim van Sinderen, Edward Stokes, Anna Tellgren, Veronika Tocha, Agata Ubysz, Rachel Verbin, Emily Wagner Phoenix, Anne-Marie Walsh, Alana West, Perin Emel Yavuz, and Fatma Zrann.

In addition to these contributors, I would like to thank the many experts in the history of photography that I've contacted in all continents for providing valuable advice. Their expertise was essential for my research over the years. Each of the following people – esteemed photography curators and historians – kindly shared with me their knowledge of photography: Vince Aletti, Stuart Alexander, Jamie Allen, Séverine Allimann, Dag Alveng, Federica Angelucci, Bérénice Angremy, Judy Annear, Alexandra Athanassiadou, Irene Attinger, Quentin Bajac, Gordon Baldwin, Els Barents, Martin Barnes, Gabriel Bauret, Barnabas Bencsik, Vladimir Birgus, Anne Biroleau-Lemagny, Jean-Christophe Blaser, Claudia Bohn-Spector, Anda Boluza, Pascale and Jean-Marc Bonnard Yersin, Michaela Bosáková, Christophe Brandt, Philip Brookman, Susanna Brown, François Brunet, Gail Buckland, Xavier Canonne, Anne Cartier-Bresson, Alejandro Castellanos Cadena, Clément Chéroux, François Cheval, A. D. Coleman, Cathie Coleman, Marguy Conzémius, Charlotte Cotton, Isobel Crombie, Emmanuel d'Autreppe, Nassim Daghighian, Claudio de Polo, Michael Diers, Nathalie Dietschy, Régis Durand, Florian Ebner, Okwui Enwezor, William A. Ewing, Angela M. Ferreira, Marc Feustel, Pepe Font de Mora, Joan Fontcuberta, Jens F. Friis, Michel Frizot, Gwenola Furic, Martin Gasser, Thierry Gervais, Frits Gierstberg, Marta Gili, Jean-Louis Godefroid, Vicki Goldberg, Claire Gould, Andy Grundberg, André Gunthert, Sophie Hackett, Patricia Hayes, Manfred Heiting, Sylvie Henguely, Pascal Hoël, Hanne Holm-Johnsen, Andréa Holzherr, Graham Howe, Vangelis Ioakimidis, Karen Irvine, Mimmo Jodice, Christian Joschke, Joanne Junga Yang, Michiko Kasahara, Jean Kempf, Susan Kismaric, Ksenia Klimanova, Gunilla Knape, Kim Knoppers, Mika Kobayashi, Fani Konstantinou, Marloes Krijnen, Zuzana Lapitkova, Luce Lebart, Lech Lechowicz, Jiyoon Lee, Anne-Françoise Lesuisse, Olivier Lugon, Celina Lunsford, Nathan Lyons, Monica Maffioli, Asko Makela, Patricia Mandoza, Lesley Martin, Patricia Martin, Alessandra Mauro, David Mellor, Pedro Meyer, Herbert Molderings, Gilles Mora, Carole Naggar, Gael Newton, Simon Njami, Alison Nordstrom, Colette Olof, Erin O'Toole, Engin Ozendes, Pascale Pahud, Martin Parr, Nissan N. Perez, Timothy Persons, Peter Pfrunder, Chris Phillips, Ulrich Pohlmann, Michel Poivert,

Marta Ponsa, Phillip Prodger, Anna-Kaisa Rastenberger, Françoise Reynaud, Jorge Ribalta, Fred Ritchin, Pamela Glasson Roberts, Caroline Roche, Brett Rogers, Jeff Rosenheim, Oliva Maria Rubio, Tatiana Grigorievna Saburova, Giuliana Scimé, Mark Sealy, Thomas Seelig, Laura Serani, Parthiv Shah, Wim van Sinderen, Carol Squiers, Urs Stahel, Charlie Stainback, Radu Stern, Michael Graham Stewart, Stefano Stoll, Olga Sviblova, Mariko Takeuchi, Anna Tellgren, Ann Thomas, Andras Török, Anne Wilkes Tucker, Roberta Valtorta, Dominique Versavel, Ruud Visschedijk, Hripsimé Visser, Michèle Walerich, Brian Wallis, Marta Weiss, Leif H. Wigh, Yuko Yamaji, Steve Yates, Lim Young-Kyun, and Christina Zelich.

I am also extremely grateful to publisher Thomas Neurath of Thames & Hudson, for having embraced and believed in the project with such enthusiasm throughout the years. Heartfelt thanks to all the staff at Thames & Hudson, in particular Andrew Sanigar, Hannah Consterdine, Rebecca Sheppard, Sam Wythe, Lisa Ifsits, Sally Nicholls, Ginny Liggitt and Jenny Wilson.

Given that this is a photography book, it is essential that I thank the photographers – and their representatives – whose work has been reproduced in this book.

Finally, to complete the list of those who have been instrumental in helping me to realize this book, I would like to acknowledge the remarkable work done by Lydia Dorner, who brought her knowledge on the history of photography, not to mention her skills in assisting with the various stages of the project.

Nathalie Herschdorfer

First published in the United Kingdom
in 2015 by Thames & Hudson Ltd,
181A High Holborn, London WC1V 7QX

*The Thames & Hudson Dictionary
of Photography*
© 2015 Thames & Hudson Ltd, London

Designed by Lisa Ifsits

British Library Cataloguing-in-
Publication Data
A catalogue record for this book
is available from the British Library

ISBN 978-0-500-54447-1

Printed and bound in China
by C & C Offset Printing Co. Ltd

To find out about all our publications,
please visit **www.thamesandhudson.com**.
There you can subscribe to our e-newsletter,
browse or download our current catalogue,
and buy any titles that are in print.